Walter Benjamin

SELECTED WRITINGS

Michael W. Jennings
General Editor

Marcus Bullock, Howard Eiland, Gary Smith
Editorial Board

Walter Benjamin

SELECTED WRITINGS
VOLUME 2, PART 1
1927–1930

Translated by Rodney Livingstone
and Others

Edited by Michael W. Jennings,
Howard Eiland, and Gary Smith

THE BELKNAP PRESS OF HARVARD UNIVERSITY PRESS
Cambridge, Massachusetts, and London, England

This work is a translation of selections from Walter Benjamin, *Gesammelte Schriften, Unter Mitwirkung von Theodor W. Adorno und Gershom Sholem, herausgegeben von Rolf Tiedemann und Hermann Schweppenhäuser,* copyright © 1972, 1974, 1977, 1982, 1985, 1989 by Suhrkamp Verlag. One piece in this volume was previously published in English, as follows: "On the Image of Proust" apppeared in Walter Benjamin, *Illuminations,* edited by Hannah Arendt, English translation copyright © 1968 by Harcourt Brace Jovanovich, Inc. "Moscow," "Surrealism," and "Marseilles" appeared in Walter Benjamin, *Reflections,* English translation copyright © 1978 by Harcourt Brace Jovanovich, Inc. Published by arrangement with Harcourt Brace Jovanovich, Inc. "From the Brecht Commentary" appeared in Walter Benjamin, *Understanding Brecht* (London: NLB/Verso, 1973). "Theories of German Fascism" appeared in *New German Critique* 17 (Spring 1979). "Goethe" appeared in *New Left Review* 133 (May–June 1982).

Publication of this book has been aided by a grant from Inter Nationes, Bonn.

Frontispiece: Walter Benjamin, Berlin, 1929. Photo by Charlotte Joël. Courtesy of the Theodor W. Adorno Archiv, Frankfurt am Main.

Library of Congress Cataloging in Publication Data

Benjamin, Walter, 1892–1940.
[Selections. English. 1999]
Selected writings / Walter Benjamin; edited by Michael W. Jennings, Howard Eiland, and Gary Smith
 p. cm.
"This work is a translation of selections from Walter Benjamin, Gesammelte Schriften . . . copyright 1972 . . . by Suhrkamp Verlag"—T.p. verso.
Includes index.
Contents: v. 1. 1913–1926.—v. 2. 1927–1934.—v. 3. 1935–1938.—v. 4. 1938–1940.
ISBN 0-674-94585-9 (v. 1: alk. paper) ISBN 0-674-94586-7 (v. 2: alk. paper)
ISBN 0-674-00896-0 (v. 3: alk. paper) ISBN 0-674-01076-0 (v. 4: alk. paper)
ISBN 0-674-01355-7 (v. 1: pbk.) ISBN 0-674-01588-6 (v. 2, pt. 1: pbk.)
ISBN 0-674-01746-3 (v. 2, pt. 2: pbk.)
I. Jennings, Michael William. II. Title.
PT2603.E455A26 1996
833'.91209—dc20 96-23027

Designed by Gwen Nefsky Frankfeldt

Contents

THE RETURN OF THE *FLANEUR,* 1929

CRISIS AND CRITIQUE, 1930

Moscow, 1927

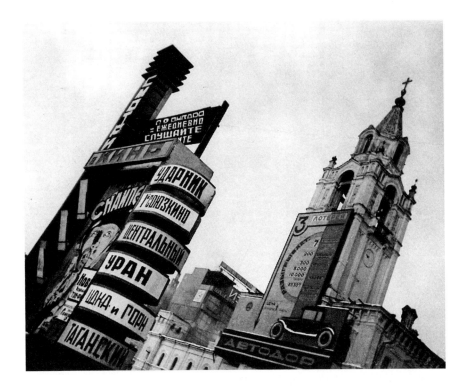

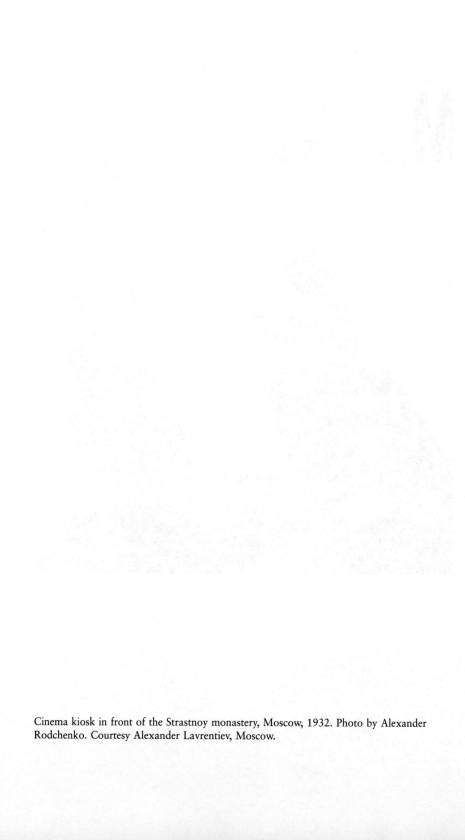

Cinema kiosk in front of the Strastnoy monastery, Moscow, 1932. Photo by Alexander Rodchenko. Courtesy Alexander Lavrentiev, Moscow.

Dream Kitsch

Gloss on Surrealism

No one really dreams any longer of the Blue Flower.[1] Whoever awakes as Heinrich von Ofterdingen today must have overslept.[2] The history of the dream remains to be written, and opening up a perspective on this subject would mean decisively overcoming the superstitious belief in natural necessity by means of historical illumination. Dreaming has a share in history. The statistics on dreaming would stretch beyond the pleasures of the anecdotal landscape into the barrenness of a battlefield. Dreams have started wars, and wars, from the very earliest times, have determined the propriety and impropriety—indeed, the range—of dreams.

No longer does the dream reveal a blue horizon. The dream has grown gray. The gray coating of dust on things is its best part. Dreams are now a shortcut to banality. Technology consigns the outer image of things to a long farewell, like banknotes that are bound to lose their value. It is then that the hand retrieves this outer cast in dreams and, even as they are slipping away, makes contact with familiar contours. It catches hold of objects at their most threadbare and timeworn point. This is not always the most delicate point: children do not so much clasp a glass as snatch it up. And which side does an object turn toward dreams? What point is its most decrepit? It is the side worn through by habit and patched with cheap maxims. The side which things turn toward the dream is kitsch.

Chattering, the fantasy images of things fall to the ground like leaves from a Leporello picture book, *The Dream*.[3] Maxims shelter under every leaf: "Ma plus belle maîtresse c'est la paresse," and "Une médaille vernie pour le plus grand ennui," and "Dans le corridor il y a quelqu'un qui me veut à la mort."[4] The Surrealists have composed such lines, and their allies among

the artists have copied the picture book. *Répétitions* is the name that Paul Eluard gives to one of his collections of poetry, for whose frontispiece Max Ernst has drawn four small boys. They turn their backs to the reader, to their teacher and his desk as well, and look out over a balustrade where a balloon hangs in the air. A giant pencil rests on its point in the windowsill. The repetition of childhood experience gives us pause: when we were little, there was as yet no agonized protest against the world of our parents. As children in the midst of that world, we showed ourselves superior. When we reach for the banal, we take hold of the good along with it—the good that is there (open your eyes) right before you.

For the sentimentality of our parents, so often distilled, is good for providing the most objective image of our feelings. The long-windedness of their speeches, bitter as gall, has the effect of reducing us to a crimped picture puzzle; the ornament of conversation was full of the most abysmal entanglements. Within is heartfelt sympathy, is love, is kitsch. "Surrealism is called upon to reestablish dialogue in its essential truth. The interlocutors are freed from the obligation to be polite. He who speaks will develop no theses. But in principle, the reply cannot be concerned for the self-respect of the person speaking. For in the mind of the listener, words and images are only a springboard." Beautiful sentiments from Breton's *Surrealist Manifesto*. They articulate the formula of the dialogic misunderstanding—which is to say, of what is truly alive in the dialogue. "Misunderstanding" is here another word for the rhythm with which the only true reality forces its way into the conversation. The more effectively a man is able to speak, the more successfully he is misunderstood.

In his *Vague de rêves* [Wave of Dreams], Louis Aragon describes how the mania for dreaming spread over Paris. Young people believed they had come upon one of the secrets of poetry, whereas in fact they did away with poetic composition, as with all the most intensive forces of that period.[5] Saint-Pol-Roux,[6] before going to bed in the early morning, puts up a notice on his door: "Poet at work."—This all in order to blaze a way into the heart of things abolished or superseded, to decipher the contours of the banal as rebus, to start a concealed William Tell from out of wooded entrails, or to be able to answer the question, "Where is the bride?" Picture puzzles, as schemata of the dreamwork, were long ago discovered by psychoanalysis. The Surrealists, with a similar conviction, are less on the trail of the psyche than on the track of things. They seek the totemic tree of objects within the thicket of primal history. The very last, the topmost face on the totem pole, is that of kitsch. It is the last mask of the banal, the one with which we adorn ourselves, in dream and conversation, so as to take in the energies of an outlived world of things.

What we used to call art begins at a distance of two meters from the body. But now, in kitsch, the world of things advances on the human being; it

yields to his uncertain grasp and ultimately fashions its figures in his interior. The new man bears within himself the very quintessence of the old forms, and what evolves in the confrontation with a particular milieu from the second half of the nineteenth century—in the dreams, as well as the words and images, of certain artists—is a creature who deserves the name of "furnished man."

Written in 1925; published in *Die neue Rundschau,* January 1927. *Gesammelte Schriften,* II, 620–622. Translated by Howard Eiland.

Notes

1. The subtitle, "Gloss on Surrealism," was used as the title of the published article in 1927.
2. *Heinrich von Ofterdingen* is the title of an unfinished novel by Novalis, first published in 1802. Von Ofterdingen is a medieval poet in search of the mysterious Blue Flower, which bears the face of his unknown beloved.
3. Leporello is Don Giovanni's servant in Mozart's opera *Don Giovanni.* He carries around a catalogue of his master's conquests, which accordians out to show the many names. In the mid-nineteenth century, there was a German publishing house, Leporello Verlag, which produced such pop-out books.
4. "My loveliest mistress is idleness." "A gold medal for the greatest boredom." "In the hall, there is someone who has it in for me."
5. Reference is to the years 1922–1924. *Une vague de rêves* was first published in the fall of 1924.
6. Pseudonym of Paul Roux (1861–1940), French Symbolist poet.

The Political Groupings of Russian Writers

What distinguishes the stance of the Russian writer most strikingly from that of all his European colleagues is the absolutely public nature of his activity. This makes his opportunities incomparably greater and the external supervision incomparably stricter than in the case of Western literati. This public supervision of his activities by the press, the public, and the party is political in nature. For the books that are published, the actual official censorship—which is, as is well known, preventive—is no more than a prelude to the political debate that constitutes most of the reviews that appear. Under these conditions, it is vital for the Russian writer to show his political colors.

The process of grappling with the political slogans and problems of the day can never be intensive enough, to the point where every important decision of the party confronts the writer with the most immediate challenge, and novels and stories in many cases come to acquire a relationship to the state not unlike that which a writer's works used to have to the convictions of his aristocratic patron in former times. In a few brief years, this situation has necessarily engendered unambiguous and highly visible political groupings among writers. These group formations are authoritative; they are exclusive and unique. Nothing can shed more light on them for the Western writer than the realization that artistic schools and *cénacles* have almost entirely vanished from Russian soil.

VAPP, the All-Union Association of Proletarian Writers, is the leading organization.[1] It has 7,000 members. Its position: with the conquest of political power, the Russian proletariat has established its right to intellectual and artistic hegemony. On the other hand, since, thanks to a centuries-

long process of development, the organizational and productive means for the creation of art are still decidedly in the hands of the bourgeoisie, a dictatorship is currently essential if the rights of the proletariat are to be asserted in the fields of art and literature. It was not until quite recently that this program was able to prevail in the public sphere, albeit only to a very limited extent. The severe setback in cultural policy that followed the liquidation of War Communism[2] and almost toppled the "left-wing cultural front," initially prevented the official recognition of a "proletarian literature" by the party. A year ago VAPP was able to chalk up its first public successes. Within this group, the extreme but also dominant wing consists of the Napostovtsi, who take their name from their journal, *Na postu* [On Guard].[3] Under the leadership of Averbakh, they represent current party orthodoxy. At the level of theory, this group is led by Lelevitch and Besymensky.[4] Or rather it was. Not long ago Lelevitch, who had openly declared his sympathy for the opposition (Zinoviev, Kamenev) and had committed the sin of a "left deviation," was stripped of his influence and banished from Moscow.[5] For all that, this former locksmith remains the leading art theorist of the new Russia. In his work he has sought to build on the foundations of the materialist aesthetic established by Plekhanov.[6] Of the leading creative writers of the group, the best-known are Demyan Bedny, the first great popular revolutionary lyric poet, and the novelists Libedinski and Serafimovitch.[7] These last should perhaps more properly be called "chroniclers." Their chief works, *Nedelya* [A Week] and *Zhelezny Potok* [The Iron Flood], which are also known in Germany, are accounts of their experiences during the Russian civil war. Their method of writing is Naturalist through and through.

This new Russian Naturalism is interesting in more than one respect. Its predecessors lie not merely in the social Naturalism of the 1890s, but even more curiously and remarkably in the pathetic Naturalism of the Baroque period. "Baroque" is the only fitting way to describe the heaped-up crassness of its subject matter, the unconditioned presence of political detail, the predominance of content. Problems of form did not exist for the German Baroque, any more than for contemporary Russia. Debate has raged for two years over whether the true value of a new literary work should be determined by its revolutionary form or its revolutionary content. In the absence of a specific revolutionary form, this debate was recently resolved in favor of revolutionary content.

It is a remarkable fact that all the radical "leftist" formal trends that made their appearance in the posters, written works, and processions of "heroic Communism" actually stem directly from the last Western bourgeois slogans of the prewar period—from Futurism, Constructivism, Unanimism, and so on. Even today, traces of these movements still survive in the second of the three major groups, the Left Poputchiki.[8] This group—literally, the Left

Fellow-Travelers—is not an organized association like VAPP, even though it had its roots in one. LEF—the "Left Front"—was an association of artists who set out to develop revolutionary forms. Their focal point was Vladimir Mayakovsky.[9] Mayakovsky had also been the leading spirit in the first Proletcult groups. Furthermore, it is the members of this school whose works and personalities are best-known in Germany: Babel, Seifullina, and the theater director Meyerhold.[10] One of Meyerhold's greatest successes took place over a year ago; it was his production of *Ritchi Kitai!* [China, Roar!]. The writer Tretyakov[11] should also be included in this group, which whole-heartedly supports the Soviet state but does not acknowledge the literary hegemony of the proletariat.

The standpoint of the third group could be described as qualified approval of the new regime—de facto, but not de jure. This is the Right Poputchiki,[12] a nationalist and even chauvinist group that includes in its ranks people as dissimilar as Yesenin and Ehrenburg.[13] It can be said that ever since he took his own life, Yesenin has continued to keep the literary public under his spell. Less than a month ago, Bukharin, who rarely intervenes in literary matters, wrote a long essay on Yesenin for *Pravda*. It is easy to understand why. Yesenin is the shining and influential personification of an "old" Russian type—that of the tortured and turbulent dreamer with a profound and confused attachment to the Russian soil. Such a man is incompatible with the new man who has brought about the revolution in Russia. The attack on the huge shadow cast by Yesenin has a distant echo in the highly topical efforts to combat hooliganism. What is at stake in both cases is the annihilation of an asocial type in which Russia can descry the specter of its own past, a specter that blocks the path to the new industrialized Eden. The great majority of the 6,000 Russian peasant writers belong to this right-wing trend. Their theoretical leaders are Voronsky and Efros.[14] Voronsky has adopted Trotsky's theory, which for a long time was official party policy. According to this, the proletariat has not yet in any sense transformed society to the point where it can be meaningful to talk in terms of "prole-tarian" literature. That spells the end of the proletarian claim to cultural hegemony. As noted, this has ceased to be the party's position. Last, we should also mention the writers of the "New Bourgeoisie" who have grown out of the NEP.[15] To mention a few names, they include the novelist Pilnyak and the well-known dramatists Alexander Tolstoy and Mikhail Bulgakov.[16] Two plays by Bulgakov are running in Moscow at the moment: *Zoykina Quartira* [Zoyka's Apartment], a play set in a brothel, and *Dni Turbini* [Days of the Turbine], a civil war drama. This play has been a fixture in Stanislavsky's program for months, and has received publicity that can stem only from a scandal. Its tendency is purely counterrevolutionary. The public, the old bourgeoisie—the "has-beens," as one puts it so nicely in Russia today—express their gratitude by filling the theater night after night. The

play was banned several times by the censor, and numerous changes had to be made to the text. Even so, the first performance caused an uproar in the theater. But the radical elements in the audience were unable to prevail, with the result that Moscow now has a reactionary historical play that would be hard put to survive even on the Berlin stage, given its inferiority in terms of theatrical competence and message.

Yet all this counts for little. The particular instance matters less in Soviet literature than in any other. There are times when things and thoughts should be weighed and not counted. But also—though this often escapes notice—there are times when things are counted and not weighed. In our time, Russia's literature is—rightly—more important for statisticians than for aesthetes. Thousands of new authors and hundreds of thousands of new readers want above all to be counted and mobilized into the cadres of the new intellectual sharpshooters, who will be drilled for political command and whose munitions consist of the alphabet. In today's Russia, reading is more important than writing, reading newspapers is more important than reading books, and laboriously spelling out the words is more important than reading newspapers. If Russian literature is what it ought to be, its best products can only be the colored illustrations in the primer from which peasants learn to read in the shadow of Lenin.

Published in *Die literarische Welt,* March 1927. *Gesammelte Schriften,* II, 743–747. Translated by Rodney Livingstone.

Notes

1. Soviet literary organization founded in October 1920. By 1928 it was the leading association for writers in the USSR.
2. "War Communism" is the term used to describe the first period of state-dominated economic and social policy, between 1918 and 1921. It was superseded by the New Economic Policy.
3. This journal became the organ of VAPP and, after 1928, of RAPP, the Russian Association of Proletarian Writers.
4. Leopold Averbakh (1903–1939), was the leader of RAPP, which assumed a dominant position on the literary scene in the Soviet Union after 1929, when it attained official approval for its program of establishing the Soviet First Five-Year Plan as the sole theme of Soviet literature. Grigory Lelevitch (pseudonym of Labori Gilelevich Kalmanson), a poet and critic, was one of the editors of the magazine *Na postu.* Expelled from the party, he died in a camp in 1928. Aleksandr Ilyich Besymensky (1898–1973), poet and official in VAPP, produced tendentious poetry consistent with current party doctrine.
5. Grigory Evseyevich Zinoviev (originally Ovsel Gershon Aronov Radomyslsky; 1883–1936) and Lev Borisovich Kamenev (originally Lev Borisovich Rosenfeld;

1883–1936) were Russian Communist revolutionaries and members of the original post-Lenin triumvirate (along with Joseph Stalin). Both were executed at the beginning of the Great Purge.

6. Georgy Valentinovich Plekhanov (1857–1918), Russian political philosopher and Menshevik revolutionary, founded the first Communist organization in Russia. He is generally considered the father of Russian Marxism.

7. Demyan Bedny (pseudonym of Efim Alekseyevich Pridvorov; 1883–1945) wrote verse in an accessible and popular mode; his work was known for its inflammatory tone. Yury Nikolayevich Libedinski (1898–1959) was a novelist; his *Nedelya* (A Week) attempted to fuse Andrei Bely's symbolism and a reportorial style that portrayed the lives of Communists in connection with their party work. Aleksandr Serafimovich Serafimovich (pseudonym of A. S. Popov; 1863–1949) was a novelist and the editor of the journal *Oktyabr.* His novel *Zhelezny Potok* (The Iron Flood) of 1924 depicts the retreat of the Bolshevik army.

8. The Left Poputchiki (Levy front iskusstva, or Left Front of Art), known as LEF, was a Marxist literary group that arose in Moscow at the end of 1922; it included much of the Russian avant-garde. LEF's rational aesthetic aspired to a union between art and production. It was attacked by the proletarian groups Oktyabr and VAPP.

9. Vladimir Vladimirovich Mayakovsky (1893–1930) was Russia's leading poet; he was considered the poet of the October Revolution and the model for Socialist Realist poetry. Mayakovsky gradually became disillusioned with the course of the postrevolutionary Soviet Union, and committed suicide in 1930.

10. Isaac Emmanuilovich Babel (1894–1941?), Jewish prose writer and dramatist known for the 1926 short-story collection *Konarmiya* (Red Cavalry) and the 1931 *Odesskiye rasskazy* (Tales of Odessa). Purged in 1939, his death was announced on March 17, 1941. Lydia N. Seifullina (1889–1954) was a prolific writer; most of her work is prose. Vsevolod Emilevich Meyerhold (1874–1942), preeminent Russian actor and director, opposed the Naturalism of the Moscow Art Theater and was the first theater director to offer his services to the new government after the Revolution. In 1923 he was given his own theater, the Teatr imeni Meyerhold (TIM).

11. Sergei Mikhailovich Tretyakov (1892–1939?) was a Futurist playwright, novelist, and poet. A member of LEF, he fought for revolutionary experimentation in art.

12. "Right Poputchiki" originally referred to writers in the Soviet Union who had neither supported nor opposed the revolution. Trotsky's use of the term in *Literature and Revolution* (1925) recognized artists' need for intellectual freedom and their dependence on links with the cultural traditions of the past. Fellow travelers such as Osip Mandelstam, Leonid Leonov, Boris Pilnyak, Isaac Babel, and Ilya Ehrenburg were officially recognized in the early 1920s. They met bitter opposition, however, from champions of a new proletarian art, and by the end of the decade the term came to be practically synonymous with "counterrevolutionary."

13. Sergei Aleksandrovich Yesenin (1895–1925), poet and member of a literary group known as the Imagists, was an early supporter of the Revolution, to which he attributed utopian and messianic potential. Ilya Grigoryevich Ehren-

burg (1891–1967) was a prose writer, journalist, and diplomat. Arrested for his revolutionary activities, he emigrated to Paris in 1908. He is best-known for his journalism, propaganda, and autobiographical works, especially his *Lyudi, gody, zhizn* (translated as *People and Life: Memoirs, 1891–1917*). Nikolai Ivanovich Bukharin (1888–1938) was a leading Communist theoretician. After the Revolution, he was appointed editor of the official party organ *Pravda* and leader of the Communist International (Comintern). He was stripped of his party posts in 1929 and fell victim to Stalin's purges.

14. Aleksandr Konstantinovich Voronsky (1884–1943) was a critic, revolutionary, and prose writer who established himself as a leading figure in Soviet cultural politics by rejecting the idea of the Proletcult. As part of the transition to Socialist Realism, Voronsky was arrested and expelled from the party in 1927. He died while in prison. Abram Markovich Efros (1888–1954) was a literary critic, art historian, poet, and translator.

15. The New Economic Policy (NEP) was the economic policy of the Soviet Union from 1921 to 1928 which revised the original emphasis on centralization and planning. The NEP included the return of most agriculture, retail trade, and light industry to private ownership, while the state retained control of heavy industry, transport, banking, and foreign trade.

16. Boris Andreyevich Pilnyak (pseudonym of B. A. Vogau; 1894–1938/41?), a prose writer who depicted the Revolution as a struggle between elemental and rational forces, was one of the first victims of the government purges in 1937. Mikhail Afanasyevich Bulgakov (1891–1940) was a playwright, prose writer, and satirist best-known for his posthumously published works, including *Master i Margarita* (The Master and Margarita).

On the Present Situation of Russian Film

The greatest achievements of the Russian film industry can be seen more readily in Berlin than in Moscow. What one sees in Berlin has been preselected, while in Moscow this selection still has to be made. Nor is obtaining advice a simple matter. The Russians are fairly uncritical about their own films. (For example, it is a well-known fact that *Potemkin* owes its great success to Germany.) The reason for this insecurity in the matter of judgment is that the Russians lack European standards of comparison. Good foreign films are seldom seen in Russia. When buying films, the government takes the view that the Russian market is so important for the competing film companies of the world that they really have to supply it at reduced prices with what are in effect advertising samples. Obviously, this means that good, expensive films are never imported. For individual Russian artists, the resulting ignorance on the part of the public has its agreeable side. Iljinsky[1] works with a very imprecise copy of Chaplin and is regarded as a comedian only because Chaplin is unknown here.

At a more serious, general level, internal Russian conditions have a depressing effect on the average film. It is not easy to obtain suitable scenarios, because the choice of subject matter is governed by strict controls. Of all the arts in Russia, literature enjoys the greatest freedom from censorship. The theater is scrutinized much more closely, and control of the film industry is even stricter. This scale is proportional to the size of the audiences. Under this regimen the best films deal with episodes from the Russian Revolution; films that stretch further back into the Russian past constitute the insignificant average, while, by European standards, comedies are utterly irrelevant. At the heart of the difficulties currently facing Russian producers

is the fact that the public is less and less willing to follow them into their true domain: political dramas of the Russian civil war. The naturalistic political period of Russian film reached its climax around a year and a half ago, with a flood of films full of death and terror. Such themes have lost all their attraction in the meantime. Now the motto is internal pacification. Film, radio, and theater are all distancing themselves from propaganda.

The search for conciliatory subject matter has led producers to resort to a curious technique. Since film versions of the great Russian novels are largely ruled out on political and artistic grounds, directors have taken over well-known individual types and built up new stories around them. Characters from Pushkin, Gogol, Goncharov, and Tolstoy are frequently taken over in this way, often retaining their original names.[2] This new Russian film is set by preference in the far eastern sections of Russia. This is as much as to say, "For us there is no 'exoticism.'" "Exoticism" is thought of as a component of the counterrevolutionary ideology of a colonial nation. Russia has no use for the Romantic concept of the "Far East." Russia is close to the East and economically tied to it. Its second message is: we are not dependent on foreign countries and natures—Russia is, after all, a sixth of the world! Everything in the world is here on our own soil.

And in this spirit the epic film of the new Russia, entitled *The Soviet Sixth of the Earth*, has just been released. It must be admitted that Vertov,[3] the director, has not succeeded in meeting his self-imposed challenge of showing through characteristic images how the vast Russian nation is being transformed by the new social order. The filmic colonization of Russia has misfired. What he has achieved, however, is the demarcation of Russia from Europe. This is how the film starts: in fractions of a second, there is a flow of images from workplaces (pistons in motion, laborers bringing in the harvest, transport works) and from capitalist places of entertainment (bars, dance halls, and clubs). Social films of recent years have been plundered for fleeting individual excerpts (often just details of a caressing hand or dancing feet, a woman's hairdo or a glimpse of her bejeweled throat), and these have been assembled so as to alternate with images of toiling workers. Unfortunately, the film soon abandons this approach in favor of a description of Russian peoples and landscapes, while the link between these and their modes of production is merely hinted at in an all too shadowy fashion. The uncertain and tentative nature of these efforts is illustrated by the simple fact that pictures of cranes hoisting equipment and transmission systems are accompanied by an orchestra playing motifs from *Tannhäuser* and *Lohengrin*. Even so, these pictures are typical in their attempts to make film straight from life, without any decorative or acting apparatus. They are produced with a "masked" apparatus. That is to say, amateurs adopt various poses in front of a dummy set, but immediately afterward, when they think that everything is finished, they are filmed without being aware

of it. The good, new motto "Away with all masks!" is nowhere more valid than in Russian film. It follows from this that nowhere are film stars more superfluous. Directors are not on the lookout for an actor who can play many roles, but opt instead for the characters needed in each particular instance. Indeed, they go even further. Eisenstein,[4] the director of *Potemkin*, is making a film about peasant life in which he intends to dispense with actors altogether.

The peasants are not simply one of the most interesting subjects for a film; they are also the most important audience for the Russian cultural film. Film is being used to provide them with historical, political, technical, and even hygienic information. Up to now, however, the problems encountered in this process have left people feeling fairly perplexed. The mode of mental reception of the peasant is basically different from that of the urban masses. It has become clear, for example, that the rural audience is incapable of following *two simultaneous narrative strands* of the kind seen countless times in film. They can follow only a single series of images that must unfold chronologically, like the verses of a street ballad. Having often noted that serious scenes provoke uproarious laughter and that funny scenes are greeted with straight faces or even genuine emotion, filmmakers have started to produce films directly for those traveling cinemas that occasionally penetrate even the remotest regions of Russia for the benefit of people who have seen neither towns nor modern means of transport. To expose such audiences to film and radio constitutes one of the most grandiose mass-psychological experiments ever undertaken in the gigantic laboratory that Russia has become. Needless to say, in such rural cinemas the main role is played by educational films of every kind. Such films range from lessons in how to deal with plagues of locusts or use tractors, to films concerned with cures for alcoholism. Even so, much of the program of these itinerant cinemas remains incomprehensible to the great majority and can be used only as training material for those who are more advanced—that is to say, members of village soviets, peasant representatives, and so on. At the moment, the establishment of an "Institute for Audience Research" in which audience reactions could be studied both experimentally and theoretically is being considered.

In this way, film has taken up one of the great slogans of recent times: "With our faces toward the village!" In film as in writing, politics provides the most powerful motivation: the Central Committee of the party hands down directives every month to the press, the press passes them on to the clubs, and the clubs pass them on to the theaters and cinemas, like runners passing a baton. By the same token, however, such slogans can also lead to serious obstacles. The slogan "Industrialization!" provided a paradoxical instance. Given the passionate interest in everything technical, it might have been expected that the slapstick comedy would be highly popular. In reality,

however, for the moment at least, that passion divides the technical very sharply from the comic, and the eccentric comedies imported from America have definitely *flopped*. The new Russian is unable to appreciate irony and skepticism in technical matters. A further sphere denied to the Russian film is the one that encompasses all the themes and problems drawn from bourgeois life. Above all, this means: *They won't stand for dramas about love. The dramatic and even tragic treatment of love is rigorously excluded from the whole of Russian life.* Suicides that result from disappointed or unhappy love still occasionally occur, but Communist public opinion regards them as the crudest excesses.

For film—as for literature—all the problems that now form the focus of debate are problems of subject matter. Thanks to the new era of social truce, they have entered a difficult stage. The Russian film can reestablish itself on firm ground only when Bolshevist society (and not just the state!) has become sufficiently stable to enable a new "social comedy" to thrive, with new characters and typical situations.

Published in *Die literarische Welt*, March 1927. *Gesammelte Schriften*, II, 747–751. Translated by Rodney Livingstone.

Notes

1. Igor Vladimirovich Iljinsky (1901–1987) was a Russian film and dramatic actor, well known for his comic portrayals of buffoons, vagabonds, rogues, and urban hustlers.
2. Ivan Alexandrovich Goncharov (1812–1891) was a Russian novelist whose works include *Oblomov* (1859) and *The Precipice* (1869).
3. Dziga Vertov (pseudonym of Denis Arkadyevich Kaufman; 1896–1954) was a Soviet director whose best-known film is *Man with the Movie Camera*. His *kino-glaz* ("film-eye") theory—that the camera is an instrument much like the human eye and is best used to explore the actual happenings of real life—had an international impact on the development of documentaries and cinema realism during the 1920s.
4. Sergei Mikhailovich Eisenstein (1898–1948) was a Russian (Latvian-born) film director whose works include *October, Strike, Alexander Nevsky,* and *Battleship Potemkin.*

Reply to Oscar A. H. Schmitz

There are replies that come close to being an act of impoliteness toward the public. Shouldn't we simply allow our readers to make up their own minds about a lame argument full of clumsy concepts? In this instance, they would not even need to have seen *Battleship Potemkin*. Any more than Schmitz did.[1] For whatever he knows about the film he could have gleaned from the first newspaper notice that came to hand. But that is what characterizes the cultural Philistine: others read the notice and think themselves duly warned; he, however, has to "form his own opinion." He goes to see the film and imagines that he is in a position to translate his embarrassment into objective knowledge. This is a delusion. *Battleship Potemkin* can be objectively discussed either as film or from a political point of view. Schmitz does neither. He talks about his recent reading. Unsurprisingly, this leads him nowhere. To take this rigorous depiction of a class movement that has been wholly shaped according to the principles of the film medium and try to see how it measures up to bourgeois novels of society betrays an ingenuousness that is quite disarming. The same cannot quite be said of his onslaught on tendentious art. Here, where he marshals some heavy artillery from the arsenal of bourgeois aesthetics, plain speaking would be more appropriate. We may well ask why he makes such a fuss about the political deflowering of art, while faithfully tracking down all the sublimations, libidinous vestiges, and complexes through two thousand years of artistic production. How long is art supposed to act the well brought-up young lady who knows her way around all the places of ill-repute yet wouldn't dream of asking about politics? But it's no use: she has always dreamed about it. It is a truism that political tendencies are implicit in every work of art, every artistic

epoch—since, after all, they are historical configurations of consciousness. But just as deeper rock strata emerge only where the rock is fissured, the deep formation of "political tendency" likewise reveals itself only in the fissures of art history (and works of art). The technical revolutions are the fracture points of artistic development; it is there that the different political tendencies may be said to come to the surface. In every new technical revolution the political tendency is transformed, as if by its own volition, from a concealed element of art into a manifest one. And this brings us at long last to the film.

Among the points of fracture in artistic formations, film is one of the most dramatic. We may truly say that with film a *new realm of consciousness* comes into being. To put it in a nutshell, film is the prism in which the spaces of the immediate environment—the spaces in which people live, pursue their avocations, and enjoy their leisure—are laid open before their eyes in a comprehensible, meaningful, and passionate way. In themselves these offices, furnished rooms, saloons, big-city streets, stations, and factories are ugly, incomprehensible, and hopelessly sad. Or rather, they were and seemed to be, until the advent of film. The cinema then exploded this entire prison-world with the dynamite of its fractions of a second, so that now we can take extended journeys of adventure between their widely scattered ruins. The vicinity of a house, of a room, can include dozens of the most unexpected stations, and the most astonishing station names. It is not so much the constant stream of images as the sudden change of place that overcomes a milieu which has resisted every other attempt to unlock its secret, and succeeds in extracting from a petty-bourgeois dwelling the same beauty we admire in an Alfa Romeo. And so far, so good. Difficulties emerge only with the "plot." The question of a meaningful film plot is as rarely solved as the abstract formal problems that have arisen from the new technology. And this proves *one* thing beyond all others: the vital, fundamental advances in art are a matter neither of new content nor of new forms—the technological revolution takes precedence over both. But it is no accident that in film this revolution has not been able to discover either a form or a content appropriate to it. For it turns out that with the untendentious play of forms and the untendentious play of the plot, the problem can be resolved only on a case-by-case basis.

The superiority of the cinema of the Russian Revolution, like that of the American slapstick comedy, is grounded on the fact that in their different ways they are both based on tendencies to which they constantly recur. For the slapstick comedy is tendentious too, in a less obvious way. Its target is technology. This kind of film is comic, but only in the sense that the laughter it provokes hovers over an abyss of horror. The obverse of a ludicrously liberated technology is the lethal power of naval squadrons on maneuver, as we see it openly displayed in *Potemkin*. The international bourgeois film,

on the other hand, has not been able to discover a consistent ideological formula. This is one of the causes of its recurrent crises. For the complicity of film technique with the milieu that essentially constitutes a standing rebuke to it is incompatible with the glorification of the bourgeoisie. The proletariat is the hero of those spaces that give rise to the adventures to which the bourgeois abandons himself in the movies with beating heart, because he feels constrained to enjoy "beauty" even where it speaks of the annihilation of his own class. The proletariat, however, is a collective, just as these spaces are collective spaces. And only here, in the human collective, can the film complete the prismatic work that it began by acting on that milieu. The epoch-making impact of *Potemkin* can be explained by the fact that it made this clear for the first time. Here, for the first time, a mass movement acquires the wholly architectonic and by no means monumental (i.e., UFA) quality that justifies its inclusion in film.[2] No other medium could reproduce this collective in motion. No other could convey such beauty or the currents of horror and panic it contains. Ever since *Potemkin,* such scenes have become the undying possession of Russian film art. What began with the bombardment of Odessa in *Potemkin* continues in the more recent film *Mother* with the pogrom against factory workers, in which the suffering of the urban masses is engraved in the asphalt of the street like running script.[3]

Potemkin was made systematically in a collective spirit. The leader of the mutiny, Lieutenant Commander Schmidt, one of the legendary figures of revolutionary Russia, does not appear in the film. That may be seen as a "falsification of history," although it has nothing to do with the estimation of his achievements. Furthermore, why the actions of a collective should be deemed unfree, while those of the individual are free—this abstruse variant of determinism remains as incomprehensible in itself as in its meaning for the debate.

It is evident that the character of the opponents must be made to match that of the rebellious masses. It would have been senseless to depict them as differentiated individuals. The ship's doctor, the captain, and so on had to be types. Bourgeois types—this is a concept Schmitz will have nothing to do with. So let us call them sadistic types who have been summoned to the apex of power by an evil, dangerous apparatus. Of course, this brings us face to face with a political formulation. An outcome which is unavoidable because it is true. There is nothing feebler than all the talk of "individual cases." The individual may be an individual case—but the uninhibited effects of his diabolical behavior are something else; they lie in the nature of the imperialist state and—within limits—the state as such. It is well known that many facts gain their meaning, their relief, only when they are put in context. These are the facts with which the field of statistics concerns itself. If a Mr. X happens to take his own life in March, this may be a

supremely unimportant fact in itself. But it becomes quite interesting if we learn that suicides reach their annual peak during that month. In the same way, the sadistic acts of the ship's doctor may be isolated incidents in his life, the result of a poor night's sleep, or a reaction to his discovery that his breakfast egg is rotten. They become interesting only if we establish a relationship between the medical profession and the state. During the last years of the Great War, there was more than one highly competent study of this topic, and we can only feel sorry for the wretched little sadist of *Potemkin* when we compare his actions and his just punishment with the murderous services performed—unpunished—a few years ago by thousands of his colleagues on the sick and crippled at the behest of the general staff.

Potemkin is a great film, a rare achievement. To protest against it calls for the courage born of desperation. There is plenty of bad tendentious art, including bad socialist tendentious art. Such works are determined by their effects; they work with tired reflexes and depend on stereotyping. This film, however, has solid concrete foundations ideologically; the details have been worked out precisely, like the span of a bridge. The more violent the blows that rain down upon it, the more beautifully it resounds. Only if you touch it with kid gloves do you hear and move nothing.

Published (along with Oscar A. H. Schmitz's "Potemkin and Tendentious Art") in *Die literarische Welt,* March 1927. *Gesammelte Schriften,* II, 751–755. Translated by Rodney Livingstone.

Notes

1. Oscar Adolf Hermann Schmitz (1873–1931), a playwright and essayist, maintained close contact with the circle around Stefan George. Benjamin's reply to Schmitz exemplifies the tenor of the arguments over *Battleship Potemkin.*
2. UFA (Universum-Film AG), the largest firm in the German film industry, was founded in 1917. Vertically integrated, UFA owned everything from machine shops and film laboratories to production and distribution facilities. It was acquired by the Hugenberg Group in 1927, nationalized by the German Reich in 1936–1937, and dismantled by the Allies in 1945.
3. The film *Mother* was made in 1925 by the Russian director and film theorist Vsevolod Pudovkin (1893–1953).

Introductory Remarks on a Series for *L'Humanité*

I belong to the generation that is now between thirty and forty years old.[1] The intelligentsia of this generation will presumably be the last for a long time to have enjoyed a completely unpolitical education. The war caught its most left-leaning elements in the camp of a more or less radical pacifism. The history of Germany in the postwar period is in part the history of the revolutionary education of this original left-bourgeois wing of the intelligentsia. It may confidently be asserted that the revolution of 1918, which was defeated by the petty-bourgeois, parvenu spirit of German Social Democracy, did more to radicalize this generation than did the war itself. In Germany, it is increasingly the case—and this is the feature of particular importance in this entire process—that the status of the independent writer is being called into question, and one gradually realizes that the writer (like the intellectual in the wider sense), willy-nilly, consciously or unconsciously, works in the service of a class and receives his mandate from a class. The fact that the economic basis of the intellectual's existence is becoming ever more constricted has hastened this realization in recent times. The political counterpressure of the ruling class in Germany, which has led, especially in this past year, to ruthless censorship and literary trials [reminiscent of the age of the Holy Alliance],[2] has had a comparable effect. Given these circumstances, the sympathy of the German intelligentsia for Russia is more than abstract fellow-feeling; they are guided by their own material interests. They want to know: How does the intelligentsia fare in a country where their patron is the proletariat? How does the proletariat shape their conditions of life, and what sort of environment confronts them? What can they expect from a proletarian government? Guided by the sense of crisis that looms

over the fate of the intelligentsia in bourgeois society, writers like Ernst Toller, Arthur Holitscher, and Leo Matthias, painters like Vogeler-Worpswede, and theater directors like Bernhard Reich have all studied Russia and established contacts with their Russian colleagues.[3] In the same spirit, I myself visited Moscow early this year and lived there for two months. For the first time in my life I found myself in a city where I enjoyed privileges of a material and administrative nature simply because I am a writer. (I know of no city apart from Moscow where a writer can obtain a reduced price for a hotel room at the behest of the state—for the hotels are all run by the Soviets.) The following pieces are excerpted from a diary I kept there regularly over a period of eight weeks. In them I have attempted to convey the image of proletarian Moscow that you can understand only when you have also seen it in snow and ice. Above all, I have tried to reproduce the physiognomy of its workday and the new rhythm that permeates the life of worker and intellectual alike.

<div align="right">Paris; May 1, 1927</div>

Written in 1927; unpublished in Benjamin's lifetime. *Gesammelte Schriften*, VI, 781–782. Translated by Rodney Livingstone, on the basis of a prior version by Richard Sieburth.

Notes

1. Benjamin composed this short text as an introduction to a series that was to appear in *L'Humanité: Journal Socialiste*. (Published between 1904 and 1940, this periodical appeared clandestinely under the Occupation as the central organ of the French Communist party.) It is unclear whether the series was to consist of reworked excerpts from the essay "Moscow" (see next page) or from the *Moskauer Tagebuch*. See *Moscow Diary,* trans. Richard Sieburth, ed. Gary Smith (Cambridge, Mass.: Harvard University Press, 1986).
2. Bracketed material is crossed out in the manuscript.
3. Ernst Toller (1893–1939), a pacifist, left-liberal Jewish writer active in the Bavarian Council Republic of 1919, was imprisoned for his political agitation. He went into exile in 1933 and committed suicide in 1939. His 1919 play *Masse Mensch* is his best-known work; his plays were frequently performed on Soviet stages in the 1920s. Arthur Holitscher (1869–1941) was a dramatist and essayist whose works were on the first list of books banned by the Nazis. Leo Matthias (1893–1970), dramatist, travel essayist, and sociologist, emigrated to Mexico in 1933, moved to the United States in 1939, and returned to Germany in 1950. Heinrich Vogeler (1872–1942), painter, printmaker, and architect, was the co-founder of the important artists' colony at Worpswede. His utopian leftism led him to spend his last years in the Soviet Union. Bernhard Reich was a prominent German theater critic working in Moscow. He was also Benjamin's rival for the attentions of Asja Lacis.

Moscow

1

More quickly than Moscow itself, one learns to see Berlin through Moscow. To someone returning home from Russia, the city seems freshly washed. There is no dirt, but no snow either. The streets seem in reality as desolately clean and swept as in the drawings of George Grosz. And how true-to-life his types are has become more obvious. What is true of the image of the city and its people applies also to the intellectual situation: a new optics is the most undoubted gain from a stay in Russia. However little you may know Russia, what you learn is to observe and judge Europe with the conscious knowledge of what is going on in Russia. This is the first benefit to the intelligent European in Russia. But, equally, this is why the stay is so exact a touchstone for foreigners. It obliges everyone to choose his standpoint. Admittedly, the only real guarantee of a correct understanding is to have chosen your position before you came. In Russia above all, you can see only if you have already decided. At the turning point in historical events that is indicated, if not constituted, by the fact of "Soviet Russia," the question at issue is not which reality is better or which has greater potential. It is only: Which reality is inwardly convergent with truth? Which truth is inwardly preparing itself to converge with the real? Only he who clearly answers these questions is "objective." Not toward his contemporaries (which is unimportant) but toward events (which is decisive). Only he who, by decision, has made his dialectical peace with the world can grasp the concrete. But someone who wishes to decide "on the basis of facts" will find no basis in the facts.—Returning home, he will discover above all that

Berlin is a deserted city. People and groups moving in its streets have solitude about them. Berlin's luxury seems unspeakable. And it begins on the asphalt, for the breadth of the pavements is princely. They make the poorest wretch a *grand seigneur* promenading on the terrace of his mansion. Princely solitude, princely desolation hang over the streets of Berlin. Not only in the West End. In Moscow there are three or four places where it is possible to make headway without that strategy of shoving and weaving that you learn in the first week (thus, at the same time as you learn the technique of achieving locomotion on sheet ice). Stepping onto the Stolechnikov, you breathe again: here at last, you may stop without compunction in front of shopwindows and go on your way without partaking in the loitering, serpentine gait to which the narrow pavements have accustomed most people. But what fullness this street has, which overflows with more than just people, and how deserted and empty Berlin is! In Moscow, goods burst everywhere from the houses; they hang on fences, lean against railings, lie on pavements. Every fifty steps stand women with cigarettes, women with fruit, women with sweets. They have their wares in a laundry basket next to them, sometimes a little sleigh as well. A brightly colored woolen cloth protects apples or oranges from the cold, with two prize examples lying on top. Next to them are sugar figures, nuts, candy. One thinks: before leaving her house a grandmother must have looked around to see what she could take to surprise her grandchildren. Now she has stopped on the way to have a brief rest in the street. Berlin streets know no such places with sleighs, sacks, little carts, and baskets. Compared to those of Moscow, they are like a freshly swept, empty racecourse on which a field of six-day cyclists hastens comfortlessly on.

2

The city seems already to deliver itself at the train station. Kiosks, arc lamps, buildings crystallize into figures that will never return. Yet this impression is dispelled as soon as I seek words. I must be on my way. . . . At first there is nothing to be seen but snow, the dirty snow that has already installed itself, and the clean slowly moving up behind. The instant you arrive, the childhood stage begins. On the thick sheet ice of the streets, walking has to be relearned. The jungle of houses is so impenetrable that only brilliance strikes the eye. A transparency with the inscription *Kefir* glows in the evening. I notice it as if the Tverskaia, the old road to Tver on which I now am, were really still the open road, with nothing to be seen far and wide except the plain. Before I discovered Moscow's real landscape, its real river, found its real heights, each thoroughfare became for me a con-tested river, each house number a trigonometric signal, and each of its gigantic squares a lake. For every step you take here is on named ground.

And where one of these names is heard, in a flash imagination builds a whole neighborhood about the sound. This will long defy the later reality and remain brittlely embedded in it like glass masonry. In the first phase, the city still has barriers at a hundred frontiers. Yet one day the gate and the church that were the boundary of a district become without warning its center. Now the city turns into a labyrinth for the newcomer. Streets that he had located far apart are yoked together by a corner, like a pair of horses reined in a coachman's fist. The whole exciting sequence of topographical deceptions to which he falls prey could be shown only by a film: the city is on its guard against him, masks itself, flees, intrigues, lures him to wander its circles to the point of exhaustion. (This could be approached in a very practical way: during the tourist season in great cities, "orientation films" would run for foreigners.) But in the end, maps and plans are victorious: in bed at night, imagination juggles with real buildings, parks, and streets.

3

Moscow in winter is a quiet city. The immense bustle on the streets takes place softly. This is because of the snow, but also because the traffic is behind the times. Car horns dominate the orchestra of great cities. But in Moscow there are only a few cars. They are used only for weddings and funerals and for accelerated governing. True, in the evening they switch on brighter lights than are permitted in any other great city. And the cones of light they project are so dazzling that anyone caught in them stands helplessly rooted to the spot. In the blinding light before the Kremlin gate, the guards stand in their brazen ocher furs. Above them shines the red signal that regulates the traffic passing through the gate. All the colors of Moscow converge prismatically here, at the center of Russian power. Beams of excessive brilliance from the car headlights race through the darkness. The horses of the cavalry, which has a large drill ground in the Kremlin, shy in their light. Pedestrians force their way between cars and unruly horses. Long rows of sleighs haul snow away. Single horsemen. Silent swarms of ravens have settled in the snow. The eye is infinitely busier than the ear. The colors do their utmost against the white. The smallest colored rag glows out of doors. Picture books lie in the snow; Chinese vendors sell artfully made paper fans and, still more frequently, paper kites in the form of exotic deep-sea fish. Day in, day out, children's festivals are provided for. There are men with baskets full of wooden toys, carts, and spades; the carts are yellow and red, yellow or red the children's shovels. All these carved wooden utensils are more simply and solidly made than in Germany, their peasant origin clearly visible. One morning, at the side of the road stand tiny houses that have never been seen before, each with shining windows and a fence around the front garden: wooden toys from Vladimir province. That is to say, a new consignment of goods has arrived. Serious, sober utensils become audacious in street trad-

ing. A basket seller with all kinds of brightly colored wares, such as can be bought everywhere in Capri, two-handled baskets with plain square patterns, carries at the end of his pole glazed-paper cages with glazed-paper birds inside them. But a real parrot, too—a white ara—can sometimes be seen. In the Miasnitskaia stands a woman with linen goods, the bird perching on her tray or shoulder. A picturesque background for such animals must be sought elsewhere, at the photographer's stand. Under the bare trees of the boulevards are screens showing palms, marble staircases, and southern seas. And something else, too, reminds one of southern climes. It is the wild variety of the street trade. Shoe polish and writing materials, handkerchiefs, dolls' sleighs, swings for children, ladies' underwear, stuffed birds, clothes hangers—all this sprawls on the open street, as if it were not twenty-five degrees below zero but high Neapolitan summer. For a long time I was mystified by a man who had in front of him a densely lettered board. I wanted to see him as a soothsayer. At last I succeeded in watching him at work: I saw him sell two of his letters and fix them as initials to his customer's galoshes. Then there are the wide sleighs with three compartments for peanuts, hazelnuts, and *semitchky* (sunflower seeds, which now, according to a ruling of the Soviet, may no longer be chewed in public places). Cookshop owners gather in the vicinity of the labor exchange. They have hotcakes to sell, and sausage fried in slices. But all this goes on silently; calls like those of every trader in southern regions are unknown. Rather, the people address the passer-by with words, measured if not whispered words, in which there is something of the humility of beggars. Only one caste parades noisily through the streets here: the ragpickers, with sacks on their backs. Their melancholy cry rings out one or more times a week in every neighborhood. Street trading is in part illegal and therefore avoids attracting attention. Women, each with a piece of meat, a chicken, or a leg of pork resting on a layer of straw in her open hand, stand offering it to passers-by. These are vendors without permits. They are too poor to pay the duty for a stall and have no time to stand in line many hours at an office for a weekly concession. When a member of the militia approaches, they simply run away. The street trade culminates in the large markets, on the Smolenskaia and the Arbat. And on the Sucharevskaia. This, the most famous of all, is situated at the foot of a church that rises with blue domes above the booths. First, one passes the neighborhood of the scrap-iron dealers. The people simply have their wares lying in the snow. One finds old locks, meter rulers, hand tools, kitchen utensils, electrical goods. Repairs are carried out on the spot; I saw someone soldering over a pointed flame. There are no seats anywhere; everyone stands up, gossiping or trading. At this market the architectonic function of wares is perceptible: cloth and fabric form buttresses and columns; *valenki* (felt boots), hanging threaded on strings across the counters, become the roof of the booth; large *garmoshkas* (accordions) form sounding walls—thus, in a sense, Memnon's

walls.[1] Whether, at the few stalls with pictures of saints, one can still secretly buy those strange icons that it was already punishable under czarism to sell, I do not know. There is the Mother of God with three hands. She is half-naked. From her navel rises a strong, well-formed hand. At right and left the two others spread in the gesture of blessing. This threesome of hands is deemed a symbol of the Holy Trinity. Another devotional picture of the Mother of God shows her with open belly; clouds come from it instead of entrails; in their midst dances the Christ child holding a violin in his hand. Since the sale of icons is considered a branch of the paper-and-picture trade, these booths with pictures of saints stand next to those with paper goods, so that they are always flanked by portraits of Lenin, like a prisoner between two policemen. The street life does not cease entirely even at night. In dark gateways you stumble against furs built like houses. Night watchmen huddle inside on chairs, from time to time bestirring themselves ponderously.

4

In the street scene of any proletarian neighborhood, the children are important. They are more numerous there than in other districts, and move more purposefully and busily. Moscow swarms with children everywhere. Even among them there is a Communist hierarchy. The "Komsomoltsy," as the eldest, are at the top. They have their clubs in every town and are really trained as the next generation of the party. The younger children become—at six—"Pioneers." They, too, are united in clubs, and wear a red tie as a proud distinction. Last, "Octobrists" *(Oktyabr)*—or "Wolves"—is the name given to little babies from the moment they are able to point to the picture of Lenin. But even now one also comes across the derelict, unspeakably melancholy *besprizornye,* war orphans. By day they are usually seen alone, each one on his own warpath. But in the evening they join up before the lurid façades of movie houses to form gangs, and foreigners are warned against meeting such bands alone when walking home. The only way for the educator to understand these thoroughly savage, mistrustful, embittered people was to go out on the street himself. In each of Moscow's districts, children's centers have already been in existence for years. They are supervised by a female state employee who seldom has more than one assistant. Her task is, in one way or another, to make contact with the children of her district. Food is distributed, games are played. To begin with, twenty or thirty children come to the center, but if a superintendent does her work properly, it may be filled with hundreds of children after a couple of weeks. Needless to say, traditional pedagogical methods never made much impression on these infantile masses. To get through to them at all, to be heard, one has to relate as directly and clearly as possible to the catchwords of the street itself, of the whole collective life. Politics, in the organization of crowds of such children, is not tendentious, but as natural a subject, as

obvious a visual aid, as the toyshop or dollhouse for middle-class children. If one also bears in mind that a superintendent has to look after the children, to occupy and feed them, and in addition to keep a record of all expenses for milk, bread, and materials, that she is responsible for all this, it must become drastically clear how little room such work leaves for the private life of the person performing it. But amid all the images of childhood destitution that is still far from being overcome, an attentive observer will perceive one thing: how the liberated pride of the proletariat is matched by the emancipated bearing of the children. Nothing is more pleasantly surprising on a visit to Moscow's museums than to see how, singly or in groups, sometimes around a guide, children and workers move easily through these rooms. Nothing is to be seen of the forlornness of the few proletarians who dare to show themselves to the other visitors in our museums. In Russia the proletariat has really begun to take possession of bourgeois culture, whereas on such occasions in our country they have the appearance of planning a burglary. Admittedly, there are collections in Moscow in which workers and children can quickly feel themselves at home. There is the Polytechnic Museum, with its many thousands of experiments, pieces of apparatus, documents, and models relating to the history of primary production and the manufacturing industry. There is the admirably run toy museum, which under its director, Bartram, has brought together a precious, instructive collection of Russian toys, and serves the scholar as much as the children who walk about for hours in these rooms (around midday there is also a big, free puppet show, as fine as any in the Luxembourg). There is the famous Tretiakov Gallery, in which one understands for the first time what genre painting means and how especially appropriate it is to the Russians. Here the proletarian finds subjects from the history of his movement: *A Conspirator Surprised by the Police, The Return from Exile in Siberia, The Poor Governess Enters Service in a Rich Merchant's House.* And the fact that such scenes are still painted entirely in the spirit of bourgeois art not only does no harm—it actually brings them closer to this public. For education in art (as Proust explains very well at various points) is not best promoted by the contemplation of "masterpieces." Rather, the child or the proletarian who is educating himself acknowledges, rightly, very different works as masterpieces from those selected by the collector. Such pictures have for him a very transitory but solid meaning, and a strict criterion is necessary only with regard to the topical works that relate to him, his work, and his class.

5

Begging is not aggressive as in southern climes, where the importunity of the ragamuffin still betrays some remnant of vitality. Here it is a corporation of the dying. The street corners of some neighborhoods are covered with

bundles of rags—beds in the vast open-air hospital called Moscow. Long, beseeching speeches are addressed to the people walking past. There is one beggar who always begins, at the approach of a promising-looking passer-by, to emit a soft, drawn-out howling; this is directed at foreigners who cannot speak Russian. Another has the exact posture of the pauper for whom Saint Martin, in old pictures, cuts his cloak in two with his sword: he kneels with both arms outstretched. Shortly before Christmas, two children sat day after day in the snow against the wall of the Museum of the Revolution, covered with a scrap of material and whimpering. (But outside the English Club, the most genteel in Moscow, to which this building earlier belonged, even that would not have been possible.) One ought to know Moscow as such beggar children know it. They know of a corner beside the door of a certain shop where, at a particular time, they are allowed to warm themselves for ten minutes; they know where one day each week at a certain hour they can fetch themselves crusts, and where a sleeping place among stacked sewage pipes is free. They have developed begging to a high art, with a hundred schematisms and variations. They watch the customers of a pastry cook on a busy street corner, approach one, and accompany him, whining and pleading, until he has relinquished to them a piece of his hot pie. Others keep station at a streetcar terminus, board a vehicle, sing a song, and collect kopecks. And there are places, admittedly only a few, where even street trading has the appearance of begging. A few Mongols stand against the wall of Kitai Gorod. Each stands no more than five paces from the next, selling leather briefcases, and each offers exactly the same article as his neighbor. There must be some agreement behind this, for they cannot seriously intend such hopeless competition. Probably in their homeland the winter is no less harsh and their ragged furs are no worse than those of the natives. Nevertheless, they are the only people in Moscow whom one pities on account of the climate. Even priests who go begging for their churches can still be seen. But you very seldom see anyone give. Begging has lost its strongest foundation, the bad social conscience, which opens purses so much wider than does pity. Beyond this, it appears as an expression of the unchanging wretchedness of these beggars; perhaps, too, it is only the result of judicious organization that, of all the institutions in Moscow, they alone are dependable, remaining unchanged in their place while everything around them shifts.

6

Each thought, each day, each life lies here as on a laboratory table. And as if it were a metal from which an unknown substance is by every means to be extracted, it must endure experimentation to the point of exhaustion. No organism, no organization, can escape this process. Employees in their

factories, offices in buildings, pieces of furniture in apartments are rearranged, transferred, and shoved about. New ceremonies for christening and marriage are presented in the clubs, as if the clubs were research institutes. Regulations are changed from day to day, but streetcar stops migrate, too. Shops turn into restaurants and a few weeks later into offices. This astonishing experimentation—it is here called *remonte*—affects not only Moscow; it is Russian. In this ruling passion, there is as much naive desire for improvement as there is boundless curiosity and playfulness. Few things are shaping Russia more powerfully today. The country is mobilized day and night—most of all, of course, the party. Indeed, what distinguishes the Bolshevik, the Russian Communist, from his Western comrade is this unconditional readiness for mobilization. The material basis of his existence is so slender that he is prepared, year in, year out, to decamp. He would not otherwise be a match for this life. Where else is it conceivable that a distinguished military leader could one day be made director of a great state theater? The present director of the Theater of the Revolution is a former general. True, he was a man of letters before he became a victorious commander. Or in which other country can one hear stories like those told me by the porter at my hotel? Until 1924 he was employed in the Kremlin. Then one day he was afflicted by severe sciatica. The party had him treated by their best doctors, sent him to the Crimea, had him take mud baths and try radiation treatment. When all proved in vain he was told, "You need a job in which you can look after yourself, keep warm, and not move!" The next day he was a hotel porter. When he is cured he will go back to the Kremlin. Ultimately, even the health of comrades is a prized possession of the party, which, against the person's wishes if necessary, takes such measures as are needed to conserve it. This is the way the situation is presented, at any rate, in an excellent novella by Boris Pilnyak.[2] Against his will a high official undergoes an operation, which has a fatal outcome. (A very famous name is mentioned here among the dead of the last few years.) There is no knowledge or faculty that is not somehow appropriated by collective life and made to serve it. The specialist is a spearhead of this increasingly practical approach and the only citizen who, outside the political sphere, has any status. At times, the respect for this type verges on fetishism. Thus, the Red military academy employed as a teacher a general who is notorious for his part in the civil war. He had every captured Bolshevik unceremoniously hanged. For Europeans such a point of view, which intransigently subordinates the prestige of ideology to practical demands, is barely comprehensible. But this incident is also characteristic of the opposing side. For it is not only the military of the czarist empire who, as is known, placed themselves at the service of the Bolsheviks. Intellectuals, too, return in time as specialists to the posts they sabotaged during the civil war. Opposition, as we would like to imagine it in the West—intellectuals holding themselves

aloof and languishing under the yoke—does not exist, or, better, no longer exists. It has—with whatever reservations—accepted the truce with the Bolsheviks, or it has been annihilated. There is in Russia—particularly outside the party—only the most loyal opposition. For this new life weighs on no one more heavily than on the outsider observing from a distance. To endure this existence in idleness is impossible because, in each smallest detail, it becomes beautiful and comprehensible only through work. The integration of personal thoughts with a preexisting force field; a mandate, however virtual; organized, guaranteed contact with comrades—to all this, life here is so tightly bound that anyone who abstains or cannot achieve it degenerates intellectually as if through years of solitary confinement.

7

Bolshevism has abolished private life. The bureaucracy, political activity, the press are so powerful that no time remains for interests that do not converge with them. Nor any space. Apartments that earlier accommodated single families in their five to eight rooms now often lodge eight. Through the hall door, one steps into a little town. More often still, into an army camp. Even in the lobby, one can encounter beds. Indoors one only camps, and usually the scanty inventory is merely a residue of petty-bourgeois possessions that have a far more depressing effect because the room is so sparsely furnished. An essential feature of the petty-bourgeois interior, however, was completeness: pictures must cover the walls, cushions the sofa, covers the cushions; ornaments must fill the mantelpiece, colored glass the windows. (Such petty-bourgeois rooms are battlefields over which the attack of commodity capital has advanced victoriously; nothing human can flourish there again.) Of all that, only a part here or there has been indiscriminately preserved. Weekly the furniture in the bare rooms is rearranged; this is the only luxury indulged in with them, and at the same time a radical means of expelling "coziness"—along with the melancholy with which it is paid for—from the house. People can bear to exist in it because they are estranged from it by their way of life. Their dwelling place is the office, the club, the street. Of the mobile army of officials, only the baggage train is to be found here. Curtains and partitions, often only half the height of the walls, have had to multiply the number of rooms. For each citizen is entitled by law to only thirteen square meters of living space. He pays for his accommodations according to his income. The state—all house ownership is nationalized— charges the unemployed one ruble monthly for the same area for which the better-off pay sixty or more. Anyone who lays claim to more than this prescribed area must, if he cannot justify his claim professionally, make manifold amends. Every step away from the preordained path meets with an immeasurable bureaucratic apparatus and with impossible costs. The

member of a trade union who produces a certificate of illness and goes through the prescribed channels can be admitted to the most modern sanatorium, be sent to health resorts in the Crimea, enjoy expensive radiation treatment, without paying a penny for it. The outsider can go begging and sink into penury if he is not in a position, as a member of the new bourgeoisie, to buy all this for thousands of rubles. Anything that cannot be based on the collective framework demands a disproportionate expenditure of effort. For this reason, there is no "homeyness." But neither are there any cafés. Free trade and the free intellect have been abolished. The cafés are thereby deprived of their public. There thus remain, even for private affairs, only the office and the club. Here, however, transactions are under the aegis of the new *byt*—the new environment, for which nothing counts except the function of the producer in the collective. The new Russians say that milieu is the only reliable educator.

8

For each citizen of Moscow the days are full to the brim. Meetings, committees are fixed at all hours in offices, clubs, and factories, and often have no site of their own, being held in corners of noisy editorial rooms, or at a cleared table in a canteen. There is a kind of natural selection and a struggle for existence among these events. Society projects them to some extent, plans them; they are convened. But how often must this be repeated until finally one of the many is successful, proves viable, is adapted, takes place. That nothing turns out as intended and expected—this banal expression of the reality of life here asserts itself in each individual case so inviolably and intensely that Russian fatalism becomes comprehensible. If civilizing calculation slowly establishes itself in the collective, this will, in the first place, only complicate matters. (A person is better provided for in a house that has only candles than in one where electric light has been installed but the supply of current is interrupted hourly.) A feeling for the value of time, notwithstanding all "rationalization," is not met with even in the capital of Russia. Trud, the trade-union institute for the study of work, under its director, Gastiev, launched a poster campaign for punctuality. From earliest times a large number of clockmakers have been settled in Moscow. Like medieval guilds, they are crowded in particular streets, on the Kuznetsky Bridge, on Ulitsa Gertsena. One wonders who actually needs them. "Time is money"—for this astonishing statement posters claim the authority of Lenin, so alien is the idea to the Russians. They fritter everything away. (One is tempted to say that minutes are a cheap liquor of which they can never get enough, that they are tipsy with time.) If on the street a scene is being shot for a film, they forget where they are going and why, and follow the camera for hours, arriving at the office distraught. In his use of time,

therefore, the Russian will remain "Asiatic" longest of all. Once I needed to be wakened at seven in the morning: "Please knock tomorrow at seven." This elicited from the *Schweizar*—as hotel porters are called here—the following Shakespearean monologue: "If we think of it we shall wake you, but if we do not think of it we shall not wake you. Actually we usually do think of it, and then we wake people. But to be sure, we also forget sometimes when we do not think of it. Then we do not wake people. We are under no obligation, of course, but if it crosses our mind, we do it. When do you want to be wakened? At seven? Then we shall write that down. You see, I am putting the message there where he will find it. Of course, if he does not find it, then he will not wake you. But usually we do wake people." The real unit of time is the *seichas*. This means "at once." You can hear it ten, twenty, thirty times, and wait hours, days, or weeks until the promise is carried out. By the same token, you seldom hear the answer no. Negative replies are left to time. Time catastrophes, time collisions are therefore as much the order of the day as *remonte*. They make each hour superabundant, each day exhausting, each life a moment.

9

Travel by streetcar in Moscow is more than anything else a tactical experience. Here the newcomer learns perhaps most quickly of all to adapt himself to the curious tempo of this city and to the rhythm of its peasant population. And the complete interpenetration of technological and primitive modes of life, this world-historical experiment in the new Russia, is illustrated in miniature by a streetcar ride. The conductresses stand fur-wrapped at their places like Samoyed women on a sleigh. A tenacious shoving and barging during the boarding of a vehicle usually overloaded to the point of bursting takes place without a sound and with great cordiality. (I have never heard an angry word on these occasions.) Once everyone is inside, the migration begins in earnest. Through the ice-covered windows, you can never make out where the vehicle has just stopped. If you do find out, it is of little avail. The way to the exit is blocked by a human wedge. Since you must board at the rear but alight at the front, you have to thread your way through this mass. But conveyance usually occurs in batches; at important stops the vehicle is almost completely emptied. Thus, even the traffic in Moscow is to a large extent a mass phenomenon. So one can encounter whole caravans of sleighs blocking the streets in a long row, because loads that require a truck are being stacked on five or six large sleighs. The sleighs here take the horse into consideration first and then the passenger. They do not know the slightest superfluity. A feeding sack for the nags, a blanket for the passenger—and that is all. The narrow bench can fit two at the most, and since it has no back (unless you are willing so to describe a low rail), you must keep

a good balance on sudden corners. Everything is based on the assumption of the highest velocity; long journeys in the cold are hard to bear, and distances in this gigantic village immeasurable. The *izvozshchik* drives his vehicle close to the sidewalk. The passenger is not enthroned high up; he looks out on the same level as everyone else and brushes the passers-by with his sleeve. Even this is an incomparable experience for the sense of touch. Whereas Europeans, on their rapid journeys, enjoy superiority, dominance over the masses, the Muscovite in the little sleigh is closely mingled with people and things. If he has a box, a child, or a basket to take with him—for all such things the sleigh is the cheapest means of transport—he is truly wedged into the street bustle. No condescending gaze: a tender, swift brushing along stones, people, and horses. You feel like a child gliding through the house on his little chair.

10

Christmas is a feast of the Russian forest. With pines, candles, tree decorations, it settles for many weeks in the streets, for the Advent of Greek Orthodox Christians overlaps with the Christmas of those Russians who celebrate the feast by the Western—that is, the new—official calendar. Nowhere does one see Christmas trees more beautifully decorated. Little boats, birds, fishes, houses, and fruit crowd the street stalls and shops, and every year about this time the Kustarny Museum for Regional Art holds a kind of trade fair for all this. At a crossroads, I found a woman selling tree decorations. The glass balls, yellow and red, glinted in the sun; it was like an enchanted apple basket in which red and yellow were divided among different fruits. Pines are drawn through the streets on slow sleighs. The smaller ones are trimmed only with silk bows; little pines with blue, pink, and green ribbons stand on the corners. But to the children the Christmas toys, even without a Santa Claus, tell how they come from deep in the forests of Russia. It is as if only under Russian hands does wood put forth such luxuriant greenness. It turns green—and then reddens and puts on a coat of gold, flares sky-blue and petrifies black. "Red" and "beautiful" are *one* word in [old] Russian. Certainly the glowing logs in the stove are the most magical metamorphosis of the Russian forest. Nowhere does the hearth seem to glow with such splendor as here. But radiance is captured in all the wood that the peasant carves and paints. And when varnished, it is fire frozen in all colors. Yellow and red on the balalaika, black and green on the little *garmoshka* for children, and every shade in the thirty-six eggs that fit one inside another. But forest night, too, lives in the wood. There are the heavy little boxes with scarlet interiors; on the outside, on a gleaming black background, a picture. Under the czars, this industry was on the point of extinction. Now, besides new miniatures, the old, gold-embellished images

are again emerging from peasant life. A troika with its three horses races through the night, or a girl in a sea-blue dress stands at night beside green flaring bushes, waiting for her lover. No night of terror is as dark as this durable lacquer night—everything that appears in it is enfolded in its womb. I saw a box with a picture of a seated woman selling cigarettes. Beside her stands a child who wants to take one. Pitch-black night here, too. But on the right a stone and on the left a leafless tree are discernible. On the woman's apron is the word *Mossel'prom*. She is the Soviet "Madonna with the Cigarettes."

11

Green is the supreme luxury of the Moscow winter. But it shines from the shop in the Petrovka not half as beautifully as the paper bunches of artificial carnations, roses, lilies on the street. In markets they are the only wares to have no fixed stall and appear now among groceries, now among textile goods and crockery stalls. But they outshine everything—raw meat, colored wool, and gleaming dishes. Other bouquets are seen at New Year's. As I passed through Strastnaia Square, I saw long twigs with red, white, blue, green blooms stuck to them, each stalk of a different color. When speaking of Moscow flowers, one must not forget the heroic Christmas roses, or the gigantically tall hollyhock made of lampshades that the trader carries through the streets. Or the glass cases full of flowers with the heads of saints looking out among them. Or what the frost here inspires: the peasant cloths with patterns embroidered in blue wool, imitating ice ferns on windows. Finally, the glistening candy-icing flower beds on cakes. The Pastry Cook from children's fairy tales seems to have survived only in Moscow. Only here are there structures made of nothing but spun sugar, sweet icicles with which the tongue indemnifies itself against the bitter cold. Most intimately of all, snow and flowers are united in candy icing; there at last the marzipan flora seems to have fulfilled entirely Moscow's winter dream: to bloom out of the whiteness.

12

Under capitalism, power and money have become commensurable qualities. Any given amount of money can be converted into a specific power, and the market value of all power can be calculated. So things stand on a large scale. We can speak of corruption only where this process is mastered too hastily. In the smooth interplay of press, boards, and trusts, there is a system of gears within whose limits the process remains entirely legal. The Soviet state has severed this communication between money and power. It reserves

power for the party, and leaves money to the NEP man.³ In the eyes of any party functionary, even the highest, to put something aside, to secure the "future," even if only "for the children," is quite unthinkable. To its members the Communist party guarantees the bare minimum for material existence—it does so practically, without actual obligation. On the other hand, it controls their further earnings and sets an upper limit of two hundred fifty rubles on their monthly income. This can be increased solely through literary activity alongside one's profession. To such discipline the life of the ruling class is subjected. But the power of the ruling authorities is by no means identical with their possessions. Russia is today not only a class but also a caste state. "Caste state"—this means that the social status of a citizen is determined not by the visible exterior of his existence—his clothes or living place—but exclusively by his relations to the party. This is also decisive for those who do not directly belong to it. To them, too, employment is open, to the extent that they do not overtly repudiate the regime. Between them, too, the most precise distinctions are made. But however exaggerated—or obsolete—the European conception of the official suppression of nonconformists in Russia may be, no one living abroad has any idea of the terrible social ostracism to which the NEP man is here subjected. The silence, the mistrust, perceptible not only between strangers, is otherwise inexplicable. If you ask a superficial acquaintance here about his impressions of however unimportant a play, however trivial a film, you may expect stock phrases in reply: "One says here . . ." or "The conviction is prevalent here . . ." A judgment is weighed innumerable times before being uttered to more distant contacts. For at any time, the party can casually, unobtrusively change its line in *Pravda*, and no one likes to see himself disavowed. Because a reliable political outlook, if not the only good, is for most people the only guarantee of other goods; everyone uses his name and his voice so cautiously that the citizen with a democratic turn of mind cannot understand him.—Two close acquaintances are having a conversation. In the course of it one of them says: "That fellow Mikhailovich was in my office yesterday looking for a job. He said he knew you." "He is an excellent comrade, punctual and hardworking." They change the subject. But as they part, the first says, "Would you be kind enough to give me a few words on that Mikhailovich in writing?"—Class rule has adopted symbols that serve to characterize the opposing class. And of these, jazz is perhaps the most popular. That people also enjoy listening to it in Russia is not surprising. But dancing to it is forbidden. It is kept behind glass, as it were, like a brightly colored poisonous reptile, and so appears as an attraction in revues. Yet always a symbol of the "bourgeois." It is one of the crude stage sets with the aid of which, for propaganda purposes, a grotesque image of the bourgeois type is constructed. In reality the image is often merely ridiculous,

the discipline and competence of the adversary being overlooked. In this distorted view of the bourgeois, a nationalist impulse is present. Russia was the possession of the czar (indeed, anyone walking past the endlessly piled-up valuables in the Kremlin collections is tempted to say "*a* possession"). The people, however, have overnight become his immeasurably wealthy heirs. They now set about drawing up a grand inventory of their human and territorial wealth. And they undertake this work with the awareness that they have already performed unimaginably difficult tasks, and built up, against the hostility of half the world, the new system of power. In admiration for this national achievement all Russians are united. It is this reversal of the power structure that makes life here so heavy with content. It is as complete in itself and rich in events, as poor and in the same breath as full of prospects, as a gold digger's life on the Klondike. From early till late, people dig for power. All the combinations of our leading figures are meager in comparison to the countless constellations that here confront the individual in the course of a month. True, a certain intoxication can result, so that a life without meetings and committees, debates, resolutions, and votes (and all these are wars, or at least maneuvers of the will to power) can no longer be imagined. What does it matter—Russia's next generation will be accustomed to this existence. Its health, however, is subject to one indispensable condition: that never (as one day happened even to the Church) should a black market of power be opened. Should the European correlation of power and money penetrate Russia, too, then perhaps not the country, perhaps not even the party, but Communism in Russia would be lost. People here have not yet developed European consumer concepts and consumer needs. The reasons for this are above all economic. Yet it is possible that in addition an astute party stratagem is involved: to achieve, at a freely chosen moment, a level of consumption equal to that of Western Europe—the trial by fire of the Bolshevik bureaucracy, steeled and with absolute certainty of victory.

13

In the Red Army Club at the Kremlin, a map of Europe hangs on the wall. Beside it is a handle. When this handle is turned, the following is seen: one after the other, at all the places through which Lenin passed in the course of his life, little electric lights flash. At Simbirsk, where he was born, at Kazan, Petersburg, Geneva, Paris, Krakow, Zurich, Moscow, up to the place of his death, Gorki. Other towns are not marked. The contours of this wooden relief map are rectilinear, angular, schematic. On it Lenin's life resembles a campaign of colonial conquest across Europe. Russia is beginning to take shape for the man of the people. On the street, in the snow, lie

maps of the SFSR,[4] piled up by street vendors who offer them for sale. Meyerhold[5] uses a map in *D.E.* (*Here with Europe!*)—it shows Western Europe as a complicated system of little Russian peninsulas. The map is almost as close to becoming the center of the new Russian iconic cult as Lenin's portrait. Quite certainly the strong national feeling that Bolshevism has given all Russians, regardless of distinction, has conferred a new reality on the map of Europe. They want to measure, compare, and perhaps enjoy that intoxication with grandeur which is induced by the mere sight of Russia; citizens can only be urgently advised to look at their country on the map of neighboring states, to study Germany on a map of Poland, France, or even Denmark; but all Europeans ought to see, on a map of Russia, their little land as a frayed, nervous territory far out to the west.

14

What figure does the man of letters cut in a country where his employer is the proletariat?—The theoreticians of Bolshevism stress how widely the situation of the proletariat in Russia after this successful revolution differs from that of the bourgeoisie in 1789. At that time the victorious class, before it attained power, had secured for itself in struggles lasting decades the control of the cultural apparatus. Intellectual organization, education, had long been pervaded by the ideas of the Third Estate, and the mental struggle for emancipation was fought out before the political. In present-day Russia it is quite different. For millions upon millions of illiterates, the foundations of a general education have yet to be laid. This is a national, Russian task. Prerevolutionary education in Russia was, however, entirely unspecific, European. The European moment in higher education, and the national moment on the elementary level, are in Russia seeking an accommodation. This is one side of the educational question. On the other, the victory of the Revolution has in many areas accelerated the process of Europeanization. There are writers like Pilnyak who see in Bolshevism the crowning of the work of Peter the Great. In the technical area this tendency, despite all the adventures of its earliest years, is presumably sure of victory sooner or later. Not so in the intellectual and scientific areas. It is now apparent in Russia that European values are being popularized in just the distorted, desolating form that they owe finally to imperialism. The second academic theater—a state-supported institution—is putting on a performance of the *Oresteia* in which a dusty Greek antiquity struts about the stage as untruthfully as in a German court theater. And since the marble-stiff gesture is not only corrupt in itself, but also a copy of court acting in revolutionary Moscow, it has a still more melancholy effect than in Stuttgart or Anhalt. The Russian Academy of Science has for its part made a man like Walzel—an average specimen

of the modern academic *bel esprit*—a member. Probably the only cultural conditions in the West for which Russia has a lively enough understanding for disagreement with it to be profitable are those of America. In contrast, cultural rapprochement as such (without the foundation of the most concrete economic and political community) is an interest of the pacifist variety of imperialism; it benefits only gossiping busybodies, and is for Russia a symptom of restoration. The country is isolated from Western Europe less by frontiers and censorship than by the intensity of an existence that is beyond all comparison with the European. Stated more precisely: contact with the outside world is through the party and primarily concerns political questions. The old bourgeoisie has been annihilated; the new is neither materially nor intellectually in a position to establish external relations. Undoubtedly Russians know far less about the outside world than foreigners (with the possible exception of the Romance-language countries) know about Russia. If an influential Russian mentions Proust and Bronnen in the same breath as authors who take their subject matter from the area of sexual problems, this shows clearly the foreshortened perspective in which European matters appear from here. But if one of Russia's leading authors, in conversation, quotes Shakespeare as one of the great poets who wrote before the invention of printing, such a lack of training can be understood only from the completely changed conditions affecting Russian writing as a whole. Theses and dogmas that in Europe—admittedly only for the past two centuries—have been regarded as alien to art and beneath discussion by men of letters are decisive in literary criticism and production in the new Russia. Message and subject matter are declared of primary importance. Formal controversies still played a not inconsiderable part at the time of the civil war. Now they have fallen silent. Today it is official doctrine that subject matter, not form, decides the revolutionary or counterrevolutionary attitude of a work. Such doctrines cut the ground from under the writer's feet just as irrevocably as the economy has done on the material plane. In this, Russia is ahead of Western developments—but not as far ahead as is believed. For sooner or later, with the middle classes who are being ground to pieces by the struggle between capital and labor, the "freelance" writer must also disappear. In Russia the process is complete: the intellectual is above all a functionary, working in the departments of censorship, justice, and finance, and, if he survives, participating in work—which, however, in Russia means power. He is a member of the ruling class. Of his various organizations the most prominent is VAPP, the general association of proletarian writers in Russia.[6] It supports the notion of dictatorship even in the field of intellectual creation. In this it takes account of Russian reality. The transfer of the mental means of production into public ownership can be distinguished only fictitiously from that of the material means. To begin

with, the proletarian can be trained in the use of both only under the protection of a dictatorship.

15

Now and again one comes across streetcars painted all over with pictures of factories, mass meetings, Red regiments, Communist agitators. These are gifts from the personnel of a factory to the Moscow Soviet. These vehicles carry the only political posters still to be seen in Moscow, but they are by far the most interesting. For nowhere are more naive commercial posters to be seen than here. The wretched level of pictorial advertising is the only similarity between Paris and Moscow. Countless walls around churches and monasteries offer on all sides the finest surfaces for posters. But the constructivists, suprematists, abstractionists who under War Communism[7] placed their graphic propaganda at the service of the Revolution have long since been dismissed. Today, only banal clarity is demanded. Most of these posters repel the Westerner. But Moscow shops are inviting; they have something of the tavern about them. The shop signs point at right angles into the street, as otherwise only old inn signs do, or golden barber-basins, or a top hat before a hatter's. Also, the last charming, unspoiled motifs that remain are most likely to be found here. Shoes falling out of a basket; a Pomeranian running away with a sandal in his mouth. Pendants before the entrance to a Turkish kitchen; gentlemen, each with a fez adorning his head and each at his own little table. Catering to a primitive taste, advertising is still tied to narrative, example, or anecdote. In contrast, the Western advertisement convinces first and foremost by the expense of which it shows the firm capable. Here almost every ad also specifies the commodity in question. The grand, showy logo is alien to commerce. The city, so inventive in abbreviations of all kinds, does not yet possess the simplest—brand names. Often Moscow's evening sky glows in frightening blue: one has unwittingly looked at it through one of the gigantic pairs of blue spectacles that project from opticians' shops like signposts. From the gateways, on the frames of front doors, in black, blue, yellow, and red letters of varying sizes—as an arrow, a picture of boots or freshly ironed washing, a worn step or a solid staircase—a silently determined, contentious life accosts the passer-by. One must ride through the streets on a streetcar to perceive how this struggle is continued upward through the various stories, finally to reach its decisive phase on the roof. This height only the strongest, youngest slogans and signs attain. Only from an airplane does one have a view of the industrial elite of the city, the film and automobile industries. Mostly, however, the roofs of Moscow are a lifeless wasteland, having neither the dazzling electric signs

of Berlin, nor the forest of chimneys of Paris, nor the sunny solitude of the rooftops of great cities in southern lands.

16

Anyone entering a Russian classroom for the first time will stop short in surprise. The walls are crammed with pictures, drawings, and pasteboard models. They are temple walls to which the children daily donate their own work as gifts to the collective. Red predominates; they are pervaded by Soviet emblems and heads of Lenin. Something similar is to be seen in many clubs. Wall newspapers are, for grownups, schemata of the same collective form of expression. They came into being under the pressure of the civil war, when in many places neither newsprint nor printing ink was available. Today they are an obligatory part of the public life of factories. Every Lenin niche has its wall newspaper, which varies its style among factories and authors. The only thing common to all is the naive cheerfulness: colorful pictures interspersed with prose and verses. The newspaper is the chronicle of the collective. It gives statistical reports but also jocular criticism of comrades, mingled with suggestions for improving the factory or appeals for communal aid. Notices, warning signs, and didactic pictures cover the walls of the Lenin niche elsewhere, too. Even inside a factory, everyone is as if surrounded by colored posters all exorcising the terrors of the machine. One worker is portrayed with his arm forced between the spokes of a driving wheel, another, drunk, causing an explosion with a short circuit, a third with his knee caught between two pistons. In the lending room of the Red Army bookshop hangs a notice, its short text clarified by many charming drawings showing how many ways there are of ruining a book. In hundreds of thousands of copies a poster introducing the weights and measures normal in Europe is disseminated throughout the whole of Russia. Meters, liters, kilograms, and so on must be stuck up in every pub. In the reading room of the peasant club on Trubnaia Square, the walls are covered with visual aids. The village chronicle, agricultural development, production technique, cultural institutions are graphically recorded in lines of development, along with components of tools, machine parts, retorts containing chemicals displayed everywhere on the walls. Out of curiosity, I went up to a shelf from which two Negro faces grimaced at me. But as I came nearer, they turned out to be gas masks. Formerly, the building occupied by this club had been one of the leading restaurants in Moscow. Today, the erstwhile *séparées* are bedrooms for peasants of both sexes who have received a *komandirovka* to visit the city. There they are conducted through collections and barracks, and attend courses and educational evenings. From time to time, there is also pedagogical theater in the form of "legal proceedings." About three hundred people, sitting and standing, fill the red-draped room

to its farthest corners. In a niche, a bust of Lenin. The proceedings take place on a stage in front of which, on the right and the left, painted proletarian types—a peasant and an industrial worker—symbolize the *smychka,* the clasping together of town and country. The hearing of evidence has just finished; an expert is called on to speak. He and his assistant have one table; opposite him is that of the defense; both tables face sideways to the public. In the background, facing front, the judge's table. Before it, dressed in black, with a thick branch in her hand, sits the defendant, a peasant woman. She is accused of medical incompetence with fatal results. Through incorrect treatment, she caused the death of a woman in childbirth. The argumentation now circles around this case in monotonous, simple trains of reasoning. The expert gives his report: the incorrect treatment was to blame for the mother's death. The defense counsel, however, pleads against harshness; in the country, there is a lack of sanitary aid and hygienic instruction. The final word of the defendant: *nichevo,* people have always died in childbirth. The prosecution demands the death penalty. Then the presiding judge turns to the assembly: Are there any questions? But only a Komsomol[8] appears on the stage, to demand severe punishment. The court retires to deliberate. After a short pause comes the judgment, for which everyone stands up: two years' imprisonment with recognition of mitigating circumstances. Solitary confinement is thus ruled out. In conclusion, the president points to the necessity of establishing centers of hygiene and instruction in rural areas. Such demonstrations are carefully prepared; there can be no question of improvisation. For mobilizing the public on questions of Bolshevik morality in accordance with party wishes, there can be no more effective means. On one occasion, alcoholism will be disposed of in this way; on others, fraud, prostitution, hooliganism. The austere forms of such educational work are entirely appropriate to Soviet life, being precipitates of an existence which requires that a stand be taken a hundred times each day.

17

In the streets of Moscow, there is a curious state of affairs: the Russian village is playing hide-and-seek in them. If you step through one of the high gateways—they often have wrought-iron gates, but I never found them closed—you stand on the threshold of a spacious settlement. Opening before you, broad and expansive, is a farmyard or a village. The ground is uneven; children ride about in sleighs; sheds for wood and tools fill the corners; trees stand here and there; wooden staircases give the backs of houses, which look like city buildings from the front, the appearance of Russian farmhouses. Frequently churches stand in these yards, just as on a large village green. So the street is augmented by the dimension of landscape. Nor is

there any Western city that, in its vast squares, looks so rurally formless and perpetually sodden from bad weather—thawing snow, or rain. Scarcely one of these broad spaces bears a monument. (In contrast, there is hardly one in Europe whose secret structure was not profaned and destroyed by a monument in the nineteenth century.) Like every other city, Moscow uses names to build up a little world within itself. There is a casino called the Alcazar, a hotel named the Liverpool, a Tirol boardinghouse. From there it still takes half an hour to reach the centers of urban winter sports. True, skaters and skiers are encountered throughout the city, but the toboggan track is closer to the center. There sleighs of the most diverse construction are used: from a board that runs at the front on sleigh rails and at the back drags in the snow, to the most comfortable bobsleds. Nowhere does Moscow look like the city itself; at the most, it resembles its outskirts. The wet ground, the wooden booths, long convoys carrying raw materials, cattle being driven to the slaughterhouse, and indigent taverns are found in the busiest parts. The city is still interspersed with little wooden buildings in exactly the same Slavonic style as those found everywhere in the surroundings of Berlin. What looks so desolate in Brandenburg stone is attractive here, with the lovely colors of warm wood. In the suburban streets leading off the broad avenues, peasant huts alternate with Art Nouveau villas or with the sober façades of eight-story blocks. Snow lies deep, and if all of a sudden silence falls, one can believe oneself in a village in midwinter, deep in the Russian interior. Nostalgia for Moscow is engendered not only by the snow, with its starry luster by night and its flowerlike crystals by day, but also by the sky. For between low roofs the horizon of the broad plains is constantly entering the city. Only toward evening does it become invisible. But then the shortage of housing in Moscow produces its most astonishing effect. If you wander the streets in the dusk, you see in the large and small houses almost every window brightly lit. If the light coming from them were not so unsteady, you would believe you had a festive illumination before your eyes.

18

The churches are almost mute. The city is as good as free of the chimes that on Sundays spread such deep melancholy over our cities. But there is still perhaps not a single spot in Moscow from which at least *one* church is not visible. More exactly: at which you are not watched by at least *one* church. A Russian under the czars was surrounded in this city by more than four hundred chapels and churches—that is to say, by two thousand domes, which hide in the corners everywhere, cover one another, spy over walls. An architectural *okhrana* surrounded him. All these churches preserve their incognito. Nowhere do high towers jut into the sky. Only with time do you

become accustomed to putting together the long walls and crowds of low domes into complexes of monastery churches. It then also becomes clear why in many places Moscow looks as tightly sealed as a fortress: the monasteries still bear traces today of their old defensive purpose. Here Byzantium with its thousand domes is not the wonder that the European dreams it to be. Most of the churches are built on an insipid, sickly sweet pattern: their blue, green, and golden domes are a candied Orient. If you enter one of these churches, you first find a spacious anteroom with a few sparse portraits of saints. It is gloomy, the half-light lending itself to con-spiracy. In such rooms one can discuss the most dubious business—even pogroms, if the occasion demands. Adjoining the anteroom is the only room for worship. In the background it has a few small steps leading to a narrow, low platform along which one advances past pictures of saints to the iconostasis. At short intervals, altar succeeds altar, a glimmering red light denoting each. The side walls are occupied by large pictures of saints. All parts of the wall that are not thus covered with pictures are lined with shining gold-colored tin plate. From the trashily painted ceiling hangs a crystal chandelier. Nevertheless, the room is always lit only by candles, a drawing room with sanctified walls against which the ceremony unrolls. The worshiper greets the large pictures by making the sign of the Cross and kneeling down to touch the ground with the forehead; then, with renewed signs of the Cross, the worshiper, praying or doing penance, goes on to the next. Before small, glass-covered pictures lying in rows or singly on desks, the genuflection is omitted. One bends over them and kisses the glass. On such desks, beside the most precious old icons, series of the gaudiest oil paintings are displayed. Many pictures of saints have taken up positions outside on the façade and look down from the highest cornices under the tinny eaves, like birds sheltering there. From their inclined, retort-shaped heads, affliction speaks. Byzantium seems to have no church-window form of its own. A magical but uncanny impression: the profane, drab windows looking out onto the street from the assembly rooms and towers of the church, as if from a living room. Behind them the Orthodox priest is ensconced like a Buddhist monk in his pagoda. The lower part of Saint Basil's Cathedral might be the ground floor of a fine boyar house. But if you enter Red Square from the west, its domes gradually rise into the sky like a pack of fiery suns. This building always holds something back, and could be surprised only by a gaze coming from an airplane, against which the builders forgot to take precautions. The inside has been not just emptied but eviscerated, like a shot deer. (And it could hardly have turned out differently, for even in 1920 people still prayed here with fanatical fervor.) With the removal of all the furniture, the colorful vegetal convolutions that proliferate as murals in all the corridors and vaults are hopelessly exposed, distorting with a sad rococo playfulness the much older decoration that

sparingly preserves in the interior the memory of the colorful spirals of the domes. The vaulted passageways are narrow, suddenly broadening into altar niches or circular chapels into which so little light falls from the high windows above that isolated devotional objects which have been left standing are scarcely discernible. Many churches remain just as untended and empty. But the glow that now shines only occasionally from the altars into the snow has been well preserved in the wooden cities of the commercial booths. In their snow-covered, narrow alleyways it is quiet. You hear only the soft jargon of the Jewish clothiers in their stalls next to the junk of the paper dealer, who, enthroned and concealed behind silver chains, has drawn tinsel and cotton-wool-tufted Father Christmases across her face like an oriental veil.

19

Even the most laborious Moscow weekday has two coordinates that sensuously define each of its moments as expectation and fulfillment. One is the vertical coordinate of mealtimes; the other, which intersects it, is the evening horizontal of the theater. You are never very far from either. Moscow is crammed with pubs and theaters. Sentries with sweets patrol the street; many of the large grocery stores do not close until about eleven at night; and on the corners, tearooms and beerhouses open. *Chainaia, pivnaia*—but usually both are painted on a background where a dull green from the upper edge gradually and sullenly merges into a dirty yellow. Beer is served with curious condiments: tiny pieces of dried white bread, black bread baked over with a salt crust, and dried peas in salt water. In certain taverns one can dine on this fare and enjoy, in addition, a primitive *intsenirovka*. This is the term for an epic or lyrical subject that has been adapted for the theater. It is often a folksong crudely scored for a choir. In the orchestra of such folk music, alongside accordions and violins, abacuses used as instruments are sometimes heard. (They can be found in every shop and office. The smallest calculation is unthinkable without them.) The intoxicating warmth that overcomes the guest on entering these taverns, on drinking the hot tea and enjoying the sharp *zakuska,* is Moscow's most secret winter lust. Therefore, no one knows the city who has not known it in snow. Each region must be visited during the season in which its climatic extreme falls, for to this it is primarily adapted, and it can be understood only through this adaptation. In Moscow, life in winter is richer by a dimension. Space literally changes according to whether it is hot or cold. People live on the street as if in a frosty chamber of mirrors; each pause to think is unbelievably difficult. It needs half a day's resolution even to mail an already addressed letter, and despite the severe cold it is a feat of willpower to go into a shop and buy something. Yet when you have finally found a restaurant, no matter

what is put on the table—vodka (which is here spiced with herbs), cakes, or a cup of tea—warmth makes the passing time itself an intoxicant. It flows into the weary guest like honey.

20

On the anniversary of Lenin's death, many people wear black armbands. For at least three days, flags throughout the city are at half-mast. Many of the black-veiled pennants, however, once hanging, are left out for a few weeks. Russia's mourning for a dead leader is certainly not comparable to the attitudes adopted by other nations on such days. The generation that was active in the civil wars is growing old in vitality, if not in years. It is as if stabilization had admitted to their lives the calm, sometimes even the apathy, that is usually brought only by old age. When the party one day called a halt to wartime Communism with the NEP, there was a terrible backlash, which felled many of the movement's fighters. At that time, many returned their membership books to the party. Cases are known of such total demoralization that trusty pillars of the party became defrauders within a few weeks. For Bolsheviks, mourning for Lenin means also mourning for heroic Communism. The few years since its passing are, for Russian consciousness, a long time. Lenin's activity so accelerated the course of events in his era that he is receding swiftly into the past; his image is quickly growing remote. Nevertheless, in the optic of history—opposite in this to that of space—movement into the distance means enlargement. Today other orders are in force than those of Lenin's time, admittedly slogans that he himself suggested. Now it is made clear to every Communist that the revolutionary work of this hour is not conflict, not civil war, but canal construction, electrification, and factory building. The revolutionary nature of true technology is emphasized ever more clearly. Like everything else, this (with reason) is done in Lenin's name. His name grows and grows. It is significant that the report of the English trade union delegation, a sober document sparing with prognoses, thought it worthwhile to mention the possibility "that, when the memory of Lenin has found its place in history, this great Russian revolutionary reformer will even be pronounced a saint." Even today the cult of his picture has assumed immeasurable proportions. One finds shops in which it can be bought in all sizes, poses, and materials. It stands as a bust in the Lenin niches, as a bronze statue or a relief in the larger clubs, as a life-size portrait in offices, as a small photo in kitchens, washrooms, and storage rooms. It hangs in the vestibule of the armory in the Kremlin, as in formerly godless places the Cross was erected by converted heathens. It is also gradually establishing its canonical forms. The well-known picture of the orator is the most common, but another one speaks perhaps more intensely and directly: Lenin at a table, bent over a

copy of *Pravda*. When he is thus immersed in an ephemeral newspaper, the dialectical tension of his nature appears: his gaze is turned, certainly, to the far horizon; but the tireless care of his heart, to the moment.

Published in *Die Kreatur*, 1927. *Gesammelte Schriften*, IV, 316–348. Translated by Edmund Jephcott.

Notes

1. Benjamin may have been thinking of "Memnon's Colossos" in Thebes—two monumental seated figures of King Amenhotep III which were later mistakenly identified as representations of the legendary Ethiopian king Memnon.
2. Boris Andreyevich Pilnyak (pseudonym of B. A. Vogau; 1894–1938/41?) was a prose writer who depicted the revolution as a struggle between elemental and rational forces. He was one of the first victims of the government purges in 1937.
3. The New Economic Policy (NEP) was the economic policy of the Soviet Union from 1921 to 1928 which revised the original emphasis on centralization and planning. The NEP included the return of most agriculture, retail trade, and light industry to private ownership, while the state retained control of heavy industry, transport, banking, and foreign trade.
4. Soviet Federated Socialist Republic.
5. Vsevolod Emilevich Meyerhold (1874–1942), preeminent Russian actor and director, opposed the Naturalism of the Moscow Art Theater and was the first theater director to offer his services to the new government. In 1923 he was given his own theater, the Teatr imeni Meyerhold (TIM).
6. VAPP (All-Union Association of Proletarian Writers) was a Soviet literary organization founded in October 1920. By 1928 it was the leading association for writers in the USSR.
7. "War Communism" is the term used to describe the first period of state-dominated economic and social policy, between 1918 and 1921. It was superseded by the New Economic Policy.
8. A member of the oldest Soviet youth organization, the Kommunisticheskiy Soyuz Molodezhi.

Review of Gladkov's *Cement*

Fyodor Gladkov, *Cement: A Novel,* translated from the Russian by Olga Halpern (Berlin: Verlag für Literatur und Politik, 1927), 464 pages.

Gladkov[1] inaugurated a new epoch in Russia. His masterpiece, *Cement,* was the first novel of the period of reconstruction. At a stroke, the environment that he depicts became visible; starting as prose, the work soon conquered the stage, and has enjoyed a run that has lasted for months. Dramatic versions of successful novels are nothing new in Russia, but the transition has never been more appropriate than here. For the strength of the novel lies in its dialogue. It imported the argot of the Bolsheviks into literature. It is this linguistic achievement—one that is even more important than its content—that constitutes the book's information value. Through the medium of an unusually perfect translation, the reader becomes conversant with the manners and the language, the procedures and the debating tactics that have developed in the congresses and commissions. At the same time, he makes the acquaintance of the human types created in the workers' struggle for freedom. God knows, many of them are far from being leaders. They include people who were struck down—as if by apoplexy—in their thought and speech by the power that suddenly fell into their hands; sinister bureaucrats who lurk slyly in their forest of paragraphs like foxes in their burrows; agitators who flee from ideas; secret agents whose effectiveness remains a mystery even to themselves. But there are also young functionaries who are prepared at any moment to transform not just their lives, but the day, the hour, and even the minute into the executive organ of a higher will, wherever it points them; fanatics who promise nothing, reveal nothing of

themselves, and silently, unexpectedly turn up at the riskiest places on the front; reformers who, thanks to their revolutionary self-confidence, promote the cause of the proletariat even in the face of obstacles thrown up by committees and soviets. The chief character is such a person: the Red Army man who returns to his home on the Black Sea after fighting at the front during the civil war. The economic key to this town is the great cement factory that is lying idle, decaying, and dragging the entire town down with it. He is the man who gets the factory going again after months of bitter conflict, a conflict that divides the camp of comrades in two. In the process, he loses his wife; no one can say why. The novel tells us, and indeed she tells us herself, that it is her work that estranges her from the family—and she is an outstanding worker. But this explanation says nothing to the reader, because the depiction of their marital relations is such that all possible side issues are invalidated by its unconstruable truth. A great experience has here found a valid form. It is not just the bonds uniting couples that have canonical forms, which change over time and often bear the features of their age in ways that are as difficult to express as the forms of love itself. The same is true of what separates couples. The true features of the emancipation of women are gradually taking shape, but in ways that differ from what was expected by the enlightened Philanthropists[2] (and this applies to Russia as much as to Europe). If the forces of command and domination really become feminine, this will bring about change in those forces, in the age, and even in the Feminine itself. Moreover, it does not mean a change into a vague humanity in general, but will present us with a new, more mysterious countenance, a political enigma, if you like, a sphinx-like expression, compared to which all the old secrets of the boudoir are no more than outworn riddles. This countenance projects itself into this book, which would have been a great work of literature if the writer had allowed it to grow out of this image. But the book suffers from the absence of a narrative focal point. The man's struggle to restore the fortunes of the cement factory is not so much the internal scaffolding of the action as a connecting thread linking the numerous events. In other words, the tension in his struggle remains external; it fails to become the central force field of the action. To make it so would have called above all for a larger context, a freer panorama. The vision of the sea and mountains closes off the horizon in a false idyll. A cement factory has to be shown against an economic background, not against a landscape. Here it is shown in miniature. This weakness of construction makes itself clearly felt at the end. The moment of apotheosis, the typical effect with which so many Russian novels seek to secure official approval, distorts a work in which the primacy of the political has asserted itself so vigorously that it has left its external justification lagging behind. Admittedly, only someone who understands nothing of the conditions affecting Russian literature could make such a fuss about such signs of

insecurity. Many efforts will be needed before new forms bring a new self-assurance. Together with Boris Pilnyak's *The Naked Year* and Konstantin Fedin's *Cities and Years* (a German edition is now being prepared by Malik Verlag), Gladkov's *Cement* is one of the crucial works of modern Russian literature.[3] For anyone who is following its development, particularly if he is able to do so only in German translation, a knowledge of it is utterly indispensable.

Published in *Die literarische Welt*, June 1927. *Gesammelte Schriften*, III, 61–63. Translated by Rodney Livingstone.

Notes

1. Fyodor Vasilyevich Gladkov (1883–1958) was a Russian writer best known for *Tsement* (1925), the first postrevolutionary novel to dramatize Soviet industrial development.
2. Philanthropism was a pedagogical reform movement of the late eighteenth century which derived many of its ideas from Rousseau. Its main theorist was Johann Bernhard Basedow (1723–1790), whose school—the Philanthropin, in Dessau—became the model for a number of similar institutions throughout Germany, Switzerland, and Russia.
3. Boris Andreyevich Pilnyak (pseudonym of B. A. Vogau; 1894–1938/41?), a prose writer who depicted the revolution as a struggle between elemental and rational forces, was one of the first victims of the government purges in 1937. Konstantin Aleksandrovich Fedin (1892–1977) was a Soviet writer best known for a series of early novels that examine the situation of the intellectual in Soviet Russia. *Goroda I gody* (Cities and Years), published in 1924, details the reactions of the intelligentsia to the Revolution.

Journalism

Alongside all the solemnity that frames Lindbergh's flight across the Atlantic, we may allow ourselves the arabesque of a joke—the amusing pendant to the regrettable frivolity with which the Paris evening papers prematurely announced the triumph of Nungesser and Coli.[1] The same papers are now exposed for the second time. They owe this to an idea conceived by a student at the Ecole Normale—an idea that Karl Kraus might envy. As is well known, this Ecole Normale is the celebrated French state school that every year admits only an elite group of applicants, after the stiffest entrance examinations. On the afternoon of the first day Charles Lindbergh spent in Paris, someone telephoned all the newspaper editors with the news that the Ecole Normale had resolved to declare the aviator "a former student." And all the papers printed the announcement. Among the medieval Scholastics, there was a school that described God's omnipotence by saying: He could alter even the past, unmake what had really happened, and make real what had never happened. As we can see, in the case of enlightened newspaper editors, God is not needed for this task; a bureaucrat is all that is required.

Published in *Die literarische Welt*, June 1927. *Gesammelte Schriften*, IV, 454. Translated by Rodney Livingstone.

Notes

1. François Coli (1881–1927) and Charles Nungesser (1892–1927) were French aviators whose plane, L'Oiseau Blanc, disappeared over the North Atlantic during their attempt to fly nonstop from New York to Paris.

Gottfried Keller

In Honor of a Critical Edition of His Works[1]

We may give lovers of the so-called "good things of life" the assurance that here they are truly in the presence of one.
—Gottfried Keller on Heinrich Leuthold's poetry

The story is told of Haydn that on one occasion he found himself unable to finish a symphony. In order to make further progress, he imagined a story: A businessman in financial difficulties is striving in vain to keep his head above water; he goes bankrupt—Andante; he resolves—Allegro ma non troppo—to emigrate to America; once there—Scherzo—things take a turn for the better; and—Finale—he returns home in triumph to his family and friends. This, roughly, is the prehistory and opening of *Martin Salander.*[2] And it would be nice to discover a formula with which to sum up the indescribable sweetness of Keller's prose style, with its rich harmonies, by inventing a story to complement this one and explain how he was inspired by melodies when writing his works. But since we have no such story, we must resort to cruder instruments. This is not the place to explain the unmistakable fact that some ten years ago the affection of the Germans at long last turned toward Stifter.[3] No sound from Keller's panpipes has ever penetrated the stillness of Stifter's winter and summer landscapes. But the Germans had just—after the end of the war—forsworn the political dances whose rhythm can be heard quite faintly in Keller's works, and instead sought out the noble Stifter landscape, more as a therapeutic clinic than as a new home.

However that may be, the old but novel truth that would include Keller among the three or four greatest prose writers in the German language has a tough time of it. It is too old to interest people, and too new to command

their support. In this respect their situation is like that of the entire nineteenth century, in whose "summery midst" Seldwyla—a *civitas dei helvetica*—has erected its towers.[4] For valid insight into Keller's work, we would need to arrive eventually at a revaluation of the nineteenth century as a whole. For only this could clear up the embarrassments of the literary historians. Who can have failed to observe the radically different assessments of this century in the bourgeois and the materialist literature? And who would not be certain that Keller's work should be reserved for a viewpoint that can claim as its own legacy the historical soil on which it has been built? Bourgeois literary history can hardly make this claim for Keller's atheism and materialism. Or rather can do so no longer. For it must be admitted that his atheism—something he acquired from Feuerbach[5] in his Heidelberg years—was not subversive. On the contrary, it fitted in with the attitudes of a strong, victorious bourgeoisie, although not a bourgeoisie on its way to imperialism. The founding of the Reich signals an ideological rupture in the history of the German bourgeoisie. Materialism disappears, in both its philistine and poetic versions. The upper strata of Swiss society were probably the last to abandon the features of a preimperialist bourgeoisie. (And they retain them even today. They lack, for example, the opportunistic savoir vivre that has enabled the imperialist states to grant de jure recognition to the Soviet Union.) Moreover, the Swiss character may well possess more love of country and less of the nationalistic spirit than any other. Toward the end of Keller's life, the clarion call of Nietzsche's warnings about the spirit of the new Reich issued from Basel. And Keller, who had found himself forced in his Munich period to earn more of his livelihood from work with his hands than he would have liked, represents a class that had not yet completely cut its links to craft methods of production. It is astonishing to see the perseverance with which the Zurich patriciate strove, over a period of years and at a cost of many sacrifices, to turn this man into a respected fellow-citizen and ultimately into one of the leading officials— clerk of the canton. For years, there was something like a joint stock company for the education and promotion of Gottfried Keller; and following his unproductive early career, its capital had to be renewed time and again, until he finally paid back his sponsors with interest and compound interest. When he was at long last and very suddenly appointed cantonal clerk, this news item, which no one had foreseen, was commented on exhaustively in the city press. On September 20, 1861, the *Zürchersche Freitagszeitung* wrote: "It is generally known that until recently Mr. Keller had not familiarized himself with politics in general, and even less with the details of administrative questions . . . More recently, however, he seems to have felt the need to write in various papers and to criticize and deride political developments in the Canton of Zurich, albeit with more wit and eloquence than expert knowledge acquired from serious study." This exalted

bureaucratic post suited a character that was burdened by fundamental inhibitions and passionate reservations. Pedagogic activity was as dear to his heart as to the hearts of the majority of the great writers of his nation, and the opportunity to engage in it indirectly but on a grander scale fitted in with his nature. In his public persona he could not be a teacher, but only a legislator. (Keller was involved in writing the new constitution of the Canton of Zurich.) It is reported that the office was safe in his hands. The effect of his duties on himself was to concentrate his efforts and thus shield him entirely from the idealist movement sweeping the Reich. In this respect it allied itself to his materialism. It is well known that Keller defended the principles of materialism—in particular, those insisting on the utter mortality of man—not as a self-righteous rationalist but as a passionate hedonist who was unwilling to permit his rendezvous with this life to be diminished by any afterlife. His work is the breakwater from which the tide of bourgeois ideas once more retreats, revealing the treasures of its own and every past, before gathering up and unleashing the idealistic floodwaters that will devastate Europe. For we have to remind ourselves how close Keller already stands to a doomed, sterile generation—and how only a fine linguistic line, a mere nothing, an obstinate spinning-out of his stories in a process obscure even to him, separates them from the decadent works of Heyse or Auerbach and makes them stand out as enigmatically perfect in comparison.[6] That Thumann, Vautier, and others of the same kind should have been commissioned to illustrate *Romeo und Julia auf dem Dorfe* [A Village Romeo and Juliet] tells us everything.[7] Keller's strict worldliness, however, did not turn him into a freethinker. His radicalism preserved him from that. The most astounding evidence of this is documented in his debates with Gotthelf.[8] Anyone to whom it means little that in a review of Gotthelf's writings Keller takes a book prize as his starting point should note his remarks at another point: "Nowadays everything is political—everything from the leather on our shoes to the tile on the rooftop. The very smoke that rises from the chimney is political, and it remains suspended in incriminating clouds above huts and palaces alike, and drifts hither and thither above towns and villages." He focuses his comments on Gotthelf's worldly-wise, uplifting manner and utters the astounding words: "The people, the peasant above all, know only black and white, night and day, and care nothing for any tear-filled, emotional twilight, where no one knows who is the cook and who the waiter. If the old natural religion no longer satisfies someone, he turns without more ado to its direct opposite, for he wishes above all to remain a human being and not turn into a bird or amphibian."

Keller's liberalism—which is as remote from the modern variety as is every thought-out attitude—had the most exacting standards of what was imperative and what reprehensible. And it sounds monstrous to say that on the whole it was that of bourgeois constitutionality. But you need only look at

it closely. In Goethe's *Wahlverwandtschaften* [Elective Affinities], an anni-hilating fate proceeds from a marriage bond shaken to its roots. Likewise, in Keller's immortal novella *Romeo und Julia auf dem Dorfe,* the catastro-phe flows from the violation of the rights of ownership to a field. In his old age, in the story of *Martin Salander,* Keller maintained the most stringent links between bourgeois constitutional forms of existence and those of the ethical human order. This would presumably secure him his place—let us say, between Dahn and Marlitt;[9] a place that even today God knows how many Germans are willing to grant him at the center of their educated hearts. So far so good. But this is precisely the point at which we cross the threshold into that "questionable" system of grottoes and caverns that by imperceptible stages tends—the more deeply it enters into Keller himself—to constrain and ultimately to repress the rhythmic babble of bourgeois voices and opinions in favor of the cosmic rhythms it captures within the bowels of the earth. If we seek a name for this miracle of grottoes and caves, it can be none other than "humor." Keller's gentle and melodious laughter is as much at home in these subterranean vaults as Homer's is in the heavenly ones. But it has repeatedly been found that to call a writer a humorist is to block any access to him. And Keller's humor is not a superficial gilded polish, but the unpredictable ground plan of his half-melancholic, half-choleric nature. This is expressed in the elaborate arabesques of his vocabu-lary. And if he shows his respect for bourgeois rules and regulations, he has learned it in the arbitrary world of internal experience; shame, Keller's most passionate emotion, lies at the root of both. In its own way, humor is itself a kind of judicial system. It is the universe of enforcement without verdict, a universe in which both verdict and pardon express themselves through laughter. This is the great reservation that stands at the source of Keller's silence and utterance. He thought little of speech, verdict, and condemna-tion—to say nothing of moral judgment, as we can see from the concluding words of his love story.[10] In its honor, he erected Seldwyla on the southern slope of the hills and forests on whose northern slope the town of Ruechen-stein could be found. Ruechenstein's inhabitants liked to have "an agreeable, windless day . . . for their executions, burnings at the stake, and drown-ings"; thus, "there was always something happening on really fine summer days." He was in no doubt that "if need arises, an entire town of unjust or frivolous people can survive the vicissitudes of time," but that "three righ-teous men are incapable of living under the same roof without getting in each other's hair." The sweet and bracing skepticism that ripens with a concentrated gaze and that, like a powerful aroma of people and things, takes possession of the sympathetic observer has never entered into any prose as it has Keller's. It is inseparable from the vision of happiness that animates it. In it—and this is the secret skill of the narrative writer, who

alone is able to communicate happiness—the most minuscule cell of the world weighs as much as the rest of reality. The hand that came down with such a resounding thud in the saloon never slipped up in weighing the most delicate and fragile things. The task of apportioning the right amounts both in sound and substance was one assigned to the officialese that makes its presence felt from time to time in Keller's prose. A spoonful of soup in the hand of an honest man is more valuable, at the crucial moment, than grace before meals and talk of salvation in the mouth of a crook. "In every situation in life where there was a soup, it was Martin Salander's custom to set to and enjoy it without delay, as soon as it was put in his plate."

Nothing illustrates more convincingly the thoroughly unromantic nature of his works than the unsentimental, epic settings of his stories. Conrad Ferdinand Meyer[11] succeeds in conveying the flavor of this when he writes to Keller in July 1889, for his seventieth birthday, with almost biblical phrasing: "Since you love the earth, the earth will refuse to part with you for as long as it can." Keller's hedonistic atheism does not allow him to festoon "nature with the tendrils of Christian faith," as Gotthelf did. "The nature that supplies him with the most fruit, and disturbs and worries him least, is the most beautiful of all." What Hehn says of the old Latinist holds good for Keller. Sunday sermons and the interpretation of nature are not his cup of tea. Only as a process does the landscape with its natural forces intervene in the economy of human existence. This confers on the narrative events something of the flavor of Antiquity. In the early Renaissance, painters and poets frequently imagined that they were portraying Antiquity when they were only depicting their own age. For Keller, almost the reverse is true. He thought he was giving us his own age, while in it he gave us Antiquity. But he treats the experiences of humanity—and antiquity is a human experience—just as he treats the individual. Its formal law is a law of shrinkage; its laconic manner is not that of ingenuity but that of the wizened dryness of old fruit, old human faces. The soothsaying, orphic head has contracted into the hollow doll's head from which the buzzing of trapped flies can be heard—as we see in one of Keller's novellas.[12] Keller's writings are filled to the brim with this kind of authentic and shriveled Antiquity. His earth has become compressed into a "Homeric Switzerland"; it is the landscape from which his similes are drawn. "She realized that she no longer had a church now, and in her woman's mind, thanks to the power of habit, she felt like a bee that had strayed from the hive and flown out over the endless ocean waves in a cold autumn night." In Keller's homesickness for his native Switzerland you can hear the echo of his yearning for distant ages. For a good half of his life Switzerland was a distant memory for him, like Ithaca for Odysseus. And when he did return home, the Alps, which he had never explored, remained beautiful, remote images. Keller the writer liked

the *Odyssey* above all other books, while the would-be painter found again and again that his studies of nature were blocked by a fantastic paraphrase of his native landscape.

The spirit in which Keller presides over this space of nineteenth-century Antiquity is palpable in his language. Keller's deliberate whittling away at the form of the language is indeed inhibited; he was quite timid in reading his own works. We can see from the textual apparatus of the *Complete Works* how for the most part it was the desire for decorum, correctness, that led him to make changes, and only rarely the wish for greater imaginative precision. It is all the more important that we now have access to what he crossed out. Nevertheless, even without this assistance his vocabulary and usage everywhere point to a Baroque strand in his homey fictional universe. The unique character of his prose is something he owes, as no other writer has since Grimmelshausen,[13] to the fact that he knows so much about the margins of the language, and that he can use both the earthiest dialect expression and the most recent foreign loanword with the greatest facility. The thesaurus of dialect is a set of token coins that circulate in the forms in which they have been minted over the centuries. And whenever the writer requires a particularly heartfelt, joyous expression, he instinctively turns to this linguistic legacy. Keller is as generous in his use of these as his sister was miserly with the metallic treasure—that same Regula of whom he said that "as a spinster, she had found herself in the less fortunate half of the nation." By way of contrast, words of foreign origin in his works are like bills of exchange, a precarious document from far away that needs to be handled with vigilant caution. He tends to use them by preference in letters. From these letters we can see beyond the shadow of a doubt that the most important and beautiful statements occur to him, even more than to other writers, in the course of writing. It is for this reason that he demanded less of himself than he might have in terms of quality, while in terms of quantity he expected more. This is why he so often yielded to the "majesty of indolence." He did not believe that there was much to be said, but his hand possessed a need to communicate that his mouth knew nothing of. "It is freezing today; the little garden beneath the window is trembling with the cold; 762 rosebuds are on the point of creeping back into the branches." Such passages with their small sediment of nonsense (something which Goethe once declared obligatory for verse) are the most tangible proof of the wholly unpredictable nature of his writing, which informed the publishing history of his work.

What fills Keller's books is the sensuous pleasure not of gazing but of describing. Describing is sensuous pleasure because the object returns the gaze of the observer, and every good description captures the pleasure with which two gazes seek each other out and find one another. It is in Keller's

prose that the interpenetration of the narrative and the poetic—the essential contribution of the post-Romantic age in Germany—has been most consummately achieved. In almost all the products of the Romantic school, these two elements appear separately. On the one side stand works like E. T. A. Hoffmann's *Serapionsbrüder;* on the other, novels like Clemens Brentano's *Godwi.*[14] For Keller, these two impulses are in equilibrium. This is why the most mundane activities of his characters possess the rounded, canonical, sensuous reality that they must have had for a Roman. According to Walter Calé, one of the very few critics who have spoken of Keller in distinctive tones: "A further characteristic along these lines is the fact that it is often impossible to describe the 'idea' in his stories. To have an idea would mean limiting oneself to a single set of symbolic meanings developed in a particular direction. But as a true imitator of nature, Keller reproduces it as it is, *infinita infinitis modis:* with countless meanings that spring up almost disturbingly at every point and that cannot be compressed into a single word, so that for this very reason they appear able to express everything and every deep truth." To reflect reality—this, of course, can never prove in theory to be the content of art. But this does not mean that it cannot be a valid description of the aspirations of great writers. Indeed, this mirroring of reality may be described as the special province of the prose writer. The unfolding of nature's plan in its fullest extent is as fundamental a creative principle as the dramatist's desire to provide a cross-section of the structure of action, and the lyric poet's attempts to achieve an infinite concentration in his verse. The world of Keller's writings is a mirror world—even down to the fact that something in it is back to front, that left and right are reversed. While the active and weighty elements of life are seemingly unaffected and are present in their true proportions, the male imperceptibly changes into the female and vice versa. Even during Keller's own lifetime, there were readers who perceived in the pale reflexes of his humor an illusory world that seemed to them uncanny. Theodor Storm wrote to him concerning the end of "Die arme Baronin" [The Poor Baroness],[15] "How the devil, Master Gottfried, can such a sensitive and tender poet portray such a callous action—all right, just let me finish—as something delightful? How can you give us a man who presents his beloved with her former husband and brothers as clowns who have come down in the world so terribly, and how can he do this to increase her pleasure at her wedding feast?"

There is an uncertain flicker in the conciliatory light that is meant to be cast on a life gone awry in "Der Landvogt von Greifensee" [The Governor of Greifensee], something demented about the old man's laugh.[16] Only as a lyric poet was it given to Keller to purify this faint, unsteady flame into a few poems—albeit poems of such perfection!

Slowly, shimmeringly fell the rain
into which the evening sun shone down.
Beneath, the wanderer strode on narrow paths
with darkness in his soul.

In such an evening sun stand the distant images that the poet, conscious of the approach of death, invokes with his mention of the scythe. His smiling face is furrowed with the strain of renunciation, comparable only to that in the Houri poems of Goethe's *Westöstlicher Divan:*[17]

Let me not be punished, guilty though I am,
for the loveliest of poetic sins:
that of inventing dear images of women
such as are not found on the bitter earth!

Among his characters we must include Judith, the most deeply desired woman, the same woman who he said was "a fantasy image, not clouded by any reality." Nor is it irrelevant that of the few women Keller loved, one ended in madness and another committed suicide. Last, those two lines in the Swiss national anthem that characterize Keller's vision as nothing else does—the rose on this shore, the rose that is Switzerland, which because the pedant cannot pluck it is anything but a sterile piece of flowery rhetoric: "Loveliest rose, although all others faded / you still smell sweetly on my barren shore." The "quiet underlying sadness" to which he confesses is the bottom of the well in which his *humor* collects again and again. To express it in graphological terms, the curious hollows and oval forms of this script are—notwithstanding all psychoanalytic investigations—in their concave aspect, the image of the "miserable den" that constituted his inner being, and, in their convex aspect, the visible equivalent of his cranky idiosyncrasies. Keller refused to approve the portrait of him drawn by Stauffer-Bern. But the weary Keller whom this artist captured in an etching at an unguarded moment was the true one: the sonorous, echoing interior of the exhausted man was his. "Often, when I lie awake in bed at night," Keller said on his deathbed to Adolf Frey,[18] "I feel as if I were already buried inside a huge vault, and above me I hear a voice constantly echoing, 'I am guilty, I endure.'" But when we encounter such sentiments in a few isolated passages in his writings, it is, significantly, always in the shape of a woman. He sees himself in the figure of a nixie[19] vainly beating against the icy surface of the water on a winter's night. He recognizes himself "in sadness" as a Danaid:

And as the weary Danaid
let fall her sieve and gazed around her curiously,
so do I gaze after you perplexed,
concerned to see how you adjust and accept.

But even in jest, which sometimes comes quite close to sadness, such utterances come easily to him. "I could readily see myself," he observes in a Berlin letter, "presiding with dignity over a respectable milliner's shop, thanks to the detailed studies I have been making, between the acts, of bonnets and ruffs of every kind." And if anyone were to conclude from such statements that Keller's gloomy composure is based on the profound equilibrium that the masculine and feminine sides of his being have reached, he would have put his finger on Keller's facial appearance, too. The hermaphrodite is not the only androgynous type recognized by Antiquity. Its pleasing forms are of late origin and owe more to Roman and Alexandrian fancy than to the Greeks. And even if it is not true that Antiquity was led by physiognomic speculation to posit a mature androgynous type, or that the Aphroditos—in other words, the bearded Aphrodite—is as real a cultic image as was the custom of Argive women to adorn themselves with a false beard on their wedding night, nevertheless the idea of such faces brings us closer than anything else to the face of this poet.

The inner world into which the observer—the Swiss citizen and politician—poured reality on rivers of good wine was no sunlit hermit's cell, but a magic space circumscribed by two slow-moving rivers of life from which visions constantly arose. Keller's *Traumbuch* [Dream Book] is an anthology of such visions. In his writings, they press up against and intertwine with one another as in coats of arms. His style of writing has something heraldic about it. He often puts the words together with a baroque defiance, just as a coat of arms joins up halves of things. In a letter written in his old age, expressing his thanks for an embroidered cushion, he says: "I cannot . . . really answer for the trouble your skillful fingers have taken to make such a beautiful setting for these two initials, particularly in the light of the fact that they will not hold together for all that much longer." The symbols of the bourgeois state laboriously gather together for one last time in his works, in this heraldic book of the cantons. As a young man he had once written:

Farewell myth, Nibelungs, Bible!
The ancient dreams have been interpreted enough,
The ancient dragon has been flayed enough . . .
Paint now a picture book of freedom!

A picture book is what his writings became. They appeared at a time when people began to forget the language they spoke, and instead the daughters of Switzerland, in whom his gaze discerned both Helen of Troy and Lucretia, began to learn the language of bookkeeping from that same America which he had so often conjured up in his novels.

Both the organization and the format of the already published volumes of the edition are remarkable. The critical apparatus includes the earlier ver-

sions of his texts, and has broken them down into certain stylistic categories. It is hard to say whether this procedure, which is rather bold from the traditional philological viewpoint, will establish itself as the norm. But we can say with some assurance that the appendix is among the few things of this sort that can be studied with pleasure. It restricts itself to essentials in a way that goes well with the austere appearance of the edition, which neither makes any concessions to snobbery nor attempts to ingratiate itself with the public. Of how many German editions of complete works can this be said? The problem of typeface and typesetting that is always especially difficult with Keller seems to me to have been satisfactorily resolved. The binding testifies to the same confident taste that can be seen in the typography.

Published in *Die literarische Welt*, August 1927. *Gesammelte Schriften*, II, 283–295. Translated by Rodney Livingstone.

Notes

1. *Gottfried Kellers Sämtliche Werke*, edited by Jonas Fränkel on the basis of Keller's unpublished papers. The edition is authorized by the administrators of the Gottfried Keller Estate, and has been published by Eugen Rentsch Verlag, Erlenbach-Zurich and Munich. [Benjamin's note]
2. Gottfried Keller (1819–1890) was one of the great German-language prose stylists of the nineteenth century. After his early attempts to establish himself as a painter in Munich were frustrated, he returned to Zurich and inaugurated a career in literature. *Der grüne Heinrich* (Green Henry; 1854–1855, revised version 1879–1880) and the story collection *Die Leute von Seldwyla* (The People of Seldwyla; first volume 1856, second volume 1874) are his best-known works. *Martin Salander* (1886) is his second, and last, novel.
3. Adalbert Stifter (1805–1868) was an Austrian writer whose short stories and novels are characterized by an unusually graceful style and a reverence for natural process.
4. Seldwyla is the imaginary Swiss town that provides the setting for many of Keller's stories. Ruechenstein is a rival town. *Civitas dei helvetica* means "Swiss city of God."
5. Ludwig Andreas Feuerbach (1804–1872) was a German philosopher and moralist who studied theology at Heidelberg and, later, philosophy with Hegel in Berlin. His most important work, *Das Wesen des Christenthums* (The Essence of Christianity; 1841), defined religion as nothing more than the consciousness of infinity. Feuerbach's work exerted an important influence on Karl Marx.
6. Paul Johann Ludwig von Heyse (1830–1914), a traditionalist German writer, received the Nobel Prize for literature in 1910. Berthold Auerbach (1812–1882) was a German novelist noted chiefly for his tales of village life.

7. Friedrich Paul Thumann (1834–1908), a German illustrator and painter, was celebrated for his illustrations of children's books and classics of German literature. Louis Benjamin Vautier (1829–1898) was a Swiss painter and illustrator known for his nature and peasant scenes.

8. Jeremias Gotthelf (pseudonym of Albert Bitzius; 1797–1854) was a Swiss novelist and short-story writer whose works, such as "The Black Spider," extol the traditional values associated with church and home life.

9. Felix Dahn (1834–1912) was a popular, nationalistic novelist. His best-known work, *Ein Kampf um Rom* (The Struggle for Rome), appeared between 1876 and 1878. Eugenie Marlitt (1825–1877) was known for her popular love stories and family novels.

10. Keller's *Romeo und Julia auf dem Dorfe* ends with an ironic commentary, in the form of a newspaper report, on the death of the lovers: "This event is presumably linked to the ship from that region which landed in the town, its cargo of hay intact but its crew vanished. It is believed that the young couple stole the ship in order to celebrate their desperate and godforsaken wedding on it—a further sign of the growing immorality and decadence of the passions."

11. Conrad Ferdinand Meyer (1825–1898) was a leading Swiss writer noted for his historical fiction and poetry.

12. This is a reference to the doll that Sali and Vrenchen play with as children in *Romeo und Julia auf dem Dorfe*.

13. Hans Jacob Christoph von Grimmelshausen (1621/22–1676) was the author of the most important novel of the German Baroque, *Der abenteuerliche Simplicissimus* (The Adventurous Simplicissimus), a satirical and partially autobiographical view of the Thirty Years' War.

14. *Die Serapionsbrüder* (The Serapion Brothers; 1819/20), by Ernst Theodor Amadeus Hoffmann (1776–1822), is a collection of stories with a frame narrative. A leading German Romantic, Hoffmann combined, in his work, wild flights of imagination with penetrating examinations of psychology and character. *Godwi* (1801), by Clemens Brentano (1778–1842), is a Romantic *Bildungsroman* with an eccentric structure and coruscating irony. Brentano, an exceptionally gifted writer, produced influential poetry, prose, and dramas.

15. "Die arme Baronin" is one of the stories in *Das Sinngedicht* (1881–1882), a novella by Keller with a cyclical, thirteen-chapter structure.

16. "Der Landvogt von Greifensee" is part of Keller's collection *Zürcher Novellen* (Zurich Novellas).

17. Goethe's *West-Easterly Divan* (1819) is a verse cycle inspired by the Persian poet Hafiz (1320–1389). Written when Goethe was almost seventy, it contains some of his most memorable love poems.

18. Adolf Frey (1855–1920) was a Swiss novelist and poet whose best-known works are his literary biographies of Swiss writers.

19. A water sprite of Germanic folklore.

Diary of My Journey to the Loire

August 12, 1927. I shall confine myself to notes. The familiar torment of loneliness that afflicts me particularly when traveling has for the first time assumed the features of growing old. L. has not come with me.[1] The likelihood that this is because of a misunderstanding is no greater than 10 percent. The likelihood that I have been deceived in the ordinary way is about 90 percent. Admittedly, I myself intentionally created this possibility. That now turns out to be a mistake. If she had come, that would have been the basis for enjoying this trip.

I can be certain that I shall now, alone, find all the places which would have been sheer delight with her. Here I am, for example, sitting in a very quiet and very good restaurant, the Hôtel St. Cathérine in Orléans. The table is precisely the right width for sitting opposite someone. The electric lights are so faint that I can barely see to write.

Until midday I was uncertain whether I should travel on my own. If Scholem hadn't been arriving today, I probably would not have done so. But I took flight. At the time, I simply did not think I could bear his sometimes ostentatious self-assurance.

This afternoon I saw Orléans Cathedral: modern colored-glass windows that mean nothing. Yet above, in the choir, plain glass. The rose window above the entrance, too, is plain: a polar sun. Behind the plain glass of the aisle windows the buttresses can be seen in the half-light, like a shoreline in banks of mist. In the transept the rose windows are in harsh, barbaric yellows and reds.—The exterior is incredibly beautiful. Outside, the chancel has a stone foundation from which the shafts and pilasters rise up. It is as if they are rooted in the stone walls.

While I was walking through the cathedral, the organist was practicing.

Everything, especially every trivial thing on this journey, makes me want to burst into tears. For example, the fact that on this trip I do not speak French. (At all!) I weep when I think about the rue de Reuilly, a magic name for me, one that I can no longer use.

August 13. At the station in Orléans, in the train to Blois. I slept better than I had expected. From the hotel I went back to the cathedral again. This time I approached it from the Hôtel de Ville, which is faced by some older houses rising up on a beautiful slope. In the cathedral I heard the story of the red hat that hangs from the ceiling. It belonged to a cardinal (probably Cardinal Touchet, who is seated at the feet of the statue of Joan of Arc) and will hang there until it falls of its own accord.—From a distance, from the boulevard St. Vincent, the buttresses look like fragments of Christ's crown of thorns. Never have I seen such a thorny cathedral as this one, with its icy cold rose window.

While I was walking through the town and visiting all the churches listed in the guidebook, it occurred to me that it is quite possible L. really had gone away; in other words, that she may well have gone on a trip with him. Considered perhaps calling at her apartment again shortly before leaving for Berlin, or at the hotel in the rue de la Chapelle, and observing her if possible.

Orléans is a center for fishing. A very alluring shop with all sorts of equipment for anglers, "Le Pêcheur Moderne," on the rue de Bourgogne.

In Blois. Here you have to sit on the terrace behind the Cathédrale St. Louis if you want to see the famous French *clarté*, the French *limpidité*, total harmony of landscape, architecture, and the art of gardening. Thank God the sky is heavily overcast; the sun has disappeared. I still feel bitterness within me, churned-up emotions that refuse to settle down. It was an infallible instinct that bid me make precisely this journey with L., a Parisian. The absent one retreats from me for the second time—like a landscape, at every moment drawing farther away. I place landscapes, courtyards, around her as frames, all of which remain empty. And the whole situation is made worse by my vanity's whispered insistence that all this happened by accident, not design. Even so, when I return to Paris, I will not let my efforts to find her again go too far. In Paris I can survive without her, and indeed cannot really make use of her, as matters stand. It was during the guided tour through the castle of Blois that I suffered most. This was where her astonishment would have made everything bearable, if not agreeable. As it was, as I gazed around the empty rooms, whose walls are painted in imitation of the Gobelins tapestries or Cordoba leather that used to hang there, I could see that I was almost the only person who was alone. I am not far from tears. What was the point of it all—not just of all these

preparations, but of having made this huge change in my life—if I cannot contrive to carry out the simplest little planned journey that any traveling salesman could manage? Am I never again to travel anywhere with a woman I desire?

August 15. To my surprise, I see that comfort is having an effect on my gloomy mood. Since I . . .

The same day, evening. In short, I have an excellent, luxurious room that will have to make up for L.'s absence as far as possible. I shall presumably not see her again, and I shall make only modest attempts to do so. But I have caught myself trying to conjure up her face, specifically to recall that expression (that coldness, that refusal to make contact with me) which is no doubt the source of my present situation. I made this effort this afternoon beneath the trees in front of the Café Universel, behind the big statue of Balzac which shows the master in his dressing gown.

Only the sight of the buildings really gives me the feeling of having arrived here in Tours, or wherever it may be, and nowhere else. I stood behind the chancel of St. Gatien. My gaze turned to the dead, gray, nondescript exterior view of the famous stained-glass windows. A moment before, I had been sitting on a bench, looking at the façade; now I was looking at the back of the church, leaning against a wall. It gave me a shock. Compared to this peace, this immediate sense of presence that comes with gazing at great works of architecture, all our ordinary activity is like traveling on a train that suddenly stops with a jerk. Here we are: nothing will take us any further. Tours has the most cheerful, most childlike rose windows I have ever seen, especially the one over the main portal. After that I took a walk behind the cathedral, through little streets with low squat buildings. But with what names! Rue Racine, rue Montaigne. And this square is the place St. Grégoire de Tours. A woman was delivering newspapers, and she blew a horn—a last vestige of the medieval town crier, probably. The houses have two stories, but much lower still are the courtyard walls with the doors in them.

In the cathedral I suddenly cheered up. It occurred to me that a month previously I had been in Chartres—it was not yet a month since I had met L.—and she had been marvelously planted (this Parisian rose) between these two cathedrals. And that was as it should be. She had her place.

August 16. I went back to St. Gatien. The stained glass must have had this appearance of faded velvet cloth right from the start. Incidentally, this rose window is an unsurpassable symbol of the Church's way of thinking: from the outside, all slaty, scaly, almost leprous; from the inside, blossoming, intoxicating, and golden. When you walk over to the other side of the Loire, St. Gatien does not stand out, as it should, in Gothic splendor above many

gables, but rises above the leaves of the trees on the Loire islands and the riverbank promenade.—Yesterday I saw two chimney stacks on a roof high above the town: a new paradise that Virgil shows with a dramatic gesture to a Dante who recoils with a shiver.—From the front the cathedral looks out onto the place du Quatorze Juillet, and from behind onto the place St. Grégoire de Tours. It looks as if it is resting its head on a cushion and has its feet in the water. Concerning street names: on the sign for the rue Auguste Comte, together with his dates, appears the word *Positiviste.* What must the good townsfolk think that means?—(Behind the cathedral: rue du Petit Cupidon.)

I would have had a photograph of L. made on this trip. Apart from that, I find I have been able to restore my equanimity by imagining that her failure to come was due to the influence of someone else. For my vanity, and the probabilities of the situation, do not allow me to consider the possibility that she deceived me from start to finish. And to contemplate the thought that we may have missed each other as a result of a misunderstanding would drive me mad.

Before coming to Tours I had never seen a town (other than Heidelberg) that allows the landscape to come so much into its own. There is scarcely more than a ribbon of gray along the banks of the Loire as they pass through the town. And the boulevard Grammont passes into the countryside as if through festively built-up, inhabited meadows. The great stone bridge is shallowly suspended above the river, like a hand stroking it. Everything is low, apart from a few lofty towers. It is a town *à la portée des enfants;* it gives me pleasure to reflect that the great Catholic children's-book publisher Mame is based in Tours.

Written August 1927; unpublished in Benjamin's lifetime. *Gesammelte Schriften,* VI, 409–413. Translated by Rodney Livingstone.

Notes

1. The identity of Benjamin's friend has not been established.

Review of Soupault's *Le coeur d'or*

Philippe Soupault, *Le coeur d'or* [The Heart of Gold] (Paris: Bernard Grasset, 1927), 260 pages.

For all its renown, Surrealism as a theory is now precisely three years old. As a practice it is significantly older. This ancient practice of complete relaxation, which is what it prescribes as the foundation of literature, constitutes the entire interest of the theory. One immediately understands why it could be formulated only under the influence of Freud, who made a late appearance in France but had an enduring effect. And indeed Surrealism made its entry into Paris on a *vague de rêves,*[1] an epidemic of dream-ridden sleep to which both the movement's leaders and their acolytes succumbed. Yet they overlooked the fact that it may be much harder for artists than for amateurs to follow the precepts of an art based on a relaxed psyche, a stock of ideas from the unconscious, and that the entire task of the "artist" is to dredge them to the surface. We realize that the dilettante sticks much closer to the stereotypes of writing or painting than the professional artist, because he is less able to grasp them or see through them. We realize that such a dilettante is necessarily unfree, because in certain matters freedom springs exclusively from knowledge and practice. It is the artist who possesses this freedom. But he is exposed to a threat of quite a different kind. The fortunate constellation and the evidence of imagination that are to be found at these deepest levels manifest themselves only intermittently. Any practice that tries to mold the mind to make it more flexible, more prompt, more adept in appropriating them runs the risk of falsifying the most important data: the time, place, and circumstances in which they become audible. This

is not a technical necessity but a vital one—in other words, the most precise specification among all the incidentals in time and space that gives the amateurish products of children, dilettantes, or the insane an autonomy amid the banalities, a freshness amid horror, that is often absent from Surrealism, for all its efforts. And if the content of these dreams is very detailed, as would be the case with the depiction of a place, the narration of an experience, or the exploration of an idea (since in reality it ought to be all these things simultaneously), then the unwilled, relaxed process of recollection would have to be highly concentrated to capture the quality of dreams. If, on the other hand, we are dealing with conscious memories that the author transposes subsequently into the unconscious, then the dreary consequences will not be long in coming. In that case, events will unfold without clarity, without fantasy, monotonously and in a nondreamlike way. Regrettably, Soupault's latest book furnishes proof of this. Nothing is good about it—and this deserves emphasis—but the dust jacket. There we read, "'Coeur d'or—coeur solitaire' (proverbe de Montrouge)." The story deals with loneliness, which it presents in a long series of images. Interspersed among these, and framed by them, we see glimpses of the woman he loves. To read this book is agonizing; to live through it was even more agonizing; to write it was not hard at all. The man who endured the sufferings described in this book has, as author, comfortably slid down the slope that, as lover, he was forced to climb laboriously. And the reader comes away empty-handed. Paul Valéry recently found an apt formula for the perceived dangers of the new literary school. It alludes to the gambling booths in large fairgrounds and marketplaces that put up huge posters to attract the public. They say, "Chaque coup gagne"—in other words, "Every throw a winner." He claims that this is the basic principle of the new school. It is only a minor bon mot, but it is just enough to offset a feeble book.

Published in *Internationale Revue* (Amsterdam), 1927. *Gesammelte Schriften*, III, 72–74. Translated by Rodney Livingstone.

Notes

1. The allusion is to *Une vague de rêves* (Wave of Dreams; 1924), by the Surrealist writer Louis Aragon (pseudonym of Louis Andrieux; 1897–1982).

The Idea of a Mystery

To represent history as a trial in which man, as an advocate of dumb nature, brings charges against all Creation and cites the failure of the promised Messiah to appear. The court, however, decides to hear witnesses for the future.[1] Then appear the poet, who senses the future; the artist, who sees it; the musician, who hears it; and the philosopher, who knows it. Hence, their evidence conflicts, even though they all testify that the future is coming. The court does not dare to admit that it cannot make up its mind. For this reason new grievances keep being introduced, as do new witnesses. There is torture and martyrdom. The jury benches are filled with the living, who listen to the human prosecutor and the witnesses with equal distrust. The jury members pass their duties on to their heirs. At last, the fear grows in them that they might be driven from their places. At the end, the entire jury has fled; only the prosecutor and the witnesses remain.

Written ca. November 1927; unpublished in Benjamin's lifetime. *Gesammelte Schriften*, II, 1153–1154. Translated by Rodney Livingstone.

Notes

1. This short text accompanied a letter from Benjamin to Gershom Scholem of November 1927. Scholem suggests that it represents a first reaction to Kafka's novel *Der Prozeß* (The Trial).

Review of Hessel's *Heimliches Berlin*

Franz Hessel, *Heimliches Berlin* [Unknown Berlin], a novel (Berlin: Ernst Rowohlt Verlag, 1927), 183 pages.

The short flights of steps, the pillared porticoes, the friezes and architraves of the villas in the Tiergarten have been taken at their face value in this book.[1] The "old" West of Berlin has become the West of Antiquity—the source of the westerly winds that fill the sails of the boatmen whose vessels pass slowly up the Landwehr Canal, laden with the Apples of the Hesperides, and tie up at the Bridge of Hercules. This neighborhood distinguishes itself from Berlin's sea of houses as unmistakably as if the entrance to it were guarded by thresholds and gateways. Its author is an expert on thresholds in every sense of the word, except for the dubious thresholds of the experimental psychology he dislikes. But the thresholds that separate situations, hours, minutes, and words from each other are something he feels more sharply beneath the soles of his feet than anyone else.

And precisely because he responds to the city in this way, it would be a mistake to expect descriptions or mood paintings here. What is "unknown," secret, about this Berlin is no windy whispering, no tiresome flirting, but simply this strict classical image-being of a city, a street, a house, even a room that, as a *cella*, holds within itself the yardstick for the events in this book, just as it does for the figures in a dance.

Every architecture worthy of the name ensures that it is the spatial sense as a whole, and not just the casual gaze, that reaps the benefits of its greatest achievements. Thus, the narrow embankment between the Landwehr Canal and Tiergarten Street exerts its charm on people in a gentle, companionable

manner—hermetically guiding them on their way. Engrossed in conversation, they stride from time to time across the stony embankment. And just as the author caused the Roman heart to beat and the Greek tongue to speak in the fourteen imagined characters of his *Sieben Dialoge*,[2] something comparable can be seen here, in these frail children of the world. They are not Greeks and Romans in modern costume, and even less are they our contemporaries in humanist carnival dress. Instead, this book is technically close to photomontage: housewives, artists, fashionable women, businessmen, scholars are all intercut contrastively with the shadowy outlines of Platonic and comic masks.

For this unknown Berlin is the stage of an Alexandrian *Singspiel*.[3] It borrows the unity of time and place from Greek drama: in twenty-four hours the love story experiences its crisis and resolution. From philosophy it has borrowed the great Greek Socratic morality that the author had previously treated in a verse play—a classical formulation of the story of the Matron of Ephesus.[4] From the Greek language it has taken its musical instrumentation. There is no writer living today who has a greater or more sympathetic understanding of the Greco-German tendency to create compound words. In his mouth, words become magnets that irresistibly attract other words. His prose is shot through with such magnetic threads. He knows that a beautiful woman can be a "Nordic blond," a cashier a "seated goddess," a hairdresser's widow "cake-beautiful," a dull prig a "do-no-harm," and a dwarf a "bound-to-be-little."

In another way, however, the novel is peopled by loving couples who are never on their own and always accompanied by friends; they are nothing but links in a well-soldered magnetic chain. And whether we are reminded of the story of Swan-Stick-On or the Pied Piper of Hamlin—in this instance the Pied Piper is called Clemens Kestner—it remains true that this procession of young Berliners, however unadmirable they may be individually, and however unenviable their fate, nevertheless draws the reader behind it, past the "river landscape with the curved footbridge, the forked chestnut branches, and the three weeping willows" that "have something of the Far East about them, as do some of the little Berlin lakes at certain moments."

Where does the narrator obtain his mysterious talent for investing the tiny territory described in his story with such a sense of temporal and spatial distance? In a generation of writers who have virtually all been affected by the phenomenon of Stefan George,[5] Hessel spent the years when others were busy spreading dogmas and wasting time on the already tottering edifice of education devoting himself to mythological studies, to Homer, and to the task of translation. Those who know how to read his books can sense how they conjure up classical Antiquity between the walls of aging big cities, and among the ruins of the past century. But even though he casts his net so widely, embracing Greece, Paris, and Italy in its sweep, the center of this

activity always comes back to his room in the Tiergarten—a room which his friends rarely enter without sensing that they are in danger of being transformed into heroes.

Published in *Die literarische Welt,* December 1927. *Gesammelte Schriften,* III, 82–84. Translated by Rodney Livingstone.

Notes

1. Franz Hessel (1880–1941) was a writer, as well as a translator of Proust, Stendhal, and Balzac. He produced the most important works of his career between 1924 and 1933, when he worked for Rowohlt Verlag in Berlin. He emigrated to Paris in 1938. "Tiergarten" here refers to the neighborhood of Berlin centered on the Tiergarten park (Berlin's equivalent of New York's Central Park) and the zoo from which it takes its name.
2. Franz Hessel, *Sieben Dialoge* (Seven Dialogues), with seven etchings by Renée Sintenis (Berlin, 1924).
3. The *Singspiel* is a simple form of opera with songs and spoken dialogue. Both Goethe and Wieland wrote *Singspiele,* but Mozart's *Zauberflöte* remains the apogee of the form.
4. Franz Hessel, *Die Witwe von Ephesos* (The Widow of Ephesus), dramatic poem in two scenes (Berlin, 1925). Hessel based his play on one of the tales in Petronius' *Satyricon.*
5. Stefan George (1868–1933) was a German neo-Romantic poet and the editor of the influential *Blätter für die Kunst,* published from 1892 to 1919. His school, the "George circle," was held together by his authoritarian personality and self-consciously backward-looking aesthetics.

A State Monopoly on Pornography

Spain probably has the most beautiful newspaper kiosks in the world. Strolling along the streets of Barcelona, you find yourself flanked by these wind-ruffled, brightly colored structures—dancing masks, beneath which the youthful goddess of information performs her provocative belly dance. A few weeks ago the authorities removed the glittering headband from this mask. They prohibited the sale of the five or six explicit series that treat of love without ". . ." or "——," the universal Morse code used in literature to represent the language of love. As is well known, this emancipation from the Morse code in the description of sexual acts is labeled "pornography." However that may be, the pastel-colored Spanish magazines were indistinguishable from such books as our *Memoirs of a Milliner, Boudoir and Racetrack,* and *Her Older Girlfriend.* What was instructive about them was something else. The list of authors contained the names of respected writers, including even such prestigious names as that of Gómez de la Serna.[1] There is undoubtedly material enough for a commentary that would eagerly consume its object in the pure flame of moral indignation. Rather than trying something of that sort, let us dwell on the object for a few moments.

In one respect, pornographic books are like other books: they are all based on language and writing. If language did not contain elements in its vocabulary that are obscene in themselves, pornography would be robbed of its best instruments. Where do such words come from?

Language in the various phases of its historical development is a single great experiment that is conducted in as many laboratories as there are peoples. And everywhere we see the striving for instant, unambiguous communication through a liberating, suggestive mode of expression. (What

the speakers of a language think it worthwhile to say depends on their opportunities for expression, what modes of discourse are generally available to them.) For this huge process of experimentation, great poetry provides what might be thought of as a formulary, while the demotic language supplies the materials. The experimental arrangements are in continual flux, and the entire corpus of knowledge has to be kept constantly under review. By-products of every kind are inevitable. They include all the idioms and fixed expressions, whether written or spoken, that stand outside normal usage: nicknames, company names, swear words, oaths, devotional expressions, and obscenities. These may be excessive, lacking in expression, sacred, a fermentation of cultic language, or else overexplicit, shameless, and depraved. The waste products of daily usage, these same elements acquire a crucial value in other contexts—in scientific contexts, above all—since there these astonishing linguistic splinters can be understood as fragments from the primeval granite of the linguistic massif. We know how precisely these extremes correspond to each other in their polar tension. And one of the most interesting subjects of study would be the role of scatological wit in the monastery language in the Middle Ages.

But, one might object, if the production of such words is so grounded in the nature of language that all words which lecherously indulge in the excesses of communicative energy already find themselves on the boundaries of the obscene, then it is all the more important to banish them from writing.

On the contrary. It is society's duty to put these natural—not to say profane—processes in the life of language into service as natural forces. Just as Niagara Falls feeds power stations, in the same way the downward torrent of language into smut and vulgarity should be used as a mighty source of energy to drive the dynamo of the creative act. What poets should actually live on is a question as shameful as it is ancient, and one that up to now has been answered only with embarrassed evasiveness. Whether they look after themselves or whether the state assumes that task, the result is the same: their starvation.

For this reason, we call for a state monopoly on pornography. We demand the socialization of this not inconsiderable source of power. The state should administer this monopoly and should ensure that this literary genre is the exclusive prerogative of an elite group of important authors. Instead of a sinecure, the writer should be given a license to supply the authorities with a specified percentage of the statistically calculated demand for pornographic works. It is in the interest of neither the public nor the state to depress the price of this commodity excessively. The writer should produce in order to supply a fixed, demonstrable need in return for cash payment, which is designed to protect him from the completely unforeseeable vagaries of the market that afflict his true writing. This enterprise will be much cleaner than a situation in which he serves—directly or indirectly, con-

sciously or unconsciously—a party or other interest group. As an expert he will be superior to the amateur, and will help to counteract the intolerable dilettantishness that prevails in this field. Moreover, the more he does this kind of work, the less he will despise it. He is not a sewer worker, but a pipe layer in a comfortable new Babel.

Published in *Die literarische Welt*, December 1927. *Gesammelte Schriften*, IV, 456–458. Translated by Rodney Livingstone.

Notes

1. Ramón Gómez de la Serna (1891–1963) was a Spanish writer whose highly associative poetic fragments *(greguerias)* were widely read in Europe and Latin America.

Image Imperatives, 1928

Maidenhair fern *(Adiantum pedatum),* magnified eight times. Photo by Karl Blossfeldt. From Blossfeldt, *Urformen der Kunst: Photographische Pflanzenbilder,* 2nd ed. (Berlin: Verlag Ernst Wasmuth, 1929), plate 55. Copyright © 1999 Karl Blossfeldt Archiv, Ann and Jürgen Wilde / Artists Rights Society (ARS), New York.

Curriculum Vitae (III)

I was born in Berlin on July 15, 1892. My father was a businessman. I went to a classically oriented grammar school, interrupting my studies there for a two-year period to become a boarder at Haubinda School in Thuringia.

I entered university in the summer semester of 1912 to study philosophy. The first and third semesters, I studied in Freiburg im Breisgau; the second, fourth, and subsequent semesters, in Berlin. In 1916 I went to the University of Munich, and in the winter semester of 1917–1918 I moved to the University of Berne. I completed my studies there in June 1919 and was awarded my doctorate *summa cum laude.*

The title of my dissertation was "Der Begriff der Kunstkritik in der deutschen Romantik" [The Concept of Criticism in German Romanticism]. I majored in philosophy and also passed exams in my minor subjects: history of German literature, and psychology. In particular, I read and reread Plato and Kant, then the philosophy of Husserl and the Marburg school. Gradually, my interest came to focus on the philosophical content of imaginative literature and artistic form, and ultimately found expression in my dissertation.

This tendency also dominated my subsequent work, in which I strove to concentrate ever more narrowly on concrete detail, both for greater precision and as a result of the content of my literary investigations. The idea of casting light on a work by confining my attention purely to the work itself was one I attempted to carry out in my essay "Goethes Wahlverwandtschaften" [Goethe's Elective Affinities]. My next piece of work, *Ursprung des deutschen Trauerspiels* [Origin of the German Trauerspiel] was devoted to

exploring the philosophical significance of a vanished and misunderstood form of art: allegory.

From the very beginning, my studies were marked by an intensive preoccupation with French literature. This led to a number of translations—Baudelaire, Proust—but above all to a recurrent interest in problems of translation associated with the philosophy of language. I attempted to engage these in an essay entitled "Die Aufgabe des Übersetzers" [The Task of the Translator]—the preface to my Baudelaire translations.

Just as Benedetto Croce opened the way to the individual concrete work of art by destroying the theory of artistic form, I have thus far directed my efforts at opening a path to the work of art by destroying the doctrine of the territorial character of art. What our approaches have in common is a programmatic attempt to bring about a process of integration in scholarship—one that will increasingly dismantle the rigid partitions between the disciplines that typified the concept of the sciences in the nineteenth century—and to promote this through an analysis of the work of art. Such an analysis would regard the work of art as an integral expression of the religious, metaphysical, political, and economic tendencies of its age, unconstrained in any way by territorial concepts. This task, one that I had already undertaken on a larger scale in *Ursprung des deutschen Trauerspiels,* was linked on the one hand to the methodological ideas of Alois Riegl, especially his doctrine of the *Kunstwollen,*[1] and on the other hand to the contemporary work done by Carl Schmitt, who in his analysis of political phenomena has made a similar attempt to integrate phenomena whose apparent territorial distinctness is an illusion.[2] Above all, however, any such approach seems to me to be a precondition for any effective physiognomic definition of those aspects of artworks that make them incomparable and unique. To that extent, I believe it is closer to an eidetic way of observing phenomena than to a historical one.

At the center of my plans for the coming years are two subjects that link up with my latest book, albeit in different ways. First, having attempted to lay bare the philosophical, moral, and theological content of allegory, I would now like to perform the same task for the fairy tale as an equally fundamental and originary repository of certain traditional themes—namely, as the disenchantment of the sinister powers embodied in the saga. The second subject for which I have been making preparatory studies for some time now is an account of classical French comedy; it will be a companion piece to my treatment of German Baroque drama. In addition, I have been planning a book on the three great metaphysical writers of our day: Franz Kafka, James Joyce, and Marcel Proust. Finally, I hope that I shall have the opportunity to expand upon the picture of Goethe that I drew in my work on *The Elective Affinities* with two further studies, one on *Pandora,* the other on "Die neue Melusine" [The New Melusine].[3]

Written in early 1928; unpublished in Benjamin's lifetime. *Gesammelte Schriften,* VI, 217–219. Translated by Rodney Livingstone.

Notes

1. Alois Riegl (1858–1905) was an influential Austrian art historian who argued that different formal and stylistic orderings of art gradually emerge as expressions of different historical epochs. Riegl defines the *Kunstwollen* as the manner in which a given culture at a given time wants to see its cultural objects; his assertion that each epoch's art is informed by its own, inherently legitimate *Kunstwollen* posed a significant challenge to reigning theories of art derived from the notion of a classical ideal.
2. Carl Schmitt (1888–1985) was a German legal scholar. His work is characterized by an emphasis on the necessity of authoritative decision in moments of constitutional crisis, a deep skepticism toward the liberal premises of the Weimar constitution, and an inherent anti-Semitism. After the Nazi assumption of power, Schmitt joined the party; certain of his ideas formed the legal-theoretical basis for the Nazi suspension of parliamentary law.
3. *Pandora* is a verse play that Goethe wrote in 1810. "Die neue Melusine" is a story embedded in his novel *Wilhelm Meisters Wanderjahre* (Wilhelm Meister's Wanderings).

André Gide and Germany

A Conversation with the Writer

A few weeks ago I asked one of France's leading critics, "Which of the great French writers seems to you to be most like us in his work and his general persona?" He replied, "André Gide." I won't deny that I had hoped for this answer, though I hadn't expected it. But let us begin by clearing up a possible misunderstanding. If Gide has a certain affinity with the German mind, both as a man and a thinker, this does not mean that as an artist he has made overtures to the Germans, or that he makes things easy for them. He does not make things easy either for them or for his own countrymen.

The Paris he comes from is not that of the countless novelists and the international marketplace for new comedies. His disposition and family bind him less to Paris than to the North, to Normandy and above all to Protestantism. You have to read a work like *La porte étroite* [Strait Is the Gate] to realize the love Gide feels for this landscape, and the extent to which the ascetic passion of his young heroine has internalized it.

There was a moralistic, Protestant strain in his work right from the outset; productive energy and critical energy have hardly ever been so closely intertwined in any writer as in him. Thirty years ago there was the protest of the youthful Gide against the primitive, sterile nationalism of Barrès; more recently, his latest novel, *Les Faux-monnayeurs* [The Counterfeiters], undertook to provide a creative corrective to the current novel form in the spirit of the Romantic philosophy of reflection. But whatever he did, he remained true to himself in one respect: his need to reject the given, whether he found it outside or inside himself.

If we have captured the essence of this author, whose significance is as much that of a moralist as that of a writer, we must add that there were

two great men who pointed him in the direction of self-discovery: Oscar
Wilde and Nietzsche. The European spirit in its Western form has perhaps
never defined itself more clearly than in this triad—in contrast, that is, to
its Eastern manifestation, with Tolstoy and Dostoevsky. But if later, in an
account of his debt to German literature, Gide omits the name of Nietzsche,
this may be explained by the fact that to talk about Nietzsche would imply
talking about himself in an overly pointed and responsible way. For anyone
who was unaware that Nietzsche's ideas meant more to him than the outline
of a philosophical *Weltanschauung* would know very little about Gide.
"Nietzsche," Gide remarked once in conversation, "created a royal road
where I could only have beaten a narrow path. He did not 'influence' me;
he helped me."

It is out of modesty if he says nothing of all this today. Modesty: this
virtue has two faces. One is the ostensible, cramped, or false modesty of the
small-minded person; the other is the heart-warming, tranquil, true modesty
of the great one. The latter type radiates convincingly from Gide's every
gesture. You feel that he is accustomed to move at his ease in the royal court
of ideas. Here, in the society of queens, is the origin of the subdued voice,
the hesitant yet imposing gestures, the unobtrusive, attentive gaze. And
when he assures me that he is normally an awkward conversationalist—shy
and fierce at the same time—I realize that for him it is both a danger and
a sacrifice for him to emerge from that courtly ambience, from his accus-
tomed, isolated existence. He quoted to me one of Chamfort's aphorisms:
"If a man has created a masterpiece, people will have nothing better to do
than prevent him from creating another one."[1] Gide is second to none in
his ability to shake off the honors and dignities of fame. "It is true that
according to Goethe," he said, "only scoundrels are modest. But there was
no genius," he went on, "who was more modest than he. What does it mean
to have had the patience, in extreme old age, to take up Persian literature?
For such a man, in the evening after a prodigious workday the mere act of
reading was modesty itself."

A rumor has long been circulating in France to the effect that Gide wanted
to translate *Die Wahlverwandtschaften* [The Elective Affinities]. And since
his recent *Voyage au Congo* [Travels in the Congo] also speaks of his
rereading the book, I asked him about his intentions in this regard.[2] "No,"
said Gide, "I am less interested in translation at present. Of course, I would
still be attracted by Goethe even now." After a characteristic hesitation he
added, "And there can be no doubt that *The Elective Affinities* contains the
whole of Goethe. But if I were to translate anything now, it would be his
Prometheus, some passages from *Pandora*, and some less obvious prose
works, such as his essay on Winckelmann."[3]

I then recollected Gide's recent translation of a chapter from Gottfried
Keller's *Der grüne Heinrich* [Green Henry].[4] What had induced him to

undertake this? Something that Jacques Rivière, Gide's late friend, had once said passed through my mind.[5] He had spoken of "the magic garden of hesitation" in which Gide had lived his whole life. Keller, likewise a writer of fundamental inhibitions and passionate reservations, had lived in a similar garden, and it is perhaps this that brought about the encounter of the two great novelists.

But there was no opportunity to explore this matter with Gide. The conversation took a sudden turn.

I'd like to tell you briefly about my intention in coming to see you. My plan was to give a lecture in Berlin. I had wanted to devote the first week of my stay there to preparing it in peace and quiet. But things turned out otherwise. The kindness of the Berliners, their friendly interest in me, proved to be so great that the leisure I had counted on never arrived. Meetings and conversations monopolized my time. On the other hand, I was firmly resolved to give only a lecture that had been fully thought out. *Je voulais faire quelque chose de très bien.* I would be greatly pleased if you could make this known, and if you could add that my resolution has not been abandoned—just that its execution has been postponed. I shall return, and next time I shall bring the lecture with me. It will perhaps have a different subject from the one I envisaged this time. I shall say only that it was not my intention, nor is it now, to talk about French literature, as has been the case a number of times recently. I have frequently discovered in the course of conversations in Berlin how very well informed people who take an interest in it actually are.

I thought I would speak about something quite different. I wanted to talk about those aspects of your literature that have been the most seminal and helpful for me as a French writer. You would have heard me discuss the role played in France, particularly in my work, by Goethe, Fichte, and Schopenhauer. I would also have used the opportunity to mention the new and intense interest that the French now take in matters German. When I compare French intellectuals of today to those of the previous generation, I can make one observation: they have become more inquisitive. Their horizon is about to expand beyond the cultural and linguistic frontiers of their native land. Compare this attitude with Barrès' statement: "Learn languages! What for? So as to say the same idiotic thing in three or four different ways?"[6] Did you notice the astonishing aspect of this statement? Barrès thinks only about speech; reading a foreign language, immersion in a foreign literature, is of no interest to him at all. What motivated Barrès was a predominantly nationalistic complacency. At around the same time there was something similar in Mallarmé, only in his case he was content not to go beyond a world of spiritual interiority that converted every gaze at the outside world, every thought of traveling or learning foreign languages, into something exotic. Wasn't it perhaps the philosophy of German idealism that induced its French disciples to adopt this attitude?

And Gide related the charming anecdote about the way in which Hegel's philosophy had gained access to the circle around Mallarmé through Villiers

de l'Isle-Adam. As a young man, Villiers had once bought some hot potatoes wrapped in paper from a street-corner vendor. The bag consisted of a page translated from Hegel's *Aesthetics*. It was in this way, and not the official route via the Sorbonne and Victor Cousin, that German idealism met up with the Symbolists.[7]

"Ne jamais profiter de l'élan acquis"—never make use of an acquired élan. In the *Journal des "Faux-monnayeurs"* [Journal of *The Counterfeiters*], Gide declares this to be one of the principles of his literary technique. But it is far more than a rule governing his writing; it is the expression of an attitude of mind that treats every question as if it were the first—indeed the only—question in a world that has just arisen from the void. And if, as we may hope, Gide is soon to address German listeners as the representative of the French intelligentsia, he will do so in the hope of a fresh start, in a spirit that owes nothing to the moods and fashions of public opinion on either side of the frontier. No one is more aware than he that the community of nations is something that can be created only where national characters achieve their highest, most precise forms, but also only where they achieve their most stringent spiritual purification. No one knows this better than the man who wrote many years ago: "The only works we recognize as valuable are those that at their most profound are revelations of the soil and race from which they sprang." Semi-darkness and haziness, of whatever kind, are alien to him; it is no accident that Gide has always claimed to be a fanatic lover of line drawing, of sharp contours.

It is in this spirit that we shall wait expectantly and with pleasure to welcome back to Germany such a great Frenchman, a man whose efforts, passion, and courage have combined to lend his physiognomy a particularly European cast.

Published in the *Deutsche allgemeine Zeitung,* January 1928. *Gesammelte Schriften,* IV, 497–502. Translated by Rodney Livingstone.

Notes

1. Nicolas-Sébastien Roch de Chamfort (1740–1794), French man of letters, was the author of the caustic and world-weary *Pensées, maximes, et anecdotes,* published posthumously in 1803.
2. Gide's diary of a trip through Equatorial Africa in 1925–1926 was published in 1927.
3. Goethe's *Prometheus,* a "dramatic fragment in two acts," was written in the 1770s but published only in 1830. His verse play *Pandora* dates from 1810. His essay on the German archaeologist and art historian Johann Joachim Winckelmann (1717–1768) emphasizes Winckelmann's embodiment of a cultural ethos that privileges form and intellect over nature and feeling.
4. *Der grüne Heinrich,* first published in 1854–1855, then in a substantially revised

version in 1879–1880, is one of the most important examples of the German *Bildungsroman,* or novel of self-formation.

5. Jacques Rivière (1886–1925), French man of letters, edited the *Nouvelle Revue Française* from 1919 until his death.

6. Maurice Barrès (1862–1923) was a French writer and politician whose individualism and nationalism were influential in the early twentieth century.

7. Victor Cousin (1792–1867), a French philosopher, wrote books on Kant and Pascal, as well as several histories of philosophy.

Main Features of My Second Impression of Hashish

Written January 15, 1928, at 3:30 P.M.

The memories are less rich, even though the immersion was less profound than it was the previous time.[1] To put this more precisely, I was less immersed, but more profoundly inside it.

Moreover, it is the murky, alien, exotic aspects of the trance that remain in my memory, rather than the bright ones.

I recollect a satanic phase. The red of the walls was the deciding factor for me. My smile assumed satanic features, even though it was the expression of satanic knowledge, satanic satisfaction, and satanic calm, rather than satanic destructiveness. The people became more deeply entrenched in the room. The room itself became more velvety, more aflame, darker. I uttered the name of Delacroix.

The second powerful perception was the game with the next room. You start to play around with rooms in general. You start to experience seductions with your sense of orientation. In a waking state, we are familiar with the sort of unpleasant shift we can voluntarily provoke when we are traveling in the back of a train at night and imagine that we are sitting in the front—or vice versa. When this is translated from a dynamic situation into a static one, as here, it can be thought of as a seduction.

The room dons a disguise before our eyes, assumes the costume of each different mood, like some alluring creature. I experience the feeling that in the next room events such as the coronation of Charlemagne, the assassination of Henri IV, the signing of the Treaty of Verdun, and the murder of Egmont might have taken place.[2] The objects are only mannequins; even the great moments of world history are merely costumes beneath which they

exchange understanding looks with nothingness, the base, and the common-place. They reply to the ambiguous wink from Nirvana.

To refuse to be drawn into this understanding is what constitutes the "satanic satisfaction" of which I have spoken. It is at this point that the roots of addiction, the collusive knowledge about nonbeing, can be bound-lessly intensified by increasing the dose.

It is perhaps no self-deception if I say that in this state you become hostile to free space—one might even call it "Uranian" space—and that the thought of an "outside" becomes almost a torture. It is no longer, as it was the first time, a friendly, sociable lingering in a room, out of sheer pleasure in the situation as it is; it is rather like being wrapped up, enclosed in a dense spider's web in which the events of the world are scattered around, sus-pended there like the bodies of dead insects sucked dry. You have no wish to leave this cave. Here, furthermore, the rudiments of an unfriendly attitude toward everyone present begin to take shape, as well as the fear that they might disturb you, drag you out into the open.

But this trance, too, has a cathartic outcome, despite its basically depres-sive nature, and even if it is not as ecstatic as the previous trance, it is at least resourceful and not without charm. Except that this charm emerges only as the drug wears off and the depressive nature of the experience becomes clearer, leading one to conclude that the increase in the dose is after all partly responsible for this depressive character.

The dual structure of this depression: on the one hand, anxiety; on the other, an inability to make up one's mind on practical matters. I finally mastered the sense of indecision; suddenly tracked down a very deeply concealed aspect of a compulsive temptation, and thereby gained the ability to pursue it a certain distance, with the prospect of eliminating it.

Hunger as an oblique axis cutting through the system of the trance.

The great hope, desire, yearning to reach the new, the untouched, in a state of trance scarcely takes wing on this occasion; instead they are attained only in a submerged, relaxed, indolent, inert stroll downhill. In this act of strolling downhill, I thought I was still able to generate some friendliness, some attractive qualities, the ability to take friends along with a smile that had a dark edge to it, half Lucifer, half Hermes *transducens*,[3] very remote from the spirit and the man I was last time.

Less human being, more daemon and pathos in this trance.

The unpleasant feeling of wanting simultaneously to be alone and to be with others, a feeling that manifests itself in a deeper sense of fatigue and has to be acquiesced in: this feeling grows in intensity. You have the feeling of needing to be alone, so as to give yourself over in deeper peace of mind to this ambiguous wink from Nirvana; and at the same time, you need the presence of others, like gently shifting relief-figures on the plinth of your own throne.

Hope as a pillow beneath your head, but only now, with an enduring effect.

Through the first trance, I became acquainted with the fickle nature of doubt; the doubt lay in myself as a kind of creative indifference. The second trance, however, made objects appear dubious.

Operation on my tooth. Remarkable trick of memory. Even now I cannot rid myself of the idea that the operation was on the left side.

On my return home, when the chain on the bathroom door proved hard to fasten, the suspicion: an experiment was being set up.

You hear the "Tuba mirans sonans,"[4] but push against the tombstone in vain.

It is well known that if you close your eyes and lightly press on them, you start to see ornamental figures whose shape you cannot control. The architectures and configurations of space you see in a hashish trance are somewhat similar in origin. At what point and in what form they manifest themselves is at first involuntary, so swiftly and unexpectedly do they make their appearance. Then, once they are there, a more conscious play of the imagination takes over and they can be treated with greater freedom.

In general, it can be said that the feeling of "beyond" is connected with a certain feeling of displeasure. But it is important to make a sharp distinction between the "outside" and a person's visual space, however extended it may be—a distinction that has the same significance for the person in a hashish trance as the relationship between the stage and the cold street outside has for the theatergoer. Yet, to extend the image, on occasion something rather like a proscenium stage intervenes between the person in a trance and his visual space, and through this a quite different wind blows—the wind from outside.

The idea of the closeness of death came to me yesterday, in the formula: death lies between me and my trance.

The image of automatic connections: certain intellectual things articulate themselves of their own accord—just like a violent toothache, for example. All sensations, especially mental ones, have a steeper gradient and drag the words along with them as they hurtle downward.

This "ambiguous wink from Nirvana" has probably never been expressed so vividly as by Odilon Redon.

The first serious sign of damage is probably the inability to deal with future time. When you look into this more closely, you realize how astonishing it is that we can exercise control over the night, or even individual nights—that is to say, over our usual dreams. It is very hard to control the dreams (or the trance) resulting from hashish.

Bloch wanted to touch my knee gently. I could feel the contact long before it actually reached me. I felt it as a highly repugnant wound to my aura. In order to understand this, it is important to realize that this happens because,

with hashish, all movements seem to gain in intensity and intentionality, and are therefore unpleasant.

Aftereffect: perhaps a certain weakening of the will. But the sense of elation gains the upper hand, though with diminishing effect. Despite my recurring depression, my writing has recently displayed a rising tendency, something I have never before observed. Can this be connected with hashish? A further aftereffect: on returning home, I tried to fasten the chain, and when this proved difficult my first suspicion (quickly corrected) was that an experiment was being set up.

Even if the first trance stood on a higher plane morally than the second, the climax of intensity was on a rising curve. This should be understood roughly as follows: the first trance loosened the objects, and lured them from their accustomed world; the second inserted them quite quickly into a new one—far inferior to this intermediate realm.

The constant digressions under the influence of hashish. To start with, the inability to listen. This seems incongruent with the boundless goodwill toward other people, but in reality they share the same roots. No sooner has the person you are talking to opened his mouth than you feel profoundly disillusioned. What he says is infinitely inferior to what we would have expected from him before he opened his mouth, and what we confidently, happily assumed him to be capable of. He painfully disappoints us through his failure to focus on the greatest object of our interest: ourselves.

As for our own inability to focus, to concentrate on the subject under discussion, the feeling resembles an interrupted physical contact and has roughly the following features. What we are on the verge of talking about seems infinitely alluring; we stretch out our arms full of love, eager to embrace what we have in mind. Scarcely have we touched it, however, than it disillusions us completely. The object of our attention suddenly fades at the touch of language. It puts on years; our love wholly exhausts it in a single moment. So it pauses for a rest until it again appears attractive enough to lead us back to it once more.

To return to the dime-novel aspect of the room: we simultaneously perceive all the events that might conceivably have taken place here. The room winks at us: What do you think may have happened here? The connection between this phenomenon and cheap literature. Cheap literature and subtitles. To be understood as follows: think of a kitschy oleograph on the wall, with a long strip cut out from the bottom of the picture frame. There is a tape running through the batten, and in the gap there is a succession of subtitles: "The Murder of Egmont," "The Coronation of Charlemagne," and so on.

In this experiment I often saw cathedral porches with Gothic windows and once said, "I can see Venice, but it looks like the upper part of the Kurfürstenstrasse."

"I feel weak" and "I know I am weak" imply fundamentally different meanings. Perhaps only the first statement has expressive validity. But in a hashish trance we can almost speak of the despotism of the second, and this may explain why, despite an intensified "inner life," facial expression is impoverished. The distinction between these two statements should be explored further.

Moreover, there is a functional displacement. I have borrowed this expression from Joël. Following is the experience that led me to it. In my satanic phase someone gave me one of Kafka's books, *Betrachtung* [Meditation]. I read the title. But then the book at once changed into the book-in-the-poet's-hand, which it becomes for the (perhaps somewhat academic) sculptor who confronts the task of sculpting that particular poet. It immediately became integrated into the sculptural form of my own body, hence far more absolutely and brutally subject to me than could have been achieved by my most derogatory criticism.

But there was also something else. It was as if I were in flight from Kafka's spirit, and now, at the moment he touched me, I was transformed into stone, like Daphne turning into ivy at Apollo's touch.

The connection between cheap fiction and the profoundest theological intentions. They reflect it through a glass darkly, transpose into the space of contemplation what is of value only in the space of active life. Namely, that the world always remains the same (that all events could have taken place in the same space). Despite everything, that is rather a tired, faded truth in the realm of theory (for all the sharpness of perception it contains); but it is spectacularly confirmed in the lives of the pious, for whom all things turn out for the *best*, much as the space of the imagination subserves the *past*. So profoundly is the realm of theology submerged in that of cheap fiction. We might even say that, far from having arisen from the dull, brutish side of mankind, the profoundest truths possess the great power of being able to adapt to mankind's dull, baser side, and even of being reflected in their own way in the irresponsible dreamer.

Written January 1928; unpublished in Benjamin's lifetime. *Gesammelte Schriften*, VI, 560–566. Translated by Rodney Livingstone.

Notes

1. This is the most extensive of Benjamin's drug protocols; he also kept records of his first hashish session, in 1927, and several subsequent sessions—in 1928, 1930, and 1934. Records of these drug sessions were also kept by other participants and supervisors: physicians Ernst Joël and Fritz Fränkel, and Benjamin's cousin

the neurologist Egon Wissing. Benjamin offers a brief account of several other sessions in a letter to Gershom Scholem dated January 30, 1928.
2. Charlemagne was crowned emperor in Rome in A.D. 800; Henri IV of France was assassinated in 1610; the Treaty of Verdun of 843 ratified the breakup of the Carolingian Empire; and Count Egmont, one of the leaders of the Flanders nobility, was executed by the Spaniards under the Duke of Alba in 1568.
3. The god Hermes in his function as guide (e.g., of the three goddesses to Paris, of the souls of the dead down to Charon the Ferryman, and of Persephone back from the underworld).
4. From the Requiem Mass. The text actually reads, "Tuba mirum spargens sonum / Per supulcra regionum" ("The trumpet, scattering a wondrous sound / through the tombs of every land").

Conversation with André Gide

It is wonderful to talk to André Gide in his hotel room. I know he owns a country house in Cuverville and an apartment in Paris, and there can be no doubt that to meet him among his books, in the very places where he conceived and carried out great works, would be an unforgettable experience. But it would not be this one—namely, to encounter this great traveler amid his bundled possessions, *omnia sua secum portans,* on the alert in the bright morning light of his spacious room on Potsdamer Platz. Admittedly, the interview, a format that has been created by diplomats, financiers, and film people for their own purposes, is not the one in which we might initially expect a writer—and the most subtle writer alive, at that—to reveal himself. But if we take a closer look, the situation appears differently. Question and answer articulate Gide's ideas in sharp focus. I like to compare his thinking to a fort: vast in its overall structure, replete with protective ramparts and protruding bastions, and above all with highly strict forms and perfect in its deliberate dialectical construction.

And even the most helpless amateur knows full well that trying to take photographs in the vicinity of a fort is dangerous and fraught with complications. Paper and pencil must be put aside, and if the following words are authentic they owe this to the soft, inspired voice that uttered them.

Scarcely any of the questions I wanted to ask Gide were those that normally turn up in an interview—ones that are posed more out of habit than genuine interest. For as he sat there in front of me on a step leading to his bay window, his back resting against the seat of his armchair, a brown silk scarf around his neck, and his hands burying themselves in the carpet or clasped around his knees, he was interviewer and interviewee simultane-

ously. From time to time a glance from his prominent horn-rimmed spectacles fell on me, when one of my rare questions aroused his attention. It is fascinating to watch his face, even if only to follow the alternation of kindness and malice that seem to inhabit the same furrows, siblings sharing his expressions. And there are moments, by no means the worst ones, when pure pleasure in a malicious anecdote lights up his features.

No European writer living today has given as cold a reception to his own fame as he did, when his finally arrived, toward the end of his forties. No Frenchman has ever barricaded himself more securely against the Académie Française. Gide and D'Annunzio: you need only juxtapose these names to realize what action a man may take for and against his own fame.[1] "How do you deal with your fame?" And then Gide told me how little he had sought it, to whom he owed the fact that he finally found it, and how he resisted it.

Until 1914 he was firmly convinced that he would be read only after his death. This was not resignation—it was trust in the enduring power of his work. "Ever since I began to write, Keats, Baudelaire, and Rimbaud have been my models, in the sense that, like them, I have wanted to owe my name only to my work and to nothing else." When a writer has adopted this view, it is not uncommon for an enemy to intervene, like Balaam's ass. In this instance it was the novelist Henri Béraud.[2] He spent so much time bombarding French newspaper readers with the assurance that there was nothing more stupid, more boring, and more corrupt than the books of André Gide, that people finally started to take notice and asked themselves, who exactly was this André Gide whom decent people should avoid reading under any circumstances? Some years later Béraud wrote in one of his outbursts that, in addition to everything else, Gide was also ungrateful toward his benefactors; whereupon Gide resolved to take the sting out of this rebuke and sent him a box of the best Pihan chocolates, together with a card saying, "Non, non, je ne suis pas un ingrat."

What really irritated the young Gide's enemies was the knowledge that Gide was held in greater esteem abroad than they were. They thought this created a completely false impression. And it is perfectly true that their own books would have given a better picture of the average novel of the day. Gide was translated into German quite early on, and he remained on friendly terms with his first translators—that is to say, with Rilke until his death, and with Kassner and Blei to this day.[3] This brings us to the topical question of translation. Gide himself did what he could as translator to popularize Conrad, and as translator he engaged critically with Shakespeare. We've heard of his masterly translation of *Antony and Cleopatra*. Quite recently, Pitoëff, the director of the Théâtre de l'Art, approached him with the request that he translate *Hamlet*.[4] "The first act took me months. When it was finished I wrote to Pitoëff, 'I can't do any more—it costs me too much.' 'But

you will publish the first act?' 'Perhaps; I do not know. At the moment, I have mislaid it. It is somewhere among my papers in Paris, or in Cuverville. I have been traveling so much, my papers have all fallen into disarray'" He intentionally diverts the conversation to Proust. He knows about the plans for a German translation, as well as the darker pages of its prehistory. All the kinder are his hopes for a favorable outcome. And because it is my experience that everyone who becomes closely involved with Proust finds that this relationship moves in phases, I ventured to inquire into his. It turned out to be no exception. As a young man, Gide had been a first-hand observer during those memorable days when Proust, the dazzling *causeur*, had first made his appearance in the salons. "Whenever we met in society, I thought him the most outrageous snob. I think he must have thought much the same of me. At that time neither of us had an inkling of the close friendship that would bind us together." And when one day the meter-high pile of student-composition books landed on the desk of the *Nouvelle Revue Française,* everyone was initially flabbergasted. At first Gide did not dare to immerse himself in the world of Proust's novel. But once he had made a start, he succumbed to its fascination. Ever since, Proust has been in his eyes one of the greatest pioneers of that latest conquest of the mind—psychology.

This word, too, opened the door to one of those endless galleries in whose corridors the eye risks losing itself when you speak with Gide. Psychology as the cause of the decline of the theater. The psychological drama as the death of the theater. Psychology as the realm of the subtle, the isolating, the disconcerting. The theater as the realm of unanimity, closeness, fulfillment, love, enmity, fidelity, jealousy, courage, and hatred: for the theater, these are all constellations, predictable and established scenarios—the opposite of what they are for psychology, which reveals hatred in love and cowardice in courage. "Le théâtre, c'est un terrain banal."

We return to Proust. Gide gives the now classic account of Proust's sickroom, of that invalid in his perpetually darkened room lined with cork to shut out the noise—even the window shutters were insulated with cushions. He seldom saw visitors. Reclining on his legless bed, surrounded by heaps of paper covered with scribbling, he wrote and wrote; instead of reading his corrected pages, he filled them with additions, "bien plus que Balzac" (even more than Balzac). For all Gide's admiration, however, he says: "I have no contact with his characters. *Vanité*—that's the stuff they are made of. I think there was much in Proust that he never expressed, buds that never opened. In his later work a certain irony gained the upper hand over the morality and religion that are evident in his earlier writings." Gide also seems to have detected an ambiguity in Proust which had been veiled by his irony—an ambiguity that was manifest in a basic element of his technique: his mode of composition. "People talk about Proust's being a great psychologist—which he certainly was. But when they keep pointing

to the artful way in which he depicts the development of his characters over the lifespan, they often overlook one factor. Each of his characters, down to the least important, was based on a single model. But this model did not always remain the same. In the case of Charlus, for example, there were always at least two. The later Charlus was based on someone completely different from the proud model of the earlier one." Gide talks of a composite image, a *fondu*. As in a film, one character dissolves imperceptibly into another.

"I came here," Gide said after a pause, "to give a lecture. But Berlin life did not give me the peace of mind I needed to work out what I had actually wanted to say. I will come back again and will bring my lecture with me. But even at this stage, I would like to tell you something about my relationship with the German language. After a lengthy, intensive, and exclusive preoccupation with German—this was in the years of my friendship with Pierre Louÿs,[5] when we read *Faust, Part II* together—I abandoned everything German for about ten years. My entire attention had been captured by English. Then, last year, in the Congo, I finally opened a German book again. It was *The Elective Affinities*. I made a curious discovery: I found reading German after this ten-year interval not harder, but easier. It is," and here Gide's tone became insistent, "not the affinity between German and English that made it easier for me. What gave me the élan enabling me to master a foreign tongue was the fact that I had felt repelled by my own mother tongue. The crucial thing when learning languages is not which language to choose; it is the ability to abandon one's own language. In principle, one begins to understand only at that point." Gide then quoted a sentence from the explorer Bougainville's account of his travels: "When we left the island, we gave it the name Ile du Salut."[6] And then he added the wonderful sentence, "Ce n'est qu'en quittant une chose que nous la nommons." (Only after taking leave of something do we give it a name.)

"If I have had any influence on the younger generation," Gide continued, "it lies in the fact that the French are now beginning to show an interest in foreign countries and languages, whereas previously they displayed only indifference and indolence. Read Barrès' *Voyage de Sparte* [Travels in Sparta] and you'll know what I mean.[7] What Barrès sees in Greece is really France, and where he does not see France, he pretends he has seen nothing at all." We have thus come around to one of Gide's pet topics: Barrès. His critique of Barrès' novel *Les Déracinés* is now some thirty years old, but it is more than a sharp repudiation of that epic of attachment to the soil.[8] It is the masterly profession of faith of a man who refuses to accept the claims of a thoroughgoing nationalism, and who recognizes French national identity only if it includes the tension-filled area of European history and the European family of nations.

"Men who have lost their roots" [*les déracinés*]—Gide has nothing but

tolerant scorn for a poetic metaphor that has so completely lost touch with the reality of nature. "I have always said it's a shame that Barrès has botany against him. As if a tree really restricted itself, instead of instinctively spreading its boughs everywhere into space, in every direction. It's unfortunate when writers don't know the first thing about natural science." Before me sat the man who once wrote, "I will have nothing to do with anything that is not nature. A vegetable cart conveys more truth than the most beautiful Ciceronian periods." Even today, Gide is in thrall to this realm of imagery.

I spoke earlier of Proust, and of the fact that many of his buds failed to blossom. It has been different with me. My aim is to make sure that everything I have inherited should be revealed, and to discover its appropriate form. This may have had its drawbacks. My work seems a little like a thicket from which my distinguishing features emerge only with difficulty. I accept this patiently. *Je n'écris que pour être relu.* (I write only to be reread.) I have confidence in the future that will follow my death. Only death will drive the figurations in my work out into the open. Only then will its unity become unmistakable. It is true that I have not made matters easy for myself. I know that there are writers who strive from the outset to confine their work within ever narrower limits. A man like Jules Renard achieves what he has achieved not by allowing his talents to develop, but by ruthlessly cutting back his instincts.[9] And Renard's achievement is far from trivial. Do you know his diaries? A most fascinating document . . . But that sort of thing can sometimes assume grotesque features. My situation is quite different. I know what a torture Stendhal's books were for me when I first encountered them—how alien his world was to me. Yet I felt myself inspired by it for that very reason. I later learned much from Stendhal.

Gide has been a great learner. If we look more closely, we may feel that this has protected him to a much greater extent from alien influences than stubborn reserve might have done. It is mainly the indolent who find themselves "influenced," whereas the learner sooner or later succeeds in taking possession of what may be of use to him, integrating it as a technique into his own work. In this sense there are few authors who have been better or more dedicated learners than Gide. "Once I had taken a particular direction, I followed it through as far as it would go and followed this up by advancing in the opposite direction with the same resoluteness." This principled rejection of every golden mean, this commitment to extremes— what else is it but dialectic, not as intellectual method but as life's breath and as passion. Gide shows no desire to contradict me (or so it seems to me) when I detect in this the basis for all the misunderstandings and much of the hostility that he has encountered. "Many people have quite made up their minds," he went on, "that I am able to write only about myself; and then, when my books make use of the most varied characters, they conclude

ingeniously that the author must be quite characterless, vacillating, and unreliable."

"Integration": this is Gide's intellectual and literary passion. His growing interest in "nature"—which appears as a mature trend in many great writers—means in his case that even in its extreme aspects the world is still whole, still healthy, still natural. And what drives him toward these extremes is not curiosity or apologetic zeal, but the highest form of dialectical insight.

It has been said of Gide that he is the "poète des cas exceptionels"—the poet of the exceptional case. Gide: "Bien entendu, that is true. But why? Day after day, we encounter modes of behavior and people who through their very existence invalidate our existing norms. A large share of our ordinary everyday decisions, as well as our extraordinary ones, are not susceptible to judgment by traditional moral values. And because this is so, it is necessary to focus on such cases, to scrutinize them, without cowardice and without cynicism." Whatever Gide has conveyed of such things in novels like Les Faux-monnayeurs [The Counterfeiters], in his essays, in his important autobiography, Si le grain ne meurt [If It Die]—his enemies would have forgiven him, if only they had contained the small dose of cynicism that reconciles snobs and philistines with the world. What gets on their nerves is not his "immorality" but his seriousness. Yet seriousness is an essential part of Gide, for all the maliciousness in his conversation, and for all the masterful irony to be found in Prométhée mal enchaîné [Prometheus Misbound], in Les nourritures terrestres [Fruits of the Earth], and in Les caves du Vatican [The Vatican Cellars].[10] As Willy Haas pointed out a few weeks ago, he is the latest Frenchman in the tradition of Pascal. In the line of French moralists that runs through La Bruyère, La Rochefoucauld, and Vauvenargues, none is more like him than Pascal, a man who would quite certainly have been described as a cas particulier, a sick man, if they had possessed the superficial clinical terminology of our age. This places Gide alongside Pascal in the ranks of the great French educators. For the withdrawn, eccentric German loner, the model educator will always be someone who in his character or his teaching represents the typical German of the sort attempted in our day by Borchardt or Hofmannsthal.[11] For the French, however, with their richer national character, based on its diversity of tribal types, and with a more powerful but also more precarious national and literary identity, it is the great moral exception who is the highest pedagogic authority. This is what Gide is. That countenance, which at times conceals rather than reveals the great writer, represents his undeviating and even threatening challenge to both moral indifference and lax complacency.

Published in Die literarische Welt, February 1928. Gesammelte Schriften, IV, 502–509. Translated by Rodney Livingstone.

Notes

1. Benjamin refers here to the vanity and ostentatiousness often seen as characterizing the life and work of Gabriele D'Annunzio (1863–1938), literary virtuoso of decadence and heroic vitalism and enthusiastic supporter of Mussolini.
2. Henri Béraud (1885–1958) was a prolific French writer. His novel *Le vitriol de lune* (Moon-Vitriol; 1921) won the Goncourt Prize. "Balaam's ass": In II Peter 2:16, the prophet Balaam is "rebuked for his iniquity" by his donkey.
3. Rudolf Kassner (1873–1959), a German writer and friend of Rilke and Hofmannsthal, translated Tolstoy, Gogol, and Pushkin as well as Gide. Franz Blei (1871–1942) was an Austrian novelist and playwright.
4. Georges Pitoëff (1888–1939) was a Russian actor and director. He established his "poetic theater" in Paris in 1918.
5. The French writer Pierre Louÿs (1870–1925) published novels, stories, and poems celebrating fin-de-siècle decadence, voluptuousness, and sensual-aesthetic refinement.
6. Louis-Antoine de Bougainville (1729–1811) led the first French expedition to circumnavigate the globe. He also attempted, unsuccessfully, to colonize the Falkland Islands.
7. This account of a trip from Athens to Sparta in 1900 was published in 1906. It contrasts the "voice of blood" and "dream of death" associated with Sparta with the sterile republicanism of Athens, and so reveals Barrès' ultranationalist, medico-determinist political and aesthetic creed.
8. Barrès' book *Les Déracinés* (Men without Roots), one of the first sociological novels, was intended as an indictment of the Third Republic; it extols the virtues of attachment to blood and soil and condemns cosmopolitan modernism and the purportedly arid intellectualism of the "uprooted." Gide's "A propos des *Déracinés*" first appeared in 1897. It opens with the words: "I was born in Paris to a father who was from Uzès and a mother who was from Normandy. Where, Monsieur Barrès, do you wish me to be rooted? I thus made the decision to travel."
9. Jules Renard (1864–1910), French man of letters, was one of the founders of *Mercure de France*, the influential journal of politics and the arts which published its first issue in 1890.
10. Gide referred to his mock-mythic *Prométhée mal enchaîné* (1899) and his novel *Les caves du Vatican* as *soties*—that is, new versions of a fourteenth-century genre of French farce. Both texts privilege spontaneity and the "exceptional moment" over social and moral convention. *Les nourritures terrestres* (1897) similarly refuses any morality that is imposed by tradition and alien to the individual's emotional-erotic needs.
11. Rudolf Borchardt (1877–1945) was a German-Jewish essayist and poet. His essays were national-conservative in tenor; his poetry is marked by great formal refinement.

Old Toys

The Toy Exhibition at the Märkisches Museum

Over the past few weeks an exhibition of toys has been on view at the Märkisches Museum in Berlin. It occupies only a medium-sized room; this tells us that the curators' focus is not on the splendid or the monstrous: life-size dolls for royal children, vast train sets, or giant rocking horses. Their aim is to show, first, the sort of toys Berlin produced during the eighteenth and nineteenth centuries, and, second, what a well-stocked toy cupboard in an ordinary Berlin home might have looked like. They have therefore concentrated on pieces that can be shown to have survived in the possession of old established Berlin families. Items owned by collectors are of secondary importance.

Let us start by explaining what is special about this exhibition: it includes not just "toys," in the narrower sense of the word, but also a great many objects on the margins. Who knows where one might otherwise find such a profusion of wonderful parlor games, building sets, Christmas pyramids, and peep shows, to say nothing of books, posters, and wall charts for teaching. All of this often inaccessible detail gives a far more vivid overall picture than a more systematically compiled exhibition ever could. And the same sure touch can be found in the catalogue. It is no dead list of objects on display, but a coherent text full of precise references to the individual exhibits as well as detailed information on the age, make, and distribution of particular types of toys.

Of these, the tin soldier must be the most thoroughly researched, ever since Hampe of the Germanisches Museum published a monograph on the subject. Here you can see them posed in front of charming backdrops, such as handbills from Berlin puppet theaters; but there are also other tin figures

from town and country, arranged in genre scenes. They were not manufactured in Berlin until relatively late; in the eighteenth century it was the ironmongers who stocked goods of this kind, made in southern Germany. This itself is enough to tell us that actual toy sellers emerged only gradually during a period in which there was a strict division of labor among tradesmen.

The toy sellers' predecessors included, on the one hand, turners, ironmongers, paper merchants, and fancy-goods sellers, and, on the other hand, door-to-door peddlers in towns and at fairs. There is even a special kind of figurine in a niche labeled "Cakes and Pastries." Here one finds the gum-resin doll familiar from Hoffmann's stories, together with parodies of monuments made from sugar and old-fashioned gingerbread. This sort of thing has vanished from Protestant Germany. In contrast, the attentive traveler in France, even in the quieter suburbs of Paris, may easily come across two of the main examples of old-style confectionery: babies in their cradles, which used to be given to older children on the birth of a brother or sister; and confirmation children, posed on blue or pink sugar pillows and holding a candle and prayer book, performing their acts of devotion, sometimes in front of a prayer stool made of the same icing. But the most fanciful specimens of this type seem to have been lost today. These were flat sugar dolls (or hearts or similar objects) which could be easily divided lengthways so that in the middle, where the two halves were joined together, there was a little piece of paper with a brightly colored picture and a motto. An uncut broadsheet is on display with examples of such confectioners' mottoes. For instance: "I have danced away / My weekly wage today." Or: "Here, you little flirt, / This apricot won't hurt." Such lapidary two-liners were called "devices" because you had to divide the figurine into two parts in order to uncover the motto. Thus, a Berlin advertisement from the Biedermeier period reads: "Zimmermann's Confectionery in Königsstrasse supplies a full range of candy figures as well as confectionery of other kinds, together with devices, at a reasonable price."

But you can also find quite a variety of texts. Natke's great Baths-and-Basins Theater Saloon, Palisadenstrasse 76, advertised "Entertainment through humor and tasteful wit of well-known quality." Julius Linde's mechanical marionette theater issued the following invitation to its latest productions: "The Robber Knight Flayed Alive, or Love and Cannibalism, or Roast Human Heart and Flesh . . . Concluding with a Great Ballet of Metamorphoses. In this ballet several dancing figures and metamorphoses, very true to life, will entertain the public's eye very agreeably with their delightful and skillful movements. In conclusion, Pussell the Wonder Dog will distinguish himself." The peep shows along with the dioramas, myrioramas, and panoramas, whose pictures were manufactured in Augsburg for the most part, lead the observer even more deeply into the mysteries of the

world of play than do the marionettes. "You can't find toys like that anymore" is what you often hear adults saying when they encounter old toys. Actually, most adults just think this; in fact they have become indifferent to such things, whereas children notice them at every turn. But here, gazing at the panoramas, they are right for once. Panoramas were products of the 1800s; they vanished with the century and are inseparable from its most curious features.

Today, old toys are important from a number of viewpoints. Folklore, psychoanalysis, art history, and the new education all find it a rewarding subject. But this alone does not explain why the little exhibition room is never empty and why, in addition to whole classes of schoolchildren, hundreds of adults have passed through it in recent weeks. Nor can its popularity be due to the amazingly primitive specimens, even though these would be reason enough for a snob to attend the exhibition.

These include not only jumping jacks, woolen sheep clearly produced by poor domestic workshops remote from modern manufacturing, and Neuruppin broadsheets with their famous garishly colored scenes,[1] but also (to mention only one item) a set of pictures recently discovered in the attic of a school in the Mark Brandenburg. They are the work of a certain Wilke, a deaf-mute teacher, and were intended to be used for instructing deaf-mute children. Their crude vividness is so oppressive that the normal person, seeing this airless world for the first time, runs the risk of losing his own hearing and voice for a few hours. There are painted carvings that were made in the mid-nineteenth century by a shepherd in the Altmark. The subjects are taken from both secular and biblical life, and in every case stand midway between miniature models of characters from Strindberg's *Dance of Death* and lifeless cloth figures of the kind seen at fairgrounds, where they perch in the rear of booths and act as targets for wooden balls.

As we have said, all this is enticing for adults, but it is not the only attraction. Or the decisive one. We all know the picture of the family gathered beneath the Christmas tree, the father engrossed in playing with the toy train that he has given his son, the latter standing next to him in tears. When the urge to play overcomes an adult, this is not simply a regression to childhood. To be sure, play is always liberating. Surrounded by a world of giants, children use play to create a world appropriate to their size. But the adult, who finds himself threatened by the real world and can find no escape, removes its sting by playing with its image in reduced form. The desire to make light of an unbearable life has been a major factor in the growing interest in children's games and children's books since the end of the war.

Not all the new impulses that have given fresh impetus to the toy industry have been beneficial. The prissy silhouettes of the varnished wooden figures that represent the modern age do not stand out to advantage among so

many old objects. On the contrary, they tend to show what adults understand by toys rather than what children expect from them. They are curiosities. Here they are useful for purposes of comparison, but have no place in the nursery.

More captivating are the older curiosities, among them a wax doll from the eighteenth century that strikingly resembles a modern character doll. But there is probably some truth in the suggestion made to me in the course of conversation by Mr. Stengel, the museum's director and the organizer of this special exhibition: that the doll's face should be seen as the wax portrait of a baby. It took a long time before people realized, let alone incorporated the idea into dolls, that children are not just men and women on a reduced scale. It is well known that even children's clothing became emancipated from that of adults only at a very late date. Not until the nineteenth century, in fact. It sometimes looks as if our century wishes to take this development one step further and, far from regarding children as little men and women, has reservations about thinking of them as human beings at all. People have now discovered the grotesque, cruel, grim side of children's life. While meek and mild educators still cling to Rousseauesque dreams, writers like Ringelnatz[2] and painters like Klee have grasped the despotic and dehumanized element in children. Children are insolent and remote from the world. After all the sentimentality of a revived Biedermeier, Mynona is probably right in his views of 1916:[3]

> If children are ever to grow up into first-rate people, they must not be spared the sight of anything human. Their innocence instinctively ensures that the necessary boundaries are not crossed; and later, when these boundaries are gradually extended, new experiences will encounter minds that have been prepared. The fact that little children laugh at everything, even the negative sides of life, is a glorious extension of radiant cheerfulness into all the spheres of life it had so shamefully neglected and that are so utterly dreary as a result . . . Wonderfully successful little bomb plots, with princes who just fall apart but are easily put back together again. Department stores with automatic outbreaks of arson, break-ins, thefts. Victims who can be murdered in a multitude of ways and with every appropriate weapon . . . My children would not like to be without their guillotines and gallows, at the very least.

Such things should not be expected in this exhibition. But we must not forget that the most enduring modifications in toys are never the work of adults, whether they be educators, manufacturers, or writers, but are the result of children at play. Once mislaid, broken, and repaired, even the most princely doll becomes a capable proletarian comrade in the children's play commune.

Published in the *Frankfurter Zeitung*, March 1928. *Gesammelte Schriften*, IV, 511–515. Translated by Rodney Livingstone.

Notes

1. The popular Neuruppin prints appeared from 1831 in a series of single sheets with humorous or sarcastic subject matter. The early ones were based on colored woodcuts; the later sheets were lithographs.
2. Joachim Ringelnatz (pseudonym of Hans Bötticher; 1883–1934) directed the Berlin cabaret Schall und Rauch (Noise and Smoke) during the Weimar Republic. His satirical, scurrilous poems and songs brought attacks on middle-class convention with a sharp political edge.
3. Mynona was the pseudonym of the German-Jewish philosopher Salomo Friedländer (1871–1946). A collaborator on the important Expressionist journals *Der Sturm* and *Die Aktion,* he published a number of satires.

Hugo von Hofmannsthal's *Der Turm*

Written following its premieres in Munich and Hamburg.

In recent weeks Hugo von Hofmannsthal's *Der Turm* [The Tower] has begun to make its way through Germany's theaters. The stage version differs significantly from the original, which appeared in the *Neue deutsche Beiträge* in 1925; the fourth and fifth acts have been completely rewritten. But this does not in itself justify a comparison of the two versions—not here, at any rate. No, what justifies our taking a second look at the play, even after our notice in *Die literarische Welt* (vol. 15, no. 2), are the extraordinary insights that his progress from one version to the other gives us into the author's method of writing and the structure of his work. We know that he took his subject from Calderón's *La vida es sueño* [Life Is a Dream].[1] This formulaic title, which gave powerful expression to the dramatic impulses of the age, has a double meaning for Calderón. On the one hand it means that life is nothing more than a dream, that its possessions are like chaff in the wind. This is his secular wisdom. But he also asserts: just as a mere nothing—this life—decides our salvation, and is weighed and judged by God, we cannot escape God even when we dream, in the illusory world of dream. Dreaming and waking—in God's eyes they are no more distinct from each other than life and death. The Christian dimension is equally present in both. This second motif of the title—dream as a theological paradigm—is one that a modern writer like Hofmannsthal could have no desire to appropriate for himself. And with compelling logic, the complete reworking of the dream motif seems to have resulted in an entirely new drama. In the first version of *Der Turm*, the dream bore all the marks

of its chthonic origins. In particular, the last act of the first version shows the prince, Sigismund, as the master who conjures up the dark forces to which he finally succumbs in the fight to the finish. In a sense we might say that the prince has been the victim of forces that rose up against him from within himself. Such an action has tragic overtones, but we should note that Hofmannsthal was careful to call his play a *Trauerspiel* [mourning play], not a *Tragödie* [tragedy]. And it will not have escaped readers that in the later version the outlines of the patient martyr in the tradition of Christian tragic drama emerge in their purity, pushing the original dream motif into the background and significantly enhancing the aura surrounding Sigismund.

The fact that on the lips of this youth every sound necessarily became a sound of lamentation—because lamentation is the primal sound of nature's creatures—was the source of one of the most touching effects of the first version. But also one of the riskiest. For to liberate the expression of suffering from the bonds of verse is an unprecedented procedure, or at any rate has not been attempted since the prose of the *Sturm und Drang*.[2] And it is far from clear whether it can be done successfully within the constraints of the drama. To be sure, even the quieter, more sharply defined Sigismund of this revised version forms a link in the chain that is constantly taken up by writers who wish to find words for the secret connection between silent suffering and all the earliest experiences of childhood, now lost in the mists of the past. Even in his revised form, the prince comes from the same stock as Kaspar Hauser.[3] In the new version, too, the hero's utterances surface only fleetingly from the turbulent sea of sounds and gaze around like naiads seeing the world for the first time. It is the same gaze that touches us so deeply in the language of children, visionaries, and the mentally disturbed. The poet has summoned up the most potent forces of language—not in its most exalted, most consummate, yet also most dependent forms, but in its primitive sounds, as auxiliaries in their struggle, which is also his. The difference is that the natural immediacy of the speech with which he endowed his first Sigismund tended, near the end, to move in the direction of the chthonic, of primitive menace. In the new version, by contrast, where the serene silence of the prince seems to dispel the morning mists, the undistorted speech of the natural Christian soul seems to strike our ears like the song of a lark. The chthonic element, whose power vanished with the disappearance of the dream motif, can be heard only as a faint echo. Nothing is more revealing about the author's rigorous and dispassionate approach to the new version than the change in meaning undergone even by the most terrible symbol of the natural: the slit-open pig's belly which Sigismund remembered seeing with horror, long before, nailed to the door lintel in the house of his peasant foster-father: "The morning sun shone into the interior, where it was dark; for my soul had been called away and had

flown off somewhere. These are all joyful signs, but I cannot tell you what they mean."

In complete contrast to the focus in the first version, the emphasis of the drama now falls on the political action. For all but two scenes the setting is the king's castle. This change is not only justified by the much tighter plot structure; it also makes the portrayal of the rebellion much more convincing. For the audience, this now has something of the features of a palace revolt, and hence situates the action much more firmly than before "in the atmosphere of the seventeenth century." The conspiracy in which the action culminates now combines political and eschatological elements. The play of forces illustrates a permanent, providential element of all revolutions. By the same token, it may be that in modern history recurring political configurations have never found clearer, more permanent expression than in the seventeenth century. But in the first version, it was the power of the violent fanatics—with their visionary figurehead, the Children's King—that had the last word. The second version ends with the triumph of Olivier, the soldier. What this means is that the figure of the Children's King has now been merged with that of Sigismund. His conflict between willing and not willing has been resolved by the author, and only now do we grasp the whole meaning of what he wishes to say to his master, the leader of the rebellion and the precursor of his own power: "You placed me in straw, like an apple, and I have become ripe. Now I know my place. But it is not where you wanted me to be." Sigismund dies not in the army camp, as the commander of troops and princes, but as a wanderer on the highroad that leads to "a large, open country." "It smells of earth and salt. That is where I shall go."

What can his dying words—"I am much too well to hope"—mean, if not the same as Hamlet's "The readiness is all: since no man knows aught of what he leaves, what is't to leave betimes"? For this reason, it is perhaps not unreasonable to regard the poetic space filled by these two versions of *Der Turm* as ruled by the same forces that transform the bloody fatalities of pre-Shakespearean tragedy into the world of Christian suffering that is portrayed in *Hamlet*. A great poet has the ability to compress into a few years a transformation of forms and subjects that originally required decades for their fulfillment.

Published in *Die literarische Welt*, March 1928. *Gesammelte Schriften*, III, 98–101. Translated by Rodney Livingstone.

Notes

1. Pedro Calderón de la Barca (1600–1681), dramatist and poet, was one of the major playwrights of Spain's Golden Age. Among his best-known secular dramas are *El médico de su honra* (The Surgeon of His Honor; 1635), *La vida es sueño*

(Life Is a Dream; 1635), *El alcalde de Zalamea* (The Mayor of Zalamea; c. 1640), and *La hija del aire* (The Daughter of the Air; 1653). He also wrote operas and plays with religious and mythological themes.

2. *Sturm und Drang* refers to a literary movement in Germany between 1770 and 1780. The young authors, centered around Goethe, produced a number of dramas remarkable for their formal innovation and especially their expression of feeling. *Sturm und Drang* prose is exemplified, in particular, by Goethe's novel *Die Leiden des jungen Werther* (The Sorrows of Young Werther).

3. Kaspar Hauser was the most famous case of a "wild child" in Germany in the nineteenth century. A foundling, he was brought before a magistrate in Nuremberg on May 26, 1828, bewildered and incoherent; he had apparently been kept in virtual isolation for years. His origins remained a mystery, though some suspected he was of royal blood. He lived under the protection of educational reformers and noblemen, finally assuming a position in the court of appeals in Ansbach. He died from a wound that was either self-inflicted or, as he claimed, the result of an attack by a total stranger. The case has inspired many creative works, including Paul Verlaine's poem "Je suis venu, calme orphelin," in his collection *Sagesse* (1881); novels by Jakob Wassermann (1908), Sophie Hoechstetter (1925), and Otto Flake (1950); a play by Erich Ebermayer (1928); and a film directed by Werner Herzog (1974).

Moonlit Nights on the Rue La Boétie

At first, it is like entering an aquarium. Along the wall of the huge darkened hall, you see what appears to be a strip of illuminated water behind glass, broken at intervals by narrow joints. The play of colors in deep-sea fauna could not be more fiery. But what we see here are supraterrestrial, atmospheric miracles. Seraglios are mirrored in moonlit waters; nights in abandoned parks expose themselves to your gaze. In the moonlight you can recognize the château of Saint Leu, where a hundred years ago the body of the last Condé was discovered hanged in a window frame.[1] Somewhere a light is burning behind the curtains. A few shafts of sunlight fall at intervals. In the purer rays of a summer morning, you can peer into the *stanze* of the Vatican; they look just as they must have appeared to the Nazarenes.[2] Not far off, you can see the whole of Baden-Baden; and if the sun were not dazzling, you might be able to pick out Dostoevsky on the casino terrace from among the doll-like figures on a scale of 1:10,000. But even candlelight comes into its own. In the twilit cathedral, wax candles form a sort of *chapelle ardente* surrounding the murdered duc de Berry;[3] and the lamps in the silken skies of an island of love almost put chubby Luna to shame.

This is a unique experiment in what the Romantics called the "moonlit night of magic." It emerges triumphantly in its noble essence from every conceivable test to which its specific form of poetry has been subjected to here. It is almost frightening to think of the impact it must have had in its cruder, more massive state—in the magic pictures of the annual fairs and in dioramas. Or was this watercolor painting never popular because the technique was always too expensive? (It was done on paper that was scraped

and rubbed, cut out in different places, given an underlay, and finally covered with wax in order to achieve the desired transparency.) We do not know the answer. For these forty transparencies are unique. We know of nothing like them and knew nothing even of these until recently, when they were discovered in someone's estate. They belonged to a collection assembled by a wealthy connoisseur, the great-grandfather of their present owner. Every piece was made for him individually. Great artists like Géricault, David, and Boilly are said to have been involved to a greater or lesser degree. Other experts believe that Daguerre worked on these plates before he created his famous diorama (which burned down in 1839, after seventeen years).

Whether the greatest artists really were involved or not is important only for the American who sooner or later will cough up the one and a half million francs that will be needed to buy the collection. For this technique has nothing to do with "art" in the strict sense—it belongs to all the arts. Its place is alongside that group of arts which is reckoned inferior at the moment but will not necessarily remain so, and which ranges from early techniques of the observer right down to the electronic television of our own day. In the nineteenth century, when children constituted the last audience for magic, these practical arts all converged in the dimension of play. Their intensity was not thereby diminished. Anyone who takes the time to dwell upon the transparency of the old spa of Contrexéville soon feels as if he had often strolled along this sunny path between the poplars, and as if he had brushed up against that very stone wall: modest magical effects for domestic use, of a sort only rarely seen—in Chinese soapstone groups, for example, or Russian lacquer paintings.

Published in *Die literarische Welt*, March 1928. *Gesammelte Schriften*, IV, 509–511. Translated by Rodney Livingstone.

Notes

1. "The last Condé" is the traditional name for Louis Henri-Joseph, duc de Bourbon (1756–1830). Having played a minor role on the side of the aristocracy in the French Revolution, he led a dissolute life in England and returned to France with his mistress, Sophie Dawes, in 1814. After he was found hanged in his château, Dawes was suspected of the murder; she was, however, released by order of Louis-Philippe, and the crime remained unsolved.
2. The Nazarenes were a group of painters roughly contemporary with the late Romantic movement who produced a body of spiritualizing work, comparable to that of the Pre-Raphaelites, though with a more explicitly religious content. The best-known artist of the group was Peter Cornelius.
3. In Catholicism, a *chapelle ardente* is a darkened room, illuminated with candles,

in which the body of a deceased person lies until placed in a casket. Charles Ferdinand de Bourbon, duc de Berry (1778–1820), served in the prince de Condé's army against the French Revolution, was exiled to England, and, after his return to France in 1815, was assassinated by Louis-Pierre Louvel, a worker obsessed with, in his own words, "exterminating the Bourbons."

Karl Kraus Reads Offenbach

Karl Kraus reads Offenbach. The orchestral music is replaced by an arrangement for piano, the French text by Treumann's translation, the troupe of costumed actors by himself in a business suit. And of himself we see only the head, arms, and torso. The rest has disappeared behind the little table which is covered by a cloth reaching down to the floor, rather like the tables used by conjurers to facilitate their acts. He thus devotes himself entirely to the business at hand, absolutely renouncing the use of any material props; but what he provides in these circumstances is unforgettable and unrepeatable in a higher sense than even the world premiere sixty years ago in the Théâtre du Palais-Royal could have been. The miracle of this evening did not spring from the fact that the work of Offenbach was being celebrated by the voice of one of the most inspired performers, the hand of one of the most indefatigable benefactors, and the gaze of one of the most courageous tamers of men. The miraculous thing about it was that it was brought about by the man who had devoted his life's work to *Die Fackel*,[1] with its world of pandemonium and paradise, whose inhabitants have now paired off and have plunged into the round dance of Offenbach's characters that opens up in delight and closes ranks behind them.

So the events on the stage stand completely outside the stubborn opposites of productive or reproductive achievement that apply only to the more or less vain or servile maneuverings of virtuosos. Kraus is no more of a "virtuoso" as a lecturer than he is a "master of language" as an author.[2] He is the same in both roles: on the one hand, the interpreter who catches out the rogue by printing his own words—often with commentary—between red covers, and, on the other hand, the man who makes a work of Offen-

bach's seem like a fairy tale merely by reading it aloud. But the fact is that he does not so much express Offenbach's words as speak from inside Offenbach. And every now and then he casts a breathtaking, half-blank, half-glinting procurer's glance at the crowd before him, inviting them to an unholy wedding with the masked figures in which they fail to recognize themselves, and invoking here too the evil privilege of the demon: the right to ambiguity.

Offenbach's works here undergo a mortal crisis. They contract, shed all superfluous trappings, venture the risky passage through this life and re-emerge at the end, redeemed and more real than before. For where this unpredictable voice is heard, the lightning shafts of illuminated advertisements and the thunder of the Métro cleave the air of the Paris of omnibuses and gaslights. And the works pay all this back with interest. At times they are transformed into a curtain; and like a fairground showman whose wild gestures accompany the entire performance, Karl Kraus tears this curtain aside, exposing the contents of their and our own chamber of horrors to our gaze. We glimpse Schober and Bekessy; and at its center point this evening, in honor of our city, we see Alfred Kerr on a lofty podium.[3]

At this point Kraus—intentionally, rightly—explodes the framework of the entire evening. Anarchically, he turns directly to the audience during an interval in a brief speech that applies to Berlin the refrain we have just heard: "I bring out the worst in every town." And in so doing he affects his listeners directly, in the same way he does with the texts he reads—that is to say, he assaults them unexpectedly, destructively, disrupting the prepared "mood," attacking the audience where they least anticipate it. In this respect he can only be compared to a puppeteer. It is here, not in the style of the operetta star, that his mimicry and his gestural language have their origin. For the soul of the marionette has entered his hands.

None of Offenbach's works fulfills the requirements of operetta as completely as *La vie parisienne*;[4] nothing in *La vie parisienne* is as Parisian as the transparent nature of that nonsensical nightlife through which not the logical but certainly the moral order makes its appearance. Of course, it does not come to judge; it comes as protest and evasion, as cunning and as mollifying gesture: in a word, as music. Music as preserver of the moral order? Music as the police of a world of pleasure? Yes, that is the splendor that falls on the old Paris ballrooms—the Grande Chaumière, the Bal Mabille, the Clôserie des Lilas—during his performance of *La vie parisienne*. "And the inimitable duplicity of this music, which simultaneously puts a plus sign and a minus sign before everything it says, betraying idyll to parody, mockery to lyricism—the abundance of musical devices ready to perform every service, uniting pleasure and pain: this gift is here developed to its purest pitch."[5] Anarchy, the only international constitution that is moral and worthy of man, becomes the true music of these operettas. The

voice of Kraus speaks, rather than sings, this inner music. It whistles bitingly about the peaks of dizzying stupidity, reverberates shatteringly from the abyss of the absurd, and in Frascata's lines hums, like the wind in the chimney, a requiem to our grandfathers' generation.

Published in *Die literarische Welt,* April 1928. *Gesammelte Schriften,* IV, 515–517. Translated by Rodney Livingstone.

Notes

1. *Die Fackel* (The Torch) was the satirical magazine edited by Karl Kraus from 1899 to his death in 1936.
2. Kraus, whose satire focused on the defects in the language and style of his opponents, always claimed to be the true servant of language, not its master.
3. Johann Schober (1874–1932), Austrian politician and Vienna's chief of police, was responsible for the bloody suppression of workers' demonstrations. Alfred Kerr (pseudonym of Alfred Klemperer; 1867–1948) was Berlin's most prominent and influential theater critic.
4. *La vie parisienne,* a farcical opera in four acts with music by Jacques Offenbach and libretto by Henri Meilhac and Ludovic Halévy, premiered at the Palais Royal in 1886.
5. Karl Kraus, "Offenbach Renaissance," *Die Fackel* 557–558 (April 1927): 47.

The Cultural History of Toys

Karl Gröber, *Kinderspielzeug aus alter Zeit: Eine Geschichte des Spielzeugs* [Children's Toys from Olden Times: A History of Toys] (Berlin: Deutscher Kunstverlag, 1928), 68 pages, with 306 black-and-white illustrations and 12 color plates.

At the beginning of Karl Gröber's book *Kinderspielzeug aus alter Zeit,* we find a self-denying ordinance. The author declares that he will not discuss children's games, so as to be able to focus more on his physical material and devote himself exclusively to the history of toys. The extraordinary density not so much of his topic as of his own method has led him to concentrate on the European tradition. If this meant Germany was at the geographic center, then in this sphere it is also the spiritual center. For a good proportion of the most beautiful toys that we still encounter in museums and homes may be described as a German gift to Europe. Nuremberg is the home of the tin soldier and the well-kept collection of animals from Noah's ark. The oldest known dollhouse comes from Munich. Even people who have no patience with claims to priority, claims that are of little consequence in this context anyway, will readily agree that they are presented with unsurpassable examples of simple beauty in Sonneberg's wooden dolls (Illustration 192), the trees made of wood shavings from the Erzgebirge (Illustration 190), the spice shops and bonnet shops (Illustrations 274 and 275, Plate X), and the harvest festival scene in pewter from Hanover.

Of course, such toys were not originally the invention of toy manufacturers, but were produced in the workshops of wood carvers, pewterers, and so forth. Not until the nineteenth century did toymaking become the province of a branch-industry of its own. The particular style and beauty of toys

of the older kind can be understood only if we realize that toys used to be a by-product of the many handicrafts that were all subject to the rules and regulations of the guilds, so that each member could manufacture only products that fell within the definition of his own trade. In the course of the eighteenth century, when manufacturing began to be specialized, producers everywhere came up against the restrictions imposed by the guilds. The guilds forbade turners to paint their own dolls, and they compelled workers in various trades who made toys from all sorts of different materials to divide the simplest work among themselves and so made the goods more expensive.

It obviously follows from this that sales, particularly retail sales in toys, were not the province of special toy sellers. You could find carvings of animals at the woodworker's shop, tin soldiers at the boilermaker's, gum-resin figurines at the confectioner's, and wax dolls at the candlemaker's. The picture was rather different at the wholesale level. Here too the middlemen, the so-called *Verlag*, originated in Nuremberg, where exporters began to buy up toys from the urban handicraft industry and above all from the homeworkers and distribute them among retailers. At around the same time, the advance of the Reformation forced many artists who had formerly worked for the Church "to shift to the production of goods to satisfy the demand for craftwork, and to produce smaller art objects for domestic use, instead of large-scale works." This led to a huge upsurge in the production of the tiny objects that filled toy cupboards and gave such pleasure to children, as well as the collections of artworks and curiosities that gave such pleasure to adults. It was this that created the fame of Nuremberg and led to the hitherto unshaken dominance of German toys on the world market.

If we survey the entire history of toys, it becomes evident that the question of size has far greater importance than might have been supposed. In the second half of the nineteenth century, when the long-term decline in these things begins, we see toys becoming larger; the unassuming, the tiny, and the playful all slowly disappear. It was only then that children acquired a playroom of their own and a cupboard in which they could keep books separately from those of their parents. There can be no doubt that the older volumes with their smaller format called for the mother's presence, whereas the modern quartos with their insipid and indulgent sentimentality are designed to enable children to disregard her absence. The process of emancipating the toy begins. The more industrialization penetrates, the more it decisively eludes the control of the family and becomes increasingly alien to children and also to parents.

Of course, the false simplicity of the modern toy was based on the authentic longing to rediscover the relationship with the primitive, to recuperate the style of a home-based industry that at this very time was locked in an increasingly hopeless struggle for survival in Thuringia and the Erzge-

birge. Anyone who has been following the statistics on wages knows that these industries are heading toward their demise. This is doubly regrettable, particularly when you realize that of all the available materials none is more suitable than wood, thanks to its resilience and its ability to take paint. And in general it is this external point of view—the question of technology and materials—that leads the observer most deeply into the world of toys. Gröber brings this out in a highly illuminating and instructive way. If we look beyond the question of materials and glance at the child playing, we may speak of an antinomian relationship. It looks like this: On the one hand, nothing is more suitable for children than playhouses built of harmonious combinations of the most heterogeneous materials—stone, plasticine, wood, and paper. On the other hand, no one is more chaste in the use of materials than children: a bit of wood, a pinecone, a small stone—however unified and unambiguous the material is, the more it seems to embrace the possibility of a multitude of figures of the most varied sort. And when adults give children dolls made of birchbark or straw, a cradle made of glass, or boats made of pewter, they are attempting to respond in their own way to the children's feelings. In this microcosm, wood, bones, wickerwork, and clay are the most important materials, all of which were already used in patriarchal times, when toys were still a part of the production process that found parents and children together. Later came metals, glass, paper, and even alabaster. The alabaster bosom that seventeenth-century poets celebrated in their poems was to be found only in dolls, whose fragility often cost them their existence.

A review like this can only hint at the riches of Gröber's work, the thoroughness of its underlying research, the beguiling objectivity of its presentation. This completely successful collection of illustrations is perfect at the technical level, too. Anyone who fails to read it attentively will scarcely know what toys are, let alone their importance. This last question leads, of course, beyond the framework of the book to a philosophical classification of toys. As long as the realm of toys was dominated by a dour naturalism, there were no prospects of drawing attention to the true face of a child at play. Today we may perhaps hope that it will be possible to overcome the basic error—namely, the assumption that the imaginative content of a child's toys is what determines his playing; whereas in reality the opposite is true. A child wants to pull something, and so he becomes a horse; he wants to play with sand, and so he turns into a baker; he wants to hide, and so he turns into a robber or a policeman. We are also familiar with a number of ancient playthings that were presumably once cult objects but that scorn the function of masks: balls, hoops, tops, kites—authentic playthings; "the more authentic, the less they meant to adults." Because the more appealing toys are, in the ordinary sense of the term, the further they are from genuine playthings; the more they are based on imitation, the

further away they lead us from real, living play. This is borne out by the different kinds of dollhouses that Gröber includes. Imitation (we may conclude) is at home in the playing, not in the plaything.

But of course, we would penetrate neither to the reality nor to the conceptual understanding of toys if we tried to explain them in terms of the child's mind. After all, a child is no Robinson Crusoe; children do not constitute a community cut off from everything else. They belong to the nation and the class they come from. This means that their toys cannot bear witness to any autonomous separate existence, but rather are a silent signifying dialogue between them and their nation. A signifying dialogue to the decoding of which this work provides a secure foundation.

Published in the *Frankfurter Zeitung*, May 1928. *Gesammelte Schriften*, III, 113–117. Translated by Rodney Livingstone.

Toys and Play

Marginal Notes on a Monumental Work

Karl Gröber, *Kinderspielzeug aus alter Zeit: Eine Geschichte des Spielzeugs* [Children's Toys from Olden Times: A History of Toys] (Berlin: Deutscher Kunstverlag, 1928), 68 pages, with 306 black-and-white illustrations and 12 color plates.

It will be a while before you are ready to read this book, so fascinating is the sight of the endless variety of toys that its illustrated section unfolds before the reader. Battalions of soldiers, coaches, theaters, sedan chairs, sets of dishes—all in Lilliputian format. The time had to come when someone would assemble the family tree of rocking horses and lead soldiers, and write the archaeology of toyshops and dolls' parlors. This has been done here in a scholarly and conscientious manner and without any archival pedantry in the book's text, which stands on a par with the illustrations. The book is cast in a single mold, and the reader can detect nothing of the labor involved in producing it. Now that the book lies before us, it is hard to imagine how it could ever have been otherwise.

But it must be said that research of this kind is in tune with the age. The German Museum in Munich, the Toy Museum in Moscow, the toy department of the Musée des Arts Décoratifs in Paris—all creations of the recent past or the present—point to the fact that everywhere, and no doubt for good reason, there is growing interest in honest-to-goodness toys. Gone are the days of character dolls, when adults pandered to childish needs under the pretext of satisfying childlike ones. The schematic individualism of the arts-and-crafts movement and the picture of the child given by the psychology of the individual—two trends that understood each other all too well— were undermined from within. At the same time, the first attempts were

made to escape from the influence of psychology and aestheticism. Folk art and the worldview of the child demanded to be seen as collectivist ways of thinking.

On the whole, the work under review corresponds to this latest state of research, if indeed it is possible to tie a standard work of a documentary kind to a theoretical stance. For in reality the stage reached here must form a transition to a more precise definition of our knowledge of the subject. The fact is that the perceptual world of the child is influenced at every point by traces of the older generation, and has to take issue with them. The same applies to the child's play activities. It is impossible to construct them as dwelling in a fantasy realm, a fairy-tale land of pure childhood or pure art. Even where they are not simply imitations of the tools of adults, toys are a site of conflict, less of the child with the adult than of the adult with the child. For who gives the child his toys if not adults? And even if he retains a certain power to accept or reject them, a not insignificant proportion of the oldest toys (balls, hoops, tops, kites) are in a certain sense imposed on him as cult implements that became toys only afterward, partly through the child's powers of imagination.

It is therefore a great mistake to believe that it is simply children's needs that determine what is to be a toy. It is nonsense to argue, as does an otherwise meritorious recent work, that the necessity of, say, a baby's rattle can be inferred from the fact that "As a rule it is the ear that is the first organ to clamor for occupation"—particularly since the rattle has always been an instrument with which to ward off evil spirits, and this is why it has to be put in the hand of a newborn baby. And even the author of the present work is surely in error when he writes, "The child wants from her doll only what she sees and knows in adults. This is why, until well into the nineteenth century, the doll was popular only when dressed in grown-up clothing; the baby in swaddling clothes that dominates the toy market nowadays was completely absent." No, this is not to be laid at the door of children; for the child at play, a doll is sometimes big and sometimes little, and as an inferior being it is more often the latter. We may say instead that until well into the nineteenth century the idea of an infant as a creature shaped by a spirit of its own was completely unknown; on the other hand, the adult was the ideal in whose image the educator aspired to mold the child. This rationalism, with its conviction that the child is just a little adult, makes us smile today, but it had the merit of declaring seriousness to be the child's proper sphere. In contrast to this, the inferior sense of "humor" manifests itself in toys, alongside the use of larger-scale objects, as an expression of the uncertainty that the bourgeois cannot free himself of in his dealings with children. The merriment that springs from a sense of guilt sits admirably with the silly distortions of size. Anyone who wishes to look

the hideous features of commodity capital in the face need only recollect toyshops as they typically were up to five years ago (and as they still often are in small towns today). The basic atmosphere was one of hellish exuberance. On the lids of the parlor games and the faces of the character dolls, you found grinning masks; they gaped at you alluringly from the black mouth of the cannon, and giggled in the ingenious "catastrophe coach" that fell to pieces, as expected, when the train crashed.

But scarcely had this militant viciousness made its exit than the class character of this toy reappeared elsewhere. "Simplicity" became the fashionable slogan of the industry. In reality, however, in the case of toys simplicity is to be found not in their shapes but in the transparent nature of the manufacturing process. Hence, it cannot be judged according to an abstract canon but differs in different places, and is less a matter of formal criteria, because a number of methods of processing—carving, in particular—can give free rein to their imagination without becoming in the least incomprehensible. In the same way, the genuine and self-evident simplicity of toys was a matter of technology, not formalist considerations. For a characteristic feature of all folk art—the way in which primitive technology combined with cruder materials imitates sophisticated technology combined with expensive materials—can be seen with particular clarity in the world of toys. Porcelain from the great czarist factories in Russian villages provided the model for dolls and genre scenes carved in wood. More recent research into folk art has long since abandoned the belief that "primitive" inevitably means "older." Frequently, so-called folk art is nothing more than the cultural goods of a ruling class that have trickled down and been given a new lease on life within the framework of a broad collective.

Not the least of this book's achievements is that Gröber decisively shows how the economic and particularly the technological culture of the collective have influenced toys. But if to this day toys have been far too commonly regarded as objects created for children, if not as the creations of children themselves, then with play it is the other way around: play has been thought about altogether too exclusively from the point of view of adults, and has been regarded too much as the imitation of adults. And it cannot be denied that we needed this encyclopedia of toys to revive discussion of the theory of play, which has not been treated in this context since Karl Groos published his important work *Spiele der Menschen* [People at Play] in 1899.[1] Any novel theory would have to take account of the "*Gestalt* theory of play gestures"—gestures of which Willy Haas recently listed (May 18, 1928) the three most important.[2] First, cat and mouse (any game of catch); second, the mother animal that defends her nest and her young (for example, a goalkeeper or tennis player); third, the struggle between two animals for prey, a bone, or an object of love (a football, polo ball, and so on). Going

beyond that, one would have to investigate the enigmatic doubles of stick and hoop, whip and top, marble and king-marble, as well as the magnetic attraction generated between the two parts. In all probability the situation is this: before we transcend ourselves in love and enter into the life and the often alien rhythm of another human being, we experiment early on with basic rhythms that proclaim themselves in their simplest forms in these sorts of games with inanimate objects. Or rather, these are the rhythms in which we first gain possession of ourselves.

Last, such a study would have to explore the great law that presides over the rules and rhythms of the entire world of play: the law of repetition. We know that for a child repetition is the soul of play, that nothing gives him greater pleasure than to "Do it again!" The obscure urge to repeat things is scarcely less powerful in play, scarcely less cunning in its workings, than the sexual impulse in love. It is no accident that Freud has imagined he could detect an impulse "beyond the pleasure principle" in it. And in fact, every profound experience longs to be insatiable, longs for return and repetition until the end of time, and for the reinstatement of an original condition from which it sprang. "All things would be resolved in a trice / If we could only do them twice." Children act on this proverb of Goethe's. Except that the child is not satisfied with twice, but wants the same thing again and again, a hundred or even a thousand times. This is not only the way to master frightening fundamental experiences—by deadening one's own re- sponse, by arbitrarily conjuring up experiences, or through parody; it also means enjoying one's victories and triumphs over and over again, with total intensity. An adult relieves his heart from its terrors and doubles happiness by turning it into a story. A child creates the entire event anew and starts again right from the beginning. Here, perhaps, is the deepest explanation for the two meanings of the German word *Spielen:* the element of repetition is what is actually common to them.[3] Not a "doing as if" but a "doing the same thing over and over again," the transformation of a shattering expe- rience into habit—that is the essence of play.

For play and nothing else is the mother of every habit. Eating, sleeping, getting dressed, washing have to be instilled into the struggling little brat in a playful way, following the rhythm of nursery rhymes. Habit enters life as a game, and in habit, even in its most sclerotic forms, an element of play survives to the end. Habits are the forms of our first happiness and our first horror that have congealed and become deformed to the point of being unrecognizable. And without knowing it, even the most arid pedant plays in a childish rather than a childlike way; the more childish his play, the more pedantic he is. He just does not recollect his own playing; only to him would a book like this have nothing to say. But when a modern poet says that everyone has a picture for which he would be willing to give the whole world, how many people would not look for it in an old box of toys?

Published in *Die literarische Welt,* June 1928. *Gesammelte Schriften,* III, 127–132. Translated by Rodney Livingstone.

Notes

1. Karl Groos (1861–1946), German philosopher, wrote a number of pioneering works on the psychology of human and animal play.
2. Willy Haas (1891–1973), German-Jewish author and critic, founded the periodical *Die literarische Welt,* which he edited until 1933.
3. The German word *Spielen* means both "to play" and "games."

Everything Is Thought

Everything is thought [*gedacht*]. The task is to make a stopover at every one of these many little thoughts. To spend the night in a thought. Once I have done that, I know something about it that its originator never dreamed of.

Fragment written ca. June 1928. *Gesammelte Schriften,* VI, 200. Translated by Rodney Livingstone.

Books by the Mentally Ill

From My Collection

A sense of embarrassment often goes unnoticed as the source of a successful enterprise.

When I began, ten years ago, to create a more satisfactory order among my books, I soon came across volumes that I could not bring myself to get rid of but that I could no longer bear to leave where they were.

Hermann von Gilm's poems are among the curiosities of German literature, but I know that at the time I was experiencing Hölderlin as a revelation, I had no wish to include them in the section on German poetry.[1] Emil Szittya's first publication, *Ecce-Homo-Ulk* [Ecce Homo Trick], is something I would not want to be without, any more than many another revealing piece of juvenilia by better-known writers. Yet I drove it from one section to another, until it finally found a refuge not far from Gilm's poetry. And Blüher's *Aristie des Jesus von Nazareth* [The Heroic Ballad of Jesus of Nazareth] was a work I did not wish to include in my books on the philosophy of religion. Nevertheless, its contribution to the pathology of anti-Semitic resentment seemed too valuable for me to dispose of it.[2]

In this way a motley collection came together over the years, a "Library of Pathology," long before I thought to actively build a collection of writings by the mentally ill—indeed, long before I even knew that books by the mentally ill existed.

Then, in 1918, in a small antiquarian bookshop in Berne, I came across Schreber's famous *Denkwürdigkeiten eines Nervenkranken* [Memoirs of My Nervous Illness], published by Oswald Mutze in Leipzig. Had I already heard of this book? Or did I read about it a few weeks later in the essay on it by Freud in volume 3 of his *Kleine Schriften zur Neurosenlehre* [Shorter

Writings on the Theory of the Neuroses], published in Leipzig in 1913? No matter. I was at once spellbound by it.

The publisher of Schreber's memoirs had built something of a reputation for specializing in the quaintest spiritualist writings. It is readily understandable that such an enterprise might be the most likely to agree to publish a theological system in which "only God might approach corpses without danger," or whose author "could be in no doubt that God is familiar with the concept of railways," or which develops a theory to the effect that God's language, the so-called "basic language, is a somewhat old-fashioned, but vigorous German." In this language God is called "that which is and will be," and the patient's former comrades from his dueling fraternity are referred to as "those suspended beneath Cassiopeia." And equally remarkable and succinct are the turns of phrase this paranoid finds at different stages of his illness to describe everyday facts that have become inexplicable to him. The idea of the end of the world, not uncommon among paranoids, obsesses him to such a degree that he can conceive of other people's existence only as a frivolous delusion. To enable him to come to terms with it, his writings abound in references to "casually improvised men," "miracle dolls," people who have been "magicked away," and so forth. The book also contains a number of other extraordinary coinages. The patient's compulsion to shout, the "shouting miracle," he contemptuously calls a "psychic throat-clearing." Similarly, references to the "countermeaning of primal words," a theme treated sporadically by Freud, also appear in this remarkable document. "Juice" is called "poison," "poison" is called "food," "reward" is called "punishment," and so on.

The entire work was originally dedicated by the author to his wife, as a guide to the religious ideas he developed during his illness. Not without a concrete reason. After being hospitalized for ten years, Presiding Judge Schreber was declared fit and able to return to his duties and was restored to his family, the result of his frequent and highly intelligent reports, which he later published as appendixes to his memoirs. The various stages of his illness, right down to the remarkably rigorous and successful process of containing his delusions, cannot be discussed here of course, any more than there is room to give a psychiatric account of his case or the others mentioned below.

This much is clear: the universe constructed by the Royal Bavarian Government and District Medical Counselor Carl Friedrich Anton Schmidt, Doctor of Philosophy, Medicine, Surgery, and Midwifery and member of several learned societies, scarcely provides a clinical picture of paranoia or any other psychosis. Psychiatry has long since progressed beyond the time when every symptom was misused to characterize a particular form of insanity; if this were not the case, we might well speak of a "cataloguing psychosis." The learned and perhaps highly esteemed author of *Leben und*

Frontispiece from C. F. Schmidt, *Leben und Wissenschaft in ihren Elementen und Gesetzen*. The eye in the center of the image symbolizes God, whose life-giving gaze encompasses the four main areas of human endeavor: religion, jurisprudence, medicine, and art. These four fields appear in the corners of the illustration as (respectively) a virgin at prayer, a female judge, Aesculapius, and a hovering Apollo, all represented with the symbols of their activities. The figures grouped around the centerpoint suggest, on one side, the stages of individual existence—man, angel, seraph—and, on the other, the higher material world, in the form of stars, moon, and sun. Beneath the eye is the sun of being, which shines down on the earth (with its symbols of time and transience). We cannot here enter into the extremely complex details of these symbols, all of which come together in various triads.

Haus

Zurichtung

Gestaltung

Grundtheile	Verbindungstheile	Schlußtheile
Grundmauern	Fußböden	Giebel
Umfassungsmauern	Decken	Dach
Verbindungsmauern	Treppen	Schlöte

Zugänge

Hauptöffnungen	Nebenöffnungen	Lichte Räume
Thore	Kellerlöcher	Vorplaz
Thüren	Bodenlöcher	Gänge
Fenster	Oberlichter	Hof

Einrichtung

Hauptpunkte des häuslichen Bedürfnisses

Wohnorte	Bereitungs- u. Verwahrungs-Orte in erster Reihe	Feuerungsplätze
Zimmer	Küche	Oefen
Saal	Keller	Heerde
Kabinet	Boden	Kamine

Nebenpunkte des häuslichen Bedürfnisses

Nebenorte des Aufenthaltes u. allgemeiner Aufbewahrung	Specielle Bereitungs- u. Aufbewahrungs-Orte in zweiter Reihe	Für Unterbringung von Thieren, Abfällen u. dgl.
Altane	Waschhaus	Stallung
Mezane	Holzlager	Dungstätten, Abtritte u. dgl.
Kammer	Remisen	Reservoirs

Hauptbaumaterial

Stein	Holz	Eisen

Hülfsbaumaterial

Ziegel oder Schiefer	Mörtel und Farbe	Glas

Bauhaltpunkte

Gewölbe und Tragbogen	Tragsteine und Tragbalken	Säulen und Pfeiler.

Wissenschaft in ihren Elementen und Gesetzen [The Elements and Laws of Life and Science], published in Würzburg in 1842, was perhaps entirely sane in the ordinary sense of the term. The text of his book betrays nothing of his obsessive idea. At most, readers might be puzzled by the excessive space devoted to model psychiatric reports in the section entitled "Anthropology and Medicine." The reports he discusses were obviously written by him. This man seems to be more like a reincarnation of an early surgeon, or rather a contemporary of the doctor in Büchner's *Woyzeck*.[3] A glance at the illustrations instantly makes clear the manic character of his worldview.

If the realm of delusion had four faculties, like the realm of knowledge, the works of Schreber and Schmidt would be a compendium of their theology and worldly wisdom, respectively. We turn now to jurisprudence. Take, for example, *Der Ganz-Erden-Universal-Staat* [The Whole-Earth Universal State]. The prodigal author has written a handbook for use by heads of state, particularly "the King of England, London," and has dedicated it to various saints, notably "H. P. Blavatsky of the Great and Universal Theosophical Society."[4] The work was presumably published at his own expense. A small rubber-stamped notice reading "Ganz-Erden-Universalstaats-Edition, Brno 2—Brünn 2, P.O. Box 13," and the label stuck on by a commissioned publisher, constitute all the bibliographic information we can glean about this book. The printer's credit gives the year 1924.

No closer examination of it is called for. If ever a lunacy was harmless, the work of this Slavic author, imbued as it is with the spirit of vagabond Russian monks, is a prime example.

Last: a document testifying to a psychosis of the most serious kind, a medical work with which we will conclude for the moment. Carl Gehrmann, a doctor practicing in Berlin, wrote *Körper, Gehirn, Seele, Gott* [Body, Brain, Soul, God], four parts in three volumes, published in Berlin in 1893. The following are from volume 4, which contains the medical histories:

Case 1. The broken reed is raised up again.

Case 7. Stimulation of the nubes—the ear of corn becomes a reed—reduction in size as the starting point for perfecting the form of a blueberry—stimulation of the "pneuma" and "mother of God" centers—forget me not—the water level of the day of the Lord—the gulf between "religion and yearning" is concerned with clandestine love and how it bears on conflict.

Case 13. Effect of sweaty feet on the sexual and respiratory systems—a cure implies the harmonious unfolding of the "stocking" [*Strümpfe*] centers—the well of the sacraments.

Case 30. The crucifix behind the green, veil-like window curtains—*pneuma and Mother of God*—the abstract window dominates the will—the scar as symbol of piety heals the crucifix *tactile*.

Deshalb können gegenwärtig die Lohnver-
hältnisse *gutherzig, liebevoll, vernünftig* und
zweckmäßig-segensreich nur auf diese Art ge-
regelt werden
(selbstverständlich unter noch bedeutend
vorteilhafteren und besseren Approvisa-
tionsverhältnissen als vor dem Kriege!)
und zwar:

1. Dienende Bürger 1000 Kronen
2. Hoffnungs-Bürger 1500 „
3. Ehrenbürger mit 4 höheren
 Volksschulklassen . . . 2000 „
4. Ehrenbürger mit Matura . 3000 „
5. Ehrenbürger mit 2facher
 Universitätsbildung . . . 4000 „
6. Ehrenbürger mit 3f. Univ. b. 4500 „
7. Ehrenbürger mit 4f. Univ. b. 5000 „
8. Ehrenbürger mit 5f. Univ. b. 5500 „

9. Ehrenbürger mit 6f. Univ. b. 6000 Kronen
10. Ehrenbürger mit 7f. Univ. b. 6500 „
11. Ehrenbürger mit 8f. Univ. b. 7000 „
12. Ehrenbürger mit 9f. Univ. b. 7500 „
13. Ehrenbürger m. 10f. Univ. b. 8000 „
14. Hervorragende Künstler,
 Komponisten, Maler, Dichter,
 Erfinder usw. (Ehrenbürger!)
 sollen jährlich mit einem
 Ehrenhonorar 9000 „
 belohnt werden.
15. Könige ausnahmsweise . 10000 „
16. Herren 6000 „
17. HErren 5000 „
18. HERRen 4000 „
19. HERREN (Asketen) . . 3000 „
20. HEILIGE im aktiven Stand 2000 „
21. KAISER — „

Salary categories. From *Der Ganz-Erden-Universal-Staat*, illustration 7. [Categories 1 and 2 give wages for "Citizens in domestic service" and "Hope citizens," respectively. Categories 3–13 give wages for workers at various ascending levels of education. Category 14 gives wages for distinguished artists, composers, painters, poets, and inventors. Category 15 = "Kings (special case)." Categories 16–19 list salaries for various levels of "Gentlemen." Category 20 = "Currently active saints." —*Trans.*]

Diagram of a region of the brain. From Carl Gehrmann, *Körper, Gehirn, Seele, Gott*, illustration 8. [Gehrmann claims to identify not only areas of the brain associated with physical attributes ("Middle finger," "Index finger") but also areas associated with spiritual states and functions ("Fear of moral sin," "Implements of the soul," "Feeling of the soul," "Infinity," "Abyss").—*Trans.*]

Case 32. The millwheel in the hot-air balloon of the church (the *red currant*).

Case 40. Lying in the forest stream of the blessing is homologous with sleeping in the bed of the church—the blue rocky pinnacle bathed in light.

Gehrmann's theological medical science, which is illustrated by 258 cases of this sort, is concerned principally with menstruation and is based on the assumption that all the organs, nerves, blood vessels, and parts of the body correspond to specific parts of the brain. To these he has given the fantastic names that are referred to in the titles to his "cases." Reproduced here is an example of the countless diagrams the sick man has included in his book.

The mere existence of such works has something disconcerting about it. So long as we habitually regard writing as—despite everything—part of a higher, safer realm, the appearance of insanity, especially when it enters less noisily than elsewhere, is all the more terrifying. How could this happen? How did it manage to slip past the passport control of the city of books, this Thebes with a hundred doors? The publishing history of such works must often be as bizarre as their contents. Nowadays, one would like to think, the situation is different. Interest in the manifestations of madness is as universal as ever, but it has become more fruitful and legitimate. The writings of the insane, so we might suppose, would have no trouble obtaining a valid passport today. Yet I know of a manuscript that is finding it as difficult as ever to obtain the approval of a respected publishing house, even though it is at least the equal of Schreber's in both human and literary terms, and far superior in intelligibility. If this brief essay should arouse interest in it, and if these all too brief excerpts could stimulate the reader to turn his attention to the posters and leaflets of the insane, then these lines would have fulfilled a twofold purpose.

Published in *Die literarische Welt*, July 1928. *Gesammelte Schriften*, IV, 615–619. Translated by Rodney Livingstone.

Notes

1. Hermann von Gilm (1812–1864) was the author of many poems, including the cycle *Sonette aus Wälschtirol* (Sonnets from the Italian Tirol).
2. Hans Blüher (1888–1955) was a German theorist of the Youth Movement and the author of *Die deutsche Wandervogelbewegung als erotisches Phänomen* (The German Youth Movement as Erotic Phenomenon; 1912). The *Aristie* was published in 1922.
3. The doctor in Georg Büchner's play hopes to cure Woyzeck of his mental delusions by prescribing a diet consisting solely of peas.
4. Helena Petrovna Blavatsky (1831–1891) founded the Theosophical Society. Her most important work is *The Secret Doctrine* (1888).

Review of the Mendelssohns' *Der Mensch* *in der Handschrift*

Anja and Georg Mendelssohn, *Der Mensch in der Handschrift* [Man in His Hand-writing] (Leipzig: E. A. Seemann, [1928–]1930), 100 pages.

Does this book need a recommendation? I think not. It will be a great success. One thoroughly well deserved.

It represents the science of graphology at its very best. It represents graphological intuition at its very best. It is also scientific exposition at its very best.

Furthermore, it is tactful in the extreme—a factor worth mentioning in books with a psychoanalytic bent. At any rate, the brevity and precision of this book may in a sense be interpreted as tact. It nowhere says too much, and says nothing too often. Hence, its tone is as stimulating as it is instructive. Last, it has the rare creative modesty typical of the person who lives wholly inside his subject and who is utterly incapable of viewing it complacently from the outside.

If there is anything about the activities of graphologists that might give offense to the plain-thinking person, it is the complacency with which vulgar practitioners have appealed to the philistines' curiosity and passion for gossip by offering to reveal the "truth" about Tom, Dick, and Harry, and a whole gallery of revelations about everyone from their ancestors to the housewife. The more recent scientific experiments of Klages, Ivanovic, and others have of course nothing in common with any of that. But it is unlikely that anyone has ever fought so tenaciously to grasp the integral riddle of mankind—a riddle that seems to survive all analysis unscathed in its purity.

This is the laudable expression of a methodology of which the aforemen-

tioned tact is only an outer manifestation. Not that the methodology is so very new. But what is crucial in this instance is the seriousness with which it is applied. It represents a systematic attempt to construe the handwriting of even civilized people as a set of hieroglyphs. And the authors have managed to preserve contact with the world of images to a hitherto unprecedented degree. People have always regarded the distinction between strokes—right and left, top and bottom, straight and sloping, heavy and light—as crucial. But these qualities always contained a vague remnant of analogy and metaphor. In the case of a person with cramped handwriting, it would be said that "he keeps his possessions close together—that is to say, he is parsimonious." This was doubtless accurate, but it was the language that had to bear the cost of this graphological insight. The same holds true for the "spiritual vision" that Klages invokes as judge of the general formal level [*Formniveau*] of someone's handwriting, of the greater or lesser amount of wealth, plenitude, weightiness, warmth, density, or depth.[1] At decisive moments it comes up against the image that we encapsulate in our handwriting as we write. This gives us some justification for arguing, against Klages, that the idea of handwriting as "fixed expressive movement" is inadequate. For the idea "claims that writing is determined by gesture—but this theory can be extended: gesture in its turn is determined by the *inner image*."

It would be an easy matter to show how this link with the image has the power to strengthen the graphologist's reluctance to make moral judgments on handwriting—something that he is always called on to do and that will no doubt continue for the foreseeable future. It would be even better if he were to take the initiative and refrain from saying any more on such matters than a man of honor can justify today—namely, anything at all. Or, to quote the authors: "Observation . . . teaches that a person carries both the light and dark sides of his character within himself." Nothing moral is ever apparent in physiognomy. Moral character is a thing without expression [*ein Ausdrucksloses*]; it emerges, invisibly or dazzlingly, from the concrete situation. It can be confirmed, but never has any predictive force. Where ignoring it can lead to is something demonstrated by Klages' own major contribution to graphology. If the authors retreat from his basic concept—that of the "formal level," which he believes affords him an ethical yardstick for assessing the character of the person writing—this retreat can be justified by reference to the abstruse arguments that Klages' vitalism [*Lebensphilosophie*] imposes on his graphology: "The vitality and plenitude of humanity and the expressive power of their precipitates in men's spirit have been in decline ever since the Renaissance, and have been hurtling toward total collapse ever since the French Revolution. It has now reached the point where the richest and most talented person of our day partakes of an incomparably impoverished medium, and can achieve at best no more in

terms of wealth of personality than what had been the *average* some four or five hundred years before." Such ideas have their place and their justification in Klages' polemics, and there is nothing new in this. But it would be intolerable to have to think of graphology as a playground for such life philosophies [*Lebensphilosophien*] or occult teachings. Its ability to free itself from sectarianism of every kind is a question of life and death for it at the present time. And it is evident that far from being conclusive, its only possible reply is for it to take the form of a creative indifference, of an *extrême milieu.*[2]

Such creative indifference can never of course be found in the golden middle way. It is an unceasingly renewed dialectical compromise; it is no geometric location, but the focal point of a process, the force field of a discharge. In terms of its contribution to a theory of handwriting, one might sketch the outlines of this realm by defining it as the dynamic (nonmechanistic) compromise between the theories of the Mendelssohns and those of Klages, something that contributes toward the theory of interpreting handwriting. The antagonism between the two is important because it is so rich in possibilities. It is rooted in the opposition of body [*Leib*] and language.

Language has a body and the body has a language. Nevertheless, the world is founded on that part of the body which is not language (the moral sphere), and on that part of language which is not body (the expressionless [*dem Ausdruckslosen*]). In contrast, graphology is concerned with the bodily aspect of the language of handwriting and with the expressive aspect of the body of handwriting. Klages' starting point is language, expression. The Mendelssohns' is the body—that is to say, the image.

Illuminating signposts lead us into the hitherto scarcely suspected richness of this pictorial dimension. In much of this, the authors have learned from Freud and Bachofen. But they are sufficiently open-minded to look for a stock of images even in inconspicuous material—anywhere, in fact, where they could discover value and expressive force for our feeling for life. Nothing is more revealing yet more appropriate to the subject, for example, than the following comparison between handwriting and children's drawings, in which the ground is represented by a straight line: "At a certain point in children's development, the letters . . . stand on the line, just as their models—people, animals, and objects—stand on the ground. The fact that the tails extend below ground level must not deter us from looking for the legs *on* the line when we translate the letters back into bodily postures. In other letters, heads, eyes, mouths, and hands can be found at the same height and next to one another, just as in the drawings of young children who have not yet learned how to draw the parts of the body in proportion or in the correct relationship to each other." Just as revealing are the sketchy outlines of a cubic graphology. Handwriting is only apparently a surface phenomenon. We can see from the impression made in the paper during

printing that there is a sculptural depth, a space behind the writing plane for the writer; on the other hand, interruptions in the flow of writing reveal the few points at which the pen is drawn back into the space in front of the writing plane, so as to describe its "immaterial curves." Could the cubic pictorial space of writing be a copy in microcosm of a clairvoyant space? Is this the source of the insights of telepathic graphologists like Rafael Scherman? Whatever the answer, the cubic theory of writing opens up the prospect that one day it may be possible to exploit graphology to investigate telepathic events.

It goes without saying that a theory which takes such an advanced position feels able to dispense both with polemics and with the need for the sort of apologias that characterized older works. The book develops its argument from its own internal logic. Even illustrations of different types of handwriting are less numerous here than is customary in such books. The authors focus so intently on their graphological inspiration that they might well have ventured to expound the elements of their science—or rather, their craft—by referring to a single specimen of handwriting. Anyone able to share their way of seeing would be able to take any scrap of paper covered with writing and discover in it a free ticket to the great *theatrum mundi*. It would reveal to him the pantomime of the entire nature and existence of mankind, in microcosmic form.

Published in *Die literarische Welt,* August 1928. *Gesammelte Schriften,* III, 135–139. Translated by Rodney Livingstone.

Notes

1. Ludwig Klages (1872–1956), psychologist and anthropologist, exerted a wide influence in the first half of the twentieth century. His central thesis—most exhaustively expressed in *Der Geist als Widersacher der Seele* (The Intellect as Opponent of the Soul; 1929–1933, 3 vols.), but also evident in his graphological treatise *Handschrift und Charakter* (Handwriting and Character; 1917)—was that an originary unity of soul and body has been destroyed by the human rational capacity. Strongly influenced by Nietzsche, Bergson, and Bachofen, Klages' ideas have gained notoriety because of their absorption into the mystagogic stream of Nazi ideology, whose anti-Semitism Klages shared.
2. A reference to the influential book *Schöpferische Indifferenz* (Creative Indifference), by Salomo Friedländer (1918).

Food Fair

Epilogue to the Berlin Food Exhibition

After the Neapolitans have celebrated Piedigrotta, on one of the days fol-
lowing the eighth of September, a herald goes around the city proclaiming
through all the major thoroughfares how many pigs, calves, goats, and
chickens, how many eggs, and how many barrels of wine were consumed
that year during the night's feasting. The public waits expectantly to learn
whether or not it has broken the previous record. The Berlin Food Exhibi-
tion resembled the gaping mouth of this herald; it was a splendid, shameless,
lip-smacking maw. We discovered to our astonishment and delight the
achievements of mankind in the realm of gourmandizing, down to our own
time. And like the Piedigrotta herald, behind the resounding Berlin mask
this giant orifice remained tuned to the tastes of the masses. It is greatly to
its credit that there was very little evidence of eccentric private dining
extravagance, and that this entire exuberant, witty proclamation rang out
in honor of the plain fare of all lands, ages, and peoples.

Until a few years ago, popularization was a dubious region on the margins
of science, a sphere of activity for joyless missionaries. More recently it has
emancipated itself, thanks to the great exhibitions—in other words, the
assistance of industry. In fact, the extraordinary improvements that have
been introduced in the art of display are merely the counterpart to the
progress that has been made in advertising.

Exhibitions like these are the most advanced outposts in the realm of
display methods. And since it is the Golem of Industry that has made these
conquests, the fact that all sorts of ugly messes have remained at the scene

is not to be wondered at. At the Berlin Food Exhibition, the mess has consisted mainly of empty beer bottles. The Golem has turned this into a gigantic tree of questionable value that has climbed up one wall of the exhibition hall. Elsewhere a Buddhist rice temple executed in the best grocery style also testifies to industry's influence. And in other places, too, you keep stumbling over traces of giant activity: sacrificial loaves of bread as tall as a man on the altar of statistics, or a huge, gaping orifice, ostensibly the model of an open mouth but in fact a display cabinet for Pantagruelesque banquets: the "whale pie complete with scales and fins" and the "Great Tower of Dorten" that Aschinger has created according to medieval recipes. What these things mean for science escapes me entirely. But their meaning to children is perfectly obvious. There is scarcely a single stand in the entire exhibition that you could not take children to. At one booth the Dual Monarchy of Giants and Dwarfs, over which the child reigns, pays homage to its ruler. Next to the giant dowry stand unambiguous, comforting toy models: miniature pies and pasties; tiny cabinets in which toy models of great physiologists like Sanctorius, Lavoisier, Liebig, and Pettenkofer perform their tasks;[1] transparent northern coastlines, with their cod fishermen; and indefatigable puppet workers that seem to have been transported from dainty mechanical mines-in-a-bottle to a didactic otherworld.

The masses do not wish to be "instructed." They can absorb knowledge only if it is accompanied by the slight shock that nails down inwardly what has been experienced. Their education is a series of catastrophes that befall them at fairs, in darkened tents, where anatomical discoveries enter their very bones, or in the circus ring, where the sight of their first lion is inseparable from the image of the lion tamer putting his fist between its jaws. It takes genius to extract such traumatic energy, the small, specific *frissons*, from things in this way. Our exhibition managers must never cease to learn from such itinerant people, the unsurpassed masters of these countless tricks of the trade.

At the Berlin Food Exhibition, they have done so. Here is a vegetable oracle, a very Delphi, where you need only aim a pointer at a particular month for a colored sign to pop up prophesying the menus to come. Here you can plunge into a sultry gloom in which nothing of the universe can be discerned, other than a process that goes "from the Atlantic Ocean to smoked eel." Next door the gates of Hades open to reveal the Lethe, a brown river flowing "from the primeval forest to the coffee table." There are resplendent wooden charts with little lights going on and off, illustrating crop cultivation in different seasons or the process of metabolism in the human body. Their red is that of a thermometer of love in which ethyl alcohol rises and falls, and their precipitate movement is the same as that

in shooting galleries, where huntsmen, devils, and mothers-in-law spring to life at the moment of the fatal shot.

Manifestations of a culinary afterlife: the gustatory pleasures of the peoples of the past. Egyptians, Greeks, Romans, the Germanic tribes of the Frankish period, and Renaissance Italians dine in illuminated niches but consume nothing, like spirits meeting for a midnight feast. Or caring for infants in the next world of the Christians: in the foreground, the kind sisters. They test the temperature of the bottles, pour a drop on their hands to make sure, cradle a baby in the right way for feeding, and wash out the bottle. Their countless virtues could only be described in a didactic poem. In the background, bathed in a murky, sulphurous red, are the bad nurses, along with the unfortunate children they are responsible for. They put the bottle to their own mouths, hold the drinking child head-down, chatter all the while to another one of the damned, and produce a picture that is enough to warm the heart of any devil.

On a pedestal, a splendid Alpine landscape. But the inscription underneath reads: "The end of the summer peak in infant mortality." The distant background shows the steep July peak in fatalities dating from some gray year before the war. Contrasting with this: layers of mountains, one after the other, with lower and lower peaks, an entire mountain range vanishing into the plain of sheer astonishment with which the observer perceives it. When he gradually comes to himself, the only thing that surprises him is the absence of the touring medical expert who conquered this statistical Matterhorn—there's no model of the fellow clambering about the massif. And next to this there is a different topographic display, as unprecedented as the others: a transport model. You see a milk delivery on its way from the producer to the consumer. It arrives at its destination in the upper half of the scene, with an endless series of stops en route. This is why the milk had to be sterilized before it could be transported. Precious vitamins were lost in the process. Thick clouds and a rainbow loom above a sterile flat landscape. In the lower half of the display, however, a fast-moving car passes through a fertile plain beneath a cloudless sky without stopping. How out-of-date the dry charts of old-fashioned statistics seem to us now, with their unattractive mess of lines. The whole earth, with its bushes and trees and fields, houses and homes, men and beasts, is all just good enough to enter into the vocabulary of this wonderful new and unspoiled sign language. We ourselves, and everything that is appropriate or congenial to us, can discover ourselves in it any time and can come into our own from our least-known side, the fourth or fifth dimension that we did not even know existed—namely, as providers of yardsticks. In the same way, the Branden-

burg Gate is constantly forced to enter the arena to do battle in heroic competitions with cabbages, apples, loaves of bread, potatoes, and other consumer goods.

All these things make the fair what it is. In every corner and in a thousand different forms, food performs its somersaults and does all its other tricks. We move from one thing to the next—from a display of babies' pacifiers to medieval feeding bottles, and from the medieval feeding bottles to the medical incunabula in which they were first depicted. In short, we come across so many things at every moment, that this fairground could dispense with the free film shows, free guides, and free amusement-park refreshments because it is an amusement park itself. And all of this is merely the obverse of the successful but tightly organized management, which could operate with a light hand because it did not lose sight of its objective: to promote an interest in rational, hygienic, and enjoyable eating.

The exhibition's political angle: the section devoted to food in wartime. I think this section has witnessed classical scenes of recognition as shattering as any in a Greek amphitheater. "Ah, that's the marvelous sausage we had in those days!" And: "I can still remember the evening Uncle Oskar opened the Lusatian beer, and we all . . ." Or again, at the sight of "blood sausage made of fish": "Well, I never made any of that." But they used to serve "Gloria," the Imperial German coffee substitute, and guests who were invited for "after dinner" would be offered a big cup of "cocoa tea," perhaps with a drop of "Bomb-and-Grenade Rum Substitute," while the children would have a glass of "Alcohol-Free" and they themselves sooner or later indulged in a glass of "War Bitters." And while the husband watched his colleagues playing cards, he could satisfy the minimum demands of German decency by downing a foaming cup of "Wartime Pearl."—This large, priceless collection is on loan from the Dresden Museum of Hygiene, and it has been displayed in a manner worthy of it. It deserves to make the rounds of all the housewives' associations throughout Germany. The Red Cross or the national women's associations would do well to send this exhibition on tour. Only it would have to be supplemented by copies of all the opinions of the medical authorities who helped to make these diabolical drinks and disgusting synthetic foods acceptable to the people. Aside from this, the exhibition provides the essentials. Nor have the well-preserved labels on the bottles and packets been forgotten. There they all are: the sadistic dried milk "DrinkOnly," "Fruitogen" jam, and the apocalyptic-sounding wartime cake "Astro"—all of them registered trademarks in which the unaccommodated truth of the day found refuge, as if in ultimate linguistic exile. When will these things return to haunt us? And when nothing is left of our generation,

who will come and unearth the remnants of the first "guaranteed gas-proof" foodstuffs?

Riepenhausen's famous engraving after Hogarth's etching *Tailpiece* is well known. It is an important work that was designed to attack the spirit of allegorical painting, but that ended up confirming it magnificently. It shows Saturn resting on a ruined heap of emblems; in his hand is a will in which he declares: "Over each and every Atom thereof [i.e., of the world], I appoint Chaos my sole executor. Witnesses: Clotho, Lachesis, Atropos"—the Three Fates.[2] The end of the world can be imagined in a less dramatic, more spacious, more peaceable and provincial manner. And it is in this sense that the end of the food exhibition would be no bad model of the place where the world gets boarded up and nailed shut. At the far end of the show, to one side of the exhibition halls and at the end of a garden path, is a shed. To the right, in the foreground, is a giant battery of tin milk churns: 3,000 liters. To the left, in the background, we can see how much food is given to the cows so that they produce milk in such quantities. We see twelve sacks containing 650 kilos of concentrated feedstuff, 900 kilos of straw, 2,700 kilos of hay in two cartloads, and 11,000 kilos of turnips in five heavy cartloads. Who wouldn't find solace in the thought that here, where everything is going downhill, the solution to the riddle of the universe is to be found where we would least expect it—casually, the way you give a picture postcard to a child. And to be found here in the shape of a few figures drifting gently in the wind above the peaceful, unknown life that lies between fodder and milk: the mystery of chewing the cud.

When we were young, we all leafed through *Robinson Crusoe* time after time, looking with beating heart for that terrifying thrill that overcame us at the sight of the picture in which Robinson gazes in horror at the traces left by cannibals. This was not simply an episode from his life; it was the Ultima Thule of food that appeared to us in that stretch of beach littered with human bones. Why have we been deprived of this sight at a show that has brought us face to face with the most exotic sights? And why are people who in a few short hours have become veritable connoisseurs of food denied the opportunity to experience the greatest artistic gratification of all—the chance to see how the circle is completed and how the mysterious serpent of the eating instinct bites its own tail?

Published in the *Frankfurter Zeitung*, September 1928. *Gesammelte Schriften*, IV, 527–532. Translated by Rodney Livingstone.

Notes

1. Sanctorius, or Santorio Santorio (1561–1636), was an Italian physician whose research on basal metabolism constituted the first use of quantitative experimental procedures in medicine. Antoine Lavoisier (1743–1794), French scientist, introduced quantitative experimental procedures to chemistry; his theory of oxidation replaced then-prevalent phlogiston theories of combustion. Justus Liebig (1803–1873), German chemist, was responsible for the first synthesis of many materials important for manufacturing. Max von Pettenkofer (1818–1901), German chemist and medical researcher, did pioneering work on the control of typhus and cholera through proper hygiene.
2. William Hogarth's *Tailpiece, or The Bathos* is an etching and engraving of 1764 depicting the end of time.

Paris as Goddess

Fantasy on the Latest Novel by Princess Bibesco

Marthe Bibesco, *Cathérine-Paris*, translated into German by Käthe Illich (Vienna and Leipzig: F. G. Speidl'sche Verlagsbuchhandlung, 1928), 365 pages. (This is a good translation.)

A bibliographic allegory: The goddess of the capital of France resting dreamily in her boudoir. A marble chimney, cornices, bulging cushions, animal skins spread over divans and floors. And knickknacks, knickknacks everywhere. Models of the Pont des Arts and the Eiffel Tower. On plinths, reminders of so many forgotten things—the Tuileries, the Temple, and the Château d'Eaux in miniature.[1] In a vase, the ten lilies from the city's coat of arms. But all this colorful bric-à-brac is intensified, outdone, buried beneath the overwhelming quantity of books of every shape and size—in sextodecimo, duodecimo, octavo, quarto, and folio in every conceivable color—held out by illiterate amoretti swooping down from above, scattered by fauns shaking out the Horn of Plenty from the hangings, spread out before her by kneeling genies: signs of poetic homage from every corner of the globe. Chaste street directories covered in shrunken leather and secured with a lock dating back to the city's youth—far more seductive for the true connoisseur than the illustrated atlases, which sumptuously reveal all; *Les mystères de Paris*, shamelessly laid bare in all the black luster of its copperplate engravings;[2] vain volumes that speak to the city of nothing but their author, of his astuteness, his distinction, if not indeed of the moments of happiness he has enjoyed with her; and books with the aristocratic modesty of crystalline mirrors, in which the object of veneration can view herself in all the shapes and poses she has adopted over the centuries. To say nothing

of the most important sign of the Baroque emblem that we are constructing here *post festum*: the sight of the flood of books in the foreground, pouring out over the curved ramp of the boudoir and landing at the feet of a committee of reviewers, who have their hands full catching them and sharing them out among themselves.

Princess Bibesco's book has the basic ingredients of all the things that may be washed ashore here. This novel has succeeded in integrating the history, statistics, and topography of Paris. Seldom has homage been paid to the city in a more imaginative and demure form. A passion comes to the surface such as only foreigners experience. For Princess Bibesco is a Romanian. Her heroine likewise, for that matter. If this conveys the impression that we are the recipients of a confession and that we should seek the key to the other characters, the impression is strengthened by internal factors. The heroine, with her divine impertinence, might well have the makings of a writer of *romans à clef* if she decided to take up her pen—and who is to say that this was not the case here? And we could perhaps gain a greater appreciation of the charm and importance of the book if we could make up our minds, hypothetically as it were, to regard the *roman à clef* as a genuine artistic genre. One would then not have to be a high-born Polish magnate, like the author's first husband, to admit that this novel is a success. But in Poland they do not waste much time on such theoretical subtleties, and instead identified the moral of the story in line with an experience of its author: "On n'épouse pas un Polonais" [You don't marry a Polish fellow]. This is a counterpart to the resigned epigraph to Chapter 4: "On n'épouse pas une ville" [You don't marry a city]—namely Paris, which she does end up marrying, in the form of an air force lieutenant.

However that may be, the *roman à clef* is a genuine romantic variant of the novel; the fact that the princess obviously learned her craft from the most romantic of contemporary writers is very much in line with this. It is only when we look at her work that we can see what a great literary tutor of princes this Giraudoux really is. And rightly so. No exponent of romantic absolutism displays such virtuosity as he. Giraudoux is the source of that remarkable wealth of nuances which was hitherto unknown in the modern novel. He is worth the effort of a closer look. His work contains none of the polished speech of Oscar Wilde's characters. Instead we find the polished angularity and multifaceted transparency of the characters themselves. The author treats them as prisms that refract his feelings into the most startling hues. This is enough to highlight the lyricism of this new type of novel. It appears in its most radiant form in *Eglantine,* one of his latest, most eccentric books. In another sense, however, we should take note of *Bella.*[3] It is no accident that this, too, is a *roman à clef*—or, as Horatio would say, "a piece of him."[4] For that is the other side of Giraudoux: his topicality, the presence of the sporting element, the political and the worldly. On this

side these books are threatened by snobbery, just as on the other side their lyricism runs the risk of descending into preciosity. These new novels are a kind of explosive compromise between these two poles. Or, to choose an image that does greater justice to such writers: the leading article and the love poem are the twin posts anchoring the tightrope on which the authors move backward and forward, with the aid of the balancing pole of cleverness to help them keep their footing. And Princess Bibesco really is very clever. In her, the wisdom of the heart and the experiences of court life merge into a Baroque ensemble that is a distant descendant of the great writers of the seventeenth century, who were also men of affairs. "He may have discovered what all ambitious men realize once they have achieved their goal—namely, that the possession of power knows only one pleasure, the pleasure of despising power." Isn't that worthy of Vauvenargues?[5]

In this spirit Princess Bibesco might relish a Baroque apotheosis—a pendant to one of the favorite subjects of the Old Masters. Don't they often depict the victorious general, in an imperial pose, receiving the keys to the city he has conquered? Here, with an equally grandiose gesture, a vanquished heart surrenders its keys to the goddess of the city.

Published in *Die literarische Welt*, September 1928. *Gesammelte Schriften*, III, 139–142. Translated by Rodney Livingstone.

Notes

1. Three Parisian landmarks. The Tuileries, the royal residence on the Right Bank of the Seine, was destroyed by arson in 1871. The Temple was originally built as the monastery for the order of the Templars, but later served as a sanctuary for artists and debtors and as a prison; it was razed in 1811. The variety theater of the Château d'Eaux, founded in 1867, had room for 4,000 spectators.
2. Published in ten volumes in 1842–1843, *Les mystères de Paris* (The Mysteries of Paris), by Eugène Sue (1804–1857), was enormously successful. The novel, in addition to its highly melodramatic plot, depicts the suffering of ordinary Parisians and life in the city's underworld during the July Monarchy.
3. *Bella* (1926), *Eglantine* (1927), and *Les aventures de Jérôme Bardini* (1930) make up Jean Giraudoux's trilogy of sociopolitical novels that—in contrast to his dramas—have received little critical acclaim.
4. *Hamlet*, I.1.19.
5. Vauvenargues (the marquis de Luc de Clapiers; 1715–1747), French moral essayist, combined a Plutarchian ethos with elements of late neoclassicism and early romanticism.

The Path to Success, in Thirteen Theses

1. There is no great success without authentic achievements. But it would be a fallacy to imagine that these achievements are its foundation. The achievements are themselves a consequence—a consequence of the increased self-confidence and working pleasure of the person who finds himself recognized. This is why a great challenge, a shrewd repartee, an advantageous transaction are the genuine achievements on which great successes are built.

2. Satisfaction with the reward paralyzes success. Satisfaction with the achievement increases it. Reward and achievement balance each other out; they lie in the pans of a set of scales. The entire weight of self-respect must lie in the pan that contains the achievement. This means that the pan containing the reward will always fly into the air.

3. Only people who seem to be or really are guided in their behavior by straightforward, transparent motives will obtain success in the long run. The masses destroy every success as soon as it seems to become opaque, or to be devoid of any instructive, exemplary value. That is to say, transparent in its own terms; such success has no need to be intellectually transparent. Any priestly rule demonstrates that. Success only has to conform to an idea, or more accurately an image, whether of a hierarchy, militarism, plutocracy, or any other. Thus, the priest has his confessional, the general his medals, the financier his mansion. Anyone who refuses to pay tribute to the masses' collection of images must fail.

4. People have no conception of the hunger for clarity. This is the supreme emotional need of any public. *One* center, *one* leader, *one* slogan. The more unambiguous an intellectual phenomenon, the greater its radius of action will be and the more the public will flock to it. People's "interest" in an

author grows; that is to say, they begin to seek his formula—in other words, the most basic, unambiguous expression of his writing. From that moment on, his every new work becomes the raw material in which his readers strive to test that formula, and to refine and prove its worth. Strictly speaking, the public has an ear only for the message that the author would just have time and strength enough to utter on his deathbed with his last breath.

5. A writer cannot remind himself too often how modern our concept of "posterity" is. It dates from the era in which the independent writer made his appearance and stems from the fact that his place in society was insecure. The reference to posterity was a form of pressure on his contemporaries. As late as the seventeenth century, it would not have occurred to any writer to appeal to posterity as a weapon against his own age. All previous ages were unanimous in their conviction that their own contemporaries held the keys that would open the doors to future fame. And how much truer this is today, when every new generation finds itself with even less time or inclination to revise already established judgments, and as its need to defend itself against the sheer mass of what the past has bequeathed it is assuming ever more desperate forms.

6. Fame, or rather success, has become obligatory and is no longer the optional extra it formerly was. In an age when every wretched scrap of paper is distributed in hundreds of thousands of copies, fame is a cumulative condition. Quite simply: the less successful the writer, the less available his works.

7. A condition of victory: the enjoyment of the trappings of success as such. A pure, disinterested enjoyment, which proclaims itself best when someone just enjoys success, even if it belongs to someone else, and especially if it is "undeserved." A pharisaical self-righteousness is one of the greatest obstacles to advancement.

8. Much is innate, but much can be improved by training. This is why success will not come to anyone who saves himself up, who exerts himself only on the most important occasions, and who is incapable of occasionally making a supreme effort for trivial goals. For the most important factor even in a crucial negotiation can be learned only through these means: the pleasure in negotiation that extends even to taking a sporting interest in your opponent, the great capacity for temporarily taking your eye off the ball (the Lord provides for his own in their sleep), and, last and most important, charm. Not the softening, straightforward, comfortable kind, but the surprising, dialectical charm that is full of verve, a lasso that unexpectedly enables you to bring your opponent into line. And isn't society full of people from whom we can learn the secret of success? Just as in Galicia pickpockets use straw dolls, little figurines covered all over with little bells, to teach their trade to their pupils, so too we have waiters, porters, officials, and managers on whom we can practice the art of giving orders with charm.

The "Open Sesame" of success is the formula begotten from the marriage between Fortuna and the language of command.

9. "Let's hear what you can do!"[1]—this is what they say in America to everyone applying for a job. But they are less interested in hearing what he says than in seeing how he behaves. Here we touch on the secret of examinations. Any examiner normally wants nothing more than to be persuaded of the suitability of the person he is testing. We have all learned by experience that the more frequently you use a piece of information, an opinion, a formula, the more it seems to lose its suggestive power. Our conviction will scarcely ever persuade others as completely as it persuaded the person who witnessed its birth in our mind. It follows that in every examination the greatest chance of success lies not with the person who is well prepared, but with the one who is best at improvising. And for the same reason, it is almost always the incidental questions and events that prove decisive. The inquisitor we have before us desires above all that we hide from him the nature of his own position. If we succeed in this, he will be grateful to us and turn a blind eye to our deficiencies.

10. Cleverness, a knowledge of human nature, and similar talents are far less important in real life than we imagine. Despite this, there is genius of some sort in every successful person. But we should not try to find it, any more than we should try to find the erotic genius in a Don Juan when he is alone. Success, too, is a rendezvous: it is no small thing to be in the right place at the right time. Because it means understanding the language in which luck makes its arrangements with us. How can anyone who has never in his life heard this language pass judgment on the genius of the successful? He has no conception of it. In his eyes it is all a matter of chance. It does not occur to him that, in the grammar of success, chance plays the same role that irregular verbs do in ordinary grammar. It is the surviving trace of primeval energy.

11. The structure of all success is basically the structure of gambling. To reject one's own name has always been the most thorough way to rid oneself of one's inhibitions and feelings of inferiority. And gambling is precisely a sort of steeplechase over the hurdles of one's own ego. The gambler is nameless; he has no name of his own and requires no one else's. For he is represented by the chips he places on specific numbers on the table—which is said to be green, like the golden tree of life, but which in reality is as gray as asphalt.[2] And what intoxication it is in this city of opportunity, in this network of good fortune, to multiply oneself, to make oneself ubiquitous and be on the lookout for the approach of Lady Luck at any one of ten different street corners.

12. A man may swindle as much as he likes. But he must never feel like a swindler. Here the confidence man is the model of creative neutrality. His inherited name is the anonymous sun around which his adopted names

revolve like planets. Pedigrees, honors, titles—they are all so many little worlds emanating from the radiant core of that sun, dispensing a gentle light and warmth over the world of ordinary people. Indeed, they are his achievement, his gift to society, and hence are evidence of the bona fides that the sharp-witted swindler always possesses but that the poor sucker almost never has.

13. The secret of success does not lie in the mind; it is revealed by language itself in the term "presence of mind." The question is not whether mind is present, or what form it takes, but only *where* it is. That it happens to be present here, at this very moment, is possible only if it enters into a person's intonation, his smile, his conversational pauses, his gaze, or his gestures. For only the body can generate presence of mind. And in the case of the highly successful person, the body keeps such a tight rein on the reserves of the mind that the latter seldom has the opportunity to let off fireworks. This explains why the success achieved by financial wizards in their careers is of the same kind as that of an Abbé Galiani in the salon.[3] For nowadays, as Lenin has remarked, what must be overcome are not people, but things. This is the source of that dullness which so often characterizes the presence of mind of great captains of industry.

Published in the *Frankfurter Zeitung*, September 1928. *Gesammelte Schriften*, IV, 349–352. Translated by Rodney Livingstone.

Notes

1. In English in the original.
2. An allusion to Mephistopheles' lines in Goethe's *Faust:* "My friend, all theory is gray, and green / The golden tree of life." *Faust, Part I,* trans. David Luke (Oxford: Oxford University Press, 1987), p. 61.
3. Ferdinando Galiani (1728–1787), Italian man of letters and economist, was a friend of the Encyclopedists. His book *Della moneta* (On Money) appeared in 1750.

Weimar

I

In small German towns, it is impossible to imagine the windows without windowsills. But seldom have I seen such wide sills as in the marketplace in Weimar, in "The Elephant,"[1] where they turned the entire room into a theater box affording me a view of a ballet which surpassed anything that the stages of Neuschwanstein and Herrenchiemsee could offer Ludwig II. For it was an early-morning ballet. Toward 6:30 A.M. the players started to tune their instruments: builders' beams on the bass, protective-umbrella violins, flower flutes, and fruit drums. The stage was still almost empty: market women, no buyers. I fell back to sleep. When I awoke again, toward 9:00, it was an orgy. Markets are the orgies of the early morning; and, as Jean Paul would have said, hunger rings in the day, as love rings it out. The syncopated clink of coins can be heard everywhere, and girls with net shopping bags, inviting the observer to enjoy their rounded shapes, slowly push and pull. But when I dressed and went downstairs, ready to make my entrance on the stage, its entire freshness and glory vanished. I realized that all the gifts of the morning hours are like the sunrise: best enjoyed from a height. And wasn't the light that had just been shining on these delicately checkered cobblestones the faint red sunrise of commerce? Now it all lay buried beneath paper and rubbish. Instead of dancing and music, there was now nothing but exchange and trade. Nothing can vanish as irretrievably as a morning.

II

In the Goethe and Schiller Archive the stairs, rooms, display cases, and bookshelves are all white. There isn't a single square inch where the eye might rest. The manuscripts lie propped up like patients in hospital beds. But the longer you expose yourself to this harsh light, the more you imagine you can discern a logic in the organization of these collections—a logic of which the archive itself is unaware. Whereas a lengthy period of confinement to a sickbed makes people's faces seem spacious and still, and turns them into the mirror of impulses that a healthy body would express in decisions, in a thousand different actions—in short, whereas a sickbed causes a human being to regress to an imitation of himself, these sheets of paper do not lie around aimlessly in their repositories like patients. The fact that everything which we know today as Goethe's *Works,* and which confronts us consciously and sturdily in countless published volumes, once existed in this unique, fragile handwritten form, and the fact that what emanated from it can only be the austere, purifying atmosphere which surrounds patients who are dying or recovering and which is perceptible to the few who are close to them—this is something we do not care to dwell on. But didn't these manuscript sheets likewise find themselves in a crisis? Didn't a shudder run through them, and no one knew whether it was from the proximity of annihilation or that of posthumous fame? And don't they embody the loneliness of poetry? And the place where it took stock of itself? And don't its pages include many whose unnameable text only rises as a glance or a breath of air from their silent, ravaged features?

III

The primitive nature of Goethe's study is well known. Its ceiling is low; it has no carpet and no double window. The furniture is unprepossessing. He could easily have done things differently. Leather armchairs and cushions existed even then. This room is not in any way ahead of its time. It was his decision to keep things within limits. No one need be ashamed of the candlelight by which the old man sat and studied in his housecoat in the evening at the table in the middle of the room, with his arms resting on a faded cushion. To think that today the quietness of such hours can be found only at night. But if we could overhear it, we would understand the pattern of existence as it was destined and created, the never-repeated blessing of having gathered the richest harvest of the past few decades, in which the wealthy man had yet to experience the harshness of life in his own body. Here the old man celebrated the vastness of the nights with his anxieties, guilt, and despair, before the hellish dawn of bourgeois comfort began to cast its light in at the window. We still await a philology that could open

our eyes to this clearly delineated and far from distant world—the true Antiquity of the poet. This study was the cell of the small house that Goethe had dedicated exclusively to two purposes: sleep and work. We cannot possibly gauge the importance of this tiny bedroom, with both its closeness to and its separation from his study. Only the threshold separated him and his work, like a step, from the towering bed. And when he slept, his work awaited him in the next room to plead nightly with the dead for his liberty. Anyone who has had the good fortune to be able to collect his thoughts in this space will have experienced in these four little rooms, in which Goethe slept, read, dictated, and wrote, the forces that bade a world give him answer when he struck the sounding-board of his innermost being. We, however, have to make an entire world resound in order to cause the feeble overtone of our inner being to ring out.

Published in the *Neue schweizer Rundschau*, October 1928. *Gesammelte Schriften*, IV, 353–355. Translated by Rodney Livingstone.

Notes

1. A renowned hotel and restaurant in Weimar.

The Fireside Saga

We are familiar with the lonely country manors of North America from which Poe derived the gloomy fairy castles of the Arnheims, Landors, and Ushers.[1] Now, once again, and as if for all eternity, we can see the emergence of a new building of this kind, enclosed by fir trees, and commanding a view over the park and forest right up to the blue hills in the distance. And no one who enters it as a reader can say what he has seen. For there can scarcely be any novels that are harder to retell, and were harder to retell right from the start, than the novels of Julien Green. None, in other words, for which it would be anything but perverse or superficial to search for a "key" or an "experience" through which to interpret them. None that resist the observer more rigorously. None more classical. Where, then, are we to look for the vital principle animating such works?

This particular work is not the product of an experience. Rather, it is an experienceable reality in itself. A sudden break in the weather overwhelms the reader. What we see here is a meteorological compromise between a climate of human primal history and that of the present day, but one that can occur only as the result of a catastrophe. How to retell the story? It would be just as easy or difficult to tell the story of last night's storm.

When shafts of lightning sunder the night sky, the sudden light projects our gaze into the furthest distances in thousandths of a second. In like manner, we glimpse pale and fleeting clearings in history, one after the other. This house—"in the simplest style of American dwellings, chest-shaped, with a colonnaded porch that extends over almost the whole of the façade"—quickly becomes as transparent as the night sky in a storm, and

turns into a vista of caverns, chambers, and galleries extending back into the primeval past of mankind.

"To dwell": Does this still mean barely having a roof over one's head, a process full of fear and magic, one that was perhaps never so voracious as it has been under the cover of civilization and the small-minded bourgeois-Christian world? For beneath the surface, things glow and smoulder; the cold flames of miserliness lick at the walls of the icy house. When at the end a fire lights up its windows and blazes from the roof, it will have been properly warm for the first time.

The primal history of the nineteenth century, whose monuments have become ever more audible since the Surrealists, have been enriched by one further unforgettable document. One of the profoundest, most legitimate features of the new schools of architecture may well be seen in their efforts to liquidate the magical powers that we are inevitably and unconsciously subject to in the rooms and furniture of our dwellings. These efforts strive to transform us from the inhabitants of houses into their users, from proud owners into practical critics. If this is the case, it is no more than the reverse side of the illuminations which have inspired this work. Here the bed really is still the throne occupied by dreamers or the dying; the fireplace really is the flame of the eternal hearth, kept alight by the dread vestal, the heroine of the book; sewing really is still concerned with the magic of destiny that the lowliest maid shares with the three Fates. And once we have listed these primitive possessions, the inventory of the house and the author's vocabulary are exhausted. The moral concepts of the catechism and the object world of the primer—these are the runes from which the three women whom the author has invited into his circle gather up their destiny, rigorously, heedlessly, as in a dream.

This world of the saga lies as far beneath the earth's surface as the fairy-tale world lies above it. Emily is the fairy-tale child—but as if in a mirror. In a fairy tale the Sunday child stands there in all his grace, helpless and victorious at the same time. Here, however, the heroine of the novel stands threatening, terrible, yet defeated. If there were a weekday that stood out above all others, if the gray of all the weekdays were concentrated into one, that would be her birthday—indeed, it would be the day of her life. In fact, that is what it is, the day that casts its pall over Mont-Cinère year in, year out. This everyday, work-a-day child of toil reaches old age in a few years, unpurified and via disreputable paths, while losing nothing of the terrible folly of early life. She stands between her mother and her grandmother; and by nature and age, she is much closer to the latter than to the former. The mother is the pious, poor, faithfully caring widow of fairy tales. But as in a mirror image: she is as pious as she is heartless, as faithful and careful with the linen, household possessions, and firewood as she is faithless and uncaring toward her mother and her child; she is as poor and as wealthy

as only a miser can be. The former—the grandmother—tells stories to her grandchild on long winter evenings, a pattern we know from fairy tales; but these stories are of the kind that paranoia inspires in the insane, and the child surrenders to them merely because the fireplace in the sickroom is the only one that has a fire in it. And then there is Stevens, the gardener's lad, the foolish prince in disguise who redeems the princess. But as in a mirror image: for only now, after the wedding, does the true story begin; and if they have not been burned to death, they are burning still. It is the fairy-tale world reflected in the pitch-black water of death. "Alas, Mother, alas!" sang the young Brentano when he glanced into the same mirror.

Emily sits in her rocking chair, at the window. She gazes out into the landscape. She studies it intently, as if it were a picture. "Her gaze slid incessantly from one point to another. You could sense that this was one of the many little distractions of which a life without major activities is full. And it was one that had become a habit." It is a day like a thousand others. Or perhaps not. Perhaps it is the mysterious day of which a great contemporary philosopher, Franz Rosenzweig, has written: "One day the self falls upon a person like an armed man, and takes possession of all that he owns in his house." The profoundly tight-lipped, truculent self, the legacy of all this author's characters, enters into this heroine as mute pride-in-possession. And gradually we perceive that in her sullen pretensions this child has become as inflexible as Oedipus in his delusion, Antigone in her sense of duty, Electra in her desire for vengeance. In the final analysis, it is the composition as a whole that provokes these comparisons. A race of men, a legendary race, that in Greek tragedy finally breaks through the imprisonment in myth for the first time—for Greek tragedy is nothing other than this breakthrough—resurfaces here amid the spectral brightness and sobriety of the nineteenth century and vanishes once more into its darkest, most ensnared, and utterly hopeless existence. This is why the extraordinary could happen—why a novel could achieve the necessity of classical tragedy, indeed a tragedy that is even more hopeless and inexorable. Because there are no gates through which the chorus might force its way in.

But ultimately is this not Germanic rather than Greek classicism, the death-defying Germanic women whose meanspiritedness is disastrously intertwined with that crooked, atrophied world of objects? Truculence has thrown itself on the most denatured things and turned possessiveness into character. This is why the heroine of Mont-Cinère has become wooden, overgrown, and smothered with passion from early childhood. In all her activities, she is a breathtaking antithesis to the innocent, matter-of-fact child found in fairy tales. Such a child finds all objects at his service. He has the right knack. How different things are here. How brilliantly this child passes the fairy-tale test with the six shirts for the poor; and despite this, the fairy, the brave Methodist sister that looks after her, creates nothing but

poverty and death with her blessing. For miserliness is always at death's door; for the miser, everything becomes a straw at which he clutches in panic. The miser always finds the bottom of the chest. In his eyes the world is threadbare from the outset. He is always at his last gasp. Giotto omitted miserliness in his allegories of vice in Padua. But with every one of their gestures, the characters in this novel declare their readiness to enter the eternal cycle of his frescoes.

Published in *Die literarische Welt,* November 1928. *Gesammelte Schriften,* III, 144–148. Translated by Rodney Livingstone.

Notes

1. This essay is Benjamin's review of Julien Green's novel *Mont-Cinère* (1926). The German title of the review, *Feuergeiz-Saga,* suggests a pun on John Galsworthy's *Forsyte Saga.* The German also combines a reference to fire with another to the miserliness *(Geiz)* that Benjamin discerns in Green's universe.

News about Flowers

Karl Blossfeldt, *Urformen der Kunst: Photographische Pflanzenbilder* [Originary Forms of Art: Photographic Images of Plants], edited and with an introduction by Karl Nierendorf (Berlin: Ernst Wasmuth, 1928), 120 pages.

Criticism is a sociable art.[1] A healthy reader mocks the reviewer's judgment. But what pleases that reader most deeply is the delicious bad taste of taking part uninvited when someone else reads. Opening a book so that it beckons like a table already set, a table at which we are about to take our place with all of our insights, questions, convictions, quirks, prejudices, and thoughts, so that the couple of hundred readers (are there that many?) in this society disappear and just for that reason allow us to enjoy life—this is criticism. Or at least the only form of criticism that gives a reader an appetite for a book.

If we can agree on this, then the table is set with the one hundred twenty plates in this book, inviting countless observations from countless observers. Yes, we really wish this rich book (poor only in words) that many friends. The silence of the scholar who presents these images must really be honored; perhaps his knowledge is of the kind that makes the one who possesses it mute. And here, doing is more important than knowing. The person who created this collection of plant photos can eat more than bread. He has done more than his share of that great stock-taking of the inventory of human perception that will alter our image of the world in as yet unforeseen ways. He has proven how right the pioneer of the new light-image, Moholy-Nagy, was when he said: "The limits of photography cannot be determined. Everything is so new here that even the search leads to creative results.

Technology is, of course, the pathbreaker here. It is not the person ignorant of writing but the one ignorant of photography who will be the illiterate of the future." Whether we accelerate the growth of a plant through time-lapse photography or show its form in forty-fold enlargement, in either case a geyser of new image-worlds hisses up at points in our existence where we would least have thought them possible.

These photographs reveal an entire, unsuspected horde of analogies and forms in the existence of plants. Only the photograph is capable of this. For a bracing enlargement is necessary before these forms can shed the veil that our stolidity throws over them. What is to be said of an observer to whom these forms already send out signals from their veiled state? Nothing can better portray the truly new objectivity of his procedure than the comparison with that highly personal but ever so brilliant procedure by means of which the equally revered and misunderstood Grandville, in his *Fleurs animées,* made the entire cosmos emanate from the world of plants. Grandville took hold of the procedure—God knows, not gently—from the opposite end. He stamped the punitive mark of creatureliness, the human visage, directly onto the blossom of these pure children of nature. This great pioneer in the field of the advertisement mastered one of its fundamental principles, graphic sadism, as hardly any other of its adepts has done. Isn't it odd now to find here another principle of advertisement, the enlargement of the plant world into gigantic proportions, gently healing the wounds opened by caricature?

Originary Forms of Art—certainly. What can this mean, though, but originary forms of nature? Forms, that is, which were never a mere model for art but which were, from the beginning, at work as originary forms in all that was created. Moreover, it must be food for thought in even the most sober observer that the enlargement of what is large—the plant, or its buds, or the leaf, for example—leads us into a wholly different realm of forms than does the enlargement of what is small—the plant cell under the microscope, say. And if we have to tell ourselves that new painters like Klee and even more Kandinsky have long been at work establishing friendly relations between us and the realms into which the microscope would like to seduce us—crudely and by force—we instead encounter in these enlarged plants vegetal "Forms of Style."[2] One senses a gothic *parti pris* in the bishop's staff which an ostrich fern represents, in the larkspur, and in the blossom of the saxifrage, which also does honor to its name in cathedrals as a rose window which breaks through the wall. The oldest forms of columns pop up in horsetails; totem poles appear in chestnut and maple shoots enlarged ten times; and the shoots of a monk's-hood unfold like the body of a gifted dancer. Leaping toward us from every calyx and every leaf are inner image-imperatives [*Bildnotwendigkeiten*], which have the last word in all phases and stages of things conceived as metamorphoses. This touches on one of the deepest, most unfathomable forms of the creative, on the variant that

was always, above all others, the form of genius, of the creative collective, and of nature. This is the fruitful, dialectical opposite of invention: the *Natura non facit saltus* of the ancients.[3] One might, with a bold supposition, name it the feminine and vegetable principle of life. The variant is submission and agreement, that which is flexible and that which has no end, the clever and the omnipresent.

We, the observers, wander amid these giant plants like Lilliputians. It is left, though, to fraternal great spirits—sun-soaked eyes, like those of Goethe and Herder—to suck the last sweetness from these calyxes.

Published in *Die literarische Welt,* November 1928. *Gesammelte Schriften,* III, 151–153. Translated by Michael Jennings.

Notes

1. Karl Blossfeldt (1865–1932) was a German photographer and art teacher whose entire photographic output was devoted to the representation of plant parts: twig ends, seed pods, tendrils, leaf buds, and so on. These he meticulously arranged against stark backgrounds and photographed with magnification, so that unfamiliar shapes from the organic world were revealed as startling, elegant architectural forms. Blossfeldt originally produced his work as a study aid for his students at the Berlin College of Art; he believed that the best human art was modeled on forms preexisting in nature.
2. Benjamin is referring to *Stilfragen* (1893), a work by Alois Riegl. It traces the influence of natural forms such as the acanthus through a series of stylistic periods in the ancient world.
3. *Natura non facit saltus:* Latin for "nature does not make a leap." In rationalist philosophy, the phrase expresses the notion that God leaves no gaps in nature.

Review of Green's *Adrienne Mesurat*

Julien Green, *Adrienne Mesurat* (Paris: Plon, 1927), 355 pages.

Paul Léautaud, the outstanding Parisian novelist and chronicler, once said, "The books that count are written from start to finish in the same tone, without showpieces or purple passages. Showpieces and purple passages are the mark of inferior books."[1] The homogeneous simplicity of narrative cannot be taken further than it is by the young Julien Green in his first two novels. Now, we all know that nothing is more difficult than such a uniform, undifferentiated mode of writing, a writing that offers no threshold. And the difficulty in question is not one of style. It is easy to understand Green when he says that style is something he hates. What he means by "style" is a technique that enables a writer to take impoverished and mundane thoughts and experiences and imbue them with the sheen of originality. The less striving for effect there is, the simpler and more comprehensible a narrative is, the denser and more extraordinary the world must be from which it sprang. If not, it will merely seem trivial, for all its matter-of-factness. In short, simplicity, if it is to stand the test, must push forward to the foundations of reality. A superficial naturalism, if stylized, may in a pinch appear readable. (Examples would fill pages, and not with the most contemptible of names.) But a work of the linguistic austerity of *Adrienne Mesurat* must be rooted in the basic metaphysical stratum of reality if it is to have substance and meaning.

And in reality the novel has never been further from naturalism than here. This is the source of this book's inner truth, something that in art always contradicts external appearance. Art means to go against the grain of reality.

Smoothing and polishing is the work of interior decorators. Books in which one thing follows another "in logical sequence," or in which "the characters are so true to life and vividly depicted"—these are the petty-bourgeois art of upholstery. But *art* is hard. It does not want one thing "to follow logically from another"; it wants much to come from little. Like Meyerhold's Russian theater, it allows us a glimpse of what is happening in the machinery of passion behind the scenes, and shows us the simple cogwheels at work: the loneliness, fear, hatred, love, or defiance that underpins every action. And these forces should be understood not as "psychological motives" propelling the actors but as forces that find expression in their destiny.

Green's distance from novelists of the normal variety is represented by the gulf between imagination [*Vergegenwärtigung*] and depiction [*Schilderung*]. Green does not depict people; he imagines them in fateful moments. That is to say, they behave as if they were apparitions. Adrienne Mesurat, who pauses in her dusting to gaze at the family portraits; old Mesurat, stroking his beard; Madame Legras, who flees, taking Adrienne's necklace with her—these would be their gestures if they were compelled to relive these moments as poor souls beyond the grave. Green's insight into the drearily stereotyped nature of all fateful moments is something he shares with but one other writer: it is the same gaze that Pirandello fixes on his six characters in search of an author. The same gaze, except that it comes from the motionless, passionless eye of a Nordic man. A Nordic man who is also a painter. Born in the United States, Green was a painter until his twenty-third year. He then wrote his first novel, *Mont-Cinère*, in five months. By way of an experiment, as he puts it, and with the near certainty that it would be received with total indifference.

"My inclination is to imagine what lies furthest from me. Whatever has not been thought out is worthless for me. And I would be incapable of describing the most trivial accident that I had witnessed." This is completely in accord with the strange impression that all his works make. Despite their precision of detail, and despite the drastic nature of the catastrophes they contain, they convey the impression that they may, or rather must, have been written by someone who has hardly experienced anything at all, let alone the events described. It sounds like a poor paradox, but only the purest, most powerful works are capable of making such an impression on the reader. (Or do *Don Quixote* and *War and Peace* read even remotely as if they had been "experienced"?) But the astonishing aspect of the book goes beyond even this. Just as this work—*Adrienne Mesurat*—seems to have arisen from a vision rather than an experience, so too we may say that it is not a contemporary novel, a novel of our time. It reads like an unassuming yet essential piece of evidence in a historical legal process that has not been launched. Like Stendhal's novels, *Adrienne Mesurat* belongs to a genre of works whose contemporary relevance is latent only at the time they are

published, so that scarcely anyone recognizes their significance; only later, in the light of their fame, does it become apparent just how central they are to their age. Everything in this novel appears timeless, from the elemental forces at work in its characters to the no less primeval nature of their world, so that we are barely able to imagine that in later times it will be immediately obvious that it was written in our day. Unless, that is—and we must conclude by at least hinting at the fundamental motif of the book—we admit to ourselves that the vision of love that dominates it could have arisen only in our day: a character who is half cleaning-woman, half Fury, wringing out the damp cloth, the human body, with her mighty hands until the last drop of life in it has been squeezed out.

Published in *Internationale Revue* (Amsterdam), December 1928. *Gesammelte Schriften*, III, 153–156. Translated by Rodney Livingstone.

Notes

1. Paul Léautaud (1872–1946) was secretary of *Mercure de France* from 1908 to 1941.

Goethe

When Johann Wolfgang Goethe came into the world on August 18, 1749, in Frankfurt am Main, the town had 30,000 inhabitants. In Berlin, the largest town in Germany at the time, there were 126,000, whereas both Paris and London had already surpassed 500,000. These figures are an important gauge of the political situation in Germany, for throughout the whole of Europe the bourgeois revolution depended on the big cities. On the other hand, it is a significant fact about Goethe that during his entire life he never lost his powerful dislike of living in big towns. He never visited Berlin,[1] and in later years he paid only two reluctant visits to his native Frankfurt, passing the larger part of his life in a small princely town with 6,000 inhabitants. The only cities he ever became more familiar with were the Italian centers Rome and Naples.

Goethe was the cultural representative and, initially, the political spokes- man of a new bourgeoisie, whose gradual rise can be clearly discerned in his family tree. His male ancestors worked their way up from artisan circles and married women from educated families or families otherwise higher in the social scale than themselves. On his father's side, his great-grandfather was a farrier; his grandfather was first a tailor and then an innkeeper; and his father, Johann Caspar Goethe, began as an ordinary lawyer. Within a short time, however, Johann acquired the title of imperial councilor, and when he had succeeded in winning the hand of Katharina Elisabeth Textor, the daughter of the mayor, he definitively established his position among the ruling families of the city.

Goethe's youth, which he spent in a patrician household in a Free Imperial City, developed and consolidated in him a trait traditionally found in the

Rhenish Franconian region: reserve toward any political commitment and a correspondingly lively appreciation of what was appropriate and advantageous to the individual. The tight family circle—Goethe had only one sister, Cornelia—soon permitted him to concentrate on himself. Despite this, the attitudes prevailing in the household prevented him from contemplating an artistic career. His father forced him to study law. With this end in view, he went first to Leipzig University at the age of sixteen, and, in the summer of 1770, to Strasbourg. He was then twenty-one.

It is in Strasbourg that we first get a clear picture of the cultural milieu from which Goethe's early poetry emerged. Goethe and Klinger from Frankfurt, Bürger and Leisewitz from Central Germany, Voss and Claudius from Holstein, Lenz from Livonia. Goethe was the patrician; Claudius was a burgher. There were the sons of teachers or parsons, like Holtei, Schubart, and Lenz; members of the petty bourgeoisie, like Maler Müller, Klinger, and Schiller; the grandson of a serf (Voss); and, finally, noblemen like Counts Christian and Friedrich von Stolberg.[2] They all worked together in an effort to "renew" Germany by means of ideology. But the fatal weakness of this specifically German revolutionary movement was its inability to reconcile itself with the original program of bourgeois emancipation: the Enlightenment. The bourgeois masses, the "Enlightened," remained separated from their vanguard by a vast abyss. German revolutionaries were not enlightened, and German enlighteners were not revolutionary. The ideas of the first centered on revolution, language, and society; those of the latter focused on the theory of reason and of the state. Goethe subsequently took over the negative side of both movements: together with the Enlightenment, he opposed violent change, while with the *Sturm und Drang* he resisted the state. It is in this division within the German bourgeoisie that we find an explanation for its failure to establish ideological contact with the West; Goethe, who subsequently made a detailed study of Diderot and Voltaire, was never further from an understanding of France than when he was in Strasbourg. Particularly revealing is his comment on that celebrated manifesto of French materialism, Holbach's *Système de la nature,* a book in which the icy draft of the French Revolution can already be felt.[3] He found it "so gray, so Cimmerian, so lifeless," that it startled him as if he had seen a ghost. He thought it "unpalatable, insipid—the very quintessence of senility." It made him feel hollow and empty in "this melancholy atheistic gloom."

These were the reactions of a creative artist, but also of the son of a Frankfurt patrician. Goethe subsequently presented the *Sturm und Drang* movement with its two most powerful manifestos, *Götz von Berlichingen* and *Werther.* But it is to Johann Gottfried Herder that these two works owe the universal form which made it possible to fuse their disparate elements into a single ideological whole.[4] In his letters and conversations with Goethe,

Hamann, and Merck,[5] he provided the program for the movement: the "original genius"; "Language: the revelation of the spirit of the people"; "Song: nature's first language"; "the unity of human and natural history." During the same period Herder was busy assembling material for his great anthology, *Stimmen der Völker in Liedern* [Voices of the Peoples in Song], a collection of poems from countries ranging from Lapland to Madagascar which had the greatest influence on Goethe. For in his own early poetry we find him using the folk song as a means of revitalizing the lyric, in combination with the great liberation that had been effected by the poets of the Göttinger Hain.[6] "Voss emancipated the marshland peasantry for poetry. He expelled the conventional figures of the Rococo from poetry with pitchforks, flails, and the Lower Saxon dialect, which only half doffs its cap to the squire." But since the basic mode of Voss's poetry is still descriptive (just as for Klopstock poetry is still conceived in terms of the rhetoric of the hymn),[7] it was left to Goethe's Strasbourg poems—"Willkommen und Abschied" [Welcome and Farewell], "Mit einem gemalten Band" [With a Colored Ribbon], "Mailied" [May Song], "Heidenröslein" [Rose on the Heath]—to liberate German poetry from the realms of description, didactic message, and anecdote. This liberation, however, could still not be anything more than a precarious, transitory phenomenon, and one that would lead German poetry into a decline in the course of the nineteenth century, whereas in the poetry of his old age, in the *West-Östlicher Divan* [West-Easterly Divan], Goethe himself had already introduced conscious restrictions. In 1773, together with Herder, Goethe produced the manifesto *Von deutscher Art und Kunst* [On German Style and Art] containing his study in praise of Erwin von Steinbach, the builder of Strasbourg Cathedral—an essay whose very existence made Goethe's later fanatical classicism an additional source of irritation to the Romantics in their efforts to rehabilitate the Gothic.

This milieu also supplied the matrix for *Götz von Berlichingen* (1772). The divided nature of the German bourgeoisie is clearly dramatized in this work. The towns and courts, as the representatives of a principle of reason which has been reduced to a coarse expression of Realpolitik, stand for the host of unimaginative Enlighteners; they are opposed by the *Sturm und Drang*, in the person of the leader of the insurgent peasantry. The historical background to this work, the German Peasants' War, could easily convey the impression that Goethe had a genuine revolutionary commitment.[8] This would be a mistake, for at bottom what Götz's rebellion expresses are the grievances of the old seigneurial class, the Imperial Knights, who are in the process of surrendering to the growing power of the princes.[9] Götz fights and dies in the first instance for himself, and then for his class. The core idea of the play is not revolution, but steadfastness. Götz's actions are redolent of reactionary chivalry. They are the fine, charming deeds of a

seigneur; they are the expression of an individual impulse and are not to be seen in the same light as the brutal destructive deeds of the peasant robbers with whom he joins forces. We see in this work the first instance of a process which is to become typical for Goethe: as a dramatist, he repeatedly succumbs to the seduction of revolutionary themes, only to deflect them or to abandon them as fragments. Examples of the first procedure are *Götz* and *Egmont;* an example of the second is *Die natürliche Tochter* [The Natural Daughter]. Goethe's essential withdrawal from the revolutionary energy of the *Sturm und Drang* movement in his very first important play emerges very clearly from a comparison with the plays of his contemporaries. In 1774 Lenz published *Der Hofmeister, oder Vortheile der Privaterziehung* [The Tutor, or The Advantages of Private Education], a work which mercilessly exposes the social constraints pressing upon the world of letters— constraints of consequence for Goethe's career, too. The German middle class was far too weak to be able to support an extensive literary life from its own resources. In consequence, literature's dependence on feudalism persisted even when the writer's sympathies had gone over to the middle class. His penury compelled him to accept free board, to act as tutor to the children of the nobility, and to accompany young princes on their travels. His state of dependence went so far as to jeopardize his literary earnings, since only works expressly named by government decree were protected from pirate editions produced in the various states of Germany.

In 1774, after Goethe's appointment to the Imperial Supreme Court of Appeals in Wetzlar, *Die Leiden des jungen Werthers* [The Sorrows of Young Werther] appeared in print. This book may well be the greatest success in the history of literature. Goethe here perfected the portrait of the writer as "genius." For if the great writer is someone who transforms his inner life into a matter of public interest from the very outset, and simultaneously makes the questions of the day into matters of immediate concern for his own personal thought and experience, then it is in Goethe's early works that we find the most consummate avatar of this kind of author. In *Werther* Goethe provided the bourgeoisie of his day with a perceptive and flattering picture of its own pathology, comparable in its way to the one supplied by Freud for the benefit of the modern bourgeoisie. Goethe knitted the story of his unhappy love for Charlotte Buff, the fiancée of a friend,[10] into his account of the adventures in love of a young writer, whose suicide had caused a sensation. In Werther's moods we see the *Weltschmerz* of the period unfolding in all its nuances. Werther is not just the unhappy lover whose unhappiness drives him to find a solace in nature which no lover had looked for since the appearance of Rousseau's *Nouvelle Héloïse;* he is also the burgher whose pride is wounded by battering at the barriers of class, and who demands recognition for himself in the name of the rights of man and even of the rights due to any living creature. This is the last occasion for a

very long time on which Goethe allows the revolutionary element in his youth to have its say. In an early review of a novel by Wieland, he had written: "The marble nymphs, the flowers, the vases, the colorfully embroidered cloth on the tables of these nice people—what a high degree of refinement they presuppose, what inequality among the classes, what want where there is so much pleasure, what poverty where the wealth is so great." In *Werther,* however, he had already softened his attitude a little: "Many things can be said in defense of the Rules [of classical drama]—the same things, more or less, that can be said in praise of bourgeois society." In *Werther* the bourgeoisie finds the demigod who sacrifices his life for them. They feel redeemed, without being liberated; hence the protest of Lessing, whose class-consciousness was incorruptible. He missed the presence of bourgeois pride as a counterweight to the nobility and called for a cynical conclusion to the book.

After the hopeless complications of Goethe's love for Charlotte Buff, the prospect of a bourgeois marriage to a beautiful, impressive, and respected Frankfurt girl appeared as a welcome solution. "It was a strange decision on the part of the powers whose will governs our lives that the remarkable twists and turns of my life should include the experience of what it feels like to be engaged." But the engagement to Lili Schönemann turned out to be no more than a tempestuous incident in that war against marriage which he conducted for over thirty years.[11] The fact that Lili Schönemann was probably the most significant woman, and certainly the most liberated one, ever to have had a close relationship with him could ultimately only increase his resistance to being bound to her. In 1775 he fled, traveling to Switzerland in the company of Graf Stolberg. The outstanding feature of the journey was his meeting with Lavater.[12] In the latter's physiognomic studies, a sensation of the period, Goethe discovered something of his own understanding of nature. In later years, Goethe came to dislike the way Lavater found it necessary to synthesize this study of the creaturely world with his own Pietistic beliefs.

On the return journey, chance brought about a meeting with Karl August, the crown prince and subsequently duke of Saxe-Weimar.[13] A little after this, Goethe accepted the prince's invitation to his court. What was intended as a visit turned out to be a lifelong stay. Goethe arrived in Weimar on November 7, 1775. In the same year he was made a privy councilor, with a seat and vote on the Council of State. From the outset, Goethe himself viewed his decision to enter into the service of Karl August as a commitment that would change the course of his life. Two factors influenced his acceptance. In an age when the German bourgeoisie harbored increased political expectations, his position at court afforded him close contact with the realities of politics. On the other hand, as a high official in a bureaucratic apparatus he was relieved of the need to make any radical decisions. For all

his inner uncertainty of mind, this position did at the very least provide him with an outward support for his self-confidence and his actions. The heavy price he had to pay was something he could have learned about easily enough from the questioning, disappointed, and indignant voices of his friends, had his own incorruptibly alert self-knowledge not kept it permanently before his mind. Klopstock and even Wieland,[14] like Herder later on, took offense at the generous spirit in which Goethe acceded to the demands of his position, and even more to the demands made on him by the personality and mode of life of the grand duke. For, as the author of *Götz* and *Werther,* Goethe represented the bourgeois *Fronde.* And his name meant all the more as the tendencies of the age were barred from almost every means of expression other than the personal and individual. In the eighteenth century an author was still a prophet, and his works were the keystone to a gospel which seemed most perfectly expressed by his life. The immeasurable personal prestige which Goethe's first works had brought him—they were received as revelations—evaporated in Weimar. But since people were unwilling to think of him as being anything other than larger than life, the most nonsensical legends about him began to take shape. He was said to be getting drunk on brandy every day; Herder was alleged to be preaching in boots and spurs and riding three times round the church after the sermon. This was how people imagined the wild escapades of those first months in Weimar. Of greater consequence, however, was the friendship between Goethe and Karl August, the foundations for which were laid during this period and which subsequently provided Goethe with the guarantee of a comprehensive intellectual and literary sovereignty—the first such universal European dominion since Voltaire. "As for the judgment of the world," the nineteen-year-old Karl August wrote at the time, "which might disapprove of my installing Dr. Goethe in my most important council without his having already achieved the status of magistrate, professor, chamberlain, or state councilor—none of that will deter me in the least."

The suffering and the inner conflict of these first Weimar years were given new shape and sustenance in Goethe's love for Charlotte von Stein.[15] An examination of the style of the letters he wrote to her in the years from 1776 to 1786 reveals the steady transition from Goethe's earlier revolutionary prose—a prose "which cheated language of its privileges"—to the great composed rhythms of the letters which he dictated for her in Italy between 1786 and 1788. As for their content, they are the most important source of our knowledge of the difficulties the young poet experienced in coming to terms with the business of administration and, above all, with court society. By nature, Goethe was not always very adaptable.

He wished to become so, however, and kept a close watch on "the so-called men of the world, to see how they did it." And in fact it was impossible to conceive of a harder school than his relationship with Char-

lotte, which, given the small-town environment, was inevitably highly exposed. An added factor was that Charlotte von Stein, even in the years when she was in such profoundly intimate communion with Goethe's world, was never prepared to flout the rules of courtly decorum. It took years before she could acquire such an unshakable and propitious place in his life that her image could enter his work in the figures of Iphigenia and Eleonore d'Este, Tasso's beloved. The fact that he proved able to put down roots in Weimar the way he did is very closely bound up with his relationship to Charlotte von Stein. Through her he came to know not just the court, but also the town and the countryside. Alongside all the official memoranda, there is a constant stream of more or less hasty notes to Frau von Stein in which Goethe appears, as was his practice as a lover, in the full range of his talents and activities: as sketcher, painter, gardener, architect, and so on. When, in the course of his account of Goethe's life in 1779, Riemer relates how Goethe spent a month and a half traveling around the duchy, inspecting the roads by day, helping to recruit young men for military service in the evenings, and resting at small inns and working on *Iphigenie* at night, he provides us with a miniature portrait of this critical and in many ways threatened phase of Goethe's life.

The poetic yield of these years includes the beginnings of *Wilhelm Meisters theatralische Sendung* [Wilhelm Meister's Theatrical Mission], *Stella, Clavigo, Werthers Briefe aus der Schweiz* [Werther's Letters from Switzerland], *Tasso,* and above all a large part of his most powerful lyric poetry: "Harzreise im Winter" [Journey to the Harz in Winter], "An den Mond" [Ode to the Moon], "Der Fischer" [The Fisherman], "Nur wer die Sehnsucht kennt" [Only the One Who Knows Longing], "Über allen Gipfeln" [Over All the Summits], "Geheimnisse" [Secrets]. Goethe also did some work on *Faust* during these years, and even laid the inner foundations for parts of *Faust, Part II,* to the extent at least that it was in the experiences of these first Weimar years that we find the origins of Goethe's nihilistic view of the state, which was to be so bluntly expressed later in Act 2. In 1781 we find him saying: "Our moral and political world is undermined by subterranean galleries, cellars, and sewers, as often occurs in a great city when there is no one to think about and concern himself with its needs and with the conditions of the inhabitants. Only, for anyone who has got wind of the situation it will come as no very great surprise if one day the earth caves in, if smoke . . . rises up in one place and strange voices are heard in another."

Every step which strengthened Goethe's position in Weimar increased the distance between himself and the friends and associates of his youth in Strasbourg and Wetzlar. The incomparable authority which had accompanied him to Weimar and which he had brought to bear to such effect in the court, was based on his role as leader of the *Sturm und Drang.* In a

provincial town like Weimar, however, this was a movement which could make only a brief appearance and, since it was prevented from bearing any fruit, it was forced to remain at the level of tumultuous extravaganza. Goethe saw this quite clearly from the outset and did everything in his power to prevent any attempts to transplant Strasbourg ways to Weimar. In 1776, when Lenz appeared in Weimar and behaved at court in the style of the *Sturm und Drang*, Goethe had him expelled. That was political expediency. But to an even greater degree it was an instinctive reaction against the boundless impulsiveness and emotional extravagance implicit in the lifestyle of his youth—a style which he felt himself unable to contain in the long run. Among his associates at that time, he had seen the most egregious examples of scandalous behavior; a statement of Wieland's from that period gives us a glimpse of the devastating effects on him of his association with such people. Wieland wrote to a friend saying that he would not like to purchase Goethe's fame if the price he had to pay was the latter's physical suffering. In later years, then, the poet took the strictest prophylactic measures to protect his constitutional sensitivity. Indeed, when we observe the precautions Goethe took to avoid certain tendencies—all forms of nationalism and most of Romanticism, for example—we are forced to conclude that he was afraid they might be directly contagious. The fact that he wrote no tragic work is something he himself attributed to that same frailty of constitution.

The more Goethe's life in Weimar approached a certain state of equilibrium—in external terms, his acceptance into court society was completed in 1782 by his elevation into the nobility—the more unbearable he found the town. His impatience took the form of a pathological irritation with Germany. He talked of writing a work which the Germans would hate. His antipathy went even deeper. After a two-year youthful enthusiasm for German Gothic, landscape, and chivalry, Goethe began to discover in himself a resistance to the climate, landscape, history, politics, and nature of his own people—a resistance which came from his innermost being. This mood began to take shape vaguely and unclearly when he was twenty-five; it gradually became clearer, and then a matter of passionate conviction, culminating in a definite view systematically rationalized. It found dramatic expression in 1786 in Goethe's abrupt departure for Italy. He himself described his journey as a flight. He was so oppressed by tensions and superstitious feelings that he had not ventured to divulge his plans to anyone.

In the course of this journey—which lasted two years and which took him to Verona, Venice, Ferrara, Rome, and Naples and down to Sicily—two issues were resolved. The first was that Goethe renounced his hopes of committing himself to a life based on the visual arts. This was an idea he had repeatedly entertained. If Goethe had unconsciously acquired the image of a dilettante in the eyes of the nation, an image which he was long reluctant

to discard, one of the reasons for this, as well as for the many instances of uncertainty and carelessness in his literary works, was his hesitation about the nature of his gifts. In order to smooth his way as a poet, he all too often allowed his genius to degenerate to a mere talent. His experience of the great art of the Italian Renaissance—which Goethe, since he was gazing at it through Winckelmann's eyes,[16] was unable to distinguish clearly from that of Antiquity—on the one hand laid the foundation for his conviction that he was not meant to be a painter, while on the other it supplied the basis for that narrow classicist theory of art which is perhaps the only sphere of thought in which Goethe lagged behind his age, rather than taking the lead. There was yet another sense in which Goethe may be said to have rediscovered his true self. In a letter home, he says, referring to the Weimar court: "The illusion that the fine seeds which are ripening in my life and in those of my friends had to be sown in this ground, and that those celestial jewels could be made to fit into the earthly crowns of these princes, has now been completely dispelled, and I find my youthful happiness wholly restored."

In Italy, the prose draft of *Iphigenie* gave way to the definitive version. The following year, 1788, Goethe completed *Egmont*. *Egmont* is no political drama, but a character study of the German tribune that Goethe, as the spokesman of the German bourgeoisie, might at a pinch have become. The only trouble with it is that this portrait of the fearless man of the people is all too idealized, and this in turn lends greater force to the political realities uttered by Alba and William of Orange. The concluding phantasmagoria— "Freedom clad in a celestial gown, bathed in light, rests upon a cloud"— unmasks the supposedly political ideas of Count Egmont and reveals them as the poetic inspiration they fundamentally are. Goethe inevitably had a very limited view of the revolutionary freedom movement which broke out in the Netherlands in 1566 under the leadership of Count Egmont. His vision was obscured, in the first place, by a social milieu and a personal temperament for which the conservative notions of tradition and hierarchy were inalienable; and, in the second place, by his basic anarchistic attitude, his inability to conceive of the state as a factor in history. For Goethe, history represented an unpredictable sequence of cultures and forms of rule in which the only fixed points were great individuals such as Caesar and Napoleon, Shakespeare and Voltaire. He was never able to bring himself to believe in national or social movements. It is true that he was unwilling on principle to make a general statement about such matters, but this is the view that emerges both from his conversations with Luden, the historian, and also from *Wilhelm Meisters Wanderjahre* [Wilhelm Meister's Wanderings] and *Faust*. It is such convictions as these that determined his relationship with the dramatist Schiller. For Schiller, the problem of the state had always been a matter of central importance. The state in its relations to the individual was the subject of his early plays; the state in its relations to the repre-

sentatives of power was the theme of the works of his maturity. In contrast, the driving force in Goethe's dramas is not conflict but a process of unfolding.—The chief lyrical product of his Italian period was the *Römische Elegien* [Roman Elegies], a collection of poems which preserve the memory of many Roman nights of love in verses remarkable for their classical definition and perfection of form. The heightened sensual intensity of his nature now drove him to the decision to concentrate his energies and henceforth to confine himself to more limited commitments. While still in Italy, Goethe wrote the duke a letter which shows his diplomatic style at its best, asking to be relieved of all his political and administrative duties. His request was granted, but despite this it was only after lengthy detours that Goethe found his way back to intensive literary production. The chief cause of the delay must be sought in his preoccupation with the French Revolution. In order to understand his attitude here—as well as his scattered, disconnected, and impenetrable utterances on political matters—it is less important to make a synthesis of his theoretical improvisations than to consider their function.

It is beyond all doubt that after his experience as a privy councilor in Weimar and long before the outbreak of the French Revolution, Goethe found the enlightened despotism of the eighteenth century problematic in the extreme. Nevertheless, he proved unable to reconcile himself to the Revolution. This was not just because of his temperamental attachment to the feudal regime, or even because of his fundamental opposition to any violent upheavals in public life, but because he found it difficult and even impossible to arrive at any considered views on political issues. If he never made the clear statement on the "limits of the efficacy of the state" that we find, for example, in Wilhelm von Humboldt,[17] the reason was that his political nihilism was too extreme to enable him to do more than drop inconclusive hints. It is enough to note that Napoleon's intention of dividing the German people up into its original tribes held no terrors for Goethe, who regarded such perfect fragmentation as the outward manifestation of a community in which great individuals could demarcate their own spheres of activity—a realm in which they could exercise patriarchal sway and communicate with one another down the ages and across the frontiers of the state. It has been rightly said that for Goethe, who was himself the quintessence of a gallicized Franconia, the Germany of Napoleon supplied the environment that suited him best. But in his relationship to the Revolution, we must also take note of the effects of his hypersensitivity, the pathological state of shock induced in him by the great political events of his age. This shock, the effect of certain episodes in the French Revolution as well as of personal blows of fate, made the idea of reordering the world of politics purely on the basis of principles as inconceivable to him as

applying such principles in order to regulate the private existence of individuals.

In the light of the class antagonisms existing in Germany at the time, we may interpret this in the following way: unlike Lessing,[18] Goethe felt himself to be less the champion of the middle classes than their deputy—their ambassador to German feudalism and the princes. His constant vacillation may be explained in terms of the conflicts arising from his position as representative. The greatest representative of classical bourgeois literature—the only indisputable claim of the German people to the honor of being admitted to the ranks of modern cultured nations—was himself unable to conceive of bourgeois culture outside the framework of a perfected feudal state. Of course, if Goethe rejected the French Revolution, this was not just so as to defend feudalism—the patriarchal idea that every culture, including bourgeois culture, could thrive only under the protection of and in the shadow of the absolutist state. Of equal importance was the petty-bourgeois motive, the efforts of the private individual who anxiously seeks to seal off his life and protect it from the political upheavals all around. But neither the spirit of feudalism nor that of the petty bourgeoisie sufficed to make his rejection absolute and unequivocal. It is for this reason that not a single one of the literary works in which he sought over a period of ten years to come to terms with the Revolution can be assigned a central place in his overall output.

Between 1792 and 1802, there are no fewer than seven works in which Goethe attempted again and again to arrive at a compelling formula or a definitive portrait. Primarily these included occasional pieces such as *Der Grosskophta* [The Great Magician] or *Die Aufgeregten* [The Agitated], which mark the nadir of Goethe's achievement, or else, as in *The Natural Daughter,* efforts that were doomed to remain fragments. In the end, however, Goethe came closest to his goal in two works that both treat the Revolution, as it were, *en bagatelle. Hermann und Dorothea* reduces it to a sinister background which serves as a useful foil to an attractive German small-town idyll; *Reineke Fuchs* [Reynard the Fox] dissolves the pathos of the Revolution into a verse satire in which it is no coincidence that Goethe reverts to the medieval genre of the animal epic. The Revolution as background to a moralistic genre scene—this is the method of *Hermann und Dorothea;* the Revolution as comic intrigue, as an intermezzo in the animal history of mankind—this is his approach in *Reynard the Fox.* It is by such methods that Goethe overcomes the traces of resentment that are evident in his earlier attempts in this direction, above all in the *Unterhaltungen deutscher Ausgewanderten* [Conversations of German Emigrés]. But the notion that has the last word here is the hierarchical, feudal belief that the high point of human history finds mankind assembled around the person of the

monarch. Despite this, it is the king in *The Natural Daughter* who makes Goethe's failure to comprehend political history so palpably plain. He is King Thoas of *Iphigenie* in a new garb, the king as "the good man," who, when transported into the upheavals of the Revolution, must inevitably be found wanting.

The political problems which the 1790s imposed on Goethe's writing explain why he made a series of efforts to escape from literature. His chief refuge was the study of science. Schiller clearly perceived the escapist character of Goethe's scientific preoccupations in these years. In 1787 he wrote to Körner:[19] "Goethe's mind has molded all the people who belong to his circle. A proud philosophical contempt for all speculation and investigation, together with an attachment to nature bordering on affectation and a retreat to knowledge as vouchsafed by his five senses—in short, a certain childlike simplicity of mind characterizes him and his whole sect here. They prefer looking for herbs or studying mineralogy to empty theorizing. This can be quite wholesome and good, but it can also be greatly overdone." His study of natural history could only estrange Goethe still further from politics. He understood history only as natural history, and comprehended it only insofar as it remained bound to creatureliness. This is why the educational theory he later developed in *Wilhelm Meister's Wanderings* represented the most advanced position he was able to adopt in the realm of the historical. His scientific bent went against the grain of politics, but it must be added that it was equally hostile to theology. In this respect it represents the most positive fruit of Goethe's anticlerical Spinozism. It explains why he took offense at the Pietistic writings of Jacobi,[20] his former friend, because the latter had argued that nature conceals God, whereas for Goethe the crucial aspect of Spinoza's thought lay in his assertion that both nature and spirit are a visible aspect of the divine. This is what Goethe means when he writes to Jacobi, saying, "God has punished you with metaphysics . . . ; whereas He has blessed me with physics."—Goethe's master concept in describing the revelations of the physical world is the "primal phenomenon" [*Urphänomen*]. It developed originally out of his botanical and anatomical studies. In 1784 Goethe discovered that the bones of the skull were the morphological development of changes in the bones of the spine; a year later he discovered the "metamorphosis of plants." What he meant by this was the idea that all the organs of plants, from the roots to the stamen, are nothing but leaves in a modified form. This led him to the concept of the "primal plant" [*Urpflanze*], which Schiller, in his celebrated first conversation with him, declared to be an "idea," whereas Goethe insisted on endowing it with a certain sensuous reality. The place occupied in Goethe's writings by his scientific studies is the one which in lesser artists is commonly reserved for aesthetics. This aspect of Goethe's work can be appreciated only when one realizes that, unlike almost all other intellectuals in this period, he never

really made his peace with the idea of art as "beautiful appearance" [*der schöne Schein*]. What reconciled poetry and politics in his eyes was not aesthetics, but the study of nature. And precisely because of this it is vital to note even in his scientific writings how obstinately Goethe opposed certain innovations in the realm of technology, just as much as in politics. On the very threshold of the scientific age, which was destined to extend the range and precision of our sense-perceptions in such a radical and unprecedented way, he reverted once more to old forms of scientific explanation and could therefore write: "Man himself, when he makes use of his own sound senses, is the greatest and most precise physical apparatus that can exist; and the great catastrophe of modern physics is that in it experiments have, as it were, been separated off from man, and aim . . . to know Nature simply by virtue of what artificial instruments can reveal." According to his way of thinking, the immediate natural purpose of science is to bring man in his thought and actions into harmony with himself. Changing the world by means of technology was not really his concern, even though as an old man he was astonishingly clear about its immeasurable implications for the future. To his mind, the greatest benefit of scientific knowledge was determined by the form it gives to one's life. This conviction was something he developed into a strict pragmatic maxim: "Only what is fruitful is true."

Goethe belongs to the family of great minds for whom there is basically no such thing as an art separated from life. In his eyes, the theory of the "primal phenomenon" in science was also a theory of art, just as scholastic philosophy had been for Dante and the technical arts for Dürer. Strictly speaking, his only genuine scientific discoveries were in the field of botany. His research in anatomy was also important and has received recognition: this was his work on the intermaxillary bone, which admittedly was no original discovery.[21] His *Meteorologie* received little attention, and his *Farbenlehre* [Theory of Colors], which for Goethe represented the crowning point of his entire scientific work—and indeed, according to a number of statements, of his whole life—became the subject of fierce dispute. In recent times the controversy surrounding this, the most comprehensive of Goethe's scientific writings, has flared up once more. The *Theory of Colors* takes up a position diametrically opposed to Newton's optics. The basic disagreement underlying Goethe's often bitter polemic, prolonged over many years, is this: whereas Newton explained white light as the composite of the different colors, Goethe declared it to be the simplest, most indivisible and homogeneous phenomenon known to us. "It is not a compound . . . least of all, a compound of colored lights." The *Theory of Colors* regards the colors as metamorphoses of light, as phenomena which are formed in the course of the struggle between light and darkness. Together with the idea of metamorphosis, the concept of polarity, which runs like a thread through

Goethe's entire scientific enterprise, is of decisive importance here. Darkness is not merely the absence of light—for then it would not be discernible—but a positive counter-light. In his old age we even find him entertaining the idea that perhaps plants and animals evolved from their primal condition through the agency of light or darkness.—A peculiar feature of his scientific studies is that in them Goethe comes as close to the spirit of the Romantic school as he remains remote from it in his aesthetics. It is much harder to explain Goethe's philosophical position in terms of his poetic writings than to explain it in terms of his scientific ones. Ever since that youthful moment of illumination which is recorded in Goethe's celebrated fragment "Die Natur" [Nature], Spinoza remained the guiding light in his morphological studies. It was these that subsequently provided the basis for his relationship with Kant. While he could not find any point of contact with Kant's main critical oeuvre—the *Critique of Pure Reason* and the *Critique of Practical Reason* (i.e., ethics)—he held the *Critique of Judgment* in the greatest possible esteem. For in that work Kant repudiates the teleological explanation of nature which had been one of the chief supports of enlightened philosophy and of deism. Goethe had to agree with him on this point, particularly since his own anatomical and botanical researches represented very advanced positions in the campaign of bourgeois science against the teleological outlook. Kant's definition of the organic as a purposiveness whose intent lay inside and not outside the purposive being was in harmony with Goethe's own concepts. The unity of the beautiful—natural beauty included—is always independent of purpose. In this, Goethe and Kant are of one mind.

The more Goethe was affected by developments in Europe, the more vigorous were his efforts to achieve security in his private life. It is in this context that we have to consider the fact that very shortly after his return from Italy he ended the relationship with Charlotte von Stein. Goethe's association with Christiane Vulpius,[22] whom he met soon after he came back from Italy and who later became his wife, continued to outrage the citizens of the town for fifteen years. Nevertheless, it would be an error to think of this relationship with a proletarian girl, who worked in a flower nursery, as evidence of Goethe's emancipated views. Even in such matters of private life, Goethe held no fixed principles, let alone revolutionary ones. At the start, Christiane was no more than his mistress. The remarkable feature of the relationship was not its beginnings but its later development. Even though Goethe was never able, and perhaps never even tried, to bridge the enormous cultural gap between himself and Christiane, even though Christiane's lowly birth inevitably gave offense to the petty-bourgeois society of Weimar and her way of life proved unacceptable to more liberal-minded and intelligent people, and even though neither partner regarded marital fidelity as sacrosanct—all this notwithstanding, Goethe dignified this union

and with it Christiane by his unswerving loyalty and by a wholly admirable perseverance in an extremely delicate situation. And with a church wedding in 1807, fifteen years after their first meeting, he forced both court and society to accept the mother of his son. As for Frau von Stein, a lukewarm reconciliation was achieved only much later, after years of profound antipathy.

In 1790, as minister of state, Goethe assumed responsibility for culture and education, and a year later he was put in charge of the court theater. His activities in this sphere are simply immeasurable. They grew in scope from one year to the next. All scientific institutes, all the museums, the University of Jena, the technical schools, the voice-training academies, the academy of art—all these were placed under the poet's immediate direction, and he frequently concerned himself with the most minute details. Hand in hand with this went his efforts to expand his own household into an institute of European culture. His activities as a collector extended to every area of study and interest. These collections have formed the basis of the Goethe National Museum in Weimar, with its picture gallery, its galleries of drawings, porcelain, coins, stuffed animals, bones and plants, minerals, fossils, and chemical and physical apparatus, to say nothing of the collections of books and manuscripts. His universality knew no bounds. In areas in which he could not achieve anything as an artist, he wished at least to be a connoisseur. At the same time, these collections provided a framework for a life which increasingly was enacted publicly on the European stage. They also endowed him with the authority which he required in his role as the greatest organizer of princely patronage that Germany had ever known. Voltaire was the first man of letters to secure a reputation on a European scale and to make use of intellectual and material resources of equal magnitude to defend the prestige of the bourgeoisie vis-à-vis the aristocracy. In this respect, Goethe is Voltaire's immediate successor. And as with Voltaire, Goethe's position must be thought of in political terms. Hence, despite his rejection of the French Revolution it remains true that he more than anyone else made purposeful and ingenious use of the increase in power which that revolution brought to men of letters. Whereas Voltaire acquired wealth on a princely scale in the second half of his life, Goethe never achieved comparable financial status. But in order to understand his remarkable obstinacy in business matters, notably in his dealings with the publishing house of Cotta, we must bear in mind that from the turn of the century onward he looked upon himself as the founder of a national heritage.

Throughout this decade it was Schiller who time and again recalled Goethe from the distractions of his political activities and his immersion in the observation of nature and brought him back to literary work. The first meeting between the two poets took place soon after Goethe's return from Italy, and was not a success. This was very much in tune with the opinion

each held of the other. Schiller, who had made his name with such plays as *Die Räuber* [The Robbers], *Kabale und Liebe* [Intrigue and Love], *Fiesko,* and *Don Carlos,* had committed himself to class-conscious statements of a directness that stood in the sharpest possible contrast to Goethe's efforts at moderate mediation. Whereas Schiller wanted to take up the class struggle all along the line, Goethe had long since retreated to that fortified position from which only a cultural offensive could be launched and any political activity on the part of the bourgeoisie had of necessity to be defensive. The fact that these two men could reach a compromise is symptomatic of the unstable character of the class consciousness of the German bourgeoisie. This compromise was brought about under the aegis of Kantian philosophy. In the interests of aesthetics, Schiller, in his letters concerning *Über die ästhetische Erziehung des Menschen* [The Aesthetic Education of Man], had stripped the radical formulations of Kantian ethics of their subversive bite and converted them into an instrument of historical construction. This paved the way for a rapprochement—or, better, an armistice—with Goethe. In reality, the association between the two men was always marked by the diplomatic reserve which was the price of this compromise. The discussions between them were almost anxiously confined to formal problems of writing. Admittedly, on this plane their exchanges were epoch-making. Their correspondence is no doubt a balanced document, carefully edited to the last detail, and for ideological reasons it has always enjoyed a greater prestige than the deeper, freer, livelier correspondence which the aged Goethe conducted with Zelter.[23] The Young-Germany critic Gutzkow[24] has rightly drawn attention to the "hairsplitting discussions about aesthetic trends and artistic theories" which go round and round in circles throughout the correspondence. And he was also right to lay the blame for this at the door of the hostility—indeed, the utter incompatibility—of art and history which we encounter here. And even when it came to their greatest works, the poets could not always rely on each other for a sympathetic reception. "He was," Goethe says of Schiller in 1829, "like all people who base themselves too much on ideas. He had no peace of mind and could never be finished with a thing . . . I had my work cut out to hold my own, and protect his work and mine and keep them safe from such influences."

Schiller's influence was important primarily for Goethe's ballads: "Der Schatzgräber" [The Treasure Seeker], "Der Zauberlehrling" [The Sorcerer's Apprentice], "Die Braut von Korinth" [The Bride of Corinth], and "Der Gott und die Bajadere" [The God and the Bayadere]. The official manifesto of their literary alliance, however, was *Die Xenien.* The almanac containing these satirical epigrams appeared in 1795. Its thrust was directed at the enemies of Schiller's *Die Horen*[25]—namely, the vulgar rationalism centered on Nicolai's circle in Berlin. The onslaught was effective. The literary success was heightened by a personal interest: both poets had put their names to

the whole collection, without revealing the authorship of the individual couplets. But all the verve and elegance of their campaign could not conceal an underlying note of desperation. The era of Goethe's popular acclaim was over; and even if his authority grew from one decade to the next, he never again achieved true popularity. The later Goethe in particular displays that resolute contempt for the reading public which is characteristic of all the classical writers with the exception of Wieland, and which receives its strongest expression at certain points in the Goethe-Schiller correspondence. Goethe had no relationship with his public. "Although he had a powerful impact, it remains true that he never lived or continued to live in that realm in which he created those first works which set the world alight." He remained unaware of the extent to which he was himself a kind of gift to Germany. And least of all was he able to commit himself to any trend or tendency of the age. His attempt to represent his alliance with Schiller as such a trend ultimately proved illusory. The destruction of this illusion was a legitimate need, and one which repeatedly led the German public in the nineteenth century to contrast Goethe and Schiller and measure each against the other. The influence of Weimar on the great mass of Germans was not that of the two poets, but that of the periodicals of Bertuch[26] and Wieland: the *Allgemeine literarische Zeitung* and the *Teutscher Merkur.* "We do not desire the upheaval," Goethe had written in 1795, "which could pave the way for classical works in Germany." The upheaval in question—that would have been the emancipation of the bourgeoisie, which came too late to give birth to any classical works. Germanness, the genius of the German language—those were undoubtedly the strings on which Goethe played his great melodies. Yet the sounding-board of this instrument was not Germany, but the Europe of Napoleon.

Goethe and Napoleon shared a similar vision: the social emancipation of the bourgeoisie within the framework of political despotism. This was the "impossible," the "incommensurable," and the "inadequate" that was the deepest source of their unease. It brought Napoleon down. Of Goethe, however, it can be said that the older he became, the more his life assumed the shape of this political idea, consciously acquiring the form of the incommensurable and the inadequate, and turning itself into a miniature model of that political idea. If we could draw clear lines of demarcation, then we could think of poetry as providing a metaphor for the bourgeois freedom of this micro-state, whereas in its private affairs the regime corresponds perfectly to the rule of despotism. But in reality, of course, it is equally essential to pursue the interweaving of these irreconcilable aspirations in both life and poetry: in life, as a freedom of erotic breakthrough and as the strictest regime of "renunciation"; in poetry, nowhere more than in the second part of *Faust,* whose political dialectics provide the key to Goethe's position. Only in this context is it possible to understand how Goethe could

spend his last thirty years subordinating his life to the bureaucratic catego-
ries of compromise, mediation, and procrastination. It is senseless to judge
his actions and his stance in terms of any abstract standard of morality. It
is such abstraction that is responsible for the touch of absurdity we see in
the attacks Börne launched against Goethe in the name of Young Germany.[27]
It is precisely when we come to examine his maxims and the most remark-
able aspects of his conduct that we find that Goethe becomes comprehensi-
ble only in the context of the political position which he created and in
which he installed himself. The subterranean but all the more profound
kinship with Napoleon is so decisive that the post-Napoleonic age, the
power that toppled Napoleon, is no longer capable of understanding it. The
son of bourgeois parents rises in the world, outstrips everyone, becomes the
heir to a revolution whose power in his hands is such that it makes everyone
tremble (French Revolution; *Sturm und Drang*); and at the very moment he
dealt the most grievous blow to the power of superannuated forces, he
established his own dominion within the selfsame archaic, feudal framework
(empire; Weimar).

Within the political constellation that governed his life, the animosity
Goethe felt for the Wars of Liberation, an animosity highly offensive to
bourgeois literary historians, becomes entirely comprehensible. In his eyes,
Napoleon had been the founder of a European public even before he had
established a European empire. In 1815 Goethe let himself be persuaded by
Iffland[28] to write one last play, *Des Epimenides Erwachen* [The Awakening
of Epimenides], in celebration of the entry of the victorious troops into
Berlin. But he could bring himself to renounce Napoleon only by simulta-
neously refusing to relinquish the chaotic and dark manifestations of the
same elemental power which Napoleon embodied and which had once
shaken the world. He could muster no sympathy for the victors. And on
the other hand, we find the same kind of idiosyncrasy in the pained deter-
mination with which he fends off the patriotic spirit which moved Germany
in 1813—something we also see in the way he could not bear to remain in
the same room with sick people or in the vicinity of the dying. His dislike
of everything military is not so much a rejection of army discipline or even
drill, as a horror of everything which is calculated to detract from the
appearance of the human being—everything from the uniform to the wound.
In 1792 his nerves were subjected to a severe test when he had to accompany
the duke in the invasion of France by the allied armies. On this occasion
Goethe was forced to display all his art in concentrating on the observation
of nature, optical studies, and sketching, in order to insulate himself from
the events he was witnessing. The "Kampagne in Frankreich" [Campaign
in France] is just as vital for an understanding of the poet as it is a
melancholy and vague response to the problems of world politics.

The change of direction toward Europe and toward politics—this is the

mark of the final stage of Goethe's poetic work. But it was only after the death of Schiller that he could feel this as the firmest of all ground beneath his feet. In contrast, the great prose work which was taken up again after a long pause and completed under Schiller's influence, *Wilhelm Meisters Lehrjahre* [Wilhelm Meister's Apprenticeship], shows Goethe still tarrying in the antechambers of idealism, in that German humanism from which he later emerged after much struggle to enter into an ecumenical humanism. The ideal of the *Appenticeship* (education) and the social milieu of the hero (the world of actors) are indeed strictly related to each other, since they are both the exponents of that specifically German realm of "beautiful appearance" that seemed so empty of meaning to the bourgeoisie of the West, which was just in the process of entering on its period of hegemony. In fact, it was almost a poetic necessity to place actors in the center of a bourgeois German novel. It enabled Goethe to avoid a confrontation with the contingencies of politics, only to take them up again with a correspondingly greater vigor twenty years later in the sequel to the novel. The fact that in *Wilhelm Meister* Goethe's hero was a quasi-artist was what guaranteed the novel's decisive influence, precisely because it was a product of the German situation at the end of the century. It led to the series of artist-novels of Romanticism, from the *Heinrich von Ofterdingen* of Novalis and Tieck's *Sternbald* down to Mörike's *Maler Nolten*.[29] The book's style is in harmony with its content. "There is no sign anywhere of logical machinery or a dialectical struggle between ideas and subject matter; instead, Goethe's prose offers a theatrical perspective. It is a thought-out piece that has been learned by heart, a work in which gentle prompting has led to a creative structure of thought. In it, things themselves do not speak but, as it were, seek the poet's permission to speak. This is why its language is lucid and yet modest, clear but without obtruding itself, diplomatic in the extreme."

It lay in the nature of both men that Schiller's influence functioned essentially as a formative stimulus on Goethe's production, without basically modifying its direction. The fact that Goethe turned toward the ballad and resumed work on *Wilhelm Meister* and the *Faust* fragment may perhaps be put down to Schiller's influence. But the actual exchange of ideas about these works almost always confined itself to questions of craft and technique. Goethe's inspiration remained undiverted. His friendship was with Schiller the man and the author. But it was not the friendship of two poets, as has often been claimed. The extraordinary charm and force of Schiller's personality nevertheless revealed themselves to Goethe in their full magnitude, and after Schiller's death Goethe left a memorial to them in the poem "Epilog zu Schillers, 'Glocke,'" [Epilogue to Schiller's "Bell"].

After Schiller's death, Goethe reorganized his personal relationships. Henceforth he would not have anyone in his immediate circle whose stature was even remotely comparable to his own. And there was hardly anyone in

Weimar who could be said to have been taken into his confidence in any special way. On the other hand, in the course of the new century his friendship with Zelter, the founder of the Berlin voice-training academy, grew in importance for Goethe. In time, Zelter came to assume the rank of a sort of ambassador for Goethe, representing him in the Prussian capital. In Weimar itself Goethe gradually acquired an entire staff of assistants and secretaries, without whose help the vast inheritance that he prepared for publication could never have been organized. In an almost mandarin way, the poet ended up putting the last thirty years of his life in the service of producing the written word. It is in this sense that we have to regard his great literary press office with its many assistants, from Eckermann, Riemer, Soret, and Müller down to clerks like Kräuter and Kohn.[30] Eckermann's *Conversations with Goethe* are the main source for these last decades, and are moreover one of the finest prose works of the nineteenth century. What fascinated Goethe about Eckermann, perhaps more than anything else, was the latter's unrestrained attachment to the positive—a quality never found in superior minds and which is rare even in lesser men. Goethe never had any real relationship with criticism in the narrower sense. The strategy of the art business, which did fascinate him from time to time, always ex-pressed itself in dictatorial ways—in the manifestos he drafted with Schiller and Herder, or in the regulations he drew up for actors and artists.

More independent than Eckermann, and for that very reason, of course, less exclusively useful to the poet, was Chancellor von Müller. But his *Conversations with Goethe* are likewise one of the documents that have helped to shape the image of Goethe as it has come down to posterity. These two should be joined by Friedrich Riemer (a professor of classical philology), not because of his gifts as a conversationalist but by virtue of his great and perceptive analysis of Goethe's character. The first great document to emerge from this literary organism which the aging Goethe created for himself was the autobiography. *Dichtung und Wahrheit* [Poetry and Truth] is a preview of Goethe's last years in the form of a memoir. This retrospective account of his active youth provides access to one of the most crucial principles of his life. Goethe's moral activity is in the last analysis a positive counterpole to the Christian principle of remorse: "Seek to give a coherent meaning to everything in your life." "The happiest man is one who can establish a connection between the beginning of his life and the end." In such state-ments we see an expression of the desire to give shape to and make manifest the image of the world he had accommodated himself to in his youth: the world of the inadequate, the compromised, the contingent; of erotic indeci-sion and political vacillation. It is only against this background that we can see the Goethean credo of "renunciation" in its right sense, in all its terrible ambiguity: Goethe renounced not just pleasure, but also greatness and heroism. This is perhaps why his autobiography breaks off before its hero

has achieved a position in society. The reminiscences of later years are scattered through the *Italienische Reise* [Italian Journey], the *Campaign in France,* and the *Tag- und Jahreshefte* [Diaries]. In his description of the years 1750–1775, Goethe has included a series of vignettes of the most important contemporaries of his youth; while Günther, Lenz, Merck, and Herder have partly entered literary history in the same formulas that Goethe devised for them. In portraying them Goethe depicted himself at the same time, and shows himself adopting a hostile or sympathetic stance toward the friends or competitors with whom he had to deal. We see here the same compulsion at work that inspired him as a dramatist to confront William of Orange with Egmont, the courtier with the man of the people; Tasso with Antonio, the poet with the courtier; Prometheus with Epimetheus, the creative man with the elegiac dreamer; and Faust with Mephisto—the ensemble of personas at work in his own personality.

Beyond this more immediate group of assistants, a further circle grew up in these later years. There was the Swiss artist Heinrich Meyer,[31] Goethe's expert on questions of art, strictly classicist in outlook, a reflective man who helped Goethe with the editing of the *Propyläen* and with the later periodical *Kunst und Altertum* [Art and Antiquity]. There was Friedrich August Wolf, the classical philologist, whose demonstration that the Homeric epics were the product of a whole series of unknown poets which were harmonized by a later editor and only then became known as the works of Homer evoked very mixed feelings in Goethe.[32] Wolf, together with Schiller, was drawn into Goethe's attempt to write the *Achilleis* as a sequel to the Homeric epics, a work that remained a fragment. We should also mention Sulpiz Boisserée, the discoverer of the German Middle Ages in painting, the inspiring advocate of German Gothic, and, as such, a friend of the Romantics, who chose him to act as spokesman for their views on art.[33] (His labors in this direction, which were spread over many years, had to rest content with a half-victory: Goethe finally allowed himself to be persuaded to submit a collection of documents and plans concerning the history and completion of Cologne Cathedral to the court.) All these relationships, and countless others, are the expression of a universality in the interests of which Goethe consciously blurred the dividing lines between the artist, the researcher, and the amateur. No poetic genre or language acquired popularity in Germany without Goethe at once turning his attention to it. Everything he achieved as translator, writer of travel books, biographer, connoisseur, critic, physicist, educationalist, and even theologian, as theatrical producer, court poet, companion, and minister—all this served to enhance his reputation for universality. But it was a European as opposed to a German arena which increasingly became the focus of these interests. He felt a passionate admiration for the great European minds who emerged toward the end of his life—for Byron, Walter Scott, and Manzoni.[34] In Germany, on the other hand, he would

often give advancement to mediocrities, and he failed to appreciate the genius of such contemporaries as Hölderlin, Kleist, and Jean Paul.[35]

In 1809, at the same time as *Poetry and Truth,* Goethe also wrote *Die Wahlverwandtschaften* [Elective Affinities]. His work on this novel coincided with his first real experience of the European nobility, an experience which gave him an insight into that new, self-assured worldly public to whom, twenty years previously in Rome, he had resolved to address his writings. *Elective Affinities* is in fact directed at a public consisting of the Silesian-Polish aristocracy, lords, émigrés, and Prussian generals who congregated in the Bohemian spas around the empress of Austria. Not that this prevents the poet from giving a critical view of their mode of life. For *Elective Affinities* provides a sketchy but very incisive picture of the decline of the family in the ruling class of the period. Yet the power which destroys this already disintegrating institution is not the bourgeoisie, but a feudal society which, in the shape of the magic forces of fate, finds itself restored to its primordial state. Fifteen years before, in his drama of the French Revolution, *The Agitated,* Goethe had made the schoolmaster say of the nobility, "For all their superciliousness, these people cannot rid themselves of the mysterious feeling of awe that permeates all the living forces of nature; they cannot bring themselves to deny the eternal bond that unites words and effects, actions and their consequences." And these words provide the magical patriarchal ground-motif of this novel. It is a mode of thought we find repeated in *Wilhelm Meister's Wanderings,* in which even the most resolute attempts to construct the image of a fully developed bourgeoisie lead him back inexorably to the pastiche of mystical, medieval organizations—the secret society of the Tower. Goethe understood the emergence of bourgeois culture more fully than any of his predecessors or successors, but he was nonetheless unable to conceive of it otherwise than from within the framework of an idealized feudal state. And when he found himself even further estranged from Germany by the mismanagement of the German Restoration, which coincided with the last twenty years of his working life, he emphasized this idealized feudalism still further by amalgamating it with the patriarchal features of the East. We witness the emergence of the oriental Middle Ages in the *West-Easterly Divan.*

Not only did this book create a novel type of philosophical poetry; it was also the greatest expression of the love poetry of old age to be found in German and European literature. It was more than political necessity that led Goethe to the Orient. The powerful late blossoming of Goethe's erotic passion in his later years made him regard old age itself as a rebirth, as a sort of fancy-dress which merged in his mind with the world of the Orient and which transformed his encounter with Marianne von Willemer into a brief, intoxicating festival.[36] The *West-Easterly Divan* is the epode of this love. Goethe could understand the past, history, only to the extent to which

he could integrate it into his life. In the succession of passionate relationships, Frau von Stein represented for him the reincarnation of Antiquity, Marianne von Willemer the Orient, and Ulrike von Levetzow, his last love, the symbiosis of these with the fairy-tale images of his youth.[37] This is the message of his last love poem, the *Marienbader Elegie*. Goethe underlined the didactic strain in the *West-Easterly Divan*, in the notes he appended to the volume; there basing himself on Hammer-Purgstall and Diez, he presented the fruits of his oriental studies to the public. Amid the expanses of the Middle Ages in the East, amid princes and viziers, in the presence of the splendor of the imperial court, Goethe assumes the mask of Hatem, a vagabond and drinker, a man without needs, and thereby commits himself in his poetry to that hidden aspect of his nature which he once confided to Eckermann: "Magnificent buildings and rooms are all right for princes and wealthy men. When you live in them, you feel at your ease . . . and want nothing more. This is wholly at odds with my nature. When I live in a splendid house, like the one I had in Karlsbad, I at once become lazy and inactive. A lowlier dwelling, on the other hand, like the wretched room we are in now, a little disorderly in its order, a little gipsy-like—that is the right thing for me; it leaves my inner being with the complete freedom to do what it wishes and to create from within myself." In the figure of Hatem, Goethe, who had by then become reconciled to the experience of his adult years, allows free rein to the unstable and untamed elements of his youth. In many of these poems he was able to use all his genius to give the wisdom of beggars, tavernkeepers, and tramps the finest poetic expression they have ever received.

In *Wilhelm Meister's Wanderings* the didactic quality of the later writings is at its most deliberate. The novel, which had long lain fallow, was then completed in a great hurry. Teeming with contradictions and inconsistencies, it was finally treated by the poet as a storehouse in which he got Eckermann to record the contents of his notebooks. The numerous stories and episodes which form the basis of the work are only loosely connected. The most important of them concern the "Pedagogical Province," a very remarkable hybrid in which we can see Goethe coming to grips with the great socialist writings of Sismondi, Fourier, Saint-Simon, Owen, and Bentham.[38] It is unlikely that his knowledge of them derived from his own reading; their influence among his contemporaries was powerful enough to induce Goethe to try to combine feudal tendencies with those of the bourgeois praxis which are so prominent in these writings. This synthesis is achieved at the expense of the classical ideal of education, which retreats here all along the line. Very typical is the fact that farming is held to be obligatory, whereas instruction in the dead languages goes unmentioned. The "humanists" of *Wilhelm Meister's Apprenticeship* have all turned into artisans: Wilhelm is a surgeon, Jarno a mining engineer, Philine a seamstress. Goethe took over the idea of

vocational education from Pestalozzi.[39] Earlier, he had sung the praises of handicraft in *Werther's Letters from Switzerland,* and now he does so again. Since at this time economists were already beginning to confront the problems of industry, we may regard this as a rather reactionary stance. But that aside, the socioeconomic ideas which Goethe supports here fit well enough into an extreme utopian version of the ideology of bourgeois philanthropy. "Property public and private" is the slogan proclaimed by one of the inscriptions on the uncle's model estates. And another motto runs: "From the useful via the true to the beautiful." The same syncretism is to be found, typically, in religious instruction. While on the one hand Goethe is the sworn enemy of Christianity, on the other he respects religion as the strongest guarantee of any hierarchical form of society. He even goes so far as to reconcile himself to the image of the sufferings of Christ, something which had provoked a violent antipathy in him for decades. The social order in the Goethean sense—that is, an order governed by patriarchal and cosmic norms—finds its purest expression in the figure of Makarie. The experience Goethe gained of practical, political activity failed to modify his basic attitudes, even though it frequently contradicted them. In consequence, his attempt to reconcile his experience and his convictions in a work of art was inevitably doomed to remain as fissured as the structure of this novel. And we even see ultimate reservations in Goethe himself, when he looks to America to provide his characters with a happier, more harmonious future. That is where they emigrate to at the end of his novel. It has been described as an "organized, communist escape."

If in the years of his maturity Goethe frequently avoided literature to follow his whims or inclinations more freely in theoretical work or administrative duties, the major phenomenon of his later years can be said to lie in the fact that the boundless circle of his continuing study of natural philosophy, mythology, literature, art, and philology, his former involvement in mining, finance, the theater, freemasonry, and diplomacy, was now all drawn together concentrically into a final, monumental work of literature: the second part of *Faust.* By his own admission Goethe spent over sixty years working on both parts of *Faust.* In 1775 he brought the first fragment, the *Urfaust,* with him to Weimar. It already contained some of the principal features of the later work. There was the figure of Gretchen, who was the naive counterpart to Faust, the prototypical reflective man; but she was also the proletarian girl, the illegitimate mother, the child-murderer who is executed and whose fate had long fueled the fierce social criticism in the poems and plays of the *Sturm und Drang* writers. There was the figure of Mephistopheles, who even then was less the devil of Christian teaching than the Earth Spirit from the traditions of magic and the Kaballah. And finally Faust himself, who was already the titan and superman, the twin brother

of Moses about whom Goethe had also planned to write and who likewise was to attempt to wrest the secret of creation from God/Nature. In 1790, *Faust: A Fragment* appeared. In 1808, for the first edition of his works, Goethe sent the completed Part I to Cotta, his publisher.[40] Here, for the first time, we find the action clearly defined. It is based on the "Prologue in Heaven," where God and Mephisto make a wager for the soul of Faust. When the devil comes and offers his services, however, Faust makes a pact with him to the effect that he will forfeit his soul only if he says to the moment:

> Ah, linger on, thou art so fair!
> Then may your fetters on me lay
> I'll gladly perish then and there.
> Then may the death-bell toll, recalling
> That from your service you are free;
> The clock may stop, the pointer falling,
> And time itself be past for me!

But the crux of the work is this: Faust's fierce and restless striving for the absolute makes a mockery of Mephisto's attempts at seduction. The limits of sensual pleasure are soon reached, but are insufficient to cost Faust his soul: "Thus from desire I reel on to enjoyment / And in enjoyment languish for desire."[41] With the passage of time Faust's longing grows and grows, surpassing all bounds. The first part of the play ends in Gretchen's dungeon, amid cries of woe. Taken on its own, this first part is one of Goethe's darkest works. And it has been said that the Faust saga articulates—as a world legend of the German bourgeoisie in the sixteenth century and as its world tragedy in the eighteenth—how this class, in each case, lost the game it was playing. The first part concludes Faust's existence as a bourgeois. The political setting of Part II consists of imperial courts and classical palaces. The outlines of Goethe's own Germany, which are still discernible through the veil of the Romantic Middle Ages in Part I, have disappeared entirely in Part II. Instead, the whole vast movement of thought is ultimately imaged in terms of the German Baroque, and it is through the eyes of the Baroque that Goethe views Antiquity. Having labored his whole life long to imagine classical Antiquity ahistorically and, as it were, suspended freely in space, Goethe now constructs, in the classical-romantic phantasmagoria of the Helen scenes, the first great image of Antiquity as seen through the prism of the German past. Around this work, which was to become Act 3 of *Faust II*, the rest of the poem is assembled. It can hardly be overemphasized how much these later parts, above all the scenes at the imperial court and in the military camp, constitute a political apology and represent a political sum-ming-up of Goethe's former activities at court. If his period of duty as a

minister had ended in a mood of profound resignation and with his capitu-
lation to the intrigues of a mistress of the prince, he nevertheless creates at
the end of his life, in the setting of an ideal Baroque Germany, a screen on
which he projects a magnified image of the world of the statesman in all its
ramifications, and at the same time shows all its defects intensified to the
point of grotesqueness. Mercantilism, Antiquity, and mystical scientific ex-
periments: the perfection of the state through money, of art through Antiq-
uity, of nature through experiment. These provide the signature of the epoch
of the German Baroque which Goethe here invokes. And it is ultimately not
a dubious aesthetic expedient but the innermost political necessity of the
poem when, at the close of Act 5, the heaven of Catholicism is unveiled to
disclose Gretchen as one of the penitent. Goethe saw too deeply to allow
his political regression toward absolutism to rest content with the Protestant
courts of the eighteenth century. Soret has made the penetrating observation
that "Goethe is liberal in an abstract sense, but in practice he inclines toward
the most reactionary principles." In the crowning stage of Faust's life,
Goethe gives expression to the spirit of his practice: the reclaiming of land
from the sea, an activity which nature prescribes to history and in which
nature is itself inscribed—that was Goethe's conception of historical action,
and any political formation was justified in his eyes only if it could protect
and guarantee such action. In the mysterious, utopian interplay between
agrarian and technological activity on the one hand with the political
apparatus of absolutism on the other, Goethe glimpsed the magic formula
which would dissolve the realities of social conflict into nothingness. Bour-
geois agricultural methods operating under the dominion of feudal tenure—
that was the discordant image in which Faust's greatest moment of fulfill-
ment was to be crystallized.

Shortly after bringing the work to completion, Goethe died, on March
22, 1832. By that time, industrialization in Europe was proceeding at a
furious pace. Goethe foresaw future developments. In a letter to Zelter in
1825, for example, he says: "Wealth and speed are what the world admires
and strives for. Railways, express mail, steamships, and all possible facilities
for communication are what the cultivated world desires in order to over-
cultivate itself and thereby to stick fast in mediocrity. The concept of the
general public has also led to the spread of a medium-level culture: this is
the goal of the Bible Societies, the Lancastrian method, and God knows
what else.[42] The fact is that this is the century for able minds, for quick-
thinking, practical men with a certain dexterity which enables them to feel
superior to the crowd, even though their gifts do not put them in the first
rank. Let us try to remain true to the principles with which we came; along
with perhaps a few others, we shall be the last members of an era which
may not return so quickly." Goethe knew that in the short run his work

would have little impact, and in fact the bourgeoisie in whom the hopes of a German democracy were burgeoning once more preferred to look up to Schiller as their model. From the circle of Young Germany came the first weighty literary protests.[43] Börne, for example, wrote as follows: "Goethe always paid homage only to egoism and coldness; hence, it is only the cold who like him. He has taught educated people how to be educated, broadminded, and unprejudiced, while remaining egoistic; how to possess every vice without becoming coarse, every foible without becoming ridiculous; how to keep a pure mind uncontaminated by the filth of the heart, how to sin with decorum and to make use of artistic form to beautify anything reprehensible or base. And because he taught all this, he is revered by educated people." Goethe's centenary in 1849 passed unnoticed, whereas that of Schiller, ten years later, was made the occasion for a great demonstration by the German bourgeoisie. Goethe did not come to the fore until the 1870s, after the establishment of the empire, at a time when Germany was on the lookout for monumental representatives of national prestige. The chief milestones are as follows: the foundation of the Goethe Society under the aegis of German princes; the publication of the Weimar edition of his works, under princely patronage; the establishment of the imperialist image of Goethe in the German universities. But despite the never-ending flood of literature produced by Goethe scholars, the bourgeoisie has never been able to make more than a limited use of his genius, to say nothing of the question of how far they have understood his intentions. His whole work abounds in reservations about them. And if he founded a great literature among them, he did so with face averted. Nor did he ever enjoy anything like the success that his genius merited; in fact, he declined to do so. And this was so that he could pursue his purpose of giving the contents [Gehalte] that fulfilled him the form which has enabled them to resist their dissolution at the hands of the bourgeoisie—a resistance made possible because they remained without effect and not because they could be deformed or trivialized. Goethe's intransigence toward the cast of mind of the average bourgeois and hence a new view of his work acquired new relevance with the repudiation of Naturalism. The Neo-Romantics (Stefan George, Hugo von Hofmannsthal, and Rudolph Borchardt)[44]—the last bourgeois poets of any distinction to attempt to rescue bourgeois ideology, if only on the plane of culture and under the patronage of the enfeebled feudal authorities— provided a new, important stimulus to Goethe scholarship (Konrad Burdach, Georg Simmel, Friedrich Gundolf).[45] Their work was above all concerned with the exploration of the works and the style of Goethe's last phase, which nineteenth-century scholars had ignored.

Written 1926–1928; condensed version published in Die literarische Welt in December 1928. Gesammelte Schriften, II, 705–739. Translated by Rodney Livingstone.

Notes

1. Benjamin was in error here: Goethe visited Berlin in 1778.
2. Friedrich Maximilian von Klinger (1752–1831) was a dramatist and novelist. His play *Der Wirrwarr, oder Sturm und Drang* (Confusion, or Storm and Stress; 1776) gave the *Sturm und Drang* movement its name. Gottfried August Bürger (1747–1794) was one of the first poets to translate the new interest in European folk song into new forms, especially the ballad. His best-known work is the ballad "Leonore" (1773). Johann Anton Leisewitz (1752–1806) was a dramatist; his one important work, *Julius von Tarent* (1776), served as a model for many *Sturm und Drang* plays that followed it. Johann Heinrich Voss (1751–1826) was a poet remembered chiefly for his translations of Homer. Matthias Claudius (1740–1815), poet and editor, was a prominent opponent of the rationalist and neo-classical spirit that had dominated German letters for much of the eighteenth century. His journal, *Der Wandsbecker Bote,* published work by Herder, Klop-stock, and Lessing, among many others. Jakob Michael Reinhold Lenz (1751–1792), Russian-born poet and dramatist, was, after Goethe, the most important of the *Sturm und Drang* writers. His plays from his Strasbourg years—a didactic comedy, *Der Hofmeister, oder Vortheile der Privaterziehung* (The Tutor, or The Advantages of Private Education; published 1774, performed 1778, Berlin); and the bourgeois tragedy *Die Soldaten* (The Soldiers; performed 1763, published 1776)—have exerted a lasting influence on German literature. He ended his life as a vagabond, and finally in insanity. Although Benjamin wrote "Holtei," he undoubtedly meant "Hölty": Ludwig Christoph Heinrich Hölty (1748–1776) was a poet and an original member of the circle known as the Göttinger Hain-bund (Union of the Göttingen Grove), a group of poets who sought to return poetry to its natural and national roots. Christian Friedrich Daniel Schubart (1739–1791), poet and editor, became famous through his journal *Die deutsche Chronik;* his writings earned him ten years of imprisonment without trial. Frie-drich Müller, known as Maler ("Painter") Müller (1749–1825), was a poet, dramatist, and painter; his play *Fausts Leben dramatisiert* (Faust's Life, Drama-tized; 1778) brought him closest to the feeling and style of the *Sturm und Drang.* Friedrich Leopold, Graf zu Stolberg (1750–1819), a poet, was, along with his brother Christian, associated with Göttinger Hainbund. After 1772, he composed a series of poems striking for their revolutionary ardor.
3. Paul-Henri Dietrich, baron d'Holbach (1723–1789), French encyclopedist and philosopher, published *Système de la nature* in 1770 under the pseudonym J. B. Mirabaud. He championed an atheistic, deterministic materialism.
4. Johann Gottfried von Herder (1744–1803) was a critic, theologian, and philoso-pher. His innovations in the philosophy of history and culture lent the initial impulse to the young writers gathered around him in Strasbourg who went on to form the core of the *Sturm und Drang* movement.
5. Johann Georg Hamann (1730–1788), philosopher and theologian, produced a series of innovative, hermetic texts that sought to reconcile philosophy and Christianity on an intuitive, antirationalist basis. His *Sokratische Denk-würdigkeiten* (Socratic Notable Thoughts; 1759) and *Aesthetica in Nuce* (Aes-thetics in a Nutshell; 1762) were key texts for Herder and the *Sturm und Drang*

writers. Johann Heinrich Merck (1741–1791), writer and critic, served as an early adviser to and supporter of several writers of the younger generation, including Herder and Goethe. His journal, the *Frankfurter gelehrte Anzeigen*, published biting social and aesthetic criticism of friend and foe alike.

6. The Göttinger Hain or Göttinger Hainbund (Union of the Göttingen Grove) was a literary association that stressed the reintroduction of national and natural themes into German poetry. Members included the young poets (mostly students at the University of Göttingen) H. C. Boie, J. H. Voss, Ludwig Hölty, J. F. Hahn, K. F. Cramer, the Stolberg brothers, and J. A. Leisewitz. The group dissolved in 1774.

7. Friedrich Gottlieb Klopstock (1724–1803) was the greatest lyric poet of the eighteenth century before Goethe. His remarkable linguistic gifts and prosodic inventiveness enabled Klopstock to virtually reinvent German poetry, pointing the way to a more natural and expressive use of language.

8. "The German Peasants' War" is a loose designation for a series of peasant uprisings in south and middle Germany that lasted from 1524 to 1526. The decisive victory of the princes eliminated the peasantry from the political life of Germany for centuries.

9. The Imperial Knights were direct vassals of the Holy Roman Emperor. Each knight had holdings that ranged in size from part of a single village to a small independent state.

10. Charlotte Buff (1753–1828), the model for Lotte in *Werther*, married J. C. Kestner (a Hannover administrator and friend of Goethe's) in 1773. Werther himself is modeled in part on the law student Karl Wilhelm Jerusalem (1747–1772).

11. Her full name was Anna Elisabeth Schönemann (1758–1817).

12. Johann Kaspar Lavater (1741–1801) was a Swiss writer and Protestant pastor whose theories of physiognomy were widely influential in the late eighteenth century. His *Physiognomische Fragmente zur Beförderung der Menschenkenntnis und Menschenliebe* (4 vols., 1775–1778; translated as *Essays on Physiognomy*, 1789–1798) were founded on the conviction that the spirit leaves its mark on people's physical features.

13. Karl August, grand duke of Saxe-Weimar-Eisenach (1757–1828), was a liberal, enlightened ruler who made his court and the University of Jena leading intellectual centers of Germany during the late eighteenth and early nineteenth centuries. After he repeatedly sided with the allies against Napoleon, Weimar's territories were increased at the Congress of Vienna (1815); but he protested the congress' reactionary spirit. In 1819 he granted his state a liberal constitution, becoming the first German ruler to do so.

14. Christoph Martin Wieland (1733–1813) was a poet, novelist, dramatist, and man of letters whose work helped define each of the major trends of his age, from rationalism and the Enlightenment to classicism and pre-Romanticism. His journal, *Der teutsche Merkur* (The German Mercury), was a leading cultural focus for thirty-seven years.

15. Charlotte von Stein (1742–1827) was a writer and woman of letters.

16. Johann Joachim Winckelmann (1717–1768) was an archaeologist and art historian whose writings on classical art, and especially the art of ancient Greece,

exerted a powerful influence on Western painting, sculpture, literature, and philosophy in the eighteenth century. His major work is *Gedanken über die Nachahmung der griechischen Werke in der Malerei und Bildhauerkunst* (1755; translated as *Reflections on the Painting and Sculpture of the Greeks*, 1765), in which he promulgated the idea that classical art is characterized by an "edle Einfalt und stille Grösse" (a noble simplicity and quiet grandeur).

17. Karl Wilhelm, Freiherr von Humboldt (1767–1835), German philologist, philosopher, diplomat, and educational reformer, is best-known for his work on the development of language and for being the founder of the modern university system.

18. Gotthold Ephraim Lessing (1729–1781), German dramatist, critic, and writer, led the struggle to found a German national literature based on indigenous models. His plays—*Nathan der Weise* (1779), *Minna von Barnhelm* (1767), and *Emilia Galotti* (1772)—form the first body of German dramatic work of lasting importance.

19. Christian Gottfried Körner (1756–1831) was a civil servant and a close friend of Schiller's.

20. Friedrich Heinrich Jacobi (1743–1819) was a novelist and philosopher whose writings champion feeling at the expense of reason. His best-known work is the novel *Woldemar* (1779).

21. The intermaxillary bone (a bone between the upper and lower jaws) played a role in the pre-Darwinian debates on evolution. Contemporary theologians insisted that humans were anatomically different from primates; Goethe, almost simultaneously with the French anatomist Vicq-d'Azyr, of whose work he was ignorant, showed that this bone, which is present in animals, also survives vestigially in humans, who therefore could not be considered generically unique.

22. Christiane Vulpius (1765–1816), Goethe's companion and, after 1806, his spouse, bore five children. Only one, their son August, survived infancy.

23. Carl Friedrich Zelter (1758–1832), a composer, founded numerous musical institutions, including the Royal Institute for Sacred Music (Berlin). He served as Goethe's musical adviser and set many of his texts.

24. Karl Ferdinand Gutzkow (1811–1878), novelist, dramatist, and social critic, was a leader of the Young Germany movement which revolted against Romanticism.

25. Schiller's journal *Die Horen* [The Hours] appeared from 1795 to 1798. Friedrich Nicolai (1733–1811) was an early advocate of the Enlightenment who became intolerant of change. He attacked Goethe, Herder, and Kant in widely read parodies.

26. Friedrich Justin Bertuch (1747–1822) was a writer, translator, and editor.

27. Ludwig Börne (originally Löb Baruch; 1786–1837), writer and social critic, lived in exile in Paris after 1830. A member of the Young Germany movement, he was one of the first writers to use the feuilleton section of the newspaper as a forum for social and political criticism.

28. August Wilhelm Iffland (1759–1814), actor, dramatist, and stage manager, was a major voice in the German theatrical world.

29. Novalis (pseudonym of Friedrich Leopold, Freiherr von Hardenberg; 1772–

1801) was a poet and theorist of the early German Romantic period. His novel *Heinrich von Ofterdingen* (1802), set in an idealized vision of the European Middle Ages, recounts the mystical quest of a young poet; the central image of his visions, a blue flower, became a widely recognized symbol of Romantic longing among Novalis' fellow Romantics. Johann Ludwig Tieck (1773–1853), a writer and critic, produced a huge corpus of fanciful work in many genres. *Franz Sternbalds Wanderungen* (2 vols., 1798) follows the life of an artist in the late Middle Ages. Eduard Friedrich Mörike (1804–1875), a lyric poet and novelist, was perhaps the greatest of the late Romantics. *Maler Nolten* (Painter Nolten; 1832) is peopled by an unusual number of mentally unbalanced characters; like many other Romantic novels, it has dramas and poems interspersed throughout.

30. Johann Peter Eckermann (1792–1854) was a writer who is remembered chiefly as Goethe's amanuensis. His *Gespräche mit Goethe in den letzten Jahren seines Lebens* (3 vols., 1823–1832; translated as *Conversations with Goethe in the Last Years of His Life*, 1836–1848), is often compared to James Boswell's *Life of Johnson*. Friedrich Riemer (1774–1845), philologist and literary historian, was, like Eckermann, a literary assistant to Goethe. He edited, with Eckermann, the final version of *Faust* (1832). Frédéric Soret (1795–1865), French natural scientist and educator, was tutor to the prince's children in Weimar between 1822 and 1836. He noted his conversations with Goethe in a series of journals, some of which Eckermann used in the third part of his *Gespräche*. The texts were published in full only in 1932.

31. Heinrich Meyer (1760–1832), an artist, was a student of the Anglo-Swiss painter Henry Fuseli. He met Goethe in Rome and in 1791 came to Weimar, where he became the director of the Ducal Drawing School. He served as Goethe's adviser on art.

32. Friedrich August Wolf (1759–1824), German classical scholar, is considered one of the founders of modern philology. He is best-known for his *Prolegomena ad Homerum* (Prolegomena on Homer; 1795).

33. Sulpiz Boisserée (1783–1854) was an art historian and collector. His collection of old German and Dutch paintings played a central role in the rediscovery of the Middle Ages by the Romantic generation.

34. Alessandro Manzoni (1785–1873), Italian poet and novelist, is best-known for the novel *I promessi sposi* (The Betrothed; 1852).

35. Benjamin here names three major authors whose style resisted any easy absorption into a period paradigm. Johann Christian Friedrich Hölderlin (1770–1843) was a German lyric poet, novelist, and dramatist whose poetry succeeds in integrating the rhythm and syntax of classical Greek verse into German. His major works include the novel *Hyperion* (1797) and the poems "Brot und Wein," "Hälfte des Lebens," "Der Rhein," "Wie wenn am Feiertage," and "Patmos." Bernd Heinrich Wilhelm von Kleist (1777–1811), dramatist and short-story writer, produced in the course of his restless and tortured life a remarkable number of major works. These include the plays *Der zerbrochene Krug* (The Broken Pitcher; 1811) and *Penthesilea* (1808), and the stories "Michael Kohlhaas," "Die Marquise von O," and "Das Erdbeben in Chile," all of

which appeared in the two-volume *Erzählungen* in 1810–1811. Jean Paul Richter (1763–1825) produced a series of wildly extravagant, highly imaginative novels that are characterized by their combination of fantasy and realism.

36. Marianne von Willemer (1784–1860) was the wife of Goethe's friend J. J. von Willemer, a Frankfurt banker. She distinguished herself from many of the women who served as models for figures in Goethe's verse in that she was the coauthor of several of the poems in the two cycles that seek to merge East and West: the *Chinesisch-Deutsche Jahres- und Tageszeiten* (Chinese-German Hours and Seasons; 1830) and the *West-Östlicher Divan* (West-Easterly Divan; 1819).

37. Ulrike von Levetzow (1804–1899) met Goethe at the spa at Marienbad in 1821. In 1823, at the age of seventy-four, Goethe made a kind of indirect proposal to Levetzow, who was then nineteen. She responded to it evasively.

38. Jean-Charles-Léonard Simonde de Sismondi (1773–1842), Swiss economist and historian, was a prominent early critic of the societal transformations that followed from industrialism. His theories of economic crises and the dangers of limitless competition, overproduction, and underconsumption were taken up by such later economists as Karl Marx and John Maynard Keynes. François-Marie-Charles Fourier (1772–1837), French social theorist, called for a reorganization of society based on communal associations known as *phalanges* (phalanxes). In each community, the members would continually change roles within different systems of production. Henri de Saint-Simon (1760–1825), French social theorist, is credited with founding Christian socialism. His most important work, *Le nouveau Christianisme* (1825), insisted that human fraternity must accompany any scientific restructuring of society. Robert Owen (1771–1858), Welsh manufacturer turned reformer, was one of the most influential socialists of the early nineteenth century. His mills in Lanarkshire, which operated under a wholly reconceived social and industrial system, became a model for utopian communities in Europe and the United States. Jeremy Bentham (1748–1832), English philosopher, economist, and theoretical jurist, was the founder and a major theorist of Utilitarianism.

39. Johann Heinrich Pestalozzi (1746–1827), Swiss educational reformer, formulated a teaching regimen centered on each student's abilities and needs. He also advocated education of the poor.

40. Johann Friedrich Cotta, Baron von Cottendorf (1764–1832), took over the family business in Tübingen and turned it into one of the leading publishing houses in Europe. Cotta eventually published Goethe, Herder, both Humboldts, Hegel, Fichte, Wieland, A. W. Schlegel, Tieck, Jean Paul, and Kleist.

41. Goethe, *Faust,* trans. G. M. Priest (New York: Covici, Friede, 1932).

42. Joseph Lancaster (1778–1838), British educator, formulated an educational system intended to reach a broad societal base. The "Lancastrian" method was based on the idea that children who were more proficient could teach other children under the supervision of an adult.

43. Young Germany (Junges Deutschland) was a movement in Germany that, between about 1830 and 1850, advocated social and literary reform. Its principal members were Ludolf Wienbarg, Karl Gutzkow, and Theodor Mundt, although Heinrich Laube, Georg Herwegh, Ludwig Börne, and Heinrich Heine were also involved. All of these writers, at one time or another, set themselves in virulent

opposition to the prevailing social and literary norms: nationalist monarchy and Romanticism. Although they attained only limited popular success, their writings were formally banned by the Diet of the German Confederation on December 10, 1835.

44. Stefan George (1868–1933), German lyric poet, attempted in his verse and through his remarkable personal influence to "purify" German language and culture around the turn of the twentieth century. See "Stefan George in Retrospect" (1933), in this volume. His conservative-nationalist ideas exerted a powerful influence on many German intellectuals. Hugo von Hofmannsthal (1874–1929), Austrian poet, dramatist, and essayist, made his reputation with lyrical poems, stories, and plays in the last decade of the nineteenth century. His operatic collaborations with the German composer Richard Strauss made him world famous. See "Hugo von Hofmannsthal's *Der Turm*," in this volume. Rudolf Borchardt (1877–1945) was a German prose writer and essayist whose works combined a polished personal style and conservative ideas; he promoted, as literary models, classical antiquity and the Middle Ages.

45. Konrad Burdach (1859–1936), German literary historian, was a main proponent of intellectual history as a mode of cultural analysis. Georg Simmel (1858–1918), German sociologist and neo-Kantian philosopher, developed a theory of modernity, starting with his *Philosophie des Geldes* (Philosophy of Money; 1900) and continuing through classic essays such as "Die Großstadt und das Geistesleben" (The Metropolis and Mental Life). His work exerted an enormous influence on the next generation of social philosophers, some of whom were his students: Georg Lukács, Ernst Cassirer, Ernst Bloch, Siegfried Kracauer, and Benjamin. Friedrich Gundolf (pseudonym of Friedrich Gundelfinger; 1880–1931) was a disciple of Stefan George, a prominent literary critic, and, after 1920, a professor at Heidelberg. See Benjamin's essays "Comments on Gundolf's *Goethe*" and "Goethe's Elective Affinities," in Volume 1 of this edition.

Karl Kraus (Fragment)

In Karl Kraus we find the most magnificent irruption of halachic writing into the massif of the German language. You understand nothing about this man if you do not recognize that everything without exception, words as well as things, is necessarily acted out within the realm of law. It is not enough that every day the newspaper brings a bundle of denunciations into his house; his eyes know how to read between the lines and cannot fail to notice that the nameless informers with their accusations, however well-founded these may be, are themselves not without guilt. His entire fire-eating, sword-swallowing philological scrutiny of the newspapers is actually concerned not with language but with justice. His linguistic investigations are incomprehensible unless they are perceived as contributions to the code of criminal procedure, unless the word of others in his mouth is regarded as nothing but a *corpus delicti,* and an issue of *Die Fackel* as only a hearing.[1] The court cases pile up around him. Not those that he has to conduct in the Viennese courts, but those whose place of jurisdiction is *Die Fackel.* Kraus, however, as public prosecutor, takes every case to appeal. Of the sentences he has handed down, none can satisfy him. He provides an unprecedented, ambiguous, genuinely demonic spectacle of the accuser eternally calling for justice, the public prosecutor who becomes a Michael Kohlhaas because no justice can satisfy his accusation and none of his accusations can satisfy him.[2] His linguistic and ethical quibbling is not a form of self-righteousness; it belongs to the truly desperate justice of a proceeding in which words and things concoct the most implausible alibi simply to save their own skin, and must be incessantly refuted by the evidence of one's eyes or straightforward calculation. The fact that this man

is one of the very few who have a vision of freedom and can further it only by assuming the role of chief prosecutor is a paradox that most purely reveals the powerful dialectic at work. His life is one that embodies the most fervent prayer for salvation that passes Jewish lips in our age.

Published in *Internationale Revue*, December 1928. *Gesammelte Schriften*, II, 624–625. Translated by Rodney Livingstone.

Notes

1. *Die Fackel* (The Torch) was the satirical magazine edited by Karl Kraus from 1899 to his death in 1936. Although it initially included contributions from other authors, after December 1911 Kraus was its sole writer and editor.
2. Michael Kohlhaas is the eponymous hero of a story by Heinrich von Kleist from 1810. After a horse is stolen from him, he tries repeatedly but in vain to obtain justice; as his efforts escalate, he becomes an outlaw and a rebel, and ends on the gallows.

The Return of the *Flâneur,* 1929

Chaplin

After a showing of *The Circus*. Chaplin never allows the audience to smile while watching him. They must either double up laughing or be very sad.

Chaplin greets people by taking off his bowler, and it looks like the lid rising from the kettle when the water boils over.

His clothes are impermeable to every blow of fate. He looks like a man who hasn't taken his clothes off for a month. He is unfamiliar with beds; when he lies down, he does so in a wheelbarrow or on a seesaw.

Wet through, sweaty, in clothes far too small for him, Chaplin is the living embodiment of Goethe's *aperçu:* Man would not be the noblest creature on earth if he were not too noble for it.

This film is the first film of Chaplin's old age. He has grown older since his last films, but he also acts old. And the most moving thing about this new film is the feeling that he now has a clear overview of the possibilities open to him, and that he is resolved to work exclusively within these limits to attain his goal.

At every point the variations on his greatest themes are displayed in their full glory. The chase is set in a maze; his unexpected appearance would astonish a magician; the mask of noninvolvement turns him into a fairground marionette. The most wonderful part is the way the end of the film is structured. He strews confetti over the happy couple, and you think: This must be the end. Then you see him standing there when the circus procession starts off; he shuts the door behind everyone, and you think: This must be the end. Then you see him stuck in the rut of the circle earlier drawn by poverty, and you think: This must be the end. Then you see a close-up of his completely bedraggled form, sitting on a stone in the arena. Here you

think the end is absolutely unavoidable, but then he gets up and you see him from behind, walking further and further away, with that gait peculiar to Charlie Chaplin; he is his own walking trademark, just like the company trademark you see at the end of other films. And now, at the only point where there's no break and you'd like to be able to follow him with your gaze forever—the film ends!

Fragment written in 1928 or early 1929; unpublished in Benjamin's lifetime. *Gesammelte Schriften*, VI, 137–138. Translated by Rodney Livingstone.

Program for a Proletarian Children's Theater

Prefatory Remarks

Every proletarian movement, whenever it has for once escaped the format of parliamentary debate, finds itself confronting many different forces for which it is unprepared. The most powerful of these, as well as the most dangerous, is the younger generation. The self-confidence of parliamentary tedium springs from the fact that a parliament is a monopoly of adults. Mere catchphrases have no power over children. True, in a year you can make sure that children are parroting them throughout the country. But the question is how to make sure that the party program is acted on in ten or twenty years. And catchphrases will not have the slightest effect on this.

Proletarian education must be based on the party program—or, more precisely, on class consciousness. But the party program is no instrument of a class-conscious education, because the element of ideology, important though it is, reaches the child only as a catchphrase. We are calling for, and shall not cease to call for, instruments for the class-conscious education of proletarian children. In what follows, we shall ignore the question of the teaching curriculum as such, because long before children need to be instructed (in technology, class history, public speaking, and so on), they need to be brought up in a proletarian manner. We shall take, as our starting point, the age of four.

In line with the class position of the bourgeoisie, the bourgeois education of little children is unsystematic. This does not mean that the bourgeoisie has no system of education. But the inhumanity of its content betrays itself in its inability to provide anything at all for the youngest children. On

children of this age, only truth can have a productive effect. The education of young proletarian children should distinguish itself from that of the bourgeoisie primarily by its systematic nature. "System" here means a framework. For the proletariat, it would be quite intolerable if every six months a new method were to be introduced with all the latest psychological refinements, as in the nursery schools of the bourgeoisie. Everywhere—and the realm of education is no exception here—the preoccupation with "methodology" is a symptom of the authentic bourgeois attitude, the ideology of laziness and muddling through. Proletarian education needs first and foremost a framework, an objective space *within* which education can be located. The bourgeoisie, in contrast, requires an idea *toward* which education leads.

We shall now explain why the framework of proletarian education from the fourth to the fourteenth year should be the proletarian children's theater.

The education of a child requires that *its entire life be engaged.*

Proletarian education requires *that the child be educated within a clearly defined space.*

This is the positive dialectic of the problem. It is only in the theater that the whole of life can appear as a defined space, framed in all its plenitude; and this is why proletarian children's theater is the dialectical site of education.

Scheme of Tension

Let us set aside the question whether the children's theater of which we shall speak has a connection with the ordinary theater at the high points in its history. Yet we must state firmly that this theater has nothing at all in common with that of the modern bourgeoisie. Economically, the theater of the modern bourgeoisie is determined by the profit motive; sociologically, both in front of the curtain and backstage, it is primarily an instrument of sensation. The proletarian children's theater is quite different. Just as the first action of the Bolsheviks was to hoist the Red flag, so their first instinct was to organize the children. In this organization the proletarian children's theater, the basic motif of Bolshevist education, has a central place. There is a way of cross-checking this. In the view of the bourgeoisie, nothing presents a greater danger to children than the theater. This is not just a vestige of the old bogey—the myth of traveling actors who steal children. What we find expressed is the fear that the theater will unleash in children the most powerful energies of the future. And this fear causes bourgeois education theory to anathematize the theater. We may easily imagine how it would react once the fire came too close—the fire in which, for children, reality and play coincide and are fused so that acted sufferings can merge with real sufferings, acted beatings can shade into real beatings.

Nevertheless, the performances of this theater—unlike those of the great bourgeois theater—are not the actual goal of the concentrated collective labor that is performed in the children's clubs. One might say that here performances come about incidentally, as an oversight, almost as a children's prank, and in this way the children interrupt the course of study that they have never actually completed. The leader is relatively unconcerned about whether or not the course has been completed. He is more interested in the tensions that are resolved in such performances. The tensions of collective labor are the educators. The overhasty, unrelaxed process of educational labor that the bourgeois director performs—far too late—on the bourgeois actor no longer applies in this system. Why? Because in the children's club no leader would survive if he attempted in the authentic bourgeois spirit to influence the children directly as a "moral personality." There is no process of moral influence here. There is no direct influence either. (And it is on this that directing in the bourgeois theater is based.) What counts is simply and solely the indirect influence of the director on the children as mediated by subject matter, tasks, and performances. The inevitable moral processes of compensating and providing correctives are undertaken by the children's collective itself. This explains why children's theater productions inevitably strike adults as having authentic moral authority. There is no superior standpoint that an audience can adopt when witnessing children's theater. Everyone who has not quite sunk into feeblemindedness will perhaps even feel ashamed.

But even this does not take us much further. To have a positive effect, proletarian children's theaters make a collective audience quite indispensable. In a word: they need the class as audience. Just as only the working class has an infallible intuition for the existence of collectives. Such collectives may be public meetings, the army, or the factory. But the child, too, is such a collective. And it is the prerogative of the working class to have a completely fresh eye for the children's collective, whereas the bourgeoisie is unable to perceive it. This collective radiates not just the most powerful energies, but also the most relevant ones. In fact, the relevance of childlike forms and modes of conduct is unsurpassed. (We draw attention here to the well-known exhibitions of the latest children's art.)

The neutralization of the "moral personality" in the leader unleashes vast energies for the true genius of education—namely, the power of observation. This alone is at the heart of unsentimental love. No pedagogic love is worth anything unless in nine-tenths of all instances of knowing better and wanting better it is deprived of its courage and pleasure by the mere observation of children's lives. It is sentimental and vain. For the true observer, however— and this is the starting point of education—every childhood action and gesture becomes a signal. Not so much a signal of the unconscious, of latent processes, repressions, or censorship (as the psychologists like to think), but

a signal from another world, in which the child lives and commands. The new knowledge of children that has been developed in the Russian children's clubs has led to the theory that the child inhabits his world like a dictator. For this reason, the "theory of signals" is no mere figure of speech. Almost every childlike gesture is a command and a signal in a world which only a few unusually perceptive men, notably Jean Paul, have glimpsed.[1]

The task of the leader is to release children's signals from the hazardous magical world of sheer fantasy and apply them to materials. This happens in the various theatrical workshops. To take an illustration from painting, we know that in this sphere of childhood activity, too, gesture is all-important. Konrad Fiedler is the first to have shown in his *Writings on Art* that the painter is not a man who sees more naturalistically, more poetically, or more ecstatically than other people. He is, rather, a man who sees more accurately with his hand when his eye fails him, who is able to transfer the receptive innervation of the eye muscles into the creative innervation of the hand. What characterizes every child's gesture is that creative innervation is exactly proportioned to receptive innervation. The development of these gestures in the different forms of expression—the making of stage props, painting, recitation, music, dance, or improvisation—is the task of the different workshops.

In all of them improvisation is central, because in the final analysis a performance is nothing but an improvised synthesis of all of them. Improvisation predominates; it is the framework from which the signals, the signifying gestures, emerge. And the synthesis of these gestures must become performance or theater, because they alone have the unexpected uniqueness that enables the child's gesture to stand in its own authentic space. The kind of "fully rounded" performance that people torment children to produce can never compete in authenticity with improvisation. The aristocratic dilettantism that is eager to make its poor pupils produce such "artistic achievements" ended up by filling cupboards and memory with junk, which was piously preserved so that our mementos of early youth might survive to enable us to torment our own children. But childhood achievement is always aimed not at the "eternity" of the products but at the "moment" of the gesture. The theater is the art form of the child because it is ephemeral.

Scheme of Resolution

Educational work in the different workshops stands in the same relationship to the performance as a tension to its resolution. For no pedagogic wisdom can foresee how children will fuse the various gestures and skills into a theatrical totality, but with a thousand unexpected variations. Even for the professional actor, the first performance can often serve as the trigger that enables him to introduce genuine improvements into a well-rehearsed role.

But in the case of a child, it brings the genius of variation to a peak of perfection. In relation to the process of schooling, the performance is like the radical unleashing of play—something which the adult can only wonder at.

The embarrassments of bourgeois education theory and of the rising bourgeois generation in general have expressed themselves recently in the "Youth Culture" movement.[2] The conflict that this new movement is destined to hush up lies in the claims that bourgeois society (like every political society) makes on the energies of young people, which can never be activated directly in a political way. And on the energies of children above all else. Now Youth Culture attempts to achieve a hopeless compromise: it drains the enthusiasm of young people by a process of idealistic self-reflection, so as gradually and imperceptibly to replace the formal ideologies of German idealism by the contents of the bourgeois class. The proletariat must not pass on its own class interest to the next generation with the tainted methods of an ideology that is destined to subjugate the child's suggestible mind. The discipline the bourgeoisie demands from *children* is its mark of shame. The proletariat *disciplines* only the proletarians who have grown up; its ideological class education starts with puberty. Proletarian education theory demonstrates its superiority by guaranteeing to children the fulfillment of their childhood. There is no need, therefore, for the realm in which this occurs to be isolated from the realm of class struggles. At the level of play, the themes and symbols of class struggle can—and perhaps must—have a place in this realm. But these themes and symbols cannot lay claim to a formal dominance of the child. Nor will they do so. Hence, the proletariat has no need of the thousand little words which the bourgeoisie uses to disguise the class nature of its education theory. It will be possible to dispense with "unbiased," "sympathetic" practices and with teachers who are "fond of children."

The performance is the great creative pause in the process of upbringing. It represents in the realm of children what the carnival was in the old cults. Everything was turned upside down; and just as in Rome the master served the slaves during the Saturnalia, in the same way in a performance children stand on the stage and instruct and teach the attentive educators. New forces, new innervations appear—ones that the director had no inkling of while working on the project. He learns about them only in the course of this wild liberation of the child's imagination. Children that have learned about theater in this way become free in such performances. Through play, their childhood has been fulfilled. They carry no superfluous baggage around with them, in the form of overemotional childhood memories that might prevent them later on from taking action in an unsentimental way. Moreover, this theater is the only usable one for the child spectator. When grownups act for children, the result is archness.

This children's theater contains a force that will annihilate the pseudorevolutionary gestures of the recent theater of the bourgeoisie. For what is truly revolutionary is not the propaganda of ideas, which leads here and there to impracticable actions and vanishes in a puff of smoke upon the first sober reflection at the theater exit. What is truly revolutionary is the *secret signal* of what is to come that speaks from the gesture of the child.

Written in late 1928 or early 1929; unpublished in Benjamin's lifetime. *Gesammelte Schriften,* II, 763–769. Translated by Rodney Livingstone.

Notes

1. Jean Paul Richter (1763–1825) is remembered for a series of wildly extravagant, highly imaginative novels that combine fantasy and realism.
2. A reference to the various movements and ideas that were prevalent between 1895 and 1920 and that are known today as the "Youth Movement." The movement embraced a wide spectrum of ideas—from tame and pragmatic revisions in pedagogy, through the nature worship of young people tramping through the countryside (the *Wandervögel*), to the virulent nationalism and anti-Semitism of the radical Right. On Benjamin's involvement in the movement and his indebtedness to his teacher Gustav Wyneken, one of the main ideologues of the movement, see the Chronology in Volume 1 of this edition.

Surrealism

The Last Snapshot of the European Intelligentsia

Intellectual currents can generate a sufficient head of water for the critic to install his power station on them. The necessary gradient, in the case of Surrealism, is produced by the difference in intellectual level between France and Germany. What sprang up in 1919 in France in a small circle of literati—we shall give the most important names at once: André Breton, Louis Aragon, Philippe Soupault, Robert Desnos, Paul Eluard—may have been a meager stream, fed on the damp boredom of postwar Europe and the last trickle of French decadence.[1] The know-it-alls who even today have not advanced beyond the "authentic origins" of the movement, and even now have nothing to say about it except that yet another clique of literati is here mystifying the honorable public, are a little like a gathering of experts at a spring who, after lengthy deliberation, arrive at the conviction that this paltry stream will never drive turbines.

The German observer is not standing at the source of the stream. This is his opportunity. He is in the valley. He can gauge the energies of the movement. As a German he has long been acquainted with the crisis of the intelligentsia, or, more precisely, with that of the humanistic concept of freedom; and he knows how frantically determined the movement has become to go beyond the stage of eternal discussion and, at any price, to reach a decision; he has had direct experience of its highly exposed position between an anarchistic Fronde and a revolutionary discipline, and so has no excuse for taking the movement for the "artistic," "poetic" one it superficially appears.[2] If it was such at the outset, it was, however, precisely at the outset that Breton declared his intention of breaking with a praxis that presents the public with the literary precipitate of a certain form of existence

while withholding that existence itself. Stated more briefly and dialectically, this means that the sphere of poetry was here exploded from within by a closely knit circle of people pushing the "poetic life" to the utmost limits of possibility. And they can be taken at their word when they assert that Rimbaud's *Saison en enfer* [A Season in Hell] no longer had any secrets for them.[3] For this book is indeed the first document of a movement like this (in recent times; earlier precursors will be discussed later). Can the point at issue be more definitively and incisively presented than by Rimbaud himself in his personal copy of the book? In the margin, beside the passage "on the silk of the seas and the arctic flowers," he later wrote, "There's no such thing."

Just how inconspicuous and peripheral a substance the dialectical kernel that later grew into Surrealism was originally embedded in was shown by Aragon in 1924—at a time when its development could not yet be foreseen—in his *Vague de rêves* [Wave of Dreams]. Today it can be foreseen. For there is no doubt that the heroic phase, whose catalogue of heroes Aragon left us in that work, is over. There is always, in such movements, a moment when the original tension of the secret society must either explode in a matter-of-fact, profane struggle for power and domination, or decay as a public demonstration and be transformed. At present, Surrealism is in this phase of transformation. But at the time when it broke over its founders as an inspiring dream wave, it seemed the most integral, conclusive, absolute of movements. Everything with which it came into contact was integrated. Life seemed worth living only where the threshold between waking and sleeping was worn away in everyone as by the steps of multitudinous images flooding back and forth; language seemed itself only where sound and image, image and sound, interpenetrated with automatic precision and such felicity that no chink was left for the penny-in-the-slot called "meaning." Image and language take precedence. Saint-Pol-Roux, retiring to bed about daybreak, fixes a notice on his door: "Poet at work."[4] Breton notes: "Quietly. I want to pass where no one has yet passed, quietly!—After you, dearest language." Language takes precedence.

Not only before meaning. Also before the self. In the world's structure, dream loosens individuality like a bad tooth. This loosening of the self by intoxication is, at the same time, precisely the fruitful, living experience that allowed these people to step outside the charmed space of intoxication. This is not the place to give an exact definition of Surrealist experience. But anyone who has perceived that the writings of this circle are not literature but something else—demonstrations, watchwords, documents, bluffs, forgeries if you will, but at any rate not literature—will also know, for the same reason, that the writings are concerned literally with experiences, not with theories and still less with phantasms. And these experiences are by no means limited to dreams, hours of hashish eating, or opium smoking. It is

a cardinal error to believe that, of "Surrealist experiences," we know only the religious ecstasies or the ecstasies of drugs. Lenin called religion the opiate of the masses, and brought the two things closer together than the Surrealists could have liked. I shall refer later to the bitter, passionate revolt against Catholicism in which Rimbaud, Lautréamont, and Apollinaire brought Surrealism into the world.[5] But the true, creative overcoming of religious illumination certainly does not lie in narcotics. It resides in a *profane illumination,* a materialistic, anthropological inspiration, to which hashish, opium, or whatever else can give an introductory lesson. (But a dangerous one; and the religious lesson is stricter.) This profane illumination did not always find the Surrealists equal to it, or to themselves; and the very writings that proclaim it most powerfully, Aragon's incomparable *Paysan de Paris* [Peasant of Paris] and Breton's *Nadja,* show very disturbing symptoms of deficiency. For example, there is in *Nadja* an excellent passage on the "delightful days spent looting Paris under the sign of Sacco and Vanzetti"; Breton adds the assurance that in those days the boulevard Bonne-Nouvelle [Boulevard of Good Tidings] fulfilled the strategic promise of revolt that had always been implicit in its name. But Madame Sacco also appears—not the wife of Fuller's victim but a *voyante,* a fortuneteller who lives at 3 rue des Usines and who tells Paul Eluard that he can expect no good from Nadja. Now, I concede that the breakneck career of Surrealism over rooftops, lightning rods, gutters, verandas, weathercocks, stucco work (all ornaments are grist to the cat burglar's mill) may have taken it also into the humid backroom of spiritualism. But I am not pleased to hear it cautiously tapping on the windowpanes to inquire about its future. Who would not wish to see these adoptive children of revolution most rigorously severed from all the goings-on in the conventicles of down-at-heel dowagers, retired majors, and *émigré* profiteers?

In other respects, Breton's book illustrates well a number of the basic characteristics of this "profane illumination." He calls *Nadja* "a book with a banging door." (In Moscow I lived in a hotel in which almost all the rooms were occupied by Tibetan lamas who had come to Moscow for a congress of Buddhist churches. I was struck by the number of doors in the corridors that were always left ajar. What had at first seemed accidental began to be disturbing. I found out that in these rooms lived members of a sect who had sworn never to occupy closed rooms. The shock I had then must be felt by the reader of *Nadja.*) To live in a glass house is a revolutionary virtue par excellence. It is also an intoxication, a moral exhibitionism, that we badly need. Discretion concerning one's own existence, once an aristocratic virtue, has become more and more an affair of petty-bourgeois parvenus. *Nadja* has achieved the true, creative synthesis between the art novel and the *roman à clef.*

Moreover, one need only take love seriously to recognize in it, too—as

Nadja also indicates—a "profane illumination." "At just that time" (i.e., when he knew Nadja), the author tells us, "I took a great interest in the epoch of Louis VII, because it was the time of the 'courts of love,' and I tried to picture with great intensity how people saw life then." We have from a new author quite exact information on Provençal love poetry, which comes surprisingly close to the Surrealist conception of love. "All the poets of the 'new style,'" Erich Auerbach points out in his excellent *Dante: Poet of the Secular World,* "possess a mystical beloved; they all have approximately the same very curious experience of love. To them all, Amor bestows or withholds gifts that resemble an illumination more than sensual pleasure; all are subject to a kind of secret bond that determines their inner and perhaps also their outer lives." The dialectics of intoxication are indeed curious. Is not perhaps all ecstasy in *one* world humiliating sobriety in the world complementary to it? What is it that courtly *Minne* seeks (and it, not love, binds Breton to the telepathic girl), if not to make chastity, too, a transport? Into a world that borders not only on tombs of the Sacred Heart or altars to the Virgin, but also on the morning before a battle or after a victory.

The lady, in esoteric love, matters least. So, too, for Breton. He is closer to the things that Nadja is close to than to her. What are these things? Nothing could reveal more about Surrealism than their canon. Where shall I begin? He can boast an extraordinary discovery: he was the first to perceive the revolutionary energies that appear in the "outmoded"—in the first iron constructions, the first factory buildings, the earliest photos, objects that have begun to be extinct, grand pianos, the dresses of five years ago, fashionable restaurants when the vogue has begun to ebb from them. The relation of these things to revolution—no one can have a more exact concept of it than these authors. No one before these visionaries and augurs perceived how destitution—not only social but architectonic, the poverty of interiors, enslaved and enslaving objects—can be suddenly transformed into revolutionary nihilism. To say nothing of Aragon's *Passage de l'Opéra,* Breton and Nadja are the lovers who convert everything that we have experienced on mournful railway journeys (railways are beginning to age), on godforsaken Sunday afternoons in the proletarian neighborhoods of great cities, in the first glance through the rain-blurred window of a new apartment, into revolutionary experience, if not action. They bring the immense forces of "atmosphere" concealed in these things to the point of explosion. What form do you suppose a life would take that was determined at a decisive moment precisely by the street song last on everyone's lips?

The trick by which this world of things is mastered—it is more proper to speak of a trick than a method—consists in the substitution of a political for a historical view of the past. "Open, graves! You, the dead of the picture galleries, corpses behind screens, in palaces, castles, and monasteries! Here

stands the fabulous keeper of keys holding a bunch of the keys to all times, who knows where to press the most artful lock and invites you to step into the midst of the world of today, to mingle with the bearers of burdens, the mechanics whom money ennobles, to make yourself at home in their automobiles, which are beautiful as armor from the age of chivalry, to take your places in the international sleeping cars, and to weld yourself to all the people who today are still proud of their privileges. But civilization will make short work of them." This speech was attributed to Apollinaire by his friend Henri Hertz.[6] Apollinaire originated this technique. In his volume of novellas, *L'Hérésiarque,* he used it with Machiavellian calculation to blow Catholicism (which he inwardly embraced) to smithereens.[7]

At the center of this world of things stands the most dreamed-about of their objects: the city of Paris itself. But only revolt completely exposes its Surrealist face (deserted streets in which whistles and shots dictate the outcome). And no face is surrealistic to the same degree as the true face of a city. No picture by de Chirico or Max Ernst can match the sharp elevations of the city's inner strongholds, which one must overrun and occupy in order to master their fate and—in their fate, in the fate of their masses—one's own.[8] Nadja is an exponent of these masses and of what inspires them to revolution: "The great living, sonorous unconsciousness that inspires my only convincing acts—in the sense that I always want to prove that it commands forever everything which is mine." Here, therefore, we find the catalogue of these fortifications, from Place Maubert, where as nowhere else dirt has retained all its symbolic power, to the Théâtre Moderne, which I am inconsolable not to have known. But in Breton's description of the bar on the upper floor ("it is quite dark, with arbors like impenetrable tunnels—a drawing room on the bottom of a lake") there is something that brings back to my memory that most uncomprehended room in the old Princess Café. It was the back room on the first floor, with couples sitting in the blue light. We called it the "anatomy school"; it was the last restaurant designed for love. In such passages in Breton, photography intervenes in a very strange way. It makes the streets, gates, squares of the city into illustrations of a trashy novel, draws off the banal obviousness of this ancient architecture to inject it with the most pristine intensity toward the events described, to which, as in old chambermaids' books, word-for-word quotations with page numbers refer. And all the parts of Paris that appear here are places where what is between these people turns like a revolving door.

The Surrealists' Paris, too, is a "little universe." That is to say, in the larger one, the cosmos, things look no different. There, too, are crossroads where ghostly signals flash from the traffic, and inconceivable analogies and connections between events are the order of the day. It is the space on which the lyric poetry of Surrealism reports. And this must be noted, if only to counter the obligatory misunderstanding of *l'art pour l'art.* For "art for art's

sake" was scarcely ever to be taken literally; it was almost always a flag under which sailed a cargo that could not be declared because it still lacked a name. This is the moment to embark on a work that would illuminate as has no other the crisis of the arts that we are witnessing: a history of esoteric poetry. Nor is it by any means fortuitous that no such work yet exists. For written as it demands to be written—that is, not as a collection to which particular "specialists" all contribute "what is most worth knowing" from their fields, but as the deeply grounded composition of an individual who, from inner compulsion, portrays less a historical evolution than a constantly renewed, primal upsurge of esoteric poetry—written in such a way, it would be one of those scholarly confessions that find their place in every century. The last page would have to show an X-ray image of Surrealism. Breton indicates in his "Introduction au discours sur le peu de réalité" [Introduction to a Discourse on the Small Bit of Reality] how the philosophical realism of the Middle Ages was the basis of poetic experience. This realism, however—that is, the belief in a real, separate existence of concepts whether outside or inside things—has always very quickly crossed over from the logical realm of ideas to the magical realm of words. And it is as magical experiments with words, not as artistic dabbling, that we must understand the passionate phonetic and graphic transformational games that have run through the whole literature of the avant-garde for the past fifteen years, whether it is called Futurism, Dadaism, or Surrealism. How slogans, magic formulas, and concepts are here intermingled is shown by the following words of Apollinaire's from his last manifesto, "L'esprit nouveau et les poètes" [The New Spirit and the Poets]. He says, in 1918: "For the speed and simplicity with which we have all become used to referring by a single word to such complex entities as a crowd, a nation, the universe, there is no modern equivalent in literature. But today's writers fill this gap; their synthetic works create new realities whose plastic manifestations are just as complex as those referred to by the words standing for collectives." If, however, Apollinaire and Breton advance even more energetically in the same direction and complete the linkage of Surrealism to the outside world with the declaration, "The conquests of science rest far more on surrealistic than on logical thinking"—if, in other words, they make mystification, the culmination of which Breton sees in poetry (which is defensible), the foundation of scientific and technical development, too—then such integration is too impetuous. It is very instructive to compare the movement's overprecipitous embrace of the uncomprehended miracle of machines—"the old fables have for the most part been realized; now it is the turn of poets to create new ones that the inventors on their side can then make real again" (Apollinaire)—to compare these overheated fantasies with the well-ventilated utopias of a Scheerbart.[9]

"The thought of all human activity makes me laugh." This utterance of

Aragon's shows very clearly the path Surrealism had to follow from its origins to its politicization. In his excellent essay "La révolution et les intellectuels" [The Revolution and the Intellectuals], Pierre Naville, who originally belonged to this group, rightly called this development dialectical.[10] In this transformation of a highly contemplative attitude into revolutionary opposition, the hostility of the bourgeoisie toward every manifestation of radical intellectual freedom played a leading part. This hostility pushed Surrealism to the left. Political events, above all the war in Morocco, accelerated this development. With the manifesto "Intellectuals against the Moroccan War," which appeared in *L'Humanité*, a fundamentally different platform was gained from that which was characterized by, for example, the famous scandal at the Saint-Pol-Roux banquet.[11] At that time, shortly after the war, when the Surrealists, who deemed the celebration for a poet they worshiped compromised by the presence of nationalistic elements, burst out with the cry "Long live Germany!" they remained within the boundaries of scandal, toward which, as is known, the bourgeoisie is as thick-skinned as it is sensitive to all action. There is remarkable agreement between the ways in which, under such political auspices, Apollinaire and Aragon saw the future of the poet. The chapters "Persecution" and "Murder" in Apollinaire's *Poète assassiné* [The Poet Assassinated] contain the famous description of a pogrom against poets. Publishing houses are stormed, books of poems thrown on the fire, poets beaten to death. And the same scenes are taking place at the same time all over the world. In Aragon, "Imagination," in anticipation of such horrors, marshals its forces for a last crusade.

To understand such prophecies, and to assess strategically the line arrived at by Surrealism, one must investigate the mode of thought widespread among the so-called well-meaning left-wing bourgeois intelligentsia. It manifests itself clearly enough in the present Russian orientation of these circles. We are not of course referring here to Béraud, who pioneered the lie about Russia, or to Fabre-Luce, who trots behind him like a devoted donkey, loaded with every kind of bourgeois ill will.[12] But how problematic one finds even the typical mediating book by Duhamel. How difficult it is to bear the strained uprightness, the forced animation and sincerity of the Protestant method, dictated by embarrassment and linguistic ignorance, of placing things in some kind of symbolic illumination. How traitorous his résumé: "the true, deeper revolution, which could in some sense transform the substance of the Slavic soul itself, has not yet taken place." It is typical of these left-wing French intellectuals—exactly as it is of their Russian counterparts, too—that their positive function derives entirely from a feeling of obligation not to the revolution but to traditional culture. Their collective achievement, as far as it is positive, approximates conservation. But politically and economically they must always be considered a potential source of sabotage.

Characteristic of this whole left-wing bourgeois position is its irremediable coupling of idealistic morality with political practice. Only in contrast to the helpless compromises of "sentiment" can certain central features of Surrealism, indeed of the Surrealist tradition, be understood. Little has happened so far to promote this understanding. The seduction was too great to enable one to regard the satanism of a Rimbaud or a Lautréamont as a pendant to "art for art's sake" in an inventory of snobbery. If, however, one resolves to open up this romantic dummy, one finds something usable inside. One finds the cult of evil as a political device, however romantic—a device that can be used to disinfect and isolate against all moralizing dilettantism. Convinced of this, and coming across the scenario of a horror play by Breton that centers on a violation of children, one might perhaps go back a few decades. Between 1865 and 1875 a number of great anarchists, without knowing of one another, each worked on their infernal machine. And the astonishing thing is that independently of one another they set its clock at exactly the same hour, and forty years later in Western Europe the writings of Dostoevsky, Rimbaud, and Lautréamont exploded at the same time. One might, to be more exact, select from Dostoevsky's entire work the one episode that was actually not published until about 1915: "Stavrogin's Confession," from *The Possessed*. This chapter, which touches very closely on the third canto of Lautréamont's *Chants de Maldoror* [Songs of Maldoror], contains a justification of evil in which certain motifs of Surrealism are more powerfully expressed than by any of its present spokesmen. For Stavrogin is a Surrealist *avant la lettre*. No one else understood, as he did, how naive philistines are when they say that goodness, for all the manly virtue of those who practice it, is God-inspired, but that evil stems entirely from our spontaneity, and in it we are independent and self-sufficient beings. No one else saw inspiration, as he did, in even the most ignoble actions, and precisely in them. He considered vileness itself as something preformed, both in the course of the world and also in ourselves, to which we are disposed if not called, as the bourgeois idealist sees virtue. Dostoevsky's God created not only heaven and earth and man and beast, but also baseness, vengeance, cruelty. And here, too, he gave the devil no opportunity to meddle in his handiwork. That is why all these vices have a pristine vitality in his work; they are perhaps not "splendid," but eternally new, "as on the first day," separated by an infinity from the clichés through which sin is perceived by the philistine.

The pitch of tension that enabled the poets under discussion to achieve their astonishing long-range effects is documented quite scurrilously in the letter Isidore Ducasse addressed to his publisher on October 23, 1869, in an attempt to make his poetry look acceptable. He places himself in the line that descends from Mickiewicz, Milton, Southey, Alfred de Musset, and Baudelaire, and says:[13] "Of course, I somewhat swelled the note to bring

something new into this literature that, after all, sings of despair solely in order to depress the reader and thus make him long all the more intensely for goodness as a remedy. So that in the end one really sings only of goodness; but the method is more philosophical and less naive than that of the old school, of which only Victor Hugo and a few others are still alive."[14] Yet if Lautréamont's erratic book has any lineage at all, or, rather, can be assigned one, it is that of insurrection. Soupault's attempt, in his edition of the complete works in 1927, to write a political curriculum vitae for Isidore Ducasse was therefore a quite understandable and not unperceptive venture. Unfortunately, there is no documentation for it, and that adduced by Soupault rests on a confusion. On the other hand, and happily, a similar attempt in the case of Rimbaud was successful, and it is the achievement of Marcel Coulon to have defended the poet's true image against the Catholic usurpation by Claudel and Berrichon.[15] Rimbaud is indeed a Catholic, but he is one, by his own account, in the most wretched part of himself, which he never tires of denouncing and consigning to his own and everyone's hatred, his own and everyone's contempt: the part that forces him to confess that he does not understand revolt. But this is the confession of a communard dissatisfied with his own contribution who, by the time he turned his back on poetry, had long since—in his earliest work—taken leave of religion. "Hatred, to you I have entrusted my treasure," he writes in *Une saison en enfer*. This is another dictum around which a poetics of Surrealism might grow like a climbing plant, to sink its roots deeper than the theory of "surprised" creation originated by Apollinaire—sink them to the depth of the insights of Poe.

Since Bakunin, Europe has lacked a radical concept of freedom.[16] The Surrealists have one. They are the first to liquidate the sclerotic liberal-moral-humanistic ideal of freedom, because they are convinced that "freedom, which on this earth can be bought only with a thousand of the hardest sacrifices, must be enjoyed unrestrictedly in its fullness without any kind of pragmatic calculation, as long as it lasts." And this proves to them that "mankind's struggle for liberation in its simplest revolutionary form (which is nevertheless liberation in every respect), remains the only cause worth serving." But are they successful in welding this experience of freedom to the other revolutionary experience, which we must acknowledge because it has been ours—the constructive, dictatorial side of revolution? In short, have they bound revolt to revolution? How are we to imagine an existence oriented solely toward the boulevard Bonne-Nouvelle, in rooms designed by Le Corbusier and Oud?[17]

To win the energies of intoxication for the revolution—this is the project on which Surrealism focuses in all its books and enterprises. This it may call its most particular task. For them it is not enough that, as we know, an intoxicating component lives in every revolutionary act. This component is

identical with the anarchic. But to place the accent exclusively on it would be to subordinate the methodical and disciplinary preparation for revolution entirely to a praxis oscillating between fitness exercises and celebration in advance. Added to this is an inadequate, undialectical conception of the nature of intoxication. The aesthetic of the painter, the poet, *en état de surprise,* of art as the reaction of one surprised, is enmeshed in a number of pernicious romantic prejudices. Any serious exploration of occult, surrealistic, phantasmagoric gifts and phenomena presupposes a dialectical intertwinement to which a romantic turn of mind is impervious. For histrionic or fanatical stress on the mysterious side of the mysterious takes us no further; we penetrate the mystery only to the degree that we recognize it in the everyday world, by virtue of a dialectical optic that perceives the everyday as impenetrable, the impenetrable as everyday. The most passionate investigation of telepathic phenomena, for example, will not teach us half as much about reading (which is an eminently telepathic process) as the profane illumination of reading will teach us about telepathic phenomena. And the most passionate investigation of the hashish trance will not teach us half as much about thinking (which is eminently narcotic) as the profane illumination of thinking will teach us about the hashish trance. The reader, the thinker, the loiterer, the *flâneur,* are types of illuminati just as much as the opium eater, the dreamer, the ecstatic. And more profane. Not to mention that most terrible drug—ourselves—which we take in solitude.

"To win the energies of intoxication for the revolution"—in other words, poetic politics? "We've tried that beverage. Anything, rather than that!" Well, it will interest you all the more to see how much an excursion into poetry clarifies things. For what is the program of the bourgeois parties? A bad poem on springtime, filled to bursting with metaphors. The socialist sees that "finer future of our children and grandchildren" in a society in which all act "as if they were angels" and everyone has as much "as if he were rich" and everyone lives "as if he were free." Of angels, wealth, freedom, not a trace—these are mere images. And the stock imagery of these poets of the social-democratic associations? Their *gradus ad parnassum?* Optimism. A very different air is breathed in the Naville essay that makes the "organization of pessimism" the call of the hour. In the name of his literary friends, Naville delivers an ultimatum in the face of which this unprincipled, dilettantish optimism must unfailingly show its true colors: Where are the conditions for revolution? In the changing of attitudes or of external circumstances? This is the cardinal question that determines the relation of politics to morality and cannot be glossed over. Surrealism has come ever closer to the Communist answer. And that means pessimism all along the line. Absolutely. Mistrust in the fate of literature, mistrust in the fate of freedom, mistrust in the fate of European humanity, but three times

mistrust in all reconciliation: between classes, between nations, between individuals. And unlimited trust only in IG Farben and the peaceful perfecting of the air force.[18] But what now? What next?

Here, due weight must be given to the insight which in the *Traité du style* [Treatise on Style], Aragon's last book, required a distinction between metaphor and image, a happy insight into questions of style that needs extending. Extension: nowhere do these two—metaphor and image—collide so drastically and so irreconcilably as in politics. For to organize pessimism means nothing other than to expel moral metaphor from politics and to discover in the space of political action the one hundred percent image space. This image space, however, can no longer be measured out by contemplation. If it is the double task of the revolutionary intelligentsia to overthrow the intellectual predominance of the bourgeoisie and to make contact with the proletarian masses, the intelligentsia has failed almost entirely in the second part of this task because it can no longer be performed contemplatively. Yet this has hindered scarcely anybody from approaching it again and again as if it could, and calling for proletarian poets, thinkers, and artists. To counter this, Trotsky had to point out—as early as *Literature and Revolution*—that such artists would emerge only from a victorious revolution.[19] In reality, it is far less a matter of making the artist of bourgeois origin into a master of "proletarian art" than of deploying him, even at the expense of his artistic activity, at important points in this image space. Indeed, mightn't the interruption of his "artistic career" perhaps be an essential part of his new function?

The jokes he tells will be better for it. And he will tell them better. For in the joke, too, in invective, in misunderstanding, in all cases where an action puts forth its own image and exists, absorbing and consuming it, where nearness looks with its own eyes, the long-sought image space is opened, the world of universal and integral actuality, where the "best room" is missing—the space, in a word, in which political materialism and physical creatureliness share the inner man, the psyche, the individual, or whatever else we wish to throw to them, with dialectical justice, so that no limb remains untorn. Nevertheless—indeed, precisely after such dialectical annihilation—this will still be an image space and, more concretely, a body space. For in the end this must be admitted: metaphysical materialism, of the brand of Vogt and Bukharin—as is attested by the experience of the Surrealists, and earlier by that of Hebel, Georg Büchner, Nietzsche, and Rimbaud—cannot lead without rupture to anthropological materialism.[20] There is a residue. The collective is a body, too. And the *physis* that is being organized for it in technology can, through all its political and factual reality, be produced only in that image space to which profane illumination initiates us. Only when in technology body and image space so interpenetrate that all revolutionary tension becomes bodily collective innervation, and all the

bodily innervations of the collective become revolutionary discharge, has reality transcended itself to the extent demanded by the *Communist Manifesto*. For the moment, only the Surrealists have understood its present commands. They exchange, to a man, the play of human features for the face of an alarm clock that in each minute rings for sixty seconds.

Published in *Die literarische Welt*, February 1929. *Gesammelte Schriften*, II, 295–310. Translated by Edmund Jephcott.

Notes

1. André Breton (1896–1966), French poet, essayist, critic, and editor, was one of the founders of the Surrealist movement and became its dominant voice. In 1924 Breton's *Manifeste du surréalisme* defined Surrealism as "pure psychic automatism, by which it is intended to express . . . the real process of thought. It is the dictation of thought, free from any control by the reason and of any aesthetic or moral preoccupation." Breton's chief works include the novel *Nadja* (1928), the prose experiments *Les vases communicants* (The Communicating Vessels; 1932) and *L'amour fou* (Mad Love; 1937), and the critical essays "Le surréalisme et le peinture" (Surrealism and Painting; 1926), "Qu'est-ce que le surréalisme?" (What Is Surrealism?; 1934), and "La clé des champs" (The Key to the Fields; 1953). In the late 1920s Breton and many of his Surrealist colleagues came to a new political engagement; Breton joined the Communist party, but broke with it in 1935, espousing his own brand of Marxism. Louis Aragon (pseudonym of Louis Andrieux; 1897–1982), French poet, novelist, and essayist, was one of the most politically active Surrealists. His novel *Le paysan de Paris* (The Nightwalker; 1926) was a key text in Benjamin's early thinking about *Das Passagen-Werk* (The Arcades Project). Aragon joined the French Communist party in 1927, visited the Soviet Union in 1930, and broke with the Surrealists in 1933 over issues of party orthodoxy. Philippe Soupault (1897–1990) was a French poet and novelist whose book *Les champs magnétiques* (The Magnetic Fields; 1920), written jointly with Breton, is regarded as the first major Surrealist work. As the Surrealist movement became increasingly dogmatic and political, Soupault grew dissatisfied with it and eventually broke with it and Breton. Robert Desnos (1900–1945), French poet, emerged as a key figure in early Surrealism because of his susceptibility to hypnotism, under which he could recite his dreams, write, and draw. His works include *La liberté ou l'amour!* (Liberty or Love!; 1927), *Corps et biens* (Bodies and Goods; 1930), and, after the inevitable break with Breton and Surrealist orthodoxy, the successful screenplay *Complainte de Fantomas* (Fantomas' Lament; 1933). Paul Eluard (pseudonym of Eugène Grindel; 1895–1952), French poet, was an early Surrealist and one of the leading lyric poets of the century. His major collections include *Capitale de la douleur* (Capital of Sorrow; 1926), *La rose publique* (The Public Rose; 1934), and *Les yeux fertiles* (The Fertile Eyes; 1936). After the Spanish Civil War, Eluard abandoned Surrealist experimentation.

2. The "Fronde" is the collective name for the series of civil wars that raged in France between 1648 and 1653, during the minority of Louis XIV. The term, meaning "sling," is derived from the toy catapults that were used in a children's game played in the streets of Paris in defiance of the civil authorities. The wars arose in part in an attempt to check the growing power of royal government; their failure prepared the way for the absolutism of Louis XIV's reign.

3. Arthur Rimbaud (1854–1891), Symbolist poet, published *Une saison en enfer,* a series of prose poems, in Brussels in 1873.

4. Saint-Pol-Roux (pseudonym of Paul Roux; 1861–1940) was a French Symbolist poet whose highly original but extravagant figurative language found a late echo among the Surrealists.

5. The comte de Lautréamont (pseudonym of Isidore-Lucien Ducasse; 1846–1870) was a French poet whose major work was the prose poem *Les chants de Maldoror* (1868–1869). The Surrealists recognized in the work's startling imagery an important precedent for their own literary practice. Guillaume Apollinaire (pseudonym of Wilhelm Apollinaris de Kostrowitzki; 1880–1918), French poet and critic, was the driving force in the French avant-garde until his early death. His most important works include the pioneering essay "Peintures cubistes" (Cubist Painters; 1913), the poem collections *Alcools* (1913) and *Calligrammes* (1918), the story "Le poète assassiné" (The Poet Assassinated; 1916), and the play *Les mamelles de Tirésias* (The Breasts of Tiresias; staged in 1917). Apollinaire described the play as "surrealist," the first use of the term.

6. Henri Hertz (1875–1966), French poet, novelist, essayist, and journalist, was an important left-liberal voice in France after about 1910. He moved easily between the avant-garde circles around Apollinaire and the world of international politics.

7. Apollinaire's volume of novellas, *L'Hérésiarque,* appeared in Paris in 1910.

8. Giorgio de Chirico (1888–1978) was an Italian painter who, with Carlo Carrà and Giorgio Morandi, founded the *pittura metafisica* style of painting. De Chirico's paintings, with their harsh juxtapositions of oddly disparate objects in deep, barren perspectives, exerted a strong influence on the Surrealists. Max Ernst (1891–1976), German painter and sculptor, moved easily from Dada in Cologne to Surrealism in Paris. His experimentation with automatism in painting formed an important parallel to the writing practices of the movement.

9. Paul Scheerbart (1863–1915), German author, produced poetry and prose oriented toward a gently fantastic science fiction. In 1919, Benjamin wrote an unpublished review of his novel *Lesabéndio* (1913).

10. Pierre Naville's pamphlet "La révolution et les intellectuels" publicly challenged the political engagement of his fellow Surrealists.

11. *L'Humanité,* the daily paper founded in 1904 by Jean Jaurès as the organ of the Socialist party, became the organ of the Communist party in 1920.

12. Henri Béraud (1885–1958), French novelist and journalist, was an active right-wing pamphleteer. During World War II, he was a collaborator of the Vichy regime and edited the weekly newspaper *Gringoire.*

13. Adam Mickiewicz (1798–1855) was one of the greatest poets of Poland and a lifelong advocate of Polish national freedom. His exalted patriotism, mystical feeling, and passionate appreciation of the positive aspects of Polish life stood

as a model for succeeding generations of Polish writers. John Milton (1608–1674), English poet and advocate of civil and religious liberty, produced a number of important political tracts ("Of Education," 1644; "Areopagitica," 1644; "The Second Defence of the English People," 1654), as well as the long poems for which he is best-known (*Paradise Lost,* 1667; *Paradise Regained,* 1671; *Samson Agonistes,* 1671). Robert Southey (1774–1843), English poet and prose writer, was an early and outspoken champion of the French Revolution, in such works as the long poem *Joan of Arc* (1796) and the verse drama *The Fall of Robespierre* (1794), which he coauthored with Samuel Taylor Coleridge. After about 1797, Southey's views became increasingly conservative, and his pen turned to support of the Tories. Alfred de Musset (1810–1857) was a French Romantic poet and playwright. Though always associated with the Romantic movement, Musset often caricatured its excesses. Charles Baudelaire (1821–1867) was a French poet whose collection *Les Fleurs du Mal* (1857) is generally recognized as the most important and influential volume of poetry of the nineteenth century. Although his political affiliations and activities remain somewhat obscure, recent studies have suggested that his radical political views led to his participation in the February 1848 riots that overthrew King Louis-Philippe and installed the Second Republic, as well as in the resistance to the Bonapartist military coup of December 1851.

14. Victor Hugo (1802–1885), French dramatist, novelist, and poet, was the most important of the Romantic writers. While his novels (*Les Misérables,* 1862; *Notre-Dame de Paris,* 1831) remain his best-known works, his legacy to the nineteenth century was his lyric poetry.

15. Paul Claudel (1868–1955), poet, playwright, and essayist, was an important force in French letters at the turn of the century. The tone and lyricism of his work owe much to his deeply felt Catholicism. Paterne Berrichon (pseudonym of Pierre Dufour; 1855–1922), French editor and man of letters, married Rimbaud's sister Isabelle. Berrichon and his wife oversaw the early editions of the poet's work and produced a quantity of biographical writing; the thrust of all of this was to present Rimbaud as a Christian author who had strayed from the true path but had reconverted near the end of his life.

16. Mikhail Aleksandrovich Bakunin (1814–1876) was the chief proponent of anarchism in the nineteenth century. He was engaged equally as a revolutionary agitator and as a prolific political writer. A quarrel with Karl Marx over the direction of the International split the European revolutionary movement for many years.

17. Le Corbusier (pseudonym of Charles-Edouard Jeanneret; 1887–1965) was a Swiss architect and city planner whose work combined a modernist functionalism with a bold, sculptural expressionism. In addition to buildings and drawings, Le Corbusier produced a large body of theoretical writings; he was perhaps the most effective public advocate of the first generation of the International school of architecture. Jacobus Johannes Pieter Oud (1890–1963), Dutch architect, founded, together with Theo van Doesburg, the influential review *De Stijl* in 1917. Oud soon became the chief proponent of the austere, geometric style identified with the circle around the journal; his best-known works include a

series of massive housing projects. Oud's book *Höllandische Architektur* (1926) solidified his international reputation.

18. IG Farben (in full: Interessengemeinschaft Farbenindustrie Aktiengesellschaft, or Syndicate of Dye-Industry Corporations) was the world's largest chemical concern, or cartel, between its founding in 1925 and its dissolution by the Allies after World War II. The IG (Interessengemeinschaft—literally, "community of interests"), partly patterned after earlier U.S. trusts, grew out of a complex merger of German manufacturers of chemicals, pharmaceuticals, and dyestuffs *(Farben)*. The major members were the companies known today as BASF, Bayer, Hoechst, Agfa-Gevaert, and Cassella.

19. Leo Trotsky (pseudonym of Lev Davidovich Bronshtein; 1879–1940), Communist theorist and agitator, was a leader in the October Revolution of 1917, and later, under Lenin, was commissar of foreign affairs and of war (1917–1924) in the Soviet Union. In the struggle for power following Lenin's death, however, Joseph Stalin emerged as victor, while Trotsky was removed from all positions of power and later exiled (1929). He remained the leader of anti-Stalinist opposition abroad, until his assassination in Mexico, allegedly by a Stalinist agent. His *Literatura i revoljucja (Literature and Revolution)* was published in 1922.

20. Nikolai Ivanovich Bukharin (1888–1938) was an early Bolshevik, a Marxist theoretician and economist, and a prominent member of both the Politburo and the Communist International (Comintern). He was stripped of his party posts in 1929 and fell victim to one of the last of Stalin's purge trials. Johann Peter Hebel (1760–1826), German journalist and prose stylist, remained one of Benjamin's favorite authors (see the essay "Johann Peter Hebel," in Volume 1 of this edition). His "Calendar Stories," composed in a lapidary style, combine humor, didacticism, and folk wisdom. Georg Büchner (1813–1837), German dramatist, has emerged as one of the great playwrights of the nineteenth century. His three plays—*Dantons Tod* (Danton's Death; 1835), *Leonce und Lena* (1836), and *Woyzeck* (1836)—combine a harshly episodic structure with extreme naturalism and materialism. Friedrich Wilhelm Nietzsche (1844–1900), German philosopher, psychologist, and moralist, composed a body of work notable for its adherence to an extreme materialism.

Chaplin in Retrospect

The Circus is the first product of the art of film that is also the product of old age. Charlie has grown older since his last film. But he also acts old. And the most moving thing about this new film is the feeling that Chaplin now has a clear overview of his possibilities and is resolved to work exclusively within these limits to attain his goal. At every point the variations on his greatest themes are displayed in their full glory. The chase is set in a maze; his unexpected appearance would astonish a magician; the mask of noninvolvement turns him into a fairground marionette . . .

The lesson and the warning that emerge from this great work have led the poet Philippe Soupault to attempt the first definition of Chaplin as a historical phenomenon. In November the excellent Paris review *Europe* (published by Rieder, Paris), to which we shall return in greater detail, presented an essay by Soupault containing a number of ideas around which a definitive picture of the great artist will one day be able to crystallize.[1]

What he emphasizes there above all is that Chaplin's relation to the film is fundamentally not that of Chaplin the actor, let alone the star. Following Soupault's way of thinking, we might say that Chaplin, considered as a total phenomenon, is no more of an actor than was William Shakespeare. Soupault insists, rightly, that "the undeniable superiority of Chaplin's films . . . is based on the fact that they are imbued with a poetry that everyone encounters in his life, admittedly without always being conscious of it." What is meant by this is of course *not* that Chaplin is the "author" of his film *scripts*. Rather, he is simply the author of his own films—that is to say, their director. Soupault has realized that Chaplin was the first (and the Russians have followed his example) to construct a film with a theme and

variations—in short, with the element of composition—and that all this stands in complete opposition to films based on action and suspense. This explains why Soupault has argued more forcefully than anyone else that the pinnacle of Chaplin's work is to be seen in *A Woman of Paris*. This is the film in which, as is well known, he does not even appear and which was shown in Germany under the idiotic title *Die Nächte einer schönen Frau* [Nights of a Beautiful Woman]. (The Kamera Theater ought to show it every six months. It is a foundation document of the art of film.)

When we learn that 125,000 meters of film were shot for this 3,000-meter work, we get some idea of the capital that this man requires, and that is at least as necessary to him as to a Nansen or an Amundsen[2] if he is to make his voyages of discovery to the poles of the art of film. We must share Soupault's concern that Chaplin's productivity may be paralyzed by the dangerous financial claims of his second wife, as well as by the ruthless competition of the American trusts. It is said that Chaplin is planning both a Napoleon-film and a Christ-film. Shouldn't we fear that such projects are no more than giant screens behind which the great artist conceals his exhaustion?

It is good and useful that at the moment old age begins to show itself in Chaplin's features, Soupault should remind us of Chaplin's youth and of the territorial origins of his art. Needless to say, these lie in the metropolis of London.

> In his endless walks through the London streets, with their black-and-red houses, Chaplin trained himself to observe. He himself has told us that the idea of creating his stock character—the fellow with the bowler hat, jerky walk, little toothbrush moustache, and walking stick—first occurred to him on seeing office workers walking along the Strand. What he saw in their bearing and dress was the attitude of a person who takes some pride in himself. But the same can be said of the other characters that surround him in his films. They, too, originate in London: the shy, young, winsome girl; the burly lout who is always ready to use his fists and then to take to his heels when he sees that people aren't afraid of him; the arrogant gentleman who can be recognized by his top hat.

Soupault appends to this portrait a comparison between Dickens and Chaplin that is worth reading and exploring further.

With his art, Chaplin confirms the old insight that only an imaginative world that is firmly grounded in a society, a nation, and a place will succeed in evoking the great, uninterrupted, yet highly differentiated resonance that exists between nations. In Russia, people wept when they saw *The Pilgrim;* in Germany, people are interested in the theoretical implications of his comedies; in England, they like his sense of humor. It is no wonder that Chaplin himself is puzzled and fascinated by these differences. Nothing

points so unmistakably to the fact that the film will have immense significance as that it neither did nor could occur to anyone that there exists any judge superior to the actual audience. In his films, Chaplin appeals both to the most international and the most revolutionary emotion of the masses: their laughter. "Admittedly," Soupault says, "Chaplin merely makes people laugh. But aside from the fact that this is the hardest thing to do, it is socially also the most important."

Published in *Die literarische Welt*, February 1929. *Gesammelte Schriften*, III, 157–159. Translated by Rodney Livingstone.

Notes

1. Philippe Soupault, "Charlie Chaplin," in *Europe: Revue mensuelle* [Paris] 18 (November 1928): 379–402.
2. Fridtjof Nansen (1861–1930) and Roald Amundsen (1872–1928) were Norwegian explorers of the Polar regions. Nansen won the Nobel Peace Prize in 1922 for his work with refugees. Amundsen, having led the expeditions that first reached the South Pole (1911) and flew over the North Pole (1926), disappeared while attempting to rescue his colleague Umberto Nobile in the Arctic in 1928.

Chambermaids' Romances of the Past Century

Chambermaids' romances? Since when are works of literature categorized according to the class that consumes them? Unfortunately, they are not—or all too seldom. Yet how much more illuminating this would be than hackneyed aesthetic appreciations! Nevertheless, such a categorization would pose problems. Above all, because we so rarely obtain any insight into the relations of production. They used to be more transparent than they are in our day. This is why a start should be made with cheap fiction, with colportage, if indeed literary history is ever going to explore the geological structure of the book-alps, rather than confining itself to a view of the peaks.

Before the development of advertising, the book trade was dependent on itinerant colporteurs or booksellers for distribution of its wares among the lower classes. It is amusing to imagine the complete literary traveling salesman of that age and those classes, the man who knew how to introduce ghost stories and tales of chivalry into the servants' quarters in the cities and the peasants' cottages in the villages. To a certain extent he must have been able to become part of the stories he was selling. Not as the hero, of course, not the banished prince or the knight errant, but perhaps the ambiguous old man—warner or seducer?—who appears in many of these stories and who, in the first illustration shown here, is about to make himself scarce at the sight of a crucifix.

It is not surprising that this entire body of literature has been despised for as long as the superstitious belief in absolute "art" has existed. The concept of the document, however, which we nowadays apply to the works of primitives, children, and the sick, has also provided essential contexts within which to consider these writings. People began to recognize the value

"Swear!"

This illustration is from a medieval tale of ghosts and chivalry entitled *Adelmar von Perlstein, the Knight of the Golden Key; or, The Twelve Sleeping Maidens, Protectors of the Enchanting Young Man.*

The Princess of Vengeance, Known as the Hyena of Paris

"I swear it: they shall all suffer the fate of this man!" The beauty portrayed here is a collector of preserved human heads, which she keeps on the shelves of a cupboard in her house.

"My Curse upon You!"
This illustration comes from a story of recent times by O. G. Der-
wicz, entitled *Antonetta Czerna, the Princess of the Wild; or, The
Vengeance of a Woman's Wounded Heart* (Pirna, n.d.). These
smartly dressed ladies have turned up for the shooting of the
young man as if for a garden party.

"Stand Back, Base Scoundrel!"

This is the notorious "Black Knight," who has just conquered York Castle and is about to overpower the beautiful Rebecca. One might say that the two figures are dancing a kind of country waltz of horror.

of typical stories [*Stoffe*—literally, subjects] and became interested in studying the few truly living ones that continue to have an impact and are capable of constant renewal. They perceived that the artistic ideals of various generations and classes were embodied just as definitively in formal idioms of these groups as in the ways in which they differed. The archive of such eternal stories is the dream, as Freud has taught us to understand it.

Works that pander so directly to the public's hunger for stories are interesting enough in themselves; but they become even more so when the same spirit is expressed graphically and colorfully through illustrations. The very principle of such illustrations testifies to the close connection between reader and story. The reader wants to know exactly what their place is. If only we had more such pictures! But where they were not protected by the stamp of a lending library—like two of those shown here—they have followed their predestined path: from the book to the wall and from the wall to the rubbish bin.

These books raise many questions. Apart from external ones, such as matters of authorship, influence, and so on, there is the question of why, in stories that were written in the heyday of the bourgeoisie, moral authority is always tied to a lady or gentleman of rank. Perhaps because the servant classes still felt a certain solidarity with the middle class and shared its most secret romantic ideals.

Many of these novels have a motto in verse at the head of each of their bloodthirsty chapters. There you can encounter Goethe and Schiller, and even Schlegel and Immermann, but also such leading poets as Waldau, Parucker, Tschabuschnigg, or the simple B.,[1] to whom we owe these lines:

> Alone she strays, abandoned,
> through the endless city streets,
> Every instant to fear
> the enemies she might meet.

We are still clumsy in our efforts to approach these clumsy works. We feel it is strange to take seriously books that were never part of a "library." But let us not forget that books were originally objects for use—indeed, a means of subsistence. These were devoured. Let us use them to study novels from the point of view of their food chemistry!

Published in *Das illustrierte Blatt*, April 1929. *Gesammelte Schriften*, IV, 620–622. Translated by Rodney Livingstone.

Notes

1. Benjamin probably refers here to Friedrich Schlegel (1772–1829), the prominent Romantic theorist, translator, scholar, critic, and novelist. Karl Leberecht Immer-

mann (1796–1840) was a German author whose novels of contemporary social analysis and village life were widely read. Max Waldau (pseudonym of Richard Georg Spiller von Hauenschild; 1825–1855) was a poet and novelist active in East Prussia; he is best-known for the novels *Nach der Natur* (After Nature; 1850) and *Aus der Junkerwelt* (From the World of the Country Squires; 1850). Adolf Ritter von Tschabuschnigg (1809–1877) was an Austrian writer and politician; after a long political career, he became minister of justice in 1870–1871. His novels *Die Industriellen* (The Industrialists; 1854) and *Sünder und Toren* (Sinners and Fools; 1875) were oriented toward societal analysis and critique.

Marseilles

The street . . . the only valid field of experience.
—André Breton

Marseilles: the yellow-studded maw of a seal with salt water running out between the teeth. When this gullet opens to catch the black and brown proletarian bodies thrown to it by ship's companies according to their timetables, it exhales a stink of oil, urine, and printer's ink. This comes from the tartar baking hard on the massive jaws: newspaper kiosks, lavatories, and oyster stalls. The harbor people are a bacillus culture, the porters and whores products of decomposition with a resemblance to human beings. But the palate itself is pink, which is the color of shame here, of poverty. Hunchbacks wear it, and beggarwomen. And the faded women of the rue Bouterie are given their only tint by the sole pieces of clothing they wear: pink shifts.

Les Bricks, the red-light district is called, after the barges moored a hundred paces away at the jetty of the old harbor. A vast agglomeration of steps, arches, bridges, turrets, and cellars. It seems to be still awaiting its designated use, but it already has it. For this depot of wornout alleyways is the prostitutes' quarter. Invisible lines divide up the area into sharp, angular territories like African colonies. The whores are strategically placed, ready at a sign to encircle hesitant visitors, and to bounce the reluctant guest like a ball from one side of the street to the other. If he forfeits nothing else in this game, it is his hat. Has anyone yet probed deeply enough into this refuse heap of houses to reach the innermost place in the gynaeceum, the chamber

where the trophies of manhood—boaters, bowlers, hunting hats, trilbies, jockey caps—hang in rows on consoles or in layers on racks? From the interiors of taverns the eye meets the sea. Thus, the alleyway passes between rows of innocent houses as if shielded from the harbor by a bashful hand. On this bashful, dripping hand, however, shines a signet ring on a fishwife's hard finger, the old Hôtel de Ville. Here, two hundred years ago, stood patricians' houses. The high-breasted nymphs, the snake-ringed Medusa's heads over their weather-beaten doorframes have only now become unambiguously the signs of a professional guild. Unless, that is, signboards were hung over them as the midwife Bianchamori has hung hers, on which, leaning against a pillar, she turns a defiant face to all the brothelkeepers of the quarter, and points unruffled to a sturdy baby in the act of emerging from an egg.

Noises. High in the empty streets of the harbor district they are as densely and loosely clustered as butterflies on a hot flower bed. Every step stirs a song, a quarrel, a flapping of wet linen, a rattling of boards, a baby's bawling, a clatter of buckets. Only you have to have strayed up here alone, if you are to pursue them with a net as they flutter away unsteadily into the stillness. For in these deserted corners all sounds and things still have their own silences, just as, at midday in the mountains, there is a silence of hens, of axes, of cicadas. But the chase is dangerous, and the net is finally torn when, like a gigantic hornet, a grindstone impales it from behind with its whizzing sting.

Notre Dame de la Garde. The hill from which she looks down is the starry garment of the Mother of God, into which the houses of the Cité Chabas snuggle. At night, the lamps in its velvet lining form constellations that have not yet been named. It has a zipper: the cabin at the foot of the steel band of the rack railway is a jewel, from whose colored bull's-eyes the world shines back. A disused fortress is her holy footstool, and about her neck is an oval of waxen, glazed votive wreaths that look like relief profiles of her forebears. Little chains of streamers and sails are her earrings, and from the shady lips of the crypt issues jewelry of ruby-red and golden spheres on which swarms of pilgrims hang like flies.

Cathedral. On the least frequented, sunniest square stands the cathedral. This place is deserted, despite the proximity at its feet of La Joliette, the harbor, to the south, and a proletarian district to the north. As a reloading point for intangible, unfathomable goods, the bleak building stands between quay and warehouse. Nearly forty years were spent on it. But by the time all was complete, in 1893, place and time had conspired victoriously in this monument against its architects and sponsors, and the wealth of the clergy

had given rise to a gigantic railway station that could never be opened to traffic. The façade gives an indication of the waiting rooms within, where passengers of the first to fourth classes (though before God they are all equal), wedged among their spiritual possessions as if between suitcases, sit reading hymnbooks that, with their concordances and cross references, look very much like international timetables. Extracts from the railway traffic regulations in the form of pastoral letters hang on the walls, tariffs for the discount on special trips in Satan's luxury train are consulted, and cabinets where the long-distance traveler can discreetly wash are kept in readiness as confessionals. This is the Marseilles religion station. Sleeping cars to eternity depart from here at Mass times.

The light from greengrocers' shops that is visible in the paintings of Monticelli[1] comes from the inner streets of his city, the monotonous residential neighborhoods of the long-standing inhabitants, who know something of the sadness of Marseilles. For childhood is the divining rod of melancholy, and to know the mourning of such radiant, glorious cities one must have been a child in them. The gray houses of the boulevard de Longchamps, the barred windows of the cours Puget, and the trees of the allée de Meilhan give nothing away to the traveler if chance does not lead him to the cubiculum of the city, the passage de Lorette, the narrow yard where, in the sleepy presence of a few women and men, the whole world shrinks to a single Sunday afternoon. A real-estate company has carved its name on the gateway. Doesn't this interior correspond exactly to the white mystery ship moored in the harbor, *Nautique,* which never puts to sea, but daily feeds foreigners at white tables with dishes that are much too clean, as if they've been surgically rinsed?

Shellfish and oyster stalls. Unfathomable wetness that swills from the upper tier, in a dirty, cleansing flood over dirty planks and warty mountains of pink shellfish, bubbles between the thighs and bellies of glazed Buddhas, past yellow domes of lemons, into the marshland of cresses and through the woods of French pennants, finally to irrigate the palate as the best sauce for the quivering creatures. Oursins de l'Estaque, Portugaises, Maremmes, Clovisses, Moules marinières—all this is incessantly sieved, grouped, counted, cracked open, thrown away, prepared, tasted. And the slow, stupid agent of inland trade, paper, has no place in the unfettered element, the breakers of foaming lips that forever surge against the streaming steps. But over there, on the other quay, stretches the mountain range of "souvenirs," the mineral hereafter of seashells. Seismic forces have thrown up this massif of paste jewelry, shell limestone, and enamel, where inkpots, steamers, anchors, mercury columns, and sirens commingle. The pressure of a thousand atmospheres under which this world of images writhes, rears, piles up,

is the same force that is tested in the hard hands of seamen, after long voyages, on the thighs and breasts of women; and the lust that, on the shell-covered caskets, presses from the mineral world a red or blue velvet heart to be pierced with needles and brooches is the same lust that sends tremors through these streets on paydays.

Walls. Admirable, the discipline to which they are subject in this city. The better ones, in the center, wear livery and are in the pay of the ruling class. They are covered with gaudy patterns and have sold their whole length many hundreds of times to the latest brand of aperitif, to department stores, to "Chocolat Menier," or to Dolores del Rio. In the poorer neighborhoods they are politically mobilized, and post their spacious red letters as the forerunners of red guards in front of dockyards and arsenals.

The down-and-out fellow who, after nightfall, sells his books on the corner of the rue de la République and the Vieux Port, awakens bad instincts in the passers-by. They feel tempted to make use of so much fresh misery. And they long to learn more about such nameless misfortune than the mere image of catastrophe that it presents to us. For what extremity must have brought a man to spill out such books as he has left on the asphalt before him, and to hope that a passer-by will be seized at this late hour by a desire to read? Or is it all quite different? And does a poor soul here keep vigil, mutely beseeching us to lift the treasure from the ruins? We hasten by. But we shall falter again at every corner, for everywhere the southern peddler has so pulled his beggar's coat around him that fate looks at us from it with a thousand eyes. How far we are from the sad dignity of our poor, the war-disabled of competition, on whom tags and tins of boot blacking hang like braid and medals.

Suburbs. The farther we emerge from the inner city, the more political the atmosphere becomes. We reach the docks, the inland harbors, the warehouses, the poor neighborhoods, the scattered refuges of wretchedness: the outskirts. Outskirts are the state of emergency of a city, the terrain on which incessantly rages the great decisive battle between town and country. It is nowhere more bitter than between Marseilles and the Provençal landscape. It is the hand-to-hand fight of telegraph poles against agaves, barbed wire against thorny palms, the miasmas of stinking corridors against the damp gloom under the plane trees in brooding squares, short-winded outside staircases against the mighty hills. The long rue de Lyon is the powder conduit which Marseilles has dug in the landscape so that in Saint-Lazare, Saint-Antoine, Arenc, Septèmes it can blow up this terrain, burying it in the shrapnel of every national and commercial language. Alimentation Moderne, rue de Jamaïque, Comptoir de la Limite, Savon Abat-Jour, Minoterie

de la Campagne, Bar du Gaz, Bar Facultatif—and over all this lies the dust that here conglomerates out of sea salt, chalk, and mica, and whose bitterness persists longer in the mouths of those who have pitted themselves against the city than the splendor of sun and sea in the eyes of its admirers.

Published in *Neue schweizer Rundschau*, April 1929. *Gesammelte Schriften*, IV, 359–364. Translated by Edmund Jephcott.

Notes

1. Adolphe Monticelli (1824-1886) was a French painter whose dreamlike courtly revels are washed with radiant light and deep shadow.

On the Image of Proust

I

The thirteen volumes of Marcel Proust's *A la recherche du temps perdu* are the result of an unconstruable synthesis in which the absorption of a mystic, the art of a prose writer, the verve of a satirist, the erudition of a scholar, and the self-consciousness of a monomaniac have combined in an autobiographical work. It has rightly been said that all great works of literature establish a genre or dissolve one—that they are, in other words, special cases. Among these cases, this is one of the most unfathomable. From its structure, which is at once fiction, autobiography, and commentary, to the syntax of boundless sentences (the Nile of language, which here overflows and fructifies the plains of truth), everything transcends the norm. The first revealing observation that strikes one is that this great special case of literature at the same time constitutes its greatest achievement in recent decades. The conditions under which it was created were extremely unhealthy: an unusual malady, extraordinary wealth, and an abnormal gift. This is not a model life in every respect, but everything about it is exemplary. The outstanding literary achievement of our time is assigned a place at the heart of the impossible, at the center—and also at the point of indifference—of all dangers, and it marks this great realization of a "lifework" as the last for a long time. The image of Proust is the highest physiognomic expression which the irresistibly growing discrepancy between literature and life was able to assume. This is the lesson which justifies the attempt to evoke this image.

We know that in his work Proust described not a life as it actually was

[*wie es gewesen ist*] but a life as it was remembered by the one who had lived it. Yet even this statement is imprecise and far too crude. For the important thing to the remembering author is not what he experienced, but the weaving of his memory, the Penelope work of recollection [*Eingedenken*]. Or should one call it, rather, a Penelope work of forgetting? Is not the involuntary recollection, Proust's *mémoire involontaire*, much closer to forgetting than what is usually called memory? And is not this work of spontaneous recollection, in which remembrance is the woof and forgetting the warp, a counterpart to Penelope's work rather than its likeness? For here the day unravels what the night has woven. When we awake each morning, we hold in our hands, usually weakly and loosely, but a few fringes of the carpet of lived existence, as woven into us by forgetting. However, with our purposeful activity and, even more, our purposive remembering, each day unravels the web, the ornaments of forgetting. This is why Proust finally turned his days into nights, devoting all his hours to undisturbed work in his darkened room with artificial illumination, so that none of those intricate arabesques might escape him.

The Latin word *textum* means "web." No one's text is more of a web or more tightly woven than that of Marcel Proust; to him nothing was tight or durable enough. From his publisher Gallimard we know that Proust's proofreading habits were the despair of typesetters. The galleys always came back covered with writing to the edge of the page, but not a single misprint had been corrected; all available space had been used for fresh text. Thus, the laws of remembrance were operative even within the confines of the work. For an experienced event is finite—at any rate, confined to one sphere of experience; a remembered event is infinite, because it is merely a key to everything that happened before it and after it. There is yet another sense in which memory issues strict regulations for weaving. Only the *actus purus* of remembrance itself, not the author or the plot, constitutes the unity of the text. One may even say that the intermittences of author and plot are only the reverse of the continuum of memory, the figure on the back side of the carpet. This is what Proust meant, and this is how he must be understood, when he said that he would prefer to see his entire work printed in one volume in two columns and without any paragraphs.

What was it that Proust sought so frenetically? What was at the bottom of these infinite efforts? Can we say that all lives, works, and deeds that matter were never anything but the undisturbed unfolding of the most banal, most fleeting, most sentimental, weakest hour in the life of the one to whom they pertain? When Proust in a well-known passage described the hour that was most his own, he did it in such a way that everyone can find it in his own existence. We might almost call it an everyday hour; it comes with the night, a lost twittering of birds, or a breath drawn at the sill of an open window. And there is no telling what encounters would be in store for us

if we were less inclined to give in to sleep. Proust did not give in to sleep. And yet—or, rather, precisely for this reason—Jean Cocteau was able to say in a beautiful essay that the intonation of Proust's voice obeyed the laws of night and honey. By submitting to these laws, Proust conquered the hopeless sadness within him (what he once called "l'imperfection incurable dans l'essence même du présent"),[1] and from the honeycombs of memory he built a house for the swarm of his thoughts. Cocteau recognized what really should be the major concern of all readers of Proust. He recognized Proust's blind, senseless, obsessive quest for happiness. It shone from his eyes; they were not happy, but in them lay happiness, just as it lies in gambling or in love. Nor is it hard to say why this heart-stopping, explosive will to happiness which pervades Proust's writings is so seldom comprehended by his readers. In many places Proust himself made it easy for them to view this oeuvre, too, from the time-tested, comfortable perspective of resignation, heroism, asceticism. After all, nothing makes more sense to the model pupils of life than the notion that a great achievement is the fruit of toil, misery, and disappointment. The idea that happiness could have a share in beauty would be too much of a good thing, something that their *ressentiment* would never get over.

There is a dual will to happiness, a dialectics of happiness: a hymnic form as well as an elegiac form. The one is the unheard-of, the unprecedented, the height of bliss; the other, the eternal repetition, the eternal restoration of the original, first happiness. It is this elegiac idea of happiness—it could also be called Eleatic—which for Proust transforms existence into a preserve of memory. To it he sacrificed in his life friends and companionship, in his works plot, unity of characters, the flow of the narration, the play of the imagination. Max Unold, one of Proust's more discerning readers, fastened on the "boredom" thus created in Proust's writings and likened it to "idle stories." "Proust managed to make the idle story interesting. He says: 'Imagine, dear reader: yesterday I was dunking a bit of cake in my tea when it occurred to me that as a child I had spent some time in the country.' For this he takes eighty pages, and it is so fascinating that you think you are no longer the listener but the daydreamer himself." In such stories—"all ordinary dreams turn into idle stories as soon as one tells them to someone"— Unold has discovered the bridge to the dream. No synthetic interpretation of Proust can disregard it. Enough inconspicuous gates lead into it—Proust's frenetic study, his impassioned cult of similarity. The true signs of its hegemony do not become obvious where he unexpectedly and startlingly uncovers similarities in actions, physiognomies, or speech mannerisms. The similarity of one thing to another which we are used to, which occupies us in a wakeful state, reflects only vaguely the deeper similarity of the dream world in which everything that happens appears not in identical but in similar guise, opaquely similar to itself. Children know a symbol of this

world: the stocking which has the structure of this dream world when, rolled up in the laundry hamper, it is a "bag" and a "present" at the same time. And just as children do not tire of quickly changing the bag and its contents into a third thing—namely, a stocking—Proust could not get his fill of emptying the dummy, his self, at one stroke in order to keep garnering that third thing, the image which satisfied his curiosity—indeed, assuaged his homesickness. He lay on his bed racked with homesickness, homesick for the world distorted in the state of similarity, a world in which the true surrealist face of existence breaks through. To this world belongs what happens in Proust, as well as the deliberate and fastidious way in which it appears. It is never isolated, rhetorical, or visionary; carefully heralded and securely supported, it bears a fragile, precious reality: the image. It detaches itself from the structure of Proust's sentences just as that summer day at Balbec—old, immemorial, mummified—emerged from the lace curtains under Françoise's hands.

II

We do not always proclaim loudly the most important thing we have to say. Nor do we always privately share it with those closest to us, our intimate friends, those who have been most devotedly ready to receive our confession. If it is true that not only people but also ages have such a chaste—that is, such a devious and frivolous—way of communicating what is most their own to a passing acquaintance, then the nineteenth century did not reveal itself to Zola or Anatole France, but to the young Proust, the insignificant snob, the playboy and socialite who snatched in passing the most astounding confidences from a declining age as if from another bone-weary Swann. It took Proust to make the nineteenth century ripe for memoirs. What before him had been a period devoid of tension now became a force field in which later writers aroused multifarious currents. Nor is it accidental that the most significant work of this kind was written by an author who was personally close to Proust as admirer and friend: the memoirs of the princesse de Clermont-Tonnerre. And the very title of her book, *Au temps des équipages*, would have been unthinkable prior to Proust. This book is the echo which softly answers Proust's ambiguous, loving, challenging call from the Faubourg Saint-Germain. In addition, this melodious performance is shot through with direct and indirect references to Proust in its tenor and its characters, which include him and some of his favorite objects of study from the Ritz. There is no denying, of course, that this puts us in a very feudal milieu, and, with phenomena like Robert de Montesquiou, whom the princesse de Clermont-Tonnerre depicts masterfully, in a very special one at that. But this is true of Proust as well, and in his writings, as we know, Montesquiou has a counterpart. All this would not be worth discussing, especially

since the question of models would be secondary and unimportant for Germany, if German criticism were not so fond of taking the easy way out. Above all, it could not resist the opportunity to descend to the level of the lending-library crowd. Hack critics were tempted to draw conclusions about the author from the snobbish milieu of his writings, to characterize Proust's works as an internal affair of the French, a literary supplement to the *Almanach de Gotha*.[2] It is obvious, though, that the problems of Proust's characters are those of a satiated society. But there is not one that would be identical with those of the author, which are subversive. To reduce this to a formula, it was to be Proust's aim to construe the entire structure of high society as a physiology of chatter. In the treasury of its prejudices and maxims, there is not one that is not annihilated by his dangerous comic treatment. It is not the least of Léon Pierre-Quint's many services to Proust that he was the first to point this out. "When humorous works are mentioned," he wrote, "one usually thinks of short, amusing books in illustrated jackets. One forgets about *Don Quixote, Pantagruel,* and *Gil Blas*—fat, ungainly tomes in small print." The subversive side of Proust's work appears most convincingly in this context. Here, though, it is less humor than comedy that is the real source of his power; his laughter does not toss the world up but flings it down—at the risk that it will be smashed to pieces, which will then make him burst into tears. And unity of family, unity of personality, of sexual morality and class honor, are indeed smashed to bits. The pretensions of the bourgeoisie are shattered by laughter. Their retreat and reassimilation by the aristocracy is the sociological theme of the work.

Proust did not tire of the training which moving in aristocratic circles required. Assiduously and without much constraint, he conditioned his personality, making it as impenetrable and resourceful, as submissive and difficult, as it had to be for the sake of his mission. Later on, this mystification and fussiness became so much a part of him that his letters sometimes constitute whole systems of parentheses, and not just in the grammatical sense—letters which despite their infinitely ingenious, flexible composition occasionally call to mind that legendary example of epistolary art: "My dear Madam, I just noticed that I forgot my cane at your house yesterday; please be good enough to give it to the bearer of this letter. P.S. Kindly pardon me for disturbing you; I just found my cane." Proust was most resourceful in creating complications. Once, late at night, he dropped in on the princesse de Clermont-Tonnerre and made his staying dependent on someone's bringing him his medicine from his house. He sent a valet for it, giving him a lengthy description of the neighborhood and of the house. Finally he said: "You cannot miss it. It is the only window on the boulevard Haussmann in which there is still a light burning!" Everything but the house number! Anyone who has tried to get the address of a brothel in a strange city and has received the most long-winded directions, everything but the name of

the street and the house number, will understand what is meant here and what the connection is with Proust's love of ceremony, his admiration for Saint-Simon, and, last but not least, his intransigent Frenchness. Isn't it the quintessence of experience to find out how very difficult it is to learn many things which apparently could be told in very few words? It is simply that such words are part of an argot established along lines of caste and class and unintelligible to outsiders. No wonder the secret language of the salons excited Proust. When he later embarked on his merciless depiction of the *petit clan,* the Courvoisiers, and the "esprit d'Oriane," he had already—through his association with the Bibescos—become conversant with the improvisations of a code language to which we too have now been introduced.

In his years of life in the salons, Proust developed not only the vice of flattery to an eminent—one is tempted to say, to a theological—degree, but the vice of curiosity as well. We detect in him the reflection of the laughter which like a flash fire curls the lips of the Foolish Virgins represented on the intrados of many of the cathedrals which Proust loved. It is the smile of curiosity. Was it curiosity that made him such a great parodist? If so, we would know how to evaluate the term "parodist" in this context. Not very highly. For though it does justice to his abysmal malice, it skirts the bitterness, savagery, and grimness of the magnificent pieces which he wrote in the style of Balzac, Flaubert, Sainte-Beuve, Henri de Régnier, the Goncourts, Michelet, Renan, and his favorite Saint-Simon, and which are collected in the volume *Pastiches et mélanges.*[3] The mimicry of a man of curiosity is the brilliant device of these essays, as it is also a feature of his entire creativity, in which his passion for vegetative life cannot be taken seriously enough. Ortega y Gasset was the first to draw attention to the vegetative existence of Proust's characters, which are planted so firmly in their social habitat, influenced by the position of the sun of aristocratic favor, stirred by the wind that blows from Guermantes or Méséglise, and inextricably enmeshed in the thicket of their fate. This is the environment that gave rise to the poet's mimicry. Proust's most accurate, most conclusive insights fasten on their objects the way insects fasten on leaves, blossoms, branches, betraying nothing of their existence until a leap, a beating of wings, a vault, show the startled observer that some incalculable individual life has imperceptibly crept into an alien world. "The metaphor, however unexpected," says Pierre-Quint, "forms itself quite close to the thought."

The true reader of Proust is constantly jarred by small frights. In the use of metaphor, he finds the precipitate of the same mimicry which must have struck him as this spirit's struggle for survival under the leafy canopy of society. At this point we must say something about the close and fructifying interpenetration of these two vices, curiosity and flattery. There is a revealing passage in the writings of the princesse de Clermont-Tonnerre: "And finally

we cannot suppress the fact that Proust became intoxicated by the study of domestic servants—whether it be that an element which he encountered nowhere else intrigued his investigative faculties or that he envied servants their greater opportunities for observing the intimate details of things that aroused his interest. In any case, domestic servants in their various embodiments and types were his passion." In the exotic shadings of a Jupien, a Monsieur Aimé, a Célestine Albalat, their ranks extend from Françoise—a figure with the coarse, angular features of Saint Martha that seems to be straight out of a book of hours—to those grooms and *chasseurs* who are paid for loafing rather than working. And perhaps the greatest concentration of this connoisseur of ceremonies was reserved for the depiction of these lower ranks. Who can tell how much servant curiosity became part of Proust's flattery, how much servant flattery became mixed with his curiosity, and where this artful copy of the role of the servant on the heights of the social scale had its limits? Proust presented such a copy, and he could not help doing so, for, as he once admitted, *voir* and *désirer imiter* were one and the same thing to him. This attitude, which was both sovereign and obsequious, has been preserved by Maurice Barrès in the most apposite words that have ever been written about Proust: "Un poète persan dans une loge de portière."[4]

There was something of the detective in Proust's curiosity. The upper ten thousand were to him a clan of criminals, a band of conspirators beyond compare: the *camorra* of consumers.[5] It excludes from its world everything that has a part in production, or at least demands that this part be gracefully and bashfully concealed behind the kind of manner that is sported by the polished professionals of consumption. Proust's analysis of snobbery, which is far more important than his apotheosis of art, constitutes the apogee of his criticism of society. For the attitude of the snob is nothing but the consistent, organized, steely view of life from the chemically pure standpoint of the consumer. And because even the remotest as well as the most primitive memory of nature's productive forces was to be banished from this satanic fairyland, Proust found an inverted relationship more serviceable than a normal one, even in love. But the pure consumer is the pure exploiter—logically and theoretically—and in Proust he is this in the full concreteness of his actual historical existence. He is concrete because he is impenetrable and elusive. Proust describes a class which is everywhere pledged to camouflage its material basis and which for this very reason is attached to a feudalism lacking any intrinsic economic significance but all the more serviceable as a mask of the upper middle class. This disillusioned, merciless deglamorizer of the ego, of love, of morals—for this is how Proust liked to view himself—turns his whole limitless art into a veil for this one most vital mystery of his class: the economic aspect. It is not as if he thereby serves his class; he is merely ahead of it. That which this class experiences begins to become

comprehensible only with Proust. Yet much of the greatness of this work will remain inaccessible or undiscovered until this class has revealed its most pronounced features in the final struggle.

III

In the 1800s there was an inn by the name of "Au Temps Perdu" at Grenoble; I do not know whether it still exists. In Proust, too, we are guests who enter through a door underneath a suspended sign that sways in the breeze, a door behind which eternity and rapture await us. Ramón Fernandez rightly distinguished between a *thème de l'éternité* and a *thème du temps* in Proust. But Proust's eternity is by no means a platonic or a utopian one; it is rapturous. Therefore, if "time reveals a new and hitherto unknown kind of eternity to anyone who becomes engrossed in its passing," this certainly does not enable an individual to approach "the higher regions which a Plato or Spinoza reached with one beat of the wings." It is true that in Proust we find rudiments of an enduring idealism, but it is not these elements which determine the greatness of his work. The eternity which Proust opens to view is intertwined time, not boundless time. His true interest is in the passage of time in its most real—that is, intertwined—form, and this passage nowhere holds sway more openly than in remembrance within and aging without. To follow the counterpoint of aging and remembering means to penetrate to the heart of Proust's world, to the universe of intertwining. It is the world in a state of similarity, and in it the *correspondances* rule; the Romantics were the first to comprehend them and Baudelaire embraced them most fervently, but Proust was the only one who managed to reveal them in our lived life. This is the work of *la mémoire involontaire,* the rejuvenating force which is a match for the inexorable process of aging. When that which has been is reflected in the dewy fresh "instant," a painful shock of rejuvenation pulls it together once more as irresistibly as the Guermantes Way and Swann's Way become intertwined for Proust when, in the thirteenth volume, he roams about the Combray area for the last time and discovers the intermingling of the roads. In an instant the landscape turns about like a gust of wind. "Ah! que le monde est grand à la clarté des lampes! / Aux yeux du souvenir que le monde est petit!"[6] Proust has brought off the monstrous feat of letting the whole world age a lifetime in an instant. But this very concentration, in which things that normally just fade and slumber are consumed in a flash, is called rejuvenation. *A la Recherche du temps perdu* is the constant attempt to charge an entire lifetime with the utmost mental awareness. Proust's method is actualization, not reflection. He is filled with the insight that none of us has time to live the true dramas of the life that we are destined for. This is what ages us—this and nothing else. The wrinkles and creases in our faces are the registration of the great

passions, vices, insights that called on us; but we, the masters, were not home.

Since the spiritual exercises of Loyola, Western literature has scarcely seen a more radical attempt at self-absorption. Proust's writing, too, has as its center a solitude which pulls the world down into its vortex with the force of a maelstrom. And the overloud and inconceivably hollow chatter which comes roaring out of Proust's novels is the sound of society plunging into the abyss of this solitude. Proust's invectives against friendship have their place here. It was a matter of perceiving the silence at the bottom of this crater, whose eyes are the quietest and most absorbing. What is manifested irritatingly and capriciously in so many anecdotes is the combination of an unparalleled intensity of conversation with an unsurpassable aloofness from one's interlocutor. There has never been anyone else with Proust's ability to show us things; Proust's pointing finger is unequaled. But there is another gesture in friendly togetherness, in conversation: physical contact. To no one is this gesture more alien than to Proust. He cannot touch his reader, either; he couldn't do this for anything in the world. If one wanted to group literature around these poles, dividing it into the deictic kind and the touching kind, the core of the former would be the work of Proust; the core of the latter, the work of Péguy.[7] This is basically what Fernandez has formulated so well: "Depth, or rather intensity, is always on his side, never on that of his interlocutor." This is demonstrated brilliantly and with a touch of cynicism in Proust's literary criticism, the most significant document of which is an essay that came into being on the high level of his fame and the low level of his deathbed: "A propos de Baudelaire." The essay is jesuitical in its acquiescence in his own maladies, immoderate in the garrulousness of a man who is resting, frightening in the indifference of a man marked by death who wants to speak out once more, no matter on what subject. What inspired Proust here in the face of death also shaped him in his intercourse with his contemporaries: an alternation of sarcasm and tenderness which was so spasmodic and harsh that its recipients threatened to break down in exhaustion.

The provocative, unsteady quality of the man affects even the reader of his works. Suffice it to recall the endless succession of "soit que . . ." ["whether it be . . ."] by means of which an action is shown—exhaustively, depressingly—in the light of the countless motives upon which it may have been based. Yet these paratactic flights reveal the point at which weakness and genius coincide in Proust: the intellectual renunciation, the tested skepticism with which he approached things. After the self-satisfied inwardness of Romanticism, Proust came along—determined, as Jacques Rivière puts it, not to give the least credence to the "Sirènes intérieures" ["internal Sirens"]. "Proust approaches experience without the slightest metaphysical interest, without the slightest penchant for construction, without the slight-

est tendency to console." Nothing is truer than that. And thus the basic feature of this work, too, which Proust kept proclaiming as having been planned, is anything but the result of construction. But it is as planned as the lines on the palm of our hand or the arrangement of the stamen in a calyx. Completely worn out, Proust, that aged child, fell back on the bosom of nature—not to suckle from it, but to dream to its heartbeat. One must picture him in this state of weakness to understand how felicitously Jacques Rivière interpreted the weakness when he wrote: "Marcel Proust died of the same inexperience which permitted him to write his works. He died of ignorance of the world, and because he did not know how to change the conditions of his life which had begun to crush him. He died because he did not know how to make a fire or open a window." And, to be sure, of his neurasthenic asthma.

The doctors were powerless in the face of this malady; not so the writer, who very systematically placed it in his service. To begin with the most external aspect, he was a perfect stage director of his illness. For months he connected, with devastating irony, the image of an admirer who had sent him flowers with their odor, which he found unbearable. Depending on the ups and downs of his malady he alarmed his friends, who dreaded and longed for the moment when the writer would suddenly appear in their drawing rooms long after midnight—"brisé de fatigue" and for just five minutes, as he said—only to stay till the gray of dawn, too tired to get out of his chair or interrupt his conversation. Even as a writer of letters he extracted the most singular effects from his ailment. "The wheezing of my breath is drowning out the sounds of my pen and of a bath which is being drawn on the floor below." But that is not all, nor is the fact that his sickness removed him from fashionable living. This asthma became part of his art—if indeed his art did not create it. Proust's syntax rhythmically, step by step, enacts his fear of suffocating. And his ironic, philosophical, didactic reflections invariably are the deep breath with which he shakes off the crushing weight of memories. On a larger scale, however, the threatening, suffocating crisis was death, which he was constantly aware of, most of all while he was writing. This is how death confronted Proust, and long before his illness assumed critical dimensions—not as a hypochondriacal whim, but as a "réalité nouvelle," that new reality whose reflections on things and people are the marks of aging. A physiology of style would take us into the innermost core of this creativeness. No one who knows with what great tenacity memories are preserved by the sense of smell—but by smells that are not at all in the memory—will be able to call Proust's sensitivity to smells accidental. To be sure, most memories that we search for come to us as images of faces. Even the free-floating forms of la mémoire involontaire are still in large part isolated—though enigmatically present—images of faces. For this very reason, anyone who wishes to surrender knowingly to the innermost sway of this work must place himself in a special stratum—the

bottommost—of this involuntary remembrance, a stratum in which the materials of memory no longer appear singly, as images, but tell us about a whole, amorphously and formlessly, indefinitely and weightily, in the same way the weight of the fishing net tells a fisherman about his catch. Smell— this is the sense of weight experienced by someone who casts his nets into the sea of the *temps perdu*. And his sentences are the entire muscular activity of the intelligible body; they contain the whole enormous effort to raise this catch.

For the rest, the closeness of the symbiosis between this particular creativity and this particular illness is demonstrated most clearly by the fact that in Proust there never was a breakthrough of that heroic defiance with which other creative people have risen up against their infirmities. And therefore one can say, from another point of view, that so close a complicity with life and the course of the world as Proust's would inevitably have led to ordinary, indolent contentment on any basis but that of such great and constant suffering. As it was, however, this illness was destined to have its place in the great work process—a place assigned to it by a furor devoid of desires or regrets. For the second time, there arose a scaffold like the one on which Michelangelo, his head thrown back, painted the Creation on the ceiling of the Sistine Chapel: the sickbed on which Marcel Proust held aloft the countless pages covered with his handwriting, dedicating them to the creation of his microcosm.

Published in *Die literarische Welt*, June–July 1929; revised 1934. *Gesammelte Schriften*, II, 310–324. Translated by Harry Zohn.

Notes

1. "The incurable imperfection in the very essence of the present."
2. The *Almanach de Gotha* is a journal that chronicles the social activities of the French aristocracy.
3. Henri de Régnier (1864–1936) was a prominent French poet. Ernest Renan (1823–1892) was a French philosopher, historian, and scholar of religion. Louis de Rouvroy, duc de Saint-Simon (1675–1755), was a soldier, statesman, and writer, whose *Mémoires* depict the French court under Louis XIV and Louis XV.
4. Maurice Barrès (1862–1923) was a French writer and politician whose individualism and nationalism were influential in the early twentieth century. The phrase translates: "A Persian poet in a porter's lodge."
5. The *camorra* was a secret Italian criminal society that arose in Naples in the nineteenth century.
6. "Ah! How big the world is by lamplight, / But how small in the eyes of memory!" Charles Baudelaire, "Le Voyage."
7. Charles Péguy (1873–1914) was a French poet and philosopher whose work brought together Christianity, socialism, and French nationalism.

The Great Art of Making Things Seem Closer Together

The great art of making things seem closer together. In reality. Or from where we are standing; in memory. "Ah! que le monde est grand à la clarté des lampes! / Aux yeux du souvenir que le monde est petit!"[1] This is the mysterious power of memory—the power to generate nearness. A room we inhabit whose walls are *closer* to us than to a visitor. This is what is homey about home. In nurseries we remember, the walls seem closer to each other than they really are, than they would be if we saw them today. The sight of them tears us apart because we have become attached to them. The great traveler is the person who passes through cities and countries with anamnesis; and because everything seems closer to everything else, and hence to him, since he is in their midst, all his senses respond to every nuance as truth. The distanced Romantic is as ignorant of this as the Positivist.

Fragment written no later than mid-1929; unpublished in Benjamin's lifetime. *Gesammelte Schriften*, VI, 203. Translated by Rodney Livingstone.

Notes

1. "Ah! How big the world is by lamplight, / But how small in the eyes of memory!" Charles Baudelaire, "Le Voyage."

Milieu Theoreticians

If we reflect how long the belief in disguises survived—how farce throughout the ages, Shakespeare's high comedy, and even the detective story of the late nineteenth century found it quite unproblematic to work with the confusions that result from disguises—it must be a matter of considerable astonishment to see how reluctant people are to accept such devices in more recent times. When it comes to disguises, they refuse to see the joke, and in the modern novel such mistaken identities are frowned on. Yet this dogged insistence on the unmistakable, unique singularity of the body comes at precisely the moment when philanthropists, the disciples of Proust, and psychoanalysts assure us that all possibilities dwell within each of us, and that nothing could be more out-of-date and philistine than the belief in the unity of personality. What can be behind this?

Fragment written in 1929; unpublished in Benjamin's lifetime. *Gesammelte Schriften,* VI, 203–204. Translated by Rodney Livingstone.

Children's Literature

Dear invisible listeners!

You've all heard people say, "Lord! In my childhood, we weren't so well off! We were all afraid of getting poor marks. We weren't even allowed to walk on the beach barefoot!" But have you ever heard anyone say, "Lord! When I was young, we didn't have such nice games to play!" Or, "When I was little, there weren't such wonderful story books!" No. Whatever people read or played with in their childhood not only seems in memory to have been the most beautiful and best thing possible; it often, wrongly, seems unique. And it is very common to hear adults complaining about the disappearance of toys they used to be able to buy without difficulty in the nearest shop. Remembering *these* things, everyone becomes a *laudator temporis acti,* a reactionary. So there must be something special about them. And without going into this for the moment, we should bear in mind that for children books, like everything else, can contain very different things from what adults see in them.

How much one could say—to start with the first reading book—about the child's relationship with the ABC's! From the earliest stages, when each sign is a yoke under which hand and tongue have to humble themselves, to the later stages, when the child masters the sounds with ease and creates his first secret society in the playground jungle of the language of robbers and games counting peas. There can be no doubt that no pirate stories or ghost stories will grip the adolescent boy as powerfully as his ABC-book did when he was little. It is true that the earliest reading primers approached children with naive pedagogic skill. These "voice books" were based on onomatopoeia. The O rang out in the mouth of a drayman urging his horses on in

the illustration; the *Sh* comes from a woman shooing the hens in another picture; the *R* is a dog growling; and the *S* is a hissing snake. But this onomatopoeia soon gave way to other things. After the Counter-Reformation, we find primers in which the startled child is presented with the majesty of script, full of clouds of arabesques and high falutin phrases. This was followed by the fans and the caste system of the eighteenth century, in which the words to be read were placed grimly together in military rank-and-file and the capital letters were sergeants issuing orders to their nouns. From this period date primers with covers that hold out the promise of 248 pictures. When you look at them more closely, you find that the whole book has only eight pages and the pictures stand packed together in tiny frames. Of course, no primer can be so eccentric as to prevent a child from taking what it needs from it, as Jean Paul shows in his delightful description of his schoolmaster Wuz: "He wrote the alphabet in beautiful copperplate, merrily and without interruption. Between all the black letters he put red ones, so as to attract attention; this is why most German children can still remember the pleasure with which they fished the ready-cooked red letters out from among the black ones like boiled crabs, and enjoyed them."[1]

Of course, schoolteachers soon discovered that not only did children have problems with the primer, but the primer had problems with children. The obvious solution was to separate the visual as far as possible from the word, and even more from the letter. In 1658 the first attempt of this sort appeared: the *Orbis Pictus* of Amos Comenius.[2] It displays all the objects of daily life—including the abstract ones—simply and crudely, in several hundred card-size illustrations. The text was restricted to a German-Latin table of contents. This work is one of the rare great successes in the field of educational children's books; and if you think about it, you can see that it stands at the beginning of two and a half centuries of development—a process that is by no means concluded. Today less than ever. The extraordinary contemporary relevance of a visually based method of instruction stems from the fact that a new, standardized and nonverbal sign system is now emerging in the most varied walks of life—transport, art, statistics. At this point, an educational problem coincides with a comprehensive cultural one, which could be summed up in the slogan: Up with the sign and down with the word! Perhaps we shall soon see picture books that introduce children to the new sign language of transport or even statistics. Among the older books, the milestones are Comenius' *Orbis Pictus*, Basedow's *Elementarwerk* [Elementary Work], and Bertuch's *Bilderbuch für Kinder* [Picture Book for Children]. The latter consists of twelve volumes, each with a hundred colored engravings; it appeared under Bertuch's direction from 1792 to 1847. The care lavished on its production shows the dedication with which books were produced for children at the time. To provide a picture book with text, to give it a basic textual form without turning it

into a primer, is a difficult, almost impossible task. It has seldom been solved. All the more remarkable is the brilliant picture book by Johann Paul Wich, *Steckenpferd und Puppe* [Hobbyhorse and Doll], which appeared in Nördlingen in 1843. It contains the following verses:

Before the little town there sits a little dwarf,
Behind the little dwarf there stands a little hill,
From the little hill there flows a little stream,
Upon the little stream there swims a little roof,
Beneath the little roof there is a little room,
In the little room there sits a little boy,
Behind the little boy there stands a little bench,
Upon the little bench there stands a little chest,
In the little chest there lies a little box,
In the little box there sits a little nest,
Before the little nest there sits a little cat,
For certain I'll remember to note the little spot.

If there is any field in the whole world where specialization is bound to fail, it must be in creating things for children. And the beginning of the decline in children's literature can be seen at the moment it fell into the hands of the specialists. I mean the decline of children's *literature,* not of children's *books.* For it was a stroke of good luck that for a long time the educational experts paid only cursory attention to the books' illustrations, or at least proved unable to set valid norms for them. So in this sphere we see maintained something that became increasingly rare in literature— namely, the pure seriousness of mastery and the pure playfulness of the dilettante, both of which create for children *without doing so deliberately.* Rochow's *Kinderfreund* [The Child's Friend] of 1772, the first reader, is at the same time the beginning of "literature for young people." It is important to distinguish two phases: the edifying, moral Age of Enlightenment, which came to meet the child, and the sentimental period of the nineteenth century, which insinuated itself into his mind. The first was certainly not as boring and the second not as mendacious as the upstart educational theory of our own day claims, but both are characterized by a sterile mediocrity. A delightful, linguistically catastrophic example that stands on the frontiers of both genres will illustrate the point:

Having arrived home, Emma at once set to work, for she had promised Auguste to embroider the letters *A.v.T.* on six handkerchiefs . . . Auguste and Wilhelmine sat on either side of her; Charlotte and Sophie, who had brought their own sewing with them, did likewise. It was most agreeable to see the four young girls so diligently at work, each eager to surpass the others.

As they sat working, Auguste wished to make use of the time for further instruction. So she asked Emma:

"What day is it today?"

"I think it is Tuesday."

"You are mistaken, child. Yesterday was Sunday."

"In that case it is Monday."

"Correct: Monday. How many days are there in a week?"

"Seven."

"And how many in a month?—Do you know?"

"How many?—I think you have told me several times that, with respect to the days, the months are not all alike."

"That is so. Four months have thirty days, seven thirty-one, and a single one has twenty-eight and sometimes twenty-nine days."

"Thirty days is a very long time."

"Can you count as far as that?"

"No."

"How many fingers do you have?"

"Ten."

"Count your fingers three times and that gives you thirty, as many as there are days in four of the months of the year."

"That's a century."

"A century?—Where did you pick that word up?—Do you know what a century is?"

"No, I do not."

"Yet you use a word you do not understand?—That smacks of boasting! You wish to be thought cleverer than you are. A century consists of one hundred years, each year consisting of twelve months. The months, as I have already told you, have either thirty or thirty-one days, with one exception. A day has twenty-four hours, the hours are divided into minutes, and these are divided into seconds. There are sixty minutes in an hour."

"A second is very small, isn't it?"

"A second flies away like lightning—it is a moment."

"So a person's life consists of an infinite number of seconds?"

"And it still flies past very quickly. And quick as it is, we should never forget our transition into the next world. In other words, we should always be mindful of our duty toward God, our fellow human beings, and ourselves, so that when the Creator and Ruler of the universe resolves in His wisdom to summon us from here, we shall be found worthy to enter Heaven, where we will find our reward for having been pious and righteous here on earth."

"What will happen to little girls who have been naughty?"

"They will go to Hell."

"Will they be unhappy there?"

"Of course! They experience the torments of remorse for their offenses forever."

"Forever?"—Oh, I shall take good care not to be naughty!"

Auguste saw full well that Emma could not understand this as clearly as she, since she had read it in her catechism and had had it thoroughly explained to her. She would have been better advised to frighten her young pupil by telling

her about caning or about Ruprecht the farmhand, instead of explaining to her about Hell."[3]

While this could scarcely be surpassed in absurdity, there are many works that are superior in quality. Nevertheless, it is significant that despite Johanna Spyri's beautiful and justly famous *Stories for Children and Those Who Love Children,* subsequent trends in children's literature have produced no masterpiece. Yet we do possess a masterpiece of morally edifying literature that is also a masterwork of the German language. This is Hebel's *Treasure Chest.*[4] Of course, strictly speaking, it is not intended for young people as such but is a product of the Philanthropist interest in the masses, particularly the rural reading public.[5] If we may attempt briefly to define this incomparable prose stylist who combines in an almost unfathomable unity the expansiveness of the epic writer with the brevity of the legislator, we might say that the crucial feature of Hebel is the way in which he overcomes the abstract morality of the Enlightenment through a political, theological morality. Yet since this is never done in general terms but always case by case, it is scarcely possible for us to give an idea of it except in concrete terms. To use a metaphor: when he tells his stories, it is as if a clockmaker were showing us his clock, explaining the springs and the cogwheels individually. Suddenly (Hebel's moral always comes suddenly), he turns it around and we see what the time is. And these stories further resemble a clock in that they arouse our earliest childhood astonishment and never cease to accompany us our whole life long.

Some years ago a literary magazine hit upon the idea, as happens from time to time, of asking a number of well-known people what their favorite childhood book had been. The answers undoubtedly included children's literature. But what was remarkable was that the great majority named works like the *Leather-Stocking Tales, Gulliver's Travels, Treasure Island, Baron Münchhausen,* the *1001 Nights,* Andersen, Grimm, Karl May, and Wörishöffer. Many of them named forgotten works whose authors they no longer knew. But when we try to put some sort of order into their varied responses, it turns out that hardly any of the books mentioned were expressly written for children or young people. Almost all of them are great works of world literature, cheap novels, or fairy tales. Among the respondents was Charlie Chaplin. His choice was *David Copperfield.* This provides us with a great example to study just what a children's book—or rather, a book that is read by a child—can mean. *David Copperfield* paved the way for that great man's intuition. A French critic has in fact made a very acute comparison between the art of Dickens and that of Chaplin. And Chaplin himself "has told us that the idea of creating his stock character—the fellow with the bowler hat, jerky walk, little toothbrush moustache, and walking stick—first occurred to him on seeing office workers walking along the

Strand." And how close other typical figures in his films are to the gloomy London of Oliver Twist or David Copperfield: "the shy, young, winsome girl; the burly lout who is always ready to use his fists and then to take to his heels when he sees that people aren't afraid of him; the arrogant gentleman who can be recognized by his top hat."

But it must not be imagined that young people growing up can obtain substantial, healthy sustenance only from the masterpieces of Cervantes, Dickens, Swift, or Defoe. It is also available in certain, though by no means all, works of cheap literature, of that colportage which emerged simultaneously with the rise of technological civilization and the leveling of culture which was not unconnected with it. The dismantling of the old, hierarchical spheres of society had just been completed. This meant that the noblest and most refined substances had often sunk to the bottom, and so it happens that the person who can see more deeply can find the elements he really needs in the lower depths of writing and graphic art rather than in the acknowledged documents of culture. Quite recently Ernst Bloch wrote a charming essay along these lines in which he attempted a vindication of the much disparaged Karl May. And one could mention many other books that one was almost ashamed to ask for on borrowing day in the school library, or even in the local paper shop: *Die Regulatoren in Arkansas, Unter dem Äquator, Nena Sahib.*[6] And if these books tend to transcend the horizon of their young readers, that only made them more exciting and impressive. For such concepts and turns of phrase seemed to contain the talisman that would guide young people as they successfully crossed the threshold from childhood into the Promised Land of adulthood. And this is why everyone has always devoured them.

"Devouring books." A strange metaphor. One that makes you think. It is true that in the world of art no form is so affected in the course of enjoyment, is so deformed and destroyed, as narrative prose. Perhaps it really is possible to compare reading and consuming. Above all, we should bear in mind that the reasons we need nourishment and the reasons we eat are not perhaps identical. The older theory of nourishment is perhaps so instructive because eating is its starting point. It claimed that we obtain nourishment by absorbing the spirits of the things we have eaten. Now, it is true that we do not obtain nourishment in that way, but we do eat via a process of absorption that is rather more than a matter of absorbing what we need to live. And our reading, too, involves such a process of absorption. That is to say, not to increase our experience, our store of memories and experiences. Such psychological substitution theories are the theories of nourishment which maintain that from the blood we consume we obtain our blood, from the bones we devour come our bones, and so forth. But matters are not as simple as that. We do not read to increase our experiences; we read to increase ourselves. And this applies particularly to children who

always read in this way. That is to say, in their reading they absorb; they do not empathize. Their reading is much more closely related to their growth and their sense of power than to their education and their knowledge of the world. This is why their reading is as great as any genius that is to be found in the books they read. And this is what is special about children's books.

Radio talk broadcast by Südwestdeutschen Rundfunk, August 1929. *Gesammelte Schriften*, VII, 250–257. Translated by Rodney Livingstone.

Notes

1. Jean Paul Richter (1763–1825) wrote a series of wildly extravagant, highly imaginative novels that combine fantasy and realism. The story "Das Leben des vergnügten Schulmeisterlein Maria Wutz in Auenthal" (The Life of the Satisfied Little Teacher Maria Wutz in Auenthal) appeared in 1793. It recounts the search for happiness of the pleasantly eccentric teacher named in the title.
2. The full title is *Orbis Sensualium Pictus* (The Visible World in Pictures).
3. *Wie Auguste und Wilhelmine ihre Puppe erzogen: Von einer Kinderfreundin* (How Auguste and Wilhelmine Educated Their Doll: By a Children's Friend) was published in Berlin in 1837.
4. Johann Peter Hebel's *Schatzkästlein des rheinischen Hausfreunds* (Treasure Chest of the Rhenish Family Friend) is a compendium of his poetry and prose published in the *Badischer Landkalendar,* an annual publication not unlike the American *Old Farmer's Almanac.*
5. Philanthropism was a pedagogical reform movement of the late eighteenth century. Its main theorist was Johann Bernhard Basedow (1723–1790), whose school—the Philanthropin, in Dessau—became the model for a number of similar institutions throughout Germany and Switzerland.
6. *Die Regulatoren in Arkansas* (The Pendulums in Arkansas) and *Unter dem Äquator* (Under the Equator) are by Friedrich Gerstacker. *Nina Sahib* is by Sir John Retcliffe (Hermann Ottomar Friedrich Goedsche).

Robert Walser

We can read much by Robert Walser, but nothing about him.[1] What in fact do we know about the few people among us who are able to take the cheap satirical gloss[2] in the right way—in other words, who do not behave like the hack who tries to ennoble it by "elevating" it to his own level? For the real challenge is to take advantage of the contemptible, unassuming potential of this form to create something which is alive and has a purifying effect. Few people understand this "minor genre," as Alfred Polgar[3] termed it, or realize how many butterflies of hope are repelled by the insolent, rock-like façade of so-called great literature, seeking refuge instead in its unpretentious calyxes. And others never guess the extent of their debt to a Polgar, a Hessel,[4] or a Walser for the many tender or prickly blooms that flourish in the barren wastes of the journalistic forests. In fact, the name Robert Walser is the last that would occur to them. For the first impulse of their meager store of cultural knowledge—their sole asset in literary matters—tells them that what they regard as the complete insignificance of content has to be compensated for by their "cultivated," "refined" attention to form. And in this respect what we find in Robert Walser is a neglect of style that is quite extraordinary and that is also hard to define. For the idea that this insignificant content could be important and that this chaotic scatteredness could be a sign of stamina is the last thing that would occur to the casual observer of Walser's writings.

They are not easy to grasp. For we are accustomed to ponder the mysteries of style through the contemplation of more or less elaborate, fully intended works of art, whereas here we find ourselves confronted by a seemingly quite unintentional, but attractive, even fascinating linguistic wilderness.

And by a self-indulgence that covers the entire spectrum from gracefulness to bitterness. Seemingly unintentional, we said. Critics have sometimes disagreed about whether this is really so. But it is a fruitless quarrel, as we perceive when we recall Walser's admission that he never corrected a single line in his writing. We do not have to believe this, but would be well advised to do so. For we can set our minds at rest by realizing that to write yet never correct what has been written implies both the absence of intention and the most fully considered intentionality.

So far so good. But this cannot prevent us from trying to get to the bottom of this neglect of style. We have already asserted that his neglect makes use of every conceivable form. We should now add: with a single exception. And this exception is one of the most common sort—namely, one in which only content and nothing else counts. Walser is so little concerned with the way in which he writes that everything other than what he has to say recedes into the background. We could claim that what he has to say is exhausted in the process. This calls for explanation. And further investigation alerts us to a very Swiss feature of Walser's writing: his reticence [Scham]. The following story has been told of Arnold Böcklin, his son Carlo, and Gottfried Keller.[5] One day they were sitting in an inn, as they frequently did. Their regular table was well known for the taciturn, reserved habits of the drinking companions. On this occasion the group sat together in silence. The young Böcklin finally broke the lengthy silence with the words, "It's hot"; and after a further quarter of an hour had passed, his father added, "And there's no wind." As for Keller, he waited for a while, but finally got up and left, saying, "I won't drink with chatterboxes." The peasant linguistic reticence [Sprachscham] that is captured in this eccentric joke is typical of Walser. Scarcely has he taken up his pen than he is overwhelmed by a mood of desperation. Everything seems to be on the verge of disaster; a torrent of words pours from him in which the only point of every sentence is to make the reader forget the previous one. When in the course of a virtuoso piece he transforms Schiller's monologue "Along this narrow pathway must he come" into prose, he begins with the classic words, "Along this narrow pathway." But then his Wilhelm Tell is overcome by self-doubt, appears weak, insignificant, lost. He continues, "Along this narrow pathway must he come, I think."[6]

No doubt, such writing has its precedents. This chaste, artful clumsiness in all linguistic matters is heir to a tradition of folly. If Polonius, the model for all windbags, is a juggler, then Walser is a Bacchus who wreathes himself in linguistic garlands that then trip him up. The garland is in fact the proper image for his sentences. But the idea that stumbles around in them is a thief, a vagabond and genius—like the heroes of his writings. He is unable, incidentally, to depict anyone who is not a "hero"; he cannot free himself from his main characters and has contented himself with three early novels

so that he can henceforth consort exclusively with his hundred favorite rascals.[7]

It is well known that the Germanic languages are particularly rich in heroes who are windbags, wastrels, and thieves, and who in general have gone to the dogs. Knut Hamsun, a master of such characters, has recently been discovered and celebrated. Eichendorff who created his Ne'er-do-well and Hebel his Firebrand Fred are others.[8] How do Walser's characters fare in such company? And where do they spring from? We know where Eichendorff's Ne'er-do-well comes from: he comes from the woods and dales of Romantic Germany. Firebrand Fred comes from the rebellious, enlightened petty bourgeoisie of the Rhenish cities around the turn of the nineteenth century. Hamsun's characters come from the primeval world of the fiords— they are drawn to the trolls by their homesickness. And Walser's? Perhaps from the Glarn Alps? Or the meadows of Appenzell, where he hails from? Far from it. They come from the night at its blackest—a Venetian night, if you will, illuminated by the faint lamps of hope—with a little of the party spirit shining in their eyes, but distraught and sad to the point of tears. The tears they shed are his prose. For sobbing is the melody of Walser's loquaciousness. It reveals to us where his favorite characters come from— namely, from insanity and nowhere else. They are figures who have left madness behind them, and this is why they are marked by such a consistently heartrending, inhuman superficiality. If we were to attempt to sum up in a single phrase the delightful yet also uncanny element in them, we would have to say: *they have all been healed.* Admittedly, we are never shown this process of healing, unless we venture to approach his "Schneewittchen" [Snow White], one of the profoundest products of modern literature, and one which is enough on its own to explain why this seemingly most fanciful of all writers should have been a favorite author of the inexorable Franz Kafka.

These tales are quite extraordinarily delicate—everyone realizes that. But not everyone notices that they are the product not of the nervous tension of the decadent, but of the pure and vibrant mood of a convalescent. "I am horrified by the thought that I might attain worldly success," he says, in a paraphrase of Franz Moor's speech.[9] All his heroes share this horror. But why? Not from horror of the world, moral resentment, or pathos, but for wholly Epicurean reasons. They wish to enjoy themselves, and in this respect they display a quite exceptional ingenuity. Furthermore, they also display a quite exceptional nobility. And a quite exceptional legitimacy. For no one enjoys like a convalescent. The enjoyment of the convalescent has nothing of the orgy about it. His reinvigorated blood courses toward him from mountain streams, and the purer breath on his lips flows down from the treetops. Walser's characters share this childlike nobility with the characters in fairy tales, who likewise emerge from the night and from madness—

namely, from the madness of myth. It is commonly thought that this process of awakening took place in the positive religions. If that is the case, it did not do so in any very straightforward or unambiguous way. The latter has to be sought in that great profane debate with myth that the fairy tale represents. Of course, fairy-tale characters are not like Walser's in any simple manner. They are still struggling to free themselves from their sufferings. Walser begins where the fairy tales stop. "And if they have not died, they live there still." Walser shows *how* they live. His writings—and with this I shall finish, as he begins—are called stories, essays, poetic works, short prose pieces, and the like.

Published in *Das Tagebuch,* September 1929. *Gesammelte Schriften,* II, 324–328. Translated by Rodney Livingstone.

Notes

1. Robert Walser (1878–1956), Swiss author, was a native of Biel (Bern canton). In his youth he was a wanderer; he later worked briefly in a bank, a publisher's office, and a library, but was unemployed for most of his life. After 1933 he was in a series of mental institutions. His work includes three novels but is made up largely of stories, sketches, glosses, and miniatures. It is characterized by a deceptively simple, fluid style that is balanced with irony and absurd elements.
2. The satirical gloss is a recognized literary form in German, more familiar than in English, where the term "gloss" refers mainly either to the interlinear gloss of medieval texts or to marginal comments of the kind Coleridge provides in "The Ancient Mariner." In German the gloss was developed into high art by Karl Kraus, who practiced it throughout his career in his commentaries on other writers and journalists in his periodical *Die Fackel.*
3. Alfred Polgar (1873–1955) was a Viennese journalist and a gifted literary critic and commentator on cultural trends. Many of his essays were collected and published in book form during his lifetime. He was famous for his elegant, ironic style.
4. Franz Hessel was a close friend of Benjamin and had worked with him both on the translation of Proust's *A la recherche du temps perdu* and in the early stages of Benjamin's *Passagen-werk* (Arcades Project). For Benjamin's evaluation of Hessel's importance, see "The Return of the *Flâneur*" and "Review of Hessel's *Heimliches Berlin,*" both in this volume.
5. Arnold Böcklin (1827–1901), the Swiss painter, was known for his Romantic treatment of mythological subjects. Gottfried Keller (1819–1890), also a Swiss, was the major exponent of literary realism in German. See Benjamin's essay "Gottfried Keller" in this volume.
6. The quotation comes from the classic monologue in Schiller's *Wilhelm Tell,* Act 4, scene 3. As Tell lies in wait for the tyrant Gessler, he reflects on the moral justification of the murder he is about to commit.

7. The three novels are *Die Geschwister Tanner* (The Tanner Siblings; 1907), *Der Gehülfe* (The Assistant; 1908), which is his best-known work, and *Jacob von Gunten* (1909).

8. Knut Hamsun (1859–1952) was a Norwegian novelist who criticized the American way of life and idealized the farmer's existence. He supported the German invasion of Norway and in 1947 was condemned for treason. His most famous— and extremely popular—novel was *Hunger* (1890). Joseph von Eichendorff (1788–1857) was one of the leading figures of German Romanticism. Known mainly for his lyric poetry, he also wrote the classic novella *Aus dem Leben eines Taugenichts* (Adventures of a Ne'er-do-well; 1826). Johann Peter Hebel (1760– 1826) was a journalist and author; he was much esteemed for the use of dialect in his writings, a practice that had fallen prey to eighteenth-century enlightened universalism. As editor and chief writer of the *Badischer Landkalendar,* an annual publication not unlike the American *Old Farmer's Almanac,* Hebel produced an enormous volume of prose and poetry. A typical calendar would include a cosmology embellished with anecdotes and stories, practical advice for the home-owner and farmer, reports on crime and catastrophe, short biographies, riddles, and, finally, political observations on the year just past. Hebel's narrative persona, the "Rhenish Family-Friend," narrates and comments; Sterne-like ironic interjections are not infrequent. See Benjamin's essays on Hebel in Volume 1 of this edition.

9. Franz Moor is the villain in Schiller's play *Die Räuber* (The Robbers).

The Return of the *Flâneur*

Franz Hessel, *Spazieren in Berlin* [On Foot in Berlin] (Leipzig and Vienna: Verlag Dr. Hans Epstein, 1929), 300 pages.

If we were to divide all the existing descriptions of cities into two groups according to the birthplace of the authors, we would certainly find that those written by natives of the cities concerned are greatly in the minority. The superficial pretext—the exotic and the picturesque—appeals only to the outsider. To depict a city as a native would calls for other, deeper motives—the motives of the person who journeys into the past, rather than to foreign parts. The account of a city given by a native will always have something in common with memoirs; it is no accident that the writer has spent his childhood there. Just as Franz Hessel has spent his childhood in Berlin. And if he now sets out and walks through the city, he has nothing of the excited impressionism with which the travel writer approaches his subject. Hessel does not describe; he narrates. Even more, he repeats what he has heard. *Spazieren in Berlin* is an echo of the stories the city has told him ever since he was a child—an epic book through and through, a process of memorizing while strolling around, a book for which memory has acted not as the source but as the Muse. It goes along the streets in front of him, and each street is a vertiginous experience. Each leads downward, if not to the Mothers,[1] then at least to a past that is all the more spellbinding as it is not just the author's own private past. As he walks, his steps create an astounding resonance on the asphalt. The gaslight shining down on the pavement casts an ambiguous light on this double floor. The city as a mnemonic for the lonely walker: it conjures up more than his childhood and youth, more than its own history.

What it reveals is the endless spectacle of *flânerie* that we thought had been finally relegated to the past. And can it be reborn here, in Berlin of all places, where it never really flourished? We should point out in reply that Berliners have changed. Their problematic national pride in their capital has started to yield to their love of Berlin as a hometown. And at the same time, Europe has witnessed a sharpening of the sense of reality, the awareness of chronicle, document, and detail. In this situation we see the arrival of someone who is just young enough to have experienced this change, and just old enough to have been personally acquainted with the last classics of *flânerie*: Apollinaire and Léautaud. The *flâneur* is the creation of Paris. The wonder is that it was not Rome. But perhaps in Rome even dreaming is forced to move along streets that are too well-paved. And isn't the city too full of temples, enclosed squares, and national shrines to be able to enter undivided into the dreams of the passer-by, along with every paving stone, every shop sign, every flight of steps, and every gateway? The great reminiscences, the historical *frissons*—these are all so much junk to the *flâneur*, who is happy to leave them to the tourist. And he would be happy to trade all his knowledge of artists' quarters, birthplaces, and princely palaces for the scent of a single weathered threshold or the touch of a single tile—that which any old dog carries away. And much may have to do with the Roman character. For it is not the foreigners but they themselves, the Parisians, who made Paris into the Promised Land of *flâneurs*, into "a landscape made of living people," as Hofmannsthal once called it. Landscape—this is what the city becomes for the *flâneur*. Or, more precisely, the city splits into its dialectical poles. It becomes a landscape that opens up to him and a parlor that encloses him.

"Give the city a little of your love for landscape," Fritz Hessel tells Berliners. They wanted only to see the countryside in their city. After all, didn't they have the Tiergarten, that sacred grove of *flânerie* with its views of the sacred façades on the Tiergarten villas; of the tents from which you can see the leaves falling to the ground even more mournfully during the jazz than usual; and of the Neuer See, whose bays and wooded islands are engraved in the mind—the lake "where in winter we artfully traced big figure-eights in the ice like Dutchmen, and in autumn clambered down into a canoe from the wooden bridge by the boathouse with the lady of our choice, who took over the rudder"?[2] But even if none of this existed, the city would still be full of landscape. Berliners would need only to see the sky stretched out above the arches of the elevated railway, as blue as over the mountain chains of the Engadine; to see how silence arises from the din as from the surf; to see how the little streets in the inner city reflect the times of day like a mountain hollow. Of course, the true life of the inhabitants—which fills the city to the brim and without which this knowledge would not exist—does not come cheaply. "We Berliners," says Hessel, "must in-

habit our city much more fully." He undoubtedly wants this to be understood literally, and to be applied less to the houses than to the streets. For it is they that are the dwelling place of the eternally restless being who is eternally on the move, the being that experiences, learns, knows, and imagines as much between the houses as the individual between his four walls. For the masses as well as the *flâneur*, glossy enameled corporate nameplates are as good a wall-decoration as an oil painting is for the homebody sitting in his living room, or even better; the fire walls are their desks, the newspaper kiosk their library, letterboxes their bronze statuettes, benches their boudoir, and the café terrace the bay window from which they can look down on their property. Wherever asphalt workers hang their coats on iron railings, that's their hall; and the gateway that leads from the row of courtyards into the open is the entrance into the chambers of the city.

Even in Hessel's earlier, masterly "Vorschule des Journalismus" [Primer of Journalism],[3] the question of what "dwelling" means could be seen as an underlying motif. Just as every tried-and-true experience also includes its opposite, so here the perfected art of the *flâneur* includes a knowledge of "dwelling." The primal image of "dwelling," however, is the matrix or shell—that is, the thing which enables us to read off the exact figure of whatever lives inside it. Now, if we recollect that not only people and animals but also spirits and above all images can inhabit a place, then we have a tangible idea of what concerns the *flâneur* and of what he looks for. Namely, images, wherever they lodge. The *flâneur* is the priest of the genius loci. This unassuming passer-by, with his clerical dignity, his detective's intuition, and his omniscience, is not unlike Chesterton's Father Brown, that master detective.[4] You have to follow the author into the "Old West" of Berlin to get to know this side of him and see how he sniffs out the *lares* beneath the threshold, how he celebrates the last monuments of an ancient culture of dwelling.[5] The last, because the cult of "dwelling" in the old sense, with the idea of security at its core, has now received its death knell. Giedion, Mendelssohn, and Le Corbusier are converting human habitations into the transitional spaces of every imaginable force and wave of light and air.[6] The coming architecture is dominated by the idea of transparency—not just of space but also of the week, if we are to believe the Russians, who intend to abolish Sundays in favor of leisure-time shifts.[7] But it should not be thought that a single reverential glance at traditional buildings is enough to reveal the entire antiquity of the "Old West" to which Hessel introduces his readers. Only a man in whom modernity has already announced its presence, however quietly, can cast such an original and "early" glance at what has only just become old.

Among the *plebs deorum* of the caryatids and Atlases, Pomonas and putti, that Hessel reveals to the reader, his favorites are those once dominant figures that have now been reduced to *penates*—unassuming household gods

on dusty landings, in nameless hall niches, the guardians of rites of passage who once served as presiding spirits every time someone stepped over a wooden or metaphorical threshold.[8] He is unable to tear himself away from them, and their power wafts over him even when their images have long since vanished, or have become unrecognizable. Berlin has few gates, but he is familiar with the lesser transitions, those that separate the city from the surrounding lowland, or one district from another: building sites, bridges, urban railway overpasses, and squares. They are all honored here and recorded, to say nothing of the transitional hours, the sacred twelve minutes or seconds of microcosmic life, that correspond to the Twelfth Nights of the macrocosm and can seem the opposite of sacred at first sight. "The tea dances of Friedrichstadt also have their instructive hour before opening time—the hour when the lights are dimmed, the instruments are still in their cases, and the ballet mistress is eating a snack and chatting with the wardrobe girl or the waiter."

Baudelaire is the source of the cruel *aperçu* that the city changes faster than a human heart. Hessel's book is full of consoling leave-taking formulas for Berlin's inhabitants. It is a genuine manual of leave-taking. And who would not be inspired to take his departure if his words could strike to the heart of Berlin, as Hessel does with his Muses from Magdeburger Strasse? "They have long since vanished. Like quarry stones, they stood there decorously holding their ball or pencil, those that still had hands. Their white, stone eyes followed our footsteps, and the fact that these heathen girls gazed at us has become a part of our lives."

And: "We see only what looks at us. We can do only . . . what we cannot help doing." The philosophy of the *flâneur* has never been more profoundly grasped than in these words of Hessel's. Once, when he was walking through Paris, he saw women concièrges sitting and sewing in the cool doorways in the afternoon. He felt they looked at him like his nurse. Nothing is more revealing about the difference between the two cities—Paris, his late, mature hometown, and Berlin, his early, strict home—than the fact that this great city walker was soon noticed and regarded with suspicion by Berliners. This is why he entitles the first chapter of his book "The Suspect." In it we can gauge the extent of the prevailing resistance to *flânerie* in Berlin, and see with what bitter and threatening expressions both things and people pursue the dreamer. It is here, not in Paris, where it becomes clear to us how easy it is for the *flâneur* to depart from the ideal of the philosopher out for a stroll, and to assume the features of the werewolf at large in the social jungle—the creature of whom Poe has given the definitive description in his story "The Man of the Crowd."

So much for the "Suspect." Chapter 2, however, is entitled "I Am Learning." Now, "learning," too, is one of the author's favorite words. Writers mostly call it "studying," when they describe their attitude to a city; yet a

whole world separates these words. Anyone can study, but learning is something you can only do if you are there for the duration. Hessel has an overriding love of the enduring, an aristocratic distaste for nuances. There is a kind of experience that craves the unique, the sensational, and another kind that seeks out eternal sameness.[9] "Paris," it was said years ago, "is the narrow latticework balcony in front of a thousand windows; the red, tin cigar in front of a thousand *tabacs;* the zinc counter in the little bar; the concièrge's cat." In much the same way, the *flâneur* memorizes lists like a child, insisting like an old man on the truth of what he knows. We now have a similar register for Berlin, a comparable Egyptian Dream Book for those who are awake. And if a Berliner is willing to explore his city for any treasures other than neon advertisements, he will grow to love this book.

Published in *Die literarische Welt,* October 1929. *Gesammelte Schriften,* III, 194–199. Translated by Rodney Livingstone.

Notes

1. A reference to Goethe's *Faust, Part II,* Act 1, in which Faust visits "the Mothers," vaguely defined mythological figures, in search of the secret that will enable him to discover Helen of Troy. The phrase has now entered into proverbial speech, evoking the search for the ultimate mysteries of life.
2. "Tiergarten" refers to the large park in the center of Berlin, to the neighborhood surrounding it, and to the zoo which gives the park its name. The Neuer See is a large lake in the park.
3. Franz Hessel, "Vorschule des Journalismus," in Hessel, *Nachfeier* [Belated Celebration] (Berlin: Ernst Rowohlt, 1929). [Benjamin's note]
4. The English author G. K. Chesterton (1874–1936) was best-known for his "Father Brown" novels, which use the figure of the sleuthing priest to mix detective fiction and social analysis.
5. The "Old West" is the west-central area of Berlin that was built up before the city expanded into the wealthier sections of the "New West." *Lares,* in the ancient Roman pantheon, were household protective deities.
6. Sigfried Giedion (1888–1968) was a Swiss architect and theorist whose book *Bauen in Frankreich* (Construction in France) exerted a deep influence on Benjamin. Erich Mendelssohn (1887–1953) was a German architect best known for his "expressionist" work in northern Germany. Le Corbusier (pseudonym of Charles-Edouard Jeanneret; 1887–1965) was one of the twentieth century's most influential architects. Born in Switzerland, he became part of the first generation of practitioners of the International Style. His work combined stark functionalism with bold, expressionistic elements.
7. A reference to the revision, in autumn of 1929, of the Soviet calendar: the week was abolished as a unit of temporal measurement and replaced by staggered four-day shifts for workers. The revision failed to have the desired effect on

industrial production, and the Soviet Union returned to the Gregorian calendar in 1940.

8. *Plebs deorum* is Latin for "the mob of the gods"—that is, the multitude of lesser deities. Pomona is the Roman goddess of fruit.

9. Benjamin here distinguishes *Erlebnis,* a single, noteworthy experience, from *Erfahrung,* "experience" in the sense of learning from life over an extended period.

Short Shadows (I)

Platonic Love. The nature and character of a love is most sharply defined by the fate that links it to someone's name—the person's *first* name. Marriage takes a woman's original surname from her and replaces it with the man's, but this does not leave her first name unaffected—and this holds good for almost every sexual encounter. Her original name is surrounded and veiled by pet names that conceal it, often for years or even decades. In this broad sense—and only with respect to the destiny of a name, not of a body—marriage stands in contrast to Platonic love in its only authentic, significant meaning: that of the love which does not satisfy its desire in the name but which loves the beloved in her name, possesses her through the name, and worships her name. The fact that Platonic love preserves and guards the name—the first name—without changing it is the true expression of the tension, the love from afar, that is its distinguishing mark. Like rays from a glowing nucleus, the existence of the loved one proceeds from her name, and even works created by the lover proceed from the same source. In this sense the *Divine Comedy* is nothing but the aura surrounding the name of Beatrice, the most powerful representation of the idea that all the forces and figures of the cosmos arise from the name born of love.

Once Is as Good as Never. The truth of this dictum is demonstrated most surprisingly in the realm of the erotic. So long as you have pursued a woman in constant uncertainty as to whether your pleas will be heard, fulfillment can come about only amid these doubts—namely, as redemption, resolution. But scarcely have your desires been fulfilled in this way when a new and unbearable yearning—for naked, bare fulfillment in itself—takes their place in an instant [*im Nu*]. In memory, the first fulfillment is canceled out more

or less in the process of resolution—that is to say, in its function vis-à-vis doubt. It becomes abstract. So this once becomes never, when measured against a naked, absolute fulfillment. Conversely, it can also devalue itself erotically as a naked, absolute event. Such is the case when a mundane adventure gets under our skin, when it takes us brutally by surprise; and we annul that first time and call it never, because we are searching for the vanishing-lines of expectation in order to experience how the woman rises up before us as their point of intersection. In Don Juan, the lucky child of love, the secret is the way he simultaneously achieves—in a flash—resolution and the sweetest pursuit in all his adventures, the way he repeats the expectation in the midst of ecstasy and anticipates the resolution in the act of wooing. This once-and-for-all of pleasure, this interlacing of different time frames can be expressed only in music. Don Juan requires music as the magnifying glass of love.

Poverty Always Has to Foot the Bill. No gala loge is as prohibitively expensive as the entrance ticket to God's own nature. And even nature—which surrenders so readily, as we've all learned, to vagabonds and beggars, scoundrels and ne'er-do-wells—maintains its most consoling, peaceful, and pure countenance for the rich when it passes through the large French windows into their cool, shaded rooms.—This is the inexorable truth that the Italian villa teaches anyone entering its gates for the first time in order to get a view of lake and mountains—a view next to which everything he has seen outside pales, like a Kodak photograph next to the work of a Leonardo. Indeed, the landscape hangs for him in the window frame, and only for him has God's master hand added His signature.

Too Close. I dreamed I was on the Left Bank of the Seine, in front of Notre Dame. I stood there, but saw nothing that resembled Notre Dame. A brick building loomed, revealing the extremities of its massive shape, above a high wooden fence. But I *was* standing in front of Notre Dame, overwhelmed. And what overwhelmed me was yearning—yearning for the very same Paris in which I found myself in my dream. So what was the source of this yearning? And where did this utterly distorted, unrecognizable object come from?—It was like that because I had come too close to it in my dream. The unprecedented yearning that had overcome me at the heart of what I had longed for was not the yearning that flies to the image from afar. It was the blissful yearning that has already crossed the threshold of image and possession, and knows only the power of the name—the power from which the loved one lives, is transformed, ages, rejuvenates itself, and, imageless, is the refuge of all images.

Keeping Mum about One's Plans. Few kinds of superstition are as widespread as the one that keeps people from talking to each other about their

most important intentions and projects. Not only is this type of behavior seen in all classes of the population, but all manner of human motives, from the most humdrum to the most complex, seem to be affected by it. Indeed, what is closest to us seems so sensible and commonplace that many people will regard talk of superstition as pointless. Nothing, one might think, is more readily understandable than that a person should wish to keep his failures to himself, and should say nothing about his intentions so as to make sure of this. But that is really the upper layer of motivation, the surface varnish that conceals the deeper factors. Underneath is the second layer: the obscure knowledge that resolve weakens through the mere fact of physical release, the physical substitute satisfaction in talking about something. People have rarely taken the destructive character of speech—revealed to us in the simplest experiences—as seriously as it deserves. If you reflect how almost every important plan is linked to a name, indeed is inseparable from it, then you see how costly uttering that name can be. There can be no doubt, however, that this second layer is succeeded by a third one. This is the idea of using other people's ignorance—above all, the ignorance of one's friends—to achieve a superior position, like someone climbing the steps of a throne. And as if that weren't enough, there is a final layer, the bitterest one, whose depths Leopardi plumbs when he says: "The admission of one's own suffering produces not compassion but pleasure, and arouses not sadness but joy—not just in enemies but in everyone who learns of it, because it provides confirmation that the person affected is less valuable, and that we ourselves are more valuable." But how many people could believe themselves if word of Leopardi's *aperçu* ever reached them? How many wouldn't rather spit it out, repelled by the bitterness of such knowledge? At this point, superstition makes its entrance—the pharmaceutical distillation of the bitterest ingredients whose taste no one would be able to endure in isolation. Man far prefers to obey the dark mysteries embodied in popular customs and proverbs, rather than allow anyone to preach to him of all the harshness and suffering of life, in the language of ordinary common sense.

How to Recognize Your Strengths. By your defeats. Where we failed through weakness, we despise and are ashamed of ourselves. Where we are strong, however, we despise our defeats; we put our misfortune to shame. Should we recognize our strengths through our victories and good fortune!? Who doesn't know that nothing reveals our foibles as much as they? Who hasn't once felt a kind of ecstatic shiver of weakness after a victory in a fight or in love, and wondered: Did I do that? Did victory fall to me, the weakest? It is otherwise with a series of defeats, in which we learn all the tricks of survival and bathe in shame as if it were dragon's blood. Whether it be fame, alcohol, money, or love—wherever someone has his strong point, he knows

nothing of honor; he has no fear of disgrace and no inner composure. No Jew haggling with a customer could be more insistent than Casanova with Madame Charpillon. Such people dwell in their strength. It is, of course, a special and monstrous kind of dwelling; that is the price of any strength. It is life inside a tank. If we live inside it, we are stupid and unapproachable, fall into all the ditches, stumble over all the obstacles, churn up a lot of dirt, and violate the earth. But only where we are so besmirched are we unconquerable.

On Belief in Things That Have Been Prophesied. To investigate the circumstances of someone who appeals to dark powers is one of the quickest and surest ways of understanding these powers and learning how to criticize them. For every miracle has two sides: one for the person who performs it, and another for the person to whom it happens. And the second is often more illuminating than the first, because it contains the latter's secret within itself. If someone has had his handwriting analyzed, his palm read, or his horoscope cast, what we would like to ask is: What is happening to him? You would think that the person concerned would start by comparing and examining—by sifting more or less skeptically one assertion after another. But far from it. If anything, you see the opposite—above all, a curiosity about the result, a curiosity as urgent as if he were waiting for information about a matter of great importance, but of which he knew nothing. The fuel for this burning curiosity is vanity. Soon it has become a sea of flames, because now he has come across his own name. Putting forth a person's name has one of the most powerful effects on its owner that can be imagined (Americans have made practical use of this by addressing Smith and Brown in neon lights). But in the case of prophecy, it is natural to combine exposition of the name with the content of what is predicted. The situation here is as follows: The so-called inner image of oneself that we all possess is a set of pure improvisations from one minute to the next. It is determined, so to speak, entirely by the masks that are made available to it. The world is an arsenal of such masks. But the impoverished and desolate human being seeks out the image as a disguise within himself. For we are generally lacking in internal resources. This is why it makes us so happy when someone approaches us with a whole boxful of exotic masks, offering us the more unusual kinds, such as the mask of the murderer, the magnate, or the round-the-world sailor. We are fascinated by the opportunity of looking out through these masks. We see the constellations, the moments in which we really were one or another of these things, or all of them together. We yearn for this game with masks as a kind of intoxication, and it is this that enables fortunetellers and palm-readers and astrologers to earn a living even today. They know how to transport us into one of those silent pauses of fate that only subsequently turn out to have possessed the seed for quite a different

lot in life from the one given us. The fact that fate may stop beating, like a heart—this is something we sense with profound, ecstatic terror in those seemingly so meager, seemingly so distorted images of ourselves that the charlatan holds out to us. And we hasten all the more to confirm his predictions, the more thirstily we feel the shadows of the lives we never lived welling up within us.

Short Shadows. Toward noon, shadows are no more than the sharp, black edges at the feet of things, preparing to retreat silently, unnoticed, into their burrow, their secret being. Then, in its compressed, cowering fullness, comes the hour of Zarathustra—the thinker in "the noon of life," in "the summer garden." For it is knowledge that gives things their sharpest outline, like the sun at its zenith.

Published in *Neue schweizer Rundschau,* November 1929. *Gesammelte Schriften,* IV, 368–373. Translated by Rodney Livingstone.

A Communist Pedagogy

Psychology and ethics are the poles around which bourgeois education theory revolves. One should not assume that it is stagnating. It has assiduous and occasionally important contributors at work. But they can do nothing to mitigate the fact that in this field, as in all others, the thinking of the bourgeoisie is badly riven and divided in an undialectical manner. On the one hand, there is the question of the nature of the child (psychology of childhood and adolescence), and on the other, the goal of education: the complete human being, the citizen. Official education theory is the attempt to harmonize these two elements—the abstract natural disposition and the chimerical ideal—and it progresses by a gradual process of replacing force with cunning. Bourgeois society hypostatizes an absolute childhood or adolescence for whose benefit it postulates the nirvana of the Wandervögel and the Boy Scouts.[1] It hypostatizes a no less absolute concept of adulthood and citizenship which it tricks out with the attributes of idealist philosophy. In reality, each is attuned to the other and they amount to no more than the masks of the useful, socially dependable, class-conscious citizen. That is the unconscious character of this education, and it relies on a strategy of insinuation and empathy. "Children need us more than we need them" is the tacit maxim of this class, underlying everything from the subtle speculations of education theory to its reproductive practice. The children of the bourgeoisie confront it as its heirs; to the disinherited, they are helpers, avengers, liberators. This is the sufficiently drastic distinction. Its educational consequences are incalculable.

In the first place, proletarian education theory is predicated not on two abstract pieces of data but on one concrete reality. The proletarian child is

born into his class—more precisely, into the next generation of his class—rather than into a family. From the outset, this is a feature of the younger generation. What determines the child's future is not any doctrinaire educational goal, but the situation of his class. This situation, like life itself, takes possession of him from the very first moment—indeed, while he is still in the womb. Contact with it is wholly aimed at sharpening his consciousness, from an early age, in the school of poverty and suffering. It develops class consciousness. For the proletarian family does not protect the child from the harsh lessons of social knowledge any more than his frayed summer jacket protects him from the biting winter wind. Edwin Hoernle gives numerous examples of revolutionary children's organizations, spontaneous school strikes, children's strikes during the potato harvest, and so on.[2] What distinguishes his views from those of even the best and most honest thinkers in the bourgeois camp is that he devotes serious attention not just to the child and the child's nature, but also to his social situation, something which the "educational reformers" can never allow themselves to see as problematic. Hoernle has devoted the powerful concluding chapter of his book to this problem. He takes issue there with "Austro-Marxist" school reformers and proponents of a "pseudorevolutionary educational idealism." But—as Hoernle shows—what are the hidden but precise functions of elementary and vocational schools, militarism and Church, youth organizations and Boy Scouts, if not to act as the instruments of an antiproletarian education for proletarians? Communist education opposes them, not defensively but as a function of class struggle. It is class struggle on behalf of the children that belong to this class and for whom it exists.

Education is a function of class struggle, but it is not only this. In terms of the Communist creed, it represents the thoroughgoing exploitation of the social environment in the service of revolutionary goals. Since this environment is a matter not just of struggle but also of work, education is also a revolutionary education for work. Offering a program for this, the book is at its best. In the process, it meets up with a point of crucial importance for the Bolsheviks. In Russia, during the Lenin years, the important debate over single-subject or polytechnic education took place. Specialization or universal labor? Marxism's response is: universal labor. Only if man experiences changes of milieu in all their variety, and can mobilize his energies in the service of the working class again and again and in every new context, will he be capable of that universal readiness for action which the Communist program opposes to what Lenin called the "most repulsive feature of the old bourgeois society": its separation of theory and practice. The bold, unpredictable personnel policy of the Russians is wholly the product of this new, nonhumanist, and noncontemplative but active and practical universality; it is the product of universal readiness. The immeasurable versatility of raw human manpower, which capital constantly brings to the conscious-

ness of the exploited, returns at the highest level as the polytechnical—as opposed to the specialized—education of man. These are basic principles of mass education—principles whose seminal importance for young people growing up is utterly obvious.

Nevertheless, it is scarcely easy to accept without reservation Hoernle's claim that the education of children does not differ in essentials from that of the adult masses. Such bold assertions make us realize how desirable, indeed necessary it would have been to supplement the political exposition he has given us with a philosophical one. But of course the Marxist dialectical anthropology of the proletarian child is a neglected field of research. (Moreover, since Marx, there have been no significant new discoveries about adult workers either.) Such an anthropology would be nothing other than a debate with child psychology, which would have to be replaced with detailed records—prepared according to the principles of materialist dialectics—of the actual experiences of working-class children in kindergartens, youth groups, children's theaters, and outdoor groups. These should be introduced as soon as possible to supplement the present handbook.

It is in fact a handbook, but it is also something more. In Germany, there is no orthodox Marxist literature apart from economic and political writings. This is the chief reason for the astonishing ignorance on the part of intellectuals, including left-wing intellectuals, about matters concerning Marxism. Hoernle's book gives us an authoritative and incisive account of education theory. By demonstrating its relevance to a question of fundamental importance, he shows us what orthodox Marxist thought is and where it leads. We should take this book to heart.

Published in *Die neue Bücherschau*, December 1929. *Gesammelte Schriften*, III, 206–209. Translated by Rodney Livingstone.

Notes

1. The Wandervögel were organized groups of young boys who took walks through the countryside. Their activities represented the beginnings of the German Youth Movement, which embraced a wide spectrum of ideas ranging from pragmatic suggestions for pedagogical reform through nature worship and on to the virulent nationalism and anti-Semitism of the radical Right.
2. See Edwin Hoernle, *Grundfragen der proletarischen Erziehung* [Basic Questions of Proletarian Education] (Berlin: Verlag der Jugendinternationale, 1929), 212 pages. [Benjamin's note]

Notes on a Conversation with Béla Balász (End of 1929)

It began quite harmlessly. Some philosophical question or other. Only what irritated me from the outset was that he represented as an extraordinary discovery the fact that words in different languages with the same conceptual values signify in different ways (needless to say, this was not how he expressed it). I felt at once that this man could produce nothing but false ideas. Now, here's my old tactic in such circumstances. *Either* you can contradict at all costs. Thus, I developed an entire theory of poetry from the point of view of the philosophy of language. This was workable only because the fellow uttered the clichés of mystical philosophies of language—clichés that I found it both difficult and useful to refute. *Or* you can steal the ideas of such a man (if they turn out to be correct) and make off with them, as you would abscond with his girlfriend. And this is how I started. He made a very true observation about foreign words: foreign words are always torn from their natural linguistic context and become inflexible. This reminded me, in a not very precise way, of Polgar's statement to the effect that I use even German words as if they were foreign[1] (an astounding intuition that starts with a reflection on my style, but proceeds to penetrate to my very core), and I went on to endorse Balász's statement with exaggerated enthusiasm, taking advantage of the subsequent conversational confusion to make off with the idea in a completely impenetrable disguise (although one very characteristic of myself): the notion that foreign words are little linguistic burial chambers.—The theory of poetry that I opposed to his banal language mysticism turned on the contrast between, on the one hand, the magic, metaphorical, cosmic sphere in which the word emerged originally from image, and, on the other, the incorporating, intentionalist,

anthropological idea of poetry, which I presented as the conqueror—the irenic, pacifying, victorious power that overcomes myth and magic. The discovery of the intentional character of the word takes place much later than that of its magic, executive nature, which constitutes the oldest form of practice. And this intentional nature of the word develops only in the sentence, and appears first, perhaps, in poetry.

Record of a conversation from 1929; unpublished in Benjamin's lifetime. *Gesammelte Schriften*, VI, 418. Translated by Rodney Livingstone.

Notes

1. Alfred Polgar (1873–1955), Viennese journalist and theater critic, was known for his elegant, ironic essays. In 1938 he escaped across the Pyrenees and spent the World War II years in the United States. Béla Balász (pseudonym of Herbert Bauer; 1884–1949) was a prominent Hungarian film theorist, scriptwriter, and director.

Some Remarks on Folk Art

Folk art and kitsch ought for once to be regarded as a single great movement that passes certain themes from hand to hand, like batons, behind the back of what is known as great art. They both depend on great art at the level of detail, but apply what they have taken in their own way and in the service of their own "goals," their *Kunstwollen*.[1]

What is the direction of this *Kunstwollen?* Well, certainly not toward art, but toward something far more primitive, yet more compelling. If we ask ourselves what "art" in the modern sense means to folk art on the one hand and to kitsch on the other, the answer would be: all folk art incorporates the human being within itself. It addresses him only so that he must answer. Moreover, he answers with questions: "Where and when was it?" The idea surfaces in him that this space and this moment and this position of the sun must have existed once before. To throw the situation that is imagined here around one's shoulders, like a favorite old coat—this is the deepest temptation awakened by the refrain of a folk song, in which a basic feature of all folk art may be perceived.

It is not just that our image of our character is so discontinuous, so much a matter of improvisation, that we are eager to fall in with every suggestion made by the graphologist, the palm-reader, and similar practitioners. Rather, our destiny may be said to be governed by the same intensive imagination that illuminates in a flash the dark corners of the self, of our character, and creates a space for the interpolation of the most unexpected dark or light features. When we are in earnest, we discover our conviction that we have experienced infinitely more than we know about. This includes

what we have read, and what we have dreamed, whether awake or in our sleep. And who knows how and where we can open up other regions of our destiny?

What we have experienced but do not know about echoes, after its own fashion, when we enter the world of primitives: their furniture, their ornaments, their songs and pictures. "After their fashion"—this means in quite a different way from great art. As we stand in front of a painting by Titian or Monet, we never feel the urge to pull out our watch and set it by the position of the sun in the picture. But in the case of pictures in children's books, or in Utrillo's paintings, which really do recuperate the primitive, we might easily get such an urge. This means that we find ourselves in a situation of the kind we are used to, and it is not so much that we compare the position of the sun with our watch as that we use the watch to compare this position of the sun with an earlier one. The *déjà vu* is changed from the pathological exception that it is in civilized life to a magical ability at whose disposal folk art (no less than kitsch) places itself. It can do so because the *déjà vu* really is quite different from the intellectual realization that the new situation is identical to the old one. It would be more accurate to say: *basically* identical to the old one. But even this is wide of the mark. For the situation is not one experienced by a bystander; it has been pulled over our heads—we have wrapped ourselves up in it. However you think of it, it ends up as the fundamental fact of the mask. In this way the primitive, with all its implements and pictures, opens up for our benefit an infinite arsenal of masks: the masks of our fate—the masks with which we emerge from unconsciously experienced moments and situations that have now, at long last, been recuperated.

Impoverished, uncreative man knows of no other way to transform himself than by means of disguise. Disguise seeks the arsenal of masks within us. But for the most part, we are very poorly equipped with them. In reality, the world is full of masks; we do not suspect the extent to which even the most unpretentious pieces of furniture (such as romanesque armchairs) used to be masks, too. Wearing a mask, man looks out on the situation and builds up his figures within it. To hand over these masks to us, and to form the space and the figure of our fate within it—this is where folk art comes to meet us halfway. Only from this vantage point can we say clearly and fundamentally what distinguishes it from "more authentic" art, in the narrower sense.

Art teaches us to look into objects.

Folk art and kitsch allow us to look outward from within objects.

Fragment written in 1929; unpublished in Benjamin's lifetime. *Gesammelte Schriften*, VI, 185–187. Translated by Rodney Livingstone.

Notes

1. Benjamin adopts the term *Kunstwollen* from the Austrian art historian Alois Riegl. Riegl defines it as the manner in which a given culture at a given time wants to see its cultural objects.

Tip for Patrons

The wretched state of German book criticism is a secret to no one. Unlike the reasons for it. But chief among these are the absence of comradeship, of opposition, and of *clarity* in the commerce between writers. Hence the astoundingly wishy-washy nature of trends and their representatives, and the sterile dignity of a criticism that is merely the expression of the stiflingly narrowminded spirit in which it is practiced. Humor needs elbow room and space. A shrewd patron who wished to do something for German literature should abandon the notion of discovering fresh talent, or of launching Kleist and Schiller prizes. Instead, he should adopt the following proposal: he should set up a fairground for German literature. The terrain does not need to be very large. Its possibilities are unlimited: a roller-coaster ride through the peaks and troughs of the German novel, starting off in the Kafka grotto, plunging suddenly into the Ludwig wolf's lair, hurtling past Samiel Fischer and Hauptmann the sharpshooter.[1]

Literary stalls: Nietzsche, Goethe, Brecht . . .

After this ceremony, a choir leader will step forward and say something to this effect: nothing of importance.

Fragment written in 1929; unpublished in Benjamin's lifetime. *Gesammelte Schriften*, VI, 168–169. Translated by Rodney Livingstone.

Notes

1. Benjamin plays here on Carl Maria von Weber's opera *Der Freischütz* (The Sharpshooter) with his reference to the wolf's lair (the word "wolf" here referring

perhaps to Ludwig Wolff, the author of popular novels serialized in the *Berliner Illustrierte,* or perhaps to Emil Ludwig, the no less popular author of romanticized biographies of Bismarck, Wilhelm II, and others), as well as his allusion to the diabolical figure of Samiel (for the publisher Samiel Fischer). The sharpshooter himself refers to Gerhart Hauptmann, whose dramas and prose made him the central figure in German Naturalism.

Crisis and Critique, 1930

"Ich bin ein Kohlkopf" ("I Am a Cabbagehead"), 1930. Rotogravure by John Heartfield, from *Arbeiter Illustrierte Zeitung,* vol. 9, no. 6 (1930), page 103. Copyright © 1999 Artists Rights Society (ARS), New York / VG Bild-Kunst, Bonn. The image expresses the Communists' hostility to the Social Democratic Party. It was accompanied by a caption that said: "Whoever reads bourgeois newspapers becomes blind and deaf. Away with stultifying bandages!" And superimposed on the image was a parody of the Prussian nationalist song, "Ich bin ein Preusse. Kennt ihr meine Farben?" ("I am a Prussian. Do you know my colors?"):

I am a cabbagehead. Do you know my leaves?
I'm nearly out of my mind with worries,
But I keep my mouth shut and hope for a savior.
I want to be a black-red-and-gold cabbagehead!
I don't want to see anything, or hear anything,
Or get mixed up in public affairs.
And you can take everything, even the shirt on my back,
Yet I won't let the Red press into my home!

Notes (II)

The so-called immortal works just flash briefly through every present time. *Hamlet* is one of the very fastest, the hardest to grasp.

Child before the goodnight kiss in bed . . .

A writing child
 The writing hand is suspended in the scaffolding of the lines like an athlete in the giddy-making wall-bars of the arena (or of the theater-flies). Mouse, hat, house, twig, bear, ice, and egg fill the arena—a pale, glacial audience. They watch their dangerous tricks.
 Salto mortale of the *s* / Watch how the hand seeks the place on the page where it should make a start. The threshold before the realm of writing. When the child writes, its hand sets off on a journey. A long journey with pauses for it to spend the night. The letter disintegrates into pauses. Panic and paralysis of the hand. The pain of leaving the accustomed landscape of space, because from now on it may move only along the surface.

The hierarchy of the senses from the point of view of consolation.

Criticism in the form of stories: Thomas Mann / Hamsun

Reading: in order to know what a book contains; to know what someone has written and how; to inform oneself about a given subject; to criticize criticisms; to read.

For the writer, it can sometimes be dangerous or unnecessary to pick a quarrel with his public. There are instances where he can dispense with doing so. But what is quite indispensable is for every writer who wishes to be effective in any way at all to adopt a precise strategic position in his own generation. For even though he may have passionate opponents among younger or older writers, only those of his own age will know his weak points. To construct a typology of critical lives, we must distinguish between literary names that have been made by older writers, those that have been made by writers of the same age, and those that have been made by younger ones. Of course, such a classification will not bring out differences of value.

Sainte-Beuve draws a distinction between *intelligence-glaive* and *intelligence-miroir*.[1]

A postscript to the case of Borchardt.[2] If we wanted to solve the problem of explaining Borchardt's writings from that curious experience of semblance [*Schein*] which hardly ever proclaims itself so vociferously, so desperately, but by the same token hardly ever so perfectly or with such consciousness of its perfection, it would mean inserting it into contexts that are anything but those of literary history. Who—we would have to inquire—knew this kind of experience in such sensuous clarity and plenitude? We might suggest Hofmannsthal, who for that very reason had been Borchardt's great teacher. But ultimately we would also have to propose Goethe. And this points to a quite astonishing historical phenomenon: it implies the claim that the Goethean conquest of a world of semblances has discovered, in Hofmannsthal and Rudolf Borchardt, successors who are both frighteningly quick to learn and frighteningly inflexible. This Goethean world—which is merely one of the Master's many worlds, although it is the *only* one in the eyes of these disciples—usurps the place of the effective and truly developing one in their minds, through a kind of temporal hallucination. Their version of his world neither has any effect nor undergoes any development, and for this very reason they not unreasonably confuse it with the world of the early Greeks, in a way that Goethe himself would never have done. It is likewise significant that neither Hofmannsthal nor Borchardt is willing to concede even the smallest space to irony. Unobtrusive reversals, voluntary parings of things: only these methods are inconceivable in their world of semblances. This also explains Hofmannsthal's hostility to Keller. The claim that they are having an impact—a claim Borchardt in particular makes all the more insistently the more he imperialistically extends the hegemony of appearance to include the realm of science—is itself a revealing sign. For nowadays, *in the realm of forms and as form,* the only art that can claim to be unpolitical in the strictest sense of the word is what is hidden, what is unassuming, what seems to—and to a certain extent really does— renounce effect.

Depiction of the southern night, based on the idea that beneath the moon-light the earth passes once again through all the past stages of its life. And also, perhaps, anticipates in a dream the stages to come.

Thought and style. Style is the rope that a thought must vault over if it is to advance to the realm of writing. The thought must gather up all its strength. But style must come toward it halfway and go slack, like a rope in the hands of children when one of them makes ready to jump.

Dialectics of happiness: a twofold will—the unprecedented, that which has never existed before, the pinnacle of bliss. Also: eternal repetition of the same situation, eternal restoration of the original, first happiness.

We wish to enjoy our rest when it is poured out for us from a jug that is painted in the most garish colors.

Books, too, begin like the week—with a day of rest in memory of their creation. The preface is their Sunday.

Karl Valentin's comic art: diversionary marches in order to mount a flank attack on Jewish wit.[3]

Effect and productiveness are incompatible. Dampness, closeness, vagueness in productiveness; dryness, outline, distance in effectiveness.

Fragment written 1928, 1929, or 1930; unpublished in Benjamin's lifetime. *Gesammelte Schriften*, VI, 200–203. Translated by Rodney Livingstone.

Notes

1. "Sword-like intelligence" and "mirror-like intelligence."
2. Rudolf Borchardt (1877–1945) was a German poet, essayist, and translator. Politically and aesthetically conservative, he adopted a writing style marked by a highly self-conscious formal mastery.
3. Karl Valentin (pseudonym of Valentin Ludwig Fey; 1882–1948) was an enormously popular German cabaret artist.

Notes (III)

People stick roses, violets, and chrysanthemums on furs. I know of nothing that is more apt to assign women a place between animals and flowers, instead of the false, banal positioning between angel and beast. Indeed, women are creatures in flowery furs, a raging flowerbed, a heap of blood-filled calyxes with makeup on. The clock with its ebony casing that gazes like a fruit from a golden wreath of plants and precociously knows more than the seasons themselves.

Ortega y Gasset. The further Nietzsche's ideas travel around the world, the more provincial they become.

Fragment written 1928, 1929, or 1930; unpublished in Benjamin's lifetime. *Gesammelte Schriften,* VI, 205. Translated by Rodney Livingstone.

Program for Literary Criticism

1. Annihilatory criticism must retrieve its good conscience. This means that the function of criticism in general has to be returned to the level of consciousness. By a gradual process, it has degenerated into sheer exhaustion and harmlessness. In such circumstances, even corruption has its good side: at least it still has a face, a definite physiognomy.

2. A principal source of error is the illusion that the corruption can be stemmed by an appeal to the personal integrity of the reviewer. Under present conditions, it is extremely rare for the noxious parasite to pursue his activities in good faith; and the greater the bribe, the less he feels he is being bought.

3. Honest criticism from the standpoint of unprejudiced taste is uninteresting and basically lacking in substance. What is crucial about any critical activity is whether it is based on a concrete sketch (strategic plan) that has its own logic and its own integrity.

4. This is missing almost universally nowadays, because political and critical strategies coincide only in the most outstanding cases. Nevertheless, such a coincidence should be the ultimate goal.

5. In this connection, the following critical work of enlightenment should be deployed. Germany's reading public has a highly peculiar structure. It can be divided into two roughly equal parts: "the public" and "the literary circles." There is scarcely any overlap between the two. The public regards literature as an instrument of entertain-

ment, animation, or the deepening of sociability—a pastime in a higher or lower sense. The literary circles regard books as books of life, as sources of wisdom, as the statutes of their small groups—groups that alone bring bliss. Hitherto, criticism has concerned itself almost exclusively—and very wrongly—with what catches the attention of the public.

6. To trace the literature of the circles would be a terrible and by no means risk-free job of enlightenment. At the same time, it would be a preliminary study for the history of sectarianism in Germany in the twentieth century. At first glance, it is difficult to discover the source of this highly potent and rapid development of sectarianism. We can only predict that it will be the authentic form of the barbarism to which Germany will succumb if Communism fails to conquer. But we should regard it as certain that what underlies this sudden outbreak of ritual complexes is the attempt to release the body from traditional collectives and to insert it into new ones, and that what makes them symptoms of madness is precisely the absence of any relationship to collective activity.

7. Furthermore, criticism has to secure its own power by developing a more effective attitude toward the relations of production in the book market. It is well known that far too many books are published. What is worse, a consequence of this is that too few good books appear. And those that have appeared have made too little impact. Until now, when critics wished to reject a book, they directed their fire at the author. It is obvious that they have not achieved very much by this procedure. Their judgments cannot be followed up by executions. Not to mention that for every bad writer who is demolished in this way, nine new ones spring up in his place. A different approach is when the critic insists, within certain limits, on the principle of the publisher's (economic) responsibility, and denounces the publisher of bad books as the squanderer of the already small capital that is available for producing books. The aim here, of course, is not to attack the commercial aspect of publishing—to criticize the publisher who makes money from bad books, just as other businessmen make money from inferior merchandise—but to appeal to the misguided idealist whose patronage supports dangerous products.

8. Good criticism is composed of at most two elements: the critical gloss and the quotation. Very good criticism can be made from both glosses and quotations. What must be avoided like the plague is rehearsing the summary of the contents. In contrast, a criticism consisting entirely of quotations should be developed.

9. The theory of the unrecognized genius should be inserted here.

10. Causes of tolerance in criticism until today.

11. Prognosis for the universities. In ten years, university chairs will have been completely divided up between the charlatans and the sectarians. The conquest of chairs by the George school was the first symptom.[1] It turns out (as I learned from a conversation with Christiane von Hofmannsthal) that there are still university teachers who possess exact knowledge and exact skills, but it has already become impossible for them to transmit this knowledge further. "The students learn nothing, but they know how to cross the street as well as their teachers." And this illustrates the truth that the transmissibility of knowledge does not depend just on its wealth and exactness. On the contrary, we can perceive its moral structure here more clearly than anywhere else.

12. What would happen if one of the twelve people whose voices carry weight with the German public were to speak out against his fellow conspirators? Everything is based on the certainty that no one will refuse to play the game.

13. Historical retrospect: the decay of literary criticism since the Romantic movement. A contributory factor is the absence of a collective authority that could judge great objects and slogans. Every cohort of critics has seen itself as a "generation" in all its limitations, as a puny guardian of "posterity." In this way, caught between productive writers and posterity, it didn't dare to move a muscle, and so foundered in epigonism. Friedrich Theodor Vischer the ultimate stage.[2]

14. The stronger a critic is, the more comprehensively he is able to digest the entire personality of his adversary, right down to the details of his character.

15. Critical procedures. The danger of their multiplicity.

 1. Speak only of the author—speak only of the work.

 2. Consider the work in relation to other works by the same author—consider the work in isolation.

 3. Place the work in a literary-historical context and compare it in terms of style or content with other works in the tradition.

 4. Treat the work—polemically, prognostically, analytically—according to its effect on its public.

 5. The work as representative of a thesis—the thesis as representative of a work.

16. The function of criticism, especially today: to lift *the mask of "pure art"* and show that there is no neutral ground for art. Materialist criticism as an instrument for this.

17. The risk in bestowing praise: the critic forfeits his credit. Looked at strategically, every expression of praise is a blank check.

18. There is fine art in giving praise. But it is also a fine art to bring out the importance of something apparently peripheral through negative criticism.

19. The critic must know how to give the public the feeling that it will know where to expect him. When he will speak out and in what way.

20. The question of space. Under this rubric the question of the critic's style should be treated. Take up the ideas from my conversations with Bernhard Reich.

21. We do not know what Hofmannsthal, Thomas Mann, and Wassermann think of each other.[3] Indeed, we do not even know what the spokesmen of the younger generation—Leonhard Frank, Alfred Döblin, Arnolt Bronnen—think of their elders.[4] Not that this would be very interesting or crucial, or that we could not imagine it for ourselves if need be. But it would clear the air. It would articulate the utterly amorphous mass of people who "live by their pen" to the point where partisanship and debate could emerge, things which are absent from our literature to an absolutely incomprehensible degree. There is a contrast here with theatrical criticism, which occupies an important place in the public eye for this reason—and for this reason *alone,* since the theater is otherwise unimportant.

22. The false and unsustainable fiction that literary criticism today can still expect to derive its standards from pure aesthetics, and that criticism is basically nothing but the application of those standards. Criticism has failed to notice that the time for aesthetics in every sense, and especially in the sense practiced by Friedrich Theodor Vischer, is gone forever.

23. "The gift of judgment is rarer than the gift of creativity" (Oskar Loerke).[5]

24. *Stefan Zweig in Böttcherstrasse* (Bremen; edited by Ludwig Roselius) I,1.[6]

25. Criticism via images (*Prochainement Ouraitre* [?]);[7] criticism via narrative *(The Magic Mountain).*

26. Topical critical themes: the war novel in Germany (Arnold Zweig, Ernst Gläser, Ludwig Renn, Erich Maria Remarque).[8] The unmasking of Jakob Wassermann.

27. The division into groups, or rather parties, that is taking place in Germany. The authors who made their debut under Expressionism, as well as others.

28. The question of war novels. The right-wing parties have been able to cash in immediately on the experience of the Great War. Their world view has not been shaken by it. Neither has that of the Communists. The situation is different with the parties occupying the middle ground, especially those of the grand bourgeoisie and, in a different way, of the petty bourgeoisie. We must bear this in mind when confronting the question: What (or whose) interest is served by the fashion for war novels? The more the "objectivity" and the "documentary nature" of these novels are emphasized, the more closely we should scrutinize the deeply hidden tendencies they serve. Of course, not all these tendencies are deeply hidden. For example, the pacifist element is strikingly obvious. And it is this that cries out for closer analysis.

29. More on the war novel. What is *hidden* about this pacifism is the fact that—and the way in which—it subserves capitalist interests at their present stage. And hard though it is to think of pacifism as an instrument of imperialism, it is no easier to trace its connection with the apparently "objective" and "documentary" reality of the war. This ideology is concealed in the "objective" [*sachlichen*] representation the way Easter eggs are hidden in the crevices of a sofa. We could sum it up in this formula: The ostensible reality of the war in these new novels is related to its true (and this means its present, contemporary) reality much as pacifist ideology is related to the necessities of the contemporary economy. In both cases, the convergence between the two is more apparent than real.

30. Further comments on the war novel. The books on the war that are appearing now were written in part immediately after the war. At that time, no one was interested. They were incompatible with the mood of the day, to which the great volumes of memoirs made a stronger appeal. On the other hand, Expressionism was—on a formal plane—the expression of life at the time (the inflation). The critique of the new war books would be contained implicitly in an account of the transition from Expressionism to the New Objectivity.[9] Such a trajectory would reveal that the New Objectivity represented the consolidation of the debt incurred by Expressionism. It

incurred this debt with its borrowings from metaphysics. The New Objectivity is the interest required to service the debt.

31. Book criticism must be based on a program. As a form of criticism that improvises the standards it applies, immanent criticism can lead to satisfying results in individual cases. But what is needed more urgently is a program. Its starting point must be the perception that the aesthetic categories (criteria) are, without exception, completely devalued. Nor can they be resurrected from the old aesthetics by any "reformulation," however ingenious. On the contrary, what is required now is a detour through materialist aesthetics, which would situate books in the context of their age. Such criticism would lead to a new, dynamic, dialectical aesthetics. Even the old aesthetics included the most profound insights into the contemporary world. But the modern critic thinks of these old concepts and schemata in absolute terms, much as he regards the works. He is firmly convinced that everything must be possible at every moment.

32. Atomization of contemporary criticism. The book regarded outside the context of the age, the author, current trends. But that is no more than a hypothetical working basis for certain lucky instances of an improvising, immanent criticism.

33. The relation of book criticism to film criticism the reverse of what it should be. Book criticism should learn from film criticism. Instead, film criticism mainly apes book criticism.

34. Writers abuse their own names and influence. When we compare this with the situation in France, it is scandalous how our best-known writers refuse to lift a finger to improve the status of book criticism.

35. "Quand on soutient un mouvement révolutionnaire, ce serait en compromettre le développement que d'en dissocier les divers éléments au nom du goût."[10] Apollinaire in conversation.

36. The atomization of criticism is connected with the demise of the art of critical portraiture.

37. One should adopt as a maxim: never write a critique without at least *one* quotation from the work under review.

38. A metaphor for criticism: Take the plants from the garden of art and transplant them to the alien soil of science, in order to obtain a detailed picture of the minute changes in color and form that appear there. The most important thing is the gentle touch, the care with which the work is taken out with its roots, for it is this that

then improves the soil of knowledge. Everything else happens of its own accord, since it is the work's merits themselves that alone deserve the title of criticism in the highest sense.

39. How times have changed. A hundred years ago Börne wrote, "What the Germans like most of all is a book about a book; . . . Whoever wishes to lead them down the path of virtue need do nothing but write, and whoever wishes for certain success should become a critic." Ludwig Börne, *Gesammelte Schriften: Vollständige Ausgabe,* edited by Karl Grün, vol. 6 (Vienna, 1868), page 3.

40. Highly symptomatic of modern criticism: it never compromises an author more than when it bestows praise. And on the whole, that is right and proper, since the critics prefer to praise worthless books. But significant works are not treated any differently. Consider Hofmannsthal, for example.

Fragment written in 1929 or 1930; unpublished in Benjamin's lifetime. *Gesammelte Schriften,* VI, 161–167. Translated by Rodney Livingstone.

Notes

1. "George school" refers to the circle around the lyric poet Stefan George (1868–1933), which included a number of influential writers and especially academics. It was held together as much by the force of George's charismatic, authoritarian personality as by his ideas, which centered on a conservative restoration of the German language and through it of the German nation.
2. Friedrich Theodor Vischer (1807–1887), a leading critic and liberal politician, is best-known for his championing of literary realism at mid-century.
3. Jakob Wassermann (1873–1934) was a German novelist best-known for his work on the mysterious foundling Kaspar Hauser and for a series of historical novels published in the 1920s.
4. Leonhard Frank (1882–1961) was a German novelist and playwright working in the wake of Expressionism. Alfred Döblin (1878–1957), a leading German novelist and essayist, is best-known for *Berlin Alexanderplatz* (1929). Arnolt Bronnen (1895–1959) was a German dramatist who combined leftism and Expressionism in a series of controversial plays.
5. Oskar Loerke (1884–1941), a German lyric poet, was best-known for his nature poetry.
6. Stefan Zweig (1881–1942) was a German biographer, poet, essayist, dramatist, and novelist. He explored a series of imagined and historical figures in a number of fictional and nonfictional genres.
7. "*Prochainement Ouraitre*" is probably a garbled reference to Henri Guilac's book

Prochainement Ouverture (Paris, 1925). It contains drawings by Guilac which caricature contemporary French books.

8. Arnold Zweig (1887–1968) was a German novelist whose book *Der Streit um den Sergeanten Grischa* (The Case of Sergeant Grischa; 1927) caused a sensation; the encounter of the Russian prisoner of war Grischa and the Prussian military machine proved a potent allegory of state power during the Weimar Republic. Ernst Gläser (1902–1962) was a German journalist and author of realist novels. Ludwig Renn (pseudonym of Arnold von Golssenau; 1889–1979) was a German novelist best-known for *Krieg* (War; 1928), which was based on his own wartime experiences. Erich Maria Remarque (1898–1970), a German novelist, is chiefly remembered for *Im Westen nichts Neues* (All Quiet on the Western Front; 1929), the best-known novel of World War I.

9. Benjamin refers here to the last throes of German Expressionism in the period after World War I; Expressionism in the visual arts and literature had arisen and reached full maturity already in the years leading up to the war. The German inflation began as early as 1914, when the imperial government began financing its war effort with a series of fiscally disastrous measures. The economic situation deteriorated rapidly in the years following the end of the war, as an already crippled economy was further burdened by war reparations. The inflation reached its critical phase—that of hyperinflation—in late 1922 and 1923. If we compare late 1913 (the last year before the war) with late 1923 using the wholesale price index as the basis for the comparison, we find that one German mark in 1913 equaled 1.26 trillion marks by December 1923. *Neue Sachlichkeit* (New Objectivity) was the term originally applied by the museum curator G. F. Hartlaub to an emergent figuration in German postwar painting. It gradually came to designate the Weimar "period style" in art, architecture, design, literature, and film: cool, objective, analytical.

10. "When you support a revolutionary movement, you would compromise its development if you were to dissociate it from certain elements in the name of taste."

Notes on a Theory of Gambling

Certain matters are clear. What is decisive is the level of motor innervation, and the more emancipated it is from optical perception, the more decisive it is. From this stems a principal commandment for gamblers: they must use their hands sparingly, in order to respond to the slightest innervations. The gambler's basic approach must, so to speak, adumbrate the subtlest network of inhibitions, which lets only the most minute and unassuming innervations pass through its meshes.—It is also an established fact that the loser tends to indulge in a certain feeling of lightness, not to say relief. Conversely, the experience of having won weighs on the gambler's mind. (This refers to his state of mind after the game, not during it.) We may say of the winner that he has to do battle with the feeling of hubris which threatens to overwhelm him. He falls, perhaps not unintentionally, into a state of depression.— Another fact: the genuine gambler places his most important bets—which are usually his most successful ones, too—at the last possible moment. He could be said to be inspired by a certain characteristic sound made by the roulette ball just before it falls on a specific number. But one could also argue that it is only at the last moment, when everything is pressing toward a conclusion, at the critical moment of danger (of missing his chance), that a gambler discovers the trick of finding his way around the table, of reading the table—if this, too, is not just an expression from the realm of optics.— The gambler may form the impression that the winning numbers are hiding from him. This happens because—we may hypothesize—he knows every winning number in advance, except for the one that he (accidentally) bet on with an optical or rational consciousness. In the case of the others, there is a twofold possibility: either he bet on them correctly, relying on his motor

innervations (inspiration), or else he knew them in advance but was unable to discover (reveal, make manifest) this knowledge in terms of motor stimuli. Hence the feeling that the number was hiding.—When a winning number is clearly predicted but not bet on, the man who is not in the know will conclude that he is in excellent form and that next time he just needs to act more promptly, more boldly. Whereas anyone familiar with the game will know that a single incident of this kind is sufficient to tell him that he must break off instantly. For it is a sign that the contact between his motor stimuli and "fate" has been interrupted. Only then will "what is to come" enter his consciousness more or less clearly as what it is.—Also established is the fact that no one has so many chances of betting on a winning number as someone who has just made a significant win. This means that the correct sequence is based not on any previous knowledge of the future but on a correct physical predisposition, which is increased in immediacy, certainty, and uninhibitedness by every confirmation, such as is provided by a win.— The happiness of the winner: the winner's highly remarkable feeling of elation, of being rewarded by fate, of having seized control of destiny. Comparison with the expression of love by a woman who has been truly satisfied by a man. Money and property, normally the most massive and cumbersome things, here come directly from the hands of fate, as if they were the caressing response to a perfect embrace.—Furthermore, one should note the factor of danger, which is the most important factor in gambling, alongside pleasure (the pleasure of betting on the right number). It arises not so much from the threat of losing as from that of *not winning*. The particular danger that threatens the gambler lies in the fateful category of arriving "too late," of having "missed the opportunity." We could learn something from this about the character of the gambler as a type.—Last, the best that has thus far been written about gambling focuses on the factor of acceleration, acceleration and danger. What Anatole France has said on pages 14ff. of *Le jardin d'Epicure* [The Garden of Epicurus] must be combined with what has been noted here: gambling generates by way of experiment the lightning-quick process of stimulation at the moment of danger, the marginal case in which presence of mind becomes divination— that is to say, one of the highest, rarest moments in life.

See, on this subject, "The Path to Success, in Thirteen Theses" [in this volume]; and Alain, *Les idées et les âges* (Paris, 1927), under "Le jeu."

Fragment written in 1929 or 1930; unpublished in Benjamin's lifetime. *Gesammelte Schriften,* VI, 188–190. Translated by Rodney Livingstone.

The Crisis of the Novel

Alfred Döblin, *Berlin Alexanderplatz: Die Geschichte von Franz Biberkopf* [Berlin Alexanderplatz: The Story of Franz Biberkopf] (Berlin: S. Fischer Verlag, 1929), 530 pages.

From the point of view of epic, existence is an ocean. Nothing is more epic than the sea. One can of course react to the sea in different ways—for example, lie on the beach, listen to the surf, and collect the shells that it washes up on the shore. This is what the epic writer does. You can also sail on the sea. For many purposes, or none at all. You can embark on a voyage and then, when you are far out, you can cruise with no land in sight, nothing but sea and sky. This is what the novelist does. He is the truly solitary, silent person. Epic man is simply resting. In epics, people rest after their day's work; they listen, dream, and collect. The novelist has secluded himself from people and their activities. The birthplace of the novel is the individual in his isolation, the individual who can no longer speak of his concerns in exemplary fashion, who himself lacks counsel and can give none. To write a novel is to take that which is incommensurable in the representation of human existence to the extreme. Simply to think of the works of Homer and Dante is to sense what separates the novel from the genuine epic. The oral tradition, the stuff of epic, is different in kind from what forms the stock-in-trade of the novel. What distinguishes the novel from all other forms of prose—folktale, saga, proverb, comic tale—is that it neither originates in the oral tradition nor flows back into it. And this is what distinguishes it above all from storytelling, which in the prose tradition represents the epic form at its purest. Indeed, nothing contributes more to the danger-

ous falling silent of the inner human being, nothing kills the spirit of storytelling more thoroughly, than the outrageous proportions that the reading of novels has undergone in all our lives. It is therefore the voice of the born storyteller that makes itself heard here, in opposition to the novelist: "Nor do I wish to mention that I consider the emancipation of the epic from the book . . . to be advantageous—advantageous above all for language. The book spells the death of real languages. The most important, creative energies of language elude the epic author who only writes." Flaubert could never have written this. This thesis is Döblin's. He has given a very comprehensive account of it in the first yearbook of the Section for Literature of the Prussian Academy of Arts; his "Structure of the Epic Work" is a masterly document of the crisis of the novel, which was initiated by the reinstatement of epic that we now encounter everywhere, even in drama. Anyone who thinks carefully about this lecture of Döblin's will have no need to concern himself with the external signs of this crisis, this reinforcement of radical epic. The flood of biographical and historical novels will cease to astonish him. The theoretician Döblin, far from resigning himself to this crisis, hurries on ahead of it and makes its cause his own. His latest book shows that his theory and practice are one.

Nothing is more illuminating than to compare Döblin's position with the one that André Gide has recently revealed in his *Journal des "Faux-monnayeurs"* [Journal of *The Counterfeiters*], which is equally magisterial, equally precise, and equally spirited in its praxis, but nonetheless opposed to Döblin's on every point.[1] In the clash of these two critical minds the contemporary situation of epic finds its sharpest expression. In this autobiographical commentary to his latest novel, Gide develops the doctrine of the *roman pur*. With the greatest subtlety imaginable, he has set out to eliminate every straightforward, linear, paratactic narrative (every mainline epic characteristic) in favor of ingenious, purely novelistic (and in this context that also means Romantic) devices. The attitude of the characters to what is being narrated, the attitude of the author toward them and to his technique—all this must become a component of the novel itself. In short, this *roman pur* is actually pure interiority; it acknowledges no exterior, and is therefore the extreme opposite of the purely epic approach—which is narration. In strict contrast to Döblin's notions, Gide's ideal is the novel as pure writing. He is perhaps the last to uphold Flaubert's views. And no one will be surprised to discover that Döblin's speech contains the sharpest repudiation imaginable of Flaubert's achievement. "They will throw up their hands in despair when I advise their authors not to shrink from introducing lyrical, dramatic, and even reflective elements into their narratives. But I insist on it."[2]

His lack of inhibition in implementing this program is revealed in the perplexity of many of the readers of this latest book. Now, it is true enough

that narrative has seldom been handled in such a manner as this. It is rare indeed for the waves of incident and reflection to sweep over the reader and destabilize his comfort to this degree, and the spray of actual spoken speech has never given him such a soaking as here. But this does not mean that we must operate with technical terms, such as *dialogue intérieur,* or refer the reader to James Joyce. In reality, something quite different is at work. The stylistic principle governing this book is that of montage. Petty-bourgeois printed matter, scandalmongering, stories of accidents, the sensational incidents of 1928, folk songs, and advertisements rain down in this text. The montage explodes the framework of the novel, bursts its limits both stylistically and structurally, and clears the way for new, epic possibilities. Formally, above all. The material of the montage is anything but arbitrary. Authentic montage is based on the document. In its fanatical struggle with the work of art, Dadaism used montage to turn daily life into its ally. It was the first to proclaim, somewhat uncertainly, the autocracy of the authentic. The film at its best moments made as if to accustom us to montage. Here, for the first time, it has been placed at the service of narrative. Biblical verses, statistics, and texts from hit songs are what Döblin uses to confer authenticity on the narrative. They correspond to the formulaic verse forms of the traditional epic.

The texture of this montage is so dense that we have difficulty hearing the author's voice. He has reserved for himself the street-ballad-like epigraphs to each chapter; otherwise, he is in no great hurry to make his voice heard. (Even though he is determined to have his say in the end.) It is astounding how long he trails behind his characters before risking any challenge to them. He approaches things in a relaxed way, as befits an epic writer. Whatever happens—even when it happens suddenly—seems to have been prepared well in advance. In this attitude, he has been inspired by the spirit of Berlin dialect—a dialect that moves at a relaxed pace. For the Berliner speaks as a connoisseur, in love with the way things are said. He relishes it. Whether he is swearing, mocking, or threatening, he takes his time, just as he takes his time over breakfast. Glassbrenner dramatically highlighted the qualities of Berlinish.[3] Here we see it in its epic profundity. The ship of Franz Biberkopf's life is heavily laden, yet never runs aground. The book is a monument to the Berlin dialect because the narrator makes no attempt to enlist our sympathies for the city based on any sort of regional loyalty. He speaks from within Berlin. It is his megaphone. His dialect is one of the forces that turn against the reserved nature of the old novel. For this book is anything but reserved. It has its own morality, one that is relevant even to Berliners. (Tieck's "Abraham Tonelli" had earlier unleashed the power of the Berlin dialect, but no one had previously attempted to find a cure for it.)[4]

It is rewarding to follow the cure that is prescribed for Franz Biberkopf.

What happens to him?—But first, why is the novel called *Berlin Alexander-platz,* with *The Story of Franz Biberkopf* only a subtitle? What is Alexanderplatz in Berlin? It is the site where for the last two years the most violent transformations have been taking place, where excavators and jackhammers have been continuously at work, where the ground trembles under the impact of their blows and under the columns of omnibuses and subway trains; where the innards of the metropolis and the backyards around Georgenkirchplatz have been laid bare to a greater depth than anywhere else; and where districts built in the 1890s have managed to survive more peacefully than elsewhere in the untouched labyrinths around Marsilius-strasse (where the secretaries of the Immigration Police are crammed into a tenement block) and around Kaiserstrasse (where the whores make their rounds in the evening). It is no industrial district; commerce above all—petty bourgeoisie. And then, there is its sociological negative, the crooks who obtain their reinforcements from the unemployed. One of these is Biberkopf. He is released from Tegel prison, and finds himself without work; he remains respectable for a time, starts selling goods on street corners, gives it up, and joins the Pums gang. The radius of his life is no more than one thousand meters. Alexanderplatz governs his existence. A cruel regent, if you like. An absolute monarch. For the reader forgets everything else around him, learns to feel his life within that space and how little he had known about it before. Everything turns out to be different from what the reader expected to find in a book he has taken out of the mahogany bookcase. It did not seem to have the feel of a "social novel." No one sleeps under the trees. They all have a room. Nor do you see them looking for one. Even the first of the month seems to have lost its terrors in the area around Alexanderplatz. These people are certainly miserable [*elend*]. But they are miserable in their rooms. What does this mean, and how does it come about?

It has two meanings. A broad one and a limiting one. A broad one, for misery is in fact not what little Moritz had imagined. *Real* misery, at least—in contrast to the kind imagined in your nightmares. It is not just people who have to cut their coat according to their cloth, and cope as best they can; this is something that holds good for poverty and misery, too. Even its agents, love and alcohol, sometimes rebel. And nothing is so bad that you cannot live with it for a time. In this book, misery shows us its cheerful side. It sits down at the same table with you, but this does not put an end to the conversation. You adjust to the situation and keep on enjoying yourself. This is a truth that the new low-life Naturalism refuses to acknowledge. This is why a great storyteller had to come and help it gain credence. It is said of Lenin that he hated only one thing more than misery: making a pact with it. There is in fact something bourgeois about this—not just in the mean, petty kinds of slovenliness, but also in the large-scale forms of

wisdom. In this sense Döblin's story is bourgeois, and it is so in its origin—
that is to say, in a much more limiting way than in its ideology and intention.
What we find here once again, in a beguiling form and with undiminished
force, is the reemergence of the magic of Charles Dickens, in whose works
bourgeois and criminals fit each other like a glove because their interests
(however opposed to each other they may be) inhabit one and the same
world. The world of these crooks is homologous with the world of the
bourgeoisie. Franz Biberkopf's road to pimp and petty bourgeois is no more
than a heroic metamorphosis of bourgeois consciousness.

The novel, we might reply to the theory of the *roman pur,* is like the sea.
Its only source of purity is its salt. Now, what is the salt in this book? Salt
in the epic is like a mineral: it makes things last when it is alloyed with
them. And duration is a criterion of epic writing far more than of other
types of literature. Duration not in time, but in the reader. The true reader
reads an epic in order to "retain" it. And it is quite certain that he will retain
two incidents from this book: the story about the arm and the events
concerning Mieze. How does it come about that Franz Biberkopf gets
thrown under a car and thus loses an arm? And that his girlfriend is taken
from him and killed? The answer can be found as early as the second page.
"Because he wants more from life than bread and butter." In this instance,
not rich food, money, or women, but something far worse. His big mouth
longs for something less tangible. He is consumed by a hunger for destiny—
that's what it is. This man is always asking for trouble in a big way; no
wonder it keeps coming to him. The way in which this hunger for destiny
is satisfied for the whole of his life, and the way he learns to be content with
bread and butter—in short, the way in which the crook becomes a sage—is
the nature of the sequence of events. At the end, Franz Biberkopf loses his
sense of destiny; he becomes "clear-headed," as the Berliners put it. Döblin
made this great process of maturation unforgettable by means of a great
artistic device. Just as at a Bar Mitzvah Jews reveal to the child his second
name, which up to then has remained a secret, so too Döblin gives Biberkopf
a second name. From now on, he is Franz Karl. At the same time, something
strange has happened to this Franz Karl, who is now working as assistant
doorman in a factory. And we would not swear that this has not escaped
Döblin's attention, even though he keeps a pretty sharp eye on his hero. The
point is that Franz Biberkopf has now ceased to be exemplary, and has been
whisked away into the heaven for characters in novels. Hope and memory
will console him in this heaven, the little porter's lodge, for his failure in
life. But we do not follow him into his lodge. This is the law governing the
novel: scarcely has the hero discovered how to help himself than he ceases
to be capable of helping us. And if this truth becomes manifest in its grandest
and most inexorable form in Flaubert's *L'éducation sentimentale,* we may

think of Franz Biberkopf's history as the "sentimental education" of the crook. The most extreme and vertiginous, the last and most advanced stage of the old bourgeois *Bildungsroman*.

Published in *Die Gesellschaft*, 1930. *Gesammelte Schriften*, III, 230–236. Translated by Rodney Livingstone.

Notes

1. André Gide, *Journal des "Faux-monnayeurs"* (1926).
2. Alfred Döblin, "Der Bau des epischen Werks" (The Structure of the Epic Work), in *Jahrbuch der Sektion für Dichtkunst* (Berlin, 1929), p. 262.
3. Adolf Glassbrenner (1810–1876) was a radical journalist who wrote satirical and comic vignettes of Berlin life in the local dialect. His writings include *Berlin, wie es ist—und trinkt* (Berlin, As It Is—and Drinks; 1832–1850) and *Buntes Berlin* (Colorful Berlin; 1837–1841).
4. Ludwig Tieck (1773–1853), a leading German Romantic writer, wrote the whimsical story "Merkwürdige Lebensgeschichte Sr. Majestät Abraham Tonelli" (Remarkable Life Story of His Majesty Abraham Tonelli) in 1798.

An Outsider Makes His Mark

S. Kracauer, *Die Angestellten: Aus dem neuesten Deutschland* [White-Collar Workers: The Latest from Germany] (Frankfurt am Main: Frankfurter Societätsdruckerei, 1930), 148 pages.

The malcontent is a type as old as the hills, perhaps as old as writing itself. Thersites, Homer's cynic; the first, second, and third conspirators in Shakespeare's histories; the Faultfinder from the only great drama of the World War—all of these are the changing faces of this one figure.[1] But the literary fame of the archetype does not seem to have given heart to its incarnations in real life. They tend to pass through existence nameless and tight-lipped, and for the physiognomist it is undoubtedly an event when one of the breed suddenly draws attention to himself and declares in public that he is not going to play the game. The writer in question here likewise appears reluctant to make free with his own name. A laconic "S." in front of his surname warns us not to take too many liberties. The reader is made aware of this laconic stance through other, more internal means as well—as in the way humanity is born from the spirit of irony. S. glances at the proceedings in the labor courts, and the merciless light reveals to him "not so much wretched human beings, as human beings made wretched by circumstances." What is clear is that this man refuses to play the game. He declines to don a mask for the carnival mounted by his fellow human beings. He has even left his Doctor of Sociology cap at home. And he rudely pushes his way through the throng, so as to lift the masks of the most impudent here and there.

It is easy to understand why he repudiates the term "reportage" as a

description of his own enterprise. In the first place, he finds modern Berlin radicalism and the New Objectivity—both of which acted as godparents to reportage—equally repugnant.[2] In the second place, a troublemaker who unmasks others has no desire to be thought of as a portrait painter. Unmasking others is this writer's passion. He forces a dialectical entry into the lives of office workers not because he is an orthodox Marxist, even less a practical agitator, but because "unmasking" is what is meant by "forcing a dialectical entry." Marx asserted that social existence determines consciousness. But he also claimed that only in a classless society would consciousness be adequate to that existence. It follows that in a class society social existence is inhuman to the degree to which the consciousness of the different classes, far from being adequate, is highly mediated, inauthentic, and displaced. And since such a false consciousness on the part of the lower classes is in the interest of the upper classes, and since that of the upper classes is explained by the contradictions of its economic situation, the creation of a true consciousness—primarily in the lower classes, who have everything to gain from it—must be the chief task of Marxism. In this sense, and originally only in this sense, the author can be said to think as a Marxist. Of course, his project leads him all the more deeply into the overall system of Marxism because the ideology of white-collar workers represents a unique combination: on the one hand it comes very close to that of the proletariat, in the sense that it reflects the given social reality, while on the other it bears the imprint of the wishes and memories of the bourgeoisie. Today, there is no class of people whose thoughts and feelings are more alienated from the concrete reality of their everyday lives than those of white-collar workers. In other words, the process of adaptation to the inhuman side of the contemporary social order has made greater strides among white-collar workers than among blue-collar ones. The white-collar worker's more indirect relations to the production process go hand in hand with a more direct involvement in the forms of human interaction that correspond to that process. And since the medium in which this reification of human relations actually takes place is that of the organization—the only medium, incidentally, in which reification could be overcome—the author arrives inevitably at a critique of the trade unions.

This critique is not carried out in terms of party politics or wage policy. Nor can it be found in a single place; rather, it is something that emerges at every point. Kracauer is not concerned with what the union achieves for its members. Instead he asks: How does it educate them? What does it do to liberate them from the spell of the ideologies that hold them in thrall? His consistent outsider status greatly helps him in formulating answers to such questions. He has no commitments that might allow authorities to trump his assertions and force him to hold his tongue. No commitment to the idea of community, for example. He unmasks this idea as a variant of

economic opportunism. What about the higher educational qualifications of the white-collar worker? Kracauer dismisses these as illusory, and demonstrates how the exaggerated claims to education increase the white-collar worker's impotence when it comes to defending his rights. What about cultural goods, then? To fix them once and for all means, in his view, to pander to the belief that "the disadvantages of mechanization can be evened out by spiritual values that can be taken like medicines." This entire ideological cast of mind "is itself the expression of the reification whose effects it is trying to counteract. It is founded on the belief that values represent ready-made realities that can be delivered to your home like commodities." Such statements do more than comment on a problem. The entire book is an attempt to grapple with a piece of everyday reality, constructed here and experienced now. Reality is pressed so closely that it is compelled to declare its colors and name names.

The name is Berlin. In the author's view, it is the quintessential white-collar worker's city—to the point where he is fully aware that he has made an important contribution to the physiology of the capital. "Today, Berlin is the city of white-collar culture par excellence; that is to say, a culture which has been made by white-collar workers for white-collar workers, and which most white-collar workers regard as culture. Only in Berlin, where the links with origins and roots have been pushed so far into the background that the weekend can become a great fashion, can the reality of white-collar workers be fully grasped."[3] Sports are an essential aspect of the weekend. The author's critique of the popularity of sports among white-collar workers shows how disinclined he is to compensate for his ironic treatment of cultural ideals by an even more passionate defense of nature. Far from it. The instinctual insecurity fostered by the ruling class is countered here by a writer who defends uncorrupted *social* instincts. He plays to his own strengths—and these consist in his ability to see through bourgeois ideologies, if not totally, then at least in every matter where they are still connected with the petty bourgeoisie. "The increased popularity of sports," Kracauer writes, "does not eliminate complexes, but is, among other things, an instrument of social repression on a grand scale. Far from promoting social change, it is a chief means of depoliticization."[4] And even more explicitly, in another passage: "A supposed natural law is erected as a counterweight to the present economic system, but no one realizes that Nature, which is also incorporated into the capitalist economy of desires, is one of its most powerful allies, and that the unqualified glorification of Nature stands in the way of the planned organization of economic life."[5] This hostility to Nature means that the author denounces it precisely at the point where traditional sociologists would talk of "decadence." What he regards as "Nature," on the other hand, is a certain traveling salesman in tobacco products who is remarkable for his expertise and jaunty attitude. Kracauer's

thorough grasp of the economy leads him to perceive the basic—not to say barbaric—character of the forces and relations of production even in their contemporary, abstract forms. We need hardly add that he sees the much-vaunted process of mechanization in a very different light from the way it is viewed by our social pastors. How much more promising in the eyes of this critic is the soulless mechanized action of the unskilled worker than the wholly organic "moral rosiness"[6] that, in the priceless words of a personnel manager, is typical of the complexion of the good white-collar worker. "Morally rosy"—this is the color of the white-collar worker's existence.

The personnel manager's flowery speech shows how the white-collar worker's jargon communicates with the author's own language, and reveals the rapport that has been established between this outsider and the language of the collective he is targeting. Quite without effort, we learn about *Blutorangen* and *Radfahrer, Schleimtrompeten* and *Prinzessinnen*.[7] And the better we become acquainted with all this, the more easily we can see how knowledge and humanity seek refuge in metaphors and nicknames in order to avoid the broad-brush vocabulary of professors and trade-union functionaries. Or should we say that in all these articles concerned with reforming, humanizing, and deepening wage labor, what we find is not so much a mode of discourse as the perversion of language itself—a perversion that uses the most heartfelt words to conceal the shabbiest reality, the most elevated words for the basest reality, and the most peaceable words for the most inhospitable reality? However that may be, Kracauer's analyses, particularly of academic, Taylorist studies, contain elements of the most scathing satire—a satire that has long since retreated from the realm of humorous political magazines in order to claim a space on an epic scale appropriate to the immeasurable scope of its subject.[8] Unfortunately, this epic scope is that of a land laid waste. And the more completely it is repressed in the minds of the social classes concerned, the more creative it turns out to be—in accordance with the laws of repression—at producing images. One might suggest a comparison between the processes in which an unbearably tense economic situation produces a false consciousness, and the situations that lead neurotics and the mentally ill along the path from unbearable private conflicts to their false consciousness.

As long as we persist in refusing to supplement the Marxist theory of the superstructure with an urgently needed theory about the origins of false consciousness, we will be unable to dispense with the concept of repression as an answer to the question: How can the contradictions of an economic situation give rise to a form of consciousness inappropriate to it? The products of false consciousness resemble picture puzzles in which the true subject peeks out from among clouds, foliage, and shadows. And the author has even descended into the advertising sections of white-collar newspapers in order to discover those true subjects that appear embedded like puzzles

in the phantasmagoria of radiance and youth, education and personality. That is to say, encyclopedias, beds, crepe soles, pens that prevent writer's cramp, good-quality pianos, rejuvenation potions, and white teeth. But the higher reality does not rest content with a fantasy existence, and so makes its presence felt in everyday life in puzzle-picture form, just as poverty does in the bright lights of distraction. Thus, in the neo-patriarchal office, where one performs work that ultimately amounts to unpaid overtime, Kracauer detects the model of the mechanical organ that emits old-fashioned musical phrases; and in the typist's manual dexterity, he sees the petty-bourgeois sterility of the piano étude. The true symbolic centers of this world are the "pleasure barracks," the white-collar worker's pipe dreams in stone, or rather in stucco.[9] In his explorations of these "refuges for the homeless," the author's language, with its sensitivity to the logic of dreams, displays its full cunning. It is astounding to see how it molds itself to fit all these artsy, atmospheric cellars, all these cosy alcazars and intimate mocha parlors, only to expose them mercilessly to the light of reason like so many carbuncles and abscesses. An infant prodigy and enfant terrible all in one, the author tells tales from the school of dreams. And he is much too clearly in the picture to caricature these institutions as nothing more than the instruments used by the ruling class for keeping people stupid, and to load the entire responsibility onto that class. Radical though his criticism of the entrepreneurial class may be, he thinks it too much like the class it dominates, too subaltern in its outlook, for us to acknowledge it as the truly shaping power and the responsible intellectual force in the general economic chaos.

Because of this evaluation of the entrepreneurial class, although not for that reason alone, his book will have to renounce any ambition to political impact, as this is understood today; in other words, it will have to give up all hope of demagogic effect. The author's awareness of this, not to say his self-assurance on this score, sheds some light on his dislike of everything connected with reportage and the New Objectivity. This left-radical wing may posture as much as it likes—it will never succeed in eliminating the fact that the proletarianization of the intellectual hardly ever turns him into a proletarian. Why? Because from childhood on, the middle class gave him a means of production in the form of an education—a privilege that establishes his solidarity with it and, perhaps even more, its solidarity with him. This solidarity may become blurred superficially, or even undermined, but it almost always remains powerful enough to exclude the intellectual from the constant state of alert, the sense of living your life at the front, which is characteristic of the true proletarian. Kracauer has taken this insight absolutely seriously. This is why his book is a milestone on the road toward the politicization of the intelligentsia, in sharp contrast to the fashionable radicalism of the writings of the latest school. There we see the horror of theory and knowledge that commends it to the sensation-seeking of the

snobs; here we find a constructive theoretical schooling that addresses neither the snob nor the worker, but is able to promote something real and demonstrable—namely, the politicization of the writer's own class. This indirect impact is the only one a revolutionary writer from the bourgeoisie can aim at today. A direct effect can proceed only from practice. When confronted with parvenu colleagues, he will keep Lenin in mind, for Lenin's writings are the best proof of how far the literary value of political practice, direct impact, is removed from the crude fact-finding and reportage that nowadays poses as such.

Thus, in the end this writer rightly stands alone. A malcontent, not a leader. No pioneer, but a spoilsport. And if we wish to gain a clear picture of him in the isolation of his trade, what we will see is a ragpicker, at daybreak, picking up rags of speech and verbal scraps with his stick and tossing them, grumbling and growling, a little drunk, into his cart, not without letting one or another of those faded cotton remnants—"humanity," "inwardness," or "absorption"—flutter derisively in the wind. A ragpicker, early on, at the dawn of the day of the revolution.

Published in *Die Gesellschaft*, 1930. *Gesammelte Schriften*, III, 219–225. Translated by Rodney Livingstone.

Notes

1. The last reference is to Karl Kraus's mammoth, sweepingly apocalyptic drama *Die letzten Tage der Menschheit* (The Last Days of Humankind). The play was published in final form in 1923; due to its great length (it has 220 scenes and approximately 500 characters), it was first performed in Vienna only in 1964—and even then in a shortened version. "The Faultfinder" (Der Nörgler), who engages in conversations with "the Optimist," is the play's stand-in for Kraus himself.
2. *Neue Sachlichkeit* (New Objectivity) was the term originally applied by the museum curator G. F. Hartlaub to an emergent figuration in German postwar painting. It gradually came to designate the Weimar "period style" in art, architecture, design, literature, and film: cool, objective, analytical.
3. Kracauer, *Die Angestellten*, p. 20.
4. Ibid., p. 129.
5. Ibid., pp. 145–146.
6. Ibid., p. 32.
7. *Blutorangen* (literally, "blood oranges") are people who are yellow on the outside and red on the inside—in other words, people who hypocritically conceal their opinions in order to succeed in the workplace. *Radfahrer* ("bicycle riders") are people who bow to those above them while kicking down hard on those below. *Schleimtrompeten* ("slime-trumpets") are official company newsletters. And *Prinzessinnen* ("princesses") are office girls who regard themselves as superior to the

salesgirls behind the counter, although the outsider can discern no difference in status. Only the term "bicycle rider" still survives in contemporary German.

8. Benjamin is alluding to the theories of Frederick Winslow Taylor (1856–1915), who established the modern discipline of business administration and pioneered in the study of rationalization and management efficiency. He is best-known for *The Principles of Scientific Management* (1911). "Taylorism" and "Taylorization" were buzzwords for a more general industrial modernization in Weimar Germany.

9. In the passage to which Benjamin refers, Kracauer describes these "pleasure barracks"—which offered stylish ambience, food, and entertainment—as "gigantic nightclubs, in which (as a gossip once put it in a Berlin paper), 'people can get a whiff of the wide world for little money,'" in the process satisfying their "hunger for glamor and distraction."

Theories of German Fascism

On the Collection of Essays *War and Warriors,* edited by Ernst Jünger

Léon Daudet, the son of Alphonse Daudet and himself an important writer, as well as a leader of France's Royalist party, once gave a report in his *Action Française* on the Salon de l'Automobile—a report that concluded, in perhaps somewhat different words, with the equation: "L'automobile, c'est la guerre."[1] This surprising association of ideas was based on Daudet's perception that there had been an increase in technological artifacts, in power sources, in tempo, and so on that private lives could neither absorb completely nor utilize adequately but that nonetheless demanded justification. They justified themselves in that they abstained from any harmonious interplay in war, whose destructive power provided clear evidence that social reality was not ready to make technology its own organ, and that technology was not strong enough to master the elemental forces of society. Without going too deeply into the significance of the economic causes of war, one might say that the harshest, most disastrous aspects of imperialist war are in part the result of the gaping discrepancy between the gigantic means of technology and the minuscule moral illumination it affords. Indeed, according to its economic nature, bourgeois society cannot help insulating everything technological as much as possible from the so-called spiritual [*Geistigen*], and it cannot help resolutely excluding technology's right of determination in the social order. Any future war will also be a slave revolt on the part of technology. Today factors such as these determine all questions of war, and one would hardly expect to have to remind the authors of the present volume of this, nor to remind them that these are questions of imperialist war. After all, they were themselves soldiers in the World War and, dispute what one may, they indisputably proceed from the experience

of this war. It is therefore quite astonishing to find, and on the first page at that, the statement: "It is of secondary importance in which century, for which ideas, and with which weapons the fighting is done." What is most astonishing about this statement is that its author, Ernst Jünger,[2] thus adopts one of the principles of pacifism—indeed, the most questionable and most abstract of all its principles. Though for him and his friends this is based not so much on some doctrinaire schema as on a deep-rooted and—by all standards of male thought—really rather impious mysticism. But Jünger's mysticism of war and pacifism's clichéd ideal of peace have little to accuse each other of. Even the most consumptive pacifism has, for the moment, one thing over its epileptically frothing brother—namely, a certain contact with reality, and not least some conception of the next war.

The authors like to speak—emphatically—of the "First World War." Yet how little their experience has come to grips with that war's realities (which they refer to with alienated exaggeration as the "worldly-real") is shown by the utterly thoughtless obtuseness with which they view the idea of future wars without any conception of them. These trailblazers of the *Wehrmacht* could almost give one the impression that the military uniform represents their highest end, their heart's desire, and that the circumstances under which the uniform later attains its validity are of little importance by comparison. This attitude becomes more comprehensible when one realizes, in terms of the current level of European armaments, how anachronistic their espoused ideology of war is. These authors nowhere observe that the new warfare of technology and matériel [*Materialschlacht*], which appears to some of them as the highest revelation of existence, dispenses with all the wretched emblems of heroism that here and there have survived the World War. Gas warfare, in which the contributors to this book show conspicuously little interest, promises to give the war of the future a face which will permanently replace soldierly qualities by those of sports; all action will lose its military character, and war will assume the countenance of record-setting. For the most prominent strategic characteristic of such warfare consists in its being waged exclusively and most radically as an offensive war. And we know that there is no adequate defense against gas attacks from the air. Even individual protective devices, gas masks, are of no use against mustard gas and Levisit. Now and then one hears of something "reassuring," such as the invention of a sensitive listening device that registers the whir of propellers at great distances. And a few months later a soundless airplane is invented. Gas warfare will be based on annihilation records, and will involve an absurd degree of risk. Whether its outbreak will occur within the bounds of international law—after prior declarations of war—is debatable, but its end will no longer be concerned with such limitations. Since gas warfare obviously eliminates the distinction between civilian and military personnel, the most important principle of international

law is abolished. The most recent war has already shown that the total disorganization imperialist war entails, and the manner in which it is waged, threaten to make it an endless war.

More than a curiosity, it is symptomatic that something written in 1930 about "war and warriors" overlooks all this. It is symptomatic that the same boyish rapture that leads to a cult of war, an apotheosis of war, is here heralded particularly by von Schramm and Günther. The most rabidly decadent origins of this new theory of war are emblazoned on their foreheads: it is nothing other than an uninhibited translation of the principles of *l'art pour l'art* to war itself. But if, even on its home ground, this theory tends to become a mockery in the mouths of mediocre adepts, its outlook in this new phase is disgraceful. Who could imagine a veteran of the Marne or of Verdun reading statements such as these: "We conducted the war on very impure principles . . . Real fighting from man to man, from company to company, became rarer and rarer . . . Certainly the front-line officers often conducted war without style . . . For through the inclusion of the masses, the lesser blood, the practical bourgeois mentality—in short, the common man—especially in the officers' and noncommissioned officers' corps, the eternally aristocratic elements of the soldier's trade were increasingly destroyed." Falser notes could hardly be sounded; more inept thoughts could not be written; more tactless words could not be uttered. The authors' absolute failure precisely here is the result—despite all the talk about "the eternal" and "the primeval"—of their unrefined, thoroughly journalistic haste to seize control of the actual present without having grasped the past. Yes, there have been cultic elements in war. They were known in theocratically constituted communities. As harebrained as it would be to want to return these submerged elements to the zenith of war, it would be equally embarrassing for these warriors on their flight from ideas to learn how far a Jewish philosopher, Erich Unger,[3] has gone in the direction they missed. And it would be embarrassing for them to see to what extent his observations—made, if in part with questionable justice, on the basis of concrete data from Jewish history—would cause the bloody schemes conjured up here to evaporate into nothingness. But these authors are incapable of making anything clear, of calling things by their names. War "eludes any economy exercised by the understanding; there is something inhuman, boundless, gigantic in its Reason, something reminiscent of a volcanic process, an elemental eruption, . . . a colossal wave of life directed by a painfully deep, cogently unified force, led to battlefields already mythic today, used up for tasks far exceeding the range of the currently conceivable." Only a suitor who embraces his beloved awkwardly is so loquacious. And indeed these authors are awkward in their embrace of thought. One has to bring them back to it repeatedly, and that is what we will do here.

And the point is this: War—the "eternal" war that they talk about so

much here, as well as the most recent one—is said to be the highest mani-
festation of the German nation. It should be clear that behind their "eternal"
war is concealed the idea of cultic war, just as behind the most recent war
hides the idea of technological war; and it should also be clear that these
authors have had little success in perceiving these relationships. But there is
something rather special about this last war: it was not only one of matériel
but also one that was lost. And thus, admittedly, it was the German war in
a special sense. To have waged war out of their innermost existence is
something that other peoples could claim to have done. But to have lost a
war out of their innermost existence—this they cannot claim. What is special
about the present and latest stage in the controversy over the war, which
has convulsed Germany since 1919, is the novel assertion that it is precisely
this loss of the war that is tied to Germanness. One can call this the latest
stage because these attempts to come to terms with the loss of the war show
a clear pattern. These attempts began with an effort to pervert the German
defeat into an inner victory by means of confessions of guilt, which were
hysterically elevated to the universally human. This political position, which
supplied the manifestos for the course of the decline of the West, was the
faithful reflection of the German "revolution" by the Expressionist avant-
garde. Then came the attempt to forget the lost war. The bourgeoisie turned
over, to snore on its other side—and what pillow could have been softer
than the novel? The terrors endured in those years became the down filling
in which every sleepyhead could easily leave his imprint. What finally
distinguishes this latest effort from earlier ones in the process involved here
is the tendency to take the loss of the war more seriously than the war
itself.—What does it mean to "win" or "lose" a war? How striking the
double meaning is in both words! The first, manifest meaning certainly refers
to the outcome of the war, but the second meaning—which creates that
peculiar hollow space, the sounding board, in these words—refers to the
totality of the war and suggests how the war's outcome also alters the en-
during significance it holds for us. This meaning says, so to speak, the victor
retains the war; the vanquished misplaces it. It says, the victor annexes the
war for himself, makes it his own property; the vanquished no longer
possesses it and must live without it. And he must live not only without the
war per se but without every one of its slightest ups and downs, every
subtlest one of its chess moves, every one of its remotest actions. To win or
lose a war reaches so deeply (if we follow language) into the fabric of our
existence, that our whole lives become that much richer or poorer in sym-
bols, images, and sources. And since we have lost one of the greatest wars
in world history, one which involved the whole material and spiritual
substance of a people, one can assess the significance of this loss.

 Certainly one cannot accuse those around Jünger of not having taken this
into account. But how did they approach it, monstrous as it was? They have

not yet stopped fighting. They continued to celebrate the cult of war when there was no longer any real enemy. They complied with the desires of the bourgeoisie, which longed for the decline of the West, the way a schoolboy longs for an inkblot in place of his wrong answer. They spread decline, preached decline, wherever they went. Not even for a moment were they capable of holding up to view—instead of doggedly holding onto—what had been lost. They were always the first and the bitterest to oppose coming to one's senses. They ignored the great opportunity of the loser—which the Russians had taken advantage of—to shift the fight to another sphere until the moment had passed and the nations of Europe had sunk to being partners in trade agreements again. "The war is being *administered,* not *led* anymore," one of the authors complains. This was to be corrected by the German "postwar war" [*Nachkrieg*]. This *Nachkrieg* was as much a protest against the war that had preceded it, as it was a protest against the civilian character they had discerned in it. Above all, that despised rational element was to be eliminated from war. And, to be sure, this team bathed in the vapors rising from the jowls of the Fenriswolf. But these vapors were no match for the mustard gases of the yellow-cross grenades. This arch-Germanic magical fate acquired a moldy luster when set against the stark background of military service in army barracks and impoverished families in civilian barracks. And without subjecting that false luster to materialist analysis, it was possible even then for a free, knowing, and truly dialectical spirit such as Florens Christian Rang[4]—whose biography exemplifies the German better than whole hordes of these desperate characters—to counter their sort with enduring statements:

> The demonic belief in fate, the belief that human virtue is in vain; the dark night of defiance which burns up the victory of the forces of light in the universal conflagration of the gods; . . . this apparent glorying of the will in this belief in death in battle, without regard for life, flinging it down for an idea; this cloud-impregnated night that has hovered over us for millennia and which, instead of stars, gives us only stupefying and confusing thunderbolts to guide the way, after which the night only envelops us all the more in darkness; this horrible world view of world-death instead of world-life, whose horror is made lighter in the philosophy of German idealism by the notion that behind the clouds there is after all a starry sky: this fundamental German spiritual tendency in its depth lacks will, does not mean what it says, is a crawling, cowardly know-nothingness, a desire not to live but also a desire not to die either . . . For this is the German half-attitude toward life; indeed, to be able to throw it away when it doesn't cost anything, in a moment of intoxication [*Rausch*], with those left behind cared for, and with this short-lived sacrifice surrounded by an eternal halo.

But in another statement in the same context, Rang's language may sound familiar to those around Jünger: "Two hundred officers, prepared to die,

would have sufficed to suppress the revolution in Berlin—as in all other places; but not one was to be found. No doubt many of them would actually have liked to come to the rescue, but in reality—not actuality—nobody quite wanted to begin, to put himself forward as the leader, or to proceed individually. They preferred to have their epaulets ripped off in the streets." Obviously the man who wrote this knows from his very own experience the attitude and tradition of those who have come together here. And perhaps he continued to share their enmity to materialism until the moment they created the language of material warfare.

If at the beginning of the war supplies of idealism were provided by order of the state, the longer the war lasted the more the troops had to depend on requisitions. Their heroism turned more and more gloomy, deadly, and steel-gray; glory and ideals beckoned from ever more remote and nebulous spheres; and those who saw themselves less as the troops of the World War than as the executors of the *Nachkrieg* increasingly adopted a stance of obstinate rigor. Every third word in their speeches is "stance." Who would deny that the soldier maintains a stance? But language is the touchstone for each and every position taken, and not just, as is so often assumed, for that of the writer. Yet those who have conspired here do not pass the test. Jünger may echo the noble dilettantes of the seventeenth century in saying that the German language is an originary language, but he betrays what he means when he adds that, as such, it inspires an insurmountable distrust in civilization and in the cultivated world. Yet this linguistic distrust cannot equal that of his own countrymen when the war is presented to them as a "mighty reviser" that "feels the pulse" of the times, that forbids them "to do away with" "a tried and proven conclusion," and that calls on them to intensify their search for "ruins" "behind gleaming varnish." Far more shameful than these offenses, however, is the smooth style of these purportedly rough-hewn thoughts which could grace any newspaper editorial; and more distressing yet than the smooth style is the mediocre substance. "The dead," we are told, "went, in death, from an imperfect reality to a perfect reality, from Germany in its temporal manifestation to the eternal Germany." This Germany "in its temporal manifestation" is of course notorious, but the eternal Germany would really be in a bad way if we had to depend on the testimony of those who so glibly invoke it. How cheaply they purchased their "solid feeling of immortality," their certainty that "the terrors of the last war have been frightfully exaggerated," and their symbolism of "blood boiling inwardly"! At best, they have defeated the war that they are celebrating here. However, we will not tolerate anyone who speaks of war, yet knows nothing but war. Radical in our own way, we will ask: Where do you come from? And what do you know of peace? Did you ever encounter peace in a child, a tree, an animal, the way you encountered a sentry in the field? And without waiting for you to answer, we can say No! It is not that you would then

not be able to celebrate war more passionately than now; but to celebrate it *the way* you do would be impossible. How would Fortinbras have borne witness to war? One can deduce how he would have done it from Shakespeare's technique. Just as he reveals Romeo's love for Juliet in the fiery glow of its passion by presenting Romeo in love from the outset, in love with Rosalinde, he would have had Fortinbras begin with a passionate eulogy of peace so enchanting and mellifluously sweet, that when at the end he raises his voice all the more passionately in favor of war, everyone would have wondered with a shudder: What are these powerful, nameless forces that compel this man, wholly filled with the bliss of peace, to commit himself body and soul to war?—But there is nothing of that here. These are professional freebooters speaking. Their horizon is fiery but very narrow.

What do they see in their flames? They see—here we can entrust ourselves to F. G. Jünger[5]—a transformation:

> Lines of psychic decision cut across the war; transformations undergone by the war are paralleled by transformations undergone by those fighting it. These transformations become visible when one compares the vibrant, buoyant, enthusiastic faces of the soldiers of August 1914 with the fatally exhausted, haggard, implacably tensed faces of the 1918 veterans of machine warfare. Looming behind the all too sharply arched curve of this fight, their image appears, molded and moved by a forceful spiritual convulsion, by station after station along a path of suffering, battle after battle, each the hieroglyphic sign of a strenuously advancing work of destruction. Here we have the type of soldier schooled in those hard, sober, bloody, and incessant campaigns of attrition. This is a soldier characterized by the tenacious hardness of the born fighter, by a manifest sense of solitary responsibility, of psychic abandonment. In this struggle, which proceeded on increasingly deeper levels, he proved his own mettle. The path he pursued was narrow and dangerous, but it was a path leading into the future.

Wherever precise formulations, genuine accents, or solid reasoning are encountered in these pages, the reality portrayed is that of Ernst Jünger's "total mobilization" or Ernst von Salomon's "landscape of the front." A liberal journalist who recently tried to get at this new nationalism under the heading "Heroism out of Boredom" fell, as one can see here, a bit short of the mark. This soldier type is a reality, a surviving witness to the World War, and it was actually this "landscape of the front," his true home, that was being defended in the *Nachkrieg*. This landscape demands that we linger.

It should be said as bitterly as possible: in the face of this "landscape of total mobilization," the German feeling for nature has had an undreamed-of upsurge. The pioneers of peace, who settle nature in so sensuous a manner, were evacuated from these landscapes, and as far as anyone could see over the edge of the trench, the surroundings had become the terrain of German

Idealism; every shell crater had become a problem, every wire entanglement an antinomy, every barb a definition, every explosion a thesis; by day the sky was the cosmic interior of the steel helmet, and at night the moral law above. Etching the landscape with flaming banners and trenches, technology wanted to recreate the heroic features of German Idealism. It went astray. What it considered heroic were the features of Hippocrates, the features of death. Deeply imbued with its own depravity, technology gave shape to the apocalyptic face of nature and reduced nature to silence—even though this technology had the power to give nature its voice. War, in the metaphysical abstraction in which the new nationalism believes, is nothing other than the attempt to redeem, mystically and without mediation, the secret of nature, understood idealistically, through technology. This secret, however, can also be used and illuminated via a technology mediated by the human scheme of things. "Fate" and "hero" occupy these authors' minds like Gog and Magog, yet they devour not only human children but new ideas as well. Everything sober, unblemished, and naive that has been considered regarding the improvement of human society ends up between the worn teeth of these Molochs, who react with the belches of 42-cm. mortars. Linking heroism with machine warfare is sometimes a bit hard on the authors. But this is by no means true for all of them, and there is nothing more revealing than the whining digressions exposing their disappointment in the "form of the war" and in the "senselessly mechanical machine war" of which these noble fellows "had evidently grown bored." Yet when one or another of them attempts to look things squarely in the eye, it become obvious how very much their concept of the heroic has surreptitiously changed; we can see how much the virtues of hardness, reserve, and implacability they celebrate are in fact less those of the soldier than those of the proven activist in the class struggle. What developed here, first in the guise of the World War volunteer and then in the mercenary of the *Nachkrieg*, is in fact the dependable fascist class warrior. And what these authors mean by "nation" is a ruling class supported by this caste, a ruling class—accountable to no one, and least of all to itself, enthroned on high—which bears the sphinx-like countenance of the producer who very soon promises to be the sole consumer of his commodities. Sphinx-like in appearance, the fascists' nation thus takes its place as a new economic mystery of nature alongside the old. But this old mystery of nature, far from revealing itself to their technology, is exposing its most threatening feature. In the parallelogram of forces formed by these two—nature and nation—war is the diagonal.

It is no surprise that the question of "governmental checks on war" arises in the best, most well-reasoned essay in this volume. For in this mystical theory of war, the state naturally plays no role at all. These checks should not for a moment be understood in a pacifist sense. Rather, what is demanded of the state is that its structure and its disposition adapt themselves

to, and appear worthy of, the magical forces that the state itself must mobilize in the event of war. Otherwise it will not succeed in bending war to its purpose. It was this failure of the powers of state in the face of war that instigated the first independent thinking of the authors gathered here. Those military formations ambivalently hovering between comradely brotherhoods and regular government troops at the end of the war very soon solidified into independent, stateless mercenary hordes. And the captains of finance, the masters of the inflation to whom the state was beginning to seem a dubious guarantor of their property, knew the value of such hordes.[6] They were available for hire at any time, like rice or turnips, by arrangement through private agencies or the *Reichswehr*. Indeed, the present volume retains a resemblance to a slogan-filled recruiting brochure for a new type of mercenary, or rather *condottiere*. One of its authors candidly declares: "The courageous soldier of the Thirty Years' War sold himself life and limb, and that is still nobler than simply selling one's politics or one's talents." Of course, when he adds that the mercenary of Germany's *Nachkrieg* did not sell himself but gave himself away, this is of a piece with the same author's comment on the comparatively high pay of these troops. This was pay which shaped the leadership of these warriors just as clearly as the technical necessities of their trade: as war engineers of the ruling class, they were the perfect complement to the managerial functionaries in their cutaways. God knows their designs on leadership should be taken seriously; their threat is not ludicrous. In the person of the pilot of a single airplane full of gas bombs, such leadership embodies all the absolute power which, in peacetime, is distributed among thousands of office managers—power to cut off a citizen's light, air, and life. This simple bomber-pilot in his lofty solitude, alone with himself and his God, has power-of-attorney for his seriously stricken superior, the state; and wherever he puts his signature, the grass will cease to grow—and this is the "imperial" leader the authors have in mind.

Until Germany has exploded the entanglement of such Medusa-like beliefs that confront it in these essays, it cannot hope for a future. Perhaps the word "loosened" would be better than "exploded," but this is not to say it should be done with kindly encouragement or with love, both of which are out of place here; nor should the way be smoothed for argumentation, for that wantonly persuasive rhetoric of debate. Instead, all the light that language and reason still afford should be focused upon that "primal experience" from whose barren gloom this mysticism of the death of the world crawls forth on its thousand unsightly conceptual feet. The war that this light exposes is as little the "eternal" one which these new Germans now worship as it is the "final" war that the pacifists carry on about. In reality, that war is only this: the one, fearful, last chance to correct the incapacity of peoples to order their relationships to one another in accord with the relationship they possess to nature through their technology. If this corrective effort fails, millions of human bodies will indeed inevitably be chopped

to pieces and chewed up by iron and gas. But even the habitués of the chthonic forces of terror, who carry their volumes of Klages in their packs, will not learn one-tenth of what nature promises its less idly curious but more sober children, who possess in technology not a fetish of doom but a key to happiness.[7] They will demonstrate this sobriety the moment they refuse to acknowledge the next war as an incisive magical turning point, and instead discover in it the image of everyday actuality. And they will demonstrate it when they use their discovery to transform this war into civil war, and thereby perform that Marxist trick which alone is a match for this sinister runic nonsense.

Published in *Die Gesellschaft*, 1930. *Gesammelte Schriften*, III, 238–250. Translated by Jerolf Wikoff.

Notes

1. Alphonse Daudet (1840–1897), French author, was known for his gentle portrayals of life in the French countryside. His son, Léon Daudet (1867–1942), edited the right-wing Catholic journal *L'Action Française,* organ of the eponymous nationalist political movement that he founded with Charles Maurras in 1898. The journal was noted for its antidemocratic and anti-Semitic views.
2. Ernst Jünger (1895–1998), German novelist and essayist, was perhaps the leading voice of the intellectual radical Right in the Weimar Republic. His ideas and writing took a dramatic turn after World War II, when he began to espouse peace and European union.
3. Erich Unger (1887–1952), German-Jewish author, was a member of the circle around the esoteric thinker Oskar Goldberg. He was a student of the Kaballah, and criticized empiricism from a magical and mystical viewpoint.
4. Florens Christian Rang (1864–1924), conservative German intellectual and author, was perhaps Benjamin's most important partner in intellectual exchange in the mid-1920s.
5. Friedrich Georg Jünger (1898–1977), German writer and Ernst Jünger's brother, published poems, novels, and stories. He is best-known for his memoirs and his essays on political, cultural, philosophical, and literary topics.
6. The German inflation began as early as 1914, when the imperial government began financing its war effort with a series of fiscally disastrous measures. The economic situation deteriorated rapidly in the years following the end of World War I, as an already crippled economy was further burdened by war reparations. The inflation reached its critical phase—that of hyperinflation—in late 1922 and 1923. If we compare late 1913 (the last year before the war) with late 1923 using the wholesale price index as the basis for the comparison, we find that one German mark in 1913 equaled 1.26 trillion marks by December 1923.
7. Ludwig Klages (1872–1956), German philosopher and psychologist, attempted to found a "metaphysical psychology" which would study human beings in their relationship to reality—a reality which he saw as composed of archetypal images. Klages became the darling of the radical Right in the course of the 1920s.

Demonic Berlin

Today I will begin with an experience that occurred when I was fourteen. At the time, I was a pupil in a boarding school. As is customary in such places, the children and teachers met together in the evenings several times a week, and made music, or else someone gave a talk, or there was a poetry reading. One evening, the music teacher was in charge of the "chapel," as these evenings were called. He was a funny little man, with an unforgettable expression in his serious eyes, and the shiniest bald pate I have ever seen, surrounded by a semicircular wreath of tightly curled dark hair. His name is known to German music-lovers: he was August Halm.[1] This August Halm came to the chapel to read to us from the stories of E. T. A. Hoffmann, the very writer I wish to discuss with you today. I no longer remember what he read to us, nor is it of any importance here. But what I did note was a single sentence from the speech in which he introduced his reading. He described Hoffmann's writings—his liking for the bizarre, the cranky, the eerie, and the inexplicable. I think his words were calculated to raise our expectations about the stories we were going to hear. He then concluded with the sentence that I have not forgotten to this day: "Why anyone should tell stories like this is something I shall tell you in the near future." I am still waiting for that "in the near future." And since the good man has died in the meantime, this explanation would now have to reach me, if at all, via such an uncanny route that I would prefer to anticipate it; and so I shall attempt today to fulfill a promise that was made to me twenty-five years ago.

If I wanted to cheat a little, I could easily do so. I would need only to replace the words "For what purpose?" with "Why?" and the answer would be very straightforward. Why does a writer write? For a thousand reasons.

Because it is fun to invent something; or because ideas, images take possession of him and he can rest only when he has written them down; or because he is preoccupied with questions and doubts for which he seeks answers in the fates of imagined people; or simply because he has learned to write; or—and this is unfortunately very common—because he has not learned anything at all. It is not hard to explain why Hoffmann wrote. He is one of those writers who are obsessed with their characters. *Doppelgänger,* horrific figures of every kind—when he wrote, he really felt surrounded by them. And not only while he was writing, but even during an innocent conversation at table in the evening, over a glass of wine or punch, he would see things; and on more than one occasion he would interrupt one or other of his companions with the words:

> Forgive me, my dear friend, if I interrupt you. But don't you see over there in the corner, to the right, that accursed little squirt pulling himself from under the floorboards? Just watch the devil of a fellow! Look, look, now he's gone! Oh, please don't be shy on our account, dear Tom Thumb—please stay with us! Pray listen to our good-humored conversation—you can't imagine how delighted we would be to enjoy your highly esteemed company. Ah, there you are again. Won't you do us the honor of coming nearer? Really—you *will* agree to partake of a little something? What did you say? Oh, you are leaving. Our humble respects!

And so on. And no sooner had he uttered all this gibberish, his eyes fixed on the corner in which he saw the vision, than he would come to his senses with a start, turn to his companions and calmly ask them to proceed. This is how Hoffmann's friends have described him for us. And we feel ourselves infected by his character when we read such stories as "The Deserted House," "The Deed of Entail," "The Doubles," or "The Golden Pot." And if the circumstances are favorable, the effect of these ghost stories can be intensified to an astounding degree. I have experienced this myself, and in my case the favorable circumstance was that my parents had forbidden me to read Hoffmann. When I was little, I could read him only on the sly, on evenings when my parents were away from home. And I can remember a particular evening, when I was sitting alone under the lamp at the giant dining-room table—it was in Carmerstrasse—and there was not a sound to be heard in the entire house. And as I sat there reading "The Mines of Falun," all the horrors gradually gathered around me at the table edge in the surrounding gloom, like fish with blank expressions, so that my eyes remained fixed on the pages of the book from which all this horror emerged, as if redemption might come from them. Another time, earlier in the day—I can still remember—I was standing right by the bookcase that was open just a crack, ready to throw the book into the case at the first noise. I stood there reading "The Entail," with hair on end, and so frozen with the twofold

horror of the terrors of the book and the risk of being caught that I failed to grasp a single word of what I was reading.

"The devil himself could not write such diabolical stuff," Heine said of Hoffmann's writings. And in fact, there is something satanic that goes hand in hand with the ghostly, eerie, uncanny aspect of these stories. If we try to explore this a little further, we shall soon progress from the answer to the question of why Hoffmann wrote his stories, and from there to the answer to the more mysterious question: For what purpose? The devil—alongside his many other peculiarities—is also an ingenious and knowing fellow. Anyone who is acquainted with Hoffmann's stories will understand me at once when I say that the narrator in these stories is always a very perceptive, sensitive fellow who detects spirits even in their most subtle disguises. Indeed, this narrator insists with a certain stubbornness that all the honest archivists, senior medical counselors, students, apple-sellers, musicians, and genteel daughters are no more what they seem to be than Hoffmann himself was a pedantic legal counselor at the court of appeals which was the source of his income. But, in other words, this means that the eerie, spectral figures who appear in Hoffmann's stories are not characters dreamed up by their author in the stillness of his own little room. Like many other great writers, he found the extraordinary not somehow floating freely in mid-air, but in quite specific people, things, houses, objects, and streets. As you may have heard, people who judge other people by their face, their walk, or their hands, or judge their character, their profession, or even their fate by the shape of their head, are known as physiognomists. In this sense, Hoffmann was not so much a seer as someone who looked at people and things. And that is quite a good definition of the term "physiognomy." One of the main things he looked at was Berlin, both the city and the people who inhabit it. In his introduction to *The Deserted House* (which in reality was a house on Unter den Linden), he speaks with a certain bitter humor of the sixth sense he had been endowed with, of the gift of being able to look at every manifestation—whether a person, an action, or an event—and perceive what was unusual about it, the sort of thing to which we have no access in our everyday life. He had a passion for wandering alone through the streets and observing the people he met, even casting their horoscopes in his mind's eye. For days on end, he would follow people unknown to him because they had something that struck him in their walk, clothing, voice, or glance. He felt he was in constant contact with the suprasensual, and the spirit world pursued him even more than he pursued it. It barred his way in the clear light of day in this rational Berlin; it pursued him amid the bustle of Königstrasse, and even to the few surviving remnants of the Middle Ages around the decaying Town Hall. On Grünstrasse it caused him to smell a mysterious scent of roses and carnations, and it cast a spell on him on Unter den Linden, the elegant street that was the meeting place of high society.

Hoffmann could be called the father of the Berlin novel. The traces of the city were subsequently submerged in generalities when people began to call Berlin the "capital," the Tiergarten the "park," and the Spree the "river"; until in our own time it sprang to life once more—in such works as Döblin's *Berlin Alexanderplatz*. He makes one of his characters say to another, standing in for himself: "You had a definite reason for setting the scene in Berlin, and calling streets and squares by their proper names. But in my opinion it is not a bad idea in general to describe the scene precisely. Apart from the fact that the whole story gains the illusion of historical truth and thus bolsters a limp imagination, it also gains uncommonly in vividness and freshness for anyone familiar with the setting."

I could certainly list the many stories in which Hoffmann thus proves himself the physiognomist of Berlin. I could name the buildings that appear in his writings, starting with his own home on the corner of Charlottenstrasse and Taubenstrasse, down to the Golden Eagle on Dönhoffplatz, to Lutter & Wegner in Charlottenstrasse, and so on. But I think we would do better to look more closely at how Hoffmann studied Berlin and what impression this has left in his stories. The writer was never a particular friend of the solitude of nature. People—communicating with them, observing them, merely looking at them—were more precious to him than anything. If he went out walking in the summer, as he did every evening if the weather was fine, it was always to public places where he might meet people. And even on the way to these places, there were few wine bars or cafés that he failed to enter, to see whether people were there and who they were. Not that he looked in at such places only to discover new faces that would give him strange new ideas. Rather, the wine bar was a kind of poetic laboratory, a place for experimentation in which he could try out the complications and effects of his stories every evening on his friends. Hoffmann was not a novelist but a storyteller; and even in book form, many of his stories—if not the majority—are told from the point of view of one of the characters. To be sure, it is really always Hoffmann himself who is the narrator, sitting around the table with his friends, each of whom tells a story in turn. One of Hoffmann's friends tells us explicitly that he was never idle in the wine bar, like the many people you see sitting there who do nothing but sip their wine and yawn. On the contrary, he would sit there gazing around with eagle eyes; whatever he saw that was ridiculous, striking, or even touching among the other customers became fodder for his work. Or else he quickly sketched it with a few bold strokes of his pen—for he had great dexterity in drawing. But woe betide the people in the wine bar if they were not to his liking, if they were narrow-minded philistines sitting around the table. On those occasions he must have been quite unbearable, making frightening use of his talent for pulling faces, embarrassing people, and intimidating them. But the epitome of horror, to his mind, were the arty tea parties that

were fashionable at the time. These were meetings of aesthetes—actually ignorant and unintelligent people who were far too conceited about their interest in art and literature. He has given a very droll account of such a party in his *Phantasiestücke* [Weird Tales].

In drawing this discussion to a close, we will not allow anyone to reproach us with having forgotten our original question about the purpose of his writing. Far from forgetting it, we have in fact already provided an unobtrusive answer to it. For what purpose did Hoffmann write his stories? Needless to say, he did not have any deliberate aims in mind. But we can undoubtedly read the tales as if he did have some. And these aims can be none other than physiognomic ones: the desire to show that this dull, sober, enlightened, commonsensical Berlin was full of things calculated to stimulate a storyteller—things that were to be found lurking not only in its medieval corners, remote streets, and dreary houses, but also in its active citizens of all classes and districts, if only you knew how to track down such things and look for them in the right way. And as if Hoffmann really had intended his works for the edification of his readers, one of his very last stories, one that he dictated on his deathbed, is in fact nothing but a textbook of physiognomic seeing. This story is entitled "Des Vetters Eckfenster" [My Cousin's Corner Window]. The cousin is Hoffmann himself; the window is the corner window in his apartment and looks out onto Gendarmenmarkt. The story is actually a dialogue. Hoffmann, paralyzed, sits in an armchair, gazing down onto the weekly market, and proves to his cousin, who is there on a visit, how much you can infer—and, even more, spin out and imagine—simply by looking at the clothes, tempo, and gestures of the market women and their customers. And now that we have said so much in praise of Hoffmann, we ought to end by pointing out something quite unknown to the majority of Berliners: he is the only writer to have made Berlin famous abroad. The French read him and loved him at a time when in Germany and in Berlin no dog would have accepted a piece of bread from him. Now all that has changed. There are a host of very affordable editions, and there are even more parents who allow their children to read Hoffmann than there were in my day.

Radio talk delivered on Berliner Rundfunk, February 1930. *Gesammelte Schriften*, VII, 86–92. Translated by Rodney Livingstone.

Notes

1. August Halm (1869–1929), German musicologist and composer, was the author of several popular introductions to music.

Hashish, Beginning of March 1930

A divided, contradictory experience. On the positive side: the presence of Gert, who, thanks to her apparently very extensive experiments of this kind (even though hashish was new to her), had the effect of intensifying the power of the poison.[1] More later on the extent of this. On the negative side: inadequate effect on her and Egon, perhaps because of the inferior quality of the drug, which was different from the one I was taking. As if that were not enough, Egon's tiny room was far too small for my imagination, and it provided such poor sustenance for my dreams that for the first time I kept my eyes shut during the entire procedure. This led to experiences that were entirely new to me. If the contact with Egon was nil, or even negative, that with Gert was rather too sensual to make possible a purely distilled intellectual outcome.

Despite these reservations, I see from certain subsequent statements of Gert's that the trance was so profound that the words and images of certain stages have escaped me. Since, in addition, contact with others is indispensable for the person in the trance if he is to succeed in formulating his thoughts in language, it will be evident from what has been said that on this occasion the insights yielded were disappointing in relation to the depth of the trance and, so to speak, the enjoyment. All the more reason to emphasize the core of this experiment as it appeared in Gert's statements and my own recollections. These statements concerned the nature of aura. Everything I said on the subject was directed polemically against the theosophists, whose inexperience and ignorance I find highly repugnant. And I contrasted three aspects of genuine aura—though by no means schematically—with the conventional and banal ideas of the theosophists. First,

genuine aura appears in all things, not just in certain kinds of things, as people imagine. Second, the aura undergoes changes, which can be quite fundamental, with every movement the aura-wreathed object makes. Third, genuine aura can in no sense be thought of as a spruced-up version of the magic rays beloved of spiritualists and described and illustrated in vulgar works of mysticism. On the contrary, the characteristic feature of genuine aura is ornament, an ornamental halo, in which the object or being is enclosed as in a case. Perhaps nothing gives such a clear idea of aura as Van Gogh's late paintings, in which one could say that the aura appears to have been painted together with the various objects.

From another stage: my first experience of *audition colorée*. I did not fully appreciate what Egon said to me, because my apprehension of his words was instantly translated into the perception of colored, metallic sequins that coalesced into patterns. I explained it to him by comparing it to the beautiful colored knitting patterns that we had liked so much as children in the *Herzblättchens Zeitvertreib*.

Even more remarkable perhaps was a later phenomenon linked to the sound of Gert's voice. It came at the point when she herself had taken morphine, and I, who had no knowledge of the effects of this drug apart from what I had read, was able to give her an accurate and penetrating account of her condition—on the evidence, as I myself remarked, of her intonation. Apart from that, this turn of events—Egon's and Gert's excursion into morphine—was in a certain sense the end of the experiment for me, although it was also the climax. It was the end because, given the enormous sensitivity induced by hashish, every moment of not being understood threatens to turn into acute unhappiness. How I suffered from the feeling that "our ways had parted." This was how I formulated it.—The climax because, as Gert busied herself with the syringe (an instrument that gives me a certain feeling of revulsion), the subdued but constant sensual relationship I had with her seemed to me to be colored black, undoubtedly a result of the black pyjamas she was wearing. And without her frequent and persistent attempts to induce me to try morphine, she might easily have appeared to me as a kind of Medea, a poisoner from Colchis.

Some attempt to characterize the image zone. An example: when we are conversing with someone and at the same time can see the person we are talking to smoking his cigar or walking around the room and so on, we feel no surprise that despite the effort we are making to speak to him, we are still able to follow his movements. The situation is quite different when the images we have before us while speaking to someone have their origins in ourselves. In a normal state of consciousness, this is of course quite impossible. Or rather, such images do arise—they may even arise constantly—but they remain unconscious. It is otherwise in a hashish trance. As this very

evening proved, there can be an absolutely blizzard-like production of images, independently of whether our attention is directed toward anyone or anything else. Whereas in our normal state free-floating images to which we pay no heed simply remain in the unconscious, under the influence of hashish images present themselves to us seemingly without requiring our attention. Of course, this process may result in the production of images that are so extraordinary, so fleeting, and so rapidly generated that we can do nothing but gaze at them simply because of their beauty and singularity. For example, as I was listening to Egon, every word he uttered deprived me of a long journey; I have now acquired a certain skill in imitating—when my head is clear—the formulations that have arisen under the influence of hashish. About the images themselves I cannot really say very much, because of the tremendous speed with which they arose and then vanished again; moreover, they were all on a very small scale. In the main, they were images of objects. Often, however, with strongly ornamental features. Objects easy to ornament are the best: walls, for instance, or vaulting, or certain plants. Right at the start, I formed the term "knitting palms" to describe something I saw—palm trees with the sort of stitching you see in pullovers. But then also quite exotic, indecipherable images of the kind we know from Surrealist paintings. For example, a long gallery of suits of armor with no one in them. No heads, but only flames playing around the neck openings. My "Decline of the *pâtissier*'s art" unleashed a gale of laughter in the others. This had the following explanation. For a time I had visions of gigantic cakes, larger than life, cakes so huge that it was like standing in front of a mountain and being able to see only part of it. I went into detailed descriptions of how these cakes were so perfect that it wasn't necessary to eat them, because the mere sight of them was enough to quench all desire for them. And I called that "eyebread." I can no longer recollect how the previously mentioned coinage came about. But I may not be far off if I reconstruct it this way: the fact that we have to eat cakes nowadays is attributable to the decline of the *pâtissier*'s art. I had the same attitude to the coffee I was given. I held the cup of coffee motionless in my hand for a good quarter of an hour, declared it beneath my dignity to drink it, and transformed it, as it were, into a scepter. In a hashish trance, you can certainly talk about the hand's need for a scepter. This trance was not very rich in great coinages. I remember *Haupelzwerg*,[2] which I tried to explain to the others. More comprehensible is my reply to a statement of Gert's that I received with my usual boundless contempt. The formula for this contempt was, "What you are saying is as much use to me as a Magdeburg roof."

It was strange at the beginning, when I could just sense the approach of the trance and I compared objects to the instruments of an orchestra that was just tuning up before the start of the performance.

Drug protocol from March 1930; unpublished in Benjamin's lifetime. *Gesammelte Schriften*, VI, 587–591. Translated by Rodney Livingstone.

Notes

1. Participating in this session were Egon and Gert Wissing, who took part in a number of Benjamin's drug experiments. Egon, a neurologist, was Benjamin's cousin.
2. A nonsense word, although *Zwerg* means "dwarf."

Julien Green

"Nous qui sommes bornés en tout, comment le sommes-nous si peu lorsqu'il s'agit de souffrir?"[1] This question of Marivaux's is one of those brilliant formulations with which the mind is sometimes rewarded by distance, detachment, from the matter in hand. For no age was further removed from the contemplation of suffering than the French Enlightenment. It was this distance that led Marivaux to such a compelling formulation. Julien Green, however, who used this quotation as an epigraph for his *Adrienne Mesurat,* is well aware of what is at stake in the idea of the Passion. And this applies not just to this novel but to his writing as a whole, in which suffering is the dominant if not the sole theme. But anyone who starts to inquire how suffering can become such an exclusive concern of a writer will soon realize how alien to Julien Green Marivaux's analytical psychology must be—or indeed any psychological view of human beings, for that matter. Anyone who wishes to study human beings from a humane, humanist standpoint— we might almost say, from the standpoint of the layman—would try to portray people in the round, as the phrase goes, but also as pleasure-loving, healthy, dominating beings. For the theological mind, however, it is suffering alone that holds the key to the deepest insights into the essence of humanity. Not, of course, without taking into account the powerful ambiguity of the Latin word *passio*—that intertwining of suffering and passion which helps *passio* become the world-historical massif, the watershed of religions. It is on these inhospitable heights that the disturbing, forbidding work of Green has its origins. Here we find the source of both tragic myth and Catholic myth—the pious heathen passion of King Oedipus, Electra, and Ajax, as well as of the pious Christian Jesus. Here, at the point of indifference, at

the mountain pass where all myths meet, the writer makes ready to delineate the situation of modern man through the traces of his *passio*.

Creaturely suffering as such is timeless. But this is not the case with the passions on which *passio* feeds. Avarice, the thirst for power, inertia of the heart, pride—each of these vices emerges in his writing in allegorically incisive figures, yet the passions that scourge his characters inwardly are not found in the old Christian canon of the deadly sins. On the other hand, anyone who wished to describe the genius and the curse of people alive today in theological terms would undoubtedly encounter impatience, the newest vice, a modern and most hellish vice. Emily Fletcher, Adrienne Mesurat, Paul Guéret—avid tongues of flame that flicker in the breeze of fate. Does Green wish to show (we might thus sympathetically interpret his writings) what would have become of this generation if it had not been able to sate its consuming impatience on enormous torrents of movement, communication, and pleasure? Or does he wish to invoke the dangerous energies that are lodged in the heart of this generation and produce its proudest achievements, and that only await the opportunity to increase their speed a thousandfold to break out in destructive processes of unprecedented rapidity? For passion—and this is a basic motif of *passio*—does not just violate God's commandments, but also offends against the natural order. This is why it arouses the destructive forces of the entire cosmos. And what passion brings down upon itself is not so much divine judgment as the revolt of Nature against whoever disturbs its peace and distorts its countenance. This profane doom is passion's lot, the consequence of its own action. Moreover it is the work of chance. In his latest and most mature work, *Léviathan*, Green presents us with the annihilation of the sufferer in a less inward way, more as the result of a tragic entanglement. He has thus done homage to this extreme of externality in much the same way as Calderón, the master of dramatic passion who constructed his plays on the most baroque of complications, the most contrived interventions of fate. Chance is the figure of Necessity abandoned by God. This is why, in Green, the depraved interiority of passion is in reality so completely in the grip of externality. So much so that passion is basically nothing but the agent of chance in the created being. Speed is the portion of chance that transmits despair to his characters' various destinies. Hope is the ritardando of fate. His characters are incapable of hope. They have no time for it; they are exasperated.

"Patience" is the word that embraces all the virtues of this author; at the same time, it contains all that his characters lack. The man who understands so much about these raving lunatics stares unblinkingly with large eyes. His face has the regular features and pale olive complexion of the Spaniard. In the unsullied nobility of his voice, there is something that seems to fend off too many words; and like his voice, his handwriting—with its transparent,

unadorned letters—advances almost in silence. One is tempted to speak of letters that have learned renunciation. The hardest part, however, is to convey a sense of the childlike composure expressed in his confession that it was not given to him to describe even the simplest incident he had experienced himself. Nothing can be more incomprehensible for anyone who is looking for some sort of bridge to the commonplace idea of the novel—that preposterous amalgam of thought and experience. Green stands beyond that deaf, sterile combination. He writes nothing that has been experienced. His experience [*Erlebnis*] is writing itself. Nor does he think anything up. For what he writes leaves no latitude. He goes on to say that nothing is more dubious than a straightforward plot, the progress of the story. These things cannot simply be thought out. He works on his manuscript in order to continue the lives of his characters as far as is required by the succeeding pages. And without thinking about it or explaining it to himself in the interval, he returns the following day to where he left off. We are not speaking loosely if we describe this procedure as visionary, and as the origin of the excessively stringent, hallucinatory clarity with which his characters move. Green's distance from novelists of the usual sort can be defined as the gulf between making present [*Vergegenwärtigung*] and depicting.

Making present: it is not the magical side of the phrase but its temporal aspect that must first be addressed. It compels us to distinguish two varieties of Naturalism: that of Zola, who depicts people and conditions such as only his contemporaries might see them; and that of Green, who imagines them in a way that they would never have appeared to a contemporary. Where does he do it?—In our imagination?—This tells us little. He does it in our temporal space, which is alien to them and which encloses them in a vault of hollow years that echoes back their whispered words and screams. Only this second present immortalizes what existed; and this is why this form of making present is a magical act. Green does not depict people; he makes them present at fateful moments. That is to say, they behave as if they were apparitions. Adrienne Mesurat standing at the window and gazing at Maurecourt's villa; old Mesurat stroking his beard; Madame Legras making off with Adrienne's necklace—each and every one of their gestures was of this kind, and as poor souls beyond the grave they are compelled to relive these moments anew. They stand before the reader in that desperate stereotypicality of all truly fateful moments, like the figures of Dante's Inferno, the embodiments of an irrevocable existence after the Last Judgment. This stereotypicality is the mark of Hell. If you get to the bottom of these moments, you understand what fate is—namely, the rule of chance in its consummate, merciless form. And its most despairing form. For consummate despair is despair in its consummate, perfected form. Just as Pascal

saw in the starry heavens the archetype of mathematical perfection, nothing but the sterility of eternal silence, in the same way Green, as the great interpreter of fate, discerns in the perfect concatenation of individual destinies nothing but the desolate abandonment of all creatures.

Yet the visionary aura that surrounds them is the very opposite of "vivid, true-to-life characterization." Such a stereotyped notion of vision likes to think in terms of dreams, of the evidence and vividness of faces. But assume that a person has a nightmare and is experiencing one of the terrifying images that are so abundant in Green's books. What will he do when he awakes? Put on the light and breathe a sigh of relief. It is quite different if you have a vision: however terrible it may be, the moment you wake up, the climax, the terror of terrors, will always lie beyond your visual horizon. For the here and now is the seal of authenticity that clings to every vision— the here and now that we find conquered, populated, colonized now and forever by its faces. A phased submerging and awakening—this is how we should envisage Green's work. A process of being shaken to the core by a thousand terrors, each one of them the terror of giving birth. The surrounding world lies there in an unwelcome light, with deep, jagged shadows. A "vale of tears" reveals itself to the waker. And perhaps this means that when a man has long ceased to shed a tear, the world around becomes moistened by the sweat or dew of misery. There are three huge heaps of coal mounded in the storage area of a coal dealer's yard, and Guéret lands in them after clambering over a wall. Green provides a very precise description of these black hillocks shimmering in the moonlight. I was familiar with it when I asked him one day whether he knew the origins of his works. A character? An experience [*Erfahrung*]? An idea? But his only answer was, "I can tell you the origin of my latest book quite precisely. It was a heap of coal I came across one day." In his works everything is assembled around such images, the way they appear to the startled gaze of a person waking up. Nowhere is this more obvious than at the beginning of his books. In all his novels, the first character readers meet is the protagonist. He or she is always absorbed by something: Guéret by his clock, Adrienne by the daguerreotypes of her ancestors, Emily by the landscape in front of her window. It is the moment of a strange absentmindedness, a commonplace moment of absorption at the point when fate enters and afflicts the characters like an illness. This is how Green sees them—just as we see ourselves after many years in our memory (a seeing which is also an awakening), engaged in pursuits of no real significance. These are moments for eternity. It is these and these alone that Green fixes on. "Toujours, semblait-il, murmura la rivière, toute la vie de même, toute la vie."[2] This is the lifelong song of these people, for their moments of destiny accompany them to the very end. They do not develop. Unless you want to call it a "development" that they stumble from

one misfortune to the next, like a body falling down a stone staircase that doesn't miss a single step.

So they fall to their deaths. And they thus experience the earthly doom of *passio:* the destruction of body and life. Impotence, sleep, and finally death—it is always the answer of the body that stands at the ultimate end of suffering. In the eyes of this novelist the bed is the hereditary site, the throne, of the living creature. "Une passion par personne, cela suffit."[3] It suffices because passion means a life of hardship, and the regular sequence of its stations is already laid down in advance. But can this rule be formulated? Does it really apply to contemporary man? Green's characters are anything but modern. Inflexible as the mask-like personae of tragedians, they live out their lives in small French towns. Their clothes and their daily lives are stunted and old-fashioned, but in their gestures survive age-old rulers, evildoers, fanatics. Amid woodcarvings and plush, their ancestors still lodge in their rooms, as if in dead tree-stumps or sedge. The merging of the old-fashioned with primal history [*Urgeschichte*], the trauma of seeing one's parents in a dual perspective—one that is both historical and part of primal history—is the abiding motif of this author. From the twilight in which the world is here embedded emerge houses and rooms in which the members of our fathers' generation passed their lives. Indeed, looked at rightly, Green's three principal works are all set in the same house, whether it belongs to Mrs. Fletcher, old Mesurat, or Mme. Grosgeorges. In the same way, the tragedies of Antiquity were all acted out before the façade of the same palace, which belonged now to Agamemnon, now to Creon or Theseus. "Having a place to live": Does this still mean barely having a roof over one's head, a process full of fear and magic—one that was perhaps never so voracious as it has been under the cover of civilization and the everyday bourgeois Christian world? The house of the fathers, which stands in the twofold darkness of what has only just happened and the unthinkably remote past, is here momentarily illuminated by the lightning shafts of destiny, and is as transparent as the night sky in a storm. It has been transformed into a vista of caverns, chambers, and galleries extending back into the primeval past of mankind. It is certain that for every generation a piece of primal history is fused with the existence, the life forms, of the immediately preceding one; thus, for the generation alive now, such a fusion takes place with the middle and end of the previous century. Nor is Green the only one to feel this. Cocteau's book *Les enfants terribles* is an expedition, equipped with all modern techniques, into the submarine depths of the nursery—to say nothing of Proust's work, dedicated as it is to time past and its cells in which we were children. Proust conjures up the magical time of childhood; Green brings order to our earliest terrors. In the cleared-out home of our childhood, he sweeps together the traces left by the existence

of our parents. And from the pile of suffering and horror that he has heaped up, their unburied corpses suddenly appear to us with as much force as, centuries ago, the human body appeared to the pious man, whom it stigmatized.

Published in *Neue schweizer Rundschau*, April 1930. *Gesammelte Schriften*, II, 328–334. Translated by Rodney Livingstone.

Notes

1. "We are limited in all things; why are we limited so little when it comes to suffering?" Pierre de Marivaux, *La vie de Marianne*, part 9.
2. "Always, it seemed, the stream kept murmuring, one's whole life long in the same way, the whole of one's life."
3. "One passion per person—that suffices."

Paris Diary

December 30, 1929. No sooner do you arrive in the city than you feel rewarded. The resolve not to write about it is futile. You reconstruct the preceding day just like children who reconstruct the table full of presents on Christmas Day. This, too, is a way of expressing your gratitude. Still, I'm holding to my plan that someday soon I will do more than just this. For the moment, at least, the plan prevents me—as does the space for reflection that I need in order to work—from abandoning my willpower and surrendering myself to the city. For the first time I elude it; I fail to turn up at the rendezvous to which loneliness, that old pimp, invites me, and arrange matters so that on many days I fail to see Paris for the Parisians. Of course—what an easy matter it is to overlook this city! It is as easy as overlooking health and happiness. You can't imagine how uninsistent it is. There are perhaps few cities in which so little is—or can be—overlooked as in Berlin. This may be the effect of the organizational and technical spirit that prevails there, for good or ill. Contrast this with Paris. Just think how the streets here seem to be inhabited interiors, how much you fail to see day after day, even in the most familiar parts, and how crucially important it is, more so than anywhere else, to keep crossing from one side of the street to the other.—You need to have lived in Paris a long time to know these things. What is the source of this unassuming exterior that seems oriented toward the needs and talents of the most insignificant members of society? Perhaps it is to be found in a way of thinking that is both conservative and urban, a synthesis quite alien to us. It's not just the Aragon who wrote the book who is a *paysan de Paris*—the real peasants are the concierge, the *marchand de quatre saisons*, and even the *flic*.[1] All of these are people who cultivate

their *quartier,* as constant and peace-loving as peasants. It goes without saying that the history of the city's construction was no less turbulent, no less full of violent ruptures than others. But just as nature heals the wounds of old castles with greenery, so here a bustling bourgeoisie has settled down and calmed the strife of the metropolis. If some out-of-the-way squares enclose their space so inwardly—as if a convention of houses had founded them—then the feeling for peacefulness and permanence that created them has, in the course of centuries, been passed on to their residents. And all this was echoed in the greeting I received from the old cashier in my money-exchange office, when I returned after a long interval: "Vous avez été un moment absent."—With a single tug he drew the moments of my absence together, like a sack in which he might hand me three years' savings.

January 6, 1930. In the first few days of January I saw Aragon, Desnos, Green, Fargue.[2] Fargue turned up in Le Bateau Ivre. The latter has bridges, portholes, loudspeakers, lots of brass, and white enameled walls. The latest fashion is for night spots to be owned by ladies from the nobility. This one belonged to a princesse d'Erlanger. Moreover, since the gin fizz costs 20 francs, the nobility can also make money on the side—and can even do so with a good conscience because a large proportion of those who are inspired by their cocktails are writers, so that the cultural capital of the nation is thereby increased. Here, then, is where I encountered Léon-Paul Fargue one evening, long past midnight, as he was emerging, boiling hot, as it were, from the cauldron. When he suddenly appeared, I just had time to whisper to Dausse, who sat next to me, "Here is the greatest living poet in France." Apart from the fact that Fargue is in fact a great poet, we discovered that evening that he was also one of the most enchanting of storytellers. Scarcely had he heard that I had been much preoccupied with Proust than he made it a point of honor to conjure up the most colorful and contradictory picture of his old friend. It was not just the physiognomy of the man that, to our amazement, his voice contrived to bring to life; not just the loud, exaggerated laugh of the young Proust, the socialite, his whole body in paroxysms, holding his white-gloved hands up to his gaping mouth, while his square monocle danced in front of him, dangling from a broad black ribbon; not just the invalid Proust living in a bedroom that could barely be distinguished from the furniture storeroom of an auction house, lying in a bed that had not been made for days on end, a bed that was really more like a cave filled with manuscripts, sheets of paper both blank and scribbled on, writing pads and books, all piled up, caught in the gap between the bed and the wall, and heaped up on the bedside table. It was not just this Proust that he conjured up. He also sketched the history of their twenty-year friendship, the outpourings of heartbreaking affection, the fits of insane mistrust, those "Vous m'avez trahi!" at the slightest pretext; not to mention his remarkable account of the dinner he had given for Marcel Proust and James Joyce, who

met each other then for the first and only time.[3] "To keep the conversation going," said Fargue, "was like lifting a deadweight. And I had even taken the precaution of inviting two beautiful women, to soften the force of the collision. But this did not prevent Joyce from vowing, as he took his leave, that he would never again enter a room where he might risk encountering Proust." And Fargue imitated Joyce's gesture of revulsion when Proust, his eyes wide with enthusiasm, declared of some imperial or royal highness, "C'était ma première altesse!"[4]—This early Proust of the late 1890s stood at the beginning of a road whose end he himself could not yet descry. In those days, he was seeking identity in the individual human being. It seemed to him the truly deifying element. This was how the greatest scourge of the idea of personality in modern literature had started out.—"Fargue," wrote Léon-Pierre Quint[5] in November 1929,

> is one of those people who write as they speak; he constantly utters works that remain unwritten—perhaps from indolence, perhaps from contempt for writing. An endless sequence of unforced flashes of wit and puns—this was the only way he was capable of speaking. He has a childlike love of Paris, with its godforsaken little cafés, its bars, its streets, and its nightlife that never ends. He must be in robust health and have a highly resilient character. During the day he works as an industrialist, and at night he is always on the move. He is constantly seen with elegant women, Americans. He is close to fifty years of age, yet leads the life of a gigolo by night, hypnotizing everyone he meets with the charm of his speech."

This describes him exactly as he appeared to me. We stayed together, amid a mini–fireworks display of reminiscences and epigrams, until they threw us out at around 3 A.M.

January 9. Jouhandeau.[6] The space in which he received me is a perfect synthesis of atelier and monk's cell. An unbroken row of windows runs along two walls. In addition, there was a skylight in the ceiling. Heavy green curtains everywhere. Two tables, both of which could rightly be described as desks. In front of them, chairs that seemed lost in space. Five in the afternoon: the light comes from a small chandelier and a tall standing lamp. Conversation about the magic of work conditions. Jouhandeau talks about the inspirational power of light that comes from the right. After this, a lot of autobiographical information. When he was thirteen or fourteen, he fell under the decisive influence of two charming sisters who lived in the Carmelite convent school of his hometown. Under their guidance he was overwhelmed by Catholicism, which up until then had been nothing but an object of education and instruction. The sight of a porcelain crucifix above his bed, on my first glance around his room, told me that his religion now meant much more to him. Yet I confessed to him that after I had read his first book I was still uncertain whether he approached Catholicism as a

believer or merely as an explorer. He was delighted with this description.
As he sat opposite me, talking insistently and animatedly, a very distin-
guished, somewhat fragile presence, I felt some regret that I was only now
coming closer to him, at a time when so many of the forces that threatened
his world had sprung to life in me. He went on talking about his life, and
especially about the night—the one following Déroulède's[7] funeral—when
he had burned all his writings, an endless pile of notes and speculations that
had finally come to seem to him nothing but an obstacle on the path to a
true life. This is when his writing had started to lose its lyrical and specu-
lative side. It was only afterward that he had begun to create the world of
characters that in fact all originated, as Jouhandeau told me, from a single
street in his hometown, the street he had lived on. It is important to him to
describe the world of these characters—a cosmos whose laws can be decoded
only from one central point. That central point is Godeau, a new Saint
Anthony, whose devils, whores, and beasts spring from speculative theol-
ogy.—Furthermore: "What fascinates me most about Catholicism are the
heresies." In his view, every individual is a heretic. And what excites him
are the countless individual distortions of Catholicism. He lives with his
characters (many of whom have never appeared in his books) for a long
while, until they become real enough for him to describe them. Often it
takes a great deal of time before a small gesture or mannerism reveals to
him their particular heresy. I talk to him about the magnificent and abstruse
playfulness of his characters, and the fact that they distract themselves not
with the objects of daily life—knives or forks, matches or pencils—but with
dogmas, incantations, and illuminations. My expression *jouets menaçants*[8]
pleases him greatly. Ermeline and Noëmie Bodeau are mentioned. And
Mademoiselle Zéline, whose history I like to represent in the allegorical
image of a vice that does not seduce her but that seizes her by the scruff of
the neck and pushes the stupefied woman along the path of virtue. It goes
without saying that I tell him my ideas about the magnificently illuminating
description of madness in "Le marié du village." One critic has compared
the author with Blake. I believe this is justified: think of the cruelty with
which Jouhandeau exposes his characters to religious experience, an expo-
sure that is expressed in the abrupt contours of his sentences. "Vos person-
nages sont tout le temps à l'abri de rien."[9]—The end of our conversation
was marked by the passage he showed me in the beautiful deluxe edition
of his *Monsieur Godeau intime*. He himself described it as the crucial point
of the book; it contains the account of God's sojourn in Hell and His struggle
with it.

January 11. Breakfast with Quint. He is planning a book on Gide. Stressed
how disconcerted the reading public had been by Gide's recent books, and
how poorly they had sold—with the exception of *L'école des femmes*.[10] The

French public had no interest in the debate on sexual questions, and even now was closer to the *retroussés*[11] of *Le Sourire* and *La vie parisienne* than to the Oscar Wilde phenomenon. My own view is that the most noticeable defect in Gide's treatment of homosexuality is his attempt to establish it as a purely natural phenomenon—in contrast to Proust, who took sociology as his starting point for his study of this tendency. But this, too, is connected with the man's makeup, which increasingly seems—to my mind—to lie in the contrast between his belated puberty, his tortured and divided disposition, on the one hand, and the pure, astringent, graphic line of his writings, on the other.

January 16. Théâtre des Champs-Elysées. Giraudoux's *Amphitryon 38,* the only play worth going to in Paris at the present time, since the talented Pitoëff has filled his stage with a production of *Les Criminels.*[12] The "38" means that it is the thirty-eighth treatment of this material. You need only reflect on that word a little to see the essence of his achievement. In fact, Giraudoux regards the story as a uniquely precious piece of material that has not lost any of its value from having passed through so many hands. On the contrary, its value has been enhanced by the aura of a radiant old age; it has set the writer the fashionable challenge of finding an elegant new shape for it and of displaying it from an unexpected angle. It is being compared with Cocteau's *Orpheus,*[13] another reworking of a classical subject: whereas Cocteau is said to have reconstructed the myth according to the latest architectonic principles, Giraudoux has understood how to renew it in line with fashion. We might perhaps equate Cocteau with Le Corbusier, and Giraudoux with Lanvin.[14]

In fact, the great fashion house of Lanvin did provide the costumes; and Valentine Tessier,[15] the actress playing Alcmena, gives a performance in which ruches, sashes, flounces, and fichus are partners with at least as much talent and vivacity as Mercury, Sosie, Zeus, and Amphitryon. Add to this the fact that the moral that insinuates itself into the spectator's mind so virtuously and seductively is one that defends marital fidelity against all the erotic sophistries of Olympus, and you have grasped the entire fashionable, conservative, and—in a word—eminently French tendency of the play. Walking home pensively on one of those mild winter evenings, you feel closer to the forces that for centuries have enabled this city to devote itself to the comprehensive economic and intellectual organization of fashion. Giraudoux, too, conveys the certainty that fashion suits the Muses as well as women.

January 18. Berl.[16] This primitive system is still the best: before meeting someone unknown to you, spend half an hour reading through his writings. My efforts were not in vain. In *La mort de la pensée bourgeoise* I came

across the following passage, which not only shed light on Berl in advance, but also illuminated retrospectively my conversation with Quint about Lautréamont. The passage dealt with sadism:

> What does Sade's work teach us, if not to recognize the extent to which a truly revolutionary mind is alienated from the idea of love? Insofar as his writings are not straightforward repressions, as would be natural for a prisoner, and insofar as they did not spring from the desire to give offense—and in Sade's case I do not think they did, since that would have been a foolish aspiration for an inmate of the Bastille—insofar as such motives are not involved, his works have their roots in a revolutionary negation developed to its ultimate logical extreme. What indeed would be the purpose of a protest against the powerful, once you have accepted the dominance of nature over human exist-ence, with all the indignities that this implies? Isn't "normal love" the most repulsive of all prejudices? Is conception anything but the most contemptible way of underwriting the fundamental design of the universe? Aren't the laws of nature, to which love submits, more tyrannical and hateful than the laws of society? The metaphysical meaning of sadism lies in the hope that the revolt of mankind might become so intensely violent that it would force nature to change its laws, and that once women have developed the resolve to cease tolerating the injustice of pregnancy and the dangers and pain of giving birth, nature would find itself compelled to find other ways of ensuring the survival of the human race on earth. The strength that says no to the family or the state must also say no to God; and just like the regulations of officials and priests, the ancient law of Genesis, too, must be broken: "In the sweat of thy face shalt thou eat bread; in pain shalt thou bring forth children." For what constitutes the crime of Adam and Eve is not that they provoked this law, but that they endured it.

—And now I am in the room inhabited by the author of this passage. Low chairs, apart from a desk chair. Along the shorter wall to the right, an aquarium that can be illuminated. Above the aquarium, a painting by Picabia. All the walls are colored green, circled by a gilt border. The book-shelves are covered in green leather: Courier, Sainte-Beuve, Balzac, Staël, the *Thousand and One Nights,* Goethe, Heine, Agrippa d'Aubigné, Meilhac, and Halévy.[17] Not hard to see that he is one of the people who like nothing better than to be allowed to descant on their favorite topic and who then recite what they have to say without brooking much interruption. His main concern now is to continue his polemical work by expelling pseudo-religi-osity from its very last hiding-places. These he discovers not in Catholicism, with its hierarchies and sacraments, nor even in the state, but in individu-alism, with its faith in the incomparable nature, the immortality, of the individual—the conviction that one's own interiority is the stage for a unique, unrepeatable tragic action. He discerns the most fashionable form of this conviction in the cult of the unconscious. That he has Freud on his side in the fanatical struggle he has instigated against this cult—that is to

say, against Surrealism, which celebrates it—is something I would have known even if he had not assured me of it. And with a glance at the copy of *Le Grand Jeu* that I had just bought (the magazine put out by some dissident members of the group): "They are seminarists, nothing more." This was followed by a few curious comments on the lifestyle of these young people—their *refus,* as Berl called it. We might translate this as "sabotage." To turn down an interview, reject the chance of a collaboration, refuse to allow a photograph to be taken—these things they view as so many proofs of their talent. Berl ingeniously connects this with the ingrained tendency toward asceticism typical of Parisians. On the other hand, there is still a vestige here of the idea of the unrecognized genius—an idea that we are just in the process of demolishing so thoroughly. A person who is a failure still has something of a halo here, and the snobs are on the point of gilding it anew. For example, the financiers who have formed a club to buy paintings and have agreed not to put them back on the market until ten years have elapsed. Their chief principle: no more than 500 francs may be paid for any single painting. Any painter whose works cost more has already succeeded; anyone who succeeds is no good. I listen to him without contradiction. But I find neither the attitude of those young people nor that of these old snobs so completely incomprehensible. How many ways there are, after all, to succeed as an artist, and how few of them have even the remotest connection with art!

January 21. M. Albert.[18] D. appeared at my hotel in the morning; asked me to keep the evening free. He will call for me at seven and introduce me to M. Albert. He will, as he puts it, visit M. Albert in his *établissement.* He claims that this is a perfectly extraordinary place. Now, this establishment— a public bathhouse in the Quartier Saint-Lazare—is indeed remarkable. But far from picturesque. The serious, genuine—in other words, socially dangerous—vices appear unassuming and try to avoid giving any impression of business; they can even seem rather touching. M. Albert's friend Proust may have known all about that. Hence, the atmosphere of this bathhouse is difficult to describe. Let us say, a pervasive family mood, but behind the scenes all the genuine vices. What is really striking, right through the evening, is the honest family intimacy of these boys, with which their amazing candidness does not conflict at all. At any rate, those I saw, for all their ostentatious and precious manner, had a naïveté, boyish rebelliousness, playfulness, and defiance that secretly reminded me of my time at boarding school.—First comes the courtyard that you have to cross: a landscape of cobblestones and peace. Lights in only a few of the windows that overlook it. But there is light behind the frosted glass of Albert's office and in a garret on the left that rises up like battlements. There were three of us: Hessel and I had to put up with being introduced by D. as translators of Proust.[19] I was

astonished to see confirmed what Hessel had said to me about him a few
days earlier: he is something of a sea-god, merging with everything, flowing
off everything. Incidentally, you can see this most clearly in the porcelain
figurines. Porcelain is the most licentious material for depicting loving
couples; I picture D. as a whoremongering porcelain river-god. Chief among
the bit players was Maurice Sachs.[20] His vivacious manner and the obviously
well-rehearsed precision of his anecdotes had the effect of making certain
episodes and pieces of information appear suspect. Scarcely was he stuffed
into the car with Hessel and myself than he began to regale us with a sort
of catalogue of the main stories about Albert that gave me the uneasy feeling
I was witnessing a *tournée des grands-ducs.* Behind the frosted-glass panes,
the reception room was sealed off by blinds from all the adjoining rooms,
where offensive scenes might be taking place. And M. Albert behind the
counter, or the till—a contrivance consisting of washcloths, perfumes, *po-
chettes surprise,* tickets to the baths, and tarty dolls. Very polite and discreet
in his manner of greeting, and agreeably occupied on the side by the backlog
of daily chores. If I remember rightly, Proust met him first in 1912. He could
not have been more than twenty at the time. And you can see from his
present appearance that he must have been very handsome in the days when
he was a personal valet to Prince von Radziwill and, before that, to Prince
Orloff. The complete fusion of utter obsequiousness and absolute decisive-
ness that characterizes the lackey—as if the master caste took no pleasure
in ordering around people they had not drilled into becoming generals—has
entered into his features through a sort of fermentation, so that at times he
looks like a gym teacher. The evening program was planned on a large scale.
At least, the intention was to follow up dinner by reinforcing the new
friendship with a visit to M. Albert's second establishment, the Bal des Trois
Colonnes. There appeared to be some uncertainty, perhaps out of excessive
politeness, about where to go for dinner. They quickly settled on the place
on the rue de Vaugirard that Hessel and I had once walked past three years
previously without even glancing inside. Today there were some astound-
ingly beautiful boys there. Including a presumably authentic Indian prince,
who interested Maurice Sachs so profoundly that he was distracted from
carrying out his intention of luring M. Albert into parting with some of his
most cherished secrets. But I'm not sure they would have interested me any
more than some very unimportant, almost involuntary comments that in-
advertently cropped up in our conversation. For I am almost wholly indif-
ferent to the question of what would emerge if someone were to use Proust's
passions—some of which strongly resemble a famous scene with Mademoi-
selle Vinteuil—as an aid to the interpretation of his works. Conversely,
however, Proust's works appear to me to point to general sadistic charac-
teristics in him, although they are well concealed. My starting point here
would be Proust's insatiable compulsion to analyze the most trivial incidents.

Also his curiosity—something which is very close to it. We know from experience how curiosity in the shape of repeated questions, constantly probing the same issue, can become an instrument in the hands of the sadist—the same instrument that is so innocent in the hands of children. Proust's relationship to existence has something of this sadistic curiosity. There are passages where his questioning may be said to provoke life to extremes; and in other passages, he stands before a fact of the heart like a sadistic teacher before an intimidated child, forcing it to reveal a suspected, perhaps not even genuine secret with ambiguous gestures, a tweaking and pinching that lies halfway between endearment and torment. Yet we can see a convergence of his two great passions—curiosity and sadism—in another of his traits: his inability to rest satisfied with any information, his compulsion to scent out in every secret an even more minute secret contained in it, and so on to infinity, but with the effect that as their size decreases, their importance grows.—All this went through my mind while M. Albert sketched the course of their acquaintance. It is generally known that some time after they had met, Proust set up a *maison de rendezvous* for him. This became a *pied-à-terre* and laboratory at the same time. Here he informed himself, partly through the evidence of his own eyes, about all the varieties of homosexual experience; this was where he made the observations that were subsequently incorporated into his depiction of the bondage of Charlus; this was where he deposited the pieces of furniture belonging to an aunt who had died, only to lament (in *A l'ombre des jeunes filles en fleur*) their unseemly end in a brothel.—It grew late. I could barely filter out M. Albert's faint voice from the noise of a gramophone, which was constantly being supplied with new records by an elegiac beauty who was unable to dance because he had a hole in his trousers and felt put out by the successful competition from the Indian prince. We were too tired to give M. Albert the opportunity of returning our hospitality *chez lui,* that is to say, at the Trois Colonnes. D. drove us home in his car.

January 26. Félix Bertaux. Despite his southern appearance, he is from Lorraine. But presumably has some French blood. Here is a nice anecdote from his time as a young teacher in Poitiers. There was an evening meeting of Action Française—this was before the war.[21] Bertaux had gone to it with some friends, in a spirit of opposition. After a recruitment address, the chairman invited comments from the floor from those who were not in agreement. To Bertaux's astonishment, no one came forward. Quickly making up his mind, he leaped from his seat at the back, stormed down the length of the hall with giant strides to the podium, and mesmerized the audience for three quarters of an hour. His speech produced a complete change of heart among this audience of Action Française fellow travelers. *Il a renversé la salle,* as they say. And the aftermath in his classroom the

next day. He dropped a piece of chalk while writing something on the blackboard. Ten boys rushed from their seats to pick it up. Bertaux was taken aback, thought about it, and dropped something else, apparently by chance. This time, twenty boys jumped up. Such was the passionate response to his speech of the previous evening. He could have made the most brilliant career as a politician—he might have become a prefect, or a member of parliament. But he prefers to spend his spare time working at a French-German dictionary which has preoccupied him for the past fifteen years and which is eagerly awaited. Our conversation turns mainly on Proust. Proust and Gide—in 1919 their ranking may have been momentarily in doubt. But not for Bertaux, even then. The canonical objections and reservations: Proust failed to enrich the substance of mankind; he did not enhance or purify the concept of *l'humanité*. Bertaux cites Gide's description of Proust's treatment of everyday reality: a piece of cheese under the microscope. You say to yourself, "Eh bien, c'est ça ce que nous mangeons tous les jours?!"[22]— My reaction. Of course, he has not elevated humanity, but only analyzed it. His moral greatness lies quite elsewhere. The task he has made peculiarly his own and that he has pursued with a passion unknown in any previous writer is that of describing with unprecedented fidelity the things that have crossed our path. His fidelity to an afternoon, a tree, a stain from the sun on the wall; his fidelity to a gown, furniture, perfumes, or landscapes. (I would say the discovery in the last volume—that the roads to the Guermantes and to Méséglise meet up—represents allegorically the greatest moral that Proust can vouchsafe.) I concede that, at bottom, Proust *peut-être se range du côté de la mort*.[23] *Jenseits des Lustprinzips* [Beyond the Pleasure Principle], Freud's late work of genius, is probably the fundamental commentary on Proust. Bertaux is willing to admit all of this, but is not won over, *se range du côté de la santé*.[24] I end up saying that if there was any health which Proust had sought and loved in his works, it was not the vigorous health of the man but the defenseless and tender health of the child.

February 4. Adrienne Monnier.[25] Shortly after three, I open the door of Aux Amis des Livres, 7 rue de l'Odéon. I sense a certain difference from other bookshops. This seems to be no second-hand bookshop. Evidently, Adrienne Monnier deals only in new books. But it all looks a little less colorful, less agitated, and less unfocused than other shops. A pale, warm ivory tone lies spread over the broad tables. Perhaps it comes from the transparent jackets on many of the books—all modern first editions, all de luxe editions. I walk up to the woman closest to me. She has given me the feeling that if this should turn out to be Adrienne Monnier, it would mean the greatest possible disappointment of my fleeting, superficial expectation of meeting a pretty, young girl. A stolid, blond woman with very clear gray-blue eyes and clad in a dress of coarse gray wool of a severe, nun-like cut. In front, a row of inlaid buttons, old-fashioned edgings. It is she. I feel

instantly that she is one of those people to whom one can never show enough respect, and who without seeming to expect that respect in any way, do nothing to reject or deprecate it. It is remarkable that this woman only twice crossed Rilke's path, as she put it, even though he lived in Paris for such a long time. I could imagine that he would have felt the deepest interest [*Neigung*] in a being of such rustic purity, in such a cosmically monastic creature. Incidentally, she speaks very beautifully of him and says, "He seems to have given everyone who knew him the feeling that he was profoundly involved in everything they did." And during his life he was able to give them this feeling quite without words, simply by virtue of his existence. We are sitting at her narrow desk, which is covered with books and right at the front of her shop. Needless to say, I.M.S. is our first topic of conversation;[26] this is followed by the wise and the foolish virgins. She talks about the different forms assumed by the *vierge sage;* such as the virgin of Strasbourg, who inspired her to write the play I had read, and the virgin of Notre Dame de Paris, "qui est si désabusée, si bourgeoise, si parisienne—ça vous rappelle ces épouses qui ont appris à se faire à leur mari et qui ont cette façon de dire, 'Mais oui, mon ami'; qui pensent un peu plus loin."[27] "And now," Paulhan[28] apparently said to her, once he had seen the *vierge sage,* "you must write us a *vierge folle.*" But not at all! There is only one *vierge sage,* even though there is a group of seven—but the *vierge folle,* well there are many of them, it's really the whole group. Moreover, her *servante en colère* was herself such a foolish virgin. And then she said something that even if I had read none of her works would have given me an insight into the nature of her world. She was speaking of the virginity of the wise virgins, and how this virginity was not entirely devoid of a hint, a shimmer, of hypocrisy. The wise and foolish virgins—of course, what she said about them was not really in line with the Church's view, but it differed by only a minute amount; they were extremely close to each other, or so she said. And as she spoke, her hands made such a winning and compelling swing-like gesture that I suddenly saw a portal in my mind's eye, with all fourteen virgins resting on their round, movable stone pedestals; and as they all swayed toward each other they perfectly echoed the meaning of her words. This naturally led us to talk about the *coincidentia oppositorum* [coincidence of opposites], without explicitly mentioning the term itself. I try to steer the conversation to Gide, since I know that she was, or is, close to him, and that here within these rooms the famous auction took place in which Gide solemnly parted company with those of his friends who had rejected his *Corydon,*[29] and did so by selling off the copies of their works that they had dedicated to him. "No, not under any circumstances"—she does not want Gide spoken of here. Gide does indeed possess both affirmation and negation, but in succession and in time, not in the great unity, the great peace, in which they can be found in the mystics. Then she mentions—and this really does interest me—Breton. She does a character sketch of

Breton: a tense, explosive person in whose vicinity life is impossible—
"quelqu'un d'inviable, comme nous disons."[30] But she thought his first
Surrealist Manifesto extraordinary, and the second contained some mag-
nificent things as well. I confess to her that it was the turn to the occult that
had struck me about the second one, and rather unpleasantly. She, too, is
impatient with the idealization of telling fortunes from cards—in Breton's
Lettre aux voyantes.[31] She recalls the time Breton appeared in her shop with
Apollinaire. How obsequious he was toward Apollinaire, at his every beck
and call. "Breton, faites cela, cherchez ceci."[32] Many customers appear. I
have no wish to prolong this situation at the table unnaturally, and I am
also worried that I might be interfering with her work. But I then found
myself fascinated to see how eagerly she leaped to the defense of photo-
graphs of works of art—an old bête noire of mine. At first she seemed struck
by my statement about how much easier it was to "enjoy" a painting—and
especially a piece of sculpture, and even architecture—in a photograph than
in reality. But when I went on to call this kind of preoccupation with art
impoverishing and nerve-racking, she resisted. "Great creations," she said,
"cannot be thought of as the works of individuals. They are collective
objects, so powerful that a condition of enjoying them is to reduce them in
stature. In the last analysis, the methods of mechanical reproduction are a
technique for reducing them. They enable people to obtain the degree of
domination over the works without which they cannot enjoy them." In this
way I exchange a photograph of the *vierge sage* of Strasbourg, which she
had promised me at the beginning of our conversation, for a theory of
reproduction that may be even more valuable to me.

February 7. Bernstein's *Mélo* at the Gymnase.[33] The architecture of this
theater is found nowadays only in the façades of old spa casinos. When it
is floodlit, as at the beginning and the end, in the style of the Paris Opéra—
so that all the projecting ties and beams become ramps from which spot-
lights show the primadonna-columns to their best advantage, while the
darkness of the night sky forms an arch in the niches above them—the
outside theater of the façade becomes immeasurably superior to the indoor
stage.

February 10. Adrienne Monnier for the second time. In the meantime I have
become more familiar with the topography of the rue de l'Odéon. In her
forgotten volume of poetry, *Visages,* I have read the beautiful lines about
her friend Sylvia Beach, who owned the little boutique opposite hers that
witnessed the turbulent events surrounding the first publication of Joyce's
Ulysses in English. "Déjà," she wrote, "Déjà midi nous voit, l'une en face
de l'autre / Debout devant nos seuils, au niveau de la rue / Doux fleuve de
soleil qui porte sur ses bords / Nos libraires."[34] She enters the shop toward
3:30, precisely one minute after me, enveloped in a fleecy gray coat, like a

Cossack grandmother, shy and very determined. And scarcely are we sitting in the same place as before than she waves to someone through the shop window. He enters the shop. It is Fargue. And since it is a heavenly day in Paris, somewhat cold, but sunny, and we are all full of the beauty of the scene outside, and I too tell them how I had strolled around Saint-Sulpice, Fargue confides that he would like to live there. And then the two of them produce a wonderful duet about the priests of Saint-Sulpice, a duet that reverberates with the warmth of their old friendship. Fargue: "Ces grands corbeaux civilisés."[35] Monnier: Whenever I cross the square, it is so beautiful, even though the wind cuts through you in the winter; and when the priests come out of the church I feel that the storm will catch in their cassocks and sweep them up into the air." In order to grasp the key to this incomparable neighborhood, and especially the square, which stands at its heart, you have to have seen this black throng coming and going with your own eyes, pausing and surging to and fro in the *quartier* and merging noiselessly with the sheer silence of the many bookshops. The two then resume their amicable quarrels, which must have been going on for years. Fargue is berated for his indolence, his failure to write. "Que voulez-vous, j'ai pitié de ce que je fais. Ces pauvres mots, je les vois, à peine écrits, qu'ils s'en vont, traînant, boitant, vers le Père Lachaise."[36] Our subsequent conversation is dominated by the Joyce translation she published. She reports on the circumstances leading up to this rare success.—Some mention of Proust: she talks of the revulsion he evoked in her with his transfiguring of high society, of the rebellious protest that prevented her from loving him. And then she speaks with fanaticism, almost hatred, of Albertine, who was so absurdly like *ce garçon du Ritz*—Albert—whose burly body and masculine gait she could always sense in Albertine. Proust's moral side prevented her from liking him, or even wanting to like him. What she says gives me an opening to tell her of the problems encountered in introducing Proust to the German public, of pointing out how such problems make penetrating studies of the writer indispensable, how rare such studies have been in Germany, and basically even in France. Her astonishment at my words is enough to persuade me to give a brief sketch of my interpretation of Proust. What has remained undiscovered, I say, is not the psychological side of Proust, not the analytical aspect, but the metaphysical element of his writings. The hundred doors that offer an entry into his world have remained unopened: the idea of aging, the affinity between human beings and plants, his portrait of the nineteenth century, his feeling for decay, for residues, and the like. And how I have become increasingly convinced that, in order to understand Proust, it is vital to realize that his true subject is the reverse side: *le revers—moins du monde que de la vie même.*[37]

Later the same afternoon a conversation with Audisio, to whom I am able to talk in some detail about his *Héliotrope,* which delights him.[38] He tells

me about the circumstances in which he wrote the book, and this leads to the subject of working in a southerly climate. We are in complete agreement about the absurdity of the belief that the southern sun is the foe of intellectual concentration. Audisio reveals his plan to write a *Défense du soleil*. We embark on a discussion of the different kinds of mystical contemplation to be found beneath the northern midnight heavens and the southern midday sky. Jean Paul on the one hand, oriental mysticism on the other.[39] The Romantic stance of the northerner, who seeks to align his dream world with infinity; and the rigor of the southerner, who, perhaps defiantly, attempts to compete with the infinity of the blue skies at noon in order to create something equally enduring. The conversation makes me think of my stay on Capri, when I wrote the first forty pages of my book on mourning drama,[40] in the middle of July: I had nothing but pen, ink, paper, a chair, a table, and the noonday heat. This competition with infinite duration—whose image is so compellingly evoked by the midday sky of the south, just as the night sky conjures up the picture of infinite space—characterizes the hermetic, constructive nature of southern mysticism of the kind expressed in the architecture of Sufi temples.

February 11. Breakfast with Quint. I would not have broached the topic of the latest developments in Surrealism so directly, had I recollected that Editions Kra—of which Quint is one of the directors—is publishing the *Second Surrealist Manifesto*. He thinks the parts that take issue with former members of the group are the weakest. This aside, his statement that the original movement is now at an end is something I needed to have confirmed. But it is the right moment to look back at the movement and establish some of the facts. The first one is also the most laudable: Surrealism reacted to that blend of poetry and journalism which has started to become the formula for literary activity in Germany with a violence that does credit to France and testifies to the vitality of its intellectuals. At a time when the idea of *poésie pure* was threatening to peter out in sterile academicism, Surrealism gave it a demagogic, almost political emphasis. It rediscovered the great tradition of esoteric poetry that is actually quite removed from *l'art pour l'art* and that is such a secret, salutary practice for poetry, a set of prescriptions. It saw through the intimate interrelationship between dilettantism and corruption that forms the basis of journalism. It brought an anarchistic passion to the task of destroying the concept of standards in literature, the decent average. And it went even further in its efforts to sabotage ever broader regions of public and private life, until finally the political rightness of this stance—its analytical or, even better, eliminating force—became evident and effective. We also agreed that one of the great limitations of the movement lay in the laziness of its leaders. When you meet Breton and ask him what he is doing, he answers, "Rien. Que voulez-vous

que l'on fasse?"[41] There is an element of affectation in this, but also much truth. Above all, Breton fails to realize that diligence has its magical side, as well as a bourgeois, philistine one.

Before that, a farewell walk down the Champs-Elysées. The unbroken surface of the days is like a mirror: as I approach their edges, they light up in all the colors of the prism. Spring has come with the cold, and when you come striding down the Champs-Elysées as if down a snowy mountain slope, with racing pulse and flushed cheeks, you suddenly call a halt in front of a small lawn behind the Théâtre Marigny—a lawn in which spring is in the air. Behind the Théâtre Marigny, an impressive building is in process of construction; a tall green fence surrounds the site, and behind it the scaffolding rises. Then I glimpsed this bit of magic: a tree growing in the fenced-off area, its bare branches extending out a little over the fence to one side. The rough-hewn fence nestled as snugly into these branches, with their delicate openwork, as a ruff around the throat of a young girl. Amid the gigantic joinery, this silhouette had been drawn by a cutter's sure hand. The sun's rays shone down dazzlingly from the right; and as the tip of the Eiffel Tower—my favorite symbol of self-assertiveness—almost dissolved in the luminous light, it became the image of the reconciliation and purification that comes with spring. The radiance of the sunshine melted the tenement blocks that barred the view to the rue La Boétie and the avenue Montaigne in the distance, and became masses of golden-brown impasto that the demiurge had spread over the palette that is Paris. And as I walked along, my thoughts became all jumbled up as in a kaleidoscope—a new constellation at every step. Old elements disappeared, and unknown ones came stumbling up—figures of all shapes and sizes. If one remained, it was called a "sentence." And among thousands of possible ones, I found this one, for which I had been waiting for many years—the sentence that wholly defined the miracle that the Madeleine—not the Proustian madeleine, but the real one[42]—had been from the first moment I saw it: in winter the Madeleine is a great furnace that warms the rue Royale with its shadow.

Published in *Die literarische Welt*, April–June 1930. *Gesammelte Schriften*, IV, 567–587. Translated by Rodney Livingstone.

Notes

1. Louis Aragon (1897–1992) wrote his *Paysan de Paris* at the time André Breton was writing his *Manifeste du surréalisme* (Surrealist Manifesto). Aragon's minute description of the Passage de l'Opéra, one of the Parisian arcades lined with restaurants and small shops, is a key document of Surrealism. His attempt to

liberate the imagination through a poetic focus on ordinary, often commercial objects spoke very directly to Benjamin, who referred to it repeatedly in the early years of his work on the *Passagen-Werk* (Arcades Project) in the late 1920s and early 1930s. A *marchand de quatre saisons* is a seller of fruits and vegetables; a *flic* is a policeman.

2. Robert Desnos (1900–1945), French poet, was one of the earliest adherents of Surrealism. He died in the Nazi concentration camp at Theresienstadt, having been deported for his Resistance activities. On Julien Green, see "The Fireside Saga" and "Julien Green" in this volume. Léon-Paul Fargue (1876–1947), poet, essayist, and critic, contributed to the *Nouvelle Revue Française* and edited (together with Paul Valéry and Valery Larbaud) the journal *Commerce,* which promoted the work of a number of Surrealist authors.

3. For a succinct account of the (mutually disappointing) encounter between Proust and Joyce, see Richard Ellmann, *James Joyce* (New York: Oxford University Press, 1959), ch. 30. "Vous m'avez trahi!" means "You've betrayed me!"

4. "That was my first Highness!"

5. Léon-Pierre Quint (1895–1958), French critic and friend of Benjamin's, was the author of the first major study of Proust's oeuvre (1925).

6. Marcel Jouhandeau (1888–1979) was the author of numerous works of autobiographically based fiction; they were stamped with a strongly Catholic focus on sin and possible redemption. Benjamin's translation of Jouhandeau's "Mademoiselle Zéline, ou Bonheur de Dieu à l'usage d'une vieille demoiselle" (1924) appeared in an anthology of contemporary French writing, *Neue französische Erzähler,* in 1930; his translation of Jouhandeau's story "Le marié du village" was published in the February 1931 issue of the *Europäische Revue.* In 1917, Jouhandeau worked in Albert Le Cuziat's well-known male brothel, which was frequented by Proust; he would sometimes serve there as Proust's assistant in acts of sadistic voyeurism, which he then recorded. As this text makes clear, Benjamin also visited Le Cuziat's establishment.

7. Paul Déroulède (1846–1914), a poet and dramatist, was president of the French League of Patriots and an active supporter of Georges Boulanger's populist, antirepublican campaign.

8. "Threatening toys."

9. "Your characters are never safe for a single moment."

10. *L'école des femmes,* Gide's novel of a woman's disillusionment in marriage, was published in 1929.

11. "Raised skirts."

12. Jean Giraudoux's drama in three acts had its premiere at the Comédie des Champs-Elysées in November 1929; it was published the same year. *Les Criminels* may refer to Offenbach's one-act comic opera of this title.

13. Jean Cocteau's one-act "tragedy" was first performed at Georges Pitoëff's theater in June 1926; it was published in 1927.

14. The Swiss-born Le Corbusier (pseudonym of Charles-Edouard Jeanneret; 1887–1965) gained fame as France's leading avant-garde architect through structures such as the "Esprit Nouveau" pavilion in Paris (1925). Jeanne Lanvin (1867–1946), with her *haute couture* house in the Faubourg Saint-Honoré, was a prominent designer of clothing for the fashionable elite of Paris.

15. Valentine Tessier (1892–1981) was the actress of choice for the first performances of Giraudoux's plays. Her great beauty and acting talent won her a number of film roles, including the lead in Jean Renoir's *Madame Bovary* (1934).

16. Emmanuel Berl (1892–1976) was a French essayist. In both the text cited here (1930) and its companion volume, *La mort de la morale bourgeoise* (1929), Berl denounced the sociocultural petrification he saw as resulting from modern bourgeois culture.

17. Paul-Louis Courier (1772–1825), French pamphleteer, was a master of irony and invective; he was a passionate opponent of the Bourbon Restoration of 1814. Charles Augustin Sainte-Beuve (1804–1869), influential and prolific critic, novelist, and poet, is now best-known for his delineation of a literary-historical method which emphasizes authorial psychology and the role of the author's milieu. Madame de Staël (née Germaine Necker; 1766–1817) rose to fame after the publication of *De l'Allemagne* (1810), a wide-ranging survey of cultural activity in Germany; the book opened a crucial bridge between German Romanticism and postrevolutionary French culture. Théodore Agrippa d'Aubigné (1552–1630), was a French historian and a champion of the Protestant Reformation. Henri Meilhac (1831–1897) was a French dramatist and a virtuoso of boulevard theater. He collaborated with Ludovic Halévy (1834–1908) on a series of operetta librettos, many of which were set to Jacques Offenbach's music; *La vie parisienne* is perhaps the best-known of these.

18. Albert Le Cuziat served Proust as an important source on the homosexual underworld in Paris. He served as the model for Jupien, the waistcoat maker (Charlus' aide in *Sodome et Gomorrhe*) in *A la recherche du temps perdu;* and he served as one of the secondary models for Albertine (though not the principal model, as Benjamin claimed in a letter to Gershom Scholem of January 25, 1930). Le Cuziat opened his male brothel in the Hôtel Marigny, 11 rue de l'Arcade, in 1916.

19. On Franz Hessel's collaboration with Benjamin on a translation of Proust's *A la recherche du temps perdu,* see the chronology to Volume 1 of this edition, pp. 513–514. They would complete three volumes of the translation, including Benjamin's now-lost version of *Sodome et Gomorrhe.*

20. Maurice Sachs (pseudonym of Maurice Ettinghausen; 1906–1945), French novelist and satirical essayist, gained notoriety as a result of his chaotic and scandal-ridden life. A convert from Judaism to Catholicism, he went on to collaborate with the Gestapo; he was nonetheless deported and murdered in a Hamburg prison toward the end of World War II.

21. Action Française was France's most potent nationalist and right-wing political movement before World War II. Founded by Charles Maurras and Léon Daudet in 1898 within the larger context of the Dreyfus Affair, its struggle against parliamentary democracy, its militant Catholicism, and its anti-Semitism were propagated in its journal, likewise named *L'Action Française.*

22. "Well, so *that's* what we eat every day?!"

23. "Perhaps sides with death."

24. "Sides with health."

25. The Paris bookshop of Adrienne Monnier (1892–1968), actually called La

Maison des Amis des Livres, was located across from Sylvia Beach's Shakespeare and Company, at 7 rue de l'Odéon. The two shops served as an important forum for European modernists such as Paul Valéry, André Gide, and James Joyce.

26. I.M.S. was the pseudonym under which Adrienne Monnier published some of her shorter prose pieces.

27. "Who is so disillusioned, so bourgeoise, so Parisian—it makes you think of housewives who have become inured to their husbands and who have a way of saying, 'But of course, darling,' while they go on thinking their own thoughts."

28. Jean Paulhan (1884–1968), French critic and man of letters, became the editor of the *Nouvelle Revue Française* in 1925. He was the first to publish experimental writers such as Antonin Artaud, Francis Ponge, and Raymond Queneau in the journal.

29. Gide's *Corydon: Quatre dialogues socratiques* was published anonymously in excerpt form in 1911, and in a full version in 1920. The text appeared under his name only in 1924. It represents Gide's most explicit exploration of his homosexuality; its publication cost him many friends.

30. "An 'unviable person,' as we say."

31. The *Lettre aux voyantes* accompanied a new edition of the *Manifeste du surréalisme,* including a frontispiece by Max Ernst, published by Editions Kra in 1929.

32. "Breton, do this, look for that."

33. The work of the French dramatist Henry Bernstein (1876–1953)—plays such as *Félix* (1926) and *Mélo* (1929)—offer a record of the moral and erotic dilemmas of the secularized French bourgeoisie at the turn of the twentieth century.

34. "Already noon sees us, opposite one another / Standing before our doors, at street level / Gentle river of sun which carries on its banks / our booksellers."

35. "Those huge civilized crows."

36. "I simply can't help taking pity on what I've written. I look at the poor words and see how—scarcely having been written down—they hobble off, limping, to Père Lachaise cemetery."

37. "The reverse—less of the world than of life itself."

38. Gabriel Audisio (1900–1978), French poet and novelist, was a public official in both Algeria and France. His work celebrates the light and sun of the Mediterranean world; his novel *Héliotrope* was published in 1928.

39. Jean Paul Richter (1763–1825) wrote a series of wildly extravagent, highly imaginative novels that, in their combination of fantasy and realism, continue to defy categorization.

40. *Ursprung des deutschen Trauerspiels* (Origin of the German Trauerspiel).

41. "Nothing. What do you expect me to be doing?"

42. That is to say, not the little sponge cakes that triggered Proust's recollection of his childhood, but the neoclassical church off the Place de la Concorde in Paris.

Review of Kracauer's *Die Angestellten*

S. Kracauer, *Die Angestellten: Aus dem neuesten Deutschland* [White-Collar Workers: The Latest from Germany] (Frankfurt am Main: Frankfurter Societätsdruckerei, 1930), 148 pages.

Many people still have memories of the time when it was normal to give their books titles such as *Toward a Sociology of . . .* In those days, this book would have been called *Toward a Sociology of the White-Collar Worker.* Or rather, it would not have been written at all. For what such fashionable titles expressed was really only the fear of making clear political analyses, instead of enveloping them in a cocoon of academic clichés so that the awkward aspects of the subject could give no offense. This is not Kracauer's way. And he has not abandoned this old approach to replace it with his own form of obfuscation. In particular, he finds reportage, this modern method of evading political realities under the guise of left-wing phraseology, just as repugnant as the euphemistic maunderings of sociologists. "Reality," he says, "is a construct. No doubt, life must be scrutinized if it is to emerge before us. But it certainly does not reside in the more or less adventitious observations of reportage. On the contrary, it is to be found exclusively in the mosaic formed by the synthesis of individual observations that results from an understanding of their content."[1] In other words, sociological knowledge and the material of observation are the mere preconditions of his method, a method that rewards precise study because of both its originality and its explanatory power.

The fact that Kracauer goes his own way is revealed by his use of language. Stubbornly and aggressively, it seeks out its own coordinates with

an obstinacy that an Abraham a Sancta Clara might have envied as he hammered out his own sermons in a series of puns.[2] The difference is that in *Die Angestellten* the role of wordplay has been replaced by that of the pictorial pun. Puns are of course anything but arbitrary; they are intimately bound up with the linguistic life of the Baroque. In the same way, Kracauer's pictorial wit is no chance affair, but is related to those composite Surrealist images that not only characterize dreams (as we have learned from Freud) and the sensual world (as we have learned from Paul Klee and Max Ernst), but also define our social reality. "In the evenings in Luna Park,"[3] we read in Kracauer, "they sometimes have fountain displays illuminated by fireworks. A whole sequence of different colored sprays—red, yellow, green— light up the darkness. Once the splendid illumination is over, you can see that it came from a tawdry jumble of pipes. This fountain display resembles the lives of many white-collar workers. They seek distraction as an escape from the shabbiness of their existence, experience a brief burst of fireworks, and, oblivious of its origins, sink back into obscurity."[4] Of course, this is more than a mere metaphor. For these fireworks dazzle the office worker himself. It is this that alerts us to the political clarity of vision that flashes from these composite images.

What is the source of this ability to interpret political dreams? We are not speaking here of literary influences. Nor need we concern ourselves with Kracauer's linguistic debt to the anonymous author of *Ginster*.[5] What is evident, however, is that his interpretive practice is solidly based on the exact study of his own most personal experience. (Just as white magic goes hand in hand with the rigorous, sober scrutiny of experience, while black magic never gets further than enchantment and mystery.) But the experience we are talking about here is the experience of the intellectual. The intellectual is the sworn enemy of the petty bourgeoisie, because he must constantly overcome the petty bourgeois in himself. Here he has played to his own strengths, which enable him to see through bourgeois ideologies, if not entirely, then at least to the extent that they are still linked with the petty bourgeoisie. In white-collar workers, we see the emergence of a more uniform, inflexible, drilled sort of petty bourgeoisie. It is incomparably poorer in types, in originals, in cranky yet conciliatory specimens of humanity. In exchange, it is infinitely richer in illusions and repressions. It is against these that the author takes aim. Not after the fashion of Gregers Wehrle, who mounts an assault against "life as a lie," much as Don Quixote does against windmills.[6] His concern is not with individuals, but with the composition of a homogeneous mass and the circumstances in which this mass is reflected. In his eyes, the sum of these circumstances is encompassed by the name "Berlin." "Today, Berlin is the city of white-collar culture par excellence—that is to say, a culture which is made by white-collar workers for white-collar workers, and which most white-collar workers regard as cul-

ture."[7] Joseph Roth is correct in his recent claim in these pages that the writer's task is not to transfigure, but to unmask.[8] Thus, we may say that the author of *Die Angestellten* has approached Berlin in a brilliant manner. That is not the least important achievement of this important book. At a time when the first signs of an active affection for the capital have begun to show themselves, we now see people starting to track down its failings. In his monumental work *Das steinerne Berlin*, Werner Hegemann has produced a political history of the tenement and explained its roots in landed property.[9] This is now followed by Kracauer's account of offices and pleasure palaces as the expression of the mentality of white-collar workers—a mentality that reaches deep into the private sector. Kracauer has also just taken up the post of Berlin correspondent for the *Frankfurter Zeitung*. It is good for the city to have its enemy within the walls. Let us hope that it will know how to silence him. In what way? Well, by making use of him in its own best interests.

Published in *Die literarische Welt*, May 1930. *Gesammelte Schriften*, III, 226–228. Translated by Rodney Livingstone.

Notes

1. Kracauer, *Die Angestellten*, p. 21.
2. Abraham a Sancta Clara (1644–1709) was a south German Catholic who became the most prominent preacher of his day. His sermons, mostly delivered in Vienna, were addressed to ordinary people and were famous for their earthy wit, their wealth of puns and metaphors, and their rhetorical power.
3. Luna Park was a fairground built in Berlin on reclaimed land at the end of the newly extended Kurfürstendamm. It has since become a generic term for "fairground."
4. Kracauer, *Die Angestellten*, p. 129.
5. Kracauer's novel of the time of the Great War, *Ginster von ihm selbst geschrieben* (Ginster Written by Himself), appeared anonymously in 1928. Benjamin was certainly aware that the debt to which Kracauer referred was to himself.
6. Wehrle is a character in Ibsen's play *The Wild Duck*.
7. Kracauer, *Die Angestellten*, p. 20.
8. A reference to Joseph Roth's article "Schluss mit der 'neuen Sachlichkeit'!" (Enough of the "New Objectivity"!), which appeared in *Die literarische Welt* in January 1930.
9. Werner Hegemann (1881–1936) was a German city planner and journalist. *Das steinerne Berlin: Geschichte der grössten Mietskasernenstadt der Welt* (Berlin in Stone: The History of the World's Biggest Tenement-City) appeared in early 1930. Hegemann's anti-Nazi activities forced him to flee Germany in 1933, initially for Prague and Paris, and finally for New York City.

Food

Fresh Figs

No one who has never eaten a food to excess has ever really experienced it, or fully exposed himself to it. Unless you do this, you at best enjoy it, but never come to lust after it, or make the acquaintance of that diversion from the straight and narrow road of the appetite which leads to the primeval forest of greed. For in gluttony two things coincide: the boundlessness of desire and the uniformity of the food that sates it. Gourmandizing means above all else to devour one thing to the last crumb. There is no doubt that it enters more deeply into what you eat than mere enjoyment. For example, when you bite into mortadella as if it were bread, or bury your face in a melon as if it were a pillow, or gorge yourself on caviar out of crackling paper, or, when confronted with the sight of a round Edam cheese, find that the existence of every other food simply vanishes from your mind.—How did I first learn all this? It happened just before I had to make a very difficult decision. A letter had to be posted or torn up. I had carried it around in my pocket for two days, but had not given it a thought for some hours. I then took the noisy narrow-gauge railway up to Secondigliano through the sun-parched landscape. The village lay in still solemnity in the weekday peace and quiet. The only traces of the excitement of the previous Sunday were the poles on which Catherine wheels and rockets had been ignited. Now they stood there bare. Some of them still displayed a sign halfway up with the figure of a saint from Naples or an animal. Women sat in the open barns husking corn. I was walking along in a daze, when I noticed a cart with figs standing in the shade. It was sheer idleness that made me go up

to them, sheer extravagance that I bought half a pound for a few soldi. The woman gave me a generous measure. But when the black, blue, bright green, violet, and brown fruit lay in the bowl of the scales, it turned out that she had no paper to wrap them in. The housewives of Secondigliano bring their baskets with them, and she was unprepared for globetrotters. For my part, I was ashamed to abandon the fruit. So I left her with figs stuffed in my trouser pockets and in my jacket, figs in both of my outstretched hands, and figs in my mouth. I couldn't stop eating them and was forced to get rid of the mass of plump fruits as quickly as possible. But that could not be described as eating; it was more like a bath, so powerful was the smell of resin that penetrated all my belongings, clung to my hands and impregnated the air through which I carried my burden. And then, after satiety and revulsion—the final bends in the path—had been surmounted, came the ultimate mountain peak of taste. A vista over an unsuspected landscape of the palate spread out before my eyes—an insipid, undifferentiated, greenish flood of greed that could distinguish nothing but the stringy, fibrous waves of the flesh of the open fruit, the utter transformation of enjoyment into habit, of habit into vice. A hatred of those figs welled up inside me; I was desperate to finish with them, to liberate myself, to rid myself of all this overripe, bursting fruit. I ate it to destroy it. Biting had rediscovered its most ancient purpose. When I pulled the last fig from the depths of my pocket, the letter was stuck to it. Its fate was sealed; it, too, had to succumb to the great purification. I took it and tore it into a thousand pieces.

Café Crème

No one who has his morning coffee and rolls served up to him in his room in Paris on a silver platter, together with little pats of butter and jam, can know anything at all about it. You have to have it in a bistro where, among all the mirrors, the *petit déjeuner* is itself a concave mirror in which a minute image of this city is reflected. At no other meal are the tempi so varied, from the mechanical gesture with which the clerk sitting at the bar downs his café au lait, to the contemplative relish with which a traveler slowly empties his cup in the interval between trains. You may be sitting next to him—at the same table, on the same bench—yet be worlds away from him, absorbed in your own thoughts. You sacrifice your morning sobriety in order to have a little something. And what don't you have along with your coffee! The entire morning, the morning of this day, and sometimes also the missed mornings of life. If you had sat at this table as a child, countless ships would have sailed across the frozen sea of the marble table-top. You would have known what the Sea of Marmara looks like. With your gaze fixed on an iceberg or a sail, you would have swallowed one mouthful for your father and one for your uncle and one for your brother, until slowly the cream would have

come floating up to the thick rim of your cup, a huge promontory on which your lips rested. How feeble your sense of revulsion has become! How quickly and hygienically you behave now! You drink; you don't crumble up your bread, or dunk it. You sleepily reach out to the breadbasket for a madeleine, break it in two, and do not even notice how sad it makes you not to be able to share it.

Falernian Wine and Stockfish

Fasting is an initiation into many secrets, not least the secrets of food. And if hunger is the best cook, fasting is the king of cooks. I made its acquaintance one afternoon in Rome, after wandering from one fountain to the next and clambering up one flight of steps after another. On my way home at around four o'clock, I found myself in Trastevere, where the streets are wide and the houses shabby. There were plenty of places to eat along the way. But I was on the lookout for a shaded room, a marble floor, snow-white linen, and silver cutlery—the dining room of a large hotel where at this hour I would have some prospect of being the solitary guest. The riverbed was dried out, and dust clouds passed over the Tiber island. Finding myself on the other side, I went down the Via Arenula. I did not count the *osterie* I left behind. But the hungrier I grew, the less inviting or even approachable they appeared. In one place I shied away from the customers, whose voices reached me out in the street; in another I recoiled from the dirtiness of the curtain billowing in the doorway. Finally, I even crept furtively past the more remote bars, so certain was I that a single glance would only increase my distaste. In addition, and quite apart from my hunger, my nerves felt increasingly on the alert; no place seemed safe enough for me, no food clean enough. Not that I was indulging in fantasies of the most exclusive delicacies—caviar, lobsters, or snipe. On the contrary, only the simplest, most basic foods would have seemed pure enough. I felt that here was an unrepeatable opportunity to unleash my senses into the folds and gorges of the most unassuming raw fruit and vegetables, melons, wine, ten varieties of bread or nuts, so as to identify a scent I had never before known. It had turned five o'clock by the time I found myself in a broad, uneven cobbled square, the Piazza Montanara. One of the narrow passages that led into the square seemed to me to point me in exactly the right direction. For by now I had decided that my best course of action was to go back to my room and buy something to eat nearby. At this moment I was struck by the light in a window, the first of the evening. It was an *osteria*, and the lights had been turned on earlier there than in the shops and houses. In the window a solitary guest could be seen. He was just standing up to settle his bill. It suddenly occurred to me that I had to take his place. I entered and sat down

in a corner. Whereas a moment before I had been immeasurably choosy and indecisive, now I suddenly no longer minded where I sat. A waiter asked me merely how much I wanted to drink; there appeared to be no choice of wine. I began to feel lonely, and so I brought out my magic little black rod which had so often conjured up that bouquet of letters with the name in the middle, and which caused the scent that was now merged with the aroma of the Falernian wine to be wafted over to me in my solitude. And I became absorbed in all that—the bouquet, the name, the scent, and the wine—until a noise made me look up. The room had filled up. With workmen from nearby who came after work to eat their evening meal away from home, bringing their wives and even their children, many of them. For they were eating as well as drinking, and what they ate was cured stockfish, the only dish that was served here. I looked down and saw that there was a plateful of the same fish in front of me and a shudder of disgust ran down my spine. I then took a closer look at the people. They were the sharply defined, closely knit inhabitants of the neighborhood, and because it was a petty-bourgeois population, there was no one to be seen from the upper classes, let alone any foreigners. My clothes and appearance must have made me stand out. But curiously, no one glanced in my direction. Did no one notice me, or did I seem, as I sat there more and more immersed in the sweetness of the wine, to be one of them? A feeling of pride overcame me at this thought—a great sense of happiness. Nothing should henceforth distinguish me from the crowd. I put away my pen. As I did so, I felt something rustle in my pocket. It was the *Impero,* a Fascist newspaper that I had picked up on my walk. I ordered another carafe of Falernian wine, opened the paper, wrapped myself up in the dirty cloak it provided, lined with the events of the day, much as the Madonna cloaked herself in the mantle of the stars, and slowly put one piece of dried fish after another into my mouth until the pangs of hunger had been stilled.

Borscht

It starts by spreading a mask of steam over your features. Long before your tongue touches the spoon, your eyes have started to water and your nose is dripping with borscht. Long before your insides have gone on the alert and your blood has become a single wave that courses through your body with the foaming aroma, your eyes have drunk in the red abundance in your bowl. They are now blind to everything that is not borscht, or its reflection in the eyes of your table companion. It's sour cream, you think, that gives this soup its rich texture. Perhaps. But I have eaten it in the Moscow winter, and I know one thing: it contains snow, molten red flakes, food from the clouds that is akin to the manna that also fell from the sky one day. And

doesn't the warm flow soften the pieces of meat, so that it lies inside you like a ploughed field from which you can easily dig up the weed Sadness by the root? Just leave the vodka next to it, untouched; do not start to cut up the piroshkis. It is then that you will discover the secret of the soup that alone among foods has the ability to satisfy you gently. It gradually pervades you entirely, while with other foods a sudden cry of "Enough!" abruptly causes a shudder to pass through your entire body.

Pranzo Caprese

She had been the Capri village cocotte, and was now the sixty-year-old mother of little Gennaro, whom she beat when she was drunk. She lived in the ocher-colored house in a vineyard on the steep mountainside. I came looking for my girlfriend, to whom she was renting the house. From Capri came the sound of the clock striking twelve. There was no one to be seen; the garden was empty. I reclimbed the steps I had just come down. Suddenly I could hear the old woman close behind me. She stood in the kitchen doorway dressed in a skirt and blouse, discolored items of clothing which you'd have searched in vain for any stains, so evenly, so uniformly was the dirt spread over them. "Voi cercate la signora. E partita colla pìccola."[1] And she was due back shortly. But this was just the start: it was followed by a flood of inviting words uttered in her shrill, high-pitched voice, accompanied by rhythmic movements of her imperious head, which decades previously must have had provocative power. I would have had to be an accomplished gentleman to decline her offer, and I was not even able to express myself in Italian. So much was comprehensible: it was an invitation to share her midday meal. I now caught sight of her wretched husband inside the cottage, taking something out of a dish with a spoon. She now went up to this dish. Immediately afterward, she reappeared in the doorway with a plate, which she held out to me without interrupting her flow of speech. I found myself bereft of the remnants of my ability to understand Italian. I felt instantly that it was too late for me to take my leave. From amid a cloud of garlic, beans, mutton fat, tomatoes, and onions, there appeared the domineering hand from which I took a tin spoon. I am sure you are thinking that I would have choked on this nauseating swill and that my sole thought would be to vomit it all up again as quickly as possible. How little you would understand of the magic of this food, and how little I understood it myself up to the moment I am describing now. To taste it was of no importance. It was nothing but the decisive yet imperceptible transition between two moments: first between the moment of smelling it, and then of being overwhelmed, utterly bowled over and kneaded, by this food, gripped by it, as if by the hands of the old whore, squeezed, and having the juice rubbed into me—

whether the juice of the food or of the woman, I am no longer able to say. The obligation of politeness was satisfied and so was the witch's desire, and I went on up the mountain enriched by the knowledge of Odysseus when he saw his companions transformed into swine.

Mulberry Omelette

I shall tell the following story for all those who would like to try figs or Falernian wine, borscht or a peasant meal in Capri. Once upon a time there was a king who could call all the power and the treasures of the earth his own, but who for all that was not happy and who became more and more despondent from one year to the next. One day he summoned his personal cook and said to him, "You have served me faithfully for many a year and have filled my table with the most marvelous foods, and I am well disposed toward you. Now, however, I wish to make a final trial of your art. You shall prepare for me a mulberry omelette just like the one I enjoyed fifty years ago in my childhood. At that time, my father was at war with his evil neighbor to the east. His neighbor had won and we had to flee. And so we fled day and night, my father and I, until we came to a dark forest. We wandered around in it and were close to perishing from hunger and exhaustion, when at long last we spied a hut. An old woman lived there and cordially bid us rest, while she busied herself at the hearth. It was not long before the mulberry omelette stood before us. Scarcely had I put the first bite in my mouth than I was overcome by a wonderful feeling of solace and new hope. In those days I was still a child, and it was not until long afterward that the memory of the blissful taste of that precious dish came back to me. But when, later on, I had my whole empire combed in search of the old woman, she was nowhere to be found, nor was there anyone who knew how to cook the mulberry omelette. If you are able to satisfy this last wish, I shall make you my son-in-law and heir to my empire. But if you are unable to gratify my desire, you shall die." The cook replied, "If that is so, Your Majesty, you should summon the executioner without delay. Of course I know the secret of the mulberry omelette and all the ingredients that are required, down to the common cress and the noble thyme. I also know the words you have to say while stirring, and know that you have to whisk the boxwood beater from left to right, for fear that otherwise all the labor will prove to have been in vain. But for all that, O King, I shall still forfeit my life. Despite all my efforts, my omelette would not taste right to you. For how could I spice it with all the tastes you enjoyed in it on that occasion: the dangers of battle, the vigilance of the pursued, the warmth of the hearth and the sweetness of rest, the strange surroundings and the dark future." Thus spake the cook. The king remained silent for a while, but not long

afterward he is said to have allowed him to retire from his service, richly laden with gifts.

Published in the *Frankfurter Zeitung,* May 1930. *Gesammelte Schriften,* IV, 374–381. Translated by Rodney Livingstone.

Notes

1. "You are looking for the lady. She is out with the little girl."

Bert Brecht

There is always an element of dishonesty when someone sets out to talk in a serene, unbiased, objective manner about living writers. Not only a personal dishonesty, and perhaps even less a personal one than a scientific one—although nobody can avoid being affected by the atmosphere surrounding a contemporary, which may take a thousand different forms, hardly any of which are under his conscious control. This does not at all imply that when tackling such a subject you can just let yourself go and seek your fortune in a vague succession of associations, anecdotes, and analogies. On the contrary, if literary history proves inadequate to the task, criticism is the appropriate form. And as a form it is all the more rigorous, the more it distances itself from a facile tone of superiority and instead engages resolutely with the topical aspects of a writer's work. In the case of Brecht, for example, it would be folly to ignore the risks inherent in his work, the question of his political attitude, or even his so-called plagiarisms. To do so would be to deny oneself access to the nature of his work. In order to unpack these matters, it is more important to convey an idea of his theoretical convictions, his way of talking, or even his outward appearance than to reel off a list of his works in chronological sequence and give an account of their content, form, and public reception. It is for this reason that we do not scruple here to take his latest book as our starting point, a blunder no doubt for a literary historian, but all the more apposite for a critic as this latest work—which is called *Versuche* [Experiments] and has been published in Berlin by Kiepenheuer—is one of his most refractory, and compels us to make a frontal assault on the entire phenomenon of Brecht.[1]

If we were to invite the author as bluntly as he treats his own characters

to make a statement about the nature of his commitment, we would hear him say, "I refuse to exploit my talent 'freely'; I exploit it as educator, politician, and organizer. There is no criticism of my literary activities—'plagiarist,' 'troublemaker,' or 'saboteur'—that I would not adopt for my unliterary, anonymous, yet systematic efforts and regard as a badge of honor." However this may be, it is certain that Brecht belongs to the very small minority of contemporary German writers who ask *where* they ought to apply their talents, who apply them only where they are convinced of the need to do so, and who abstain on every occasion that does not meet this standard. The *Versuche* are such chosen points at which Brecht applies his talents. What is new about them is that these points of application emerge there in their full significance; the writer takes leave of his *Works* for their sake, and, like an engineer who starts drilling for oil in the desert, he starts operations in carefully calculated sites in the desert of the present day. Such sites are the theater, the anecdote, and the radio—others are to be added at a later date. "The publication of the *Versuche*," the author begins, "takes place at a time when certain works are intended less as individual experiences (or as possessing the character of finished 'works') than as a means of using (transforming) certain institutes and institutions." Instead of proclaiming reform, he plans innovations. Literature here no longer expects anything from a feeling on the part of the author, other than one in which the will to change this world has allied itself to sobriety. It is fully aware that its only chance is to become a by-product in a highly ramified process designed to change the world. That is what it is here. An invaluable by-product. The principal product, however, is a new attitude. Lichtenberg says, "It is not a person's convictions that matter, but what they make him."[2] In Brecht's case, this "what" is his "stance" [*Haltung*]. This is something new, and what is new about it is that it can be learned. "The second *Versuch*, the *Geschichten vom Herrn Keuner* [Stories of Herr Keuner], represents an attempt to make gestures quotable." But it is not just Keuner's stance which is quotable; that of the pupil in *Der Flug der Lindberghs* [The Lindberghs' Flight] is, with some practice, no less so, as is also that of the egoist Fatzer. And what is quotable about them is not just their stance, but also the words that accompany them. Yet these words need to be practiced—that is to say, first noticed, and then understood. They have first a pedagogical effect, then a political one, and last a poetic one.

These few remarks give you—perhaps in an overly compressed form—all the important motifs in Brecht's work, and after this run-up we have probably earned the right to take a breather. "Breather" here means a pause to take a general view of the figures he has created, focusing on one or another in whom the author's intentions may be seen to their best advantage. I would like to give pride of place to the already-mentioned Herr Keuner, who first appears in Brecht's latest work. We need not inquire where his name origi-

nates. Let us assume with Lion Feuchtwanger, one of Brecht's former collaborators, that it is based on the Greek root χοινός [*choinós*]—the universal, that which concerns all, belongs to all.[3] And in fact, Herr Keuner is the man who concerns all, belongs to all, for he is the leader. But in quite a different sense from the one we usually understand by the word. He is in no way a public speaker, a demagogue; nor is he a show-off or a strongman. His main preoccupations lie light-years away from what people nowadays understand to be those of a "leader." The fact is that Herr Keuner is a thinker. I can remember Brecht once envisaging how Keuner might make his entrance on the stage. He would be brought in on a stretcher, because a thinker does not go to any pains. He would then follow—or perhaps would not follow—the events on the stage in silence. For it is symptomatic of so many situations today that the thinker is unable to follow them. His entire stance will prevent our confusing this thinker with Greek sages—the strict Stoics or the life-enjoying representatives of the school of Epicurus. He is rather more akin to Paul Valéry's character Monsieur Teste: a purely thinking man without any emotions. Both characters have Chinese features. They are infinitely cunning, infinitely discreet, infinitely polite, infinitely old, and infinitely adaptable. Herr Keuner, however, differs entirely from his French counterpart in that he has a goal he never forgets for a single minute. This goal is the new state. A state that has literary and philosophical foundations as deep as those of Confucius. But—abandoning the Chinese analogy—we may say that we can also discern Jesuitical features in Herr Keuner. This is anything but an accident. The more closely we analyze the types created by Brecht (we shall follow up our discussion of Herr Keuner with an examination of two other characters), the more clearly it emerges that for all their vigor and vitality, they represent political models, or, as the doctors would say, phantoms. What they all have in common is the desire to bring about rational political actions that spring not from philanthropy, love of one's neighbor, idealism, nobility of mind, or the like, but only from the relevant attitude. This attitude may be essentially dubious, unsympathetic, or self-interested. If only the man it belongs to does not delude himself, if only he clings fast to reality, the attitude will itself provide its own corrective. Not an ethical corrective: the man does not become any better. But a social one: his behavior makes him useful. Or, as we read elsewhere in Brecht: "'All vices are good for something,' / said [Baal], 'Only the man who practices them isn't.'"[4]

Herr Keuner's vice is cold and incorruptible thought. What is this good for? It is good for bringing people to the point where they become clear about the assumptions that have led them to the so-called leaders, the thinkers or politicians, their books or speeches, and then to subject these assumptions to as thorough a criticism as possible. It will turn out to be a whole bundle of assumptions that will all fall apart once you have loosened

the string that binds them together. The string of fixed opinion: somewhere or other, people are certainly thinking—we can rely on this. Notables who have the right posts, and are paid for it, will think for everyone else, are conversant with the relevant procedures, and are permanently occupied in disposing of the doubts and obscurities that remain. If you were to deny this, if you could prove that this is not the case, the public would undoubtedly be overcome by a certain anxiety. Because it might run the risk of having to think for itself. Now, Herr Keuner concentrates his attention on showing that the plethora of problems and theories, theses and world views, is a fiction. And the fact that they all cancel each other out is neither accidental nor grounded in thought itself; rather, it is grounded in the interests of the people who have placed the thinkers in their posts.—Does this mean, the public will now want to know, that thinking corresponds to specific interests? Doesn't thought stand above all interests?—At this point, the public will undoubtedly start to feel uneasy. If people think in the service of specific interests, who will guarantee that these are the interests of the public? And with this the knot is untied and the bundle of assumptions falls apart, transforming itself into sheer question marks. Is thinking worthwhile? Should it be of use? What benefit is it in reality? And to whom?—Blunt questions all of them, no doubt. But we, or so says Herr Keuner, have nothing to fear from blunt questions; we have our most refined answers ready to hand for those blunt questions. For this is the nature of our relationship to these other people. They understand how to pose subtle and sophisticated questions, but they swamp the sewers of their questions with the tidal sludge of their answers—that unfiltered wealth which is beneficial for a few and detrimental to almost everyone. We, on the other hand, pose down-to-earth questions. But we let the answers through only if they have been screened three times over. Precise, clear answers in which the attitude of the speaker, as well as the substance of what is said, becomes transparent. So much for Herr Keuner.

This Herr Keuner is, as we have noted, the most recent of Brecht's characters. No sudden leap of logic is required for us to pass on to one of his earliest. You may perhaps remember that I spoke of the risks attached to Brecht's work. They are to be found in Herr Keuner. If he is a daily guest of the writer, he must inevitably—or so we must hope—encounter other visitors who are very unlike himself, and who will banish the dangers he brings with him. And in fact he meets Baal, Mack the Knife, Fatzer, and the entire horde of hooligans and criminals who people Brecht's plays and who above all are the true singers of his songs, the songs that have been collected in the astounding *Hauspostille* [Book of Family Devotions]. This entire business of songs and rowdiness goes back to Brecht's youth, to his life in Augsburg, where, in the company of his friend and collaborator Caspar Neher[5] and others, he traced the motifs of his later plays in strange melodies

and uncouth, heartrending refrains. It is this world that gave birth to Baal, the drunken poet and murderer, and finally, as well, to the egoist Fatzer. It would be a great mistake to suppose, however, that these characters interested the author only as a warning. Brecht's true interest in Baal and Fatzer goes much deeper than this. They do indeed stand for egoism, for the asocial. But Brecht's constant effort is to describe these asocial figures and hooligans as virtual revolutionaries. What sways him in this is not just his own personal sympathy with this character type, but also a theoretical element. Marx, we may say, set himself the task of showing how the revolution could arise from its complete opposite, capitalism, without the need for any ethical change. Brecht has transposed the same problem onto the human plane: he wants the revolutionary to emerge from the base and selfish character devoid of any ethos. Just as Wagner produced a homunculus in a test tube from a magic brew, so Brecht hopes to produce the revolutionary in a test tube from a mixture of poverty and nastiness.[6]

For my third example, I have chosen Galy Gay. He is the hero of a comedy, *Mann ist Mann* [A Man's a Man].[7] No sooner has he walked out his own door to buy a fish for his wife, than he meets some soldiers belonging to the Anglo-Indian army who have lost the fourth man in their unit while plundering a pagoda. They all have an interest in finding a substitute as quickly as possible. Galy Gay is a man who is unable to say no. He follows the three of them without knowing what they want with him. Bit by bit, he assumes possessions, thoughts, attitudes, and habits of the kind needed by a soldier in a war. He is completely reassembled, ceases to recognize his wife when she comes looking for him, and ends up as a dreaded warrior and the conqueror of the fortress of Sir El Dchowr. The nature of this transformation is explained in the following statement:

Herr Bertolt Brecht maintains: A man's a man.
And this is something anyone can say.
But Herr Bertolt Brecht goes on to prove
That you can make as much of a man as you want.
This evening you'll see a man assembled like a car,
Without his losing anything by it.
The man is humanly approached;
He will be asked calmly, but with force,
To follow the world and its ways
And to let his private fish go for a swim.
Herr Bertolt Brecht hopes you will see the ground on which you stand
Melt beneath your feet like snow
And will learn from the packer Galy Gay
That it's easy in life to go astray.[8]

The process of reassembling which we learn of in this passage—we have already heard Brecht proclaim it as a literary form. What he writes is not a

"work" but an apparatus, an instrument. The higher it stands, the more capable it is of reshaping, dismantling, and transforming. The study of the great canonical literatures, Chinese literature above all, has shown him that the supreme claim which can be made of the written word is that of its quotability. This suggests that we may find here the beginnings of a theory of plagiarism that will speedily reduce the quipsters to silence.

Anyone who wants to define the crucial features of Brecht in a few words could do worse than confine himself to the comment that Brecht's subject is poverty. How the thinker must make do with the few applicable ideas that exist; the writer, with the few valid formulations we have; the statesman, with the small amount of intelligence and energy man possesses: this is the theme of his work. "What they have made," the Lindberghs say of their machine, "must be enough for me."[9] Stick closely to the bare reality: this must be our watchword. Poverty, Herr Keuner thinks, is a form of mimicry that allows you to come closer to reality than any rich man can. This, of course, is not Maeterlinck's mystical view of poverty. Nor is it the Franciscan idea that Rilke has in mind when he writes, "For poverty is a great light from within."[10] This Brechtian poverty is more like a uniform and is calculated to confer a high rank on anyone who wears it. It is, in short, the physiological and economic poverty of man in the machine age. "The state should be rich; man should be poor; the state should be obliged to do much; man should be permitted to do little." This is the universal human right to poverty as Brecht has formulated it. He has explored its potential in his writings and has displayed it in public in his own slight, ragged appearance.

We will not offer any conclusions, but will just break off. You can, Ladies and Gentlemen, follow up these observations with the assistance of any good bookshop, but even more thoroughly without one.

Talk broadcast by Frankfurter Rundfunk, June 1930. *Gesammelte Schriften*, II, 660–667. Translated by Rodney Livingstone.

Notes

1. Bertolt Brecht, *Versuche 1–3* (Berlin: Kiepenheuer, 1930).
2. Georg Christoph Lichtenberg (1742–1799), writer and experimental psychologist. Although Lichtenberg was a feared satirist in his time, he is remembered today as the first great German aphorist. More than 1,500 pages of notes were published posthumously; alongside jokes, puns, linguistic paradoxes, and excerpts from other writers, they contain thousands of memorable aphorisms like this one.
3. Lion Feuchtwanger (1884–1958), a prominent German novelist, was best-known for his historical novel *Jud Süss* (Jew Süss; 1925). He collaborated with Brecht

on a translation of Christopher Marlowe's play *Edward II*. He was exiled in 1933 and spent the remainder of his life in California.

4. Bertolt Brecht, *Brechts "Hauspostille," mit Anleitungen, Gesangsnoten und einem Anhange* [Brecht's "Book of Family Devotions," with Instructions, Notes on the Songs, and an Appendix] (Berlin: Propyläen-Verlag, 1927), p. 117.

5. Caspar Neher (1897–1962), a prominent stage designer, was a close friend of Brecht's from their youth. Among many other projects, he designed the sets for Brecht's *Threepenny Opera* and *Man Is Man;* and the opera *Mahagonny,* by Brecht and Kurt Weill.

6. The Wagner referred to is Faust's assistant. The experiment referred to is performed in Goethe's *Faust, Part II*, Act 2, Laboratory.

7. Bertolt Brecht, *Mann ist Mann* (Berlin: Propyläen-Verlag, 1926).

8. Ibid., p. 62.

9. Brecht, *Versuche*, p. 6. Brecht's play *Der Flug der Lindberghs* (The Lindberghs' Flight) was first published and performed in 1929.

10. Rainer Maria Rilke, *Das Stundenbuch* (The Book of Hours), section 3: "Von der Armut und vom Tode" (Concerning Poverty and Death).

The First Form of Criticism That Refuses to Judge

I

The first form of criticism that refuses to judge. The initial task is to present the critic's own subjective viewpoint. In connection with the experience of reading. Sealsfield: there is nothing more beautiful than lying on a sofa and reading a novel.[1] The speechlessness of the great physiognomist. Read the highest achievements of traditional physiognomy. Very insistent on this. Then, however, objective truth as the antithesis to this subjective view. That is to say, Goethe's insight that classical works do not really allow for their criticism. Imperative to try to interpret this sentence. Various attempts: for example, that since classical works are the foundations of our judgments, they cannot be made its objects. But this is extremely superficial. Rather deeper: that the exegesis, the ideas, the admiration and enthusiasm of past generations have become indissolubly part of the works themselves, have completely internalized them and turned them into the mirror-images of later generations. Or something along these lines. And here, at this highest stage of the investigation, it is vital to develop the theory of the quotation— since hitherto quotation has been discussed only under the rubric of technique. What emerges at this highest stage is that strategic, polemical, scholastic criticism and an exegetical, commentating form of criticism are antitheses that sublate each other [*sich aufheben*] and merge in a criticism whose sole medium is the life, the ongoing life, of the works themselves.

II

Even though criticism must be divorced from literary history, the exclusive focus on the new and the topical must be no less lethal. Indicate that this

theory of criticism as a manifestation of the life of works has a connection with my theory of translation.

Fragment written June 1930 or later; unpublished in Benjamin's lifetime. *Gesammelte Schriften*, VI, 170–171. Translated by Rodney Livingstone.

Notes

1. Charles Sealsfield (pseudonym of Karl Anton Postl; 1795–1864) was a Czech-German novelist and journalist who emigrated to the United States in 1823. His novels, written in English and in German, show a keen awareness of social crisis and economic change.

From the Brecht Commentary

Bert Brecht is a difficult phenomenon. He refuses to make "free" use of his great literary gifts. And there is not one of the slurs leveled against his style of literary activity—"plagiarist," "troublemaker," "saboteur"—that he would not claim as a compliment to his unliterary, anonymous, yet noticeable activity as educator, thinker, organizer, politician, and theatrical producer. In any case, he is unquestionably the only writer writing in Germany today who asks himself where he ought to apply his talent, who applies it only where he is convinced of the need to do so, and who abstains on every occasion that does not meet this standard. The writings assembled under the title *Versuche 1–3* are such points of application of his talent.[1] The new thing here is that these points emerge in their full importance; that the author, for their sake, takes temporary leave of his *Works* and, like an engineer starting to drill for oil in the desert, takes up his activity at precisely calculated places in the desert of the present day. Here these points are situated in the theater, the anecdote, and radio; others will be engaged at a later stage. "The publication of the *Versuche*," the author begins, "marks a point at which certain works are not so much meant to represent individual experiences (that is, to have the character of finished works) as they are aimed at using (and transforming) certain institutes and institutions." What is proposed here is not renovation but innovation. Here literature no longer trusts any feeling of the author's which has not, in the desire to change the world, allied itself with sober intelligence. Here literature knows that the only chance left to it is to become a by-product in the highly ramified process of changing the world. *Versuche 1–3* is such a by-product, and an inestimable one; but the principal product is a new attitude. Lichtenberg said: "It is not what a man is convinced of that matters, but what his convictions make

him." This thing that a man's convictions make him Brecht calls "attitude." "The second *Versuch, Geschichten vom Herrn Keuner* [Stories of Herr Keuner]," says the author, "represents an attempt to make gestures quotable." Anyone who reads these stories will see that the gestures quoted are those of poverty, ignorance, and impotence. The innovations introduced—patents, so to speak—are only small ones. For Herr Keuner, a proletarian, stands in sharp contrast to the ideal proletarian of the humanitarians: he is not interiorized. He expects the abolition of misery to arrive only by the logical development of the attitude which poverty forces upon him. Herr Keuner's attitude is not the only one that is quotable; the same applies to the disciples in *Der Flug der Lindberghs* [The Lindberghs' Flight], and likewise to Fatzer the egoist. In each case what is quotable is not just the attitude but also the words which accompany it. These words, like gestures, must be practiced—which is to say, first noticed and later understood. They have their pedagogical effect first, their political effect second, and their poetic effect last of all. The purpose of the commentary from which a sample is reproduced below is to advance the pedagogical effect as much as possible and to retard the poetic one.

I

Leave your post.
The victories have been gained. The
 defeats have been gained:
Now leave your post.

"The defeats have been gained . . . ": less by him, Fatzer, than for him. The victor must not allow the defeated the experience of defeat. He must snatch this, too; he must share defeat with the defeated. Then he will have become master of the situation.

Plunge back into the depths, conqueror.
Jubilation resonates where the fighting
 was.
Be no longer there.
Expect the cries of defeat where they
 are loudest:
In the depths.
Leave your old post.

"Plunge back . . . ": "No glory to the victor, no pity for the defeated." Pokerwork inscription on a wooden plate, Soviet Russia.

Withdraw your voice, orator.
Your name is wiped off the tablets.
 Your orders
Are not obeyed. Allow
New names to appear on the tablets
 and
New orders to be carried out.

"Allow . . . ": Here a harshness bordering on cruelty is permeated with courtesy. The courtesy is persuasive because one senses why it is there. It is there to

(You who no longer command
Do not incite to disobedi-
 ence!)
Leave your old post.

You were not up to it.
You did not finish it off
Now you have had experi-
 ence and are up to it
Now you can start:
Leave your post.

induce the weakest and most worthless
creature (to put it quite simply, man, in
whom we recognize ourselves) to
perform the greatest and most important
action of all. It is the courtesy inherent
in the act of sending a rope to someone
committing hara-kiri, an act whose
wordlessness still leaves room for pity.

"Now you can start . . . ": The "start"
is dialectically made new. It manifests
itself not in a fresh beginning but in a
cessation. The action? The man must
leave his post. Inward beginning =
ceasing to do an outward thing.

You who ruled over offices
Stoke your oven.
You who had no time to eat
Cook yourself soup.
You about whom much is written
Study the ABCs.
Make a start at once:
Take up your new post.

"You who ruled . . . ": this is to
emphasize the forces which the Soviet
practice of moving officials around the
various ministries releases in the person
concerned. The command "Start all over
again" means, in dialectical terms: (1)
learn, for you know nothing; (2) occupy
yourself with fundamentals, for you
have grown wise enough (through
experience) to do so; (3) you are weak;
you have been relieved of your post.
Take it easy now, so that you can get
stronger; you have the time for it.

One who is beaten does not escape
Wisdom.
Hold on tight and sink! Be afraid! Go
 on, sink! At the bottom
The lesson awaits you.
You who were asked too many ques-
 tions
Receive now the inestimable
Teaching of the masses:
Take up your new post.

"Go on, sink!": Fatzer must find a
foothold in his hopelessness. A foothold,
not hope. Consolation has nothing to do
with hope. And Brecht offers him
consolation: a man can live in
hopelessness if he knows how he got
there. He can live in it because his
hopeless life is then of importance. To
sink to the bottom here means always:
to get to the bottom of things.

II

The table is finished, car-
penter.
Allow us to take it away.
Stop planing it now
Leave off painting it
Speak neither well nor ill of it:
We'll take it as it is.
We need it.
Hand it over.

"Carpenter . . . ": The carpenter we
have to imagine here is an eccentric who
is never satisfied with his "work," who
cannot make up his mind to let it out of
his hands. If writers are taking
temporary leave of their *Works* (see
above), then statesmen, too, are
expected to show the same attitude.
Brecht tells them: "You are amateur
craftsmen; you want to make the State
your *Work* instead of realizing that the
State is supposed to be not a work of art,
not an eternal value, but an object of
practical use."

You have finished, statesman.
The State is not finished.
Allow us to change it
To suit the conditions of life.
Allow us to be statesmen, statesman.
Beneath your laws stands your name.
Forget the name
Respect your laws, legislator.

Submit to order, man of order.
The State no longer needs you
Hand it over.

"Hand it over": Here is what "the
Lindberghs" say of their machine: "The
thing they made will have to do for us."
Keep hard by hard reality: that is the
order of the day. Poverty, so the bearers
of knowledge teach, is a mimicry which
brings the poor man closer to reality
than any rich man can ever be.

Published in the *Literaturblatt der Frankfurter Zeitung,* July 1930. *Gesammelte Schriften,*
II, 506–510. Translated by Anna Bostock.

Notes

1. Bertolt Brecht, *Versuche 1–3* (Berlin: Kiepenheuer, 1930).

Against a Masterpiece

Max Kommerell, *Der Dichter als Führer in der deutschen Klassik* [The Poet as Leader in German Classicism]: *Klopstock, Herder, Goethe, Schiller, Jean Paul, Hölderlin* (Berlin: Georg Bondi, 1928), 486 pages.

If there were such a thing as a German conservatism worth its salt, it would have to regard this book as its Magna Carta. But none has existed for eighty years now. Hence, we are probably not far from the truth if we say that Kommerell is unlikely to have received a more comprehensive critique than this one, which comes from another direction. This book provides the critic with one of those rare and memorable occasions when no one questions him about the book's quality, its stylistic form, or the author's qualifications. We have no reservations about any of these things. Seldom has literary history been written like this: with the diverse approaches, the sharp-edged, impenetrable surface of that symmetrical, adamantine certitude which we have long since come to recognize as the George school's Black Stone of Kaaba.[1] From the praise of blood, the contempt for music, and the hatred of the mob, down to the love of young boys, there is not a single motif that is not invoked either aloud or in a whisper, and that has not grown in importance since we last encountered it. The critical maxims, the sense of values that even in Gundolf's[2] writings had been wheeled out in mastersinger style have here been thrown on the scrap heap, or rather melted down in the heat of an experience that can afford to renounce the hieratic separation of life and work because it approaches both with the same physiognomic and—in the strictest sense—unpsychological mode of seeing. For this reason, almost everything we find here about individual writers—not so much about themselves per se as about their friendships, feuds, meetings, and separa-

tions—is characterized by its singular precision and boldness. As is so often the case in horoscopes, chiromantic texts, and other esoteric writings, the wealth of authentic anthropological insights is astounding. Stefan George's theory of the hero should be counted among these occult disciplines. Here it throws light on the principal figures in the Weimar court of the Muses— sometimes on a prophetic aspect, other times on a Pan-like aspect, still others on a satyr-like or centaur-like aspect. You become aware of just how at ease the classical writers were on horseback.

What is the source of this dynamism in figures that so easily tend to lapse into the poses struck by their own monuments? The author does not confine himself to what has actually happened; he even uncovers what *didn't* happen. This does not mean that he invents it—say, as a vision. Rather, he simply and clearly discovers it—namely, as something that in truth did not actually happen. His picture of the past emerges against the background of what might have been, and it is against this background that what actually happened casts its shadow. It is in keeping with this that nothing aims at effects and highlights, and that the offbeat and the obscure detail seem to have been most consummately shaped. In this book, the great controversies have been reproduced for the first time—Jacobi's with the younger writers, Herder's with the Weimar Goethe, Schiller's with the Schlegels, Klopstock's with the king[3]—and it is in interaction with them that the friendships of the classical period acquire their firm contours. It can be neither expected nor desired that the historian of these controversies should abstain from taking sides. But the judgments that are made are symptomatic of the book and its hidden intention. Nothing happens by chance here, but few things are more illuminating than the annihilation of the two Schlegels in their confrontation with Schiller. It would be absurd to ask for "historical justice" here. Other things are at stake. Romanticism stands at the origin of that rebirth of German lyrical poetry accomplished by George. It stands also at the inauguration of the philosophical and critical development that has turned against that achievement today. Looked at strategically, to nudge Romanticism into the background is no idle enterprise, still less a guileless one. By denying the origins of its own attitudes, Romanticism simultaneously denies the forces that proliferate from its core. The Classicism we learn about here is a late and very statesmanlike discovery of the George circle. It is no accident that a student of Wolters has been the one to undertake the task.[4] Every dialectical analysis of George's poetry will have Romanticism at its heart, while every orthodox hagiography will be best advised to downplay Romanticism as much as possible.

And in fact, with a radicalism unattained by any of its predecessors in the George circle, this book constructs an esoteric history of German literature. Only the *profanum vulgus* will see this as literary history at all; in reality, it is a salvation history of the Germans. A history that is enacted in



encounters, alliances, testaments and instructions, and that risks collapsing at every moment into the apocryphal, the ineffable, and the meretricious. A theory of true Germanness and the inscrutable paths of the ascent of Germany revolves, pregnant with the future, around the affinity between the genius of the Germans and that of the Greeks. Germans are the heirs to the mission of Greece; that mission is the birth of the hero. It goes without saying that this understanding of the Greeks has been wrenched from every historical context and inserted into a mythological force field. Nor is it mere coincidence that Kommerell echoes, albeit faintly, a famous passage in a letter of Hölderlin's about the spirit of Greece and Germany—a passage in which he calls for a patriotic literature that is imbued with the tradition of the tribe and at the same time inwardly stands at the opposite pole from it, and in which he declares that shame is the surest seal of its authenticity.[5] Words that give some idea of the culture that has set in motion the forces working here toward the twilight of the Teutonic gods. For runes, interpretation, eons, blood, fate[6]—now that Lechter's sun,[7] which once bathed them in its glow, has gone to its resting place, they all stand there like so many thunderclouds in the sky. It is they who give us the lightning flashes that serve as signposts according to which—in the words of Florens Christian Rang, the profoundest critic of the cult of the Teutonic since Nietzsche— "the night only embroiders us more darkly: this monstrous world view of universal death, instead of universal life."[8] How feeble, though, and how long-winded is the rhetorical thunder that follows! It booms throughout all the books of the George circle. It does not exactly win friends for its teachings; its arguments fail to carry conviction if you feel that the speakers never run out of breath. "The fact is that all preachers and propagandists— even if they are recruiting for the purest cause and preaching of nothing but love—leave you feeling empty because they treat everyone, even the richest man, as so much fodder for their intentions."—Something of this insight, which Kommerell formulates so magisterially and which Goethe was destined to learn from Lavater, is transmitted to the reader by Kommerell's own book.[9] The longer you read it, the more his image of Hellas fades in the dazzling light of a morning "in which youth senses the birth of a new nation in glowing unity and in the clanking of arms that were hitherto buried all too deeply." "Our word 'hero,'" we read in another passage, "has not yet passed through this reality . . . But something not yet real surrounds the word: if neighboring peoples borrow their word for 'hero' from the Greeks, it is *we* who possess the organic word-stem, and hence the claim to the thing it names. But if hero becomes demigod, who would then shy away from the hardest hammer and the hottest forge of our future fate?"

Grandiloquent imagery? Not at all. It is the clanking of steel runes, the dangerous anachronism of sectarian language. This book can be fully understood only by close observation of the relationship of the sects to history.

For them, history is never a subject of study; it is only an object of their claims. They attempt to coopt the past as the seal of their origins or as paradigm. In this instance, German Classicism becomes their model. The preeminent concern of the author is to construe Classicism as the first canonical German insurrection against time—a holy war of the Germans against the century, as George himself later proclaimed. It would be one thing to argue this thesis; another, to investigate whether this campaign was successful; a third, to discover whether it was truly paradigmatic. For the author, all these things are inseparable, but the third one has pride of place. In other words, he regards the campaign as paradigmatic, and hence declares it victorious; ultimately, he loses no sleep over its object, the position of the warring parties. But what is their position? Are we justified in reducing this complex process—a process that is, as Goethe shows, oppressive in its complexity—to the interplay and conflict between the heroic and the banal? There is heroism enough among the classical writers, but in itself it was anything but heroic. Its stance was one of resignation. And only Goethe proved able to sustain it to the end without being broken by it. Schiller and Herder were destroyed by it. And those who remained outside Weimar— Hölderlin not the least of them—hid their heads from this "movement." Goethe's opposition to his age was that of a born leader of conservative tendencies. Yet what he wished to restore stemmed not from any classical past but from a geological antiquity of pristine power—indeed, from the most ancient natural relations themselves. For his part, Schiller constructed his opposition in historical terms. His conservatism was a matter of moral sensibility, and far removed from any fundamental spontaneity. Kommerell knows all this as well as anyone. But it means nothing to him. It is as if Antiquity, and indeed the whole of history, had come to an end with Napoleon, the last hero.

The greatness of this book is of course wholly bound up with such anachronisms. For it revives the great Plutarchan style of biography once more. At the same time, Kommerell's distance from the more recent, fashionable form of biography as practiced by Emil Ludwig is even greater than from Gundolf's history of the poets.[10] Plutarch presents his heroes to the reader pictorially, even paradigmatically, but always externally. Ludwig attempts to interiorize them, for the sake of the reader, but even more for the sake of the writer. He incorporates them into himself; he consumes them, and nothing remains. This is the secret of their success: they provide every reader with an "inner Goethe," an "inner Napoleon." Yet just as it has been wittily but correctly claimed that there are few people who have not at some point in their lives just missed becoming a millionaire, we may also say that most people have not lacked the opportunity to become great men. Ludwig's cleverness consists in his ability to lead the reader back over slippery paths to these turning points, and to show them that their worn-out, colorless

existence really has the great format of a heroic life. When Kommerell evokes the image of Goethe, it does not even breathe the same air as the reader, let alone share his mood. Thus, while giving an account of Goethe's early years, Kommerell can grant *Der Wanderer und seine Gesellen* [The Wanderer and His Companions] the status of a commentary on *Dichtung und Wahrheit* [Poetry and Truth]. To think of Goethe's early years as a process of coming to terms with contemporary forms of leadership is more than illuminating. Here we find the basis for his discussion of the poet's relationship with Karl August [duke of Weimar], which Kommerell has declared to be the exemplary case of education and personality formation in Goethe, and whose influence he still detects in Goethe's relations with Napoleon and Byron—a passage that ranks among the few inspired pieces that have been written about Goethe's life. No one will expect the relationship between the ruler and the poet to be given a historical treatment here, rather than a timeless, mythological one, nor will anyone call for a description of the specificities of the German state around 1780. What Kommerell provides is sufficient. The tone in which Schelling addresses the old Goethe in his letters is marked by such respect that it takes your breath away; even death failed to lift any of its burden. In such passages the "interpretation" has undergone an inversion and, at the pinnacle of its boldness and success, has achieved a simple, objective, incorruptible reading. This author collects lived hours the way another might collect antiques. Not that he talks about them; you see them because of the knowing, exploratory, reverent, involved, testing, inquiring way he turns each around in his hand, examining it from every side, conferring on it not the false life of empathy but the true life of tradition. Closely related to this is the author's own bent: that of a collector. For whereas with the systematic thinker the positive and negative are always cleanly separated, worlds apart from each other, here preferences and antipathies lie close together. The author picks out a single poem from a cycle, a single moment in an existence, and he makes very sharp distinctions between people and ideas that seem very closely related.

The extent of Kommerell's inability to venture a "redemption" of Classicism is best seen in the chapter "Legislation." Not for nothing does it show how absolutely we are estranged from what provided Goethe with his revelation of classical art on his Italian journey; it reveals just how much rococo lies concealed even in Goethe's work and how unacceptable are the model works of art on which he based his criticism, even if that criticism itself still stands up. Kommerell's picture of Classicism, insofar as it is of permanent value, lives on the basis of the claim to authority he recognizes in it. But the impotence of that claim is as much a part of that picture as its title. "To this day," the author writes, "the average educated person has failed to understand completely the essential features of Weimar culture, and his beggar's pride seeks to cover his shameful nakedness with the theological,

philosophical, musical cloak that consists in declaring he is unconcerned about physical appearance." If this is true—and it is true—Weimar Classicism must contain great scope for misunderstanding, not to say ambiguity, at its heart. Scope for misunderstanding—to such a frightening degree that when the philistines resolutely turned their backs on the most precious heritage of the nation, they did so in the name of Schiller, and that it required a Nietzsche to raise doubts about the possibility of reconciling the spirit of Weimar and that of Sedan.[11]

It is consistent only if the author's concluding remarks about Classicism are consigned to the realms of destiny and the stars:

> Thus, we were endowed with a destiny difficult to decipher, more so than any other nation: dual authority and a dual moment, an open one and a secret one. The destruction of Hölderlin by the spirit of the age—although coinciding with this in terms of strict chronology—comes into a different eon: his moment is no less valid, but has a different focal point from Goethe's, and Jean Paul's dream figures appear anemic only until their terrestrial brothers actually tread our soil. All this amazing activity took place in Germany within two decades; and in our heavens can be seen, simultaneously, the sun, a dawn, and the eternal stars.

This is true, beautiful, and important. Nevertheless, confronted by this openly flowery—passionately flowery—gaze, we must declare our preference for the unvarnished truth, for a laconic conception of the seminal, of fertility; and this means opting for the realm of theory and bidding farewell to the world of "vision" [*Schau*]. If images are timeless, theories certainly are not. It is not tradition but their vitality that determines their worth. The authentic image may be old, but the authentic idea is new. It is of today. Admittedly, this "today" may be paltry. But whatever form it takes, our task is to seize it by the horns so that we can interrogate the past. It is the bull whose blood must fill the grave if the spirits of the departed are to appear at its edge. It is this deadly thrust of ideas that is absent from the works of the George circle. Instead of offering up sacrifices to the present, they avoid it. Every critique must contain some militant element; it, too, knows the daemon of battle. A critique that is nothing but vision loses its way, and deprives literature of the interpretation it owes it, and of the right to grow. Nor should we forget that if criticism is to achieve anything, it must absolutely affirm its own claims. Perhaps it must even claim the highest rank for itself—as do the Brothers Schlegel in their theories. Such claims are worlds away from this author. In his view, the critic is "forever denied the creative innocence of the artist." The disciple of Stefan George cannot admit the carefree verity that innocence never preserves creativity, but that creativity constantly produces innocence.

This salvation history of the Germans concludes with a chapter on

Hölderlin. The image of the man that unfolds here is a fragment of a new life of the saints, and can no longer be assimilated into any historiography. Its almost unbearably dazzling contours lack any of the shading or nuance that theory might have provided. But this is not its purpose. Kommerell's intention was to erect a warning about the future of Germany. Overnight, ghostly hands will write a sign saying "Too Late!" in huge letters. Hölderlin was not of the breed that is resurrected, and the country whose seers proclaim their visions over corpses is not his. This land can become Germany once again only when it is purified, and it cannot be purified in the name of Germany—let alone the "secret Germany" that ultimately is nothing but the arsenal of official Germany, in which the magic hood of invisibility hangs next to the helmet of steel.[12]

Published in *Die literarische Welt*, August 1930. *Gesammelte Schriften*, III, 252–259. Translated by Rodney Livingstone.

Notes

1. "George school" refers to the circle of conservative intellectuals around the poet Stefan George (1868–1933), whose high-modernist verse appeared in such volumes as *Das Jahr der Seele* (The Year of the Soul; 1897), and *Der siebente Ring* (The Seventh Ring; 1907). George's attempt to "purify" German language and culture exerted a powerful influence on younger poets. The Kaaba is the building in the Great Mosque at Mecca that houses the Black Stone, a meteorite that was the object of worship before Muhammad.
2. Friedrich Gundolf (pseudonym of Friedrich Gundelfinger; 1880–1931) was a prominent literary critic, a professor at Heidelberg, and a disciple of Stefan George. For Benjamin's attacks on Gundolf, see the essays "Comments on Gundolf's *Goethe*" and "Goethe's Elective Affinities" in Volume 1 of this edition.
3. Friedrich Heinrich Jacobi (1743–1819) was a novelist of the late Enlightenment whose best-known work is *Woldemar* (1779). Johann Gottfried von Herder (1744–1803), philosopher, historian, and theologian, first met Goethe in Strasbourg in the 1770s; he later became the court pastor in Weimar. Friedrich Gottlieb Klopstock was the most important lyricist of the eighteenth century before Goethe. His lyrical odes, composed between 1747 and 1780, remain widely influential.
4. Friedrich Wolters (1876–1930) was a German historian and an early member of George's circle.
5. Benjamin alludes here to Hölderlin's often-cited letter to his friend Böhlendorff, dated December 4, 1801.
6. Benjamin parodies the cult of old Germanness (a cult embraced by the George school) by using a series of archaic words that purport to evoke the Teutonic spirit.
7. Melchior Lechter (1865–1937), German painter and book illustrator, was the

member of the George school charged with overseeing the first editions of George's works.

8. Florens Christian Rang, *Deutsche Bauhütte: Ein Wort an uns Deutsche über mögliche Gerechtigkeit gegen Belgien und Frankreich und zur Philosophie der Politik* [German Master-Builder's Huts: A Word to Us Germans on the Possibility of Justice toward Belgium and France and on the Philosophy of Politics] (Leipzig: Eberhard Arnold, 1924), p. 51. Rang, a conservative intellectual, was one of Benjamin's most important conversational partners in the mid-1920s.

9. Johann Kaspar Lavater (1741–1801), preacher and theorist of physiognomy, was befriended by Goethe in 1794; Goethe broke off the relationship in 1786 and ridiculed his former friend in *Faust*, returning to a more balanced assessment only in *Dichtung und Wahrheit*.

10. Emil Ludwig (pseudonym of Emil Cohn; 1881–1948) blended empirical research and fictional narration in his popular biographies; his highly successful biography of Goethe appeared in 1920.

11. Marking the end of the first phase of the Franco-German war, the Battle of Sedan on September 1, 1870, led to the capture and fall of Napoleon III and the proclamation of a new French Republic.

12. The George circle thought of itself as the "secret Germany" that upheld properly German values against the onslaught of modernity. The slogan lasted down to the bomb plot of Count Stauffenberg against Hitler, and beyond.

Myslovice—Braunschweig—Marseilles

The Story of a Hashish Trance

This story is not mine. Whether the painter Eduard Scherlinger (whom I saw for the first and last time the evening he told it) was a great storyteller or not is not a matter I wish to enlarge on, since in this age of plagiarism there are always listeners prepared to ascribe a story to you when you have insisted that you are only reporting it faithfully. Nevertheless, this is a story I heard one evening at Lutter and Wegener's, one of Berlin's few classic locations for storytelling and listening. We were a small party, sitting comfortably at a round table, but the conversations had long since dried up and carried on only fitfully, in an undertone, in groups of two or three that paid no attention to each other. At one point (I never learned in what context), my friend Ernst Bloch, the philosopher, let fall the remark that there was no one who had not at some point in his life just missed becoming a millionaire. People laughed. They thought this was just one of his paradoxes. But then the conversation took a strange turn. The more we considered his remark, debating its pros and cons, the more each of us in turn began to take it seriously, until each person arrived at the point where he had come close to getting his hands on the millions. A number of curious stories then came to light, among them this one by the late lamented Scherlinger. I reproduce it here, as far as possible in his own words.

"Following my father's death," he began, "I inherited a not insignificant sum of money, and hastened to make arrangements for my departure for France. I was particularly fortunate to be able to go to Marseilles before the end of the 1920s, since that was the home of Monticelli,[1] to whom I owe everything in my art, not to mention all the other things that Marseilles symbolized to me at the time. I had left my funds invested in a small private bank that had advised my father to his satisfaction for decades on end, and

whose junior director was, if not a close friend, at any rate someone with whom I was very well acquainted. Furthermore, he was emphatic in agreeing to keep a watchful eye on my capital; should a favorable opportunity to invest it arise, he would notify me immediately. 'The only point to remember,' he said, 'is that you must leave us a code name.' I looked at him blankly. 'We can carry out instructions per telegram only if we are able to protect ourselves against fraud. Suppose that we wire you and the telegram falls into the wrong hands. We can protect ourselves against the consequences by agreeing on a code name with you—a name you would use instead of your own for transmitting instructions by telegraph.' I understood, but was momentarily in some perplexity. It is not so easy to slip suddenly into a strange name as if it were a costume. There are countless thousands available; the realization that they are all arbitrary has a paralyzing effect, but even more paralyzing is the feeling—an almost unconscious feeling, scarcely capable of articulation—that the choice is irrational but may have grave consequences. Feeling like a chess player who is in a difficult situation and would rather not move at all, but who is finally forced to make a move, I said, 'Braunschweiger.' I knew no one of this name, and had never been to the town from which it derives.

"Around noon on a sultry day in July, I arrived at Saint-Louis Station in Marseilles after a four-week interlude in Paris. Friends had recommended the Hotel Regina, close to the harbor. I left myself just enough time to make sure I obtained a room, tried out the bedside lamp and the taps, and set out to explore. Since this was my first visit to the town, I faithfully followed my old rule for travelers. Unlike average tourists—who, as soon as they arrive in a city, begin hanging awkwardly around the alien city center—I make it my policy to head straight for the suburbs so as to learn my way around the outskirts. I soon discovered the rightness of this principle in the case of Marseilles. Never had the first hour been as profitable as the one I spent in and among the inner port and dock installations, the warehouses, the poorer neighborhoods, the scattered refuges of the destitute. The outlying districts represent, in fact, a town in a state of emergency; they are the terrain upon which the great decisive battles between town and country are continuously being fought out. These battles are nowhere more bitter than between Marseilles and the Provençal countryside. It is the hand-to-hand combat of telegraph poles with agaves, barbed wire with prickly palms, the stench of steamed-up corridors with the damp, sycamore-lined, brooding squares, short-winded flights of steps with overbearing hills. The long rue de Lyon is the road Marseilles blasted through the landscape, exploding it into Saint-Lazare, Saint-Antoine, Arenc, and Septèmes, burying it in the clouds of shrapnel created by the languages of every nation and business concern: Alimentation Moderne, Rue de Jamaïque, Comptoir de la Limite, Savon Abat-Jour, Minoterie de la Campagne, Bar du Gaz, Bar Facultatif. And over

everything hang dust clouds comprising an amalgam of sea salt, lime, and mica. From there the road goes on to the most distant quays, which are used only by the largest oceangoing liners, beneath the piercing rays of the slowly setting sun, between the battlements of the Old Town on the left and the bare hills or quarries on the right, down to the towering Pont Transbordeur, which closes off the rectangular Old Port resembling a huge town square that the Phoenicians[2] had reserved for the sea. Up to now, I had followed my path quite alone amid the most densely populated suburbs. But from this point on, I found myself caught up in the procession of celebrating sailors, dockworkers returning home, and housewives out for a stroll, all interspersed with children, which wended its way past the bazaars and cafés, disappearing finally in the side streets, with only the occasional sailor or *flâneur,* such as myself, persevering to the great central artery, La Canebière, the center of commerce, the stock exchange, and tourism. Right through the bazaars, the mountain range of souvenirs extends from one end of the port to the other. Seismic forces have created this massif of paste, seashells, and enamel in which inkwells, steamers, anchors, mercury thermometers, and sirens are all jumbled together. To my mind, however, the pressure of a thousand atmospheres, beneath which this entire world of images crowds together and rears up and then arranges itself, appears to be the same force embodied in the sailors' calloused hands which fumble women's breasts and thighs after a long voyage; and the lust that brings forth a red or blue velvet heart from the geological world and fixes it to the little boxes made of seashells, so that it can be used as a pincushion, is the same force that reverberates through the streets on payday. Preoccupied with such thoughts, I had long since left La Canebière behind me; without really noticing much, I found myself walking beneath the trees of the allée de Meilhan, past the barred windows of the cours Puget, until at last chance, which was still guiding my steps on my first visit to the town, led me to the passage de Lorette, the town mortuary, the narrow courtyard where in the sleepy presence of a number of men and women the whole world seemed to shrink into a single Sunday afternoon. I was overcome by a feeling of sadness, like the sadness I love to this day in the light in Monticelli's paintings. I believe that, at such moments, the stranger experiences something that normally only the long-standing inhabitants can discern. For it is childhood that is able to seek out the sources of sadness and to understand the mournful side of such celebrated and radiant cities; it is necessary to have lived in them as a child.

"It would be a fine piece of romantic embroidery," Scherlinger said with a smile, "if I were to go on and describe how I landed up in some disreputable harbor dive and obtained some hashish from an Arab who worked in the boiler room of a freighter, or who was perhaps a porter. But such embroidering would be of no use to me, since I was probably closer in spirit

to those Arabs than to the tourists whose journeys led them to such dives. Closer in one respect at least, since I carried my own hashish with me on my travels. I do not believe that what induced me to take some hashish at around seven o'clock in the evening, upstairs in my room, was the unworthy desire to escape my depressed mood. It is more likely that this was an attempt to yield entirely to the magic hand with which the city had gently taken hold of me by the scruff of the neck. As I have said, I was not a novice when it came to using poison; but whether it was my almost daily feelings of homesickness, or the paucity of human contact and the uncongenial localities, never before had I felt myself so at home in the community of cognoscenti whose records of their experiences—from Baudelaire's *Paradis artificiels* to Hermann Hesse's *Steppenwolf*—were perfectly familiar to me.[3] I lay on my bed, read, and smoked. Through the window opposite me, far below, I could see one of the narrow black streets of the port district that intersect the body of the city like the marks of a knife. I was thus able to enjoy the absolute certainty that I could surrender to my dreams quite undisturbed in this city of hundreds of thousands in which not a single soul knew of my existence. But the expected effects failed to appear. Three-quarters of an hour had already passed, and I began to feel suspicious about the quality of the drug. Or had I been carrying it around for too long? Suddenly there was a loud knock at my door. I was completely baffled. I was frightened out of my wits, but made no attempt to open the door, and instead asked who it was, without even changing my position. The servant: 'A gentleman wishes to speak to you.'—'Let him come up,' I said; I did not have the courage, or perhaps just the presence of mind, to ask his name. I stood where I was, leaning against the bedpost with my heart palpitating, and staring at the open door until a uniform appeared. The 'gentleman' was a telegram boy.

"'Advise purchase of 1,000 Royal Dutch STOP Friday opening price STOP Wire approval.'

"I looked at my watch; it was eight o'clock. An urgent telegram would reach the Berlin branch of my bank first thing the following morning. I dismissed the messenger with a tip. I felt my mood alternate between anxiety and irritation. Fear of having to deal with a business matter, a chore, at precisely this time; irritation because the drug was still not working. The wisest course seemed to me to set out for the main post office at once, since I knew it was open until midnight for telegrams. In view of my adviser's reliability in the past, I had no doubt that I should agree to his suggestion. On the other hand, I was afraid that the hashish might start to work after all and that I might forget my code name. It was better to waste no time.

"As I went downstairs, I thought about the last time I had taken hashish—it had been several months previously—and how I had been unable to

still the pangs of hunger that had suddenly overwhelmed me late one night in my room. It seemed advisable to buy a bar of chocolate. In the distance a shopwindow beckoned, with candy jars, shiny tinfoil wrapping, and piles of beautiful *pâtisserie*. I entered the shop and was pulled up short. There was no one to be seen. But I was less struck by this than by the very strange chairs that compelled me to admit for good or ill that in Marseilles people drank chocolate while enthroned on high chairs that bore a remarkable resemblance to the chairs used to perform operations. At that moment the owner came running from across the street wearing a white coat, and I had just time enough to decline, with a loud laugh, his offer of a shave or a haircut. Only now did I realize that the hashish had begun to work, and if I had not been alerted by the way in which boxes of powder had changed into candy jars, nickel trays into chocolate bars, and wigs into cakes, my own loud laughter would have been warning enough. For the trance always begins with such laughter, or sometimes with a less noisy, more inward, but more joyful laugh. And now I recognized it by the infinite tenderness of the wind that was blowing the fringes of the curtains on the opposite side of the street.

"Then the hashish eater's demands on time and space came into force. As is well known, these are absolutely regal. For anyone who has taken hashish, Versailles is not too large, nor eternity too long. Against the background of these immense dimensions of inner experience, of absolute duration and immeasurable space, a wonderful beatific humor dwells all the more fondly on the limitless contingencies of all existence. Moreover, my steps became light and sure, so that the stony, uneven ground of the great square I was crossing seemed like the surface of a main road along which I strode at night, like an energetic hiker. At the end of this huge square, however, was an ugly, symmetrical hall-like building, with an illuminated clock over the door: the post office. I can say now that it is ugly; at the time, I would not have conceded this. Not just because we do not wish to hear of ugliness when we have taken hashish, but primarily because the post office aroused a profound feeling of gratitude in me—this gloomy building, waiting expectantly for me, its every nook and cranny ready to receive and transmit the priceless confirmation that would make me a rich man. I could not take my eyes off it; indeed, I felt how much would have escaped me if I had approached too closely and lost sight of the building as a whole and especially the welcoming beacon of its moon-like clock. At that moment I could hear the chairs and tables of a little bar, a truly disreputable one no doubt, being moved around in the darkness. I was still quite far away from dangerous districts, but even so, there were no middle-class customers; at most, alongside the proletarians were a few local shopkeepers' families. I went and sat down in the bar. It was the riskiest thing of this kind I could contemplate, and in my trance I estimated the danger with the same accuracy

you display when you are very tired and try to fill a glass of water to the brim without spilling a drop—something you would never manage to do when you're in full control of your senses. But scarcely had the hashish felt me relax than its magic began to have an effect, with an elemental sharpness I have never experienced before or since. It turned me into a physiognomist. I am normally quite unable to recognize people I know only slightly, or to retain people's features in my memory. But on this occasion I positively fixed my gaze on the faces around me, faces I would normally have had a twofold reason to avoid. On the one hand, I would not have wished to attract their gaze; and on the other, I would have been unable to endure the brutality of their expressions. I suddenly understood how for a painter (isn't this the case with Leonardo and many others?) ugliness is the true reservoir of beauty, better than any treasure chest; it was a fissured mountain, with its entire inner deposits of gold flashing through wrinkles, glances, and features. I particularly recollect the unpleasant, infinitely bestial face of one man: I was deeply shaken when I suddenly perceived the 'furrow of resignation' in it. It was men's faces above all that interested me. Now began that game in which every new face seemed to be the face of someone I knew; often I knew his name, often not. The illusion faded again, as illusions do fade away in such dream states—that is to say, not with a feeling of shame, of indiscretion, but peaceably and amicably, like a being that has done its duty. The face of my neighbor, however—a petty bourgeois to judge by his appearance—kept changing in shape, expression, and fullness. His haircut and black-rimmed glasses gave him, by turns, a severe and a good-humored expression. Of course, I told myself that a man could not change so quickly, but it made no difference. And he had already experienced much of life when he suddenly changed into a high school boy in a tiny eastern European town. He had a pretty, cultivated study-room. I wondered how this young man could have acquired so much culture. What did his father do? Was he a cloth merchant? Corn trader? Suddenly, I realized that this was Myslovice.[4] I looked up. And then I saw, right at the end of the street—in fact, at the end of the town—the high school in Myslovice; and the school clock (had it stopped? it didn't seem to be moving) pointed to shortly after eleven. Classes must have started again. I became completely immersed in this image, but couldn't find firm ground again. The people who had captured my attention just before (or was it two hours before?) seemed to have been completely erased. 'From century to century, things grow more estranged'—this thought passed through my mind. I hesitated to taste the wine. It was a half-bottle of Cassis, a dry wine that I had ordered. A piece of ice was floating in the glass. I do not know how long I gazed at the images within it. But when I next looked up at the square, I saw that it tended to change with each person who entered it, just as if it formed a configuration for him that of course had nothing to do with the way he looked at it, but rather had to do with

the view that the great portrait painters of the seventeenth century create by placing their dignitaries, according to their character, against the background of a colonnade or a window, so that the view is generated by this backdrop.

"I was suddenly aroused with a start from the deepest contemplation. I was completely alert, and was conscious of only one thing: the telegram. It had to be sent off at once. To stay awake, I ordered black coffee. An eternity seemed to pass before the waiter appeared with the cup. I greedily seized it; I smelled the aroma; the cup was almost at my lips, when my hand stopped suddenly—Who could say whether it was automatic or from astonishment? I suddenly saw through the instinctive haste of my arm; I became aware of the beguiling scent of the coffee, and only now recollected what makes this drink the high point of pleasure for every hashish eater—namely, the fact that it intensifies the effect of the drug like nothing else. This is why I wanted to stop, and I did stop in time. The cup did not touch my lips. Nor did it touch the tabletop. It remained suspended in mid-air before me, held by my arm, which began to go numb and clutched it in a rigid grip like an emblem, a sacred stone or bone. My gaze fell on the creases in my white beach trousers, I recognized them, the creases of a burnous. My gaze fell on my hand—I recognized it, a brown, Ethiopian hand. And while my lips stayed firmly sealed, refusing drink and speech in equal measure, from within me a smile rose up to them—a supercilious, African, Sardanapoline smile, the smile of a man about to see through the world and its destinies and for whom nothing remains a mystery anymore, either in objects or in names. Brown and silent, I saw myself sitting there. *Braunschweiger.*[5] The Open Sesame of this name, which was supposed to contain all the riches of the earth in its interior, had opened up. Smiling a smile of infinite compassion, I now began to think for the first time of the Braunschweigers who lived a wretched life in their little central German town, in complete ignorance of the magic powers they possess thanks to their name. At this moment, by way of confirmation, the bells of all the church towers of Marseilles rang out to signal midnight, like a solemn choir.

"It was now dark; the bar was closing. I wandered along the quayside, reading the names of the boats that were tied up there. An incomprehensible feeling of joy came over me and made me smile at the names of the girls of France that appeared in a row: Marguerite, Louise, Renée, Yvonne, Lucile. The promise of love that these boats seemed to have been given along with their names was wonderful, beautiful, and moving. Next to the last one, there was a stone bench: 'Bank,' I said to myself,[6] and felt disapproval that it too did not have its name in gold letters on a black background. This was the last lucid thought I had that night. The next one came from the midday papers, which I read sitting on a bench by the water in the hot noon sun: 'Sensational Rise in Royal Dutch.'

"Never," the narrator concluded, "have I felt so ebullient, clear, and festive after a hashish trance."

Published in *Uhu*, November 1930. *Gesammelte Schriften*, IV, 729–737. Translated by Rodney Livingstone.

Notes

1. Adolphe Monticelli (1824–1886) was a French painter known for his landscapes and his skill as a colorist.
2. Benjamin here confuses the Phoenicians with the Phoceans, a Greek tribe from Asia Minor that established Massilia as a trading post around 600 B.C.
3. Serving as a literary template for Benjamin's own hashish experiments, Baudelaire's essay on opium and hashish was first published in 1860. Hesse's portrayal of psychic fragmentation—understood as the key to a personal authenticity beyond bourgeois convention—appeared in 1927.
4. Myslovice is a town in Silesia about seventy miles southeast of Wroclaw, Poland.
5. Benjamin puns here on the German word *Braunschweig*, whose components mean "brown" and "silent."
6. In German, *Bank* means both "bench" and "bank."

A Critique of the Publishing Industry

Writers are among the most backward sectors of the population when it comes to exploiting their own social experience. They regard one another simply as colleagues; their readiness to form judgments and protect their own interests is, as in all people concerned with status, far prompter toward those beneath them than toward those higher up. They do sometimes manage to obtain a good deal from a publisher. But for the most part they are unable to give an account of the social function of their writing, and it follows that in their dealings with publishers they are no better able to reflect on their function to any effect. There are undoubtedly publishers who take a naive view of their own activities and who genuinely believe that their only moral task is to distinguish between good books and bad, and that their only commercial task is to distinguish books that will sell from those that will not. In general, however, a publisher has an incomparably clearer idea of the circles to whom he is selling than writers have of the audience for whom they write. This is why they are no match for him and are in no position to control him. And who else should do that? Certainly not the reading public; the activities of publishers fall outside their field of vision. This leaves the retailer as the only court of appeal. It is superfluous to remark how problematic retailers' control must be, if only because it is irresponsible and secret.

What is called for is obvious. That it cannot happen overnight, and that it can never be fully implemented in the capitalist economic system, should not prevent us from stating it. As a prerequisite for everything else, what is indispensable is a statistical survey of the capital at work in the publishing world. From this platform, the investigation should proceed in two direc-

tions. On the one hand, as a follow-up to the question: What is the source of these capital sums? In other words, how much capital has migrated into publishing from the banking, textile, coal, steel, and printing industries? On the other hand, what does publishing capital supply to the book market? It would be but a short step from there to combine these questions and investigate whether, when capital flows into publishing, it is directed at specific customer strata and trends that correspond, say, to coal and steel, as opposed to textiles. But the statistical foundations of this third area are too difficult to obtain for there to be any prospects of undertaking such a project soon. In contrast, the more unreliable opinion surveys of the public and of booksellers could easily be supplemented by information gathered at intervals from the publishers themselves about the sales figures in different markets for their main products. Since publishers already inform us about the size of editions, this should not prove to be such a perilous step, or so one might think. Of the very greatest interest, furthermore, would be statistical information about the relation between the size of an edition and advertising costs; likewise, a statistical picture of the relation between commercial success (sales figures) and literary success (critical reception in the press). Last, and the most difficult of all: the percentages of successful books and failures among all the titles issued annually by individual publishers and by the German book trade as a whole.

The objection that such methods would lead to thinking that commercial success is the only criterion relevant to books is as obvious as it is false. Of course, there are valuable books that fail to sell, and that a good publisher will nevertheless wish to sell not only as a matter of honor but on publishing principles. (In the same way, confectioners will put sugar-icing castles and candy towers in their shopwindows without any intention of selling them.) But of course the analysis we are calling for, and which has the additional benefit of being the most reliable method of making use of books to inquire into the spiritual currents of the nation, also has the particular merit of eliminating the most common—and most erroneous—view of publishing in vogue at present. According to this view, a publishing house is a combined operation, consisting of organized patronage on the one hand and a lottery on the other, in which every new book is a number and the reading public acts as banker. From the players' (in other words, the publishers') winnings, a part is used to bet on numbers that look splendid and significant but that scarcely figure in the roulette of the reading public. In short, this is the abstract view of publishing: on the one hand, the publisher as a broker between individual manuscripts; on the other, "the" reading public. But this view is false through and through, because the publisher is not in a position to form an opinion in a vacuum about either the ideal value or the commercial value of a book. In the final analysis, a publisher has to have a close relationship with specific literary fields—within which he does not need to

follow any particular line—because this is the only way for him to maintain contact with his reading public, without which his business is doomed to failure. Obvious though this is, it is no less striking that in Germany, which possesses a number of physiognomically clearly defined publishing houses— Insel, Reclam, S. Fischer, Beck, and Rowohlt—no attempt has ever been made to undertake a sociological study, let alone a critique of these institutions. Yet this would be the only way to measure the gulf that divides our great publishing houses from those dilettantish private operations that disappear every year by the dozen, only to be replaced by similar firms that open up in their wake. Moreover, it would be hard to resist the observation that even the straightforward commercial satisfaction of demand would be, if not exactly laudable, at any rate far more respectable than a pretentious idealism that floods the market with meaningless books, tying up capital in them that could be much better invested for nonliterary purposes.

Only experience will enable us to discover the benefits of an annual critical survey of German publishing policy. Such a critique, in which literary standards would have to take a back seat to sociological ones—which, themselves, would be only one aspect—would lay bare the antinomy between what might be called constructive and organic publishing policies. A publisher may construct his operations so as to encompass and establish certain sectors. But he can also let his business develop organically out of loyalty to particular authors or schools. These two approaches cannot always go hand in hand. This very fact ought to lead a publisher to make a definite business plan and approach writers with specific projects. Not that such an approach is entirely unknown. But in an age in which both economic production and intellectual production have been rationalized, it should become the norm. One reason there is no sign of it at present lies in the general underestimation of the role of publishers' referees. The time when a Julius Elias or a Moritz Heimann could exercise a decisive influence on a publisher appears to be over.[1] But publishers are making a great mistake when they treat their referees merely as gatekeepers or else as naysayers, instead of as experts in publishing policy who are intelligent enough to solicit usable manuscripts rather than merely sifting through useless ones. And for their part, the editors are wrong to set their own idealism against publishers' materialism, instead of treating ideas in such a way that the publisher will be tied to them for the sake of his material interests. It may lend additional weight to these brief proposals if publishers come to see that the leaders among them will benefit more in terms of both honor and profit from a sound criticism of their activities than from a case-by-case opinion of their products or their sense of fair play.

Published in the *Literaturblatt der Frankfurter Zeitung*, November 1930. *Gesammelte Schriften*, II, 769–772. Translated by Rodney Livingstone.

Notes

1. Julius Elias (1861–1927), German historian of art and literature, was a champion of Impressionism and the editor of Ibsen's collected works. Moritz Heimann (1868–1925), senior editor at Fischer Verlag, furthered the careers of such authors as Gerhart Hauptmann, Hermann Hesse, and Thomas Mann.

Graphology Old and New

Today scientific graphology is a good thirty years old.¹ With certain reservations, it can undoubtedly be described as a German achievement; and 1897, when the German Graphological Society was founded in Munich, can be deemed the year of its birth. It is a striking fact that academic science still withholds recognition, even though this technique has been providing proofs of the precision of its principles for the past three decades. To this day, no German university has established a chair for the interpretation of handwriting. But it is worthy of note that one of the free colleges, the Lessing-Hochschule in Berlin, has now taken the step of adopting the Central Institute for Scientific Graphology (under the direction of Anja Mendelssohn). Evidently this fact has also been acknowledged abroad as a milestone in the history of graphology. At any rate, the oldest living representative of this science, Jules Crépieux-Jamin, arrived from Rouen to attend the opening of the institute.² We found him to be an elderly, somewhat unworldly gentleman who at first glance looked like a doctor. An important practical doctor, that is, rather than a pioneering researcher. And this would also be an apt description of Crépieux-Jamin and his disciples' position in graphology. He inherited the mantle of his teacher, Michon, who in 1872 had published his *Geheimnis der Handschrift* [Secret of Handwriting], in which the concept of graphology appears for the first time.³ What teacher and pupil have in common is a sharp eye for handwriting and a large dose of healthy common sense, in conjunction with a gift for ingenious inference. All of this shows to advantage in their analyses, which for their part do more to satisfy the requirements of practical life than those of a science of character. The demands of the latter were first articulated by Ludwig Klages in his fundamental works *Prinzipien der Charakterologie* [The Principles of Characterology] and *Handschrift und Charakter* [Handwriting and Char-

acter].[4] Klages takes aim at the so-called sign theory of the French school, whose proponents linked qualities of character to quite specific written signs that they used as stereotypes on which to construct their interpretations. In contrast, Klages interprets handwriting basically as gesture, as expressive movement. In his writings, there is no talk of specific signs; he speaks only of the general characteristics of writing, which are not restricted to the particular form of individual letters. A special role is assigned to the analysis of the so-called formal level—a mode of interpretation in which all the characteristic features of a specimen of handwriting are susceptible to a dual evaluation—either a positive or a negative interpretation—and where it is the formal level of the script that decides which of the two evaluations should be applied in each case. The history of modern German graphology can be defined essentially by the debates surrounding Klages' theories. These debates have been initiated at two focal points. Robert Saudek criticized the lack of precision in Klages' findings concerning the physiological features of handwriting, as well as his arbitrary preoccupation with German handwriting style.[5] He himself has attempted to produce a more differentiated graphological analysis of the various national scripts, on the basis of exact measurements of handwriting motion. In Saudek, characterological problems recede into the background; whereas in a second trend, which has recently taken issue with Klages, they stand at the center of attention. This view objects to his definition of handwriting as expressive movement. Max Pulver and Anja Mendelssohn, its leading representatives, are seeking to create a space for an "ideographic" interpretation of handwriting—that is to say, a graphology that interprets script in terms of the unconscious graphic elements, the unconscious image fantasies, that it contains.[6] The background to Klages' graphology is the philosophy of life of the George circle, and behind Saudek's approach we can discern Wundt's psychophysics; whereas in Pulver's endeavors the influence of Freud's theory of the unconscious is undeniable.[7]

Published in the *Südwestdeutsche Rundfunkzeitung*, November 1930. *Gesammelte Schriften*, IV, 596–598. Translated by Rodney Livingstone.

Notes

1. Benjamin was himself an amateur graphologist. See also his review of the Mendelssohns' *Der Mensch in der Handschrift*, in this volume.
2. Jules Crépieux-Jamin (1858–1940) was the author of many graphological treatises, including *L'écriture et le caractère* (Handwriting and Character; 1892), which went through numerous editions and was translated into many languages.
3. The abbé Jean Hippolyte Michon (1806–1861) published several studies of graphology, as well as work in other "border zones" such as the psychology of banditry.

4. Ludwig Klages (1872–1956), philosopher and psychologist, attempted to found a "metaphysical psychology" that would study human beings in the context of their relationship to a reality that was, for Klages, made up of archetypal images.
5. Robert Saudek (1880–1935), German novelist, playwright, and graphologist, was the author of *Wissenschaftliche Graphologie* (Scientific Graphology; 1926) and the editor of the American journal *Character and Personality.* His edition of Otto Weininger's notorious *Gedanken über Geschlechtsprobleme* (Thoughts on Sexual Problems) was published in 1907.
6. Max Pulver (1889–1952), Swiss poet, playwright, and graphologist, published his *Symbolik der Handschrift* (Symbolism of Handwriting) in 1931.
7. Wilhelm Max Wundt (1832–1920), German physiologist and psychologist, founded the first laboratory for experimental psychology at Leipzig in 1878.

Characterization of the New Generation

1. These people make not the slightest attempt to base their activities on any theoretical foundations whatsoever. They are not only deaf to the so-called great questions, those of politics or world views; they are equally innocent of any fundamental reflection on questions of art.

2. They are uneducated. Not just in the sense that their knowledge is very limited, but above all because they are incapable of extending their diminishing knowledge in a systematic manner. Never has a generation of writers been so oblivious to the need to understand the techniques of scholarly work as this one.

3. Although these writers stride blithely on from one work to the next, it is impossible to discern any sort of development—and above all any consistency—in their work, except at the level of technique. Their efforts and their ambition seem to exhaust themselves in the acquisition of a new subject or a grateful theme, and this is enough for them.

4. Popular literature has always existed—that is to say, a literature that acknowledges no obligations to the age and the ideas that move it, except perhaps the desirability of presenting such ideas in an agreeable, fashionably packaged form for immediate consumption. Such consumer literature of course has the right to exist; in bourgeois society at least, it has its place and its justification. But never before, in bourgeois or any other society, has this literature of pure consumption and enjoyment ever been identical with the avant-

garde at its technically and artistically most advanced. This is precisely the pass to which the latest school has now brought us.

5. Give respect to economic necessity where it is due: it may well force the writer to produce much inferior work. The nuances of his writing will then show what stuff he is made of. However dubious much literary journalism may be, there is hardly anything so bad that it cannot be salvaged from the worst excesses by certain aspects of its content and especially its style. Where a writer succeeds, he owes it to his grasp of technique; where he fails, it is the moral or substantive foundation that is lacking. What is astonishing is how completely alien to members of the new school the salutary, protecting reservations are—not just the moral ones, but even the linguistic ones too. And how these new writers absolutely take for granted their right to display an infinitely pampered, narcissistic, unscrupulous—in short, journalistic—ego. And how their writing is imbued to the very last detail with the *arriviste* spirit!

Fragment written ca. 1930; unpublished in Benjamin's lifetime. *Gesammelte Schriften*, VI, 167–168. Translated by Rodney Livingstone.

The Need to Take the Mediating Character of Bourgeois Writing Seriously

The need to take the mediating character of bourgeois writing seriously. Such art does indeed blur the distinctions between political and nonpolitical literature, but it ensures that the differences between opportunist writing and radical writing emerge all the more clearly.

It should also be pointed out that in reality even the effect of "unmediated opinion" is indirect—which is true of everything written that has not grown out of political activity. The disadvantage of this involuntary mediatedness: it lacks a clear awareness of which class it is addressing. The advantages of voluntary mediatedness.

The claim to originality that the form of literary journalism imposes on *everyone*.

The New Objectivity and war books.[1]

Originality and, simultaneously, an uninhibited harmlessness is what these fellows lay claim to.

False criticism.

The entire account in this section will be examined in the light of the concept . . .

[Breaks off; continued in the fragment titled "False Criticism."]

Fragment written ca. 1930; unpublished in Benjamin's lifetime. *Gesammelte Schriften*, VI, 174–175. Translated by Rodney Livingstone.

Notes

1. *Neue Sachlichkeit* (New Objectivity) was the term originally applied by the museum curator G. F. Hartlaub to an emergent figuration in German postwar painting. It gradually came to designate the Weimar "period style" in art, architecture, design, literature, and film: cool, objective, and analytical.

False Criticism

The entire account in this section will be examined in the light of the concept of objective corruption and related to present-day conditions.[1]

The distinction between personal criticism and object-based criticism, which is used to bring polemics into discredit, is a principal instrument of objective corruption. The whole prescriptive section reaches its pinnacle in an apologia on polemics. This amounts to the assertion that, in our day, the image of Karl Kraus seems to be that of the only champion of the power and technique of the art of polemics. The precondition of his mastery in polemics is the fact that he attacks people less for what they are than for what they do, more for what they say than for what they write—and least of all for their books, which according to accepted notions of criticism constitute the only object of study. The polemicist engages his entire person. Kraus goes even further. He sacrifices himself. The significance of this should be further developed.

Expressionism as the basis of objective corruption. (Kraus was always intransigently opposed to it.) Expressionism is the mimicry of revolutionary gesture without any revolutionary foundation. In Germany it was overcome only through a change of fashion, not as the result of criticism. This is why all its perversions have managed to survive in a different form in the New Objectivity, which succeeded it. Both movements base their solidarity on their efforts to come to terms with the experience of the war from the standpoint of the bourgeoisie. Expressionism attempts this in the name of humanity; subsequently this was done in the name of objectivity. The works of the latest German writers are milestones on a road from which a left or a right turn can be taken at any moment. They are the works of a caste

between the classes that is at the highest state of alert. This *tendancisme sans tendance,* which has left its mark on literature ever since Expressionism, is best defined by the fact that there are no longer any feuds between literary coteries. Every writer wants to prove only one thing: that he has mastered the latest fashion. This is why the new manifestos are constantly being signed by the old names. Rarely has there been an age in which the old tread so hard on the heels of the young.

No one is claiming that it is essential, or even useful, for criticism to be based directly on political ideas. But this is absolutely indispensable for polemical criticism. The more individually the personal is brought to the fore, the more necessary it is for the critic and his public to agree about the image of the age that serves as backdrop and foil. Every authentic picture of the age, however, is political. The wretched state of criticism in Germany results in the fact that even in the extreme case of Communism, political strategies do not coincide with literary ones. This is the misfortune of critical and perhaps also political thought.

If the personal note predominates in successful polemics, this is merely an extreme instance of the general truth that critical objectivity which can express only individual judgment—from case to case and without any larger conception—is always insignificant. This "objectivity" is no more than the obverse of the haphazard nature and lack of authority of the reviewing business, with which journalism has destroyed criticism.

It is consistent with this objectivity (which could be called "new" but also "unscrupulous") that, in its products, its so-called bona fides always turn out to be no more than the "temperamental" reaction of an "original" critical mind—that uninhibited, unprejudiced being of which bourgeois criticism is so proud, and whose gestural language, obtrusively embodied in Alfred Kerr,[2] is in reality nothing but the servile zeal with which the literary reviewer satisfies the demand for character sketches, temperaments, originals, and personalities. The integrity of the literary reviewer is just a straining for effects; and the deeper his tone of conviction, the more his breath stinks.

The reaction of Expressionism, on the other hand, was pathological rather than critical. It strove to overcome the age that had given birth to it by becoming its expression. The negativism of Dada was much more revolutionary. And down to the Dada movement, there prevailed a far greater solidarity of the German intelligentsia with the French. But whereas in France the Surrealist movement was born, in Germany thought was emasculated and the banner of the New Objectivity was unfurled.[3] The true tendencies of this last movement can be grasped only through a comparison with Surrealism. Both are manifestations of a regression to 1885. On the one hand, a regression to Sudermann; on the other, to Ravachol.[4] At any rate, there is a difference between the two.

"Quand on soutient un mouvement révolutionnaire, ce serait en com-

promettre le développement que d'en dissocier les divers éléments au nom du goût" (Guillaume Apollinaire).[5] With these words, Apollinaire has also condemned the journalistic criticism that continues to speak in the name of taste. For what characterizes the run-of-the-mill reviewing industry is its unrestrained indulgence in its own reactions (the result is the famous "opinion of one's own"), and its pretense that an aesthetics still exists, whereas there has long been none. In truth, the starting point of criticism must be the perception that aesthetic criteria are in all cases completely devalued. Nor can they be resurrected from the old aesthetics by any "updating," however ingenious. On the contrary, criticism must—initially, at any rate—base itself on a program which must be committed to revolutionary politics if it is to tackle the tasks that face it. (Apollinaire's assertion is nothing but a call for such a program.) Even the old aesthetics, such as Hegel's, contained the greatest insights into the contemporary world. But the modern critic thinks of these old conceptual schemes in absolute terms, much as he regards the works.

Attempt to illustrate the genuinely mediated effectiveness of revolutionary writing with reference to the works of Karl Kraus. The conservative semblance of such writing. Since it focuses on the best that has been produced by the bourgeois class, it shows in exemplary fashion that the most valuable things this class has created must be stifled among the bourgeoisie and can be conserved only through a revolutionary stance. But it also teaches that the methods with which the bourgeoisie built up its knowledge will overthrow that knowledge today, if they are applied rigorously and without opportunism.

With the New Objectivity, criticism has finally obtained the literature it deserves.

Nothing characterizes our literature industry better than the attempt to produce a great effect at small cost in terms of effort. Publishers' gambles replace literary responsibility. It is absurd to behave like the writers of the New Objectivity and claim political effects without individual commitment. This commitment may be practical and consist in disciplined action in a political party; it may also be literary and consist in the principled publicity of private life—a polemical omnipresence as practiced by the Surrealists in France and by Karl Kraus in Germany. The left-wing writers practice neither one nor the other. This is why it is important to stop competing with them for the right to own the program of "political literature." For everyone who approaches the mediating character—even more, the mediating effect—of serious bourgeois writing recognizes that the distinctions between political and nonpolitical writing become blurred at this point. Whereas the distinctions between the programs of opportunist and radical writing stand out all the more clearly.

We may say of every approach to art that any analysis which fails to uncover hidden relationships in the work, and hence those that are not

contained in the work, misses the point of the object under scrutiny. To see inside the work means giving a more precise account of the ways in which the work's truth-content and material content interpenetrate. At all events, a form of criticism which at no point establishes its solidarity with the truth contained in the work, and which retains a hold only on externals, has no claim to our recognition. Unfortunately, however, this is the case with almost everything that goes by the name of Marxist criticism. In almost every example, what we find is a thick-skinned tracing out of the lines in the works themselves, where the social content—if not the social tendency—lies partly on the surface. But this leads in no way into the interior of the work—only to statements about it. In contrast, the Marxist's hope that he can look around inside the work with the gaze of the sociologist is doomed to disappointment. A deductivist aesthetic, which no one needs more urgently than the Marxist, has not yet been devised. Only in the interior of the work, where truth-content and material content meet, is the sphere of art definitively left behind. At its threshold, all aesthetic aporias disappear too—the quarrel about form and content, and so on.

The structure of the final section will be grouped around these theses: (1) the works live on; (2) the law governing their survival is that of shrinkage; (3) with the survival of the works, their character as art recedes; (4) a successful form of criticism breaks through the limits of the aesthetic realm; (5) the technique of magical criticism.

Opposition of the categories "totality" (*Gestalt*-quality) and "authenticity."

Fragment written in 1930 or 1931; unpublished in Benjamin's lifetime. *Gesammelte Schriften*, VI, 175–179. Translated by Rodney Livingstone.

Notes

1. Like many of Benjamin's fragments on literary criticism, this one was part of the planning stages for a book on the topic. See the Chronology in this volume.
2. Alfred Kerr (pseudonym of Alfred Klemperer; 1867–1948) was, in his day, Berlin's most prominent and influential theater critic.
3. *Neue Sachlichkeit* (New Objectivity) was the term originally applied by the museum curator G. F. Hartlaub to an emergent figuration in German postwar painting. It gradually came to designate the Weimar "period style" in art, architecture, design, literature, and film: cool, objective, analytical.
4. Hermann Sudermann (1857–1928) was a Naturalist dramatist whose reputation waned rapidly as he turned to symbolism and biblical tragedy. François-Claudius Koenigstein, known as Ravachol (1859–1892), was part of a group of anarchists responsible for a series of bombings; he was guillotined in 1892.
5. "When you support a revolutionary movement, you would compromise its development if you were to dissociate it from certain elements in the name of taste."

Antitheses

CRITICIZABLE		UNCRITICIZABLE	
Primacy of truth-content	{Judgment of taste	Primacy of material content	Table of contents
	Journalism	Inspired	Philistine
Truth-content as model [*Vorbild*]		Material content as primal image [*Urbild*]	Literary history
Gloss	Reaction	Quotation	Source of quotation
Strategic	Mass communication		
Society (Platonic)	Originality	Nature (Goethean)	Convention
Dominant	Presumptive	Serving	Dependent
Polemics (minimum of representation)	Rules}	Representation (minimum of criticism)	Moderation

The negation of criticism that the antithesis expresses is in a sense the position of the work. Commentary represents the dialectical overcoming of

the antinomies in criticism. Only at this stage is the work fully criticizable—and noncriticizable at the same time. Only at this stage, therefore, is criticism the pure function of life, or, as the case may be, of the ongoing life of the work. Only at this stage do quotation and gloss become part of the formal characteristics of criticism. Whereas Goethe's theory coincides in all essentials with a mediated criticism, the relation of Platonic criticism to Romantic criticism remains to be clarified.

Fragment written in 1930 or later; unpublished in Benjamin's lifetime. *Gesammelte Schriften,* VI, 169–170. Translated by Rodney Livingstone.

A Note on the Texts · Chronology, 1927–1934 · Index

The hardcover edition of this book was printed in one volume. For ease of use, the complete Chronology and Index for Parts 1 and 2 of Volume 2 are reprinted here.

A Note on the Texts

Most of the texts included in this second volume of Benjamin's selected writings were published during his lifetime. In the years 1927–1933, Benjamin established himself as a public intellectual in the Weimar Republic; this volume, with its mix of essays, critical glosses, travel writings, reviews, and radio talks, documents that emergence. The volume also offers a rich selection of the form Benjamin had pioneered in *One-Way Street* (reprinted in Volume 1): the "thought figure" [*Denkbild*], a prose form which combines aspects of the aphorism and the Romantic fragment with a decidedly materialist interest in things. Benjamin published dozens of these short texts in the period under scrutiny here. Alongside this array of texts that Benjamin succeeded in publishing, the volume also includes a representative selection of unpublished writings from the period. Some, like the "Introductory Remarks on a Series for *L'Humanité*," are simply parts of projects that were never completed. Others are fragments found in Benjamin's notebooks long after his death; many of these fragments, such as "Mickey Mouse" or "Notes on a Theory of Gambling," articulate important stages and aspects of his thought, and provide much of what we know about Benjamin's ideas on a wide range of topics. But the bulk of these posthumously published texts are autobiographical. They range from résumés through protocols of hashish experiments and on to extensive journals ("Diary of My Journey to the Loire") and intensive self-examination ("Agesilaus Santander").

The German edition of Benjamin's collected writings groups texts generically (volumes of essays, of reviews, of fragments, and so on). In the present volume, all texts are arranged chronologically by date of composition; if this differs markedly from the date of publication, both dates are given. Each text is accompanied by the following information: date of composition; place of publication, or a statement that the piece was unpublished during Benjamin's lifetime; and the word "Fragment" if the text is designated as such in the German edition. All endnotes other than Benjamin's were produced by the editors in collaboration with the translators.

The *Selected Writings* aims to present to English-language readers a very broad and representative selection from Benjamin's oeuvre. Every major text published during Benjamin's lifetime is included in this edition. We have attempted to supplement these major texts with examples of every *form* in which Benjamin worked: thought figures, radio plays, autobiographical writings, book reviews, letter collections, essays, fragments, cultural histories, travel accounts. Examples of each of the remarkable number of *fields* to which Benjamin contributed are likewise included: cultural theory; epistemology; art history; toys; the French avant-garde, especially Surrealism; the new Soviet Union; cinema; radical pedagogy; contemporary writers ranging from André Gide and Julien Green through Karl Kraus and Hugo von Hofmannsthal (to say nothing of Proust and Kafka, the subjects of two of Benjamin's most famous essays); graphology; political and social analysis; media theory; the theory of experience; marginalized popular forms such as novels by the mentally ill and penny romances; photography; and the theory of language. We hope that the English-language reader will for the first time be able to assess the remarkable breadth and intensity of Benjamin's achievement.

All translations are based on the text of the standard German edition: Walter Benjamin, *Gesammelte Schriften,* seven volumes (Frankfurt: Suhrkamp Verlag, 1972–1989), edited by Rolf Tiedemann and Hermann Schweppenhäuser. The editors of the present volume are indebted to Benjamin's German editors for the meticulous dating and preparation of his texts.

The editors would like to thank a number of friends, colleagues, and collaborators who provided information and assistance at crucial stages of the project. Above all, an immense debt of gratitude is due two research assistants, Joel Golb in Berlin and Daniel Magilow in Princeton, whose vigorous research formed the basis for a number of the notes to the text. Eduardo Cadava, Stanley Corngold, Michael Curschmann, James Eggleston, Barbara Hahn, Thomas Levin, Michael Wachtel, and Christian Wildberg answered our questions with patience and generosity. Hans Puttnies gave us his time and energy as we sought to procure images of Benjamin from the period in question. Very special thanks are due our colleagues at Harvard University Press. The idea for an expanded edition of Benjamin's writings came from Lindsay Waters, and without his now patient, now insistent godfathering, the edition would certainly never have been completed. And Maria Ascher, through her consistently insightful and meticulous editing—based on a brilliant ear for the sound of English prose—of the final manuscript, improved not just the texts themselves but the conception and the apparatus of this second volume of the edition.

Chronology, 1927–1934

1927

On New Year's Day Benjamin was in Moscow, where the long winter of the Stalinization of Soviet cultural policy was beginning. He had arrived some three weeks earlier, after learning that the Latvian-born Bolshevik actress and educator Asja Lacis—his "holiday love" from a vacation on Capri—had suffered a nervous breakdown. Benjamin had financed the trip by securing an advance from the journal *Die Kreatur* for an article on Moscow. He found the city in ferment, rundown yet extremely expensive—"an improvised metropolis," as he calls it in the extensive diary he kept during his two-month stay there.[1] A letter written at the end of December reflects his own excitement: "In the current state of affairs, the present—though fleeting—is of extraordinary value. Everything is being built or rebuilt, and almost every moment poses very critical questions. The tensions of public life—which, for the most part, are actually of a theological sort—are so great that they block off all private life to an unimaginable degree . . . It remains to be seen to what extent I'll be able to establish concrete relations with developments here" (*MD*, 127). In this matter of establishing contacts, Benjamin, who did not speak Russian, was almost entirely dependent on the good graces of his Moscow host, the German-born Bernhard Reich, a prominent theater critic then living in Moscow and a rather tolerant rival for the affections of Asja Lacis. (She and Reich would remain together through banishment and imprisonment during the Stalin era, and after the war would write about and produce the plays of Bertolt Brecht.) Benjamin's position as a freelance writer, "without party or profession," was a subject of conversation among his friends in Moscow, and to Reich he admitted that he "was in a critical situation" insofar as his "activity as an author was concerned" (*MD*, 60, 47).

Benjamin was weighing the advantages and disadvantages of becoming a professional fellow traveler. In his diary, at the beginning of January, he wrote about the choice that was facing him: either join the Communist party and gain a solid

institutional framework and mandate, at the sacrifice of his private independence; or seek to consolidate a marginal position as "a left-wing outsider," and organize his existence on "this narrow base" (*MD*, 72–73). At issue, of course, was the continuation of his scholarly work, "with its formal and metaphysical grounding"— something that in itself might have a revolutionary function. He asked himself whether his "illegal incognito among bourgeois authors makes any sense," and whether, for the sake of his work, he should "avoid certain extremes of 'material-ism'" (73). "As long as I continue to travel," he concluded, "joining the party is obviously something fairly inconceivable" (73).

Benjamin was intent on observing a wide variety of the daily affairs—as well as the cultural and political affairs—of Moscow, for, as he believed, "one knows a spot only after one has experienced it in as many dimensions as possible" (*MD*, 25). He visited shops (toy shops were his delight), restaurants, pubs, museums, offices, a factory manufacturing Christmas tree decorations, a children's clinic, a famous monastery. He took in life on the streets—beggars, children, street vendors, shop signs and posters, the relative absence of cars and church bells, the clothing and idiosyncrasies of the inhabitants. He went to plays, films, and ballets. He saw Sergei Eisenstein's film *Potemkin*, and the ballet *Petrushka*, set to Igor Stravinsky's music. He saw a shortened production (still more than four hours long) of Vsevolod Meyerhold's adaptation of Gogol's *Inspector General*, whose extravagant staging—involving a series of tableaux—he compared to the architecture of a Muscovite cake. And he was present at the Meyerhold Theater for a crowded public debate involving writers such as Vladimir Mayakovsky, Andrei Bely, Anatoly Lunacharsky, and Mey-erhold himself. He was interviewed by a Moscow newspaper as an expert on literature and the plastic arts. Everywhere in the city he witnessed the "thorough-going politicization of life" (*MD*, 71). His observations on these particulars, and on more general features of Russian society as it pursued its grand experiment, were recorded in his Moscow diary, which he then mined, over the next four years, for articles and radio scripts. And throughout all the organized *flânerie* in the stunning cold, there was the lure of Asja Lacis, as mercurial and difficult of access as the city itself.

On his return, at the beginning of February, from Moscow to Berlin, where he was living with his wife and son in an apartment in his parents' villa, Benjamin found that the translation of Proust's *Within a Budding Grove,* which he had undertaken together with Franz Hessel, had just appeared and was getting generally respectful reviews. Hessel was editor-in-chief of the Rowohlt publishing house, which was due to bring out Benjamin's books *One-Way Street* and *Origin of the German Trauerspiel* (though their publication was on hold for the moment; they would not appear until 1928). Meanwhile, and amid "a great deal of idleness,"[2] Benjamin was busy on a number of fronts. Through Reich he had obtained a commission for a compendious article on Goethe for the *Great Soviet Encyclopedia,* although in February he heard from Reich that the editorial board was balking at his synopsis. (The article would eventually be written the following year and would appear, in 1929, drastically modified by the editors.) The article on Moscow for *Die Kreatur* was now claiming his attention. To Martin Buber, who ran the journal, he wrote of his intention to allow the "creatural" to speak for itself; in his picture of Moscow, he said (adapting Goethe), "everything factual is already theory" (Letters,

313). This statement seems prophetic for the direction of much of his future activity as an author, as does what he wrote to Siegfried Kracauer on the same day: his presentation of Moscow would take the form of "small, disparate notes, and for the most part the reader will be left to his own devices."[3] The critic Kracauer, with whom Benjamin had become friendly in 1923, was cultural affairs editor at the *Frankfurter Zeitung;* this newspaper, along with *Die literarische Welt* (published by Rowohlt under the editorship of Willy Haas), was to become a mainstay of Benjamin's work for the duration of the Weimar Republic.

It was at this point, in the second half of the Weimar Republic's brief life, that Walter Benjamin emerged as a public intellectual. In 1927 he not only brought out a number of articles stemming from his visit to Moscow—articles on the city itself, on Russian literature, and on Russian film—but he also published the first results of his intense involvement with French culture. And he made his debut at the microphone of a radio station on March 23, when he broadcast a talk entitled "Young Russian Writers." Regular work in this medium would begin for him two years later; between 1929 and 1932, he would be heard more than eighty times on Frankfurt and Berlin radio stations, usually presenting material he himself had written or was improvising. In an overview of the work he had undertaken in 1931, Benjamin could in fact write that he had succeeded in getting every word he had written published. This commercial activity—along with that of his wife, Dora, who in 1926 had become editor of a Berlin fashion magazine—helped to fund his few independent projects of these years, especially his work on the Paris arcades, begun in the summer of 1927.

In April, Benjamin traveled to Paris for what he expected would be a two- or three-month stay, to assess new developments in French literature. Much of the time he was reading Proust. At the end of the month, he met for a few days with his old friend Gershom Scholem, who had become a lecturer in Jewish mysticism at the newly founded Hebrew University in Jerusalem and was visiting libraries in England and France to research kabbalist texts. Benjamin remarked to Scholem that he wanted to settle permanently in Paris because he found the city's "atmosphere" suited him.[4] In mid-May he was joined by Dora and his son, Stefan; they went on to the Riviera and Monte Carlo, where Benjamin won enough money in the casinos to finance a week's vacation in Corsica on his own. He took a plane back from Corsica to Antibes, "and this brought me up to date on the latest means of human transportation" (Scholem, 132).

At the beginning of June, Benjamin sent a letter to the Austrian writer Hugo von Hofmannsthal, whose journal, *Neue deutsche Beiträge,* had published Benjamin's essay "Goethe's Elective Affinities" in 1924–1925 and would publish a chapter on melancholy from the forthcoming *Trauerspiel* book in August. The letter describes his current projects, including the essay on Moscow, in which he claims to have concentrated on "rhythmic experiences" more than on purely visual ones. At the moment, he says, his work is mainly devoted to consolidating his position in Paris, to gaining proximity "to the French spirit in its modern form," given that "it incessantly preoccupies me in its historical form" (Letters, 315). In Germany, he adds, he feels "completely isolated" among those of his generation (315). He mentions that he is writing a piece on the Swiss poet and novelist Gottfried Keller, covering matters that have long run through his mind. This work would continue

into July, and the piece would appear in *Die literarische Welt* in August, inaugurating a series of major essays on important literary figures for the German newspapers. The Keller essay announces a characteristic set of motifs, ranging from the revaluation of the nineteenth century to the concepts of image space and mirror world, from the interfusion of humor and choler to the efflorescence of Antiquity within the smallest cell of the present day.

Another trip, in August, took him to Orléans, Blois, and Tours, where he visited some of the châteaus on the Loire. In a travel diary he noted the peace, the "immediate sense of presence," that comes with gazing at great works of architecture; he also felt gloom at being stood up by "a Parisian woman . . . with whom he had fallen in love—something he did rather easily and frequently in those years" (Scholem, 133). In mid-August, Scholem again came to Paris to examine manuscripts at the Bibliothèque Nationale and often met with Benjamin, mostly in cafés around the Boulevard Montparnasse. On one occasion, he visited Benjamin's "shabby, tiny, ill-kept room, which contained hardly more than an iron bedstead and a few other furnishings" (133). They went to the movies (Benjamin especially admired the American actor Adolphe Menjou) and took part in violent mass demonstrations in the boulevards against the execution of Sacco and Vanzetti on August 23. Benjamin spoke of his plans for an (unrealized) anthology of Wilhelm von Humboldt's writings on the philosophy of language, and he read to Scholem from the early drafts of *The Arcades Project,* which at that epoch wore the guise of an essay that would number "about fifty printed pages" (135). After parting in Paris, he and Scholem would see each other only one more time, in February 1938, when they met for a few days, again in Paris.

Benjamin's letters of the period point to his rapidly growing interest in photography. In October, Benjamin attended an International Exhibition of Photography in Paris but was disappointed in the selection of early photographs of that city. In a letter to his old schoolmates Grete and Alfred Cohn, he comments that photos of persons mean more than those of localities, because fashions in clothing provide such a reliable temporal index (*GB,* III, 291). He was reading Flaubert's *Sentimental Education* and, under the great impression which this novel was making on him, felt unable to focus on contemporary French literature (291–292). And "with fear and trembling" in his heart, he was giving himself up to "a new work that deals with Paris," on which he was spending every available hour in documentation at the Bibliothèque Nationale (292–293).

Benjamin returned from Paris to Berlin in November, and soon afterward came down with a case of jaundice. A letter of November 18, to Scholem, mentions that he was reading Kafka's novel *The Trial* in bed. It also comments on the cover for the upcoming Rowohlt edition of *One-Way Street,* with its collage by Sasha Stone; he calls it "one of the most effective covers ever" (*GB,* III, 203). At the end of this letter he adds a short allegorical spinoff of Kafka's novel—a piece entitled "The Idea of a Mystery," in which history itself is represented as a trial. While he was ailing, Benjamin received a visit from the poet and philosopher Karl Wolfskehl, a friend of Stefan George and Ludwig Klages: "It's a good thing I've hardly read a line of his; it enabled me to follow his wonderful conversation without any scruples" (312). An account of this visit would appear in *Die literarische Welt* in 1929. In November and December, Benjamin stepped up his efforts to gain entry into the circle sur-

rounding the German art historian Aby Warburg, but Warburg's Hamburg associate Erwin Panofsky, to whom Hofmannsthal had written at Benjamin's request, was put off by his work. On December 12, he wrote to Alfred and Grete Cohn that he had finished *The Trial* in a state verging on agony, "so overwhelming is the unpretentious abundance of this book" (312).

Soon after this, Benjamin made his first experiment with hashish, which he took orally under the supervision of two doctors with whom he was friendly. Baudelaire's writings on hashish and opium, as well as the influence of Surrealism, played a part in this experiment, which he repeated at various times over the next seven years or so. It would seem that he owed his idea of the aura, at least in part, to his experience with hashish. Benjamin was particularly interested in what he called the "colportage phenomenon of space," a kind of spatiotemporal palimpsest effect afforded by the drug. This played a role in the concept of the *flâneur,* which he was developing in connection with *The Arcades Project.* Over the next few years his letters sometimes refer to a book on hashish intoxication, but he never managed to write the work; it was only in 1972, under the title *On Hashish,* that the protocols he kept for the experiments, along with related texts, were first collected and published.

1928

The competing claims on Benjamin's attention continued to intensify during 1928. His unflagging efforts as strategist in the literary wars were balanced by greater immersion in his independent study of the Paris arcades, while his engagement with Marxism, in part mediated through Asja Lacis (with whom he would live in Berlin at the end of the year), and later through Brecht, was carried on in conjunction with constantly revamped plans to emigrate to Palestine. In August of the previous year, in Paris, Scholem had introduced Benjamin to the chancellor of the Hebrew University in Jerusalem, Rabbi Judah L. Magnes, who listened with emotion to Benjamin's description of his career in the philosophy of language. Their two-hour conversation, in which Benjamin maintained that he "had already done what he could as a critic of significant texts" and "that his position had found virtually no response in Germany," so that the interpretation of Hebrew literature remained his only viable option (Scholem, 138), led to Magnes' request for letters of recommendation as a first step in considering Benjamin for a teaching position in Jerusalem. Naturally, such a position would require that he learn Hebrew. Benjamin therefore set about collecting copies of his published work to send to Magnes and requesting academic references (including one from Hofmannsthal) attesting to his scholarly qualifications; these reached Magnes in the spring and were pronounced excellent. His immediate goal was to secure some sort of financial support from Jerusalem.

In January, at long last, *One-Way Street* and the *Trauerspiel* book were published by Rowohlt Verlag. Among the reviews which appeared in Germany, France, Switzerland, Holland, and Hungary, the most important for Benjamin were those by Kracauer, Willy Haas, Franz Hessel, Ernst Bloch, and Marcel Brion (a friend of Hofmannsthal's who was associated with the *Cahiers du Sud*). He also found it noteworthy that Hermann Hesse wrote very favorably to Rowohlt about *One-Way Street*. He was bothered, however, by a rather catty review by Werner Milch (later a specialist in Romanticism at Marburg) which appeared in a Berlin daily. Yet this

review, despite its unpleasant tone, nevertheless made the fundamental point that what unites these two texts, outwardly so different, is a formal predisposition, reminiscent of Friedrich Schlegel, for the collection of fragments.

One incident gives some indication of Benjamin's growing recognition. When André Gide came to Berlin in January, he took part in a two-hour interview with Benjamin, who was the only German journalist he agreed to see. This encounter, which Benjamin found "enormously interesting" and "delightful," resulted in two articles on Gide, published soon afterward in the *Deutsche allgemeine Zeitung* and *Die literarische Welt.*

At the end of January, Benjamin wrote to Scholem outlining his need for a subsidy of 300 marks a month if he was "now to jump off the cart that, although slow-moving, is traveling the career path of a German writer" (Letters, 322). He declared himself ready to take up the study of Hebrew just as soon as he completed his current project—"the highly remarkable and extremely precarious essay 'Paris Arcades: A Dialectical Fairy Scene' . . . [with which] one cycle of work, that of *One-Way Street,* will have come to a close for me in much the same way in which the *Trauerspiel* book concluded the German cycle. The profane motifs of *One-Way Street* will march past in this project, hellishly intensified" (322). At this point Benjamin could not have known that the project initially conceived as a newspaper article (to be written in collaboration with Hessel) would expand exponentially during the subsequent decade, coming eventually to fill two fat, posthumously published volumes.

Early 1928 was a period in which Benjamin cultivated a number of old and new intellectual relationships. In February, Theodor Wiesengrund Adorno spent some weeks in Berlin, and he and Benjamin were able to resume the discussions they had begun in Frankfurt in 1923. Benjamin reported to Kracauer in mid-February that he was "often and profitably together with Wiesengrund," who had just met Ernst Bloch (*GB*, III, 334). Adorno and Benjamin would see each other again in Königstein in early June and, a month after that, would begin their historic twelve-year correspondence. Earlier in the year, Benjamin had come to know Margarete (Gretel) Karplus, later Adorno's wife, another important correspondent of his in the Thirties and a provider of financial aid in 1933. Also that February, Benjamin became personally acquainted with the critic Ernst Robert Curtius, and he had his first meetings with Hofmannsthal, to whom he had sent his two books. The *Trauerspiel* book carried the dedication: "For Hugo von Hofmannsthal, / who cleared the way for this book, / with thanks, / February 1, 1928, WB" (333n), a sentence clarified by his remark to Marcel Brion that Hofmannsthal had been the first reader of the work (336). About *One-Way Street* he wrote to Hofmannsthal—echoing here the Baudelairean concept of *modernité*—that its object was "to grasp topicality [*Aktualität*] as the reverse of the eternal in history and to make an impression of this, the side of the medallion hidden from view" (Letters, 325). His conversation with Hofmannsthal touched on his own relation to his Jewishness and to Hebrew, as well as on his ideas about "Paris Arcades"—"an essay," he told Scholem, "that might turn out to be more extensive than I had thought" (327). To Scholem he described "an almost senile tendency" in Hofmannsthal, moments "when he sees himself completely misunderstood by everybody" (328).

Although Dora had been hard at work translating a detective novel by G. K. Chesterton, giving radio lectures on the education of children, and contributing book

reviews to *Die literarische Welt* (including one that concerned Joyce's "Work in Progress"—*Finnegans Wake*), Benjamin told Scholem that their current situation was "gloomy" (*GB*, III, 348). He himself had just completed an essay, "Old Toys," which at the end of February he had sent to Kracauer, along with a routine request for a book to review. In his accompanying letter he observes that this essay (which would appear in the *Frankfurter Zeitung* in March) stands in close proximity to his study of the Paris arcades. About the latter he says that he knows one thing: what it's like, "for weeks on end, to be carrying around a subject in one's head and, for the present, enjoying its only success in the fact that I am totally incapable of occupying myself with anything else whatsoever" (359). The emerging intellectual centrality of his work on the arcades, which he liked to call the *Passagen-Werk*, is further indicated by the investigations he was now undertaking into the philosophical significance of fashion—"into the question of what this natural and wholly irrational temporal measure of historical process is all about" (Letters, 329)—and by his response to Karl Kraus's reading of Offenbach's *La vie parisienne* at the end of March, which set in motion, as he remarks to Alfred Cohn, "a whole mass of ideas" connected to the arcades project (*GB*, III, 358). His account of Kraus's performance was published the following month in *Die literarische Welt*.

In April, Benjamin moved into a new room located "in the deepest, most forgotten section of the Tiergarten," where "nothing but trees peer at me through two high windows" (Letters, 335). For the two months that he lived there, before subletting it to Ernst Bloch, he took advantage of the easy access it provided to the Prussian State Library, where he pursued his research on the arcades. He characterized the project in a pointed manner to Scholem: "The work on the Paris arcades is taking on an ever more mysterious and insistent mien, and howls into my nights like a small beast if I have failed to water it at the most distant springs during the day. God knows what it will do when . . . I set it free. But this will not happen for a long time, and though I may already be constantly staring into the abode in which it does what comes naturally, I let hardly anyone else have a look inside" (335). This beast of his was inhabiting "an old and somewhat rebellious quasi-apocryphal province of my thought," and what he had in mind with its subjugation was a testing of "the extent to which it is possible to be 'concrete' in the context of the philosophy of history" (333). An advance which he had received from Rowohlt for "a projected book on Kafka, Proust, and so on" (335–336) was helping to maintain the *Passagen-Werk*.

In his letter of May 24, he announced to Scholem: "I have firmly put an autumn visit to Palestine on my agenda for the coming year. I hope that, before then, Magnes and I will have reached an agreement about the financial terms of my apprenticeship" (Letters, 335). A few weeks later he met with Magnes in Berlin, and the latter "promised, on his own and without further ado," to provide him with a stipend to study Hebrew (338). Meanwhile, he interrupted his research on the arcades to resume work on his Goethe article for the *Soviet Encyclopedia*; this would occupy him until October. At the same time, he was working on a translation of part of Louis Aragon's *Paris Peasant* for *Die literarische Welt*; on an article eventually entitled "The Path to Success, in Thirteen Theses," which would appear in the *Frankfurter Zeitung* in September (and which bears a close relation to the theory of gambling elaborated in *The Arcades Project*); and on a short meditative piece called

simply "Weimar," to be published in the *Neue schweizer Rundschau* in October. This last was a by-product of his encyclopedia article on Goethe, which in June had taken him to the Goethe house in Weimar to check his documentation. There, quite unexpectedly, he had suddenly found himself alone for twenty minutes in the great author's study, without even the shadow of a guard to disturb him. "And thus it happens," he wrote to Alfred and Grete Cohn, drawing the moral, "that the more cold-bloodedly one accosts things, the more tenderly they sometimes respond" (*GB*, III, 386).

Amid "all the deadlines" for articles long and short, including "some long articles about French literary currents" (Letters, 335), and amid drawn-out, ultimately fruitless negotiations in May regarding the transfer of rights for the Proust translation to Piper Verlag (a development that led to his and Hessel's abandonment of any further work on this project which had had such "an intense effect on my own writing"; 340), Benjamin characteristically began, that summer, to meditate an escape from Berlin: "I sit and brood—a penguin on the barren rocks of my thirty-seven [*sic*] years—on the possibility of a lonely Scandinavian cruise. But it is probably too late in the year" (*GB*, III, 399). In fact, this plan would have to wait two years for its realization. Meanwhile, he had received news of Asja Lacis' transfer to the Soviet Embassy in Berlin, where she was to work as a trade representative for Soviet films, and so he wrote to Scholem at the beginning of August that the trip to Palestine was "a settled matter" and that he would be staying in Jerusalem "for at least four months," but that his departure "may have to be delayed until mid-December. This will depend, first of all, on whether I can make up my mind to complete the arcades project before I leave Europe. Second, on whether I get together with a Russian woman friend in Berlin in the fall" (Letters, 339). He goes on to mention that Dora has no fixed income of any kind at the moment, while there is nothing presently in the works at Rowohlt for him; "therefore, please have Magnes send something on September 1" (339). In this matter, too, he would have to wait a little longer.

His alleged lack of funds did not stand in the way of a trip to Italy in September. From Lugano, whence he would travel to Marseilles at the end of the month, he wrote to Scholem that the encyclopedia article on Goethe was nearly finished and that he would be returning soon to the arcades project. "It would be splendid," he affirms, "if the ignominious writing I do for profit did not, for its part, need to be maintained at a certain level, so as not to become disgusting to me. I cannot say that I have lacked the opportunity to publish bad stuff; what I have always lacked, despite everything, is only the courage to compose it" (*GB*, III, 414). After this rueful boast, he put off his arrival in Palestine to January.

In October, Benjamin received a check from Magnes for 3,642 marks. The thank-you would come only eight months later, after he finally got around to arranging some Hebrew lessons. On October 22, he wrote to Alfred Cohn of the leisure he had been enjoying "for the past few weeks" since finishing the Goethe article (*GB*, III, 418). Soon, though, he was immersed in a new round of reviewing and feuilleton work. This included reviews of Kraus's reading and of a novel by Julien Green, for the Dutch journal *Internationale Revue;* a series of sketches of Marseilles, for the *Neue schweizer Rundschau;* reviews of a new edition of Goethe's book on color theory and of a startling volume of botanical photographs by Karl

Blossfeldt, for *Die literarische Welt;* and the essay "Hashish in Marseilles," for the *Frankfurter Zeitung.* But the most important of the journalistic projects undertaken at this time was the essay "Surrealism," which would appear in three installments in *Die literarische Welt* in February 1929. The preoccupation with Surrealism had a particular bearing on his ideas for the *Passagen-Werk.* He spoke of this in a letter to Scholem at the end of October: "An all too ostentatious proximity to the Surrealist movement might become fatal to the project, . . . well-founded though this proximity might be. In order to extricate the project from this situation, I have had to expand my ideas of it . . . , making it so universal within its most particular and minute framework that it will take possession of the inheritance of Surrealism . . . Enough of it exists now . . . for me to be able to accept the great risk entailed in slowing the pace of the work while expanding the subject matter" (Letters, 342–343). From this, of course, it followed that his trip to Palestine would have to be postponed again: "I now think I will be coming in the spring of next year" (343).

In November, Asja Lacis came to Berlin in the company of Bernhard Reich (who was there for a short visit only, while Brecht was finishing *The Threepenny Opera*). Before she returned to Moscow in 1930, she would try to arrange for Benjamin's emigration to the Soviet Union, in another of her vain attempts to find something for her friend there. According to Scholem, she advised Benjamin against moving to Palestine. Through her, he would get to meet Brecht in the course of the following year, along with a number of "revolutionary proletarian" authors. And for two months, from December 1928 through January 1929, he would live with her in an apartment at 42 Düsseldorfer Strasse.

1929

At the end of January, Benjamin moved back into his parents' villa on Delbrück-strasse in the Grunewald section of Berlin West—a wealthy haven from Berlin's poverty and misery—where Dora and Stefan were living with his mother. In the spring, after a series of turbulent scenes, he asked his wife for a divorce so that he could marry Asja Lacis and provide her with German citizenship. In August, Dora would insist that he leave his parents' house, which he described rather pathetically as his home of "ten or twenty years," and he would go to live for a while with the Hessels. The legal process that began on June 29 and ended on March 27, 1930, the date of their divorce, would prove financially draining (he would sign over his entire inheritance—including his cherished collection of children's books—to cover the 40,000 marks he owed her). It was because of this, and also to escape the nervous exhaustion of the entire process, that Benjamin flew to his writing desk. In 1929 he would produce more writings (including many newspaper reviews and radio scripts) than in any year before or after. "The year 1929 constituted a distinct turning point in his intellectual life," writes Scholem, "as well as a high point of intensive literary and philosophical activity. It was a visible turning point, which nevertheless did not exclude the continuity of his thought . . .—something that is more clearly discernible now than it was then" (Scholem, 159).

Benjamin was working on his Surrealism essay and also thinking about Proust. To Max Rychner, editor of the *Neue schweizer Rundschau,* which was practically the only German-language periodical to have published articles on Proust on a

regular basis, he wrote: "German Proust scholarship is sure to have a different look to it, when compared to its French counterpart. There is so much to Proust that is greater and more important than the 'psychologist,' who, as far as I can tell, is almost the exclusive topic of conversation in France" (Letters, 344). His essay "Surrealism," which he described as "an opaque screen placed before the arcades" (347), began appearing in *Die literarische Welt* on February 1. It, too, announced a movement beyond psychology: "Language takes precedence. / Not only before meaning. Also before the self." The priority of language was, of course, a longstanding concern of Benjamin's—indeed, the hallmark of his thought. And reaching just as far back in his thinking was the emphasis on an expanded concept of experience, which, in Surrealism, takes the form of a "profane illumination" of the world of things, a recognition of mystery within the orders of the everyday. Occupying "its highly exposed position between an anarchistic *Fronde* and a revolutionary discipline," Surrealism, in Benjamin's presentation, discloses a crisis of the intellect, or, more specifically, of "the humanistic concept of freedom."

That the question of revolution was, for Benjamin, necessarily a question of tradition is nicely indicated by a letter of February 15 to the Swiss art historian Sigfried Giedion, whose 1928 study *Architecture in France* had had an "electrifying" effect on Benjamin and was to figure prominently in the pages of *The Arcades Project*. "As I read through your book (together with so many others claiming my attention at the moment), I am struck by the heart-quickening difference between a radical attitude and radical knowing. What you exemplify is the latter, and therefore you are capable of highlighting tradition—or rather, discovering it—within the present day itself" (*GB*, III, 144). The present day had become a kind of well from which tradition could be drawn, or a ground in which mystery was embedded. This was the logic of his work on the Paris arcades, which was aimed at excavating the everyday life of the nineteenth century in France. Benjamin touched on this conception in a letter to Scholem in March: "The issue here is . . . to attain the most extreme concreteness for an era, as it occasionally manifested itself in children's games, in a building, or in a particular situation. A perilous, breathtaking enterprise, repeatedly put off over the course of the winter—not without reason" (Letters, 348).

In the same letter, Benjamin informed Scholem of his latest projects and personal contacts. He had been seeing the political philosopher Leo Strauss, whom he found "sympathetic," and Martin Buber, to whom he detailed his plans for visiting Palestine, and he had received "a delightful, delighted, even enthusiastic letter from Wolfskehl" praising his Surrealism article, "as well as one or two friendly notices" (Letters, 349). He had recently completed a piece called "Marseilles," which would be coming out in April in the *Neue schweizer Rundschau* (of all his cityscapes, he found this one the most difficult to write), and he was working on a piece called "Short Shadows," which would form part of the sequence "Thought Figures" published in November in the same periodical. And he had begun an essay entitled "On the Image of Proust": "I have produced a pack of reviews for the next French issue of *Die literarische Welt,* and am currrently hatching some arabesques on Proust" (349). This "very provisional but cunning essay on Proust," he later tells Scholem, was "begun from a thousand and one different angles" (*GB*, III, 462)—in this respect it resembled *The Arcades Project,* which he had been working "toward, not nearly on" (459). He wanted to know which of all these things, or of his other

things, Scholem considered part of the Benjaminian "experimental demonology" (Letters, 349). To borrow a moment from Thomas Mann: he was playing Leverkühn to Scholem's Zeitblom.

A quite different sort of relationship developed in May, when Asja Lacis introduced Benjamin to Brecht. Benjamin was nearly thirty-seven at the time; Brecht, thirty-one. Together with Lacis, they met for long discussions in Brecht's apartment near the zoo—discussions on the crucial importance of winning over the petty bourgeoisie to the side of the Left before Hitler appropriated it first; or on the instructive example afforded by Charlie Chaplin, whose film *The Circus* had opened in Berlin at the beginning of 1929 and had impressed Benjamin as "the first work of maturity in the art of film." Brecht encouraged Benjamin's efforts in radio and introduced him to fellow Marxists, such as the philosopher Karl Korsch, whom Benjamin would cite extensively in *The Arcades Project*. Scholem's portrait is just: "Brecht brought an entirely new element, an elemental force in the truest sense of the word, into his life . . . As early as June 6, he informed me of his rather close acquaintance with Brecht: 'There is a lot to say about him and about it' . . . Three weeks later he wrote: 'You will be interested to know that a very friendly relationship between Bert Brecht and me has recently developed, based less on what he has produced (I know only *The Threepenny Opera* and his ballads) than on the well-founded interest one must take in his present plans'" (Scholem, 159). During the years of exile, Benjamin would find at Brecht's house near Svendborg, Denmark, one of his oases, and with Brecht he would continue the sort of personal confrontation with German thinking that he had begun with Fritz Heinle and Florens Christian Rang. It was also around this time that his relationship with Adorno became closer.

From Scholem's point of view, Benjamin seemed to be Janus-faced: turned simultaneously toward Moscow and Jerusalem. On May 22, he had written to Scholem that his daily Hebrew lessons were beginning the next week, although "inwardly" he was preoccupied with the historical significance of the movement in art and literature known as Jugendstil, partly in the context of the *Passagen-Werk*, partly as a subject for the collection of essays he was planning with Rowohlt (but which never materialized). On June 6 he wrote to Magnes, apologizing for the long delay in thanking him for the stipend, and announcing that his study of Hebrew with the Orthodox rabbi Max Mayer of the *Jüdische Rundschau* had been going on "for a month." He reassured Magnes of his own earnestness, as witnessed in their Paris conversation of 1927, and he went on to express the hope that he would be in Palestine in the fall. To Scholem, the same day, he wrote that his "coming in the fall depends strictly on my material circumstances" (Letters, 350). He countered his friend's "reproaches" by admitting that he was up against "a truly pathological inclination to procrastinate in this matter," although he would "absolutely go on with Hebrew" (350). He even declared that he kept his Hebrew grammar book with him at all times. In fact, the Hebrew lessons were discontinued in July, when Benjamin went off on a trip to Italy with an old friend, and they never resumed.

Before this, he had taken a two-day trip with the same friend—the dramatist and novelist Wilhelm Speyer, with whom he had been a pupil at Haubinda twenty-three years earlier, and with whom he was now collaborating on a detective play. On June 24, from Bansin, France, he wrote to Scholem of his satisfaction with his current

literary relations (a feature article on *One-Way Street* had just appeared in a Rotterdam newspaper), and of his dissatisfaction with his friend Ernst Bloch. Back in February, he had complained to Scholem of Bloch's shameless, if subtle, pilferings of his ideas and terminology; now he announced the appearance of "two new books by Bloch, *Traces* and *Essays,* in which a not insubstantial proportion of my immortal works, in part somewhat damaged, has been transmitted to posterity" (*GB,* III, 469). On his return to Berlin he wrote to Hofmannsthal, enclosing some of his recent publications, of which the essay on Proust then appearing in *Die literarische Welt* was to serve as the showpiece. Benjamin's "synthetic interpretation" of Proust underscores the novelist's "impassioned cult of similarity" and his unprecedented revelation of the world of things, arguing that the Proustian idea of happiness transforms existence into "a preserve of memory." As it happened, these were all key motifs of Benjamin's own writing at that period.

Hofmannsthal died on Benjamin's birthday, July 15, and a couple of weeks later Benjamin wrote to Scholem from Italy to express his sadness at the event. He was busy with a number of other articles in July and August, including a review entitled "The Return of the *Flâneur*" (concerning his friend Hessel's book about Berlin) and "a hostile essay" on the Swiss prose writer Robert Walser (Letters, 357). At the end of August, he published in *Die literarische Welt* a piece entitled "Conversation with Ernst Schoen," in which he and the composer Schoen—one of his oldest friends, who had just become director-general of the radio station Südwestdeutscher Rundfunk in Frankfurt—discussed the educational possibilities of radio and television. Benjamin renounced the use of these media for any specific propaganda purposes, although he was interested in combating "false consciousness" among the bourgeoisie. In the latter half of 1929, he began to do radio broadcasts (lectures and readings) more regularly.

In September, Benjamin sent a telegram to Scholem announcing his upcoming arrival in Palestine on November 4—this at a time when his financial situation had stabilized with his steady work for the newspapers, when his relationship with Brecht was blossoming, and when Asja Lacis (as he informed Scholem in a letter of September 18) had suddenly fallen ill again and he had put her on a train to Frankfurt to see a neurologist. He visited her often in Frankfurt during September and October. In the course of these visits, Benjamin also met with Adorno, Gretel Karplus, and Max Horkheimer for intensive discussions of the key theoretical elements of his work. Benjamin now read early drafts of his *Arcades Project,* including "the magnificently improvised theory of the gambler," as Adorno later described it. These "Königstein conversations" left a deep imprint on the thought and writings of all concerned; an important strand of the Frankfurt School's thinking on cultural theory had its beginnings here.

On November 1 Benjamin wrote to Scholem of the unexpectedly "cruel" dimensions that the divorce process was assuming, of Dora's "relentless bitterness," and of the help she was getting from "one of the most cunning and dangerous lawyers in Germany" (*GB,* III, 489). Dora—and the judges—saw the matter rather differently. She had already written, in 1915 (two years before their marriage), "If you love him, then you already know that his words are grand and divine, his thoughts and works significant, his feelings petty and cramped, and his actions of a sort to correspond to all of this."[5] Now, deeply embittered by Benjamin's initiation of

divorce proceedings (which centered on accusations of her infidelity) and by his behavior toward her and his son, Stefan (Benjamin had by his own admission lived for years on Dora's earnings as a journalist; he now refused to repay her the 40,000 marks from her inheritance that he had borrowed, and in addition refused all requests to assist in the support of his son), Dora became even more explicit in a letter to Scholem: "The thing with Asja began as early as April 1924, on Capri. Since then he has always made his pacts: with Bolshevism, which he was unwilling to negate, so as not to lose his last excuse (for in the moment of denial he would have had to admit that it is not the sublime principles of this lady that bind him to her, but rather only sexual things); with Zionism, partly for your sake, partly (don't be angry, but these are his own words) 'because his home lies there, where someone can give him the possibility of spending money'; . . . with the literary life (not with literature), for he is naturally ashamed to admit his Zionist leanings in front of Hessel and in front of the little ladies that Hessel brings him during the breaks in his affair with Asja."[6] The judges, in granting a divorce, found that the fault in the marriage lay unequivocally on Benjamin's side. The text of their decision confirms that the accuser "had denied the accused marital intercourse since 1921 (aside from a brief period in 1923) and since then had had sexual relations with other women, in particular with a Frau Lacis. He has, furthermore, repeatedly conceded, orally and in writing, the same freedom to the accused that he, the accuser, has for years claimed for himself in the sexual realm."[7] Benjamin naturally spared Scholem such details, merely remarking that, aside from this all-consuming process (which had even brought on a ten-day nervous collapse), nothing was keeping him in Germany. Nevertheless, he could not for the moment think of leaving.

At the end of December, however, he did leave the country—not for Jerusalem, but for Paris. *Die literarische Welt* was covering his traveling expenses. In return, the periodical expected him to write a "Paris Diary," based on his interviews with literary celebrities.

1930

Benjamin's deepening friendship with Brecht was an important motivating factor in a good deal of his writing during the years 1930–1933; although his political convictions had gradually deepened, he had up to now produced little that could be called engaged writing. In 1930 and 1931, though, Benjamin overtly sought to claim for himself a role as "strategist in the literary struggle." He first issued a series of challenges to the political Right. On the cultural front, he published a long review of "the most astonishing publication to have come out of the George circle in the past few years": Max Kommerell's *The Poet as Leader in German Classicism*. Benjamin's review, "Against a Masterpiece," is his most detailed encounter with the conservative forces that dominated the German cultural scene. And the long review "Theories of German Fascism" offers a devastating critique of the war mysticism that characterized the writings of Ernst Jünger and his circle. If Benjamin was uncompromising in his critique of the Right, however, he was positively merciless in his attacks on left-liberal intellectuals. The review "Left-Wing Melancholy," with Erich Kästner's poems as its ostensible topic, accuses such moderate-left writers as Kästner, Kurt Tucholsky, and Walter Mehring of providing not ammunition in the

class struggle but commodities for the entertainment industry. The tone of this review was sufficiently bitter to cause its rejection by the *Frankfurter Zeitung;* like many of Benjamin's political writings of the period, it finally appeared in the social-democratic periodical *Die Gesellschaft.*

In Paris, Benjamin met with acquaintances of Proust and with various Surrealists, including Louis Aragon and Robert Desnos. He was able to follow at first hand the quarrel that had just erupted in the Surrealist group after the publication of André Breton's second *Surrealist Manifesto* in December 1929 and its rejection by the dissidents gathered around Desnos. He interviewed Julien Green, Marcel Jouhandeau, Emmanuel Berl, and the bookseller Adrienne Monnier, who told him that all methods of mechanical reproduction were basically techniques of reduction. Benjamin's "Paris Diary," a kind of supplement to the essays on Proust and Surrealism which he extracted from the actual diary kept during his trip, would appear in *Die literarische Welt* in three installments from April to June.

From his hotel on the Boulevard Raspail, Benjamin wrote to Marcel Brion, at the beginning of January, that he had had "to abandon, at least provisionally," his plans for going to Palestine (*GB,* III, 498). His communication to Scholem was less bald. Ending a silence of nearly three months, during which Asja Lacis had returned to Moscow, he wrote, on January 20, an extraordinary letter in French, beginning "Cher Gerhard."[8]

"You will probably think me crazy," the letter begins, "but I find it immensely difficult to end my silence and write you about my projects. I find it so difficult that I may never manage it without resorting to this mode of alibi that French is for me.

"I cannot delude myself any longer that the question I have been putting off for so long threatens to turn into one of my life's most serious failures. Let me begin by saying that I will not be able to think about my trip to Palestine at all until my divorce becomes final. It does not look like this will happen very soon. You will understand that this subject is so painful to me that I do not want to speak about it" (Letters, 358–359). He added that he had to give up all hope of learning Hebrew as long as he remained in Germany.

On the one hand, requests for contributions were coming in "from all quarters"; on the other—and here he sounded a note that would become a constant refrain through the next decade—his economic situation was "too precarious" for him to think of ignoring such opportunities. Of course, it was not in itself the worsening economic situation of the country (the number of unemployed would reach three million by March) but rather the change in political climate that would spell the end of his career as a man of letters in Germany.

This career was the real subject of his letter to Scholem: "I have already carved out a reputation for myself in Germany, although of modest proportions . . . The goal is that I be considered the foremost critic of German literature. The problem is that literary criticism is no longer considered a serious genre in Germany, and has not been for more than fifty years . . . One must thus recreate criticism as a genre [*le créer comme genre*]. Others have made some progress in doing this, but myself especially" (Letters, 359). His expression of confidence in a positive reception of his work by his contemporaries, if it did not give the lie to his assertions to Magnes of two and a half years earlier, at least signaled his sense of accomplishment since his last stay in Paris. For not only was he the author of two respected, and highly original

books of criticism, but he was now publishing regularly with the two most important literary journals of the day. Furthermore, there was the negotiation with Rowohlt for a collection of his essays, on which he laid particular emphasis to Scholem. In 1930 and 1931 Benjamin sought to further solidify this position by publishing a major statement on the theory of literary criticism. A rich variety of preliminary studies and partial drafts of this planned work are included in this volume under titles such as "Program for Literary Criticism" and "Criticism as the Fundamental Discipline of Literary History." The work would never appear, although central ideas that emerged from this process found their way into two little-noticed reviews, "The Rigorous Study of Art" and "Literary History and the Study of Literature."

But he was founding his hopes, above all, on his study of the Paris arcades. "This book," he told Scholem, "is the theater of all my struggles and all my ideas" (Letters, 359). His plan was to pursue the project on "a different plane," in comparison to what, under the influence of Surrealism, he had conceived in 1927 and 1928. Faced with the problem of "documentation" on one side, and of "metaphysics" on the other, he was looking to Hegel and Marx to provide "a solid scaffolding" for his work. An explicit discussion of the theory of historical knowledge would be necessary: "This is where I will find Heidegger on my path, and I expect sparks will fly from the shock of the confrontation between our two very different ways of looking at history" (359–360). In actual fact, though, Benjamin now put his arcades work on the back burner for the next four years. Other projects, in combination with the rapidly worsening political situation in Germany, began to intervene. Not until late 1934 would Benjamin again turn to the arcades and begin to follow the direction he was laying out here.

In February, Scholem wrote a tart letter to Benjamin seeking an end to all equivocation. He accused his friend of "indulging in false illusions" and of lacking candor. He demanded to know where Benjamin really stood vis-à-vis Palestine and Hebrew, and whether or not he was serious about a "true confrontation with Judaism . . . outside the medium of our friendship" (Letters, 363–364). He was also upset about Benjamin's securing a stipend from Magnes under what now appeared to be false pretenses. He would have to wait another two months for Benjamin's response, on April 25, in which he again vaguely suggested that he would be coming to Palestine "before the end of the year" (365). Benjamin offered a direct rejoinder to Scholem's challenge in the matter of Judaism ("I have come to know living Judaism in absolutely no form other than you"; 364), but otherwise sidestepped the issues Scholem had raised by alluding to "that procrastination . . . which is second nature to me in the most important situations of my life" (364), and by shifting attention to his recent divorce with Dora and the "makeshift existence" into which he had been forced as a result. Benjamin, of course, had long since spent the stipend granted him from Jerusalem, and he had no intention of paying it back. When Scholem's wife brought the matter up again in June, while Benjamin was visiting her in Berlin, he once more changed the subject.

That April, Benjamin signed a contract with Rowohlt for the collection of essays he had been meditating. In addition to already published articles—"The Task of the Translator" and "Surrealism," as well as essays on Keller, Hebel, Hessel, Walser, Green, Gide, and Proust—the book was to contain pieces entitled "The Task of the Critic," "Novelist and Storyteller," and "On Jugendstil."

Benjamin was also busy with his broadcasts for radio stations in Berlin and Frankfurt. In February and March, he had presented a series of talks for young listeners on the city of Berlin, and these were followed by lectures on E. T. A. Hoffmann and on Bertolt Brecht, among others. With the journalist Wolf Zucker, he was working on a series of "radio models" (*Hörmodelle*), which consisted of dialogues and short scenes on everyday situations, followed by spontaneous discussions. He was planning an article (unrealized) on the political aspects of radio for the *Frankfurter Zeitung;* it was to incorporate ideas of his colleague Ernst Schoen on the feasibility of transforming radio from a medium of entertainment to one with educational and political significance as well—one that would work against "the limitless spread of a consumer mentality" (as he put it in a sketch of 1930–1931, "Reflections on Radio") and would serve as a model for a new "people's art." On April 4, he wrote to Schoen, listing some thirteen points to be discussed in his proposed article. These include the trivialization of radio as a consequence, in part, of the failure of a liberal and demagogic press and, in part, of the failure of Wilhelminian ministers; the domination of radio by trade unionism; radio's indifference to things literary; and the corruption in the relations between radio and the press (*GB*, III, 515–517).

Among his publications that spring was a review of Kracauer's book *White-Collar Workers,* in *Die Gesellschaft.* Entitled "An Outsider Makes His Mark," it suggests something of Benjamin's own conception of himself as a left-wing outsider, alienated from the "morally rosy" adaptation of the white-collar workers to "the inhuman side of the contemporary social order," yet sufficiently aware—in pointed contrast to Brecht's position—that "the proletarianization of the intellectual hardly ever turns him into a proletarian." Rejecting both the depoliticized "sensation seeking of the snobs" and the depoliticized subordination of white- and blue-collar workers, the writer "rightly stands alone." At the conclusion of the piece, Benjamin compares the writer to a "ragpicker, at daybreak, picking up rags of speech and verbal scraps with his stick." If Benjamin here outlines a materialist criticism in terms of the unmasking of false consciousness among the bourgeoisie, his essay "Food," which appeared in the *Frankfurter Zeitung* at the end of May, is a small masterpiece of materialism in a very different vein, one more personal and, above all, bodily oriented. What he would call "anthropological materialism" was centered in the body as understood philosophically.

His divorce had left him, after he had finally found the "strength" to end his marriage, "at the threshold of my forties, without property or position, dwelling or resources," as he wrote, somewhat exaggerating, to Scholem in June (*GB*, III, 530). Applying himself diligently to labors that (in writing to Scholem) he often derided as "tomfoolery" or "stupidities," he felt overworked and exhausted. He was longing for some sort of "relaxation" (531). The idea of a trip to Scandinavia, first broached some two years earlier, now came to his rescue. At the end of July, he set sail on a voyage that took him over the Arctic Circle into northern Finland. On board ship, he translated a novel by Jouhandeau and read Ludwig Klages, whom he considered, despite Klages' "clumsy metaphysical dualism" and his suspect political tendencies, a great philosopher (Letters, 366). Benjamin's spirits, as he indicated in a letter to Gretel Karplus, were restored: "Once Berlin has been left behind, the world becomes spacious and beautiful, and it even has room on a 2,000-ton steamer, swarming with

assorted tourists, for your quietly exhilarated servant" (*GB*, III, 534). An account of his trip would appear in the *Frankfurter Zeitung* in September.

In October, Benjamin moved into a quiet two-room studio apartment in the Wilmersdorf section of Berlin, opposite his cousin Egon Wissing. Sublet from the artist Eva Boy, it would remain his home until he emigrated from Germany in 1933. He had a large study, with space for his 2,000-volume library and for Paul Klee's drawing *Angelus Novus*. Someone had given him a gramophone and he was putting together a record collection, which he enjoyed with his son, Stefan. As Scholem remarks, "it was the last time he had all his possessions together in one place" (Scholem, 178). Pressured by money worries, he was busy, as usual, on several fronts. A major essay on Karl Kraus was nearing completion, and he was working on the review essay "Left-Wing Melancholy." He was preparing his sparkling radio script "Myslovice—Braunschweig—Marseilles" for publication in the humor periodical *Uhu*. He had been present at a conference of the National Socialists' Strasser group (a branch of the Sturmabteilung, or SA—the Storm Troopers) and had witnessed a "debate that was in part fascinating" (*GB*, III, 546–547). He was reading Karl Korsch's *Marxism and Philosophy*, and he would soon be quite absorbed in a German translation of Charles Dickens' *Old Curiosity Shop*.

With Brecht, who had now become the *enfant terrible* of the Berlin theater world, he was engaged in long conversations about a plan for a new journal to be published by Rowohlt, one oriented toward the recognition of a crisis in art and science. "Its formal stance," he told Scholem, "will be scholarly, even academic, rather than journalistic, and it will be called *Krisis und Kritik*. I have completely won Rowohlt over to the plan . . . Beyond this is the difficulty inherent in working with Brecht. I of course assume that I am the one who will be able to deal with that, if anyone can" (Letters, 368). The journal was to be edited by the theater critic and dramatist Herbert Ihering, with Benjamin and Brecht as coeditors. Potential contributors included Adorno, Kracauer, Korsch, Georg Lukács, Robert Musil, and Alfred Döblin. Benjamin's own first contribution was to be an essay on Thomas Mann.

Furthermore, Benjamin was planning, with Adorno and Horkheimer, to deliver a lecture at the end of 1930 entitled "The Philosophy of Literary Criticism" at Frankfurt's Institut für Sozialforschung, of which Horkheimer had become the director in October. On November 2, however, Benjamin's mother died after a long illness (his father had died in 1926), and he asked for a postponement of the lecture, which then was never rescheduled. At this time, he was helping to support himself by working as a publisher's reader for Rowohlt. His translation of Proust's *The Guermantes Way* appeared about a month later, from Piper Verlag.

In December, Benjamin wrote a brief letter accompanying the delivery of his *Trauerspiel* book to the conservative political philosopher Carl Schmitt, whose treatise *Political Theology* had been a principal source. "You will quickly notice how much this book, in its exposition of the doctrine of sovereignty in the seventeenth century, owes to you" (*GB*, III, 558). He referred to Schmitt's recent work in political philosophy as a confirmation of his own work in the philosophy of art. Schmitt would later make use of Benjamin's book in his *Hamlet or Hecuba* of 1956. A different sort of influence is indicated in a letter of mid-December to the literary historian Franz Glück, who had sent Benjamin a volume of the selected writings of the Viennese architect Adolf Loos. To Glück, Benjamin speaks of the importance of

Loos's work to his present studies in particular (559). Loos would be cited at pivotal moments in the essay on Kraus.

1931

Unusually for the peripatetic Benjamin, he spent much of 1931 in Berlin. The pleasure he derived from the security of his apartment in Berlin-Wilmersdorf is a recurrent theme in his letters: "The study is pleasant and livable. All of my books are here now and, even given these times, their number has increased gradually from 1,200—although I certainly have not kept all of them, by a long shot—to 2,000. The study . . . has a panoramic view of the old filled-in bog, or, as it is also called, Lake Schramm—almost *l'atelier qui chante et qui bavarde;* and now that the weather is cold, a view of the ice-skating rinks and a clock is in sight at all seasons. As time goes by, this clock, especially, becomes a luxury it is difficult to do without" (Letters, 387). The lovely essay "Unpacking My Library" is the result of this sentiment. Yet the apartment was not merely the kind of bourgeois refuge Benjamin depicted with such glee throughout his work; if his thought was, as he described it, a "contradictory and mobile whole," then this apartment certainly mirrored that configuration. Benjamin wrote to Scholem with self-mocking irony: "To my horror, I already have to answer for the fact that only saints' pictures are hanging on the walls of my communist cell" (Letters, 386).

The security and continuity of this Berlin existence had a marked effect on Benjamin's self-conception. He could write in October: "I feel like an adult for the first time in my life. Not just no longer young, but grown up, in that I have almost realized one of the many modes of existence inherent in me" (Letters, 385). This state of mind was highly productive. In 1931 he published two of his most important essays, "Karl Kraus" and "Little History of Photography," as well as a number of fine literary and political essays, some radio talks, and several autobiographical pieces. And this was only the completed work. In February, Benjamin mentioned to Scholem that he was at work on what he hoped would be his definitive statement on literary criticism, "The Task of the Critic" (which would stand as the preface to his collection of literary essays), as well as on a "major essay on Jugendstil" (Scholem, 167). A letter to Scholem from October 28 gives an indication of the "ridiculous variety of projects" on which he typically worked: "The series of letters is to be continued;[9] there is a somewhat more detailed physiognomic attempt to describe the connections between Kant's feeblemindedness (in old age) and his philosophy; additionally, a shattering review of Haecker's Virgil;[10] a position as a judge in an open competition for sound-film scripts, for which I am reading and judging approximately 120 drafts a week; a short study of Paul Valéry . . . and I do not know whether the list is complete" (Letters, 385). This diversity in his writing was complemented by the diversity in his reading at the time: Shmarya Levin's *Childhood in Exile,* a life of Johann Heinrich Pestalozzi, Brecht's *Versuche,* and works by Nikolai Bukharin.

From his base in Wilmersdorf, Benjamin made sorties into the social world of the Berlin intelligentsia. He continued to meet frequently with Ernst Bloch and Franz Hessel and discuss ideas; he formed a close friendship with the bank official Gustav Glück; and he continued to frequent the company of journalists such as Willy Haas

and Albert Salomon. Max Rychner, editor of the *Neue schweizer Rundschau,* dined with Benjamin in November 1931 and left us a portrait of him in this period: "I observed the massive head of the man across from me and couldn't break free from this observation: of the eyes—hardly visible, well fortified behind the glasses—which now and then seemed to awaken; of the moustache, obliged to deny the youthful character of the face and functioning like two small flags of some country I couldn't quite identify."[11]

But of all of Benjamin's social and intellectual contacts at this time, it was the ones with Brecht that had the most obvious and immediate impact. The two writers debated the relative merits of Stalin and Trotsky, and Benjamin was keen to collaborate on a study of Heidegger's *Being and Time,* which had appeared in 1927. "We were planning to annihilate Heidegger here in the summer," he reported to Scholem, "in the context of a very close-knit circle of readers led by Brecht and me. Unfortunately, Brecht . . . will be leaving soon, and I will not do it on my own" (Letters, 365).

In early 1931, though, the plans for *Krisis und Kritik,* the journal they had hoped to coedit, foundered. It was not merely the foreseeable financial difficulties that brought the journal to a halt before it had begun; differences between Brecht's conception of the work and Benjamin's soon arose. Benjamin had placed enormous weight on the project, not only because of its potential for solidifying the increasingly important relationship with Brecht, but also because it would have embodied the strongest form of Benjamin's now overtly political criticism. Feeling that his intellectual independence would be compromised by further participation, though, Benjamin withdrew from the enterprise in February 1931. Notes on the discussions between Brecht and Benjamin have survived, as has a programmatic memorandum written by Benjamin in October or November.

But the contact with Brecht and his circle was by no means the only manifestation of Benjamin's political will. Just as characteristic is his great essay on Karl Kraus, which appeared in March 1931. Kraus himself, who may well have met Benjamin through a common acquaintance, the composer Ernst Krenek, judged the essay with his own very typical irony: "I can only express the hope that other readers have understood his writings better than I have. (Perhaps it is psychoanalysis.)"[12] The essay, which intertwines a radical politics and a no less radical theology, provoked a series of queries and attacks from friendly quarters and a series of highly revealing defenses and justifications from Benjamin. In a letter of March 7, 1931, to Max Rychner, Benjamin offered a direct apology for the mixture of political and theological elements in his work. He described himself as "a scholar to whom the stance of the materialist seems scientifically and humanely more productive in everything that moves us than does that of the idealist. If I might express it in brief: I have never been able to do research and think in any sense other than, if you will, a theological one—namely, in accord with the talmudic teaching about the forty-nine levels of meaning in every passage of Torah. That is: in my experience, the most trite Communist platitude possesses more hierarchies of meaning than does contemporary bourgeois profundity" (Letters, 372–373). Scholem, in a letter of March 30, delivered what can only be described as a frontal assault on the position Benjamin now occupied: he asserted that Benjamin was "engaging in an unusually intent kind of self-deception" based on a "disconcerting alienation and disjuncture between your

true way of thinking and your *alleged* way of thinking." Scholem objected to what he saw as a tendency in the Kraus essay to conflate "the metaphysician's insights into the language of the bourgeois" with the insights "of the materialist into the economic dialectic of society" (Letters, 374–375). Benjamin's reply was a model of restraint—and of no little evasion: he finally, much later, sent Scholem a copy of the letter to Rychner, as a kind of belated answer. If he did not defend his politics, though, he did issue Scholem an apology for his continued failure to make good on his promise to learn Hebrew and come to Palestine. "Where is my productive base? It is—and I have not the slightest illusion about this—in Berlin W[ilmersdorf-West]. WW, if you will. The most advanced civilization and the most 'modern' culture not only are part of my private comforts but are, in part, simply the means of my production" (Letters, 378).

In late spring, Benjamin made an extended trip to the south of France, in the company of his friends the Speyers and his cousins the Wissings; they stayed in Juan-les-Pins, Saint-Paul de Vence, Sanary, Marseilles, and Le Lavandou, where they met Brecht, Carola Neher, Emil Hesse-Burri, Elisabeth Hauptmann, Marie Grossman, and Bernhard and Margot von Brentano. As always when he was together with Brecht, Benjamin engaged in a series of long and heated discussions on a wide range of problems and writers—from the Hegelian dialectic and Trotsky to Proust, Kafka, and Schiller.

During this trip, Benjamin's letters and diaries began to show signs that his new stability and self-confidence were being increasingly punctuated—and not for the first time in his life—by periods of deep depression and thoughts of suicide.

"I feel tired. Tired above all of the struggle, the struggle for money, of which I now have enough in reserve to enable me to stay here. But tired also of aspects of my personal life with which, strictly speaking—apart from my economic situation—I have no reason to be dissatisfied . . . This dissatisfaction involves a growing aversion to and also a lack of confidence in the methods I see chosen by people of my kind and my situation to assert control over the hopeless situation of cultural politics in Germany . . . And to take the full measure of the ideas and impulses that preside over the writing of this diary, I need only hint at my growing willingness to take my own life."[13]

This "growing willingness" is most evident in a diary Benjamin kept in August, 1931—a diary on whose first page he wrote "Diary from August 7, 1931, to the Day of My Death."

"This diary does not promise to become very long. Today there came the negative response from [Anton] Kippenberg, and this gives my plan the relevance that only futility can guarantee. I need to discover 'a method that is just as convenient, but somewhat less definitive,' I said to I[nge] today. The hope of any such discovery is fast disappearing. But if anything can strengthen still further the determination—indeed, the peace of mind—with which I think of my intention, it must be the shrewd, dignified use to which I put my last days or weeks. Those just past leave a lot to be desired in this respect. Incapable of action, I just lay on the sofa and read. Frequently, I fell into so deep a reverie at the end of each page that I forgot to turn the page. I was mainly preoccupied with my plan—with wondering whether or not it was unavoidable, whether it should best be implemented here in the studio or back at the hotel, and so on."

Suicide—whether thoughts of his own or that of people close to him—had played

a remarkable role in his work starting as early as 1914, with the writing of "Two Poems by Friedrich Hölderlin" and its commemoration of the suicide of his friends Fritz Heinle and Rika Seligson. An attempted suicide emerges as the "secret" that organizes his reading of Goethe's *Elective Affinities*. And the problem of suicide informs one of Benjamin's most provocative short texts, "The Destructive Character" of 1931. Now, however, despite his deepening depression, Benjamin failed to carry through on his plan; but thoughts of taking his life would never be far from him in the years to come.

Benjamin returned to Berlin in July 1931 and remained there until April 1932. In August he published his "Little History of Photography." Benjamin here establishes himself as an early and significant theorist of photography; the essay contains, in addition, an important early formulation of his concept of the aura. His letters from these months are full of capsule descriptions of the political situation and, naturally, of foreboding. "The economic order of Germany has as firm a footing as the high seas, and emergency decrees collide with each other like the crests of waves. Unemployment is about to make revolutionary programs just as obsolete as economic and political programs already are. To all appearances, the National Socialists have actually been delegated to represent the unemployed masses here; the Communists have not as yet established the necessary contact with these masses and, consequently, the possibility of revolutionary action" (Letters, 382).

It was in late 1931 that Benjamin began to sense the end of his career as a public intellectual in Germany. "The constriction of the space in which I live and write (not to mention the space I have for thought) is becoming increasingly difficult to bear. Long-range plans are totally impossible" (Letters, 384). This is one of the first soundings of what will be the dominant theme of his letters in the years to come: the progressive elimination of all but a very few sites for the publication of his work, and with that elimination, his gradual reduction to abject poverty.

1932

Benjamin's long preoccupation with the bourgeois letter as a literary form bore fruit in early 1932. First in a radio talk called "On the Trail of Old Letters," delivered in January, and then in a series of letters called "From World Citizen to Haut Bourgeois," coedited with Willy Haas, Benjamin began to explore possibilities for grouping and commenting on a series of letters that he hoped would have revelatory and potentially revolutionary potential. This line of his thought would culminate in the pseudonymously published *Deutsche Menschen* of 1936, one of the keystones of Benjamin's work in the 1930s.

In January and February 1932, he also began to set down the first drafts of the recollections of his childhood and youth that Scholem would eventually publish as *Berlin Chronicle*. The short texts, for which he had received a contract from *Die literarische Welt* in the fall, took advantage of the form Benjamin had first developed in *One-Way Street*: often aphoristic but always dense and allusive meditations on things and places. He would continue to refine his drafts in the months to come. But no longer in Berlin.

Driven by the bleakness of his long-term economic prospects and the short-term presence of a bit of cash, Benjamin boarded a ship in Hamburg on April 7, bound

for Barcelona. From there he took the mail boat to Ibiza, the Balearic island on which he would spend important parts of the coming years. While on the island, he shared lodgings with Felix Noeggerath (a friend from the days of the Youth Movement) and Noeggerath's family. His first remarks on Ibiza, contained in a letter to Scholem of April 22, reflect a subdued hope. He was prepared to do without "any kind of comfort" because of the "composure the landscape provides; the most untouched landscape I have ever come across" (Letters, 390). In a letter to Gretel Karplus written early in his stay, he elaborated on the particular forms of "deprivation" he had to endure. After rising early, swimming, and sunbathing, he faced "a long day of doing without countless things, less so because they shorten life than because none of them is available, or, when they are, they are in such bad condition that you are glad to do without them—electric light and butter, liquor and running water, flirting and reading the paper" (Letters, 393). Nothing, of course, could deter Benjamin from reading (Stendhal's *Charterhouse of Parma*—an already familiar text; Theodor Fontane's *Der Stechlin*; Trotsky's autobiography and his history of the February Revolution). Or, apparently, from flirting. While on Ibiza, he proposed marriage to a German-Russian woman named Olga Parem, who turned him down. In subsequent months, Benjamin saw a number of other women, including the divorced wife of a Berlin physician.

While on the island, he pushed forward with his autobiographical project. He brought *Berlin Chronicle* to a provisional conclusion, though he remained unsure of just what to do with it. The short form that he was developing there, which he now came to call a "thought figure," found other uses. "Ibizan Sequence," a series of these short texts, was published in June. Benjamin also used the time on Ibiza to produce an unusual number of novellas, travel reports, and landscape sketches. "Spain, 1932," "The Handkerchief," and "In the Sun" all date from this period. He complained, meanwhile, of the island's relative lack of detective novels, which were always a passion with him; and he commented on his reading of Thornton Wilder's novel *The Cabala* and Proust.

Although Benjamin had planned to extend his stay on Ibiza at least through August, on July 17 he boarded a ship for the French mainland. His departure was undoubtedly comical: "When we finally arrived at the quay, the gangplank had been taken away and the ship had already begun to move . . . After calmly shaking hands with my companions, I began to scale the hull of the moving vessel and, aided by curious Ibizans, managed to clamber over the rail successfully."[14] His reasons for leaving Ibiza were considerably less comical: he planned to take his life in a hotel in Nice. In a letter to Scholem of July 26, written in Nice, Benjamin spoke of his "profound fatigue" and of his horror and disgust at events in Germany. On July 20, 1932, Franz von Papen, who had been German chancellor for only a month, suspended the democratically elected Prussian government, naming himself "Imperial Commissar for Prussia" and preparing the way for Hitler's assumption of power. Benjamin was all too aware of the immediate and possibly future results of Germany's political demise. By the end of July he had already, as a Jew, received a letter from the building-safety authorities ordering him to abandon his apartment because of alleged code violations; his radio work had also been brought to a halt by the dismissal of the left-leaning directors of the Berlin and Frankfurt stations. The tone of the July 26 letter, in which he compiles a retrospective assessment of his accom-

plishments and failures, leaves little to the imagination. "The literary forms of expression that my thought has forged for itself over the last decade have been utterly conditioned by the preventive measures and antidotes with which I had to counter the disintegration constantly threatening my thought as a result of such contingencies. And though many—or a sizable number—of my works have been small-scale victories, they are offset by large-scale defeats." He goes on to name the "four books that mark off the real site of ruin or catastrophe" in his life: the unfinished work on the arcades of Paris, his collected essays on literature, the edited series of old letters, and a truly exceptional book about hashish (Letters, 396).[15]

Now, in the Hôtel du Petit Parc, he prepared to put an end to his life. He wrote out a will, leaving his manuscripts and those of his friends Fritz and Wolf Heinle to Scholem as executor, and he drafted farewell letters to Egon Wissing, Ernst Schoen, Franz Hessel, and Jula (Cohn) Radt. Whether it was a change of heart or a failure of will that led Benjamin to stop short of suicide itself will undoubtedly remain a mystery (Scholem, 185–188).

From Nice, Benjamin went to join the Speyers in Povoremo, Italy, in order to collaborate with Speyer on a detective play. "I live away from all the bustle, in a simple but quite satisfactory room, and I am rather content, insofar as conditions and prospects allow me to be" (Scholem Letters, 16). In Povoremo, Benjamin turned again to the series of short autobiographical texts he had completed on Ibiza three months before, and the project underwent a decisive conceptual change. In the early texts finished on Ibiza that Scholem would later publish as *Berlin Chronicle*, the autobiographical element of the project had been predominant. But in Italy, Benjamin began to turn the texts toward the poetical and philosophical form of the "thought figure"—an attempt to capture the essence of a place and a time. He soon began referring to this project as *A Berlin Childhood around 1900*. Benjamin worked hard on the project, and was able to send a provisionally completed text to Scholem from Berlin in December. That mailing inaugurated the long and troubled publication history of the *Childhood*. The version of December 1932 contains thirty sections; the version published in 1972, in the fourth volume of the Suhrkamp edition of Benjamin's writings, contains forty-one sections, in a different order; and the "definitive" version, published in Volume 7 of the Suhrkamp edition and based on a manuscript long believed lost, contains thirty again, but in a still different order.

The collaboration with Speyer at least held out some prospect of eventual remuneration; all other prospects seemed to be vanishing. Just as his radio contracts had disappeared during the summer, his two major publishing venues were rendered inaccessible. The *Frankfurter Zeitung* left his letters unanswered, and *Die literarische Welt* asked explicitly that he submit no more work. Even the few hopes that dangled from Berlin were to prove futile. Rowohlt again hinted at the publication of the volume of literary essays that he had hoped, in 1931, would make his career and that was now seen only as a source of a few marks; but this, too, led to nothing. Benjamin was now destitute, totally dependent upon Speyer's generosity. "I am now engulfed in [the economic crisis] like a fish in water, but I am hardly as well off as the fish" (Scholem Letters, 20). Scholem had been in Europe, working at a series of archives on kabbalistic texts, since early in the year; Benjamin had avoided a meeting for reasons he never articulated, but which undoubtedly were bound up with his commitments to Brecht and his politics. Now, in the fall, when Benjamin expressed

an interest in seeing Scholem, he was unable to afford the return fare to Berlin, where Scholem stayed until mid-October. Benjamin returned only when Speyer—along with his automobile—was ready, in mid-November. While Benjamin wrote and worried, he read Arthur Rosenberg's *A History of Bolschevism* and Rudolf Leonhard's *The Word*.

Returning directly from Italy to Berlin, Benjamin had to turn down a gratifying invitation to visit, in Frankfurt, the first university seminar devoted to his work. The young *Privatdozent* Theodor Wiesengrund Adorno was offering a seminar to selected students on Benjamin's *Origin of the German Trauerspiel*. In turning down Adorno's invitation, Benjamin affirmed that he was "less than ever the master of my decisions . . . As such, the temptation to stay in Germany for any length of time is not very great" (Letters, 398).

In Berlin, Benjamin detailed to Scholem the way in which intellectuals were continuing to betray one another. He had been stung by a letter from his former collaborator Willy Haas, the editor of *Die literarische Welt*, one of his central organs of publication. "In order to know how someone fares who deals with such 'intellectuals,' in the form of editors or newspaper owners, you need only remember that the 'intellectuals' among our 'coreligionists' are the first to offer the oppressors hecatombs from their own circles, so as to remain spared themselves. True, I have been able to stem the boycott led against me simply by showing up. But whether the energy I invested over these first few weeks will avert the worst cannot yet be judged" (Scholem Letters, 23).

1933

In early 1933, Benjamin made the acquaintance of a woman who would figure prominently in his correspondence with Scholem in the coming years: Kitty Marx (who would soon become Kitty Marx-Steinschneider, after her marriage to Scholem's friend Karl Steinschneider). Unusually for Benjamin, a deep and lasting friendship sprang up between them almost immediately; their subsequent correspondence is filled with a courtly irony that borders on long-distance flirtation. This new friendship represented, though, only a temporary respite from concerns that were becoming more pressing every day.

Benjamin was experiencing first-hand the preparations for the "opening ceremonies of the Third Reich" that he had already prophesied in spring of 1932. The persecution of political opponents, the book burnings, the unleashing of the Brownshirts—all this was part of daily life in Germany's capital. "The little composure that people in my circles were able to muster in the face of the new regime was rapidly spent, and one realizes that the air is hardly fit to breath anymore—a condition which of course loses significance as one is being strangled anyway" (Scholem Letters, 27). After the night of February 27, 1933, when the Reichstag was burned, Benjamin's friends began to disappear: Ernst Schoen and Fritz Fränkel into hastily erected concentration camps; Brecht, Bloch, Kracauer, and Speyer into exile. Benjamin was prescient regarding the implications for his own work. "I don't know how I will be able to make it through [the coming months], either inside or outside Germany. There are places where I could earn a minimal income, and places

where I could live on a minimal income, but not a single place where these two conditions coincide" (Letters, 402).

What is perhaps most remarkable about these months is Benjamin's ability to suppress the ugly clamor in the streets outside his window and push on with his work. While still in Berlin, he completed a radio play on the German aphorist Lichtenberg (long one of his heroes), began an essay on Kafka, and, above all, finished one of his most important "private" essays, intended only for his own use and the eyes of a few adepts. This essay, "Doctrine of the Similar," represented a "new theory of language," an important building on the foundations of his language essay of 1916, "On Language as Such and on the Language of Man." In a letter of this period to Scholem, he continued to press his friend to read two texts about which Scholem has a host of reservations: Adorno's *Kierkegaard* and Brecht's *Versuche*.

On about March 18, Benjamin left Berlin. From Paris, his first stop, he wrote to Scholem: "I can at least be certain that I did not act on impulse, out of panic: the German atmosphere in which you look first at people's lapels, and after that usually do not want to look them in the face anymore, is unbearable. Rather, it was pure reason which bid all possible haste" (Letters, 406). Another letter sounded a note that would become recurrent: Benjamin's concern for friends and family who, for various reasons, delayed their departure from Germany. He was anxious first and foremost about the safety of his son. "All of this . . . would be bearable, if only Stefan weren't where he still is. In my first letter from here, I urged Dora to send him to Palestine, where her brother owns a plantation" (Scholem Letters, 36). In Paris, where Benjamin stayed only a short time, he met acquaintances from his stay on Ibiza in 1932: Jean Selz and his wife. He left Paris for the island in their company on April 5, arriving ten days later after a stay of several days in Barcelona.

On Ibiza, Benjamin returned to his former, remarkably simple lifestyle. He lodged with acquaintances (including the Noeggeraths) or in rented accommodations; for a good part of his stay, he lived in an isolated house that was half finished and devoid of any conveniences. Ibiza represented for Benjamin a reduction of his living expenses to "the European minimum of about sixty or seventy reichsmarks a month." He was able to raise this sum through a combination of income from his writings, income from the slow selling-off of the most valuable contents of his library, and regular contributions from friends such as Gretel Adorno and Fritz and Jula Radt (Letters, 410). But even Ibiza had begun to change, with many new residents, many new buildings, and not a few Nazis. Without knowing how long he would—or could—remain there, Benjamin began to learn Spanish. His reports from the island contrast markedly with those from his stay in 1932, which had been so idyllic in tone; now he gave way to irritation with the "blastings and hammer blows, the gossip and debates that constitute the atmosphere of San Antonio" (Scholem Letters, 58). Only on occasional rambles in the interior of the island, some of them in the company of Paul Gauguin, a grandson of the famous painter, could he escape the tumult and recover some of the earlier sense of place. Benjamin's account of one such walk takes even this encounter with a more primitive side of the island and organizes it around a symbol of death: "A man came walking toward us, carrying a tiny white child's coffin under his arm" (Letters, 420).

News from Germany persistently added to his sense of despair. In early May, he

learned that his brother Georg, who had been active in Germany's Communist party, had been arrested. First reports had him in the hands of the SA, tortured, and blinded in one eye. Benjamin soon learned that his brother was in fact in "preventive detention" in a regular prison, and relatively healthy; better news, but hardly the sort to allay his fears. Dora and Stefan remained in Berlin. And a new source of anxiety soon made itself felt: his passport would expire at the end of the summer, and he was doubtful that he would be allowed to reenter France without one.

Among his most pressing personal concerns was, naturally, the problem of finding new sources of income. He was surprised to learn that Germany was, at first, not as closed to him as he had feared. Both the *Vossische Zeitung* and the *Frankfurter Zeitung* continued to publish reviews and short prose (including individual sections of *A Berlin Childhood*). These and other efforts were published under a series of pseudonyms, "Detlev Holz" remaining his favorite. The first major statement from his time of exile to appear in Germany was his final reckoning with an author who had preoccupied him since his earliest encounters with literature: Stefan George. "Stefan George in Retrospect" is predictably cautious in its political assessment of George, the most important figure in the conservative literary world in the first half of the twentieth century. Benjamin's remarks on this aspect of George are more direct in a letter to Scholem: "If ever God has smitten a prophet by fulfilling his prophecies, then this is the case with George" (Scholem Letters, 59). Benjamin's published critique takes on George, instead, in the coded language he had developed in his own work: the terms "nature," "daemonic," and "hero" carry with them philosophical and theological associations first developed in the 1921 essay "Goethe's Elective Affinities." The George essay was followed by a commission to write a piece commemorating the two hundredth anniversary of the birth of Christoph Martin Wieland, one of the chief literary figures of the German Enlightenment.

Older journals now in exile represented further publishing outlets. One of the first such opportunities was a commission from the Institut für Sozialforschung, which had managed to transfer its endowment from Germany to Switzerland. Benjamin agreed to produce a very substantial review of the current state of French letters, although he repeatedly expressed reservations about his ability to carry out this task on Ibiza, with no scholarly library and few books; early in the process, he called the essay "sheer fakery" (Scholem Letters, 41). By late May, however, when he had finished "The Present Social Situation of the French Writer," he accorded himself grudging approval: "It wasn't possible to produce something definitive. Nonetheless, I believe that the reader will gain insight into connections that until now have not been brought out so clearly" (Scholem Letters, 54). And late in the year in Paris, with the Bibliothèque Nationale at his disposal, he began to work on two further commissions from the Institut: a major essay on the collector and historian Eduard Fuchs, and a collective review of recent publications on the philosophy and sociology of language.

But the paths to the exile journals were often tortuous. At Scholem's urging, Benjamin overcame a strong personal disinclination and submitted two pieces to Max Brod for publication in the *Prager Tageblatt*. Brod not only rejected the pieces, but gave them without the author's permission to Willy Haas, editor of the periodical *Die Welt im Wort*. Haas, now an object of Benjamin's scorn, agreed to publish both "Experience and Poverty" (Benjamin's important reflection on the thoroughly posi-

tive reduction of modern experience to a "new barbarism") and a small piece on Johann Peter Hebel. Before they appeared, and certainly before Benjamin had been paid, *Die Welt im Wort* failed—an event which Benjamin described as "gratifying" (Scholem Letters, 100). Brod eventually published both pieces in the *Tageblatt*.

Despite isolated successes, most of Benjamin's efforts to find new venues failed. A review of Brecht's *Threepenny Novel* had initially been accepted and indeed typeset by the journal *Die Sammlung*, edited by Klaus Mann; Benjamin was bold enough to ask for 250 francs rather than the offered 150, and Mann returned the piece without comment. And an attempt late in the year to find a home for some longer works with an émigré press planned in Jerusalem by Shoshanah Persitz came to nothing.

By late May, Benjamin's isolation and the poor nutrition that resulted from his lack of funds began to take effect. He reported to Scholem that his health was not good and that he saw no hope of relief. Unable to work on "what matters most to me"—the continuation of *A Berlin Childhood*—he began to work with Jean Selz on a French translation of his text. Selz knew no German, but Benjamin paraphrased in French, leading to results that Benjamin deemed excellent. And he continued to think about his new language theory; he asked Scholem to forward a copy of the 1916 essay, so that he could compare it with the new writings.

With the increasing desperation of exile and poverty, Benjamin again began to weigh a possibility he had discarded with seeming finality early in the decade: emigration to Palestine. Scholem had written him a few mildly discouraging sentences regarding possibilities for work for European professionals and intellectuals. Benjamin now responded with a long, circuitous account of his current state of mind. "Thousands of intellectuals have made their way to you. One thing distinguishes them from me—and this seems to work in my favor at first glance. But thereafter—as you well know—the advantage becomes theirs. Precisely this: they represent blank pages. Nothing would have more fateful consequences than an attitude on my part that could be construed as though I were attempting to cover up a private calamity with a public one . . . I would be glad and fully prepared to come to Palestine if you, or others concerned, assume that I could do so without provoking such a situation . . . Is there more room for me—for what I know and what I can do—there than in Europe? If there is not more, then there is less . . . If I could improve upon my knowledge and my abilities there without abandoning what I have already accomplished, then I would not be the least bit indecisive in taking that step" (Scholem Letters, 59–60).

Translated into the plain language which Benjamin was incapable of using with Scholem on this topic, the letter indicates that Benjamin was at this point willing neither to give up his engagement with European ideas, nor to use Palestine as a mere base for that engagement. Scholem, long a shrewd reader of Benjaminian prose, understood immediately. He replied that he found it "questionable whether a person could possibly feel well in this country without directly participating in the life here, whether . . . this would not rapidly bring about a morally unbearable state of estrangement in which life cannot be sustained" (Scholem Letters, 66).

Late spring and early summer brought an intense fascination with the work of Arnold Bennett. Benjamin recommended the novel *Clayhanger* to each of his correspondents, wrote a review of the German translation of *Constance and Sophie,* and

described Bennett as a kind of Benjaminian alter ego. He recognized in Bennett "a man whose stance is very much akin currently to my own and who serves to validate it—that is to say, a man for whom a far-reaching lack of illusion and a fundamental mistrust of where the world is going lead neither to moral fanaticism nor to embitterment but to an extremely cunning, clever, and subtle art of living. This leads him to wrest from his own misfortune the chances, and from his own wickedness the few respectable ways to conduct himself, that amount to a human life" (Letters, 422).

In mid-July the first of a series of illnesses overtook Benjamin. Upon his return from Majorca, where he had succeeded in obtaining a new passport, a leg wound became inflamed while he was visiting friends in the town of Ibiza, and the resultant fever combined with bouts of intense summer heat to keep Benjamin from returning to his room in San Antonio. Even so, he managed during his illness to write one of the most compelling sections of *A Berlin Childhood*, "Loggias," which he described as a "kind of self-portrait" (Letters, 427). And a glimmer of hope revealed itself to him when, through Wilhelm Speyer's intervention, he received an invitation to live, free of charge, in a house in Paris funded by the Baroness Goldschmidt-Rothschild for refugee Jewish intellectuals.

A relationship with a woman to whom Benjamin alluded only in the vaguest terms in his letters seems to have been a dominant element in his life during these months. By the end of the summer, he could pay her the highest of compliments—calling her the female counterpart to the *Angelus Novus*—while continuing to conceal her identity. Whether or not this relationship played a role, during the summer Benjamin produced two of his most important "private" writings of the period of exile: "On the Mimetic Faculty" (the later version of his new theory of language) and two pieces entitled "Agesilaus Santander" (versions of a highly esoteric meditation on naming and identity). Scholem speculates that the lovely last line of "Agesilaus Santander"—"And so, scarcely had I seen you the first time than I returned with you to where I had come from"—could well refer to the unnamed woman of the summer. During the summer Benjamin was also able to arrange for the transfer of part of his "archive" (his own writings and those of the Heinles) from Berlin; he continued to be anxious about the fate of his library, whose packing and shipping he simply could not afford.

By early September, Benjamin's condition had not improved; he continued to run a fever, and experienced prolonged periods of exhaustion during which he was bedridden in an isolated country house. He realized that his recovery was made difficult by his sparse diet and his emotional state. Ill as he was, Benjamin retained his sense of humor, at least when it came to reading. Commenting to Scholem on their shared interest in Christian theology (he had just finished a book on Luther), Benjamin claimed: "I have now grasped for the fifth or sixth time in my life what is meant by justification through faith. But I have the same trouble here as I have with infinitesimal calculus: as soon as I have mastered it for a few hours, it vanishes again for just as many years" (Scholem Letters, 77).

He planned to return to Paris when he had regained his health, but even Paris seemed to be less a superior haven for an exile than a marginally preferable place of suffering. "It hardly needs to be stated that I am facing my stay in Paris with the utmost reserve. The Parisians are saying, 'Les émigrés sont pires que les boches' [The

émigrés are worse than the Krauts]" (Scholem Letters, 72). When he finally did make the trip to the French capital in early October, it was under "unimaginable conditions" (82): he was diagnosed on his arrival with malaria and treated with a course of quinine. Exactly when the lingering illness related to his leg wound gave way to this far more serious disease remains unclear.

Paris was all he had feared. The lodging in the house provided by the baroness proved to be "by no means free of charge" (83); it soon revealed itself as no option at all. And the possibility of earning a living from his writings in French was just as hopeless. "I am faced here with as many question marks as there are street corners in Paris. Only one thing is certain: that I have no intention of making a futile attempt to earn my living by writing for French journals" (82). He would eventually receive a commission from *Le Monde* for a piece on Baron Haussmann, but this was never completed; like so much of Benjamin's work, the research for the newspaper article found its way into *The Arcades Project*.

By the end of the year, Paris had begun to present difficulties to which Benjamin had no solution. "Life among the émigrés is unbearable, life alone is no more bearable, and a life among the French cannot be brought about" (Scholem Letters, 93). And although the city was far too expensive, he had no other place to go. Brecht had invited him to follow in his footsteps and emigrate to Denmark, luring him with attractive estimates of living costs. "But I am horrified by the winter, the travel costs, and the idea of being dependent on him and him alone" (Scholem Letters, 93). Dora and Stefan were still in Berlin; his brother Georg had been released from the Sonnenburg concentration camp, but refused to flee Germany. It was the beginning of a Parisian exile that would, with a few interruptions, extend to the end of Benjamin's life.

1934

Material hardship and intellectual isolation remained the key elements in Benjamin's existence in Paris. "I have hardly ever been as lonely as I am here," he wrote to Scholem in January. "If I were seeking opportunities to sit in a café with émigrés, they would be easy to find. But I avoid them" (Letters, 434). He wandered into Sylvia Beach's bookshop, and lingered over the portraits and autographs of British and American writers; he strolled the boulevards as a latter-day *flâneur;* and trapped by day, he dreamed at night. "In these times, when my imagination is preoccupied with the most unworthy problems between sunrise and sunset, I experience at night, more and more often, its emancipation in dreams, which nearly always have a political subject . . . They represent a pictorial atlas of the secret history of National Socialism" (Scholem Letters, 100).

Benjamin's first letters in the new year inaugurated what would be the dominant theme for the year as a whole: Franz Kafka. In a letter to Scholem, he expressed the hope that he would some day be able to lecture on Kafka and S. J. Agnon, the Jewish writer whose story "The Great Synagogue" would have figured prominently in the first issue of Benjamin's planned journal *Angelus Novus* in 1921. Discussions on Kafka also opened the way for Benjamin to take up new, albeit cautious, relations with his old friend Werner Kraft, with whom he had broken in 1921. Kraft had,

until 1933, been a librarian in Hannover; he now shared Benjamin's exile and experienced the same dilemmas that confronted the émigré intellectual.

Rejections and disappointments continued to frustrate Benjamin's attempts to find venues for his work. He placed great hopes in some talks on the German avant-garde, to be delivered in French—a series of subscription lectures that he was to hold in a Parisian art salon; aside from the funds they would have brought, Benjamin hoped that they might establish a bridgehead on the French intellectual scene. The talks, which would have included an introduction on the German reading public and individual lectures on Kafka, Bloch, Brecht, and Kraus, were canceled when their sponsor, a prominent gynecologist, fell ill. Similarly, a commission from the *Nouvelle Revue Française* for an article on Johann Jakob Bachofen led to much research, a completed essay, and a rejection. And a major project intended for the *Zeitschrift für Sozialforschung* fell prey not to rejection but to Benjamin's failure to complete it. He devoted months to the preparation of this "retrospective recapitulation of the cultural politics of *Die neue Zeit*" (Scholem Letters, 139), the ideological organ of Germany's Social Democratic party; he hoped to "demonstrate for once how collective literary products are particularly suited to materialist treatment and analysis and, indeed, can be rationally evaluated only when treated in such a way" (Letters, 456). Though he mentioned the project in nearly every letter he wrote in the late summer and early fall, the project simply disappeared. One notable exception to this pattern of frustration and failure was the championing of *A Berlin Childhood* by Hermann Hesse, who approached two publishers, S. Fischer and Albert Langen, in an effort to find a home for the text. His efforts ultimately came to nothing, but Benjamin was gratified by the attention paid to his work by the prominent novelist.

In addition to the small gifts of money from friends, Benjamin was able to supplement his income through stipends paid by various organizations and by the ongoing sale of his books. In the spring, he began to receive 700 francs a month from the Israélite Alliance Universelle; at about the same time, the Institut für Sozialforschung initiated a stipend of 500 francs per month that would continue throughout the 1930s. And the institute, in the person of Friedrich Pollack, performed another important service: it funded the transfer of Benjamin's books— "about half the library, but the more important half"—from Berlin to Denmark, care of Brecht (Letters, 437). This transfer not only put the library at Benjamin's disposal for his writing, but allowed him to make important sales, foremost among them a tortuously negotiated sale of the complete works of Franz von Baader to the library of the Hebrew University in Jerusalem.

In March, his fortunes had so declined that he was forced to move from his cheap hotel in the sixth arrondissement. Fortunately, his sister Dora had recently moved to Paris. Benjamin's relations with his sister had long been troubled, but now, in Paris, they improved, and Benjamin moved into her small apartment on a temporary basis. Sometime that month, Benjamin also broke with one of his few remaining French acquaintances, Jean Selz, under circumstances that remain clouded. His family in Germany was still an object of intense concern. Dora and Stefan remained in Berlin, while Benjamin's brother Georg, freed from prison, returned to Berlin from a trip to Switzerland and Italy and immediately resumed his clandestine political work.

Despite these conditions, Benjamin continued to write. He finished the long review essay "Problems of the Sociology of Language" for the *Zeitschrift für Sozialforschung*, and a review of Max Kommerell's book on Jean Paul, which he published under the pseudonym K. A. Stempflinger in the *Frankfurter Zeitung*. In late spring, he finished a long piece on literary politics, "The Author as Producer." The text, as published twenty-six years after Benjamin's death, indicates that it was delivered as a lecture at the "Institute for the Study of Fascism" in Paris on April 27. This institute, with Arthur Koestler at its head, was a research group controlled by the Comintern but financed by French workers and intellectuals. The essay is one of Benjamin's most significant analyses of the relations between literary form and politics; whether it was ever delivered remains a mystery.

Once again, he sat in the Bibliothèque Nationale and took up his work on the Paris arcades. "The arcades project is the *tertius gaudens* these days between fate and me. I have not only been able to do much more research recently, but also—for the first time in a long while—to imagine ways in which that research might be put to use. That this image diverges greatly from the first, original one is quite understandable" (Scholem Letters, 100).

A letter from Scholem of April 19 opened the way for one of Benjamin's most significant essays, "Franz Kafka." Scholem had approached Robert Weltsch—editor of the *Jüdische Rundschau,* the largest-circulation Jewish publication still allowed in Germany—regarding the possibility of Benjamin's contributing an essay on Kafka. When Weltsch followed up Scholem's suggestion with an invitation, Benjamin on May 9 accepted enthusiastically, while warning Weltsch that his essay would not conform to the "straightforward theological explication of Kafka" (Letters, 442). And this was not the only activity on Benjamin's behalf that his friend had undertaken: he also asked Moritz Spitzer, editor of the Schocken Library (a series of small, somewhat popular volumes with a largely German-Jewish readership), to solicit "one or more small books" from Benjamin (Scholem Letters, 106). Despite Benjamin's willingness, this plan, too, foundered, as the German exchange office soon stopped all payments to Schocken authors living abroad.

Scholem's important letter also rekindled the old, uncomfortable debate between the friends regarding Benjamin's politics. After reading the relatively mild and straightforward essay "The Present Social Situation of the French Writer," Scholem claimed that he was unable to understand it and asked Benjamin if the essay was a "Communist credo" (107). Scholem wanted to know where Benjamin stood, and reminded him that he had been unwilling to give clear answers to this question in the past. Scholem's letter elicited an important and highly revealing response from Benjamin. A draft later found in East Berlin reads: "I have always written according to my convictions—with perhaps a few minor exceptions—but I have never made the attempt to express the contradictory and mobile whole that my convictions represent in their multiplicity" (109). In the letter he finally sent, he defined his communism as "absolutely nothing other than the expression of certain experiences I have undergone in my thinking and in my life. That it is a drastic, not infertile expression of the fact that the present intellectual industry finds it impossible to accommodate my life; that it represents the obvious, reasoned attempt on the part of a man who is completely or almost completely deprived of any means of production to proclaim his right to them, both in his thinking and in his life . . . Is it really

necessary to say all this to you?" (110). Benjamin continued with a passage on Brecht that showed he was all too aware of the real stakes here: Scholem's objection to his incorporation of a Brechtian, engaged politics alongside both his theological inclinations and the carefully considered, though still markedly leftist social analyses that allied him with the Institut für Sozialforschung. In a letter written that summer, Benjamin again alluded to this controversy while also claiming that he could not send Scholem the much more provocative essay "The Author as Producer," because he had failed to have enough copies made; when Scholem asked for a copy in person in 1938, Benjamin said (as Scholem later recalled), "I think I had better not let you read it" (113).

In early summer 1934, Benjamin undertook the trip to Skovsbostrand (near Svendborg), where Brecht and Helene Weigel were living in an isolated farmhouse; it was to be the first of three such extended summer visits, the others coming in 1936 and 1938. Shortly before leaving Paris for Denmark, Benjamin had suggested to Brecht that a series of affinities exist between his plays and the game of Go, with its initially empty board and its strategy of placing, rather than moving, pieces. "You place each of your figures and formulations on the right spot, whence they fulfill their proper strategic function on their own and without having to act" (443). He now took a room in a neighboring house in the countryside, which limited his social relations to Brecht and Weigel. His entertainment consisted of his customary walks (solitary, because neither of his hosts was interested) and evenings in front of Brecht's radio. "Thus, I was able to listen to Hitler's Reichstag speech, and because it was the very first time I had ever heard him, you can imagine the effect" (Scholem Letters, 130).

Despite the manifest difference in their personalities, Brecht and Benjamin shared a remarkable friendship. As Ruth Berlau, a member of Brecht's circle, remembers: "Whenever Benjamin and Brecht were together in Denmark, an atmosphere of confidence and trust immediately arose between them. Brecht had an enormous liking for Benjamin; in fact, he loved him. I think they understood each other without saying a word. They played chess wordlessly, and when they stood up, they had had a conversation."[16] When they did speak, the conversations were extensive and memorable. In the summer of 1934, they discussed Rimbaud and Johannes R. Becher, Confucius and Euripides, Gerhart Hauptmann and Dostoevsky. But most of their conversations concerned Kafka and the essay Benjamin was writing (see "Notes from Svendborg," in this volume).

An odd, three-part conversation on this topic soon arose, with Scholem the silent partner in Palestine. His frequent letters challenged Benjamin to answer a series of explicitly theological questions. Benjamin's replies are noteworthy. In reflecting on the question as to how one is to conceive, "in Kafka's sense, the Last Judgment's projection into world history," Benjamin emphasized not the answers to such questions, but rather Kafka's failure. "I endeavoured to show how Kafka sought—on the nether side of that 'nothingness,' in its inside lining, so to speak—to feel his way toward redemption. This implies that any kind of victory over that nothingness . . . would have been an abomination for him" (Scholem Letters, 129). A few weeks later, Benjamin admitted a "small, nonsensical hope" intended for Kafka's creatures and helpers, so memorably portrayed in the essay. "That I do not deny the compo-

nent of revelation in Kafka's work already follows from my appreciation—by declaring the work to be 'distorted'—of its messianic aspect. Kafka's messianic category is the 'reversal' or 'study'" (135). Just as the great essay on Karl Kraus had done, the essay on Kafka marked a point of crystallization in Benjamin's thought. In a letter of November 12 to Werner Kraft, he asserted that "the study brought me to a crossroads in my thoughts and reflections. Devoting additional thought to it promises to do for me precisely what using a compass would do to orient a person on uncharted terrain" (Letters, 462).

The world and its politics penetrated, if somewhat slowly, to Skovsbostrand. In September, Benjamin was dismayed by what he saw as Kraus's "capitulation to Austro-fascism, the glossing-over of the white terror instituted against the Viennese workers, the admiration of the rhetoric . . . of Starhemberg." He was led to ask, "Who can still give in?" (Letters, 458). By October, Benjamin was clearly desperate to leave Denmark, and this despite continuing productive and cordial relations with Brecht. He badly wished to return to his arcades work, an undertaking impossible on an isolated farm with no access to a library. This to some extent explains Benjamin's enthusiastic response to a proposal by Horkheimer that he follow the Institut für Sozialforschung, which was moving to New York. "I would most gratefully welcome the chance to work in America, regardless of whether it is to do research at your institute or at an institute associated with yours. Indeed, allow me to say that you have my prior consent to any arrangement that seems appropriate to you" (Letters, 460).

In late October, Benjamin left Denmark for Italy. After a layover of a few days in Paris, he continued on to San Remo, where Dora had bought and was running a pension, the Villa Verde. In the years since the divorce, her relations with her former husband had gradually improved. She had actively sought publication possibilities for him while she remained in Berlin, and she now offered him food and shelter in Italy, and not for the last time. As one can imagine, Benjamin was acutely aware of the ambiguous position in which his acceptance of Dora's hospitality placed him. In a moment of self-laceration, he said it was "pitiful and a disgrace to nest, as it were, in the ruins of my own past" (465). But in the relative peace and security of the Italian countryside, he returned to his habits of long walks, much reading, and a good deal of writing. Aside from the customary detective novels (Somerset Maugham and the ever-present Simenon), he read Julien Green's latest book, *Visionnaire* (which he found quite disappointing) and Karl Thieme's *The Old Truth: A Cultural History of the West*, a gift from the author. He also told each of his correspondents of his esteem for Robert Louis Stevenson's *Master of Ballantrae*, which he ranked "ahead of almost all great novels, and right behind *The Charterhouse of Parma*" (Letters, 464).

In December, his sense of isolation was relieved by a visit from Stefan, who intended to return to Berlin and his schooling at least until he could be registered in the Italian school system in the spring. Benjamin found his son composed, confident, and rather too serious. Even this visit was not enough, though, to lend Benjamin a sense of rootedness, and he continued to cast about for opportunities for movement. Scholem, having abandoned all hope of bringing Benjamin back onto the path of a fully committed Judaism, now proposed for the first time that Benjamin

pay a short, three-to-four-week visit to Palestine. As the year came to an end, Benjamin responded to this idea with the same enthusiasm he had expressed at Horkheimer's theoretical invitation to visit America.

Notes

1. Walter Benjamin, *Moscow Diary,* ed. Gary Smith, trans. Richard Sieburth (Cambridge, Mass.: Harvard University Press, 1986), p. 31. Subsequent references to this work will appear in the text as *MD.*
2. *The Correspondence of Walter Benjamin,* trans. Manfred R. Jacobson and Evelyn M. Jacobson (Chicago: University of Chicago Press, 1994), p. 312. Subsequent references to this work will appear in the text as Letters.
3. Walter Benjamin, *Gesammelte Briefe,* vol. 3, 1925–1930, ed. Christoph Gödde and Henri Lonitz (Frankfurt: Suhrkamp, 1997), p. 233. Subsequent references to this work will appear in the text as *GB.*
4. Gershom Scholem, *Walter Benjamin: The Story of a Friendship,* trans. Harry Zohn (Philadelphia: Jewish Publication Society of America, 1981), p. 130. Subsequent references to this work will appear in the text as Scholem.
5. Dora Pollak to Herbert Blumenthal and Carla Seligson, June 29, 1915. Cited in Hans Puttnies and Gary Smith, *Benjaminiana* (Giessen: Anabas Verlag, 1991), p. 140.
6. Dora Benjamin to Gerhard Scholem, July 24, 1929. Cited in Puttnies and Smith, *Benjaminiana,* p. 150.
7. Divorce Decree, April 24, 1930. Cited in Puttnies and Smith, *Benjaminiana,* p. 159.
8. Benjamin always addressed Scholem as "Gerhard," using his original name. (Scholem took the name "Gershom" only after moving to Palestine.)
9. See the essay "German Letters," in this volume.
10. See the essay "Privileged Thinking," in this volume.
11. Puttnies and Smith, *Benjaminiana,* p. 33.
12. Karl Kraus in *Die Fackel* 33, nos. 852–856 (1931): 27.
13. See "May–June 1931," in this volume.
14. Gershom Scholem, ed., *The Correspondence of Walter Benjamin and Gershom Scholem, 1932–1940,* trans. Gary Smith and André Lefevere (New York: Schocken, 1989), p. 13. Subsequent references to this work will appear in the text as Scholem Letters.
15. Benjamin refers here to (1) an early conception of *The Arcades Project;* (2) a book of his collected criticism on which he had pinned the greatest hopes; (3) a series of selected examples of bourgeois prose that would eventually be published pseudonymously in Switzerland as *Deutsche Menschen;* and (4) a book that would include his hashish protocols and commentary.
16. Ruth Berlau, *Brechts Lai-tu* (Darmstadt, 1985); cited in Momme Brodersen, *Spinne im eigenen Netz* (Bühl-Moos: Elster Verlag, 1990), p. 233.

Index